FRENCH PAINTING IN THE SEVENTEENTH CENTURY

ALAIN MÉROT

French Painting
in the Seventeenth Century

TRANSLATED BY CAROLINE BEAMISH

Yale University Press
New Haven and London 1995
published with the support of the French Ministry of Culture

Acknowledgments

My greatest debt of gratitude is to Jean-Loup Champion, who requested this book and has edited it, in the fullest sense. To Antoine Gallimard and the team at Editions Gallimard, in particular to Laurence Peydro, Brigitte Lemonnier, Emmanuel de Saint-Martin, Jacques Maillot and Isabelle Mariana who produced the design, Béatrice Petit who collected the illustrations, Christian Delval and Isabelle Loric who saw the book through production, and to Claire Marchandise who compiled the index.

Also deserving of heartfelt thanks are the keepers and curators of museums and public collections all over the world, and those private collectors who have generously authorised the reproduction of works in their possession. I should also like to give special thanks to Jean-Claude Boyer, Etienne Breton, Nicole Garnier, Gabrielle Kopelman, Robert Manning, Pierre Rosenberg, Antoine Schnapper, Jacques Thuillier and Patrick Violette for having provided me with particular documents or items of information during the editing of the book and the search for illustrations. I have benefited enormously from the wealth of documentation in the Department of Painting in the Louvre, under the curatorial care of Jacques Foucart.

A. M.

© Gallimard–Electa, 1994
© Yale University, 1995, English edition
Originally published in 1994 under the title *La Peinture française au XVIIe siècle* by Gallimard/Electa, 5 rue Sébastien-Bottin, 75007 Paris

Typeset in Bembo by Best-set Typesetter Ltd., Hong Kong
Printed in Italy by Amilcare Pizzi SpA, Milan

Library of Congress Catalog card number
95-60931

ISBN
0-300-06550-7

Contents

Foreword

Like many books written to order, this work responds to a need deeply felt by its author: the need, after twenty years spent in detailed study of a certain period, to step back and take some bearings. The editor's friendly challenge was accepted first and foremost on personal grounds. This kind of assessment is, in fact, always timely and, as work proceeds, seems ever more urgent. During the last few decades, studies of seventeenth-century French painting (the problems inherent in the title will be discussed later) have multiplied. A glance at the bibliography at the end of this volume, in which recent work has been deliberately given most prominence, should be sufficient evidence. General books by Anthony Blunt (1953), Bernard Dorival (1942, then 1979) and, in particular, Jacques Thuillier (1963–1964) have provided some guidelines, but many of these have been shifted by later, more detailed studies. Some memorable exhibitions, the vagaries of the art market and the work of experts have led to the reappearance of more than one first-rate painting. Taking up the search where nineteenth-century scholars left off, researchers have scoured the archives and begun to publish their finds. Numerous articles and a few monographs have enriched or reconstructed the careers and the catalogues of different painters. The development of the social sciences has made it possible to clarify or redefine the relationship between the works and the environment from which they sprang. In short, although there are still enormous (and irremediable) gaps, it is no longer possible to write about the painting of the Grand Siècle in the way it was written about thirty or forty years ago; our knowledge has broadened and matured to such an extent that our perception of the subject has changed considerably.

This is, of course, a matter for rejoicing, but also a signal for renewed vigilance. The more the raw material increases, the more subtlety piles on subtlety, the less is simplification possible. Scholarship constantly recalls the historian to a proper feeling of modesty; erudition can feed his arguments, but can also correct or even invalidate them. Hence the dilemma of this book. The aim was to offer the reader or scholar of today a clear panorama, appropriately illustrated, which would take into account the recent contributions made by art historians and scholars from other disciplines, as well as the educational demands of the genre. I am not sure to what extent I have achieved this. I am certainly very aware of my great and twin-pronged debt: first, to all the researchers who have patiently brought the whole seventeenth century, misunderstood or simply unknown as it was, to light, and who, from basic information through to rectification, have often profoundly altered our misguided convictions; also to my students who, year after year, have obliged me to make specialist knowledge, on this and other subjects, accessible.

At the cost of a number of sacrifices, I wanted to keep this book to a reasonable size. To do this I had to weigh personal preferences against concerns for objectivity, and to avoid listing great numbers of painters in order to concentrate on the most worthwhile. The need to master more than one century prevented me from including more detail, and even obliged me to leave out some quite important developments. I could not

linger over the paintings I thought the most beautiful or the most significant (not always the same). Other artistic forms, often closely linked to painting, are only referred to allusively, even though printmaking, drawing and sometimes tapestry have of necessity made their contribution. Such restrictions have, on the other hand, allowed me to identify some dominant themes, discussed at length in the first two chapters, which could be read as an introduction to the remainder of the book. I have endeavoured to reconcile the chronological study of the main stylistic movements with the study of the different categories of painting. All great works of art belong to a period; they bear within them a response to the preceding period and a set of responses for the future. Within their time and place they were also intended for the use and pleasure of one or more people, whom we think of as their public. The traditional approach, focusing on the chronology of the artists and their work, has been not so much overturned as modified to reveal routes and groupings that a monograph might have obliterated. My hope, and it may be sheer presumption, is that at any given moment such and such a painter or such and such a painting can be correctly situated; that the unique, often overwhelming position of the painter or painting which is linked (by a hundred near-invisible threads) to a certain historical and cultural milieu should be established even if only for a very brief space of time. This view of the whole is probably only a temporary one; it will be interesting to compare it with the view held by the historians of the future.

I wished in this way to respond to a regrettable situation: the confrontation, denounced by some (but in fact to a large extent deliberate and sustained), between a positivist discipline, linked to the history of objects and the meticulous study of sources, and a theoretical process that attempts to analyse and decode a work of art using the methodology of the social sciences. As far as the seventeenth century is concerned, recent contributions from both camps suggest that much would be gained from resolving the confrontation peacefully and abandoning sectarianism: without the combined efforts of scholarship and the trained eye of the expert, any theory would inevitably close in on itself, returning ceaselessly to the same paintings and failing to recognise the disturbing and endless diversity of reality; conversely, economic and social history, literary and religious history, semiology and aesthetics have, whether we like it or not, considerably modified our way of perceiving and interpreting old masters during the last thirty or forty years. The facts and the material presence of works of art are organised and brought to life by reflection, but they in their turn monitor its relevance. Dare I suggest that this two-way process, not always a comfortable or convenient one, has been the motive force behind my reasoning? This is the price of aesthetic satisfaction, or rather of what Poussin termed 'delectation', the ultimate goal of painting.

CHAPTER 1

SPACE, TIME, STYLES

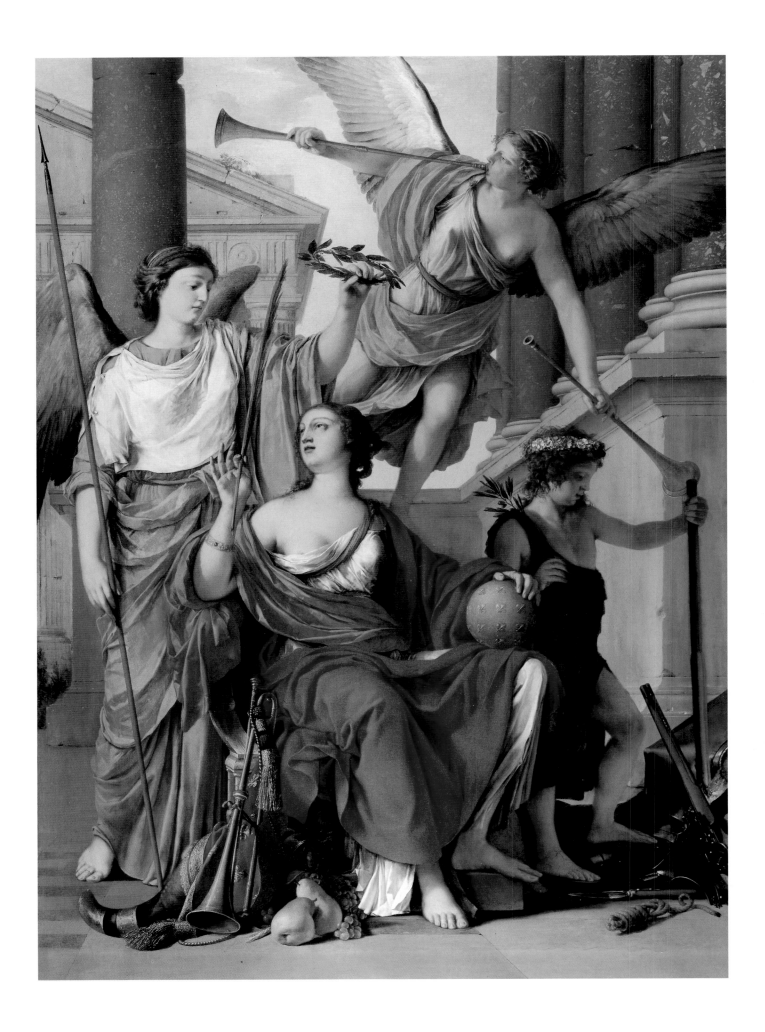

Although apparently quite anodyne, the title of this book begs a number of important questions. *French painting in the seventeenth century*: it could not be more convenient for the publisher, nor more reassuring for the public, yet it could not be less satisfactory for the author. Did *French painting* really exist as such at this period? And what should we understand as the *seventeenth century*? The time has gone when, for want of sufficiently detailed knowledge, the author could get away with the mention of a couple of famous names and two complementary centres, Paris and Versailles, the town and the court. For the last thirty years or more, paintings and painters almost unknown before have been appearing with great regularity. Areas that were shrouded in darkness have gradually become a little less obscure. The historian is obliged to simplify. But the perceptible growth in the material at his disposal has led to old ideas and long-held prejudices being questioned. The same goes for traditional geographical and chronological divisions, accepted without question for years.

In 1699, in his *Abrégé de la vie des peintres*, the critic and theorist Roger de Piles introduced the idea of a *French school*, which was to enjoy lasting renown. National pride is evident in his description of a century notable for some spectacular successes. French art had found its identity, an identity that put it on a par with Italy and the Low Countries. Thirty years earlier, in his poem *La Peinture* (1668), which combined praise of Colbert and Le Brun with praise of Louis XIV, Charles Perrault already proclaimed France to be the worthy heir to Athens and Rome, where the fine arts had excelled.[1] The word 'school' implies teachers and pupils, tradition and instruction. Perrault's paean of praise and Roger de Piles's definition combined to endorse the role of the Académie Royale de Peinture et de Sculpture, founded in 1648, in the cultural life of the kingdom as well as in the renown of the personalities proposed as models. Three names in particular won unanimous approval in the eighteenth century: Poussin, Le Sueur and Le Brun reigned supreme in Voltaire's *Temple of Taste* (1733),[2] completely overshadowing their fellow artists. Thanks to them, France took on the mantle of Renaissance Italy and her fame spread throughout Europe.

Guardians of the national genius, these three could hold their own with the other great masters: Raphael, Titian, Annibale Carracci or Rubens. Lesser talents clustered around these great stars. The classification proposed by de Piles was suited to a rapidly expanding trade in fine art. The distinction made between the different schools served to divide painters on a geographical basis and to create a hierarchy among them; by isolating identifying features, order was imposed and attributions and prices decided upon.[3] At a later date, after the Revolution, official administrators given the task of setting up the first museums took up the divisions between the separate schools again,[4] and thus they entered the statute books; in the nineteenth century political nationalism reinforced the divisions and in general they still remain in place today.

Nevertheless, the notion of a French school, even when presented under the less loaded title 'French painting', is far from adequate. It smacks of monarchic then Jacobin centralisation and of the pre-eminence of Paris, already very pronounced at the time when de Piles wrote his book. It does not take into account the instability and openness of European frontiers, nor the widely differing regional characteristics. Italy, traditionally divided into separate states and strengthened already, after Vasari, by the possession of a written history of art, presented a very different aspect in the seventeenth and eighteenth centuries. Art experts and dealers made a clear distinction between the regional schools: Venice, Bologna, Florence, Rome, Naples and Genoa. This method of classification corresponded perfectly well with historical reality in Italy: communication between the many artistic centres was frequent, but each held firmly to its own identity. Could the Italian model apply to France in the seventeenth century? Few towns, it is true, could offer artists as skilled as those of Paris or Rome. It is also true that a Parisian career, for a growing number of talented craftsmen, was becoming *de rigueur*. Nevertheless, as more research is done on the history of the provinces, and more documents and scarce drawings and paintings come to light, the more our narrow view has to be broadened and a map drawn up to take account of the great

1. *previous pages*: Claude Vignon, *The Triumph of Hercules*, 1634. Oil on canvas, 162 × 217 cm. Caisse Nationale des Monuments Historiques.

2. Laurent de La Hyre, *Allegory of the Regency of Anne of Austria*, 1648. Oil on canvas, 225 × 162 cm. Musée National du Château, Versailles.

diversity of the period, already hinted at (to some extent) by scholars in the nineteenth century.[5] Such a map would not tally with the map of the kingdom of France which, anyway, was subject to constant alterations, particularly in the north and east, where a succession of annexations took place (pl.3). Political frontiers have little bearing on the history of art. It would seem to be good sense to limit this study to the history of a few centres and the connections between them. Rouen, Lyon and Marseille need to be considered separately, but their relationship with larger poles of attraction such as Paris, Antwerp, Rome or Genoa also needs to be taken into account. None of these centres operated in a vacuum: each was defined by the amount of influence it wielded (measured in terms of what it received as well as what it gave), and by its capacity to accommodate, assimilate and disseminate talent. The extreme mobility of artists and their work should not be forgotten either.

A good deal of emphasis has rightly been placed in recent years on the trips to foreign countries made by French artists and their sojourns abroad, particularly in Italy. Their presence was very strongly felt there during the first thirty or forty years of the seventeenth century, before Paris was in a position to offer adequate training or career prospects. Some of these artists, like Valentin, Claude Lorrain, Poussin or Dughet, spent the whole or the best part of their careers there. Others, like Vouet, Perrier or Pierre Mignard, stayed for a considerable time. It would be absurd in the case of the last three to consider only the specifically French phase of their careers, but a few cases are less cut and dried. Dughet was the son of a Frenchman but he was born, lived and died in Rome; Claude, born in Lorraine, went to Rome before he was twenty and stayed there for the rest of his life. Should they be counted as French painters, or does their residence in Rome not fit them better for a place in the history of Italian art? They can nevertheless be distinguished from their Italian *confrères* by certain identifying traits, as well as by the links they maintained with France. Dughet's family relationship with Poussin, Claude's particular kind of sensibility and the role his work played in defining landscape

painting in France encourage a certain measure of caution. Besides this, the debate over where to place Poussin is still in full swing.[6] It is a spurious debate, however, because the two cities, Paris and Rome, complemented one another perfectly in their contribution to Poussin's development as an artist, producing works of enormous originality, and suggesting new avenues of exploration to artists working in France.

A further problem is posed by the border provinces, like Lorraine under the Dukes or the Principality of Liège, which had their own political structure. Lorraine had dynastic links with Florence and Mantua, and before being annexed in 1633 turned its attention towards the Empire as much as towards France. Nevertheless most of Lorraine's greatest painters – Deruet, Callot, La Tour – worked for Louis XIII and were known and appreciated in France once they had returned from fraternising with their French counterparts in Italy. In spite of what Barrès has said,[7] it would be impossible to envisage a Lorraine school of painting cut off from contacts with France, focused on Italy, producing work in which national characteristics were entirely concentrated. Equally Liège, strongly attracted to Rome and then to Paris, developed an artistic style that owed little to Flemish tradition and cannot be analysed with reference to any local input; it has to be seen in relation to contemporary European artistic developments.[8] Finally, a number of regions or towns, while belonging indisputably to the kingdom of France, were attracted to other places: Lyon, Provence and Languedoc all had a special relationship with Italy and the Mediterranean, and these lasted well into the second half of the century. Rouen and Paris, on the other hand, played host to large colonies of Flemish painters and this naturally had some effect on their outlook. The originality of Paris as a centre arose partly from its geographical location, at the crossroads where northern and southern influences met. Both Gentileschi and Rubens worked in Paris, as did Willem Kalf and Romanelli, all foreigners certainly, but all essential to the development of a great international centre.

The existence of fixed and mobile elements (artistic centres and painters and painting) needs to

be taken into account; the mobile elements rotated around the fixed elements with variable range and frequency. An historian may focus attention more on one element than on another, sometimes emphasising stable factors, sometimes fluctuations. In the first case he will give priority to political institutions, to the economic situation and to social structure, describing patronage by different sections of society. The study of commissions and outlets is central, but these varied at different periods in the strength they exerted in different centres: thus, at the beginning of the century, Rouen, Nancy, Lyon or Aix-en-Provence were just as important as Paris, but as the monarchy grew progressively stronger, causing a concentration of wealth and talent of all kinds around the court and the city from 1625 onwards, the balance of power changed completely. Each centre had periods of expansion, followed by periods of maximum influence, stagnation and decline. Local traditions and regional differences managed to persist, however. On the other hand, the study of the movement of painters and their work, and the consequent analysis of models to be imitated or rejected, of the diffusion and synchronisation of styles, would have the effect of emphasising change and interruption. No situation lasts for ever: the historian can only log convergences, and spot routes and stopping places that are more frequented than others.

The journey to Italy, an important stage in the training of an artist, has particularly captured attention. Sometimes the accent has been on the itinerary and physical conditions,[9] sometimes on the length of the stay;[10] the background to the trip, and in particular the cultural background, has not been neglected. In a few well-documented cases a detailed chronology of departures and returns has been established and this affords a better appreciation of the way change affected the artist's work. The mobility of artists was matched by the mobility of their paintings. Many of the leading international artists had no need to put in an appearance to make themselves known. Art collecting and the art trade, which developed in the Paris of Richelieu and Mazarin, are beginning to be studied in detail.[11] Study of the leading engravers of Europe, and their role in art education and

the transmission of ideas should also further our understanding.[12] Two examples come to mind: the prevalence, then persistence of Mannerism in Paris and the provinces was not only attributable to the influence of Fontainebleau, but also to the immense diffusion of engravings from Antwerp at the end of sixteenth and beginning of the seventeenth centuries. Later on, the authority of Poussin was founded on the presence in Parisian collections of most of the paintings of his maturity, as well as on their reproduction as engravings.

The acceleration or decline in exchanges between centres accounted for developments taking place rapidly or less rapidly: art history at variable speed. The centres that were in a constant state of flux, to which artists and styles from elsewhere could gain easy access, which were blessed with prosperity and a demanding patronage, enjoyed intense activity: talented artists would flock there, bringing with them culture and ambition and public taste would duly be modified. Paris took over from the Rome of Urban VIII during the regency of Anne of Austria and the early years of Louis XIV, playing host to a succession of innovations. Construction work was booming, there was infatuation with painting among certain echelons of society and earnest debate about artistic theory; perhaps the most influential factor in stimulating creativity was the inclusion of fine art among the educational and cultural requirements of the 'honnête homme', or gentleman. By contrast the side effects of stability won the day in the provinces, where local tradition ceased to be endlessly renewed and where the most talented artists were inevitably attracted towards the capital. The local clientèle clung to the functional purpose of works of art, thence to iconography and forms that had been established for centuries. Local painters guarded their prerogatives jealously. With a few exceptions, innovations were slow in coming, delay and the persistence of old forms being in evidence everywhere. In short, no clear-cut picture of the general evolution of painting can be built up because of the time-lag between centres as well as between artists.

It is also difficult to trace a general path because the chronological divisions of the period, particu-

larly of political history from the reign of Henri IV to that of Louis XIV, have never been satisfactorily established. Should the period be divided in a different manner? In his anxiety to put a date on the emergence of a national school, Louis Dimier (for sound enough reasons) chose 1627, the date of Simon Vouet's return to Paris.[13] Before that, with Fontainebleau and the ascendancy of international Mannerism, the talent and prestige of Italian and Flemish painters tended to overshadow lesser-known French artists, who could then only excel in subsidiary areas like portraiture. The fact remains that even as late as 1621, Marie de Médicis asked Rubens to decorate the Palais du Luxembourg because there were no Italians currently available, and certainly no French muralists experienced in handling such large and ambitious decorative schemes. It was not until the arrival of Louis XIII that any big Parisian studio could be said to have established a tradition – a French school. Dimier's singularly restrictive view of the situation reflects the blinkered nationalism of its author, who chooses to ignore the activities of French painters during the first thirty years of the century – painters like Lallemant and Varin in Paris, and artists in the provinces as well, including Lorraine, which was just reaching its artistic zenith at that time.

Nowadays we are a little more familiar with this hazy period, which certainly abounded with talent, than it was possible to be in Dimier's day. The exhibition in Meaux (1988–9) entitled *De Nicolò dell'Abate à Nicolas Poussin: aux sources du classicisme* (1550–1660),[14] proposed historical divisions that were equally artificial, but which had the merit of overturning certain entrenched ideas. The aim was to loosen the ties attaching the seventeenth century, or at any rate the first half of it, to the preceding period. The importance of the two Schools of Fontainebleau had already been recognised. A major artistic movement stemmed from there: sophisticated, elegant decorative painting; a celebratory style linked to the court and courtly values which made use of fable and allegory rather than the direct representation of reality; concern for abstraction and style. The exhibition in Meaux and the research that went in to mounting it also shed light on the importance of

large studios like that of Lallemant, and the achievement of native painters like Varin or painters from elsewhere like Frans Pourbus the Younger. At the same time the artistic activity of all the French centres during the early part of the century was re-evaluated. Simon Vouet was reassigned to a position as part of a movement of which he may have been the most gifted representative, and the symbolic date 1627 could no longer be regarded as a fixed date of departure.

At what final date at the other end of the century would it be appropriate to close our period? Here again Dimier's choice of the death of Le Brun in 1690 is unnecessarily limiting, and seems as debatable as his earlier choice. Direct disciples of Le Brun, among whom should be included innovators like La Fosse, cannot be presented separately from their teachers. The famous dispute about colour, the first of a series of exchanges of opinions that became customary between French artists, far from causing a rupture produced an enriching dialogue in the history of French painting, and one that is impossible to understand unless one has some idea what preceded it. The terminal date chosen for this book (the death of Louis XIV in 1715) is not a particularly original choice. The year 1699 might have been preferable, the year when Jules Hardouin-Mansart was appointed clerk of works to the King, when Roger de Piles's *Abrégé* was published and its author was made a member of the Royal Academy and when, at the Salon du Louvre, there was a breakthrough with new trends and even new types of painting. In fact, during the years 1700 to 1720, many different kinds of painting co-existed simultaneously. Before the Regency and the reign of Louis XV there was a gradual evolution in matters of taste and in the art market, although in religious and monumental art the style favoured under Le Brun was still producing successful results. The art of Watteau, who died in 1721, belongs incontestably to the most modern tendency, while the art of Antoine Coypel, who died only one year after, still lingers in the aesthetic of the Grand Siècle.

To give rhythm to this considerably expanded seventeenth century, a strong musical beat needs to be introduced, a hazardous task, complicated

by the fact that regional variations have to be taken into account. It is tempting to contrast the two periods that flank the crucial date, 1661, when the reign of Louis XIV began. The first period embraces the reigns of Henri IV and Louis XIII and the regencies that followed them. Nothing seemed stable, everywhere there was movement, indecision, contradictions: strong and adventurous personalities; constant and initially unequal communication between France and her neighbours; local disparities that were still very marked. For years this period has been a favourite with historians and public alike. The 'painters of reality' and the rehabilitation of the Le Nain brothers and La Tour, Poussin's intellectual quest and Philippe de Champaigne's austerity, the enthusiastic resurrection of the Baroque, in painting as much as in literature and music: such a wealth of assets adds up to a period that was colourful yet emotionally very demanding. The forties and fifties, generally much less liked, saw the triumph of the over-refined style of Parisian Atticism and the burgeoning of the Academy. This period, and the work of La Hyre and Le Sueur in particular, has recently been re-evaluated.

The second half of the century is still regarded as a housekeeping period. The authoritarian rule of the King and his ministers reinforced the centralisation of artistic life and seems to have crushed all attempts at independence. Under Le Brun's stern guidance, the Academy promulgated dogma of a highly restrictive nature. At Versailles, the mythical palace and repository of the French nation's shared memory, the *art de cour* persisted in its most rigid and withered forms.[15] This picture of the period, however, needs to be considerably qualified and adjusted. The pre-eminence of Le Brun ceased well before his death. The Academy was riddled with dissension from the 1670s on, with the followers of Poussin in conflict with the followers of Rubens. The end of the century was generally a difficult period for the Academy, and centralisation was not in fact so pronounced as to crush all local variants, particularly in the southern part of the country. At the end of Louis XIV's reign, Paris regained its importance while that of the court at Versailles declined, making way for the emergence of smaller and more liberal courts

in outlying areas: princely taste took over from royal taste in preparation for the style of the Regency. More intimate subjects, lighter and more brightly coloured, began to find favour. New approaches and new experiments of bewildering diversity were tested.

Division of the period according to the life-span of different kings and ministers can offer only a partial and often inexact version of reality. Too much importance is accorded to personalities, and to the interest and authority of rulers and their entourage. Should this version of history be rejected in favour of a version based on the life-span of the artists, and divided by generations? This would presuppose something that is only partially true – that painters born at about the same time share a common way of seeing, follow the same models and seek similar solutions to the common problems that books on the art of the period attempt at once to define and to resolve. The second half of the nineteenth century and our own late twentieth century, with their successive movements, their groups and manifestos have strongly contributed to the endorsement of this version.

According to this version, a first wave of painters born in about 1570 can be identified which includes late Mannerists like Fréminet, Varin or Lallemant: this generation marked a transition. They were still involved in the declining Renaissance and were subsequently looked upon with disdain. After them came the prestigious generation of the founders of the French School, with their exceptional taste for adventure and strength of character. They were fascinated by Italy and challenged current style in a way that was at times quite fundamental.[16] Vouet and Poussin, contrasting characters, dominate this period, which was rich in colourful personalities like Valentin, La Tour or Champaigne. Vouet's disciples and heirs, born between 1610 and 1620, were soon focusing their attention on new models: the uncompromising painting of Poussin, who was recalled to Paris for a short time in 1640, was to contribute to the development of a stricter, more measured style by Le Sueur, Le Brun, Pierre Mignard, La Hyre and Bourdon. It was at this time that the recently established Academy began to give these young

painters a heightened sense of the dignity of their art. Their direct successors, born in about 1640–50, like Jouvenet, La Fosse or Verdier, started their careers at the beginning of the reign of Louis XIV and were subject to the ascendancy of Le Brun. They worked in Paris, Versailles and the Gobelins. A tradition was establishing itself (the 'grand goût' of the reign of Louis XIV), but it was actually being undermined by members of the Academy, as well as by independent endeavours from the provinces by painters like Puget or Michel Serre in Provence, Rivalz in Toulouse or Blanchet in Lyon. Finally, the last generation of the century, born around 1660 and painting after the 1680s, including Largillierre and Antoine Coypel, were to query the achievements of their predecessors. Significantly enough, the most radical innovations made at this time were in the field of easel painting, and their effect was felt throughout all the painting styles.

This method of dividing the century fails to take into account the diversity of talents and of individual careers. There is an enormous difference between La Tour, born in 1593, and Poussin, born in the following year; between Claude Lorrain, born in 1600, and Champaigne, born in 1602! And the geographical difference in those painters' origins (Lorraine, Normandy, Brussels) could also offer some clue to the various nature of their talents. Even if a sample is chosen from a single centre, in this case Paris, the nuances that distinguish La Hyre from the Le Nain brothers, or Le Sueur from Le Brun, are still very pronounced. The determining factors such as race, class and moment in time, introduced by Taine and the positivist historians, have to come to terms with the internationalisation of artistic life, already very advanced in the seventeenth century. Painters often had reason to cross over into different milieux, or to react to a series of situations that altered the course of their careers in some way. A detailed study of such alterations in circumstances would go a long way towards correcting our over-generalised view of the period.

Economic and social factors, and fluctuations in patronage need therefore to be measured carefully.[17] The century started in crisis because of the aftermath of the Wars of Religion. From 1595 to about 1620 the position of art and artists in a country in the throes of reconstruction was a difficult one, although Lorraine at the time was enjoying a period of prosperity. Outlets remained scarce, royal patronage enfeebled and commissions from the aristocracy and bourgeoisie alike still spasmodic. Only the Church, obedient to the edicts of the Counter-Reformation, continued to employ artists. This trough in the market, during which foreign centres exerted their strongest pull, finished in the 1620s with the return of prosperity; the art market woke up and the first collections, headed by Richelieu's own, began to be developed. Royal politics became more active and policies more coherent. The attitude of the upper classes towards painting changed radically: painting began to be thought of as a symbol of wealth and prestige, and also as a source of pleasure and spiritual inspiration. Vouet's return in 1627 and the return of Poussin in 1640 thus can be seen as having symbolic value.

The aristocracy and nobility followed the lead of the King and his Minister. The years between 1630 and 1660 witnessed a great burgeoning in the arts and the pre-eminence of Paris was confirmed. The number of commissions for decorative schemes increased, secular painting for private clients equalling religious commissions for the first time. Talented artists flocked to the capital, references multiplied and the development of different styles accelerated, assisted by the vagaries of fashion. The establishment of the Academy bore witness to the King's desire to enlist painters to his support, and also demonstrated the social and intellectual aspirations of the painters themselves. In spite of the problem of the Fronde and the slowing of growth it provoked in the 1650s, it is quite evident that at the time of the accession of Louis XIV French painters were possessed of a prestige and social ease that were seldom to be seen at the beginning of the century. The independence of Poussin, Vouet and Le Brun's versatility, all of them teachers as well as running studios, played their part. After this climax, the brilliant successes at Versailles and in some of the great building works in the provinces should not distract attention from the crisis that was looming. An economic crisis, certainly, but also a crisis of fashion.

Painting was being replaced in decorative schemes by ornamentation; cabinet paintings, Poussin's speciality, were admired by a widening circle of enlightened collectors and were becoming increasingly important. Thanks to the debate over colour that began in 1673, things became more relaxed; new avenues for painting opened up, the purely visual element beginning to override invention and ideas. Taste grew more refined and less narrow, more connoisseurs emerged who were aware of the craft of the painter and took an educated view of subject matter, assisted by examples from further north. Public demand diversified and styles hitherto held in little regard by the educated classes blossomed; the artists, encouraged by their recent successes, painted away with gusto.

The different geographical and chronological contexts, though not mutually exclusive, are self-regulating and should help not hinder the historical investigation of successive styles. French art historians have shown little faith in the history of styles in recent years; their distrust is understandable given that German art historians and theoreticians in the late nineteenth century, led by Wölfflin, seldom if ever took examples from French art when they elaborated their notions of Classicism, the Baroque and Mannerism.[18] As a reaction to a history of art without any artists, the French withdrew into a narrow concentration on individual painters. This led to an overzealousness that was the reverse of the German position, the French replacing historical discourse with a series of monographs. We need to try to go beyond this paralysing state of affairs. It would be absurd to devalue individual artists as it would be to deny the irrefutable, sometimes awkward, presence of their work. Should this, however, prevent us from taking an overview of important trends, from following up clues, from trying to elucidate? Movements and styles need to be seen for what they are: labels which give only a rough idea, but which are useful signposts in a maze with a thousand twists and turns. These labels are not manifestations of any act of will on the part of the artists,[19] they are not common to any particular period nor do they conform to any current whim. They should not be given too great importance

nor autonomy that might be regretted later. The opinions and shades of meaning that will be met with later in this book will, I hope, make generalisation and broad conceptualisation fruitless. But there will be descriptions of tendencies, of groups of artists and sequences of paintings, justifying the names of styles as a useful piece of investigatory equipment.

It must be recognised that French painting, standing as it did at the cross-roads of the different traditions of Europe, during the seventeenth century carved out for itself an identity distinct from any other. Its history is a history of encounters, all of which left their mark, sometimes durable, sometimes less so: the sophistication of late Mannerism; the coarseness and dramatic lighting effects of Caravaggism; the cultivation and measure of the Bolognese school; decorative Roman Baroque; the colours used by Flemish painters and their enjoyment of realism . . . All these contributions were modified and assimilated in a fashion that should not be viewed as a one-way process, although it is often still thus regarded.[20] The historian's task is to trace connections and terms of exchange. Facts cannot be recreated as a continuum, and to imagine that they can has to be an illusion. The historian can only indicate routes on a map, and place situations and relationships within their time-scale. This often involves exploding an individual career or a personality. The aim of this book is not to chart the progress of each great painter, but to attach the different stages of a career to the different temptations met with by the artist, and to chronicle the different circumstances of his life. Analysis of the most important works of each artist is deliberately curtailed in favour of a more general overview that aims to take in the environment and period in which these works were produced.

A fresco, an altarpiece, a cabinet painting had to respond to a number of fixed requirements or, if you prefer, challenges. Spatial, technical and iconographic constraints (a painting contains meaning as well as form) had to merge with the artist's training and education plus the expectations of his public, who would be looking for references to existing works of art, for what I shall refer to as formulae and models. At the same time,

alongside the Noble art of history painting (religious, mythological, historical or allegorical), some of the specialised kinds of painting – realistic subjects known as genre paintings, portraiture, landscape, animals and still lifes, posed particular problems for the artists. These must therefore be dealt with in separate chapters. Vouet's portraits and Bourdon's landscapes belong to families of works whose development, though often accompanying a more general movement, also had its own rhythms. The history of styles is not a straightforward series of actions and reactions. There is a danger that an altar painting and a still life might be grouped together because they seem to contain similar evidence of the Baroque, according to Wölfflin's categories: 'open form' or 'pictorial vision'.[21] To do this would be to ignore the essential difference between the two types of painting, for both artist and spectator. Trouble has therefore been taken to respect the diversity of situations, and to use all the evidence available today to emphasise this diversity. The proportion of documents and works still extant is relatively tiny,[22] and it would be a delusion to think otherwise. But it is nevertheless sufficient to give some idea of the richness of seventeenth-century French painting, with all its contradictions, its impatience and enthusiasms, its hesitations and even its failures, aided and abetted by the dim traces contained in written history.

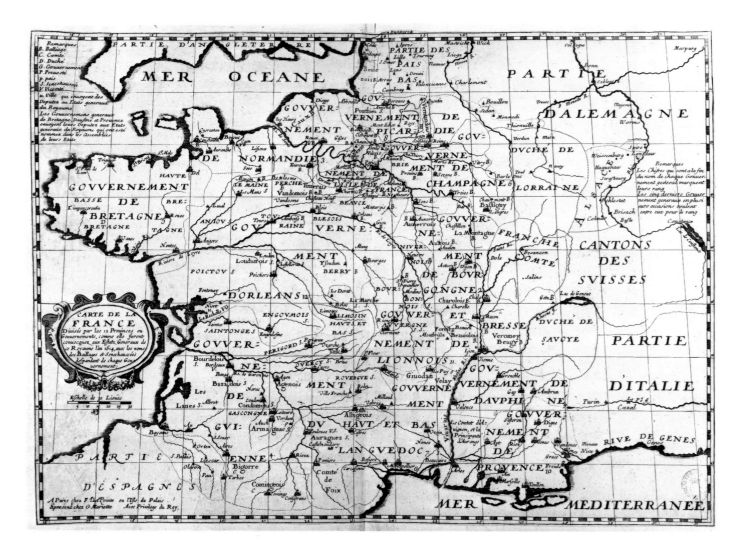

Notes

1. Perrault, 1668 (1992), v. 205ff., p.99.

2. Voltaire, *Mélanges*, Paris 1961, 'Bibliothèque de la Pléiade', p.147. Following the example of Roger de Piles, Voltaire sees painting as a mixture of the qualities of the three great French masters, plus Rubens.

3. Note in particular the part played by the dealer, Jean-Baptiste-Pierre Le Brun, who presented his paintings classified into schools in his *Galerie des peintres flamands, hollandais et allemands* (Paris 1792–6).

4. It is worth remembering, however, that the organisation into schools was opposed from the time the Museum opened, in particular by Alexander Lenoir, who favoured a chronological presentation (see E. Pommier, *L'Art et la Liberté. Doctrines et débats de la Révolution française*, Paris 1991, p.372).

5. Chennevières, 1847–62, vol. I, preface: 'The division of France into provinces was never more clear-cut than at the moment of the birth of the first French school [. . .] Paris had no stranglehold over the provinces, as it offered no organised school to tempt them. Each painter got his training in the place where he was born'.

6. See J. Thuillier: 'Poussin, French painter or Roman painter?' Rome and Düsseldorf, 1977–8, pp.36–37.

7. See the passage in Barrès *Cahiers* (1901) quoted in exh. cat. Nancy, 1992 (2), p.100: 'When my heart swells with pride over my Lorraine, when I say to the editors of dictionaries 'I forbid you to write Claude Gellée, French painter, Callot, French engraver, etc.' [. . .] I know that there is one question that would solve all our problems, and that is whether Gellée, Callot, Richier were really primarily from Lorraine.'

8. Hendrick, 1973; Thuillier, 1987 (1).

9. Thuillier, 1984 and 1987 (2).

10. Bousquet, 1980.

11. Bonnaffé, 1884; Schnapper, 1994.

12. Bibliography in Grivel, 1986.

13. Dimier, 1926–7. On Dimier, see the anthology of his writings on French art compiled by H. Zerner, Paris 1965.

14. Exh. cat. Meaux, 1988–9 (by J-P. Changeux and various collaborators).

15. See in particular the omissions of Teyssèdre, 1967.

16. See Thuillier, 1963 (1992), p.157; 'La grande génération du XVIIe siècle'.

17. As recently emphasised by J. Thuillier, exh. cat. Montreal, Rennes and Montpellier, 1993, p.22ff.

18. See the recent studies in French: E. Darragon, 'L'esprit du style', in Friedlaender, 1957 (1991), pp.5–16; Bottineau, 1986, pp.25–31; A. Mérot and M. Mosser, 'Le retour du baroque: us et abus', *La Revue de l'Art*, 90 (1990–4), pp.5–7; R. Zuber, 'Classicism', and C. Mignot, 'Baroque', in Bluche, 1990.

19. On Aloïs Riegl's *Kunstwollen*, see the preface by P. Philippot to the French edition of *L'Origine de l'art baroque à Rome*, Paris, 1993, p.10ff.

20. 'France is a filter. It receives and it sifts. France is penetrable from all sides. [. . .] If a definition of French art is sought, in addition to these movements of acquisition and sifting, only a paltry and disappointing answer is arrived at, which is quickly exhausted in the midst of the celebration of delicacy and clarity'. (A. Chastel, *Introduction à l'histoire de l'art français*, Paris 1993, p.63.

21. H. Wölfflin, 1915; English edition, *Principles of Art History*.

22. J. Thuillier (exh. cat. Montreal, Rennes and Montepellier, 1993, pp.30–4) gives a rough estimate of four or five million paintings executed in France in the seventeenth century; the number of works still extant is only about four per cent.

3. Map of the provinces of France in the seventeenth century, by F. de la Pointe.
Bibliothèque Nationale, Paris.

CHAPTER 2

PAINTERS AND THEIR PUBLIC

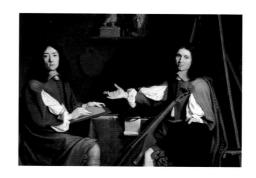

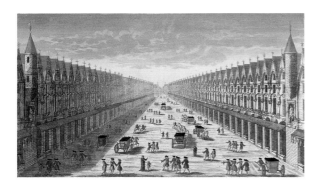

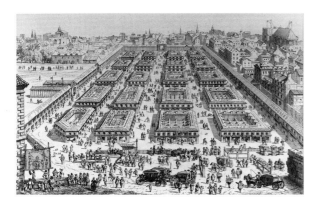

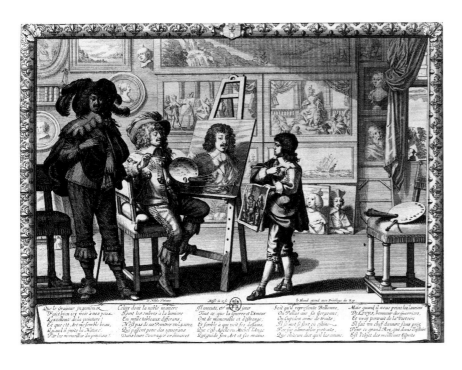

4. *previous pages*: Jean-Baptiste de Champagne and Nicolas de Plattemontagne, *Double portrait*, 1654. Oil on canvas, 132 × 185 cm. Boymans-van Beuningen Museum, Rotterdam.

5. Aveline, *View and perspective from the Pont Notre-Dame*, beginning of the eighteenth century. Engraving. Musée Carnavalet, Paris.

6. A. Guillaumot, *The Foire Saint-Germain in about 1670*. Engraving. Musée Carnavalet, Paris.

7. Abraham Bosse, *The Artist's Studio*. Engraving. Département des Estampes, Bibliothèque Nationale, Paris.

'Painter: a person who employs colour with art to represent all manner of objects'. The definition provided by Furetière in 1690, though brief, makes the important distinction between the artist-painter and the person who 'paints roughly with a brush, who covers a wall or floor with colour'. The definition, however, covers a variety of practices, from house painting to the composition and execution of sophisticated works of art; and, as well as those who compose and invent, it also embraces painters who repeat or copy well-tried forms to satisfy the demands of a clientèle with little interest in innovation. The study of old contracts and sales is revealing:[1] the painter in seventeenth-century France was still regarded as a craftsman, but an important shift in attitudes was just beginning to transform him into an artist in the fullest sense of the word. At the outset, this shift affected only a small number of well-established personalities, and was restricted to Parisian intellectual circles before it became more generalised. While the material and cultural status of painters developed, their relationship with their clientèle was also beginning to change. The idealised picture of themselves that they wanted to convey, to proclaim their new ambitions and intentions, was in sharp contrast to the traditional view.

It is not particularly appropriate to speak of a painter's vocation in the seventeenth century. True, some semi-legendary examples are often quoted: Callot leaving his family as a child to follow the gypsies to Italy; Claude Gellée, arriving as a young orphan in Rome and going into domestic service in the house of a famous painter; Poussin, thwarted by his father's wishes, leading a frugal life in pursuit of his passion. None of these cases is typical, and their stories have probably been doctored by biographers in search of the sensational. For the great majority, painting was a trade like any other, to be passed down from father to son, controlled by a guild with very strict rules; it was also a career that followed well-established stages, from apprenticeship to expertise. Few surprises then: the painter was usually the son of a painter, sculptor or craftsman. The social environment encouraged such natural arrangements. Poussin, or the Le Nain family, who

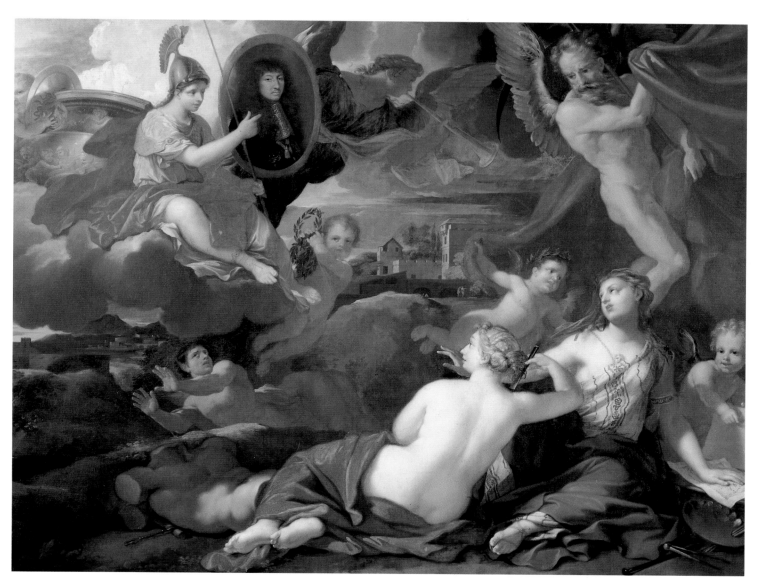

were borderline gentry or in royal employ, were the exception. From one end of the century to the other, these dynasties, so typical of the Ancien Régime France, passing down their patrimony and their skills, were to be found. Family workshops were the norm, with parents and children, brothers and sisters working together, not infrequently, like the Le Nain family, under a single signature. Among these tightly knit groupings only the ones that survived over several generations will be discussed here: the Elle family, the Corneilles, the Boullognes or the Coypels. The

upholding of family tradition goes some way towards explaining the conservatism of their enormous output. But it had its advantages as well: the workshop and its trade mark ensured that young members of the family had access to training and to a ready-made clientèle.

During the first half of the century at least, when the corporate model prevailed, the status of painters in an ordered society was decidedly inferior. The successful, established ones, who had achieved the rank of *maître*, occupied the same category or stratum[2] as tradesmen or master crafts-

8. Nicolas Loir,
Allegory of the Founding of the Académie Royale de Peinture et de Sculpture, known as *The Advancement of the Arts during the Reign of Louis XIV,* 1666.
Oil on canvas,
141 × 185.5 cm.
Musée National du Château, Versailles.

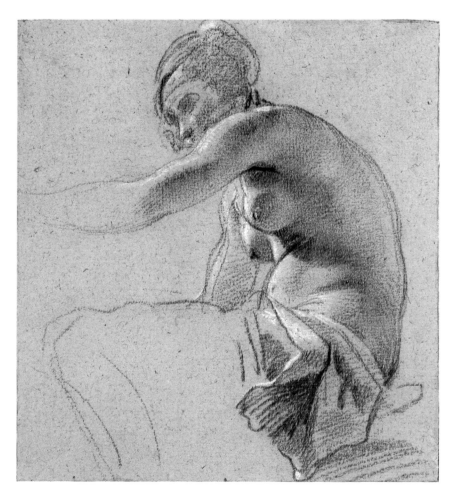

9. Simon Vouet,
Seated Woman, semi-nude.
Drawing, graphite with
white heightening on
light brown paper,
20.6 × 18 cm.
Département des Arts
Graphiques, Musée du
Louvre, Paris.

10. Jean Boucher,
Seated Nude.
Drawing, graphite and
stump,
35.3 × 20.4 cm.
Musée du Berry, Bourges.

men. They produced manufactured objects and
sold them in shops. The manual or mercantile
nature of their work prevented their joining the
gentry in the higher strata. The cohesion and
isolation of the milieu was increased by the ten-
dency of its members to marry among themselves.
A young painter would generally marry the
daughter of a craftsman or a tradesman, or the
daughter or widow of a painter and this would
facilitate his starting a career. The network of
relationships was very tight. Thus Vouet married
off his daughters to several of his pupils and col-
laborators, consolidating the clan thereby and re-
inforcing his already pre-eminent position.
Poussin, who died childless and without real dis-
ciples, seems an extraordinary exception to the
general rule.[3] This situation had changed very

little by the end of the century, although the most
celebrated painters did see some improvement in
their social status. The case of Pierre Mignard,
whose daughter was to become a countess, was
unusual enough to cause a stir.

The training of painters at the beginning of the
century was basically the responsibility of the
Corporations, the most important of which was
the Corporation of Paris, whose statutes and regu-
lations were drawn up in 1391.[4] In 1430, Charles
VI granted certain exemptions to the *maîtres*, and
these rights and privileges were renewed in 1619.
The influx of foreign artists, particularly from
Flanders,[5] working in locations that lay outside
the jurisdiction of the Corporation like the Abbey
of St-Germain-des-Prés or the Temple, and the
pressure of artists who had enhanced their status

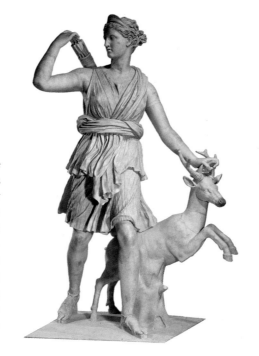

by being granted a royal warrant, encouraged the authorities to strengthen their own position. This meant supervising the training of apprentices by licensed master-painters, and controlling the number of painters allowed to work in each zone and the quality of the materials used. The Corporation also claimed the right to prevent anyone but its members from opening a shop or from doing business with painters, including selling paintings, or from employing workmen. An elected body of jurors made the rounds to make sure the statutes were being strictly enforced. Other craftsmen, including masons, carpenters, woodturners and haberdashers were forbidden to undertake any painting or sculpture. This increased protectionism would provoke reactions that would eventually cause the break-up of the monopoly.

The power of the master-painters rested on the training system, over which they had control. Apprenticeship began in adolescence and lasted between five and eight years. For a fee (some heads of well-known studios charged a lot), the master gave board and lodging to the student painter and undertook to teach him his craft. The training was exclusively practical. To begin with the apprentice learnt to grind colours and prepare canvases and brushes. There was much copying of prints, drawings and plaster casts. In large studios the apprentice then moved on to life-drawing: evidence that this is what happened, for instance, in the studio of Jean Boucher in Bourges (pl.10, 12), or Vouet (pl.9) in Paris, is provided by a number of drawings. If the master was a decorative artist the apprentice would make his début on site, first as an assistant carrying out the most menial tasks, later as a collaborator painting ornaments, landscape backgrounds or flowers: this is how Champaigne and Poussin started their painting careers, working under Duchesne at the Palais du Luxembourg. In the larger studios, like the studios of Lallemant or Vouet or, at a later date, Le Brun, the number of assistants and the scale of the commissions demanded a division of labour comparable to the sharing of tasks in Rubens's studio in Antwerp. Different specialists would be in charge of particular parts of a painting or a decorative scheme; journeyman painters, who had

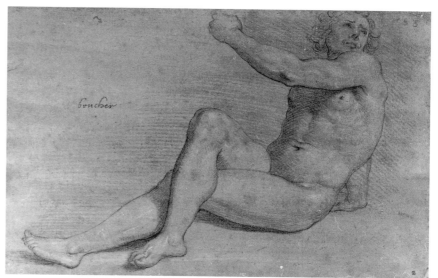

completed their apprenticeship, would be allowed to paint figures and the master would apply the finishing touches. The skill of these privileged collaborators was such that it is often difficult to identify the different hands at work in a single painting. Imitation was the key to this mass instruction, and should any individual show originality, a concept that belongs anyway to our age, not theirs, this would scarcely find an outlet. A master's style had a profound influence on his pupils, who would take years to escape from it — as witness, for example, Eustache Le Sueur, in spite of the fact that he was Vouet's most talented apprentice. The most reputable and well-patronised workshops gave freer rein to their apprentices' talent, thanks to the diversity and scale of their commissions.

11. *Artemis* known as *The Versailles Diana.* Marble; Roman replica of a 2nd century B.C. adaptation of an original attributed to Leochares. Musée du Louvre, Paris.

12. Jean Boucher, *Male nude seated on the ground with his right arm raised.* Graphite drawing with white heightening on light brown paper, 12.3 × 30.1 cm. Musée du Berry, Bourges.

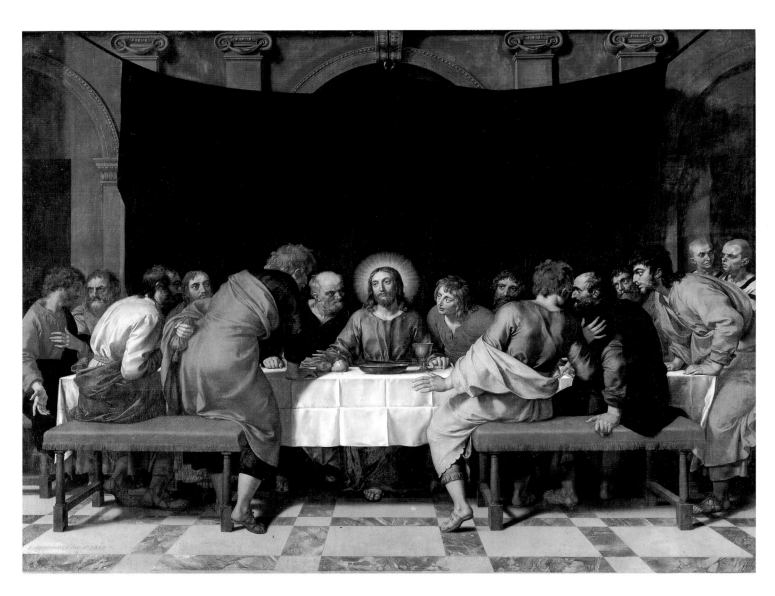

13. Frans Pourbus the
Younger,
The Last Supper.
Oil on canvas,
287 × 370 cm.
Musée du Louvre, Paris.

Once a tax had been paid and a masterpiece produced (in this case a painting on a prescribed subject, conforming to certain dimensions[6]), the journeyman would be promoted to *maître* and could set up on his own account. The sons of masters were exempt from these formalities, which later was a contributory factor in the closing down of the Corporation. Having reached the end of the *cursus* the painter possessed a certain skill, but no real knowledge. Each *atelier*, and all were still following the Mannerist example, had its own recipe for drawing the human form, com-

posing a group or groups, juxtaposing colours or painting shadows. But no anatomy was taught, nor was there any systematic life-drawing. Perspective, so vital for painters of historical scenes and landscapes, was reduced to a few empirical observations. The apprentices acquired no culture, in either the visual or the intellectual sense of the word. Poussin's dissatisfaction when, having arrived in Paris, he worked his way round different studios without finding what he was looking for, is revealing. The need for an ambitious young artist to keep moving can be easily understood. In

the provinces young men who had trained first
with some local craftsman would leave for the
nearest town or for the capital, there to acquire
the skills they needed and to enlarge their hori-
zons. The Château de Fontainebleau played a vital
role in this education because of the works of art
it contained: frescoes by Rosso and Primaticcio;
decorative schemes by Dubois, Dubreuil and
Fréminet; innumerable antiques, whether origi-
nals or bronze replicas; and important paintings
from the royal collections, including works by
Leonardo and Raphael (pl.15). Nor should the im-
portance of other paintings that were to be seen,
often in churches, be under-estimated: Salviati's
Doubting Thomas (pl.14), then in the Chapelle des
Florentins in Lyon, or *The Last Supper* by Frans
II Pourbus (pl.13), in Saint-Leu-Saint-Gilles in
Paris, were among the most notable.

The situation of France at this time, recovering
from the Wars of Religion, considerably reduced
prospects for young painters. The tiny number of
reputable studios and the restrictions on artistic
life obliged painters to look elsewhere, sometimes
very far away. Some, like Quentin Varin (pl.17),
were to be itinerant for a large part of their lives.
Many left for Italy, attracted by the paintings to be
seen in Rome, Florence or Venice, and by the
careers being pursued there by some very talented
artists. Travel in Italy, with a long stay in Rome,
became more and more an obligatory stage in
one's career. The form such travel took varied
according to circumstances:[7] the often precarious
lifestyles of Valentin or the young Poussin contrast
sharply with the comfortable study tours made by
painters enjoying financial support, like Vouet or
Le Brun. These trips, which were sometimes very
prolonged during the first half of the century,
tended to get shorter later when Paris began to
have plenty of work to offer and a more compre-
hensive training. Itineraries were equally diverse:
some painters, like Vouet, visited a great number
of artistic centres, thereby enriching their own
culture with local nuances. Others concentrated
on Rome and stayed there long enough to be-
come completely integrated into the artistic com-
munity; first the 'Caravaggesques', then Perrier
and Stella, Pierre Mignard and Dufresnoy. A few,
including Poussin and Claude, stayed perma-

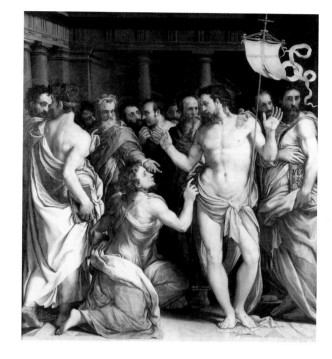

14. Francesco Salviati,
Doubting Thomas.
Oil on canvas,
275 × 234 cm.
Musée du Louvre, Paris.

15. Raphael,
The Holy Family.
Oil on canvas,
207 × 140 cm.
Musée du Louvre, Paris.

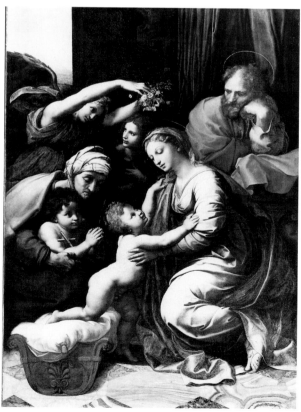

18. *opposite*:
Abraham Bosse,
plates for *La Manière
universelle de Monsieur
Desargues pour pratiquer la
perspective*, 1647.
Département des Estampes,
Bibliothèque Nationale,
Paris.

19. Claude Lorrain,
*Draughtsman in front of a
Statue.*
Pen and brown ink,
12.8 × 9.3 cm.
Royal collection, Windsor.
© Her Majesty Queen
Elizabeth II.

16. Title page of Ripa's
Iconology,
French edition, 1643.

17. *right*:
Quentin Varin
The Martyrdom of St Clare,
1612.
Oil on canvas,
230 × 180 cm.
Collégiale Notre Dame, Les
Andelys.

nently. The generation of Vouet's pupils, however, made do with brief incursions. Some, and not the least talented, never left Paris, like Le Sueur. The necessity to make the trip was diminishing, particularly for Parisians. It became merely a short stage, advisable but not indispensable, in the education of an artist. The establishment of the French Academy in Rome at the beginning of the reign of Louis XIV gave the city an institutional focus, but the Rome school was in fact never more than an adjunct to the Académie in Paris.[8] Provincial artists, nevertheless, and particularly artists from the South of France, still felt almost obliged to spend time in Italy, before coming home to seek their fortune in their native town.

By way of a reaction to the pragmatic and often limited training offered by the *maîtres* who were members of the Corporation, the need for an outlet was felt. The attraction of Italy was not simply the promise it held out of a more adventurous, more expansive life. The famous 'light', aspired to by Poussin[9] and numerous others, illuminated a thousand masterpieces, from the relics of antiquity, to the palaces and churches decorated by Bernini and Pietro da Cortona, via the classic Renaissance canon which mention of the name of Raphael was sufficient to evoke. At the same time the great Italian painters, past and present, gave a brilliant account of themselves. A great

painter was characterised by the range of his qualities and of his knowledge. Abraham Bosse (pl.7), when the French Académie was first established in Paris, proclaimed the universality of the talents of his fellow-artists:[10]

My feeling is that, of all the arts, there is none requiring such diligence and industry as the one to which the name portraiture and painting is given; any person wanting to become at all proficient in the practice of these must have a universal intellect, a strong imagination, an eye capable of discerning the form of an object, in all circumstances, and a free hand with the workman-like skill and training to represent it; in addition he must be familiar with the measurements of many of the items visible in nature, or he must be equipped to take these measurements as need arises.

The intellect guides the 'workman-like' hand: painting was beginning to venture forth from the studios and workshops to which it had hitherto been confined.

The early age at which apprenticeship started precluded extended study. There were a few exceptions, like Poussin, destined by his father for the legal profession, who may have spent some time under the Jesuits in Rouen; or Le Brun, who was related through his mother to some 'masters of the written word' of renown. A case like that of La Hyre, to whom his father gave a solid grounding in the rudiments of writing and arithmetic, suggests that some painters could claim more cerebral foundations for their art than others. We should not think of them as intellectuals or scholars, however. Even Poussin, the 'painter-philosopher' could probably not read Latin with any fluency and took the subjects for his paintings from translations or adaptations rather than from original sources. Where the contents of a painter's bookshelves are known[11] they are generally reduced to the bare essentials: the Bible, a few history books, ancient and modern, some religious tracts and some handbooks on iconography and artistic theory (treatises on anatomy and perspective). The main source of education seems to have been contact, frequent or infrequent, with educated people or groups of people, or simply keeping good company. Various levels of cultivation are evident, and the further any particular painter is from the influence of the Corporation the more cultivated he seems to be. Clients and patrons played a vital role in this emancipation.

Martin Warnke has already drawn our attention to the importance of the princely courts in the cultural and social advancement of artists, following important changes during the Renaissance.[12] There is no question that, in seventeenth-century France, to be in the service of the king, or a royal prince or a powerful lord allowed a painter to penetrate society at the highest levels and to meet the artists, writers and scholars who frequented such milieux. Some of the coteries occupying the fringes of court life welcomed artists in their midst; the artists learned fine manners and the art of conversation and, like fashionable portrait painters such as Le Nain or the Beaubrun family, knew how to make themselves popular. The influence of these circles was certainly just as important as that of the intellectual élite of the day: philosophers, theologians, scientists, doctors and scholars of all kinds did not play the crucial role that has sometimes been attributed to them. Poussin at any rate was linked to the libertines of Paris and Rome; his protectors were the poet Marino, princes of the church like the Barberini family and scholars and polymaths like Cassiano dal Pozzo. His, in fact, was an isolated case: direct contact with learned folk seems to have been scarce, even if they did sometimes supply subjects and themes. When the most sublime intellectual and spiritual meditations of the day seem to have influenced painters, and to be reflected in their work, it is almost always via a series of intermediaries, or adaptations and consequent distortions, and this must be taken into account when the work is judged or analysed.

The foundation of the Académie Royale de peinture et de sculpture (pl.8)[13] can be seen as both a symptom of the tensions of Parisian life and a symbol of the increased ambition of the artists, who, having escaped the control of the Corporation, now constituted a serious threat to its position. Royal warrant holders were permitted to exercise their profession without constraint and to train pupils. They were exempt from inspection by the police or the Corporation. As a result the *maîtres* were forced to reduce the number of trainees they took in and to place strict controls on the exercise of the profession. A parliamentary decree passed in August 1647 worked to their advantage.

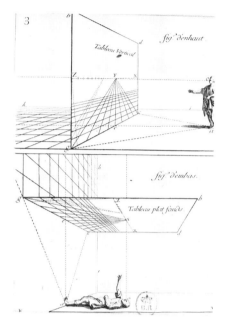

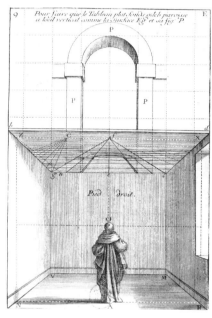

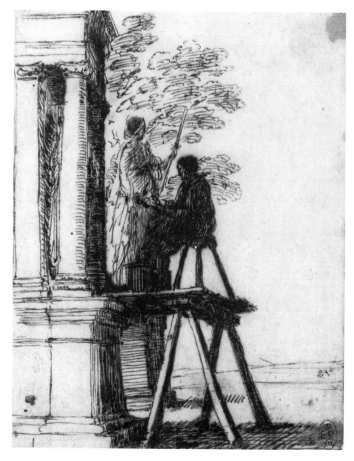

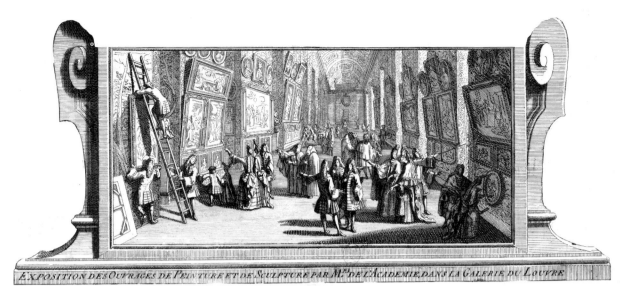

20. A. Hadamart,
*Exhibition of Painting and
Sculpture by Members of the
Academy, in the Louvre*,
1699.
Engraving.
Département des Estampes,
Bibliothèque Nationale,
Paris.

This provoked a counter-attack by a small group of court painters, gathered around Charles Le Brun and Martin de Charmois, former secretary to Chancelier Séguier and an amateur painter. By demanding the establishment of an academy under government protection and functioning without interference from the master-painters, they hoped primarily to defend their threatened interests, but also to promote the dignity and prestige of an art that they were tired of seeing relegated to the ranks of the 'mechanical professions'.[14] Their inspiration was the illustrious artistic academies established in Italy during the previous century: the Accademia del Disegno in Florence in 1563 and the Accademia di San Luca in Rome in 1577. In the Roman academy French painters like Vouet had held honorary positions. State patronage under Richelieu had created favourable circumstances, particularly since the foundation of the Académie Française in 1642. Painters and sculptors were following the prestigious examples of the professional writers.[15]

Faced with a situation that jeopardised their very existence, the master-painters attempted to retaliate. Fortified by the support of Vouet (pl. 9), who had stood back from the new project, they formed themselves into the Académie de Saint-Luc and, following their rivals' example, tried to set up a drawing course based on study of the model. The death of Vouet in 1649, however, prevented this. Some of the new academicians had remained on friendly terms with the Corporation and in 1651 they attempted to unite, but this quickly came to grief. The royal Académie, meanwhile, was attracting all the talent and undermining the prestige of the old *maîtrise*. The latter nevertheless served as a place of refuge for the opponents of Le Brun, led by Pierre Mignard, who did not change sides until the death of his rival in 1690. The Académie de St-Luc survived until the eighteenth century, but, deprived of the most active and most talented group of artists, the court painters, it assembled mainly artists of lesser calibre who still followed the old craft traditions.

The founder members of the Académie adopted the title of 'ancients'. Twelve in number, they taught life drawing in rotation for one month a year. This was the central tenet of their doctrine: art based on the rigorous observation of nature, to avoid the pitfalls of Mannerism, with diligent and systematic training of the eye and hand. The term *dessin* (drawing, then spelt *dessein*) comprehended anatomy, perspective, and the study of proportion according to correct examples taken from classical models, a necessity for the history painter. The syllabus, put together gradually and with difficulty because of fluctuations in the company's finances, was progressive.[16] Beginners started by drawing from prints and from work provided by their teachers, then moved on to plaster casts of famous works of sculpture, of which a collection was being built up. After that they were permitted to start working from the model, nude or draped, who posed in a room set aside for the purpose. At the same time they followed courses in anatomy, delivered by a surgeon, and perspective; Abraham Bosse (pl.18) was the self-appointed and uncompromising lecturer in perspective until his expulsion by Le Brun in 1661.

The reforms requested by Colbert in 1667 reinforced the institutional character of the Académie and strengthened its doctrinal role. To the monthly meetings of 'ancients' now were added lectures, during which a commentary was given on selected works from the royal collections deemed worthy to be held up as models; some of the problems facing painters were systematically discussed. The definition of the different types of painting, given in Félibien's preface to the

Conférences of 1667,[17] was to last for generations. At the apex of the hierarchy comes history painting, the representation of human action that surpasses ordinary imitation and puts the artist on a level with the poet. Lower down come the categories requiring less imagination and intellect, with, in decreasing order of standing, portraiture, genre painting, landscape and still life. The establishment of annual awards and public exhibitions encouraged the competitive spirit (pl.20). Debates on artistic theory began to develop; these will be discussed in more detail later. The Académie became, as a result, the place where French 'artistic literature' was worked out. The debate on the fine arts gradually took hold, in spite of the material and moral crises encountered by the Académie at the end of the century. The establishment of the French Academy in Rome in 1666 and the founding of similar institutions in the provinces, first in Lyon where a drawing school was set up in 1676 to be followed by the Académie des Beaux-Arts in 1713, endorsed the new-found status of painting, henceforward to be admitted to the ranks of the liberal arts.[18]

These important changes, introduced into French artistic life by the new institution from 1650, should not hide other, more gradual changes, less visible but no less fundamental. These concern the relationship between painters and their patrons and clients, the people who place orders or buy paintings, who by this time already constituted what could be called a 'public'. The few studies that have been dedicated to this question have emphasised the gulf existing between the different social strata. A commendable but dangerous desire to classify things tidily provides a distinction between the different types of patronage (royal, religious, ministerial, bourgeois) and of consumption (decorative painting, church painting, easel painting).[19] It is certainly true to describe the seventeenth century as a period of intense social compartmentalisation, when the function of a work of art was strictly defined. But any method of approaching the question should be flexible enough to take into account simultaneously all the factors coming into play: the social origins of the clientèle, the destination of the paintings, the amount of free rein given to

21. Thomas de Leu (after Antoine Caron), *Phaeton*, illustration for *Les Images* or *Tableaux de platte-peinture* by Philostratus, translated by Blaise de Vigenère, 1614. Département des Estampes, Bibliothèque Nationale, Paris.

22. Thomas de Leu (after Antoine Caron), *Ajax of Locris*, illustration for *Les Images* or *Tableaux de platte-peinture* by Philostratus, translated by Blaise de Vigenère, 1614. Département des Estampes, Bibliothèque Nationale, Paris.

23. Eustache Le Sueur,
Gathering of Friends.
Oil on canvas,
136 × 195 cm.
Musée du Louvre, Paris.

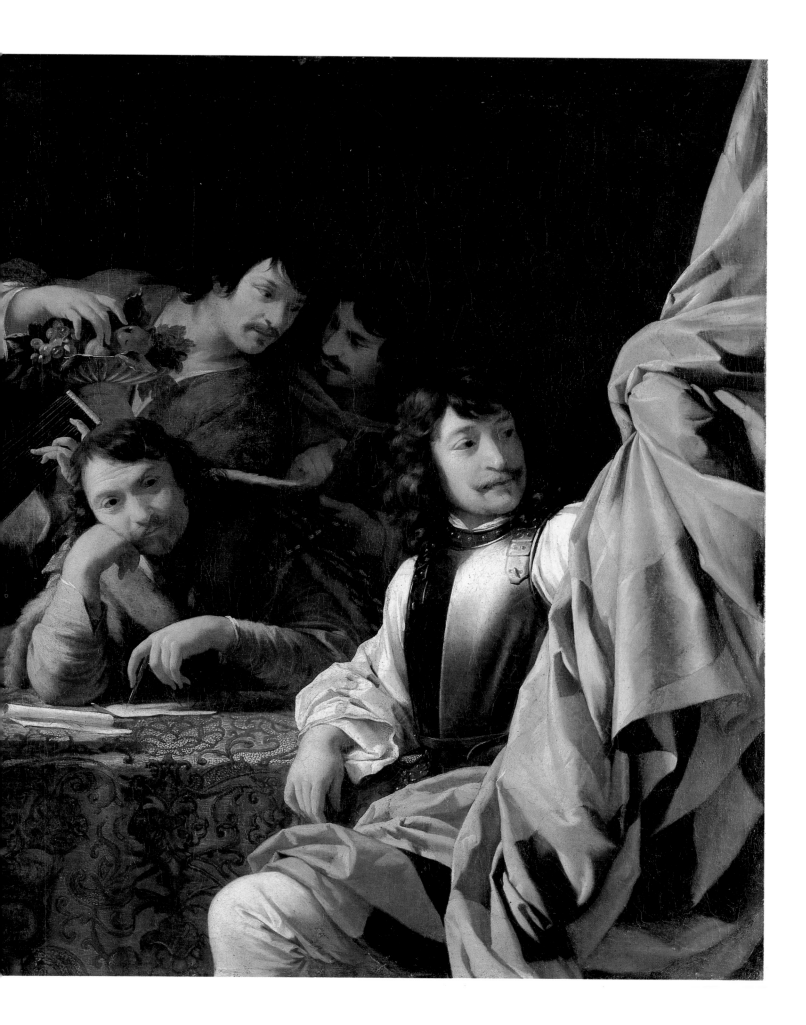

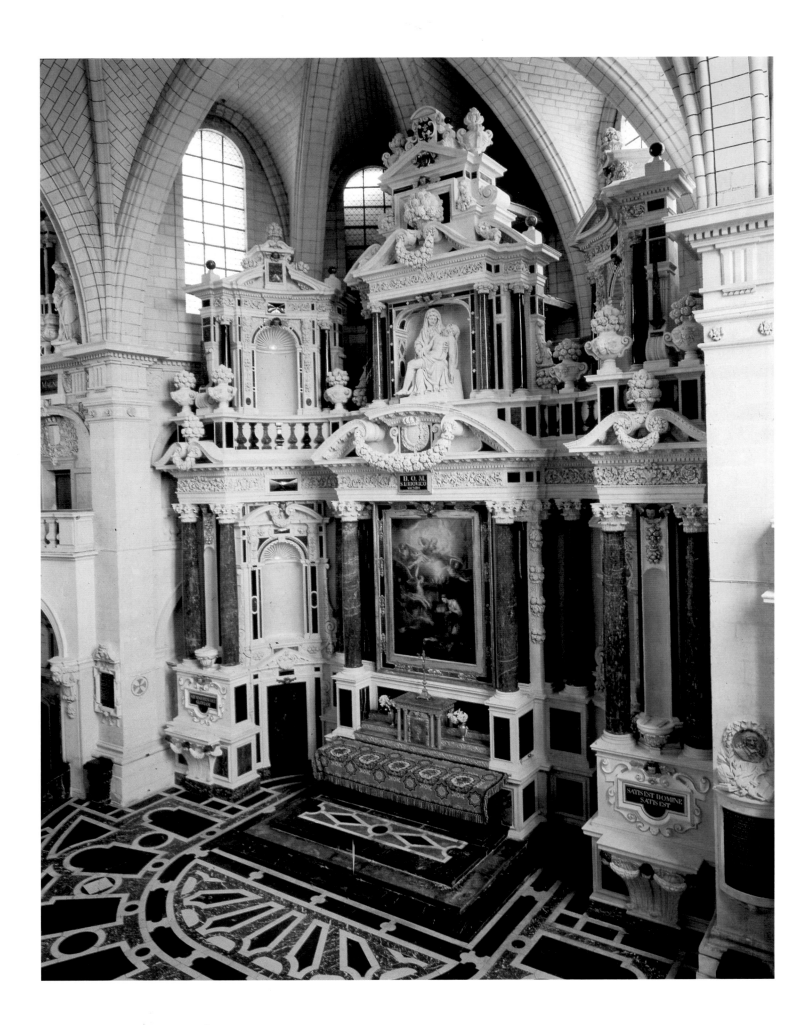

the painters and the sweeping developments of the great stylistic movements, all combining at any given moment to define a whole set of attitudes towards painting, and a variety of ways of using it and seeing it.

Large religious paintings and decorative schemes for the church constitute the first sector, a sector of the utmost importance which was particularly vigorous at the beginning of the century. This initial vitality was stimulated by a reaction to Protestant iconoclasm, by the need to rebuild churches destroyed during the civil wars, by the rapid expansion of the religious orders and, in the background, by the *montée mystique*, the rise in mystical fervour, detected by the Abbé Brémond[20] in the provinces as well as in Paris. Religious painting offered an opening to painters who were not particularly tempted to come to Paris to earn their living: La Tour in Lunéville, Létin in Troyes, Tassel in Langres, not forgetting of course Boucher in Bourges and the Provençal painters like Levieux or Nicolas Mignard. The majority of religious orders, confident of the power of images and concerned about pomp and circumstance, had their churches and monasteries decorated to their hearts' content with vaults painted in fresco or oils, painted altarpieces and sequences of paintings recounting the lives of their founders. Parochial fabric committees competed with one another in the embellishment of the churches in their care: retables (pls 24 and 25) and sometimes tapestries fulfilled their double role as prestigious items of decoration as well as means of instructing the congregation. The chapels disposed around the perimeter of the nave and chancel would be designated to separate individuals who would order altarpieces; or they would be granted to professional or religious societies who would multiply the ex-voto offerings, or sometimes choose an excessively ambitious scheme. Undeniably, the role of certain prelates or abbots in the commissioning of paintings was often of crucial importance; parish priests, monks and nuns had their say and were probably well briefed on the latest trends in painting, like Olier at Saint-Sulpice or Mère Madeleine de Saint-Joseph at the Carmelite convent of the Incarnation. But the role of the churchwardens,[21] and particularly in

25. Théodor van Thulden, High altar, Eglise des Mathurins, Paris, 1649. Engraving.
Département des Estampes, Bibliothèque Nationale, Paris.

26. Thomas Blanchet, Triumphal arch erected in Lyon for the entry of Cardinal Flavio Chigi, 1664. Engraving.
Bibliothèque Municipal, Lyon.

24. *opposite*:
View of the high altar, Chapelle du Prytanée Militaire, La Flèche (Sarthe), 1633.

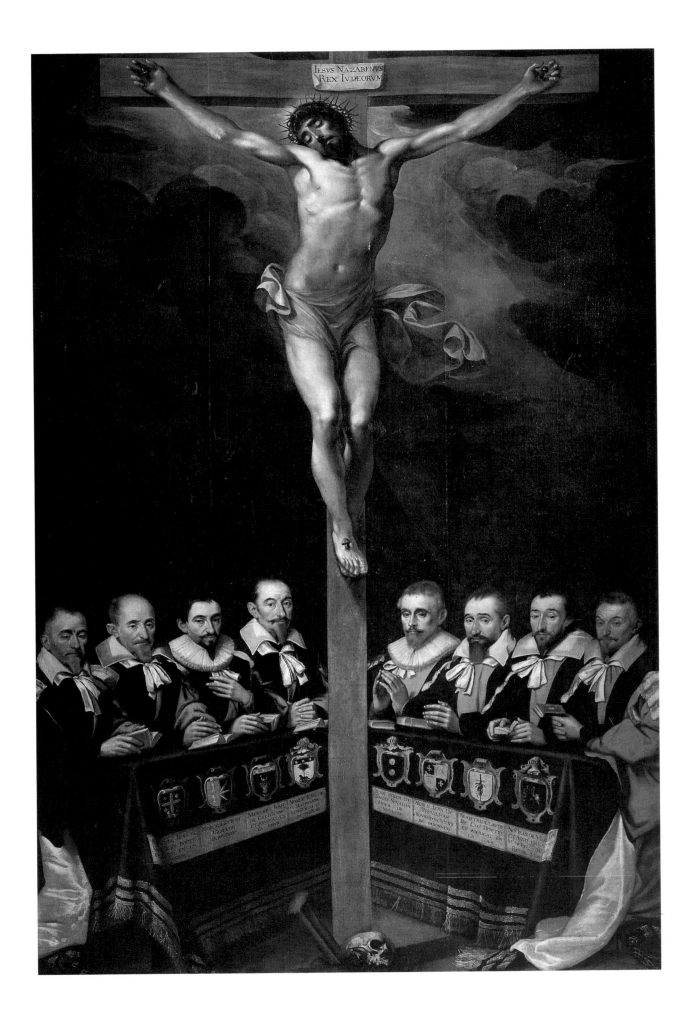

honorary positions who were frequently persons of considerable standing, was just as important. Whether individually or in groups or associations, the laity controlled and directed religious painting to quite a large extent. Finally, the importance of brotherhoods of penitents in the South of France,[22] or rich Parisian trade guilds like the goldsmiths, which annually offered a painting known as a *may* at the cathedral of Notre-Dame,[23] should not be forgotten.

Such commissions were much sought after, not because they were particularly remunerative but because they ensured excellent publicity. Hung in a church, the public gallery *par excellence*, religious art could endorse and enhance a painter's reputation. Some buildings were like real museums in this respect, exhibiting the most recent trends in painting: in Paris, besides Notre Dame, an example was the Carmelite church in the Rue Saint-Jacques, with its ceiling painted by Philippe de Champaigne in 1628 and a succession of altars adorned with paintings by the most celebrated painters of the day; or the Carthusian church at Vauvert at the end of the century. Major religious orders, with their branches throughout the kingdom as well as abroad, could make an artist known well beyond his own sphere of activity by sending paintings hither and thither, or by ordering further copies to be made. Altarpieces in particular, widespread throughout France, had to adhere to certain fixed principles.[24] These were functional items containing an agreed number of figures and tightly controlled iconography; a mediocre or even inferior talent was equipped to paint these, because in general, except in large urban centres where styles changed rapidly, church painting was conservative and repetitive. Obliged to make an instant impression, and subject to strict regulations about location and lighting, church paintings often dispensed with subtlety. At the same time, occasional innovations introduced here and there took on the status of great events: Vouet at the high altar in Saint-Nicolas-des-Champs, Pourbus in the same church or in Saint-Leu-Saint-Gilles, Pierre Mignard in the dome of the Val-de-Grâce and La Fosse in the dome of the Invalides (both royal commissions, it must be emphasised), or Jouvenet with his outsize

compositions for Saint-Martin-des-Champs, to mention only Paris. On occasions like these, religious painting became truly involved in contemporary developments, and shrugged off the constraints that had cramped its style.

Municipal commissions were another fertile field for painters. Here too, criteria of usefulness governed what was required. The civic artist had to be a jack of all trades, not only able to paint a quick ex-voto or a portrait but also to turn his hand to architecture and interior design, constructing temporary buildings to put up for a visiting king or prince (pl.26) and designing costumes and emblems with the aid of some local scholar. The example of Lyon, well-documented, is a particularly prestigious one thanks to the association between Thomas Blanchet and the Jesuit, Père Ménestrier. Often local talent was lacking

and magistrates would summon artists domiciled in Paris: Errard, Noël Coypel and Jouvenet decorated the parliament in Rennes; Jouvenet the parliament in his native city of Rouen. Like Blanchet in the Hôtel de Ville in Lyon or Rivalz and others in the Capitole in Toulouse, they had to combine monumental decorative schemes, epic narratives and allegory with depicting great moments in the history of the city. Both a mythic past and a gilded future under the protection of the reigning monarch had to be evoked. Paintings like this have

27. *opposite*:
Jean Chalette,
The Capitouls of 1622–1623 with Christ on the Cross.
Oil on canvas,
375 × 245 cm.
Musée des Augustins, Toulouse.

28. *left*:
François Chavreau,
Titlepage of the *Cabinet de M. de Scudéry*, by Georges de Scudéry, 1646.
Engraving.
Département des Estampes, Bibliothèque Nationale, Paris.

29. Abraham Bosse (after Claude Vignon), *Roger showing a Picture Gallery to a Group of Cardinals*, illustration of *La Pucelle* or *La France délivrée* by Jean Chapelain, 1656.
Engraving.
Département des Estampes, Bibliothèque Nationale, Paris.

often survived with difficulty, and the elements that have come down to us cannot sufficiently convey the versatility of the artists employed. In many cases, the painter was also the architect and sculptor and had to handle complicated schemes with enough flexibility to create a festive, exuberant environment. The same feeling of pomp and circumstance characterises the group portraits of civic dignitaries executed by celebrated portrait painters, for instance in Paris or Toulouse (pl.27). Here too the rules governing such work were strict and there was little relaxation of the time-honoured formulae until late in the century. The artist had to be objective and exact, above all, while respecting decorum. However, like a church painting, a municipal portrait would have plenty of exposure to the public and could confirm an artist's reputation, guaranteeing him a network of heavyweight clients in the future.

Where secular decorative painting is concerned, it has been customary to make a distinction between royal commissions and those of the aristocracy, government ministers, the upper middle class and the new rich. It is certainly possible to detect nuances from one group of patrons to another, often depending on the scale of a decorative scheme and the amount of money spent. It is also true that royal commissions, supervised by the the Surintendance des Bâtiments, had to be markedly political in character: painting was used to express a pictorial paean of praise to the monarchy. But a number of common factors connect these prestigious clients and the painters who worked for them. The decoration in the royal palaces, the princely châteaux and the residences of ministers or financiers was ostentatious. The same hierarchical distribution of apartments, the vast acreage of surface given to the artists to decorate, the opulence of the materials and the variety and complexity of the iconography can be found in any number of schemes. In order to glorify the owner of the premises, all the resources of art and luxury had to be summoned. From Fontainebleau to Versailles or Saint-Cloud, via the Palais-Cardinal, the hôtels Lambert and Séguier, and Vaux-le-Vicomte, the task of the painter was to proclaim the power and wealth of the owner, and a certain amount of exaggeration was not frowned

upon. The walls were covered with painted, gilded and carved panelling bearing mythological and historical scenes, allegories, portraits, landscapes, flowers and fruit, and still lifes. Ceilings grew more and more important, harbouring painted lacunae and illusionistic skies filled with figures in imitation of Italian models. Illusions created by the architecture were enhanced by *trompe-l'œil* painting; space was opened out to seem much bigger than it was, Parisian and provincial schemes competing in ingenuity. The magnificence flaunted unashamedly by top financiers was designed to draw attention to their position and advertise their recently acquired nobility; it was also a means of publicity and an insurance in case ruin or disgrace should come their way.[25]

The success enjoyed by painted galleries (pl.29) is significant.[26] They first appeared in France in the late Middle Ages in châteaux of a certain size; their design made them useful for displaying a series of images glorifying a family or an individual, for celebrating achievements in battle or for exhibiting a succession of portraits. Henri IV, followed by Marie de Médicis, had galleries of different shapes built into their palaces: paintings extolling a sovereign or a dynasty often borrowed the symbolic language of mythology or allegory, or the more direct language of history. Richelieu followed suit with the Galerie des Illustres in his palace in Paris, a collection of triumphs of the French nation that allowed him to glorify the King and himself as well. Under the veil of Fable, Chancellor Séguier evoked good government in his upper gallery, a library and meeting room for the Académie Française, and the politics of Louis XIII and the Cardinal in his lower gallery. Shortly after this the same elements appeared in Mazarin's residence: mythology and Roman history were used to paint an indirect but generally flattering portrait of the minister and, in addition, the décor provided an excellent setting for his collection of antiquities. In the same way, the enormously wealthy Louis Phelypeaux de la Vrillière designed the gallery in his residence as a showcase for the large paintings he had commissioned from Italy's most celebrated painters. In the years 1650–60 the fashion for galleries was so powerful in Paris that

30. View of the gallery in the Hôtel Amelot de Bisseuil (Hôtel des Ambassadeurs de Hollande), Paris.

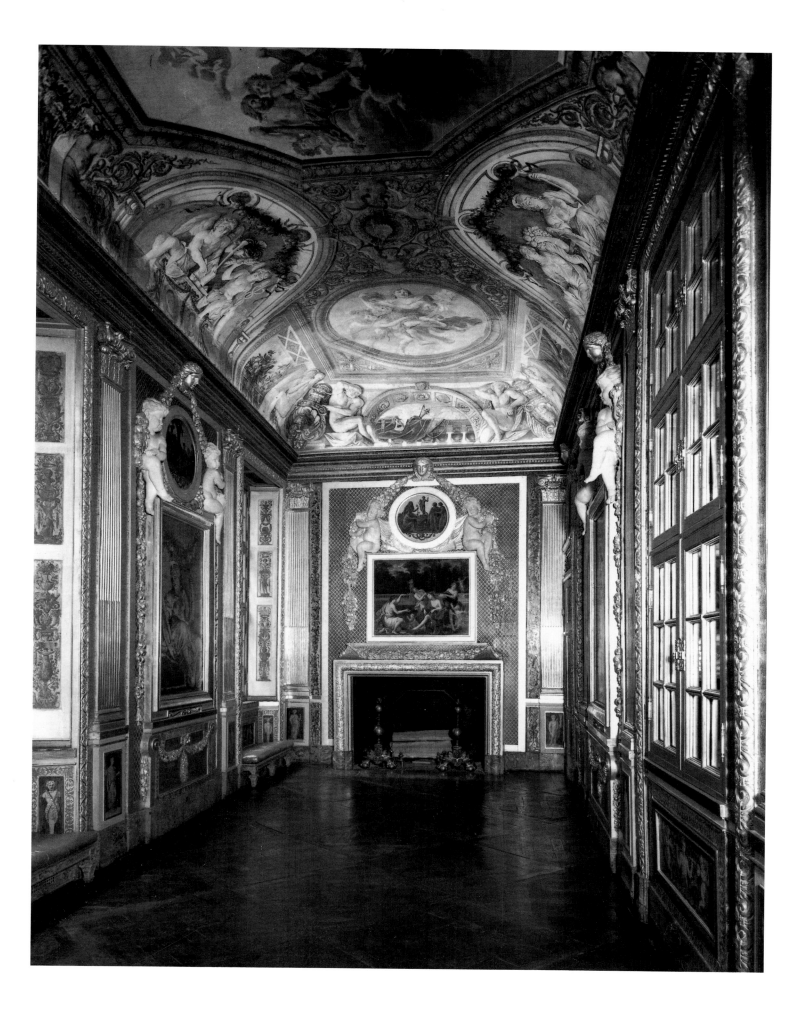

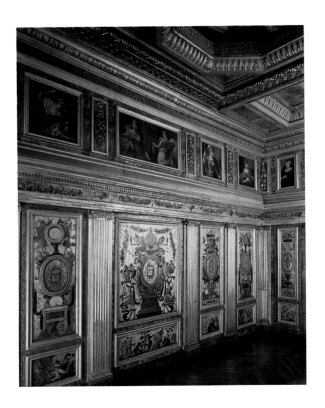

31. View of the Cabinet de la Maréchale de la Meilleraye in the Arsenal de Paris.

in the residences of the newly rich and receiving the technical improvements and stylistic input that such a crowning achievement deserved. Perrier, followed by Michel I Corneille, Bourdon and especially Le Brun developed the lessons of Annibale Carracci and Vouet. When the building of royal palaces began again after the Fronde, there was another rash of galleries, in the Louvre, the Tuileries and at Versailles, which assimilated and developed the Parisian model. Once again the court set the tone until interest in such a use of space and the iconography began to flag. More than any other art, decorative painting is subject to the whims of fashion. Economic circumstances play their part as well, to be sure: ambitious building works require enormous amounts of money, and there are reverses of fortune. Periods of expansion and recession can be identified, but the phenomenon of social snobbery has not been sufficiently taken into account. Models from a higher class, basically from the court,[27] were imitated and adapted by an ascendant group, then the transformed models were returned to their original source; this process took place with redoubled vigour because of the paroxysm of change in Paris and its surroundings. The effect was much less exaggerated in the provinces, although provincial high society was evidently alert to innovations in the capital and the owner of some country château or manor house was always making enquiries (often very late in the day) about panelling or ceilings.[28] Hence the incessant reconstructions, with their accompanying destruction. Because the trend had come and gone at earlier periods, it is extremely difficult today to chart the history of painted decoration in France, although there are a few schemes that have miraculously survived untouched. Supporting documentary engravings cannot fill the huge lacunae that affect the output of some of the greatest painters of the day: Vouet, Bourdon, Mignard or even Le Brun.

A different type of painting, distinct from the art of ostentation, existed within the same cultural milieu. It is tempting to identify this with a particular type of aristocratic commission. Again, however, the links binding certain groups of individuals in specific circumstances (groups generally dealt with separately by social historians) need to

no really splendid home could be without one. In the residences of the Lamberts, the Bretonvilliers, the Amelots de Bisseuil (pl.30), architects and decorators competed with one another to design the best. This led to the climax, the masterpiece of the genre, the Galerie des Glaces at Versailles, where glorification of the monarch regained its rightful position. Le Brun's achievement should not efface the memory of other schemes, sadly now destroyed: Pierre Mignard made his name decorating Monsieur's palace at Saint-Cloud, as did Antoine Coypel in the residence of the Duc d'Orléans in the Palais Royal.

As an example, the gallery demonstrates the interdependence of the various categories of patron: first an aristocratic (or feudal) model was rescued from oblivion and transformed by the reigning monarch, just as the monarchy was beginning to reassert its authority under Henri IV and Louis XIII. Then the new fashion was adopted by ministers and financiers: the gallery became the symbol of social status, an exhibition hall and reception room in one, reigning supreme

be carefully considered. Traditionally the French nobility, in the strict sense of the word, were little drawn to the fine arts, painting in particular. Italian travellers who visited France during the Renaissance had noticed it.[29] The French liked building, but in their châteaux they were content with carved woodwork, dyed leather and above all tapestries, on more or less sophisticated subjects. In this environment a painter supplied images with a well defined social function: portraits in particular and military scenes often hung together in special cabinets or galleries (pl.32). The impoverishment of the nobility, and the growing requirement that they be present at court did not favour the emergence of a taste for painting, even among the most eminent members of the class. Certain circles in Paris, however, initially the circle centring round the Marquise de Rambouillet,[30] were paving the way to considerable change under Louis XIII. Parisian hostesses were beginning to introduce new refinements into their houses, partly following the Italian example. A more elegant and more comfortable use of space was sought, an element of wit and surprise, more colour and light. The taste for portraiture grew keener. Likenesses, intended to establish the identity of the sitter and to ensure his inclusion in the family tree, were no longer adequate: now mythological or romantic disguises, encouraging social and amorous complicity, were popular. Heroic status was dreamt of, or even something saintly, and many a room was hung with a series of 'Beauties' or 'Powerful women' (pl.31). Art was imitating the codes of gallantry, as it did in the literature of the *précieuses*. Devices and emblematic images proliferated, often integrated into the painted decoration, which itself was frequently an extended metaphorical portrait of its owner. History paintings gave visual support to a description or a literary conceit in prose or verse.[31]

It would be a mistake to ignore this shift, particularly as it was not confined to a narrow circle but penetrated throughout a large proportion of high society. There were certainly groups who withstood the shift, for whom interior design and paintings were serious matters required to be conducive to moral elevation or spiritual meditation. Examples of virtue found in Roman history, so

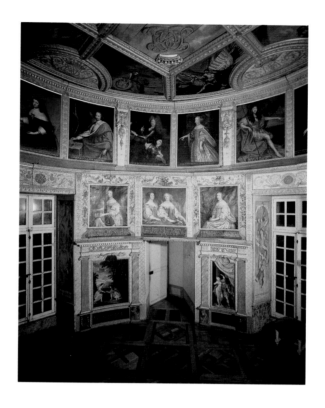

32. View of the Cabinet Doré in the Château de Bussy-Rabutin (Côte-d'Or).

much appreciated by parliamentarians and court functionaries, demonstrate this clearly. Like gallantry, painting rightly rejects pedantry, taking as its indispensable weapons conceits, overt artifice and sweet illusion. The spread of a culture based on sophisticated social life to other echelons of society, avid to take it up, did a great service to painters and their art, contributing to a relaxation of the formulae for portrait painting, to the enrichment of decorative design and to the general legibility of the iconographic content of paintings. At the beginning of the century a great many compositions were overloaded and pedantic: worldly society and the 'science de la Cour'[32] (courtly knowledge) certainly contributed to the definition of a more refined, lighter style, a welcome counterbalance to the rule of the doctors of philosophy. By 1660 the transformation was complete. After painters like Vouet or Le Sueur, the offhand way in which Le Brun dealt with Ripa's *Iconology* (pl.16) and with classical mythology, the passionate disagreement that led to Abraham Bosse's exclusion from the Académie, Félibien's

obvious disdain for painters who slavishly followed others' precepts,[33] were all symptoms. The time had come when the main aim of the majority of painters was 'to please and to affect'.[34]

To one side of the prestigious commissions, public and private, sacred and profane, which could make the name of an artist, there was a more run of the mill style of painting which already enjoyed a vast clientèle at all levels of society. The paintings, often small in size, could be bought in shops or at fairs (pl.6) and markets. They sustained a busy retail trade set up by the painters themselves in various places; in Paris their quarter was around the Pont Notre-Dame (pl.5). Output was enormous, and of very variable quality (often worse than mediocre), but it satisfied a great public desire for pictures. The inventories of painters and dealers list series of paintings at different prices.[35] Works are classified by their subject matter: 'devotional', 'nudes', 'courtisans', 'landscapes', 'Passions', 'smoking dens' . . . The number of still lifes and genre paintings reminds us of northern tastes and of the Flemish painters. Some artists already had several versions of the same subject in their studios.[36] The perceptible variations in the prices seem to indicate a production deliberately organised on different levels, from the original painted exclusively by the master himself to simple copies, with, somewhere in between, replicas touched up to a greater or lesser extent. There was something to suit every pocket and every taste, although as long as this very stereotyped painting had to meet certain functional requirements, the notion of taste was still very approximate. An analysis made from probate inventories could highlight the utilitarian nature of these paintings by identifying the different rooms in the house to which they were allocated.

However much the real connoisseurs and intellectuals connected with the Académie might despise 'works in which the mind plays little part',[37] and art whose main criterion was the detailed depiction of the most mundane reality, the success of this work was great and painters of the first rank made their name with it, the more willingly once they discovered what a good source of income it could be. A small section of society, however, enlightened and demanding, required more: lofty subjects (in Poussin's words: a 'noble subject matter'), skilful composition and paint elegantly applied, in short, painting of excellent quality. Between the run of the mill products and the commissions reserved for the Church, royalty and the nobility, there was space for easel painting of high quality, painting for admirers of fine art. Following the example of Italy, cabinet pictures suitable for private rooms were on the increase. Collections were beginning to be built up, and it was thanks to these that eyes and judgement were becoming sharper. Paintings could now be appreciated independently of their decorative content and their subject matter. Poussin's faithful clientèle, those fortunate few in Rome, Paris and Lyon, were less interested in the themes he chose (they were strictly limited), than in the ingenuity with which he varied them. Later, when great commissions were no longer forthcoming, painters were forced to paint religious or mythological scenes in very reduced sizes for their rich private patrons; it was still their hand, their skill and training that were being bought. The 'delight' demanded of painting was cerebral at mid-century, more sensual as the end approached. It was at this time that the first connoisseurs and people with an intellectual interest in painting appeared in France, bringing with them a modern approach to the art of painting. Thanks to the new category of clients, who belonged to different social groups but who were linked by a common passion (not always entirely disinterested), the distinction between the artist and the artisan could at last be made and the artist was able to form a more personal relationship with admirers of his work. A real dialogue had finally become possible.

Notes

1. In addition to the large number of published documents in the *Bulletin de la Société de l'Histoire de l'Art français*, the *Archives de l'Art français*, and monographs on particular painters, see also Fleury, 1969, and Richefort, 1989.

2. See Mousnier, 1976 and 1978, chap. XIV. This historian identifies nine strata, including sub-strata (or nine orders including the different estates). Painters belong to the sixth (merchants) and especially the seventh (masters of manual trades).

3. See Thuillier, 1988, p.135: 'Some artists took the advice given by Vasari and other theorists at face value. This recommended that painters should not start families in order to devote themselves to their art in peace, like clerics who dedicate their lives to God.'

4. Lespinasse, 1892.

5. Toliopoulou, 1991.

6. Guiffrey, 1915 (this gives the list of reception pieces from the inventory of the community drawn up in 1776).

7. Thuillier, 1984 and 1987 (2); Bousquet, 1980.

8. Lapauze, 1924. See below, chapter 6, p.152.

9. Passeri (quoted by Thuillier, 1988, p.75) reports that in Paris Poussin met Alexandre Courtois, *valet de chambre* to Marie de Médicis, who had in her possession a number of prints and drawings by, or after, Raphael, Giulio Romano and other Italian masters: Poussin confessed that this encounter was a stroke of good fortune, and gave him the opportunity to inspect the light to which he had always aspired.

10. Bosse, 1649 (1964), p.170.

11. Richefort, 1989, pp.150–5. The libraries of Daniel Dumoustier, a well-known bibliophile, and of Philippe de Champaigne, were particularly large ones.

12. Warnke, 1993.

13. Vitet, 1861; Fontaine, 1914; Schnapper, 1984 (1990). See below chapter 4, p.133.

14. In 1667, Nicolas Lamoignon de Basville, during his defence of the sculptor Gérard Van Obstal against the successors of one Sieur N., who were refusing to pay him, called for the abolishment of the annual ordinance for the liberal arts; in his eyes, painting and sculpture should both be included under that heading (Teyssèdre, 1957 [1965], p.66).

15. M. Fumaroli, 'Les leurres qui persuadent les yeux', extr. car. Paris, New York and Chicago, 1982, pp.1–33.

16. The minutes of the Académie Royale were published under the editorship of A. de Montaiglon by the Société de l'Histoire de l'Art français (Paris, 1875–92, 10 vols). On the teaching methods of the Academy, see Pevsner, 1940 (1973).

17. Félibien, 1668 (1725), vol. v. pp.310–11.

18. In about 1660, painting was allotted its own muse, notably at Vaux-le-Vicomte, where painting is represented by Polyminia (see Georgel and Lecoq, 1987, pp.46–7), and in the small apartment of Louis XIV in the Tuileries (see Sainte-Fare-Garnot, 1988, p.72, no.36).

19. De Crozet, 1954, to Richefort, 1989.

20. H. Brémond, *Histoire littéraire du sentiment religieux en France depuis la fin des guerres de Religion jusqu'à nos jours* (vol.II: *L'invasion mystique* (1590–1620), Paris 1923.

21. Mérot, 1983 (1985).

22. See exh. cat. Marseilles, 1978, passim.

23. Bellier de la Chavignerie, 1864; Auzas, 1949 and 1953. See also, on Le Brun and the Parisian brotherhoods, Montgolfier, 1960.

24. See in particular Tapié, Le Flem and Pardailhé-Galabrun, 1972; Ménard, 1980; Minguet, 1988.

25. F. Bayard, 'Manière d'habiter des financiers dans la première moitié du XVIIe siècle,' *XVIIe Siècle*, 162 (1989), pp.53–66.

26. Sabatier, 1985 (1986). W. Prinz, *Die Entstehung der Galerie in Frankreich und Italien*, Berlin, 1970, does not mention painted interiors.

27. There should be a detailed study of the way models spread, in the same vein as N. Elias, *La Société de cour* (French edition, Paris, 1974).

28. Thus the Château de Cormatin in the Haute-Saône (1626–7) was decorated in direct imitation of the Hôtel de Rambouillet and the Palais du Luxembourg (see Mérot, 1990, [2], p. 61); in the Hôtel de Châteaurenard in Aix-en-Provence, the stair-well decorated by Jean Daret in 1654 excited the admiration of Louis XIV and his courtiers when they passed through the town in 1660 (see exh. cat. Marseille, 1978, p.35).

29. R. Weiss ('The Castle of Gaillon in 1509–1510', *Journal of the Warburg and Courtauld Institute*, XVI–XVII (1953–1954), pp.1ff.) cites the following comment by one of Isabella d'Este's agents: 'The main preoccupation of the French nobility has always been arms and lineage; they leave business to other people. They have little interest in literature or architecture, although it is a country adorned by many learned men and handsome, wealthy religious foundations.' See also A. Chastel, 'L'art français et l'Occident au XVIe siècle', *Culture et demeures en France au XVIe siècle*, Paris 1989.

30. Blunt, 1957; Babelon, 1991, passim; Mérot, 1990 (2), pp. 107ff.

31. See in particular Scudéry, 1646 (1991). The masterpiece of *précieuse* description is the letter from Madeleine de Scudéry 'on the subject of a painting depicting the story of Tobias' by the painter Jean-Baptiste de Faudran, from Marseille (about 1647, published in the *Archives de l'Art français*, 1856, vol.VI, pp.39–42).

32. In his *Entretiens d'Ariste et d'Eugène* (1671) Father Bouhours contrasts 'book learning' with the '*science de la Cour*' (courtly knowledge), à propos devices and emblems.

33. Félibien, 1666–88, part 3, *Entretien* 5, (1679), p.83.

34. Racine, preface to *Bérénice* (1670): 'The most important rule is to please and to affect: other rules are invented to assist in the achievement of this one aim.' Molière had already written: 'I'd like to know if the great rule above all others isn't simply to please.' (*La critique de l'Ecole des Femmes*, 1663, scene VII.)

35. Fleury, 1969. One particularly interesting inventory belonged to the second wife of the still-life painter and dealer, François Garnier, in 1636 (See Richefort, 1989, pp.102ff.).

36. Like Claude Deruet (see Jacquot, 1894).

37. Félibien, 1666–88, part 5, *Entretien* 9 (1688), p.487.

THE END OF MANNERISM

In 1621 the poet Giambattista Marino, who was spending time at the French court in the entourage of Marie de Médicis, had this to say about French painters:[1] 'Most of them can only paint portraits, and are incapable of painting large compositions or history paintings, even those who have studied in Italy.' As for French art-lovers, 'they are not even clever enough to recognise the excellence and perfection' of the Venetian painter, Palma Giovane, then reaching the end of his long career. In fact, the forty odd years between the end of the reign of Henri IV and Vouet's return to Paris (roughly the years 1590 to 1630) have long been thought of as a kind of Dark Age. The autumn of the Renaissance or the dawning of the Grand Siècle? No-one has yet decided. The recent reassessment of Mannerism, and the esteem in which Rosso, Pontormo and the School of Prague are held today, have obliged us to focus more attention on the period and to think more highly of it. It was undeniably less brilliant than the age of François I or Henri II, or the age of Louis XIII or Louis XIV. The after-effects of the Wars of Religion were disastrous for the arts in France: a ravaged country, uncertain and intermittent patronage and the existence of very active studios abroad all contributed to a shortage of projects, or to their interruption, and to the disappearance of artists to other countries. The work that was produced was mainly mediocre. Nevertheless an ambitious and sophisticated artistic movement was gathering strength at the court at Fontainebleau and would reach its zenith in Lorraine; in the towns, local worthies and the clergy, intent on rebuilding the town and enhancing their own prestige, made use of local talent and also employed visiting artists, thus contributing to the perpetuation of well tried formulae. Although Paris had not yet gained artistic pre-eminence, increasing activity in Parisian studios and the presence of the Court were in her favour: an environment was created in which the old and the new would often mingle, the *maniera* that was slipping inexorably out of fashion, and reactions to it, which grew increasingly strong from the time of Marie de Médicis onwards. In spite of this, the ramifications of French Mannerism were manifold and survived well into the new century,

to the extent that the decorative work of Vouet, for instance, or the Atticism of the 1640s can both (each in its own way) be considered as heirs to the art of Fontainebleau.

THE PAINTERS OF HENRI IV

The Château de Fontainebleau, a celebrated artistic centre during the Renaissance, fell into slumber until the end of the sixteenth century, when Henri IV arrived and roused the palace. The King was very attached to Fontainebleau and began the ambitious restoration programme that he thought befitted the most beautiful of the royal palaces. He commissioned frescoes by Rosso and Primaticcio and brought in paintings from the collection of François I. A new team of painters was formed, later to be called the second School of Fontainebleau,[2] although their activity extended well beyond Fontainebleau to all the royal houses that were either under construction or were being restored. The team included an Italian, Ruggero de' Ruggeri, who, as a former collaborator with Primaticcio, sustained the link between the two periods; two naturalised Flemish artists, Jean I d'Hoey and Ambroise Bosschaert known as Dubois; and, finally, French painters such as Toussaint Dubreuil, Guillaume Dumée and Martin Fréminet. Henri IV employed them wisely, without conferring particular favour on any of them, although the personalities of Dubois, Dubreuil and Fréminet emerge the most strongly. As well as finding their inspiration in the examples around them, they evolved a new style that incorporated developments made in Italian and Flemish painting during the second half of the sixteenth century.

At Fontainebleau they were faced with areas in a great variety of dimensions and layout to work on.[3] From 1600, the Galerie de Diane, under the supervision of Dubois, received a mythological and historical décor, demolished in the nineteenth century. Disguised portraits of the monarch and his queen (Henri IV as Mars and Marie de Médicis as Diana) presided over battle scenes on the walls and mythological figures on the ceiling. The model of a *galerie royale* in the French style, promoted at this time by Antoine de Laval,[4] was

35. Toussaint Dubreuil,
The Toilet of Hyanthe and Clymène.
Oil on canvas,
107 × 96 cm.
Musée du Louvre, Paris.

36. Toussaint Dubreuil,
Cybele awakening Sleep.
Oil on canvas,
97 × 107 cm.
Musée National du Château, Fontainebleau.

37. Ambroise Dubois,
The Baptism of Clorinda.
Oil on canvas,
188 × 189 cm.
Musée National du Château, Fontainebleau.

beginning to take hold. The ensemble at Fontainebleau in all probability lacked the elegance and unity of François I's gallery, in which the painting and the ornamentation blended with one another seamlessly. Smaller rooms were decorated with a series of paintings on literary themes embedded in the panelling: in the Oval room it was the adventures of Theagenes and Chariclea (about 1604–5, *in situ*) from Heliodorus's *Aetheopica*; in the Chambre de la Reine the story of Tancred and Clorinda (about 1605, now dispersed; pl.37) proved that Tasso's *Gerusalemme Liberata* was still in fashion. These two decorative schemes, with paintings by Dubois and decorations apparently by Jean d'Hoey, spawned many others: rooms decorated with narrative paintings and romantic landscapes became popular in Paris and the provinces under Louis XIII and during the regency of Anne of Austria.

The most ambitious scheme undertaken at Fontainebleau under Henri IV was undoubtedly the Chapelle de la Trinité, decorated by Martin Fréminet (pl.34). This was begun in 1608 and was not finished until after the King's death, the paintings in 1614 but the plaster work and the high altar a good while later. Fréminet had spent a long time in Italy and was a fervent admirer of

Michelangelo; here he produced a French version, within the space available, of the Sistine Chapel. His complex iconography,[5] inspired by the Jesuits and based on the theme of the Redemption, spreads across the six sections of the ceiling (scenes from the Old Testament), the springing (*Patriarchs, Prophets* and *Virtues*) and the ovals between the windows (scenes from the *Life of Christ*). The tone is grandiose, sometimes overpowering, and Fréminet uses (and abuses) heavily emphatic figure-painting with dramatic foreshortening and strongly contrasting colours.

At the Louvre, connected by Henri to the Tuileries by the long Galerie du Bord-de-l'Eau, Jacob Bunel and Toussaint Dubreuil began decorating the Petite Galerie (now the Galerie d'Apollon) in 1607.[6] The paintings were destroyed by fire in 1661, particularly unfortunate as their political message was very clear; they represented a compromise between the sixteenth-century tradition of mythological epic and the new historical and dynastic compositions. The vault bore a mixture of Ovid's *Metamorphoses* and the Old Testament in its various sections. In the centre Jupiter could be seen striking down the Titans with his thunderbolts, a clear allusion to the King's victory over the League. On the walls, between the windows there were portraits of the kings and queens of France, from Clovis to Henri IV, executed by Bunel assisted by his wife Marguerite Bahuche and by Frans Pourbus the Younger. The only surviving remains of this series are a portrait of Marie de Médicis by Pourbus, a drawing by Bunel for his portrait of Henri IV and a *modello* by Dubreuil for one of the piers.[7] As well as these prestigious works, other pieces (which have also now disappeared) should be mentioned: the ceiling of the Audience chamber on the ground floor of the Pavilion and the Grande Galerie was decorated by Bunel in about 1609 with allegories of the Seasons, the Winds, the Elements and the Zodiac. In the apartment of Marie de Médicis, the 'cabinet dore' received scenes from *Gerusalemme Liberata* (1600–14) from the brushes of Guillaume Dumée and Gabriel Honnet. Only a few drawings remain from which to reconstruct this scheme.[8]

The third of the great royal residences, the new

Château de Saint-Germain-en-Laye, was enlarged by two *galeries* overlooking the Seine, both receiving ambitious decorative treatment but all now destroyed, buildings and paintings. The King's gallery was painted by Louis Poisson (who also painted landscapes and hunting scenes for the Galerie des Cerfs at Fontainebleau) and was supposed to be geographical, with pictures of towns the world over. The Queen's gallery, decorated by Dubreuil and Dumée, followed the dynastic model but by rather an obscure route: the significance and overall plan of the few paintings and drawings that remain was soon lost and has only recently been retrieved.[9] The subject was a series of episodes from Ronsard's *Franciade*, an epic poem extolling Henri II and retracing the myth of the Trojan (and divine) origins of the French monarchy. The political argument was couched in an effusive narrative scheme with a romantic and fabulous content, very typical of the period. Dubreuil, whose major work this was, was skilled at making the transition from dreamlike episodes (*Cybele awakening Sleep*, Fontainebleau; pl.36) to scenes of gallantry (the *Toilet of Hyanthe and Clymène*, Louvre; pl.35).

Painters during the reign of Henri IV were very receptive to European developments in art. Their models were certainly now different. They no longer followed the modified Mannerism of Florentine and Emilian painters such as Rosso, Primaticcio or Nicolò dell'Abate. They were seeking a solid monumentality, a robustness that was sometimes on the heavy side, and emphatic effects. Their two principal models were Michelangelo and Giulio Romano, sometimes known at first hand. Fréminet used his long stay in Italy between 1587 and 1602 to good advantage, and the *terribilità* of the *Last Judgement* is echoed in the Chapelle de la Trinité.[10] More frequently, prints and drawings were used, or tapestries: this is how the work of Giulio Romano spread to France, and the tormented paintings of the Prague School which fascinated Fréminet and Bellange. This style, with its sophisticated outlines, was also diffused in innumerable re-interpretations by Flemish engravers. No studio could do without this huge repertory of images. The output of the second School of Fontainebleau demonstrates it

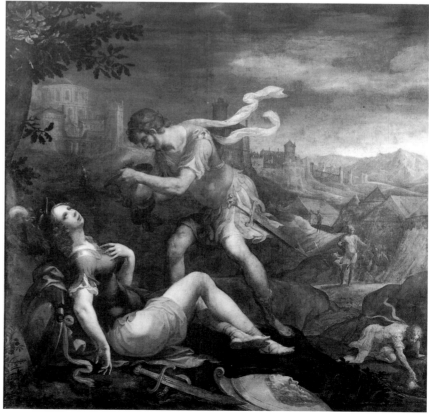

38. Jacques de Bellange (attributed to), *Lamentation for the dead Christ*. Oil on canvas, 116 × 173 cm. Hermitage Museum, St Petersburg.

quite clearly: ample figures in the foreground often in eye-catching positions, irregularities of scale and asymmetry, compositions based on interlocking triangles, strong, clear colours with oil paint replacing fresco. Even in its excesses, this firming and tightening can be seen as a prelude to the Classicism that was to follow: in his earliest pen and wash drawings for Marino, the young Poussin often comes close to Dubreuil.

Although the painting of Fontainebleau never achieved the extreme sophistication of centres like Prague or Nancy, it was nevertheless undeniably scholarly. Erudition was sovereign, and the artist's ideal source was Rhetoric. In 1601 Père Richeome stated:[11] 'Nothing gives more delight nor appeals more directly to the soul than painting, nor engraves a subject more durably in the memory, nor more effectively inspires the will and goads it into action.'

Les Tableaux de platte-peinture by Blaise de Vigenère, adapted from Philostrates's *Images* (pls 21 and 22), perpetuated the tradition of *ekphrasis*,

raising the description of works of art to the level of a literary form and encouraging painters to compete with poets.[12] Subjects from classical mythology were the most popular, allowing painters to spotlight the human form and the actions of mankind, and offering a wide choice of themes and ample scope for 'design', now of paramount importance. From 1614 on, an illustrated edition of Vigenère's book offered models to artists who were eager to present 'history' correctly and to earn the praise of learned critics. This erudition, in academic dress borrowed from mythology, inclined in two directions: first, towards the fantastic element to be found in romances and epics, ancient and modern, with their succession of episodes, their dramatic turns of events and the presence in them of the supernatural; second, towards historical accuracy and the preoccupation with evidence and propriety advocated by Antoine de Laval. There is a hesitancy about these decorative schemes that combine such wildly heterogeneous elements as battle scenes, portraits,

mythology . . . And also a profusion that may either stimulate or exhaust the spectator: the narrative cycles are still over generous, figures and events crowd and jostle each other, with a great wealth of detail.

So pedantic in certain respects, this painting is also descriptive. The Flemish influence was crucial. Landscape, in particular, seems the appropriate setting for any number of romantic scenes. Meadows, forests and the sea provide an accompaniment to the narrative that is either soothing or mysterious. Figures and objects have a real presence: in the painting from the cycle at Saint-Germain entitled the *Toilet of Hyanthe and Clymène* (Louvre; pl.35) the eroticism of the Fontainebleau School has gained a density of flesh and a tranquility that were lacking in Primaticcio. The theme of the woman bathing has become bourgeois: the unattainable goddesses modelled on Diane de Poitiers have been superseded by more down-to-earth beauties portrayed at home. The portrait said to be of *Gabrielle d'Estrées and one of her Sisters* (Louvre) embodies these twin aspirations, idealised beauty and close attention to reality.

LORRAINE: STYLE AND TRUTH

At a time when Paris was beginning, not very gracefully, to recognise the presence of its royal family, painting in Lorraine was enjoying its most brilliant period. A constellation of favourable conditions had brought this about: a sophisticated court, open to the influence of Italy thanks to a series of alliances and matrimonial connections with Mantua and Florence, France and the Empire; patrons among the nobility and aristocracy, and among the very active bourgeoisie, keen collectors of paintings, and, of course, among the religious orders whose ranks were swelling now that they had become the spearhead of Catholic reform; finally, a large number of painters and engravers, certainly more numerous here than in any of the big French towns. The names of about two hundred and sixty painters and twenty engravers have been listed for the years 1580 to 1635, often forming dynasties and over half of them in the city of Nancy alone.[13] This golden age

39. Jacques de Bellange, *Beggars' Brawl*, 1614. Engraving.

Département des Estampes, Bibliothèque Nationale, Paris.

40. Jacques de Bellange, *The Raising of Lazarus*. Engraving.

Département des Estampes, Bibliothèque Nationale, Paris.

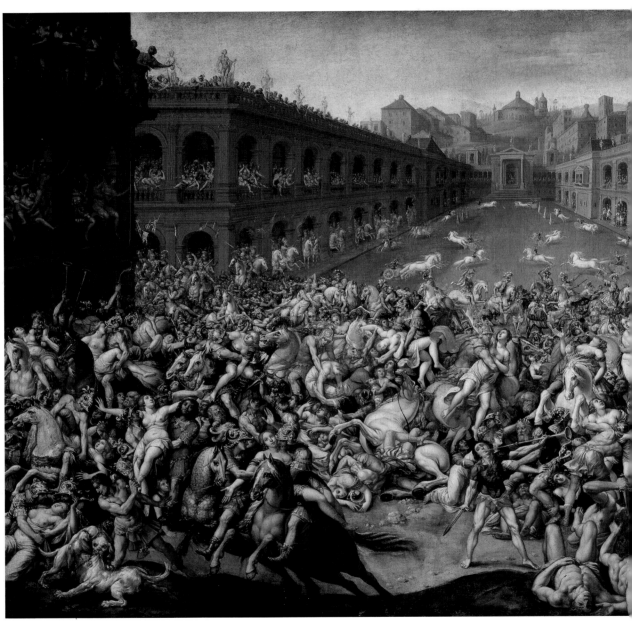

41. Claude Deruet,
*The Rape of the Sabine
Women.*
Oil on canvas,
114.8 × 186.5 cm.
Alte Pinakothek, Munich.

began in about 1580, when the new city of Nancy was created by Duke Charles III, and ended with the capture of the city by French troops in 1633, followed by the sack of Saint-Nicolas-de-Port in 1635 and the sack of Lunéville in 1638. Times of misery, war, plunder and plague, should not obliterate the memory of the preceding years of peace and prosperity when Lorraine opened its arms to the whole of Europe. Such a wealth of experience

was matched by rapid development of the arts led by key artistic figures.[14] From among a great mass of obscure, mediocre painters the names of Jacques de Bellange and Georges Lallemant, both born in about 1575, stand out; Claude Deruet, ten years or so younger, and Jean Le Clerc, born in about 1587, whose training was mainly Italian, in the school of Caravaggio. Jacques Callot and Georges de La Tour, born in 1592 and 1593,

above all a court art, passionate in its pursuit of novelty and spectacle; now that the great decorative schemes are lost and the feasts and celebrations vanished into thin air, this art has to be sought out in the prints and drawings of the day. The theatre, parades and masquerades were an essential part of it. The art of Bellange, Deruet and, at least initially, Callot was dominated by fancy dress and revelry: one need only look at Bellange's costume designs, or at the paintings of processions by Deruet in the series of *Elements* in the Château de Richelieu (Orléans; pl.45), or Callot's commentaries from his training ground in Florence under Medici rule. Manly prowess was at the heart of this aristocratic universe: feats of horsemanship, hunting scenes, battles, cavaliers and amazons, all transformed by a faintly exaggerated style. Bellange used a technique of distortion, Callot a kind of acrobatic precision; Deruet's compositions teem with life, as demonstrated in his *tour de force*, the *Rape of the Sabine Women* in Munich (pl.41). The reverse side of this *pré-précieuse* preciosity appeared frequently as surprisingly decorative satire, as in Bellange's engravings *The Hurdy-gurdy Player* or *The Beggars' Brawl* (pl.39). The fashion for recording military and civil life, though often based entirely on imagination, encouraged an unusual depth of observation and an enjoyment of pithy, often witty, detail. The development of Callot's art in all its breadth resulted from the fusion of a stylised version of the picturesque and a lucid and unforgiving eye for realistic detail; a fusion that recalls the musings of classic authors on the human predicament.[15] In the absence of chronological guidelines and authenticated paintings, it is not easy to pass judgement on the art of Bellange. His decorations for the ducal palace in Nancy (Galerie des Cerfs, Cabinet de Catherine de Bourbon) have disappeared. Extant paintings are extremely few and far between and attributions often very insecure. The famous nocturnal *Lamentation* in the Hermitage (pl.38), with its strange lighting effects that cut off the figures in seemingly arbitary fashion and spotlight faces wearing exaggerated expressions of grief in the shadows, has recently been demoted to the rank of a replica of a lost prototype.[16] Nevertheless the painting reflects a broad range of

belong to another generation, influenced by contact with late forms of Mannerism but in reaction against it.

The artistic dominance of Nancy over other centres in the region can easily be explained by the presence of the dukes. Apart from the vast and repetitive output of works for churches and monasteries, generally very conservative in their requirements and taste, the art of Lorraine was

42. Jean Le Clerc,
*St Francis Xavier preaching
to the Indians.*
Oil on canvas,
246 × 171 cm.
Musée Historique Lorrain,
Nancy.

43. Georges Lallemant,
The Charity of St Martin.
Oil on canvas,
276 × 206 cm.
Musée Carnavalet, Paris.

'licentious imagination'. This judgement pays no respect to the strength of his forms and the solidity of the composition of works like the *Raising of Lazarus* or the *Pietà*, both imbued with the emotion and anxieties bred in a sensitive soul by the conflict of the Counter-Reformation. Bellange is far less superficial than his super-refinement would lead one to believe, and to compare him with masters of the Prague School, like Spranger or Aachen, from whom he made some minor borrowings,[17] is to do less than justice to his true qualities.

It is impossible to gauge the influence of such a personality with any accuracy. Certain aspects of his style can be recognised in the work of his compatriots, but there was no single variety of Mannerism in Lorraine; painters underwent different experiences and developed different orientations, according to their circumstances. The *maniera* of Lorraine was a combination of all these plus the local interpretation of the style. We shall return to Lallemant, who spent nearly all of his career in Paris. Claude Deruet showed a solid conservatism in his work. Trained in Bellange's studio, he later spent a long period in Rome (1613–18), where he adopted the tranquil style of the Cavaliere d'Arpino and Pulzone. On his return to Nancy, however, he reverted permanently to a complicated and brilliant manner of painting, remaining faithful to it until his death in 1660, long after it had gone out of fashion. His vast and repetitive output, almost industrial in scale as the post mortem inventory of his effects demonstrates,[18] was nevertheless highly successful locally, with princes and ordinary clients alike. Louis XIII honoured him with his friendship and Richelieu employed him on the King's behalf, on the same terms as he employed Poussin and Stella, two painters who in 1640 were members of the avant-garde. As for Le Clerc, who should really be studied with the Caravaggesque painters, he brought certain new ideas back from Italy when he returned in 1622: the art of Saraceni and the Venetians, Elsheimer's sensitivity to landscape . . . His *St Francis Xavier preaching to the Indians* (Musée Lorrain, Nancy; pl.42) and his two *Adorations of the Shepherds* (Langres, and St-Nicolas, Nancy) are as foreign to Bellange as are the stereotypical out-

influences, from the refinements of Parmigianino to the grimacing faces of Passarotti, from Bologna. The only painting attributed to Bellange for certain is the *Ecstasy of St Francis* (Musée Lorrain, Nancy): the simple, solid composition recalls the modified Mannerism of northern Italy or of the Cavaliere d'Arpino rather than the Mannerism of the Prague court, suggesting that this is an early painting, earlier than his more celebrated engraved works. His engravings (*Christ carrying the Cross*, still under the influence of Fontainebleau, the *Adoration of the Magi*, the *Raising of Lazarus* (pl.40) or the impressive *Pietà*) are probably memorials to lost paintings. Although the chronology of these works is very uncertain, they present a perceptible progress from an extroverted towards a more measured and reflective style. Bellange, however, died prematurely in 1616 and his *oeuvre* remains incomplete. Today he is regarded as a draughtsman and engraver of great skill and, on occasions, perversity; a strange artist of only minor importance. Mariette spoke of his

pourings of local religious painters such as Jean de Wayembourg or Rémond Constant.[19]

The position of Lorraine at the beginning of the seventeenth century, at the crossroads of Catholic Europe, favoured its opening to outside influences rather than withdrawal into a purely regional school. In Rome, the 'nation of Lorraine' was referred to, but so was 'de-nationalisation':[20] artists developed independently, adapting their style according to where they had travelled and who they had met. How else to explain a character like François de Nomé, from Metz, who settled in Naples in 1610 and specialised in architectural capriccios lit by conflagrations? His bizarre, elegant art, typically Mannerist in its conceits, cannot (as it has been hitherto) be explained away by the assumption that the artist was deranged; no, the artist was keen to exploit a well tried formula already widely known through engravings, and commanding a huge clientèle. The allure of Rome and Venice, of Germany and Flanders, and then of Paris played its part in the creation and subsequent great success of Lorraine, whose importance diminished after the misfortunes of the Thirty Years War and the re-annexation of the Duchy by France.

PARISIAN WORKSHOPS, 1600–30

The personality of Georges Lallemant, about whom very little is known, forges a link between the artistic worlds of Lorraine and Paris.[21] Lallemant started work in Nancy, producing genre paintings in the style of Bellange which today are known mainly through wood-cuts and the occasional drawing; he was established in Paris by 1601. He opened a studio which, until the end of the 1620s and Vouet's return, was to be the liveliest in the capital. Many a young man with glorious prospects passed that way, including Vignon, La Hyre and even Poussin. He was well regarded as a portrait painter (his painting of *Echevins* dates from 1611) but in particular he was able, thanks to his many assistants, to undertake large decorative schemes in fresco, and altar decorations. In the chapel of the De Vic family, in Saint-Nicolas-des-Champs, he painted an *Assumption* on the ceiling that was ambitious for the

period; Lallemant forced himself to concentrate on the foreshortening of the figures. In 1620, in the same church, he painted a monumental *Sorrowing Virgin* in which his handling of space and volume is again ambitious, the results not without some awkwardnesses. Most of his extant works are late productions: the two *mays* for Notre-Dame, *St Peter and St Paul healing the lame man* (1630, lost, an engraving exists) and *St Stephen at prayer before being stoned* (1633, lost); cartoons for tapestries illustrating the *Life of St Crépin and St Crépinien*, also for the Cathedral (1634); various altarpieces, for example the *Charity of St Martin* for Sainte-Geneviève (1634–6, Musée Carnavalet; pl.43) or *Pentecost* (1635, Saint-Ouen, Rouen). Smaller works, designed to appeal to the general public, could be added to the list: the brilliant *Adoration of the Magi* (Lille; pl.33), with meticulous drawing reminiscent of some of Bellange's engravings, or the *Good Samaritan* (Nancy), in which the nude figure and the landscape are highlighted by dramatic lighting effects, inspired by northern artists such as Abraham Bloemart.

Lallemant remained faithful to formulae that might have seemed archaic in the Paris of Simon Vouet: he muddles simultaneous events in his compositions, and makes errors of scale; the outlines of his figures are tortured; his brushstrokes are rapid and relaxed, with paint applied quite thickly; his use of colour is careful, if occasionally on the garish side. The narrative, illustrative quality of his painting adapts well to serious subjects. At the end of his career, his *Pentecost* (now in Rouen) is lively in its composition yet symmetrical and statuesque, and firm in its execution. It shows that the painter has absorbed certain influences, first and foremost the influence of his own pupil, Philippe de Champaigne, whom he had once reproached for being too interested in perspective.

Such progressive clarification can also be seen in the work of Quentin Varin, whose visual culture was very broad. Had he travelled in Italy before stopping in Avignon, where documentary evidence exists of his arrival in 1597? A painting like the *Entombment* in the Louvre suggests contact with the Mannerism of Parmigianino and the dramatic lighting effects of Bassano. The two

46. Quentin Varin,
The Presentation of Jesus in the Temple.
Oil on canvas,
600 × 300 cm.
Eglise Saint-Joseph-des-Carmes, Paris.

scenes of martyrdom, now in Les Andelys, painted in 1612 under the gaze of the youthful Poussin, are ambitious in spite of some obvious archaisms: Varin proves himself capable of telling a tale and breathing life into a crowd of protagonists. It was in Paris, however, after 1616, in the circle of the Queen Mother and the Duc de Chevreuse that Varin's painting began to blossom, thanks to a new approach to structure and composition. Evidence of this blossoming can be observed in the *Marriage at Cana*, painted in 1618 for the church of Saint-Gervais, Rennes. Varin's mastery of architectural perspective, which undoubtedly owes a lot to the Flemish painter Martin de Vos, produces straightforward rhythmical compositions, in strong contrast to Lallemant's, empirical, relaxed approach.

44. Quentin Varin,
Healing the Paralytic.
Oil on canvas,
343 × 260 cm.
Eglise Saint-Louis,
Fontainebleau.

45. Claude Deruet,
Water.
Oil on canvas,
113 × 227 cm.
Musée des Beaux-Arts,
Orléans.

47. Ferdinand Elle,
Moses striking the Rock.
Oil on canvas,
202 × 142 cm.
Eglise Notre-Dame-des-
Blancs-Manteaux, Paris.

48. Nicolas Poussin
(after),
The Death of the Virgin.
Pen and brown ink and
watercolour,
39.5 × 31 cm.
Private collection, Great
Britain.

49. *opposite*:
Jean Senelle,
*The Preaching of St John
the Baptist*, 1629.
Oil on wood,
131 × 214 cm.
Musée Bossuet, Bourges.

50. Nicolas Bollery,
*The Adoration of the
Shepherds.*
Oil on canvas,
226 × 171 cm.
Parish church, Fontenay-
Trésigny (Seine-et-Marne).

The climax to Varin's development as an artist can be found in two masterpieces. *Healing the Paralytic* (pl.44), presented to the church of Saint-Louis in Fontainebleau by Louis XIII in 1624, pays tribute to the sculpture of classical antiquity and to Michelangelo, *via* Fréminet. The nude plays an important part. Varin's virtuosity is demonstrated in powerfully foreshortened figures, a rational use of architectural elements and gesture in a composition still hesitating between anomalies of scale and the traditional diagonals, and a symmetry presaging the new age. In the *Presentation of Jesus in the Temple* (pl.46), presented by Anne of Austria in the same year to the Carmelite church in Paris to adorn the high altar, the composition is firmly frontal and might seem stiff and dull if this were not corrected by the arabesque described by the few figures. The silhouettes are still full of movement, but the two figures on the left (the prophetess Anna and the seated woman with two children) have a strong presence, reinforced by vividly explicit gestures. The colour scheme enhances the legibility of the painting, proceeding in solid blocks across the canvas, intense for the main protagonists and more discreet for the minor figures. The composition was designed to be seen from the entrance to the church, from a considerable distance and centrally, a fact that can still be appreciated today.

In 1624, after several unsuccessful attempts, Poussin, aged twenty-eight, finally left for Italy. He had already made a name for himself in Paris. He was not typical of his kind, however, because of his class (his family belonged to the *noblesse de robe*, or magistrature), his education, his refusal to submit to the routine of the large studios, his search for models in classical Antiquity and the Renaissance and his study of anatomy and perspective. Unfortunately, not a single work from his early days in Paris survives. The monumental *St Denis* in Rouen is still under discussion, but seems to represent a meeting of the styles of Varin, Pourbus and Champaigne. Archive sources mention six large decorative paintings executed in 1622 for the Jesuits to celebrate the canonisation of Saints Ignatius Loyola and Francis Xavier and, in 1623, a *Death of the Virgin* painted for one of the chapels in Notre-Dame and known through a

watercolour copy (private collection; pl.48). Here the composition seems cluttered; references to Michelangelo, to Pourbus and even to Rubens betray strong ambitions, but also insecurity. The drawings commissioned by Giambattista Marino on subjects from Ovid (Windsor Castle) still frequently display the influence of Fontainebleau. Some quotations from Roman bas-reliefs, however, distinguish these compositions from anything by a Dubois or a Dubreuil, and display the artist's fascination with order and harmony, and with that quality of light that he went to Italy to discover.[22] Poussin's hesitations, and his restless searching, prevent one from regarding him (before he reached the age of thirty) as a straightforward mouthpiece for Mannerism.

Among the well known painters who mixed with Poussin in Paris the name of Ferdinand Elle le Vieux is worth recalling; he came originally from Malines but had been resident in the capital since 1609. He was best known as a portraitist, but also painted robust religious paintings, somewhat unimaginative, brilliantly coloured as can be observed in the series of paintings in the church of Notre-Dame-des-Blancs-Manteaux (pl.47), formerly attributed to Lallemant. Nicolas Bollery, born in Paris in about 1560, collaborated with Dubreuil in Saint-Germain-en-Laye. His principal work, the *Adoration of the Shepherds* in Toulouse cathedral (there is another version in the church of Fontenay-Trésigny; pl.50), probably about 1615–20, is the work of a conscientious successor to the second school of Fontainebleau, albeit with a rustic charm of its own. If Carel van Mander is to be believed, Bollery painted 'beautiful night scenes, masquerades and other celebrations, and also flocks of sheep after the manner of Bassano'.[23] Thus a Venetian element entered rather awkwardly into religious painting, the artist seeking new inspiration by borrowing from genre subject matter. The work of Jérémie Le Pileur, active in Touraine during the 1620s, shows the same trend: *Christ on the Mount of Olives*, Rouen, or *Gideon in the Midianites' Camp*, in the Louvre, combine the lessons of Bassano with direct inspiration from Flemish engravings. Late Mannerism, therefore, and especially that of Lallemant and the Antwerp print-makers, continued its hold even

51. Jacques Boulbène,
*Allegory of Providence,
Vigilance and Honour*,
1595.
Oil on canvas,
334 × 255 cm.
Musée des Augustins,
Toulouse.

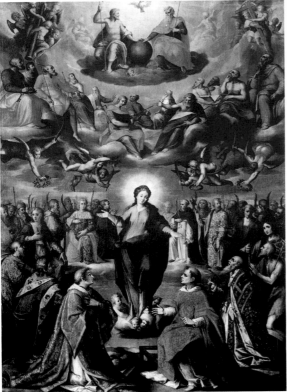

52. Richard Tassel,
The Triumph of the Virgin,
1617.
Oil on canvas,
197 × 143 cm.
Musée des Beaux-Arts,
Dijon.

53. *opposite*:
Martin Fréminet,
*The Adoration of the
Shepherds*, 1602–1603.
Oil on canvas,
235 × 158 cm.
Musée départemental, Gap.

after the return of Vouet in 1627, but would abate
rapidly thereafter. Not far from Paris, in Meaux,
the work of Jean Senelle illustrates this develop-
ment: his *Preaching of St John the Baptist* (1629,
Bourges; pl.49) bears traces of the old models. But
the paintings that succeeded this one, in the for-
ties, such as the *Raising of Lazarus* (Eglise Sainte-
Aldegonde, Villenoy) show clearly how one style
drives away the other. Vouet, then Le Sueur,
were henceforth to be the authorities to whom
these second-rank artists turned, and from whom
they drew their daily bread, in order to satisfy
their clientèle of local worthies.

SOME EXAMPLES FROM THE PROVINCES

In the provinces, Mannerism had taken root
firmly and took longer to uproot than it did in
the capital. Painting was weighed down by a
long tradition. The prestige of centres like
Fontainebleau and Nancy, their influence and that
of the Parisian studios, was reinforced by the trips
made by the artists, and their contacts with Rome,
Florence, Parma or Venice, to mention only Italy.
The wanderings of Quentin Varin provide a typi-
cal example. Print-making also interpreted and
prolonged the life of the Italian models.
Fontainebleau, Lorraine and Antwerp in particu-
lar flooded the market with figures in complicated
poses, ornaments endlessly repeated and composi-
tions based on the hackneyed formulae. In the
larger towns a clientèle of tradespeople or lawyers,
with little interest in innovation, was satisfied by
these elaborate offerings. Municipal commissions
favoured allegory, and the painters, sometimes
assisted by local intellectuals, made great use of
works of iconography like Ripa's manual: Jacques
Boulbène in Toulouse, with his *Allegory of Provi-
dence, Vigilance and Honour* (pl.51), painted in
1595, for the Capitole,[24] or Richard Tassel, who
decorated the Gold Chamber in the parliament in
Dijon with *Virtues* in grisaille (1619).

The taste of the local aristocracy was for sub-
jects from chivalry and romance for the decora-
tion of their châteaux. Tapestry was very widely
used and tapestry designs influenced decorative
painting: the compositions were simple, consist-
ing of large contrasting blocks of colour. The epic

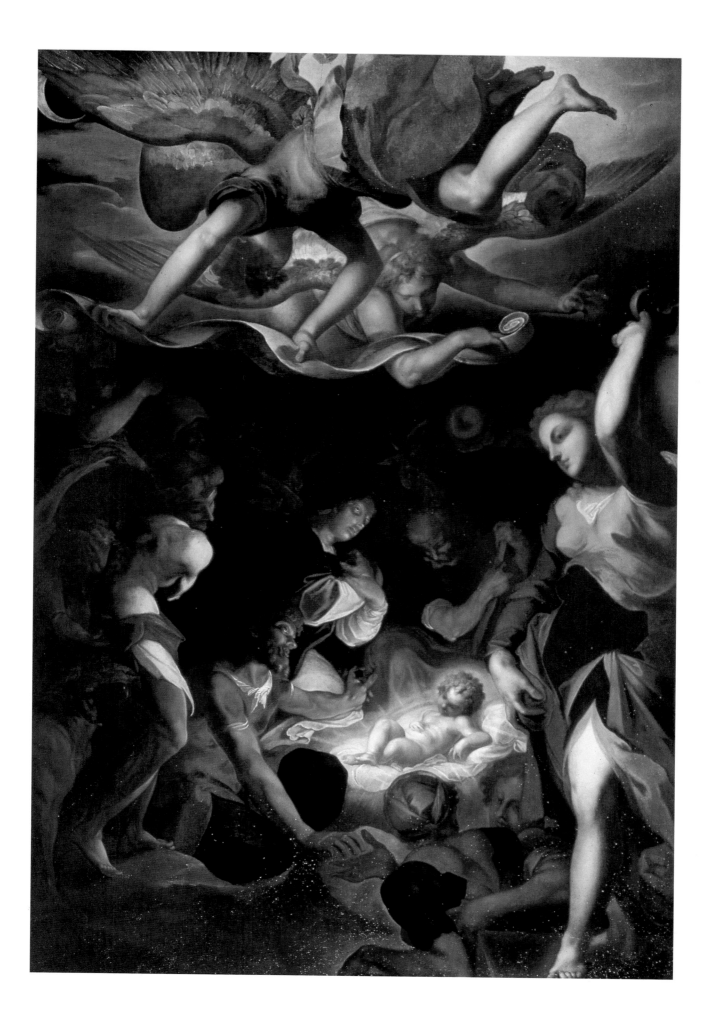

note was tempered with touches of Flemish realism, particularly in landscape painting. Extant examples are very scarce, but mention must be made of an anonymous series of paintings, probably executed between 1620 and 1630 for the Château d'Effiat, in Auvergne, and now in the Musée de Clermont-Ferrand (pl.57).[25] These illustrate Ariosto's *Orlando Furioso* and suggest the work of an experienced hand, probably a specialist in cartoons for tapestries, with a robust, almost aggressive style, in which echoes of Dubois and Dubreuil disport themselves against a background of dense woodland and meadows. In general painting at this time disappeared into small 'cabinets', inspired by the Italian *studioli* in which series of paintings, often tinged with well mannered humanism, were built in to the panelling: examples in Burgundy include the Cabinets of the Muses at Ancy-le-Franc and La Motte-Ternant, and the Cabinet of the *Pastor Fido* at Ancy-le-Franc.

Religious painting was by the far the most popular genre. Every church or monastery ordered new decorations for the altar, or restored or completed the old ones. Three works are worth mentioning here because they illustrate the relationship between centres that, though geographically distant, had in common the language of Mannerism. Fréminet's *Adoration of the Shepherds* (Gap; pl.53) was painted in 1602–3 for the Hospice du Montgenèvre, while the artist was returning from Turin to France. This is a powerful painting, with quite artificial lighting effects, which bears similarities to the work of the Prague painters, Heintz and Spranger, well known through engravings. Richard Tassel's *Triumph of the Virgin*, dated 1617 (Dijon; pl.52), is a good example of this painter's huge output. Tassel, who was also an architect and sculptor, travelled to Venice and Rome, and his reputation extended well beyond Langres, his home town, to Dijon and Lyon. François Mimault's *Baptism of Christ* (La Madeleine, Aix-en-Provence; pl.55) may have seemed anachronistic in 1625, with its busy and very superficial composition, its cherubs and northern landscapes, painted while Provence was undergoing a strong reaction against Mannerism. Mimault's use of colour, however, has its own

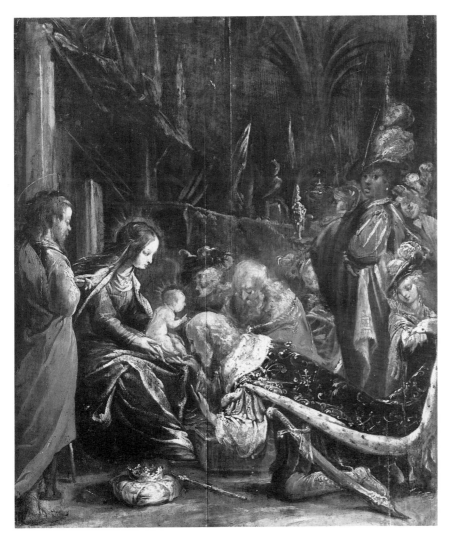

54. Jean de Saint-Igny,
The Adoration of the Magi.
Oil on wood,
57 × 45 cm.
Musée des Beaux-Arts,
Dunkerque.

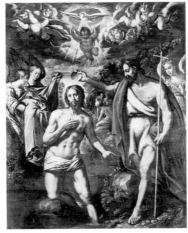

55. François Mimault,
The Baptism of Christ,
1625.
Oil on canvas,
22.3 × 173.5 cm.
Eglise de la Madeleine,
Aix-en-Provence.

56. Anonymous,
Jesus expelling the Merchants from the Temple.
Oil on canvas,
176 × 230 cm.
Eglise Saint-Patrice, Rouen.

57. Anonymous,
Orlando, in love with Angelica, believes he sees her appear.
Oil on canvas,
222 × 312 cm.
Musée Bargoin, Clermont-Ferrand.

charm and is reminiscent of the Venice of Tintoretto, or of El Greco; his handling of forms and his general sobriety, suited to the religious feeling of the period, could be seen as symptomatic of some kind of development.

The town of Rouen[26] presents an interesting case; the proximity of the Château of Gaillon to the wealthy and flourishing town encouraged faithful imitation of early Italian Renaissance models, particularly in sculpture, while Flemish art also took firm hold there thanks to artists like Michel Du Joncquoy, from Tournai, who had done his tour of Italy. The 'Roman' influence can be clearly seen in his *Christ on the Cross*, 1588, in the Cathedral. The vitality of the religious orders and parishes, typical of France at the beginning of the century, produced an enormous output of paintings, a lot of which are anonymous: examples include the *Adoration of the Shepherds* in the church of Saint-Martin in Boscherville, influenced by Abraham Bloemaert; *Jesus expelling the Merchants from the Temple*, in Saint-Patrice, a later work (about 1620–5; pl.56) containing obvious references to Michelangelo. Mannerism persisted for a long time in Rouen thanks to Jean de Saint-Igny, who divided his time between Rouen, his home town, and Paris, where his somewhat precious style, influenced by Claude Vignon, was much in demand. In his *Adoration of the Magi* of 1636, in grisaille (Rouen, *modello* in Dunkerque; pl.54), and its pendant *Adoration of the Shepherds*, the accumulation of picturesque details, an effete elegance in the drawing of the figures and self-conscious light effects cannot hide the weakness of the composition. Saint-Igny is more at home with small paintings. In him, the life of the quintessential vehicles of Mannerism (the paintings of Bellange or Lallemant) was extended into the fourth decade of the century.

Horace Le Blanc, from Lyon, was the official artist of his city in 1623 and the following year was elected painter in ordinary to the king; he was probably the ablest interpreter of Italian models on French soil in the 1620s. A jack-of-all-trades, he moved easily from painting altarpieces to portraits, from ephemeral constructions built for royal or princely visits, to the decoration of galleries (for instance the gallery in the Château de Grosbois for

58. Claude Vignon, *The Death of Lucretia*. Oil on canvas, 138 × 149 cm. Musée des Beaux-Arts du Château, Blois.

the Duc d'Angoulême). His double training, with Palma Giovane in Venice, and in the circle of Lanfranco and Perrier in Rome, may explain his style, in which elegance and meticulous use of colour combine with forms that are a shade too emphatic. In his *St Sebastian* in the Musée de Rouen, his manner of planting an elongated nude in front of a silver-hued landscape recalls Fontainebleau. He uses the traditional formulae, but in a relaxed fashion, as displayed in his *Entombment with Donors* (1621, Saint-André, Grenoble). His successful vocabulary of gesture places him squarely with the avant-garde, as witness the thrilling *Ecstasy of St Theresa* (1621, Lyon; pl.59) and the *Trinity appearing before St Ignatius*. He was the forerunner of a brilliant artistic period in Lyon, and was able to pass on to his pupil, Jacques Blanchard, his facility with the brush and the rich, clear colours that make him especially pleasing as a painter.

THE MANNERIST INHERITANCE

Between 1620 and 1630, a number of young painters were making their way to the top: Claude Vignon and Laurent de La Hyre, for instance, both pupils of Lallemant, and also the three Le Nain brothers and Michel I Corneille. The earliest painting known to be by Corneille, *Jacob and*

59. Horace Le Blanc, *The Ecstasy of St Theresa*, 1621. Oil on canvas, 242 × 188 cm. Musée des Beaux-Arts, Lyon.

60. Claude Vignon,
The Adoration of the Magi,
1624.
Oil on canvas,
140 × 265 cm.
Eglise Saint-Gervais, Paris.

61. Laurent de La Hyre,
*The Meeting of Abraham
and Melchisedech.*
Oil on copper,
63 × 60 cm.
Musée des Beaux-Arts,
Rouen.

62. Laurent de La Hyre,
Hercules and Omphale.
Oil on canvas,
150 × 214 cm.
Kurpfälzisches Museum,
Heidelberg.

Esau, dated 1630 (Orléans), sits half way between Lallemant's romanticism and a firm realism more attributable to Flemish art than to the Italy of Caravaggio. The persistence of the traditions of Fontainebleau[27] and of contacts with a number of different centres in Italy favoured a vague kind of Mannerism whose effects could still be felt (though in an attenuated form) among pupils of Vouet such as the younger Le Sueur around 1635–40, or even, as late as the beginning of the 1650s, Lubin Baugin.

It is no easy task to find a unifying thread in the career and the works of the versatile and eclectic Vignon. Mannerism dominates his output, but it is a subtle kind of Mannerism, constantly moderated and modified by the artist's rich visual culture. The two most important experiences of his early life were his training under Jacob Bunel before 1616 and a period in Rome between 1617 and 1623, when he was influenced by Caravaggio. Add to this several trips to Spain and association with dealers in engravings (international by definition), through whom Vignon came into contact with the works of Rembrandt in particular. A connoisseur of paintings and a skilled imitator,

Vignon was a virtuoso who kept at his fingertips everything that the painting of his day had to offer, whether outstanding for its excellence or bizarre. Charles Sterling has suggested[28] that he could be placed in a different context, in a 'pre-Rembrandtist' movement, with links with Roman and especially Venetian Caravaggists like Domenico Fetti. The influence of northern artists like the German Elsheimer, and Lastman, Jan and Jacob Pynas and Bramer, all from the Netherlands, can be detected; Bramer's scintillating style is very close to that of Vignon. His mannered, sometimes whimsical use of colour, heightened by thickened and incrusted paint, combined with the elegant draughtsmanship of the Mannerists of Lorraine or Paris to produce, in the 1620s, a number of masterpieces. The *Adoration of the Magi* (1624; pl.60), in the church of St-Gervais in Paris, is a well constructed painting, yet it still displays a fantastic tendency in its treatment of dress, in the distribution of light and in the unusual juxtaposition of colours. This mannered theatricality persisted into the following decades even though Vignon's signature became less firm and the slips and omissions more numerous.

Vast and of uneven quality, Vignon's work excited the admiration of intellectuals like Georges de Scudéry, who included in his *Cabinet* in verse entitled *Thalestris, reine des Amazones* (1646),[29] one of the 'powerful women' fashionable at the time, the subject of a series of engravings by Vignon:

> L'on voit sur ses beaux habits
> Les perles et les rubis,
> Parmi des couleurs plus sombres.
> Et l'Art nous a si bien peint
> Les plis, les jours et les ombres,
> Qu'on croit tout, où tout est feint.

(Pearls and rubies can be seen on her sumptuous dress, among the deeper shades. Art has so skilfully represented each pleat, each openwork border, light and dark, that we believe it real though all is fake.)

The *Death of Lucretia* (Blois; pl.58), and some of the half-figures of saints (*St Jerome*, private collection) belong to the later period; the looser brushwork, dark, saturated colours and tortured figures

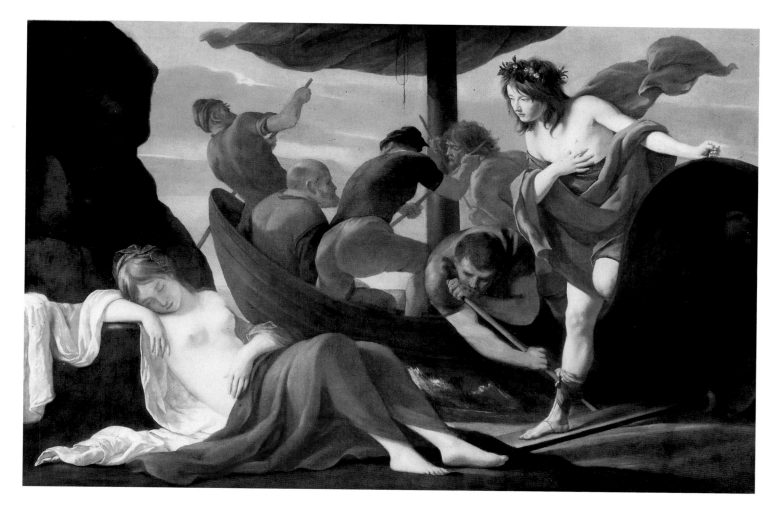

contrast with the precise, clear painting of his youthful classical period in Paris. Vignon survived until 1670, having been made a member of the Académie in 1653: his career spans the reigns of Louis XIII and Louis XIV, prolonging far into the century his particular imaginative, relaxed way of painting. This, having for years militated against him, should by rights ensure his total rehabilitation today.

One of Lallemant's disciples developed in a completely different direction: the well educated, thoughtful Laurent de La Hyre. His early years, from about 1625 to 1630, were influenced by Fontainebleau, and by Primaticcio in particular, rather than by the painters of the second School; other influences to be taken into account were the prints and engravings of international Mannerism, from Bellange to Spranger via Goltzius. Evidence of these influences can be found in his poetic illustrations to the epic romances, *Rinaldo and Armida*, *Tancred and Clorinda*, *Cyrus and Pantheus*, *Alcestis and Admetus*, or his first known painting, *Hercules and Omphale* (about 1626, Heidelberg; pl.62). Later, his composition grew firmer and his forms more thickset in, for example, *The Tile* (Louvre), in which the artist's enjoyment of geometrical forms became evident, and *Christ on the*

Mount of Olives (Le Mans), a nocturne in the style of Lallemant. From 1630, La Hyre turned his attention to different subjects, but inspiration from epic romances, the exoticism of some of his figures and the liveliness of his carefully chosen colours sustained his magical quality well into the fourth decade of the century; the elegance of his figures and a certain tenderness are characteristic (*Abraham and Melchisedech*, pl.61, *Elijah in the Desert* in Rennes; paintings from his *Story of Pantheus* in Montluçon and Chicago). The movement and asymmetry of the *may* of 1637, *The Conversion of St Paul* (Notre-Dame, Paris, *modello* in a private collection) are still redolent of La Hyre's earliest inspiration; though more in control in later years his painting never lost its rarefied charm.

In about 1625–30, three young artists, trained in Laon by an itinerant painter who seems to have had Mannerist tendencies, set up as painters in the Paris of Louis XIII. These were the brothers Le Nain, and the eldest, Antoine, was named master painter in Saint-Germain-des-Prés in 1629. Their earliest output, though little known, has been much written about. Jacques Thuillier includes in it *Bacchus and Ariadne* (Orléans; pl.63), a mythological painting in which simplified references to Primaticcio's Galerie d'Ulysse at Fontainebleau

63. The Le Nain brothers, *Bacchus and Ariadne*. Oil on canvas, 102 × 152 cm. Musée des Beaux-Arts, Orléans.

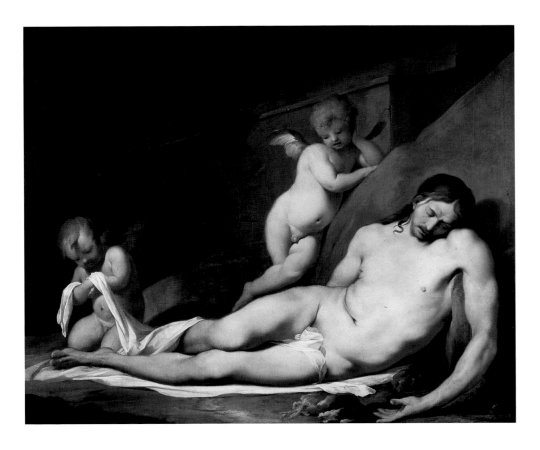

64. Lubin Baugin,
The Dead Christ.
Oil on canvas,
150 × 180 cm.
Musée des Beaux-Arts,
Orléans.

can be plainly identified, as well as various religious scenes grouped around the two versions of the *Adoration of the Magi* in the museums of Abbeville and of Meaux (pl.66): the *Last Supper* and the *Supper at Emmaus* in the Louvre, the *Virgin with the Wine Glass* in Rennes, the *Ecce Homo* in Reims, and two *Adorations of the Shepherds*, one in London, one in Dublin.[30] Jean-Pierre Cuzin and Pierre Rosenberg[31] ascribe all these works to the youngest of the three brothers, Mathieu Le Nain, alone, placing them at the end of his career and maintaining that he returned to the Mannerism of his youth after the death of his two older brothers in 1648. To me, however, these appear to be the work of beginners who, having learnt their *métier*, employ conventional formulae and weighty composition, with figures heaped up, in an attempt at high seriousness. The result is far removed from the world of Lallemant or Vignon. The figures are awkward, rustic types with suspicious faces, very carefully observed, painted in muted colours: the paintings belonging to the 'Adoration' group proclaim the maturity of the Le Nain brothers, but also demonstrate their indebtedness to their Parisian environment.

The younger generation had moved beyond the monumental style and deliberately didactic approach of painters like Dubois and Dubreuil, and were discovering and re-inventing the elegant art of Primaticcio and the first School of Fontainebleau. Although Mannerism contained within itself, within its very sophistication, the seeds of the hackneyed formulae to which it was eventually reduced, it also possessed in its maturity the basic principles of order and harmony, and a striving for poetry that greatly attracted history painters and their clientèle. The work of both Vouet and Poussin can partly be understood in the light of this inheritance. 'A passionate attempt to recreate Primaticcio on Nature', as Jacques Thuillier wrote, paraphrasing Cézanne,[32] and this phrase could be used to characterise the painters, young and less young, who were active during the 1630s and 1640s. The lessons of Fontainebleau made a durable impression on Lubin Baugin. His career began at St-Germain-des-Prés, where he appears to have painted a number of his celebrated still lifes.[33] Between 1636 and 1640 he was in Italy where he had a chance to ponder the examples of Raphael and Guido Reni, and Correggio and Parmigianino as well. On his return to Paris in 1641 he was welcomed into the art establishment and painted with a subtle, selective Mannerist touch which probably harked back to a stay in Parma. The elegance of his nude figures, displayed in subjects from antiquity, is well illustrated in the *Childhood of Jupiter* (about 1645–50, Troyes; pl.65). Large compositions like the *Birth of the Virgin Mary* and the *Presentation of the Virgin* (Aix-en-Provence), impress because the almost abstract interplay of the elongated forms, and the way the bright, glowing colours, warm and cool shades

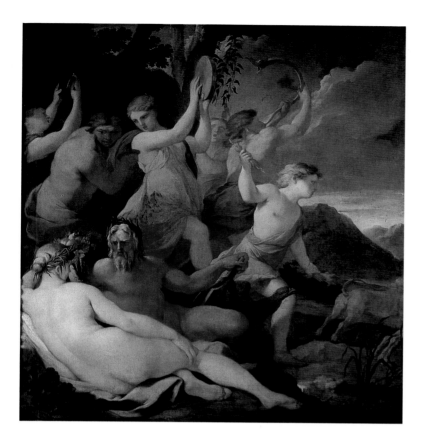

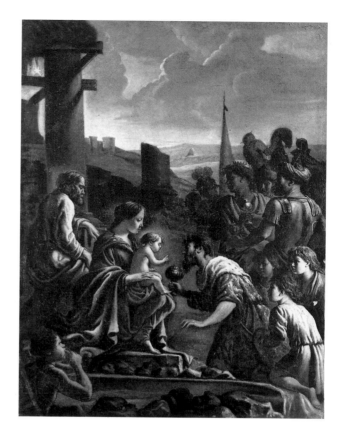

being juxtaposed with dexterity, give a subtle rhythm to the whole. Devotional subjects like the *Dead Christ being watched over by an Angel* (Orléans; pl.64) reject sentiment while managing to reconcile idealism with emotion. This self-restraint, allied to a stylised quality that is the reverse of dull, can be found at the same time in the work of Le Sueur, still under the influence of Vouet. The light-hearted, expansive approach of the episodes illustrating the *Dream of Polyphilus* (Malibu; Musée Magnin, Dijon; Salzburg; Le Mans; Rouen) sums up the achievement of the French Renaissance, in form and in content.

Notes

1. G.B. Marino, letter to G.B. Ciotti (1621), *Epistolario*, ed. A. Borzelli and F. Nicolini, Bari, 1911–12, vol.i, pp.303–4. Quoted and translated by M. Hochmann, *Peintres et commanditaires à Venise (1540–1628)*, Rome 1992, p.113.

2. See exh. cats, Paris, 1972 (1), (with a useful topographical index) and Meaux, 1988–9, and the Fontainebleau symposium, 1992.

3. See exh. cat., Fontainebleau, 1978.

4. This concept put the emphasis on historical accuracy and the exaltation of a dynasty, thereby detracting from myth; it has been studied in detail by Thuillier, 1975.

5. Samoyault-Verlet, 1972 (1975).

6. On the Petite Galerie, see Aulanier, 1955; Collard and Ciprut, 1963, pp.16–24.

7. Cordellier, 1990. See also below, chapter 8, p.187.

8. On this apartment and its decor, see Erlande-Brandenburg, 1965; Béguin, 1967.

9. Cordellier, 1985.

10. On Michelangelo in France, see Thuillier, 1957; Chastel, 1966 (1978); Cordellier, exh. cat., Meaux, 1988–9, pp.38–40.

11. Richeome, 1601 (introduction).

12. See Cordellier's essay: 'Le peintre et le poète', exh. cat., Meaux, 1988–9, pp.34–6.

13. M. Sylvestre, 'Aspect social de l'art en Lorraine', exh. cat., Nancy, 1992 (1), pp.53–9.

14. Exh. cat., Nancy, 1992 (1).

15. See also below, chapters 7, p.161, and 9, p.217.

16. By J. Thuillier, exh. cat. Nancy, 1992 (1), no.4, p.142. The work was published as being by Bellange by Linnik, 1973.

17. On the links between the art of Lorraine and the School of Prague, see Da Costa-Kaufmann, 1985, p.161.

18. Published by Jacquot, 1894.

19. On these minor artists, see exh. cat., Nancy, 1992 (1).

20. A. Chastel, 'Italianités', *Le Monde*, 6 May 1982, p.18. On the artists from Lorraine living in Rome, see exh. cat., Rome and Nancy, 1982.

21. On Parisian studios of the early seventeenth century, in the absence of any detailed study, see exh. cat., Meaux, 1988–9.

22. See above, chapter 2, note 9.

23. Van Mander, *Het Schilderboeck* (1604), translated and quoted by S. Kerspern, exh. cat., Meaux, 1988–9, p.82.

24. Boyer, 1991.

25. S. Laveissière has made a study of these paintings, exh. cat., Meaux, 1988–9, pp.86–91.

26. Rouen as an artistic centre in the seventeenth century has been studied in depth in two exh. cats, Rouen, 1980–1 and 1984.

27. Thuillier, 1972 (1975) and exh. cat., Meaux, 1988–9, *passim*.

28. Sterling, 1934.

29. Scudéry, 1646 (1991), pp.85–7.

30. See exh. cat., Paris, 1978–9, *passim*; Thuillier, 1979; exh. cat., Meaux, 1988–9, no.43.

31. Cuzin, 1979; Rosenberg, 1979 and 1993.

32. Thuillier, 1972 (1975), p.263.

33. See below, chapter 10, p.241.

65. *left*:
Lubin Baugin,
The Childhood of Jupiter.
Oil on canvas,
150 × 144 cm.
Musée des Beaux-Arts,
Troyes.

66. The Le Nain
brothers,
The Adoration of the Magi.
Oil on canvas,
117 × 87 cm.
Musée Bossuet, Meaux.

REACTIONS TO MANNERISM

IOANNES BOVCHERY DICTVS
INVENIT ET FECIT 1613

In a pioneering essay on Italian art,[1] Walter Friedlaender identified an 'anti-Mannerist' style consisting of a combination of different ingredients – some Caravaggio, of course, but also some Barrocci, Santi di Tito, the Carracci and various others. In order to describe an 'anti-Mannerist' style in French painting an art historian would be faced with an almost equally complex situation. The great movements that intersected during the first quarter of the seventeenth century were not all of the same importance or scope. The longer the reign of international Mannerism lasted and the more it filtered into almost every artistic sphere in Europe (in forms that, it must be said, grew increasingly banal), the more the reactions it elicited varied in duration, in distribution and in their effect. We shall examine three of these reactions, whose impact was significant even if not clearly perceived. The most prominent, and certainly the most brutal, although also the briefest and perhaps the most circumscribed, was Caravaggism; its international ramifications and principal protagonists have been studied in depth over the last thirty years. Less prominent, although brought to light this century in Italy,[2] the search for a kind of stylistic neutrality or middle way was only identified in France when painters like Jean Boucher were rediscovered.[3] This movement was unobtrusive but powerful, heralding the radical stance of the Classicism of the 1640s and 50s and allowing later historians to make a connection between some of the dictates of Catholic reform and developments in painting. It would be tempting to diagnose this as a typical French reaction to invasion by a 'foreign' style, Mannerism. But this would be asking the question the wrong way round: in the France of Henri IV, Mannerism became *the* national tradition, epitomised by Fontainebleau. To renew it, painters were obliged to look beyond the borders of France. To escape from ossification and to find new ideas, the French badly needed the Italy of Cavaliere d'Arpino and Caravaggio, as they needed Flanders. The contribution of Flanders was crucial, particularly for Paris. The role played by Rubens is well-known, but the importance of Pourbus and others, equally if not more important, is less clearly perceived in spite of recent

67 *previous pages*:
Valentin de Boulogne,
Concert.
Oil on canvas,
173 × 214 cm.
Musée du Louvre, Paris.

68. Jean Boucher,
Nativity, 1610.
Oil on canvas,
189 × 152 cm.
Cathédrale Saint-Etienne,
Bourges.

69. Philippe Quantin,
The Annunciation.
Oil on canvas,
465 × 223 cm.
Eglise Saint-Michel, Dijon.

70. Trophime Bigot,
*The Assumption of the
Virgin*, 1639.
Oil on canvas,
220 × 170 cm.
Parish church, La Tour-
d'Aygues (Vaucluse).

71. Philippe Quantin,
A Muse.
Oil on canvas,
118 × 159 cm.
Musée des Beaux-Arts,
Dijon.

72. Jean Le Clerc,
The Concert.
Oil on canvas,
137 × 170 cm.
Alte Pinakothek, Munich.

studies.[4] Cross-fertilisation opened new avenues, as it had during the reign of François I.

COUNTER-REFORMATION AND THE MIDDLE WAY

From about 1580 onwards, a reaction set in in Italy against the excesses of an art that was as dry as dust, having been dragged into an impasse by over-sophistication of form, and an intellectual pretentiousness that was out of control. The art of the Carracci in Bologna and Caravaggio in Lombardy, then in Rome and Naples, was the most celebrated manifestation of a return to reality, to truth to life, to naturalism. Not that the idea of *nature* meant the same thing to all the artists: for the Carracci, nature meant principally a sober and balanced style, the resumption of links with the classical Renaissance, with Raphael as well as Correggio, and the combination of fullness of forms with the colour values of the Venetians; for Caravaggio, nature justified a dramatic approach to reality, commonplace at times but also intensely religious, intended to convey emotion with powerful immediacy. The two streams diverged very quickly, and it would be difficult to imagine artists more different than the Bolognese pupils of the Carracci on one hand, and the

Caravaggesques on the other. Nevertheless, in both cases the new naturalism complied with the recommendations of the Church, at the time anxious to clarify to its followers dogmas that had been redefined and clarified by the Council of Trent.[5] The Counter-Reformation was trying to distance itself from allegorical flights of fancy by re-inserting Christian truth firmly into the heart of everyday life. Rejecting subjects that were too complicated or smacked of heterodoxy, the Counter-Reformation encouraged simplicity and austerity in compositions, the rejection of extremes and gratuitous effects. In most of the large centres there were painters willing to comply with the Church's recommendations: Cerano in Milan, Santi di Tito in Florence, Muziano and Pulzone in Rome. In many cases, the over-elaborate style to which Mannerism had been reduced was being replaced by a search for something more impersonal, the artist's own *maniera* being required to take a discreet second place to the subject, which was to be treated in a straightforward manner and with respect. Rome, which for a time remained a conservative, even reactionary centre, played host to an art that was 'outside its time',[6] or that could also be seen as having found the middle way. In fact, with Cavaliere d'Arpino or Pomarancio, it was merely a modified Mannerism in which simplified language sought renewal through eclecticism.

French painters arriving in Rome at the end of the sixteenth century or the beginning of the seventeenth century gravitated towards Cavaliere d'Arpino. Annibale Carracci and Caravaggio did not start working in Rome until about 1595 and had not yet established their position as models to be imitated. Nowadays, when the decoration of the Farnese gallery and the paintings in S. Luigi de' Francesi seem to outshine all contemporary production, it is hard to comprehend the prestige then enjoyed by Cavaliere d'Arpino, *il Giuseppino*, who was overwhelmed by commissions from a great variety of quarters. Even as late as the 1620s, the fragmentary decorative scheme executed by Vouet in the Cappella Alaleoni in S. Lorenzo in Lucina echoes his work, as do Poussin's *Battles*, his Roman début. The more reason for thinking, therefore, that Roman art *senza tempo* can assist us

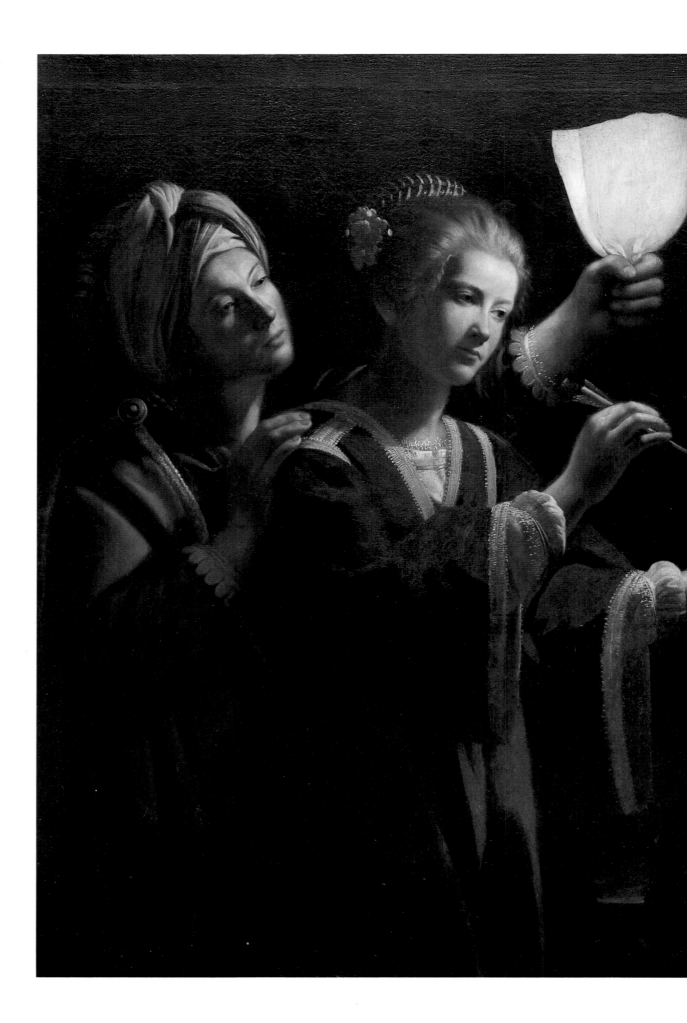

73. Trophime Bigot,
*St Sebastian being tended by
Irene.*
Oil on canvas,
130 × 170 cm.
Musée des Beaux-Arts,
Bordeaux.

74. Valentin de
Boulogne,
Judith.
Oil on canvas,
97 × 74 cm.
Musée des Augustins,
Toulouse.

75. Simon Vouet,
David with Goliath's Head.
Oil on canvas,
132 × 102 cm.
Palazzo Bianco, Genoa.

in understanding some of the French reactions to Mannerism.

The best-known example is Jean Boucher, from Bourges. His first visit to Rome, and the first of several, took place in 1596 when the moderate ideas of Muziano, Pulzone and others prevailed. Through their influence, the Classicism of the early sixteenth century returned to the forefront. Boucher's drawings, which are in a relatively good state of preservation, bear witness to this return to basics. He made copies of antique sculpture and the works of Raphael. His life drawings display powers of observation and a robustness that differentiate his work sharply from the virtuosity of the followers of Michelangelo. Once he had set up his studio in Bourges in 1604 he remained there for the rest of his career as the official town painter. He seems to have had enough assistants to allow him to take on various commissions for the decoration of state occasions such as royal visits, as well as large numbers of altarpieces, secular works and portraits. Boucher became a household name all over the west of France and beyond; Pierre Mignard, his most celebrated pupil, came from Troyes.

Straightforward and accessible, Boucher's painting, which evidently met the requirements of his clientèle perfectly, nonetheless reflects a high level of education and a broad cultural range. Compared with the fireworks of Fontainebleau, or even more, of Lorraine, his work may appear lifeless and flat because he rejected sensational or strained effects. In his *Nativity* of 1610, in Bourges Cathedral (pl.68), it is the tranquility of the composition, the clarity of the colours and the familiar details that charm. A work such as *Lamentation over the dead Christ* (1621, Angers Cathedral) resumes links with the carved *Entombments* of the fifteenth century, and with the intensity of a painter such as Fouquet. Boucher's return to real-life models and the way he took a fresh look at the natural world in order to represent it faithfully should be accorded their true value. His directness was echoed in other parts of France. In Arles, Trophime Bigot, confused for years with the 'Candlelight Master' painted a monumental *Assumption* in 1635 (Saint-Trophime, Arles, and a

second version dated 1639 in the Church of La Tour-d'Aygues, pl.70). In Dijon, Philippe Quantin used lighting effects to accentuate the sculptural quality of his figures, in compositions characterised by their serenity: his *Annunciation* in the church of Saint-Michel (pl.69) is like a reinterpretation of Caravaggio's poetics. His rejection of Mannerism also emerged as a new kind of extremely austere stylisation: examples include *Christ giving the Host to St Catherine of Siena* (Dijon) and the *Muses* in the Château de la Motte-Ternant (Dijon, pl.71). Another painter of the same generation, Nicolas Prévost, who trained in the studio of Varin but who was later profoundly influenced by the first paintings of Vouet's Parisian period, also developed a method of painting figures and objects that was far removed from Mannerism. Examples of work done by him during the 1630s include paintings in the Château de Richelieu such as the *Kiss of Justice and of Peace* (*in situ*).

FRENCH CARAVAGGISM

Caravaggism represents an important chapter in the history of painting in Europe.[7] As is often the case, the spread of Caravaggism was attributable more to the success of those able to simplify and adapt the master's work to satisfy popular demand than to the innovative genius of the master himself. The masterpieces of Caravaggio's Roman period, painted between 1600 and 1606, the decoration of the Contarelli chapel in S. Luigi de' Francesi or his large altarpieces, like the scandalous *Death of the Virgin* now in the Louvre, had no direct influence – probably precisely because of their audacity. International acclaim was won by Caravaggio's followers, who exploited the realism of paintings like the *Fortune Teller*,[8] emphasising two of the most seductive and highly commercial aspects of the genre: the everyday quality of the scenes and characters, and the handling of light. Dutch painters like Baburen, Honthorst or Ter Brugghen, all in Rome between 1610 and 1620, Italians like Manfredi, who was Caravaggio's student and closest follower, perfected a formula that was to meet with unqualified success, portraying half-figures with brilliant chiaroscuro

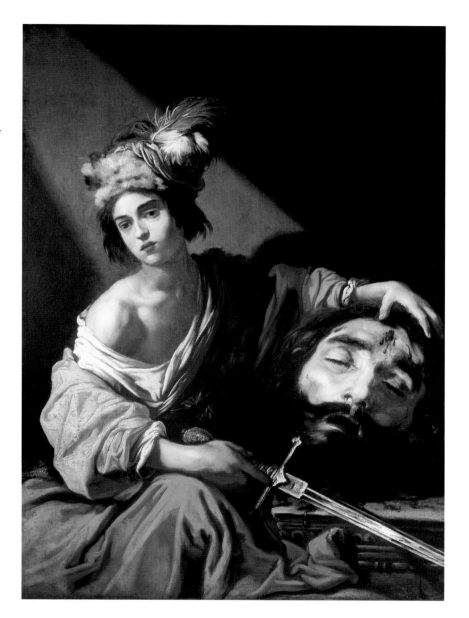

76. Claude Vignon,
David with Goliath's Head.
Oil on canvas,
134 × 96 cm.
Private collection.

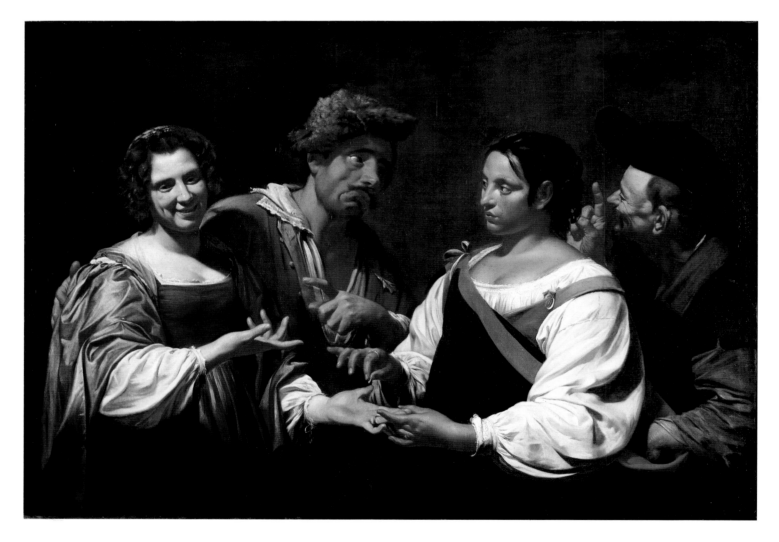

77. Simon Vouet,
The Fortune Teller.
Oil on canvas,
120 × 170.2 cm.
National Galley of Canada,
Ottawa.

effects: Sandrart refers to this formula as the *Manfrediana methodus*.[9]

There were other variations on the theme, a remarkable one to be found in the work of the Venetian, Carlo Saraceni,[10] who, until his death in 1620, produced lyrical, intimate paintings and latterly developed a way of seeing that was more serene, more subtle than anything coming from farther north. His influence, which pre-dated the influence of Manfredi, was considerable and can be glimpsed in the work of Jean Le Clerc (pl.72), from Lorraine, who was in Venice in 1619, and also in the work of the Auvergnat Guy François, active in and around Le Puy during the first half of the century. In his work, which is a little timid

and static, Guy François uses soft chiaroscuro effects which sometimes are exquisitely successful (the *Magdalen* in the Louvre, painted between 1620 and 1630). His stylish realism achieves meditative serenity in altarpieces like the *Adoration of the Shepherds* (1621, Jesuit College, Le Puy); this sobriety contrasts strikingly with the work of Lallemant, or Varin, for example. The mysterious 'Pensionante del Saraceni', sometimes mistaken for François, painted religious scenes and still lifes, both possessed of a poetic yet sensuous quality. Was he a Frenchman or not? Another variation on the theme was provided by Orazio Gentileschi,[11] who was in Paris from 1624 to 1625 and painted the *Allegory of Public Felicity*, now in

the Louvre, for Marie de Médicis. In his work, authoritative form combines with glowing and, at times, extremely subtle, colour as in *Diana the Huntress* in Nantes; this caught the attention of painters like the Le Nain brothers, as is evident in their *Allegory of Victory* (Louvre),[12] an enigmatic-looking nude in front of a vast landscape.

The real Caravaggists, in the strict sense of the term, were in Rome during the second decade of the century. At the outset they were a small, homogeneous group but they were soon to disperse. The most important of them, Valentin de Boulogne, arrived in Rome in 1611 and was the only one who stayed in the papal city until his untimely death in 1632. Vouet, then Vignon, Régnier and Tournier joined him there. Georges de La Tour should perhaps be added to the list as he was probably in Italy before 1616,[13] as were a number of enigmatic characters like the 'Master of the *Judgement of Solomon*' and the 'Candlelight Master', sometimes confused with Trophime Bigot who may have been his cousin. Soon after the departure of Manfredi and the northern painters they began to react against their influence and to break away from them.

The painting of 'nights', artificially lit nocturnal scenes, had an enormous vogue. Heir to painters from Lombardy and Venice like Lotto, Savoldo, Jacopo Bassano and his sons, Caravaggio replaced the distortions, the dramatic effects and seedy refinement of Mannerist nocturnes with a brutal style that emphasised volume and dislocated composition with what looked like violent sweeps of a searchlight; he viciously undermined the process of idealisation, the traditional mode of expression, particularly in religious painting. It is in this respect that the word simplification can be used or, as Poussin would have said, 'destruction' of painting.[14] Honthorst and Ter Brugghen followed in his footsteps, in celebratory or grotesque fashion. The painters of Lorraine promoted these two aspects, the worldly and the satirical: Le Clerc's *Concerts* (about 1620, Munich and private collection, Rome), so indebted to Saraceni, have a worldly side to them while La Tour's *Money* (Lvov) is grating and theatrical. The 'Candlelight Master', Sandrart's enigmatic 'Trufemondi', who specialised in 'the representation of half-figures

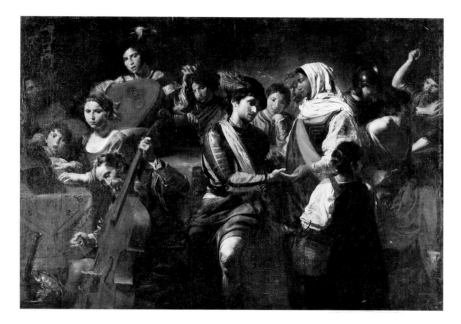

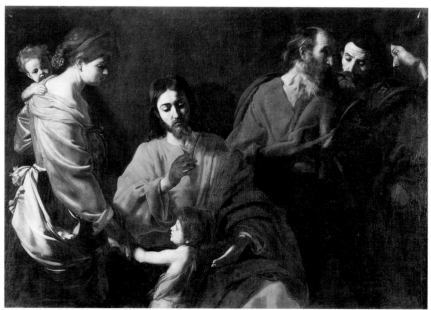

78. Valentin de Boulogne, *Gathering with Fortune Teller.* Oil on canvas, 190 × 265 cm.

Collection of Count von Schönborn, Schloss Weissenstein, Pommersfelden.

79. *below:* Nicolas Tournier, *Christ and the Children.* Oil on canvas, 125 × 169 cm.

Galleria d'Arte Antica, Palazzo Corsini, Rome.

and nights',[15] was in Rome from 1620 to 1634. Strongly influenced by Honthorst, his painting lacked originality but had a certain austere, meditative quality as illustrated in his *St Sebastian tended by Irene* (Bordeaux; pl.73); it is interesting to compare this with La Tour's more ambitious composition on the same subject (Berlin and the Louvre).

The formula regularly adopted was a simple one. Figures cut off at waist level (or, more frequently, at mid-thigh) are portrayed at the front of the painting, thus eliminating two major problems that Mannerist painters, notwithstanding their outstanding technical skill, had attempted solve:[16] the management of quite large numbers of standing figures and the handling of linear and aerial perspective. These sometimes brutal close-ups could be used for genre paintings as well as for biblical and historical subjects, giving the latter new impact by emphasising the drama of a particular scene. Isolated figures, commonplace and heroic at the same time, were the result, like Valentin's *Judith* (Toulouse; pl.74), Vouet's robust *David* (Palazzo Bianco, Genoa; pl.75) or Vignon's more picturesque *David* (private collection; pl.76). Paintings with two figures could create an intense dialogue between the two, well suited to religious subjects. St Matthew and the angel was one very popular theme, used unforgettably by Caravaggio himself in S. Luigi de' Francesi. Compositions with more figures include religious paintings like *Christ and the Children*, by Tournier (Galleria Corsini, Rome, pl.79) and Vignon's strange, cruel *Martyrdom of St Matthew* (Arras), an altarpiece distinguished by its great height; historical paintings like Vouet's *Sophonisba* (Kassel) and allegorical paintings like Valentin's *Ages of Man* (London).

Genre paintings were more numerous, but again the French produced something very different from the brashly insouciant products of the Dutch painters. Both Vouet, in his *Fortune Teller* (Ottawa; pl.77), or later La Tour with his *Cardsharps* (Louvre and Fort Worth) courted danger by depicting a great diversity of gestures and facial expressions. Others placed the emphasis on the dignity of simple folk gathered together to listen to music; some examples of this genre are master-

pieces (for instance Valentin's *Concerts*, in the Louvre, pl.67 Pommersfelden and elsewhere) far outstripping the normal conventions of the genre, whereas paintings by Tournier (such as the *Topers* in Modena), or by Régnier (*Fortune Teller* in the Louvre, *Vanitas* in Lyon) have a more vulgar feel to them. Their panache makes them comparable to the work of Ter Brugghen or Honthorst.

No-one reflected the cosmopolitan artistic milieu of Rome during the years 1610 to 1630 better than Valentin; daily life was difficult and often dangerous. Drinking dens and low dives abounded, as did courtisans and shady characters, but he depicts them with solemnity and a kind of fierce reserve. Valentin's poetic world is directly descended from Caravaggio. At first his technique favoured strong contrasts and bright colours, but later all became lighter and subtler. The blues and greys that succeeded the black shadows give these 'slices of life' an almost dreamlike quality. The sadism manifest in *David holding Goliath's Head* (about 1620–2, Thyssen collection) or *Judith decapitating Holofernes* abated in favour of something calmer; in later compositions violence is replaced by melancholy. Just before his death, Valentin broadened his register considerably, as can be seen in the *Judgement of Solomon* in the Louvre, and in large commissioned works like the *Allegory of Rome* (Villa Lante, Rome; pl.80), of 1628, in which the artist's symbolic language comes to terms with his tortured realism. The *Martyrdom of SS Processus and Martinian* in St Peter's (1629, Vatican Galleries) marks the pinnacle of his Caravaggesque grand manner, but it has been consigned to oblivion thanks to the work of his many popularisers.

Valentin left no disciples, except perhaps Nicolas Tournier, whose withdrawn, austere painting was done mainly in Toulouse. Tournier arrived in Toulouse in 1632, after spending at least seven years in Rome. His *Descent from the Cross* and *Entombment* in the Musée des Augustins are justly famous: they demonstrate the emotional intensity that could be achieved by Caravaggism tempered by a rigorous sense of order. Tournier's most astonishing work is the *Battle of the Red Rocks* (Toulouse; pl.81) painted for the Pénitants Noirs; with its sculptural weight, strong, dark colours

80. Valentin de Boulogne, *The Allegory of Rome*, 1628. Oil on canvas, 330 × 245 cm. Institutum Romanum Finlandiae, Villa Lante, Rome.

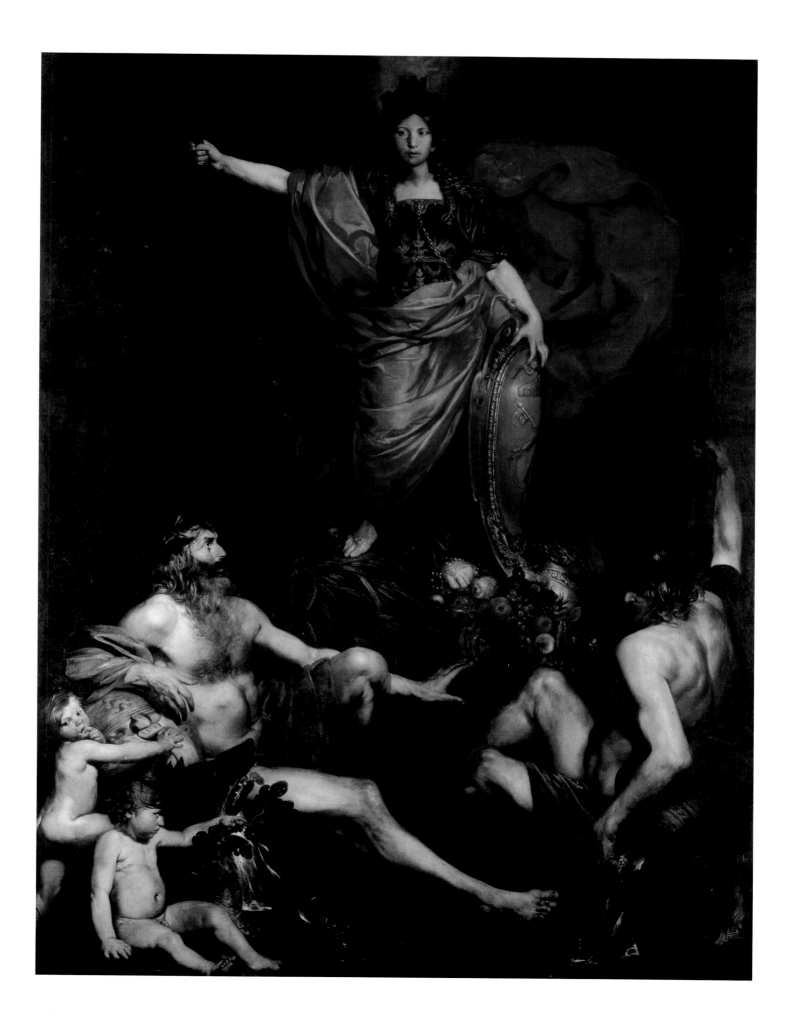

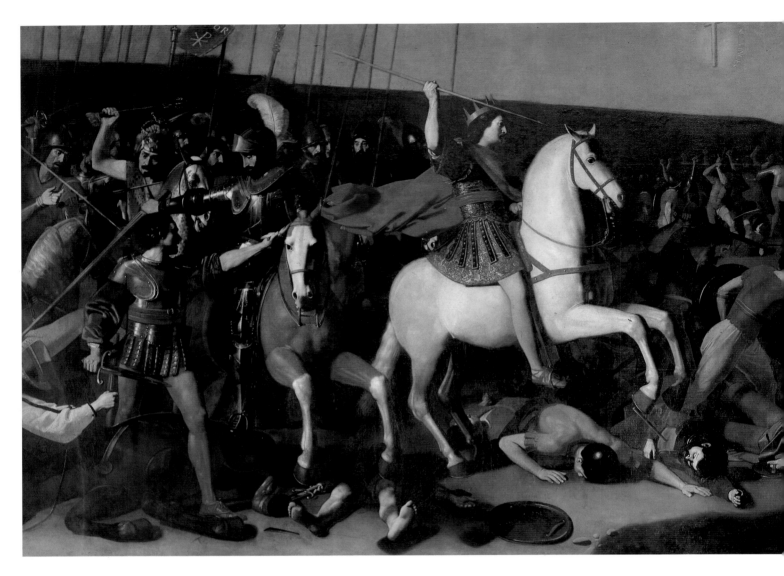

81. Nicolas Tournier,
*The Battle of the Red
Rocks.*
Oil on canvas,
260 × 550 cm.
Musée des Augustins,
Toulouse.

and vivid facial expressions it represents a deter-
mined effort to connect the Imperial Rome of
Trajan's column with the Rome of Caravaggio.[17]

In quite a number of cases, then, Caravaggism
was mere opportunism, and the *Manfrediana
methodus* a quick way of meeting the demands of
a particular market; the exclusiveness of the mar-
ket precluded any significant artistic development.
Some of the centres in the south, the centre and
the east of France were affected: Provence with
Louis Finson, Toulouse with Tournier and Jean
Chalette, Lorraine with La Tour and Langres with
Jean Tassel. But in every case, Caravaggism was
reinterpreted to meet local requirements with lo-
cal variations: the contrast between the powerful,
sober *Virgin of the Prisoners* by Chalette
(Toulouse), and La Tour's scintillating, ironical
Cardsharps,[18] is spectacular. Moreover it was a
fashion that quickly ran its course. In Paris,
Claude Vignon, who returned there in 1623,
picked up the threads of his earlier Mannerist style
and Vouet, who had already distanced himself
from Rome, expounded a grand decorative style

that could not have been more different. La Hyre
went through a brief Caravaggesque period with
the *Martyrdom of St Bartholomew* (1627, Mâcon
Cathedral) and particularly his *Pope Nicholas V
visiting St Francis of Assisi in his Cave* (1630, Lou-
vre; pl.82); the over-emphatic contrasts of light
and shade are modified by a straightforward and
highly legible structure. At the same time the art
of Régnier, who took up residence in Venice in
1626, took a worldly, seductive turn, bowing to
the traditions of the artist's new home. Jean Daret,
in Aix, displayed the same sophistication: he used
the old formula of musicians, half-length, notably
in the *Guitar Player* (1636 [?], Aix) and the *Girl
playing a Lute* (1638, Yale University). In both
spirit and execution these derive mainly from
Parisian portrait painting of the 1630s.

THE FLEMISH PRESENCE IN PARIS

In Paris, the reaction to the painting of artists like
Lallemant or Varin came from the painters of
Flanders rather than from the Caravaggesques.

Between 1615 and 1620 the names of Finson and especially Pourbus were very influential in the history of French painting and its quest for renewal; Rubens followed in the 1620s. Born in Bruges before 1578, Louis Finson spent long periods in Rome and Naples, where he came under the influence of Caravaggio. On his return in 1613, he stopped in Marseille, then in Aix where he became the protégé of the statesman and antiquary Peiresc, who admired his measured, monumental style although, as he wrote in a letter to Rubens,[19] it was without 'nobility'; Peiresc commended him to the notable Parisian, Merri de Vic, for whom Finson painted the *Circumcision* in Saint-Nicolas-des-Champs in 1615 (pl.84). The painting is ponderous, the figures huddled together, their faces grimacing crudely. But the composition with its architectural framework and the alignment of the heads shows great strength.

This example of greater solidity of composition was developed further by an artist of quite different calibre, the portrait painter from Antwerp, Frans Pourbus the Younger, a protégé of the

Queen Mother and other influential people. He also painted a quantity of religious paintings, as the series of four altarpieces executed before 1620 illustrates: the *Virgin of the de Vic family* for the de Vic chapel in Saint-Nicolas-des-Champs (1617, *in situ*; pl.85); the *Last Supper* in Saint-Leu-Saint-Gilles (1618, Louvre); and, for the Jacobins in the Rue Saint-Honoré, an *Annunciation* (1619, Nancy) and *St Francis receiving the Stigmata* (1620, Louvre). The paintings are very static, and contain some impressive portrait painting in the faces. The lighting is frequently extreme, creating sharp shadows, and the metallic colours shrill. Pourbus's immaculate attention to detail gives the paintings impressive depth: the lily in the *Annunciation*, the skull in *St Francis*, embroidery and weapons in the de Vic altarpiece. This naturalism has often been remarked upon, and has been taken to categorise Pourbus as a straightforward representative of the Northern tradition. This view, however, ignores the long period he spent in Italy, principally at the court of Mantua, and the perceptible influence this had on his painting. The de Vic *Virgin* re-

82. Laurent de La Hyre,
Pope Nicholas V visiting St Francis of Assisi in his Cave, 1630.
Oil on canvas,
221 × 164 cm.
Musée du Louvre, Paris.

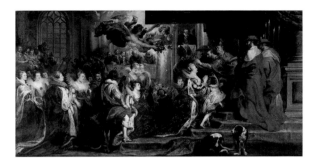

83. Peter-Paul Rubens,
*The Coronation of Marie de
Médicis.*
Oil on canvas,
394 × 727 cm.
Musée du Louvre, Paris.

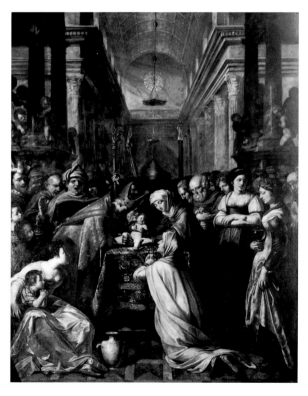

84. Louis Finson,
The Circumcision, 1615.
Oil on canvas,
399 × 282 cm.
Eglise Saint-Nicolas-des-
Champs, Paris.

states Italian altarpiece painting of the high Re-
naissance, with its structural clarity. In the *Last
Supper* the expressions on the disciples' faces are
very carefully observed; Pourbus's debt here to
Leonardo da Vinci is great. With its careful sym-
metry and the powerful simplicity of its composi-
tion, this masterpiece is said to have made a strong
impression on Poussin when he first arrived in
Paris.[20] In any case, it demonstrated a continuing
intransigence towards the vagueness of Manner-
ism in decline, and prolonged the austere art that
stemmed from the Counter Reformation. It is
certainly true to say that the example of Pourbus
helped shift the art of Varin and even Lallemant
towards a great sobriety, as can be clearly seen in
the altarpieces painted by them in the twenties
and thirties and discussed in the preceding chap-
ter. The same 'objective' austerity was developed
by the young Philippe de Champaigne, who ar-
rived in Paris from Brussels in 1621, the year
before Pourbus died. He joined Lallemant's studio
and took part in the decoration of the Palais du
Luxembourg, where he worked with the little-
known Nicolas Duchesne, succeeding him as
painter in ordinary to Marie de Médicis in 1628.
Rubens also took part in the scheme in the Lux-
embourg. The construction of the Palais du Lux-
embourg began in 1615 under Salomon de
Brosse, and its status as a palace meant that it
required elaborate mural paintings, a team of
painters and an architect-in-chief.[21] The genera-
tion of decorators that had worked at
Fontainebleau had just disappeared, Dubreuil in
1602, Dubois and Bunel in 1614 and Fréminet in
1619. Neither Lallemant, nor Varin nor Pourbus
was appointed to undertake the new scheme.[22]
The Queen Regent had to turn to Italy and
Flanders to acquire the decoration she wanted for
the residence in which she was to live, in spite of
quarrels with her son, from 1620 to 1630, be-
tween two periods of exile. The Cabinet Doré[23]
was adorned with paintings depicting the history
of the Medici family, by various Florentine artists
(private collection). The Cabinet des Muses[24]
received ten pictures by Baglione, the
Caravaggesque painter, sent by the Duke of
Mantua in 1624. At about the same date, in Paris,
Orazio Gentileschi painted an allegory entitled

85. Frans Pourbus the
Younger,
*The Virgin of the de Vic
Family*, 1617.
Oil on canvas,
363 × 270 cm.
Eglise Saint-Nicolas-des-
Champs, Paris.

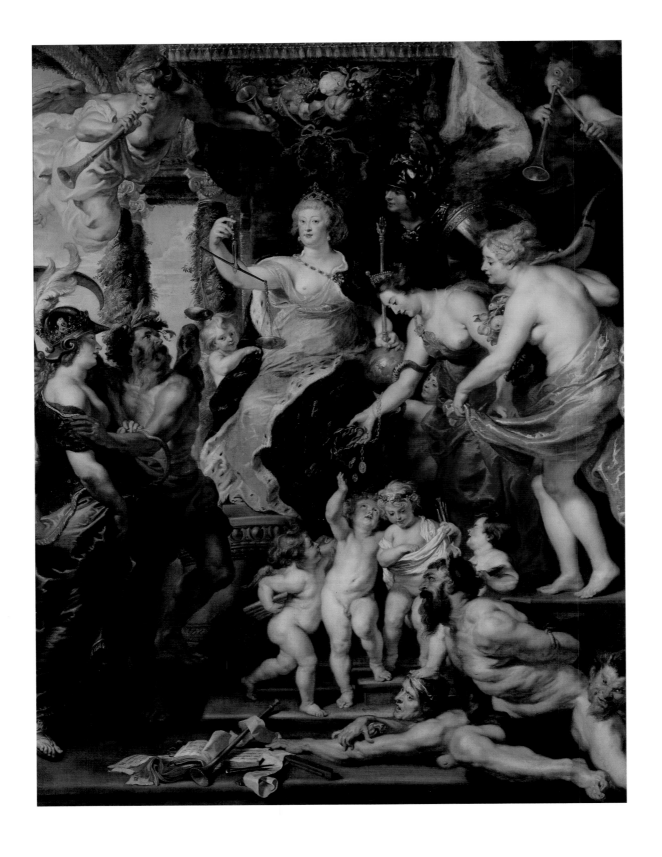

Public Felicity triumphing over Danger (Louvre), an allusion to the Queen Mother's very temporary victory over her enemies. Under the guidance of Duchesne, Jean Monier and Philippe de Champaigne shouldered a variety of painting tasks, probably mainly ornamentation.

Marie's most ambitious project was to decorate the two galleries in the palace with cycles dedicated to the praise of Henri IV and herself, and work started on this before anything else.[25] The choice of Rubens in preference to an Italian artist may have surprised some people. But he was by no means unknown in Paris, having been granted a royal privilege for the engraving of his paintings in France in 1619. Above all, he had been in the service of the Duke of Mantua, the Queen Mother's brother-in-law; it is also possible that the Archduchess Isabella recommended him. He was in fact famous throughout Europe, frequenting the highest echelons of society as a diplomat as much as a painter; he was certainly one of the artists best equipped for such a herculean task, assisted by members of the large studio he ran in Antwerp.

In February 1622 he came to Paris to sign the contract and receive a plan of the gallery and documents such as engravings and portraits to provide guidance. The space to be decorated, in the right-hand wing of the palace, was enormous and of a type traditional to France. The roof consisted of beams and joists, gilded and painted. On the walls, between the windows, there were spaces for twenty-four large canvases framed by black and gold borders. These were to surmount a low panelled dado, carved and decorated alternately with landscapes and monochrome designs. At one end of the hall, around the fireplace, were portraits of Marie de Médicis and her family. The whole arrangement was conceived as a cycle; a series of large mural paintings recounted the whole history (pls 83 and 86). The scheme necessitated endless discussions, as can be gathered from the voluminous correspondence between the painter, who had returned to Antwerp, and Marie's advisers, Maugis, Peiresc and the young Richelieu. Changes of design ensued, adding recent episodes (the disputes and reconciliations between the Queen Mother and her son) which

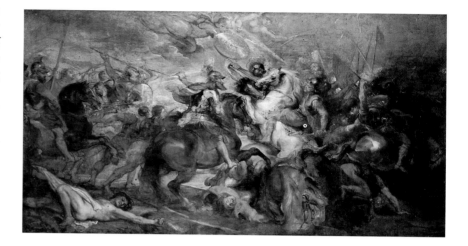

87. Peter-Paul Rubens, *Henri IV at the Battle of Ivry.* Oil on canvas, 367 × 693 cm. Uffizi, Florence.

Rubens was able to treat with the requisite tact. Once the sketches had been prepared, work progressed very quickly. On 24 May 1623, Rubens himself delivered the first nine paintings to Paris. By February 1625 the whole series was in place, in time for the marriage of Henrietta of France to King Charles I of England.

The finished result, which belonged to the tradition of royal galleries decorated with historical and dynastic subjects, was nevertheless quite different from the type of gallery advocated by Antoine de Laval at the time of Henri IV.[26] Myth and fantasy were used throughout to disguise any truth that might prove unpalatable. The overall significance is still open to various interpretations:[27] was the general emphasis on the reconciliation of mother and son, and a diplomatic compromise that was to prove all too fragile? Or was it a hot-blooded defence of her policy of appeasement by Marie de Médicis, and at the same time revenge against her adversaries? The use of allegory and the language of emblem allowed the painter's amazing erudition to express itself simultaneously on various levels. Rubens created a world in which reality could be transformed into enchantment as easily as it was at the court entertainments of the day. The political message, which involved depicting government action, tended to retire into the background to allow the glamorous story of the heroine to run its course. From her upbringing in Florence to the vicissitudes of her Regency, by way of her en-

86. Peter-Paul Rubens, *The Felicity of the Regency.* Oil on canvas, 394 × 295 cm. Musée du Louvre, Paris.

88. Theodor van
Thulden,
Two episodes from the
Life of St John of Matha,
1633.
Engravings.
Département des Estampes,
Bibliothèque Nationale,
Paris.

counter with and marriage to the King of France, Marie became one of those historical 'powerful women' whom she would have liked to have seen portrayed in the dome of the Luxembourg, judging by a letter from Peiresc to Rubens written in 1622.[28]

In 1627, Rubens began a series of paintings for another gallery, dedicated to Henri IV. Only five episodes of this were begun and they were never finished. Others are known from preparatory drawings.[29] The *Battle of Ivry* (pl.87) and the *Entry into Paris* (Uffizi) give an idea of the blatantly political and militaristic flavour of the scheme. The Queen Mother's quarrel with Richelieu, her flight after the Day of the Dupes in November 1630 and her subsequent exile led to the suspension of the scheme and the closure of the palace.

It is not surprising, therefore, that the Galerie Médicis had no immediate influence on French painting. Rubens's vigour, his extraordinary brushwork, the range of his register, all interpreted by a team of well-trained assistants, were lost to other artists until the end of the century, when Philippe d'Orléans re-opened the palace. The generation that included Antoine Coypel and, a little later, Watteau, was to discover the Luxembourg cycle with great enthusiasm. But the narrative significance of the work had by then become obscure, as can be gathered from the misconstructions that litter the descriptions by Bellori and Félibien, and the collection of engrav-

ings produced by Nattier in 1710. It is only recently that, thanks to the discovery of letters and memoirs, and to the systematic study of the symbolism of Medicean emblems, modern scholarship, with great skill and patience, has managed to interpret some of the episodes correctly. Laval's worst fears were well founded: reliance on allegory and the mixture of history and mythology, though perhaps essential to the history painter, certainly helped make the narrative of the paintings virtually unintelligible. It was this kind of ambiguity that Le Brun tried to do away with during the reign of Louis XIV. In spite of all this, however, Rubens created a coherent and magnificent world of forms that was unique in France at the time, and which even the subsequent successes of Vouet and Philippe de Champaigne could not overshadow.

As well as Rubens, there were a number of Flemish painters working successfully in Paris. Pieter van Mol, born in Antwerp, arrived in 1631 and became painter to the Queen before appearing as one of the founders of the Académie.[30] Altarpieces such as the *Annunciation* for the Ursulines (about 1625, Lille) or *St James of Compostella*, the focal point of a very ornate chapel in the Eglise des Carmes (about 1635, *in situ*; pl.89) possess the robustness that was the current fashion. Theodor van Thulden, on the other hand, started work under the aegis of Primaticcio, whose work he copied at Fontainebleau, making engraved copies of the Galerie d'Ulysse (1633). He spent the years 1631 to 1634 in Paris, painting twenty three episodes of the *Life of St John of Matha* (all lost but one; engraved in 1633; pl.88) for the choir of the church of the Mathurins.[31] Here he reinterpreted and simplified Mannerist models in a detailed narrative sequence, paving the way for later series such as Le Sueur's *Life of St Bruno*. Later, in 1647, he painted three pictures for the ornate altarpiece in the Mathurins in which the lessons of Rubens have been perfectly absorbed: the modulations are soft and delicate and the colours diaphanous (*Pentecost*, now in the church of Notre-Dame-de-la-Couture, Le Mans; the *Assumption* and the *Trinity* in the museums of Angers and Grenoble). These works were more available to the public than the Rubens in the

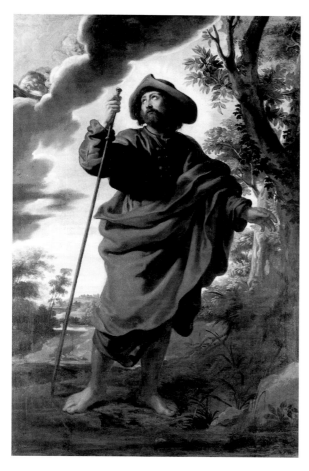

Medici Gallery and certainly made an immediate impact. Thanks to certain of their outstanding features, they encouraged Parisian painters in their endeavours and helped them towards the definition of a new style – the style that Vouet and his pupils were later to lead to a triumphant success.

Notes

1. Friedlaender, 1957 (1991).

2. Most notably in the essay by Zeri, 1957, which concentrates on Scipione Pulzone, and in studies by H. Röttgen on Cavaliere d'Arpino (see in particular the one-man exhibition in Rome in 1973).

3. By J. Thuillier. See in particular exh. cat. Bourges and Angers, 1988.

4. See the statements made by Jacques Foucart, exh. cat. Paris, 1977–8, and Meaux, 1988–9.

5. Mâle, 1951 (1972).

6. Zeri, 1957 ('arte senza tempo').

7. On international Caravaggism, see Nicolson, 1979. On the French Caravaggesque painters the main reference work remains the exh. cat. Paris and Rome, 1973.

8. On this subject, see exh. cat. Paris, 1977.

9. See J.P. Cuzin, 'Manfredi e i Francesi', exh. cat. Cremona, 1987.

10. Cuzin and Rosenberg, 1978; A. Ottani Cavina, 'Les peintres de la réalité et le cercle caravagesque de Rome. Réflexions sur l'atelier de Saraceni', exh. cat. Nancy, 1992 (1), pp.60–8.

11. Sterling, 1958 and 1964.

12. Painting attributed to Mathieu by Rosenberg, 1993 (no. 49).

13. See below, chapter 7, p.163.

14. 'M. Poussin could not stomach anything by Caravaggio and used to say that he had come into the world to destroy painting. But his aversion should cause no surprise, for Poussin looked for nobility in his subjects whereas Caravaggio always got carried away by the natural look of the things he saw. So they were really at opposite ends of the spectrum.' (Félibien, 1666–8, part III, Entretien no. v [1679], p.205).

15. Sandrart, 1675 (1925), p.259.

16. Thuillier, preface to the catalogue to the exhibition in Rome and Paris, 1973–1974, p.XVI.

17. It has even been suggested that Tournier knew the frescoes by Piero della Francesca in S. Francesco in Arezzo (cf. H. Naef, 'Französische Meisterwerke aus Provinzmuseum', Du, July 1951).

18. See below, chapter 7, p.165.

19. Quoted by Thuillier, exh. cat. Marseille, 1978, no.96, p.71: 'Our Finson paints with good colours, he draws well, his figures are sturdy and robust. He paints without nobility, but the expressions on the faces of his figures are pleasing.'

20. At least according to Sauval, 1724, vol.I, pp.467–8. On the validity of a comparison between Pourbus and Poussin, see J. Foucart, exh. cat. Meaux, 1988–9, no.18, pp.95–6.

21. On the building works at the Palais du Luxembourg and the painters employed by Marie de Médicis, see Marrow, 1979 and 1982.

22. See Marino's acid comments on French painters quoted in chapter 3, p.47 and n.1.

23. Blunt, 1967 (2). The paintings, which for a long time belonged to Lord Elgin, are by Francesco Bianchi, Jan van Bijlert, Jacopo Empoli, Anastasio Fontebuoni, Jacopo Ligozzi, Valerio Marucelli and Domenico Passignano.

24. See the notes by A. Brejon, exh. cat. Paris, 1988–9, nos 11–19. The paintings are now in the Musée d'Arras.

25. On the Galerie Médicis, see Foucart and Thuillier, 1969; Thuillier, 1969 and 1983.

26. See above, chapter 3, p.47.

27. See Millen and Wolf, 1989, who propose a reading of the layout of the gallery that is significantly altered.

28. MacLean, 1977, p.210.

29. On the gallery of Henri IV see Jost, 1964, and the notes by D. Bodart, exh. cat. Florence, 1977, nos 93–4.

30. On van Mol and the decoration of the Eglise des Carmes, see the note by J. Foucart, exh. cat. Paris, 1977–8, no.93.

31. On the decorations by van Thulden in the Mathurins, see A. Roy, exh. cat. Bois-le-Duc and Strasbourg, 1991–2, pp.67–9 and nos 5–6.

89. Pieter van Mol, *St James of Compostella.* Oil on canvas, 190 × 140 cm.

Eglise de Saint-Joseph-des-Carmes, Paris.

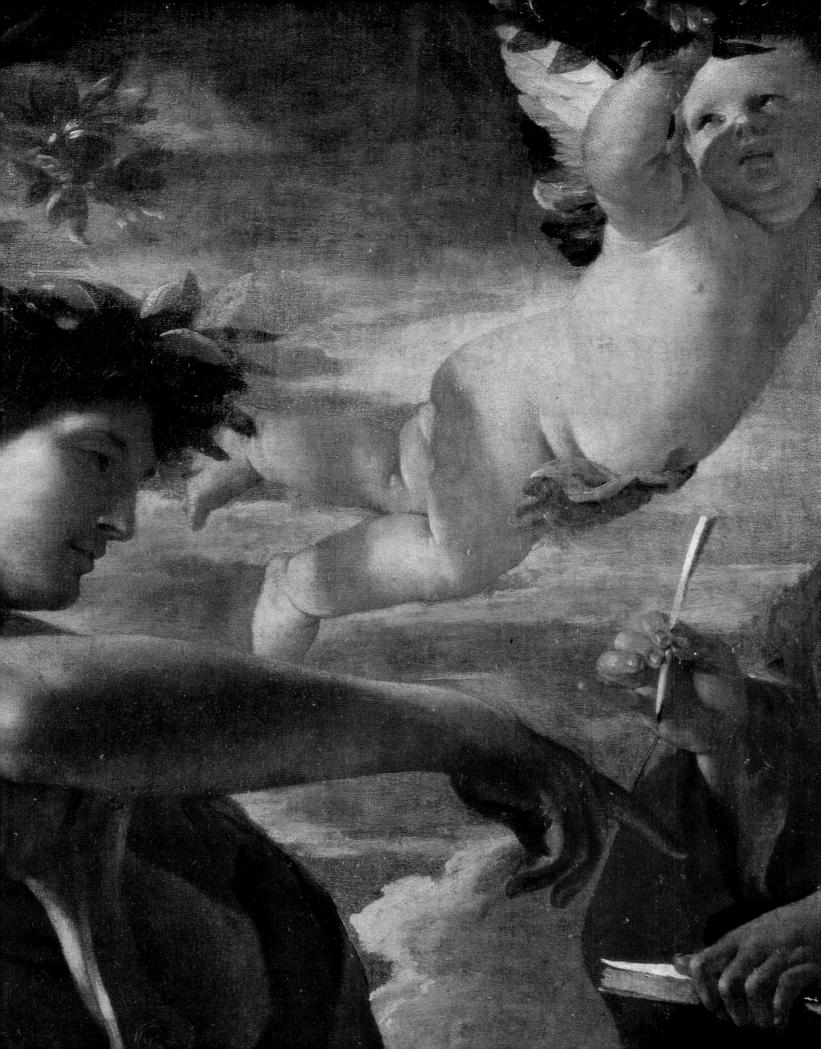

ROME, PARIS, ROME

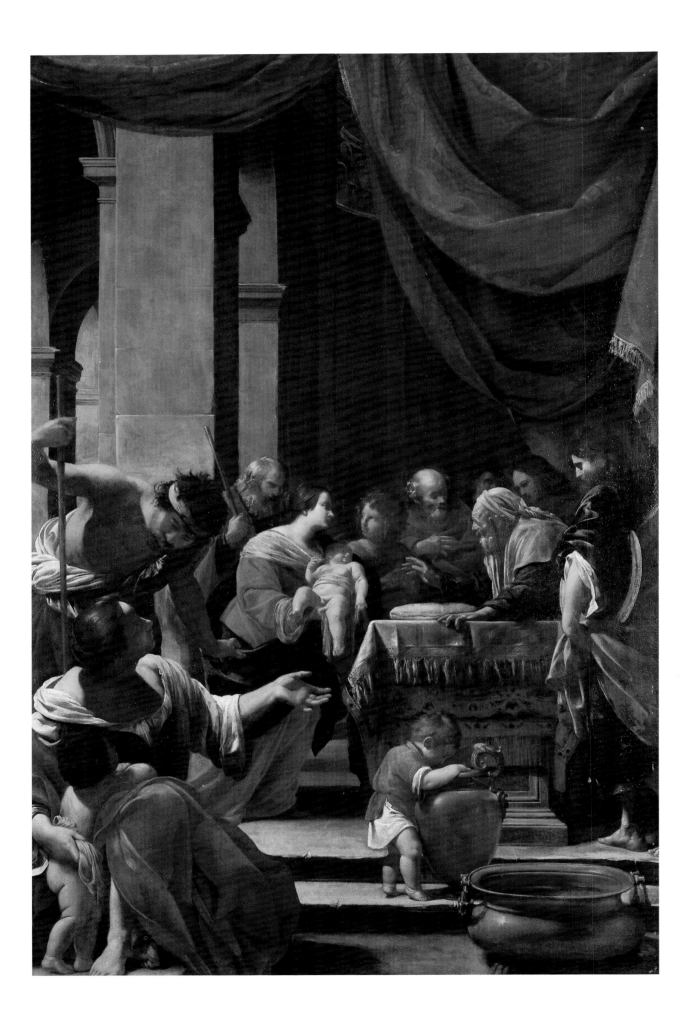

Poussin left Paris for Rome in 1624 and Vouet left Rome for Paris in 1627. The symmetry of these two journeys calls for some explanation: at the same time as reminding us of the strong attraction exerted by the Papal city on French artists, it also shows how things were slowly beginning to change. With the help of the monarchy, Paris was becoming a leading artistic centre too. Except possibly for a period at the end of the eighteenth century, the dialogue between the two centres had never been so intense. For an understanding of the changes affecting French painting at this favoured moment in its history, we should turn our attention to Rome and to the principal players there.[1] During the 1620s the scene was dominated by the pupils of Annibale Carracci, who monopolised major commissions at the time, and offered new and original styles and techniques. The Caravaggesques, meanwhile, confined themselves to their own distinctive repertory, using the facile old formulae; with the one exception of Valentin they had difficulty coping with the demands of large-scale decorative schemes. The painters from Bologna, on the other hand, were consummate craftsmen, able to work on a much more ambitious scale, with a very wide range. They drew inspiration from Annibale Carracci's masterpiece in the Galleria Farnese,[2] which epitomised the legacy of the classical Renaissance, giving it a new turn. Carracci's disciples were first and foremost decorators who covered large areas in churches and palaces with their designs. The Carracci brothers attempted to reconcile Tuscan and Roman mastery of form with the realism and the luminous colours of Lombardy and the Veneto. Rather than rejecting any particular theory, they rejected extremes: the excessive intellectualism of Mannerism and the trivialisation of Caravaggism. The work of the next generation of painters in Rome bears witness to this extraordinary ability to produce a synthesis of the different styles on offer there at this period.

From 1624 to 1648 two of these artists worked jointly, although more as rivals than as collaborators, on the site of the new church of S. Andrea della Valle. Lanfranco had successfully wrested the decoration of the cupola from Domenichino, who had to make do with the pendentives and the apse. Both developed a monumental and highly decorative style, but while Domenichino, faithful to his great paintings of the previous decade (like the *Flagellation of St Andrew* in S. Gregorio Magno, the *Last Communion of St Jerome* in St Peter's and his *Scenes from the Life of St Cecilia* in a chapel in S. Luigi dei Francesi) painstakingly and accurately outlines his forms, thereby strongly enhancing the clarity of the composition, Lanfranco, a true scion of his native Parma and influenced by Correggio, likes to have his figures whirling in motion, caressed by his mellow brushwork, in a blaze of light into which they appear to dissolve. His warm, dynamic manner was understood and appreciated by François Perrier, working at his side, and by Pierre Mignard. To return momentarily to Wölfflin's classification, the decorations in S. Andrea della Valle thus delivered the twin aspects of the earliest Roman Baroque: the linear and the pictorial.[3] The second was the more immediately attractive of the two, and coincided with the current infatuation with Venetian painting, noticeable in Italy as it was in France.

NEO-VENETIANISM

The city of the Doges was an important stopping place on the Grand Tour of Italy, often visited on the way to, or the way back from, Rome. Poussin was there in 1623–4 and Vouet from 1612 to 1613, then again in 1626–7. Some artists stayed longer, like Jacques Blanchard, nicknamed the French Titian, who spent the years 1626 to 1628 there. Which Venice, and which Venetian painters were they looking for? Tintoretto's troubled, sombre paintings captured attention far less than the flowing, harmonious compositions and clear sparkling colours of Veronese, whose influence on Vouet is evident even before Vouet returned to Paris. Bassano's naturalism had its partisans, particularly among the genre painters. The great name to conjure with, however, was still Titian, especially the Titian of the *Bacchanals*, painted for the *camerino* of Alfonso d'Este in Ferrara, and transferred to the Aldobrandini collection in Rome in 1598. It is known that Poussin studied them and was inspired to paint his first mythological canvases:[4] *Acis and Galatea* (Dublin; pl.94),

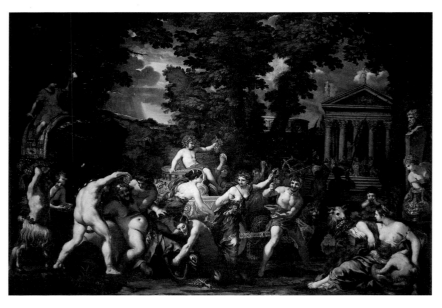

92. Pietro da Cortona,
The Triumph of Bacchus.
Oil on canvas,
144 × 207 cm.
Museo Capitolino, Rome.

Diana and Endymion (Detroit) and a number of bacchanals, of which the one of the sleeping nymph in the Louvre derives directly from Titian's *Andriens*. The energy of Titian's compositions, with their interplay of diagonals and curves, and the carnal abandon of his figures can be observed in Vouet's *Time vanquished* in the Prado (1627). The same excitement affected Roman painters like Pietro da Cortona at this time; Cortona's *Triumph of Bacchus* (pl. 92) in the Capitoline Museum is echoed in Poussin's *Triumph of Flora* (Louvre; pl.93). Other painters active in Venice at this period should not be forgotten, including Domenico Fetti and Johann Liss. The originality of their inspiration, their freedom of style and their unusual range of colours define a characteristically unreal and glittering manner which partakes neither of Caravaggism nor of the elevated style of Bologna or Rome; this manner influenced Vignon (for

93. Nicolas Poussin,
The Triumph of Flora.
Oil on canvas,
165 × 241 cm.
Musée du Louvre, Paris.

example) on his return to France (see his *Adoration of the Magi*, 1619, in Dayton). The spirit of the Venetian manner can also be found in the graphic work of an artist like Pierre Brébiette, whose small *Bacchanals* engraved as a frieze were such a success.

Venice, therefore, for the French, signified tonality, sensuality of inspiration and liberty of execution. The case of Jacques Blanchard is the most striking. On his return to France he prolonged the lessons learned from his Venetian experience in altarpieces such as *The Virgin and Child handing the Keys to St Peter* in the Cathedral in Albi, painted in Lyon in 1628, and even more so in his fleshy nudes and his mythological scenes, the best of these being the *Bacchanal* in Nancy, dated 1636, and *Venus and the Graces surprised by a Mortal* in the Louvre (pl. 95). The same interest in sprawling female bodies can be found in allegories such as the *Charities* in the Louvre and Toledo, and in subjects from epic literature, like *Angelica and Medoro* in the Metropolitan Museum; here the opulent, tranquil figures are bathed in a soft, golden light like a perpetual afternoon sunshine that harmonises all the colours. This manner of lighting was to be used with variations throughout the century, from the earliest Parisian canvases of Sébastien Bourdon, his *Anthony and Cleopatra* in the Louvre (pl.97), for example, to the mythological scenes of Charles de la Fosse.

Before very long, Simon Vouet was combining the traditional Caravaggesque half-length figures with rich, glowing colours, as can be seen in his series of *Angels carrying the Instruments of the Passion* (about 1615, Naples and private collection). His encounter with the art of Lanfranco had a decisive influence, as he hesitated between surface sensuality and more rigorous deep structure. In the *Birth of the Virgin* painted by him for S. Francesco a Ripa (1619) the fullness of the forms and the elegant composition are reminiscent of Michelangelo; the intense harmony of the colours, however, and the powerful humanity of the figures reveal the real preoccupations of the young artist. The two scenes from the *Life of St Francis*, in the Alaleoni chapel in S. Lorenzo in Lucina (1623–4), and the altarpieces executed at the beginning of the 1620s, like the *Crucifixion* in the Gesù, Genoa or the Naples *Circumcision* (pl.

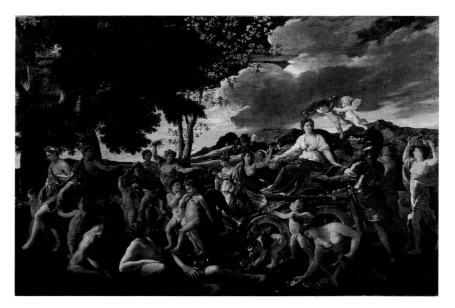

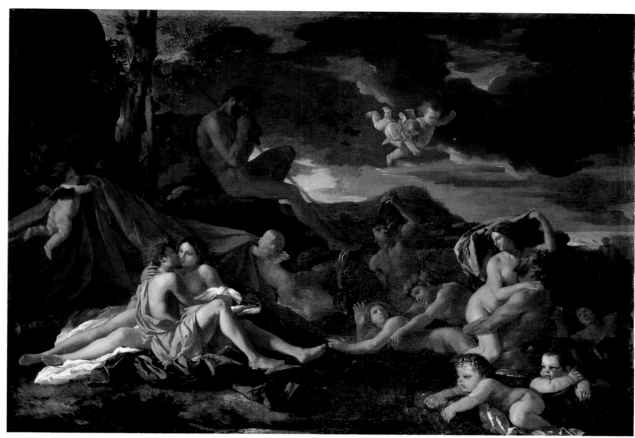

94. Nicolas Poussin,
Acis and Galatea.
Oil on canvas,
97 × 135 cm.
National Gallery of Ireland,
Dublin.

95. Jacques Blanchard,
*Venus and the Graces
surprised by a Mortal.*
Oil on canvas,
170 × 218 cm.
Musée du Louvre, Paris.

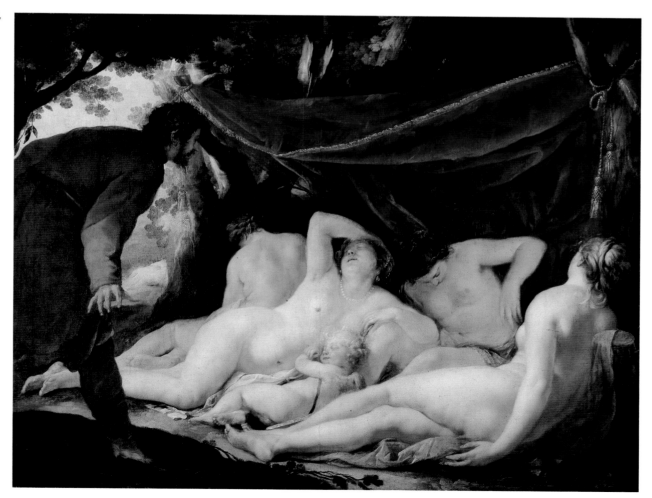

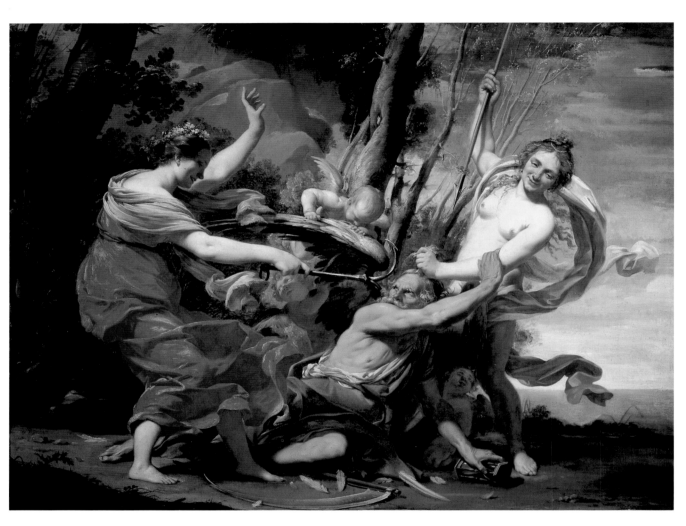

96. Simon Vouet,
Time vanquished, 1627.
Oil on canvas,
107 × 142 cm.
Museo del Prado, Madrid.

91), display great facility in the movement of the figures, elegance of line and a good eye for detail. Vouet's increasingly light touch and delicate colours mark a rejection of Caravaggism, and show the effects of the time he spent in Genoa and northern Italy in 1621. Lanfranco's style is developed even more strikingly by Charles Mellin, from Lorraine, in Santa Trinita dei Monti as well as elsewhere; his *Assumption*, now in Ponce (pl.102), is a brilliant example of his work.[5] Claude Mellan was a painter and engraver, and also a companion of Vouet; he adopted an expansive and balanced style in which carefully observed details from nature set off well-modelled figures bathed in light. The *Herodias* attributed to him (about 1627, Montpellier) and various etch-

ings of lost canvases such as *St John the Baptist* (1629; pl.98) or *Mary Magdalene* (about 1630) have something of the modified naturalism of Orazio Gentileschi: the union of figures and landscape, and the stylisation of the figures (certainly owing something to classical sculpture) combine to produce work of great originality.

Just at the moment when Vouet was recalled to France from Rome, never to return, Poussin's career began to make headway, thanks to the patronage of the Barberini family. In the *Death of Germanicus* of 1627 (Minneapolis; pl.100),[6] the harmonious colour scheme helps to reconcile Roman austerity with neo-Venetian lyricism. The powerfully rhythmical composition is inspired by classical reliefs as well as by Rubens's

Death of Constantine; the vigour and tension of the group of soldiers is juxtaposed with the sorrowful, resigned posture of the women and children surrounding the deathbed. Poussin's painting is perfectly in tune with contemporary circumstances, yet by his choice of subject and manner of interpreting it, he already stands out; from the painter's point of view, this is one of Tacitus's most significant and richest moments. The hero is shown unjustly persecuted and dying, rather than triumphant: such pathos was seldom to be found in the painting of the day. The stoical pessimism of the artist's maturity is already to be found in this painting, in which opposing forces are skilfully balanced. Later references to this work in French historical painting are legion, right up to Jacques-Louis David and beyond.

Poussin's two altarpieces painted in 1628–9 (the *Martyrdom of St Erasmus*, in the Vatican Museums, pl.99, one his most prestigious commissions, and the *Virgin appearing to St James the Great* in the Louvre) show him manifestly trying to compete with his contemporary rivals. In his busy, highly-coloured canvases the figures are painted in heightened relief, as if Poussin were experimenting in the same way as a sculptor like

97. Sébastien Bourdon, *Anthony and Cleopatra*. Oil on canvas, 145 × 197 cm. Musée du Louvre, Paris.

98. Claude Mellan, *St John the Baptist in the Desert*, 1629. Engraving. Département des Estampes, Bibliothèque Nationale, Paris.

99. Nicolas Poussin, *The Martyrdom of St Erasmus*. Oil on canvas, 320 × 186 cm. Pinacoteca del Vaticano, Rome.

100. Nicolas Poussin,
The Death of Germanicus,
1627.
Oil on canvas,
148 × 198 cm.

Institute of Arts,
Minneapolis. The William
Hood Dunwoody Fund.

101. Charles Mellin,
The Annunciation.
Preparatory drawing for
one of the chapels in the
church of San Luigi dei
Francesi in Rome. Pen
and sepia ink, graphite
and brown wash,
20 × 23.5 cm.

Graphische Sammlung
Albertina, Vienna.

102. *below:*
Charles Mellin,
*The Assumption of the
Virgin.*
Oil on canvas,
100 × 105 cm.

Museum of Art, Ponce
(Puerto Rico). The Luis A.
Ferré Fund.

Bernini. There is a perceptible awkwardness, however, caused probably by the overall height of the canvases. The artist's sensibility lent itself ill to scenes of martyrdom or ecstasy, the bread and butter of painters of the period. Vouet was much more at ease with such subjects. It is a pity that his *Celestial Glory*, painted in 1625–6 for the choir of the Canonesses of St Peter, should be lost. The *modello* (in a private collection) and such preparatory drawings (Lille, etc) as remain show that his work could well stand comparison with the work of Lanfranco. Compared with him, Poussin seems almost clumsy, although his *St Erasmus* possesses a tonal grandeur and an eloquence that aroused strong admiration. In spite of this success it was to Mellin that the commission to paint the chapel dedicated to the Virgin in S. Luigi dei Francesi was awarded in 1630: his art must certainly have seemed suppler, more suited to fresco work in both structure and emotional content, and, to put it bluntly, more decorative. This date marks a turning point in Poussin's career. From now on he was to devote himself almost exclusively to easel painting, better suited than fresco to his serious-minded reflections on life. During the following decade he developed a highly individual and exacting style of painting, while Vouet, in Paris, triggered a flurry of innovations in both subject matter and technique.

VOUET AND DECORATIVE PAINTING IN PARIS

Efforts have been made to interpret Vouet's recall to Paris by Louis XIII as the start of a new era in French painting. However, in spite of his very thorough training in Paris, in spite of the great public esteem he earned in Rome and his prodigious skill, and in spite of the way his commanding and attractive personality could produce innovations in Paris as well as in the provinces, 1627 marked no absolute beginning. Some of the Italian experiments were already known in Paris, thanks to the artists whom Marie de Médicis had tried to retain, or to tempt to work for her. The importance of Orazio Gentileschi's stay in Paris and the impression made by paintings such as his *Public Felicity* (pl.105), painted for the Luxembourg, have already been noted.[7] The large seated

female figure, draped in light-coloured fabrics, in a skilfully balanced pose, and the slightly chilly combination of blue, white and yellow, caught the attention of a number of painters, starting with Jean Monier and Philippe de Champaigne. In 1627 Marie donated an *Annunciation* by Guido Reni (Louvre; pl.104)[8] to the Carmelites in the Faubourg Saint-Jacques and, four years later, La Vrillière was enabled to acquire the *Abduction of Helen* by the same artist, the starting point of his prestigious collection. The lessons of the Carracci came filtered through the extreme refinement of Guido Reni. Tender, luminous colours, stylish heads, elegant figures in richly glowing garments, plus something poetic about the expression and the atmosphere of romance – all this brought new grace to Paris. Vouet had no trouble then in becoming the leader of a movement that had already begun.

A combination of favourable circumstances allowed him to establish his own style and to create his own visual world: first and foremost the rapid increase in orders, the strengthening of patronage and the renewal of building work in Paris. In theory, Vouet was employed exclusively by the King; in practice his activity extended to ministers and financiers as well as to religious orders and parishes. To cope with the influx of orders he displayed a rare capacity for hard work and a business sense rivalling that of Rubens. Like Rubens, he understood the importance of a well-run studio, with a team of efficient, well-trained collaborators. He was also aware of the need for publicity, and made sure his compositions reached a wide audience through the medium of tapestry (he supplied a large number of cartoons[9]) and, especially, of engraving.[10] It is really thanks to his engravings that we can appreciate the scope of his talent today; most of his decorative work has disappeared with the destruction or refurbishment of the buildings for which it was designed.

Vouet's art, like the art of the Bolognese painters, especially Annibale Carracci, was based on meticulous drawing.[11] Although few complete schemes by him remain, there are on the other hand a large number of figures studies and it is the elegant, effective linking of these figures that informed Vouet's composition. Vouet possessed an

103. Simon Vouet,
The Death of Dido.
Oil on canvas,
215 × 175 cm.
Musée Municipal, Dôle.

104. Guido Reni,
The Annunciation.
Oil on canvas,
319 × 222 cm.
Musée du Louvre, Paris.

105. Orazio Gentileschi,
*Public Felicity prevailing
over Danger.*
Oil on canvas,
268 × 170 cm.
Musée du Louvre, Paris.

106. Simon Vouet,
*Time vanquished by Love,
Hope and Renown*, 1645.
Oil on canvas,
187 × 142 cm.
Musée du Berry, Bourges.

the allotted space to best advantage: in the *Assumption* of 1629, still in place in Saint-Nicolas-des-Champs, the lower part, sombre in tone and filled with powerful figures of the Apostles, contrasts with the light and airy upper part. In the altarpiece painted for Saint-Eustache (1635, *in situ*, and Nantes) an apotheosis in a golden aureole was originally placed above a tumultuous depiction of a martyrdom.

In most cases, the structure of the painting is dictated by the figures themselves. Architectural detail provides focal points and overall control as well as decorative features, as for example the handsome curved colonnade in the *Presentation in the Temple* in the altarpiece painted for the Jesuits (Louvre). But the architecture in fact fails to provide a sufficiently solid framework for the action, nor is the rhythm it imposes on the use of space very meaningful; Venetian painters of the sixteenth century had been equally relaxed about its use. There is no perspective, in the Albertian sense of the term, and very little depth. The figures, often placed parallel to the foreground of the painting, seem to expand inexorably to fill every available inch. Whirling drapery exaggerates the movement even further. Posture and gesture, conforming to the conventions of the diagonal and the curve, describe powerful arabesques. The result is more decorative than expressive: ten years separate *Wealth* (about 1635, Louvre), turned in on itself, from *Time vanquished* (1645, Bourges; pl.106), in which each figure seems to grow out of its predecessor in a continuous spiral, but both hark back to the *grotesques*[13] used by Vouet in a number of decorative schemes, for example in the bath chamber of Anne of Austria in the Palais-Royal (about 1646–7). This flexibility grows more and more exaggerated. The artist seems gradually to abandon Italian sturdiness in favour of the elegance of Fontainebleau. Even in tragic paintings like his *Death of Dido* (Dôle; pl.103), reminiscent of the declamatory passages in the operas of the day, the interplay of gesture and drapery seems to evoke a world in which conflict can be as harmoniously resolved.

An important factor in Vouet's wholesale seduction of the Parisian world of fashion was his sparkling and increasingly subtle use of colour.

instinctive feel for the opportunities offered by the surfaces he was required to decorate. His work in the Hôtel Séguier, known through engravings (pl.108), was full of variety: in the chapel, a frieze depicted the journey of the three kings in the Venetian style; in the library the oval or octagonal caissons in the ceiling gave an all over impression of gyrating movement. In the lower gallery the square paintings on the walls were enlivened by diagonals. Even where the foreshortening of his figures fails to meet the strictest geometrical standards, Vouet was a past master of perspective: one of his most admired works was the ceiling of the Chapelle d'Achère, in the Eglise des Feuillants, which depicted *St Michael in Combat with the Rebel Angels*: the twisting figure and whirling drapery to be seen in the Munich drawing[12] must have lent a dynamic thrust to the whole composition. In his stepped altarpieces Vouet was also adept at using

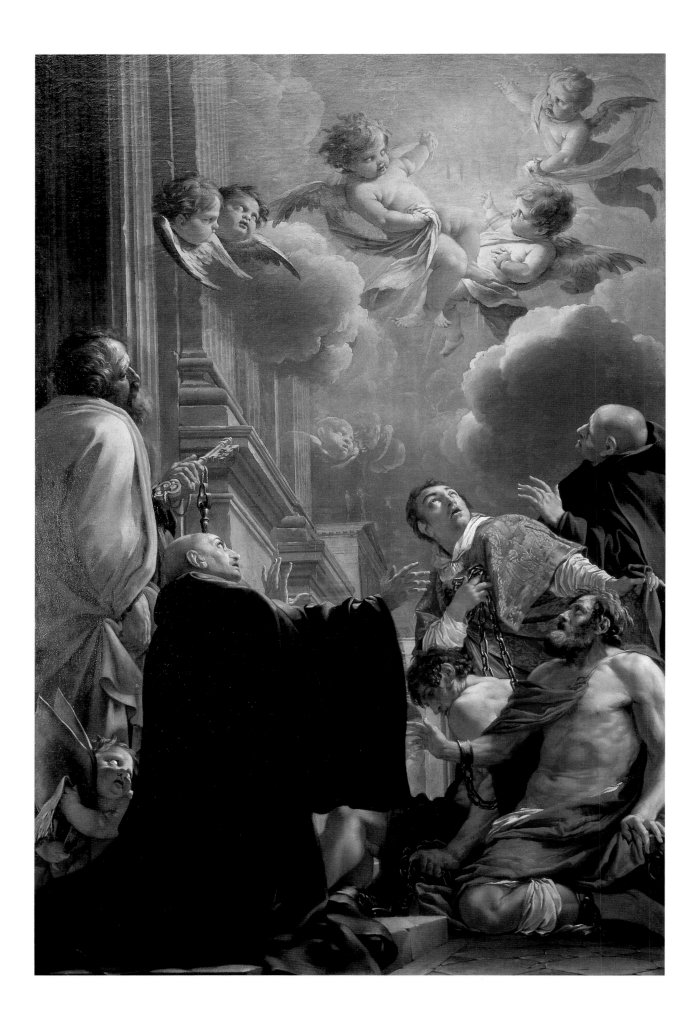

The warm reds and browns, present after his re-
turn from Italy, were modified. Blues and pale
yellows, pinks and raspberry reds, pale greys and
creamy whites are used in various juxtapositions.
Beginning with a restricted set of colours his pal-
ette slowly grew richer until some of his later
works, like the *Assumption* painted for the oratory
of Anne of Austria in the Palais-Royal (1643,
Reims), caress the onlooker's gaze with the fresh-
ness of a bouquet of flowers. The landscape back-
grounds, painted in half-tones, often set off the
foreground to remarkable advantage. The paint-
ings still in good condition contain glancing high-
lights that betray an extraordinary visual
sensitivity. In the black chalk drawings on dark or
light buff paper the light gleams on the skin.
Vouet has complete mastery over the whole range
of tonalities, from the darkest black to the lightest
transparent shade. His lighting sometimes ema-
nates from supernatural sources: in his last altar-
piece, *The Adoration of the Holy Name by Four
Saints* (Saint-Merri, Paris; pl.107), the black cowl
of the kneeling monk in the foreground sets off
the gilded halo against which other colours pale
into insignificance, the divine light absorbing all
terrestrial irridescence. The visual brilliance of
Vouet's work, an important feature of his innova-
tive decorative painting, was in tune with the
theocentricity of seventeenth-century religion.

There is something exhilarating about this
painting, which falls somewhere between the
work of Veronese and of Boucher. Roger de
Piles, however, followed by most commentators
in the succeeding century, criticised the way
Vouet lapsed into Mannerism, turning his back on
correctness and naturalness:[14]

Vouet had this advantage over other painters: there was no-one
else whose students held their master's *maniera* in such high
esteem, of both heart and hand. But although in one respect this
manner brought relief to the drabness that reigned in France
when he arrived, in another it was so far removed from natural-
ness, so wild, so facile and was absorbed so hungrily that it
infected the minds of all his disciples. They fell into bad habits
and then had the greatest difficulty in giving them up.

Vouet's influence over his followers and the
handing down of his well-tried formulae, com-
bined with the continuing growth of demand,

108. Michel Dorigny,
(after Simon Vouet),
The Adoration of the Magi.
Detail of the frieze
around the lower part of
the ceiling in the chapel
in the Hôtel Séguier.
Engraving.

Département des Estampes,
Bibliothèque Nationale,
Paris.

109. Simon Vouet,
altarpiece in the church
of Saint-Nicolas-des-
Champs, Paris.

107. *opposite*:
Simon Vouet,
*The Adoration of the Holy
Name by Four Saints.*
Oil on canvas,
265 × 176 cm.
Eglise Saint-Merri, Paris.

110. Nicolas Chaperon,
*The Presentation of the
Virgin in the Temple*,
1639.
Oil on canvas,
59 × 44 cm.
Museum of Fine Art,
Houston. The Laurence H.
Favrot Bequest.

111. Charles Poërson,
*St Peter preaching in
Jerusalem*.
Oil on canvas,
76 × 62 cm.
County Museum of Art, Los
Angeles. The Ahmanson
Foundation Bequest.

112. Charles Le Brun,
*The Martyrdom of St John
the Evangelist*, 1642.
Oil on canvas,
282 × 224 cm.
Eglise Saint-Nicolas-du-
Chardonnet, Paris.

were responsible for the persistence of a style that
reigned unchallenged from the end of the 1620s
to the beginning of the 1740s, in Paris and else-
where. By the time the Premier Painter died in
1649 it had gone out of fashion, but not before
some of the leading artists of the new generation
had become imbued with it.

In Rome, without running a proper studio,
Vouet had had a circle of companions: his brother
Aubin Vouet, then Jacques de Létin, the brothers
Muti and Virginia da Vezzo, his first wife. Some
of his companions are still little known, like the
brothers Jacques and Jean Lhomme. In Paris, on
the other hand, a huge team was built up. This
was based on the family: Virginia taught painting
to young women; Michel Dorigny and François
Tortebat, Vouet's sons-in-law, put his art into
circulation through their engravings; a nephew by
marriage Michel Corneille the Elder, was also part
of this family circle. Vouet's pupils were not ap-
prentices in the conventional sense of the term,
and this distinguished Vouet's studio from a studio
like that of Lallemant, for example, which was
organised on strict workshop lines. Far from being

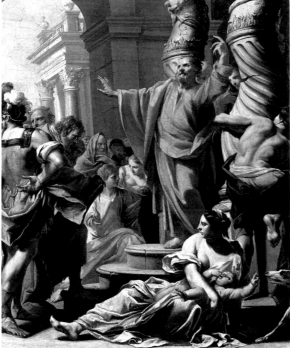

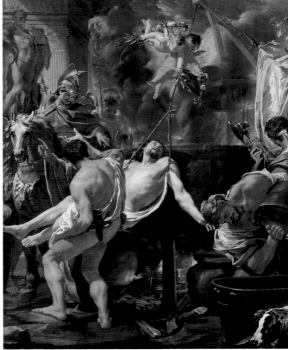

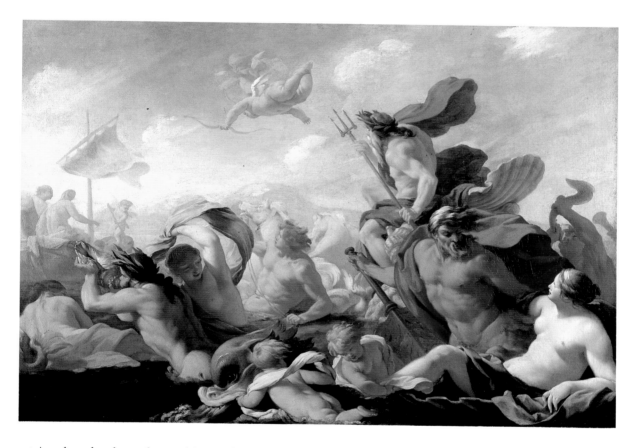

restricted to lowly and repetitive tasks the most talented pupils learnt their trade most thoroughly, had different models at their disposal and benefited from the advice and vast experience of their master. These pupils need to be differentiated from Vouet's trained collaborators,[15] like François Perrier, who worked with Vouet from 1631 to 1635, collaborating with him in the Château de Chilly before returning to Rome; there were also painters specialising in landscape, animals or ornamentation, very useful on large projects or when cartoons were being prepared for tapestries. Some of these, like Pierre Patel, could also pursue an independent career. Many of the disciples stayed only a short time with Vouet. This was the case with Charles-Alphonse Dufresnoy and Pierre Mignard, who left for Italy in 1633 and 1635, or Rémy Vuibert, mentioned as being in the Vouet studio at the beginning of the 1630s, but who then turned up in Rome in 1635. The Roman experience of these painters soon erased their ear-

lier studies. Others were more dependent, including Noel Quillerier, later to become a well-patronised decorator in his own right, Michel Corneille the Elder, Charles Poërson or Nicolas Chaperon. All of them painted in the style of Vouet, at least until the early 1640s by which date they were beginning to distance themselves. Chaperon's *Presentation of the Virgin in the Temple*, painted for the Chapelle Saint-Nicolas in Compiègne (1639, pl.110, *modello* in Houston) or Poërson's *St Peter preaching in Jerusalem*, the Notre-Dame *may* of 1642, (*in situ*; *modello* or reduced version in Los Angeles pl.111) bear witness to their mentor's firm grip: the compositions are sustained by architectural features and high-toned figures in the foreground; curves and diagonals hold sway; modified realism is allied to a skilful way with scenery. The same abundance can be found in the series of tapestries illustrating the *Life of the Virgin* (Strasbourg Cathedral), for which Poërson drew most of the cartoons; the *modello* for

113. Eustache Le Sueur,
The Sea Gods.
Oil on canvas,
95 × 135 cm.
The J. Paul Getty Museum,
Malibu.

114. Laurent de La Hyre,
The Conversion of St Paul,
1637.
Oil on canvas,
340 × 220 cm.
Cathédrale Notre Dame,
Paris.

115. Sébastien Bourdon,
The Martyrdom of St Peter,
1643.
Oil on canvas,
360 × 260 cm.
Cathédrale Notre Dame,
Paris.

the *Annunciation* (Musée Carnavalet) is a good example. Vouet's style was also carried forward by Dorigny, his son-in-law and close collaborator. Dorigny's forms tended to be on the heavy side, however, and his compositions busier, with an added atmosphere of high emotion, as in the *Calvary* in the Louvre (after 1647) and the Sillery *Annunciation* (Quebec). As late as the 1650s he was still producing opulent, artificial work, quite out of fashion, in the Hôtel de Lauzun. Charles Dauphin, who was a member of Vouet's studio between 1638 and 1646, settled in Turin in 1655 and remained there as a court painter until he died in 1677, still faithful to the style of his youth. He stands as a typical example of the transfer of a style to a distant location, where it became fossilised.

Vouet's two most talented pupils, Le Sueur and Le Brun, were able to develop in their individual ways during the decade from 1635–1645. The series of tapestry designs on the theme of the *Dream of Polyphilus*, dating from this period, mark

the maturity of Le Sueur, who gradually divested himself of the stock formulae he had learnt as a young man. A diffidence appeared, enhanced by the colours he used, which were much less violently juxtaposed than Vouet's colours. Youthful emotion emerges in a painting like his *Coriolanus* in the Donation Kaufmann et Schlageter in the Louvre (before 1640); here the masses are balanced quite methodically. The painter's sensuality is manifest (as it is in the *Sleeping Venus* in San Francisco, one of the frankest nude paintings of the period) but it is rendered inoffensive by the lightness of Le Sueur's touch, seen again to good advantage in the union between the figure and the hazy landscape in *Diana and Callisto* in the Musée Magnin. Little by little his compositions grew less cluttered, the poses simpler and the figures more grounded. Later, Le Sueur turned to other models, better suited to his calm temperament and his refined tastes. The personality of Le Brun, by contrast, seems violent and easily roused. He collaborated closely with Vouet from 1637

and imitated him in his *Christ on the Cross* in the Hermitage (1637), to assert himself later in his *Hercules and Diomedes* for the Palais-Cardinal (about 1640, Nottingham), and particularly in his *Martyrdom of St John the Evangelist* (1642, Saint-Nicolas-du-Chardonnet, Paris; pl.112), his reception piece for the *maîtrise*. The influence of Perrier, his first master, is perceptible in his sombre colours and in the fierce expressions on his subjects' faces. Le Brun rejected supernumerary figures as he rejected artless lyricism in favour of closer analysis of form and gesture. Like Le Sueur, however, he had learnt 'to dispose masses in large blocks, and the art of grouping figures as well as light and shade, in a word [...] to do things on a grand scale, admitting nothing mean or debased into his compositions.'[16]

Similar qualities can be found in the work of artists who did not belong to the Vouet circle, but who were reacting as he was against the fossilised forms of the past by introducing a more fluent, straightforward style, often quite turbulent and subtly hued. One result of the spectacular increase in religious commissions was the establishment, in Paris for a time and more permanently in the provinces, of an eloquent style, expressing active piety coupled with an evident anxiety for approval. The four paintings executed by the Le Nain brothers in collaboration for the chapel of the Virgin in the church of the Petits-Augustins (1630–2), now scattered between the Louvre and various churches in France, illustrate the strengths as well as the limitations of these novices, who were aspiring to a grand decorative style, but with specific naturalistic tendencies. A short time later, the two altar paintings for Notre-Dame, *St Michael dedicating his Arms to the Virgin Mary* (Saint-Pierre, Nevers) and the *Birth of the Virgin* (*in situ*, pl.117)[17] reveal a softening of forms, a brightening of the palette and a sensitivity to light and landscape (in the *St Michael*) which are all the more attractive because Vouet's seductive but cardboard characters have been replaced with figures observed with the tenderness and attention

116. Jacques Blanchard, *Pentecost*, 1638. Oil on canvas, 360 × 260 cm. Cathédrale Notre Dame, Paris.

117. The Le Nain brothers, *The Birth of the Virgin.* Oil on canvas, 220 × 145 cm. Cathédrale Notre Dame, Paris.

113

118. Jacques de Létin,
The Death of St Louis.
Oil on canvas,
282 × 356 cm.
Eglise Saint-Paul, Paris.

found in the best of the genre paintings that were to issue later from the studio of the three brothers.

The succession of *mays* presented to Notre-Dame-de-Paris[18] includes some excellent examples of Vouet's style at its most successful. In Jacques Blanchard's *Pentecost* (1638; pl.116) the silvery-blond tones in the Venetian manner, and the rigorously classical architectural framework, distract attention from somewhat sloppy painting and some bombastic poses. In *St Peter healing the Sick with his Shadow*, by La Hyre (1635) and, in particular, the *Conversion of St Paul*, also by La Hyre (pl.114), the normally reticent temperament of the artist gives way for once to unrestrained movement and to a composition based on jostling diagonal lines, very different from the calm dignity of his *Nativity*, painted in 1635 for the Capuchins in the Marais. Similar agitation is to be found later in Bourdon's *Martyrdom of St Peter* (1643, pl.115), painted just before he was converted to Classicism.

Delayed reactions to the lessons of Vouet

sometimes turned up even later in the provinces. Engravings and the large output of his disciples provided models for artists of lesser calibre engaged in painting altarpieces that were being hung all over the country. Simon Vouet's own brother, Aubin, received in 1639 a commission for five huge paintings for the chapel of the Pénitents-Noirs in Toulouse. The *Finding of the True Cross* and the *Brazen Serpent* can still be seen in the museum in Toulouse. The paintings contain brilliant passages, but there is inconsistency in the composition and anatomical exaggeration suggesting a return to Mannerism, even more pronounced in the paintings of Brother Ambroise Frédeau, one of the outstanding figures in the art of seventeenth-century Toulouse: dancing, waving their arms, the figures in his compositions (*Jesus Christ reincarnate appearing to his Mother* and *St Nicholas of Tolentino listening to the Music of the Angels*) perpetuate Vouet's style of the 1650s while distorting it even further. In Provence, Nicolas Mignard and Jean Daret show similar

awareness of recent innovations (as Mignard's *Assumption* [1633, Notre-Dame-des-Doms, Avignon] demonstrates) regardless of having to abandon them later. The case of Jacques de Létin is even more typical. His work was well regarded in Paris. He painted a *may* in 1636 (now lost, engraving by Bosse) and, in about 1640, a brilliant *Death of St Louis* for the professed house of the Jesuits (church of Saint-Paul-Saint-Louis, pl.118). He worked mainly in his home town of Troyes, however, and his renown spread as far as Provins, Nevers and Orléans. Filled with plagiarisms, his work was of uneven quality; though still bearing echoes of Caravaggism, it was often powerful and lyrical enough to stand out from amongst the vast ouput of the period, much of which remains undiscovered to this day.

Philippe de Champaigne enjoyed his earliest success as a religious painter just at the moment when Vouet's career in Paris was beginning, but their styles are quite distinct. Champaigne's training in Flanders is perceptible in his first large commissioned work, the paintings for the Carmelite church in the Rue Saint-Jacques (1628–30), now scattered: the *Nativity* (Lyon), the *Presentation in the Temple* (Dijon; pl.119), the *Raising of Lazarus* (Grenoble) and the *Adoration of the Magi* (Wallace Collection, London). Bernard Dorival has emphasised the eclecticism of his sources.[19] These range from Rubens tempered by the lessons of Pourbus, to Italian influences; he borrowed designs for compositions from Mannerists like Federico Zuccaro, but also absorbed the monumental, luminous paintings of Gentileschi. Particular attention has been paid to the carefully observed detail in these paintings of the 1630s, the distinctive treatment of hands and faces, the *trompe l'œil* architectural effects and the unusually refined modelling of the figures. Far less attention has been paid to the painter's eloquence, to his taste for luxury and measured movement, or to his preference for very bright colours – in short, to his style, which has grandeur but tends towards heaviness. That Champaigne has none of Vouet's decorative facility can be seen, for example, in his *Assumption*, painted for Saint-Germain-l'Auxerrois, Grenoble, so different from the altarpiece in Saint-Nicolas-des-Champs. After his spell

119. Philippe de Champaigne, *The Presentation of Jesus in the Temple.* Oil on canvas, 398 × 327 cm. Musée des Beaux-Arts, Dijon.

120. Philippe de Champaigne, *The Vow of Louis XIII,* 1637. Oil on canvas, 342 × 267 cm. Musée des Beaux-Arts, Caen

as painter in ordinary to the Queen Mother, Champaigne entered the service of Richelieu,[20] who overwhelmed him with work from the Galerie des Hommes Illustres in the Palais-Cardinal (about 1630), a series of historical portraits, to the decorations in the dome of the chapel of the Sorbonne (1641), where instead of executing a unified painting in the early Baroque manner he returned to the compartmentalisation used forty years earlier by Cavaliere d'Arpino in St Peter's, Rome. The *Vow of Louis XIII* (1637, Caen; pl.120), painted for Notre-Dame in Paris, clearly demonstrates the difference between Champaigne and Vouet: there is little movement or vigour apart from the flight of angels. In its place, restrained emotion expressed through a calm, careful structure in which each object, each fold of drapery, each body possesses a definite presence and each emphasises the symbolic meaning of the whole. The artist's descriptive, devotional style of painting, which in the early days succumbed to the blandishments of scenery, grew increasingly austere in the 1640s.

ROME: POUSSIN AND THE CLASSICISM OF THE 1630s

As Vouet was beginning to make his name in Paris, there was a movement in artistic circles in Rome away from the florid style of Pietro da Cortona, then at the height of his career. Reigning monarch of the Accademia di San Luca from 1634 to 1638, he spent these years painting the *Triumph of Divine Providence* on the ceiling of the *Gran Salone* in the Palazzo Barberini, a star in the Baroque firmament that was to leave an indelible mark on Western painting. Meanwhile Poussin, surrounded by colleagues and well-informed patrons, consistently narrowed the scope of his compositions, estimating, like Leonardo da Vinci, that painting is first and foremost *cosa mentale*.[21] The years 1630 and 1631 were of crucial importance to his career. Rejecting Pietro da Cortona's (and his imitators') decorative exuberance, and assimilating influences from new sources, he chose a rigidly controlled form of expression. The purism of Domenichino (preferred by Poussin to Guido Reni) encouraged him to take another look at

Raphael. Through his friendship with archaeological enthusiasts like Cassiano dal Pozzo, his principal patron, and with artists like the sculptor François Duqesnoy, he became involved in the study of classical antiquity. This led him to start measuring the dimensions of the most celebrated statues, and building up an inventory in an attempt to re-discover the pristine purity of genuine classical art and to expose second-rate copies for what they were; he was henceforth to regard classical art as the true source of all contemporary art. There is a new sense of harmony in the *Inspiration of the Poet* in the Louvre (pl.90); although the figures appear motionless, the composition is intensely rhythmical, far removed from the riotousness and intoxication of his first Titianesque *Bacchanals* or the smaller *Inspiration* in Hanover. Apollo succeeded Dionysius, and in similar fashion the passionate, complex poetry of Marino now made way for creations that were more serene, in which conflicting elements were reconciled.[22] In paintings that look unbearably cruel, like the *Massacre of the Innocents* in Chantilly, the precision of the planning and execution, the enclosure of the subject in a restrictive architectural framework, the use of animated and coloured statues serve to fix and congeal the movement, giving the episode (depicted with extreme clarity by the artist) a very strong physical presence.

Two paintings, one of them biblical and one mythological, painted in about 1631, together represent a kind of manifesto for this new way of painting: one is the *Plague of Azoth* in the Louvre (pl.122), the other the *Kingdom of Flora* in Dresden (pl.121). In the first the drama of a man struck by divine fury is presented in an urban landscape inspired by Vitruvius and Serlio. The centred vanishing point and the precision of the perspective hark back to Renaissance models, and this produces a series of skilfully handled acknowledgments and quotations. The painter's aim here was to be as expresssive as a poet or a musician. In his own way, he aimed to create a connected, hierarchical discourse, subject to an overall harmony in which line, posture and colour would converge. The Roman rigour of the *Plague* contrasts vividly with the Hellenic, or at least Hellenistic refine-

121. Nicolas Poussin, *The Kingdom of Flora*. Oil on canvas, 131 × 181 cm. Gemäldegalerie Alte Meister, Dresden.

122. Nicolas Poussin, *The Plague of Azoth*. Oil on canvas, 148 × 198 cm. Musée du Louvre, Paris.

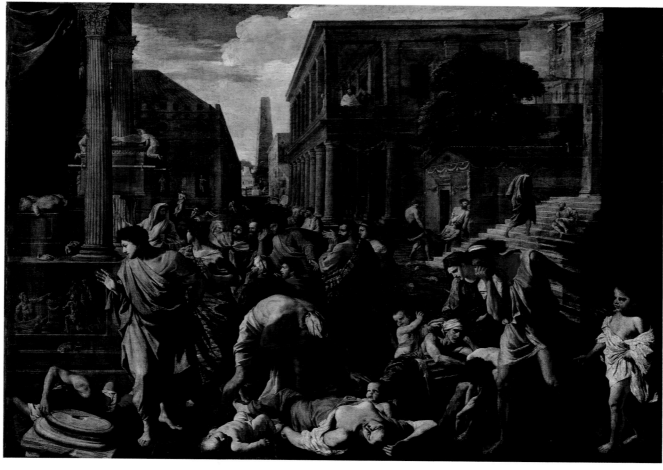

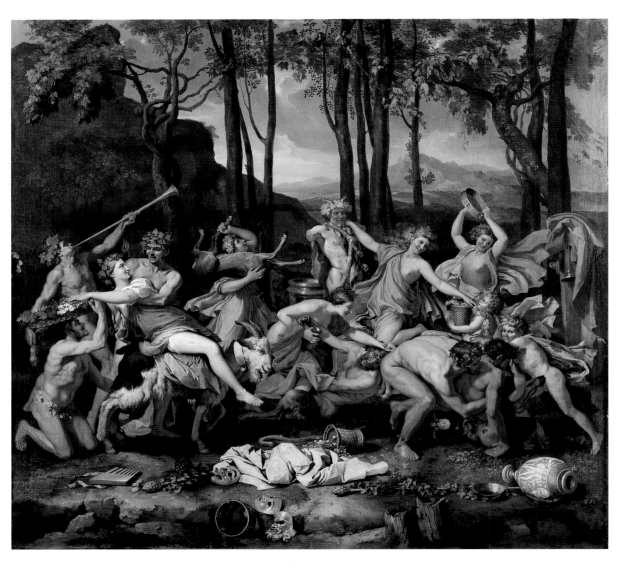

ment of the *Kingdom of Flora*. The first painting tells a story (a narrative with a moral dimension), the second is a much freer, more flowing composition, more akin to lyric poetry: the star-crossed lovers, whose metamorphosis into flowers was described first by Ovid then by Marino, are juxtaposed like the stanzas of an ode, in a delightful setting that evokes some sensual, irresistible *locus amoenus*. Death and renewal are closely linked, as they are in other paintings of the same period (the *Adonis* in Caen, the *Narcissus* in the Louvre or the *Dead Christ* in Munich). In each of these the artist's desire to breathe new life into classical statuary is obvious. The tension between the very controlled drawing and the expressive potential of the colours is strong.

This was the time when learned debate was rocking Roman artistic circles. In 1634 the Accademia di San Luca was the scene of heated discussions between Pietro da Cortona and Andrea Sacchi.[23] The abundant style of Pietro da Cortona, who manipulated vast masses for big effects, was in contrast to the more diffident, in-

tense approach of Sacchi, who sought a more lifelike quality. He used fewer figures, less movement, and his composition was light but sturdy, as illustrated on the ceiling in the room next to the one decorated by Pietro da Cortona in the Palazzo Barberini in Sacchi's *Triumph of Divine Wisdom* (1629–33). At the same period, Poussin, within the much narrower framework of easel paintings, was trying to achieve perfect legibility without any sacrifice of historical complexity. He has been compared to the writer who, according to Aristotle, should aim at greater clarity by practising moderation or 'mediocrity', one of the components of which is restricted size, with materials organised into a measured space.[24] Poussin's submission to these restrictions can be seen in the subjects taken from the story of Moses: the *Crossing of the Red Sea* (Melbourne) and the pendant *Adoration of the Golden Calf* (London), or the *Striking of the Rock* (Edinburgh). Ancient history also makes its contribution, in the *Rape of the Sabine Women* (New York) and the *Rescue of the young Pyrrhus* (Louvre). In these two experimental

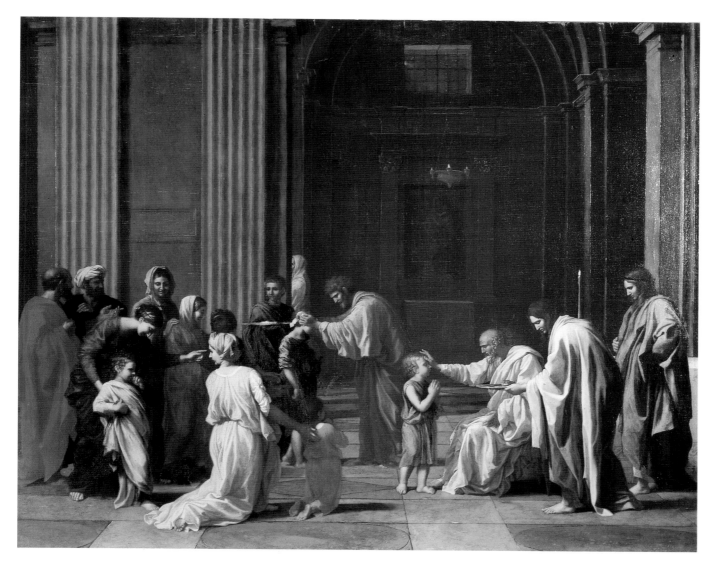

paintings the artist exchanges his usual lyricism for a rationalist rigour; the placing of each element in the picture is calculated according to the part it plays in the *storia*. Starting with a carefully selected episode, a climactic moment containing the past as well as the future, Poussin studies the whole range of *affetti*, human emotions, through the characters' reaction to the event. His analytical approach contrasts strongly with Bernini's studied syntheses of the same period; Bernini, through the *bel composto* achieved by combining all the arts, aspired to express the inexpressible.[25]

Poussin's redefinition of the space within a painting and the relationship between the figures and their setting is accompanied by a quality of thought that has been compared with that of the leading thinkers of the period.[26] Poussin was neither an academic nor a theologian, however. His education, though quite advanced for a painter, had many gaps. But his assiduous association with the Roman *intelligentsia*, beginning with the circle of Cassiano dal Pozzo in which scientists and antiquaries rubbed shoulders and the most ad-

vanced ideas were debated, lent his paintings an extraordinary appeal. It is significant that at this time, in about 1635, he prepared two cycles of paintings, the *Triumphs* of the gods of classical mythology for Richelieu (pl.123) and the *Seven Sacraments* for Cassiano (pl. 124).[27] The two series proceeded from the same spirit of archaeological and historical enquiry: Poussin hoped, through the study of sources and relics of the past, to arrive at the origins of pagan and Christian forms of worship. The architecture and stage props, the clothes and postures are all painstakingly reproduced from the documents available. The artist, however, goes further than this: by including in his paintings, behind the portrayal of ritual, a picture of the cycle of life, death and rebirth, he gives an added emotional depth. The tone and rhythm of the two cycles are very dissimilar. But all the paintings follow the general rules of bas-reliefs, the figures being presented frieze-fashion, sometimes dense and compact and sometimes more relaxed, alternately, and with a timeless air.

Poussin seems less inspired in his allegorical

124. Nicolas Poussin, *Confirmation*. Oil on canvas, 95.5 × 121 cm. Collection of the Duke of Rutland, Belvoir Castle, Grantham, Great Britain.

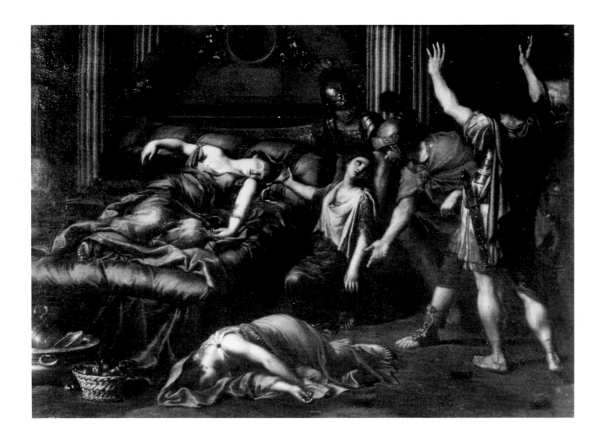

paintings, so dear to the members (like Giulio Rospigliosi) of the literary set that clustered round the Barberini. The *Dance to the Music of Time* (Wallace Collection, London) and the *Arcadian Shepherds* (Louvre), painted at the end of the 1630s, are highly idealised, if not actually pedantic. These give some idea of the distance Poussin had already travelled towards the nostalgic re-creation of antiquity, neo-classical before the term had been coined,[28] harmonious but threatened. The key to the success of paintings like *St John on Patmos* (Chicago) and *St Matthew* (Berlin), painted in 1640–1, is the sense of the ineluctable passing of time. The light of religion shines on the ruins of the ancient world, on a landscape regarded with severity. Once again, hazy, neo-Venetian sentimentality is galvanised to comply with the Bolognese sense of structure. Domenichino had set an example in his landscapes by following the advice of Giovanni Battista Agucchi, who recommended a 'ragionevole compartimento dei sitti'.[29]

The sensuality and *furia di diavolo* that the Cavaliere Marino spotted in the work of the young Poussin died away, and his later works convey an impression of strangeness. *Venus showing her Weapons to Aenaeas* (Rouen; pl.126), painted in 1639 for his friend Jacques Stella, captures the quintessential moment, the moment when the future of Rome was to be decided, from Virgil's tale. The unbearable solemnity of the moment is expressed in the almost abstract quality of the composition: the obsessive compound rhythm, the sharply-etched forms, the splashes of strong colour on a quiet background. Everything is recreated in the classical manner, from the nymphs to the trophies of weaponry. The elements are linked in an authoritarian, definitive manner. *The Gathering of Manna*, painted in 1638 for Paul Fréart de Chantelou (Louvre; pl.127), a far more complex work with its crowds of people, develops the analysis of individual reactions to misfortune and divine mercy, and Poussin extends the scope of his art at the same time. Reviewing the whole time scale of the biblical story, he extracts a moral from it. He makes appropriate use of figures from the sculpture of antiquity, grouping them in such a way as to guide the spectator's gaze through the different layers of the painting; he packs the picture with incident in order to transport the spectator imperceptibly from a human state to a state of grace. The distribution of the patches of colour and the alternation of light and shade contribute to the harmony of the whole; there are constant cross-references from the whole to the parts and from the parts to the whole. In 1639, *Manna* was sent off to Paris where it caused a stir and a buzz of admiration. As late as 1685, Félibien reserved a prominent place for it in his *Entretiens*[30] treating it as an example of history painting at its best, on a par with rhetoric and poetry.

Poussin was by this time famous in France. In

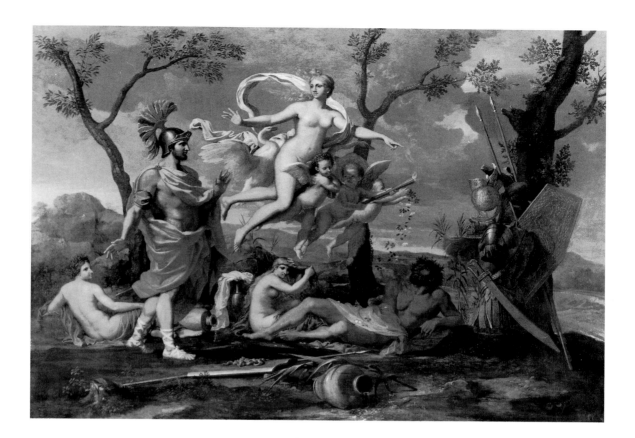

126. Nicolas Poussin,
*Venus showing his
Weapons to Aenaeas*, 1639.
Oil on canvas,
107 × 146 cm.
Musée des Beaux-Arts,
Rouen.

Rome too, a circle of painters took their inspiration from him, without being real disciples. Charles Mellin, who became Lanfranco's only real rival when he decorated the choir of the abbey of Monte Cassino (1636–7, destroyed), refined and darkened his painting during his stay in Naples from 1643 to 1647. His *Annunciation* and *Immaculate Conception* for Santa Maria di Donnaregina are remarkable for their exclusively frontal composition, their few figures and for their internalised expression. François Perrier spent a second spell in Rome from 1638 to 1645 and, having been influenced by a stint in Vouet's studio, now re-immersed himself in classical antiquity, producing two sets of engravings, the *Statuae antiquae* (1638) and the *Icones et segmenta illustrium e marmore tabularum* (1645). He strove to equal Lanfranco or Pietro da Cortona in his collaboration with Grimaldi and Ruggieri in the gallery of the Palazzo Peretti-Almagia, preparing himself for the task that lay ahead for him in Paris in the Hôtel de La Vrillière (pl.140). His historical or mythological paintings such as the *Deification of Aeneas* (private collection, United States of America) contain classical statues and landscapes painted in glowing colours. Jacques Stella, influenced by Albani and very close to Poussin, had a very individual anecdotic sense, as can be seen in his drawings, his genre paintings and in his series illustrating the *Life of St Philip Neri*. He later painted successful small paintings on religious and mythological themes,

delicate informal paintings on jewelled supports that recall his training in Florence. He left Rome, however, in 1634 and did not really come into his own until he was in the service of Richelieu.

Poussin's example had a stronger effect on younger painters, who were enthusiastic about classical antiquity and united in their dislike of Roman Baroque: Italians like Gimignani, Camassei and Chiari, and also French painters, frequently fresh from Vouet's studio in Paris, which they had left in their impatience to see Italy. Among these Rémy Vuibert (pl.135) and Nicolas Chaperon (pl.139) made engravings of Raphael's work; their paintings, virtually unknown, are often confused with the work of Poussin. Charles Errard used his long stay (1627–43) to make innumerable drawings of monuments and statues. Dufresnoy arrived in 1634 and was joined the following year by Pierre Mignard: few paintings produced by them during this period are known, and the attributions of those known are insecure. The *Death of Cleopatra*, attributed to Mignard[31] (private collection, Great Britain; pl.125), and *Socrates drinking Hemlock* by Dufresnoy (Uffizi), show the influence of Poussin's purism. The décor and the closely observed classical dress match the careful, slightly dry figure drawing. Their study of the way passion is expressed could not have been further from Vouet's informality. *St Charles Borromeo giving Holy Communion to Plague Sufferers*, a commission

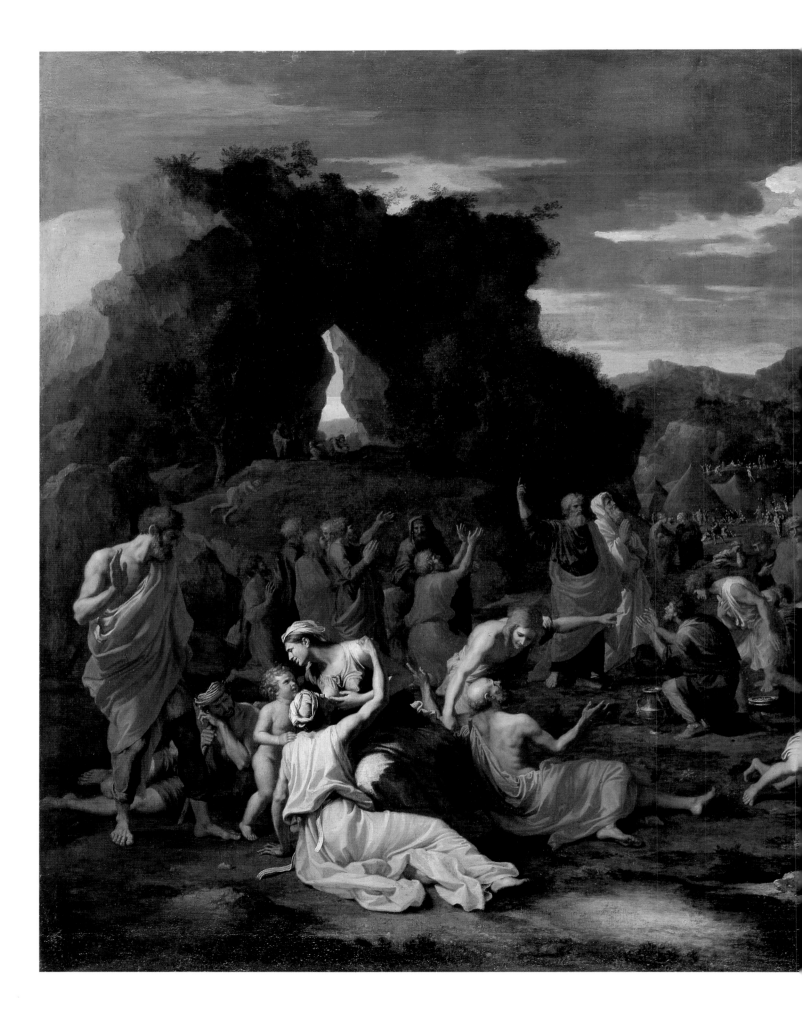

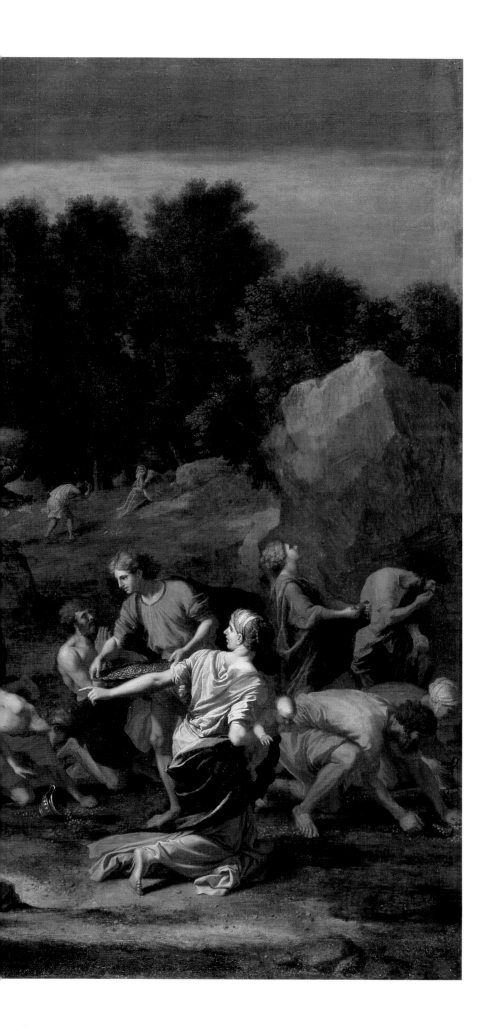

127. Nicolas Poussin,
The Gathering of Manna,
1638.
Oil on canvas,
149 × 200 cm.
Musée du Louvre, Paris.

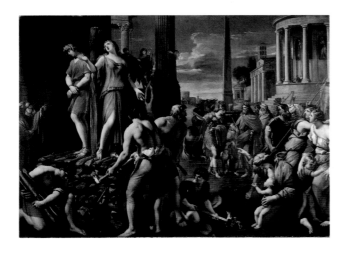

128. François Perrier,
*Olinda and Sophronia at
the Stake.*
Oil on canvas,
240 × 321 cm.
Musée des Beaux-Arts,
Reims.

129. Thomas Blanchet
and Jean Lemaire,
Cleobis and Biton.
Oil on canvas,
88 × 130 cm.
Statens Konstmuseer,
Stockholm.

awarded to Mignard for an altarpiece in San Carlo ai Catinari shortly before 1657[32] (*modello* in Le Havre), reveals his admiration of Domenichino. These ideas could sometimes lead the painter down an impasse, as the pedantic work of Berthollet Flémalle from Liège demonstrates. But they could also produce oddly charming pictures: architectural landscapes populated by tiny people were the speciality of a group of young artists who were close to Poussin, but who were more interested in elegant or unusual details than in history. Their names include Jean Lemaire, Thomas Blanchet, Dufresnoy and Nicolas Loir. Such archaeological fantasies, painted with great finesse, were in demand with the kind of purchaser who was susceptible to the romance of ruins.

In 1639, Maréchal d'Estrées, the French ambassador in Rome, ordered sixteen large paintings illustrating Tasso's *Gerusalemme Liberata*[33] from a number of painters – Gimignani, Pierre Lemaire, Pierre Mignard and Errard. These were apparently destined to adorn the gallery of the Hôtel de La Ferté-Senneterre in Paris, demolished in 1683. A few scraps of the series remain: Perrier's *Olinda and Sophronia at the Stake* (Reims; pl.128); a drawing by Mignard for *Erminia's Sleep disturbed by Love* (Louvre); and also three paintings in the Musée de Bouxwiller: the *Meeting of Rinaldo and Armida*, signed by Gimignani, *Rinaldo leaving Armida*, attributed to Errard (pl.130), who must have executed a large number of the paintings, and *Godefroi de Bouillon being cared for by an Angel*, which may be attributable to Mignard. These paintings bear no relation to the work of either Vouet or Pietro da Cortona. They are over formal at times, but the clarity of their composition (just short of stiffness) and the meticulous drawing put to the service of volume and expression are in their favour. The brilliant, distinctive colours of Errard's recently restored painting, emphasise the romantic aspects of the subject, and remind us again of Fontainebleau. In a rapidly changing artistic environment, the intellectual pretensions of these young painters are quite evident. Passionately interested in theory (Dufresnoy was in the middle of writing his didactic Latin poem: *De Arte graphica*[34]), they played quite an important part in the consolidation of a classical doctrine, later fully

established by Bellori and Félibien. Poussin's return to Paris by order of Louis XIII and Richelieu marks the consecration on French soil of an ambitious new style that had attempted a return to orderliness and to primary sources.

Notes

1. For an account of the Roman artistic milieu, see Wittkower, 1958 (1973), Part I; Bonnefoy, 1970.

2. On the importance of the Galleria Farnese to French painters, and the influence of the Carracci family in France, see Thuillier, 1986 (1988).

3. *Principes fondamentaux de l'histoire de l'art* (1915; French edition, Paris, 1952).

4. Poussin's neo-Venetianism has been highlighted by, among others, Whitfield, 1979; Brigstocke and MacAndrew (exh. cat., Edinburgh, 1981); Oberhüber (exh. cat., Fort Worth, 1988).

5. On Mellin and neo-Venetianism, see Thuillier, exh. cat., Rome and Nancy, 1982, p.223.

6. See exh. cat., Paris, 1973.

7. See above, chapter 4, p.82.

8. On Guido Reni and France, see Auzas, 1958 (1959); Cuzin, exh. cat., Frankfurt, 1988–9.

9. See Lavalle, exh. cat., Paris, 1990–1, pp.489–523.

10. See Thuillier, *ibid.*, pp.61–85; Grivel, 1991 (1992); Meyer, 1991 (1992).

11. See B. Brejon de Lavergnée, exh. cat., Paris, 1990–1, pp.357–84; and also: B. Brejon, 1987; exh. cat., Munich, 1991.

12. Exh. cat., Munich, 1991, no. 27.

13. See Mérot, 1991 (1992).

14. De Piles, 1699, p.467.

15. See J. Thuillier, 'Vouet et son atelier', exh. cat., Paris, 1990–1, pp.23–60.

16. Comte de Caylus: *Vie d'Eustache Le Sueur* read before the Académie in 1748 (manuscript in the Ecole Nationale Supérieure des Beaux-Arts, 101/1, quoted by Mérot, 1987, p.135).

17. On the collaborative works of the Le Nain brothers, see the recent studies by Rosenberg, 1979 and 1973.

18. Auzas, 1949 and 1953.

19. Dorival, 1976, vol.I, pp.83 ff., and 153 ff.

20. On Richelieu and Champaigne, see Dorival, 1985 (1987).

21. On Poussin's reaction to the Baroque of the 1630s, see Mahon, 1947 and 1958 (1960).

22. On the importance of the *Inspiration of the Poet*, and its literary and intellectual context, see the study by M. Fumaroli, exh. cat., Paris, 1989 (2).

23. See Mahon, 1947; Bonnefoy, 1970.

24. 'Concentrated events are more to be appreciated than events occurring over a long period of time' (Aristotle, *Poetics*. 1462 b 18, quoted by Arikha, 1989, p. 221).

25. On Bernini's 'bel composto' and the idea of a 'total' work of art, see I. Lavin, *Bernini and the Unity of the Visual Arts*, Princeton, 1979. At the end of the last century, A. Riegl made the comparison between Poussin, 'the painter who thinks in terms of sculpture' and Bernini, 'the sculptor who thinks in terms of painting' (*L'Origine de l'art Baroque à Rome*, French translation, Paris, 1993, p. 57).

26. Thuillier, 1974 (preface on 'Poussin, ou la générosité du peintre'). On Poussin's education, the classic study remains the monograph by Blunt, 1967, although his opinions have been somewhat qualified in subsequent studies.

27. Exh. cat., Edinburgh, 1981.

28. See in particular Dempsey, 1988.

29. See Whitfield, 1973; and also below, chapter 9, p.225.

30. Félibien, 1666–88, part 4, *Entretien* no.8 (1685), pp.365–91.

31. By J-C. Boyer, exh. cat., Paris, 1989 (1), no.33.

32. Boyer, 1984. The large painting was apparently never executed, and in 1667 the high altar received a composition by Pietro da Cortona. Mignard had already in 1641 painted an altarpiece for the high altar in San Carlo alle quattro fontane depicting *St Charles Borromeo and two founders of the Order of the Trinity at Prayer (in situ)*.

33. On this commission, see Boyer and Brejon, 1980; exh. cat., Paris, 1988–9, no.80 (by A. Brejon); exh. cat. Montreal, Montpellier and Rennes, 1993, no.52 (by P. Ramade).

34. See below, chapter 6, p.147. On Dufresnoy as a theorist, see Thuillier, 1965.

130. Charles Errard,
Rinaldo leaving Armida.
Oil on canvas,
242 × 337 cm.
Musée Municipal,
Bouxwiller.

THE FOUNDERS OF THE ACADEMY

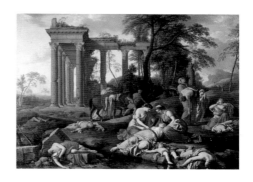

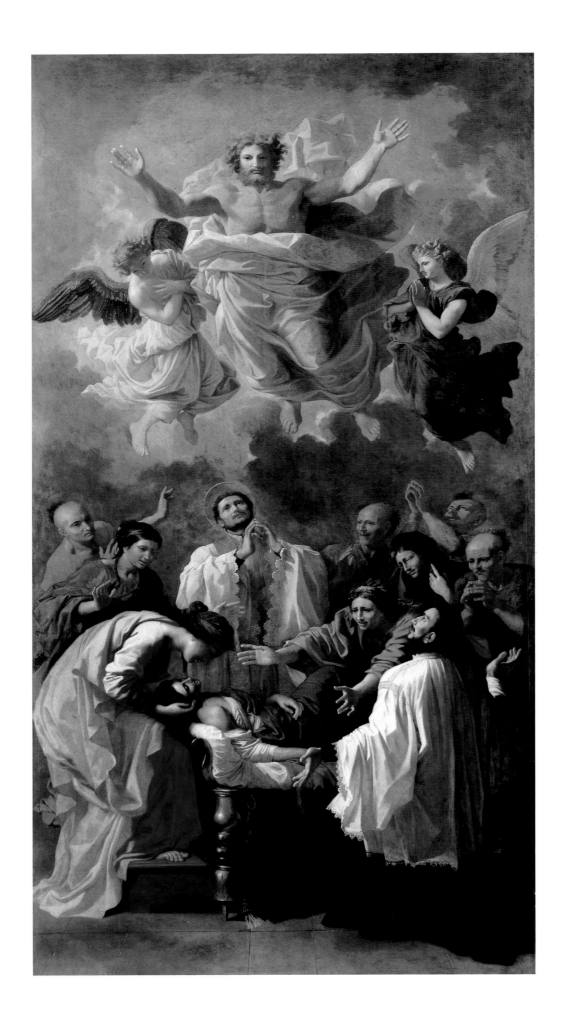

At the end of 1640, Poussin's arrival in Paris and his nomination as premier painter to the King, in preference to Vouet, signalled a new departure. The return of Stella in 1635, Mellan in 1636 and Vuibert in 1639 had already paved the way. During his final years in Rome, Mellan had been a follower of Lanfranco and Sacchi, then later of Poussin. His religious engravings were becoming increasingly austere: the *Crucifixion* (about 1635), *St Francis* (1638) and *St Bruno* (1638), the latter apparently related to a painting (private collection).[1] Vuibert's engravings of paintings by Domenichino and Raphael helped towards the spread of neo-classical models; the engravings done after his return to Paris, *St Peter and St John healing the Man possessed* (1639), or the *Presentation in the Temple* (1641) have a spare elegance, very different from anything painted by Vouet. Stella, in his *Marriage of the Virgin* (about 1636–40, Toulouse), the cartoon for a tapestry designed for Notre-Dame, transfers the lesson learned from Poussin's first *Sacraments* to a larger scale, giving it an edge of hardness in a meticulously drawn architectural setting. His return to a more rigorous style can be explained by the prestige politics practised in the arts at the end of the reign of Louis XIII by Cardinal Richelieu[2] and his Superintendent of Buildings, François Sublet de Noyers, who himself took advice from his cousins, Roland Fréart de Chambray and Paul Fréart de Chantelou. Their purist taste, which claimed to synthesise the best of Classical Antiquity with the best of the Renaissance, could be examined on two large building schemes with which Poussin, much against his will, was heavily involved, the church of the Jesuit novitiate and the Grande Galerie in the Louvre.

The dignified, harmonious architecture of the novitiate, built in the Faubourg Saint-Germain between 1630 and 1642 under the direction of Père Martellange,[3] won unanimous acclaim and was especially admired by Fréart de Chambray, who was to voice his opinions in his *Parallèle de l'architecture antique avec la moderne* (1650). The bareness of the structure marked a reaction to the heavily ornamented style employed some years earlier by Père Derand for the professed house in the Rue Saint-Antoine. In the novitiate, three

131. *previous pages*: Laurent de La Hyre, *The Death of the Children of Bethel*, 1649. Oil on canvas, 104 × 140 cm. Musée des Beaux-Arts, Arras.

133. Michel Dorigny (after Simon Vouet), *The Virgin taking the Society of Jesus under her Protection*, 1642. Engraving. Département des Estampes, Bibliothèque Nationale, Paris.

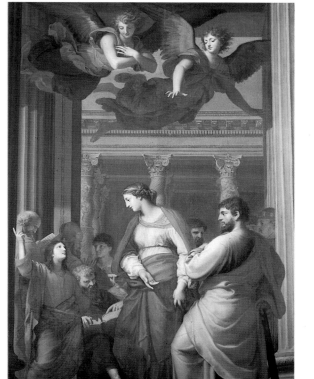

134. Jacques Stella, *The Child Jesus found in the Temple by his Parents*. Oil on canvas, 380 × 200 cm. Église Notre-Dame, Les Andelys (Eure).

132. Nicolas Poussin, *A Miracle of St Francis Xavier*. Oil on canvas, 444 × 234 cm. Musée du Louvre, Paris.

135. Rémy Vuibert,
*The Healing of the Man
Possessed by St Peter and St
John*, 1639.
Engraving.
Département des Estampes,
Bibliothèque Nationale,
Paris.

severe Christ in majesty, with an angel on either side; below this a crowd of people watching the miraculous resuscitation of the young Japanese woman. Here the accent is on the reaction of the onlookers, and Poussin's orchestration of their emotions assured the success of the painting; in other respects the composition failed to win approval. The brilliant colours grouped around the white tunic worn by Christ and the white surplices worn by the two priests have been revealed quite recently. On the altar on the right-hand side, Stella went even further along the path of simplicity and austerity, and his painting must have been the only one of the three to be thoroughly acceptable to Père Martellange. His *Child Jesus found by his Parents in the Temple* (now in the church at Les Andelys; pl.134) is striking because of the precision of the architectural framework, the interplay of straight lines and the figures squarely, though not inelegantly, placed under a clear, cold light that sets off the pale, predominantly blue, colour scheme. This painting, more than the painting by Vouet, marks the end of an era; with Poussin's somewhat ill-defined and over-complicated altarpiece it was to influence a whole new generation of painters.[4]

In the scheme planned for the large Galerie du Bord-de-l'Eau in the Louvre, tribute was to have been paid to the ambitions of a reign in a highly original decorative scheme.[5] However, Poussin's return to Paris in 1642, the death of Richelieu then of Louis XIII and the disgrace of Sublet de Noyers brought work to a halt. When building was started again in the eighteenth century the plan had completely changed. The original plan, nevertheless, was new and splendid; it rejected the current fashion for illusion and a crowded composition in favour of designs led by the architecture itself, with surfaces painted to look like stonework and sculpture. Rather than opening up the sides and top of the roof-space, the *trompe-l'œil* painting imitated bas-reliefs, grisaille motifs and stucco mouldings in the classical style. The panels between the windows were to have contained views of French towns by Jacques Fouquières. In combination with the story of Hercules (which covered the ceiling) the landscapes constituted a hymn of praise to the Bourbon dynasty and the

altarpieces commissioned in 1641 by Sublet can be regarded as a kind of summary of the current position of painting in Paris. Poussin, who had been selected to decorate the high altar, found himself working with his rival Vouet and his friend Stella, the latter two having been employed to paint chapels on either side of the transept. On the left-hand side, Vouet painted the *Virgin taking the Society of Jesus under her Protection* (lost, an engraving survives; pl.133), a crowded, busy composition in which action on various levels was linked by supple diagonals, without the support of an architectural structure. Poussin's response to this was the *Miracle of St Francis Xavier* (now in the Louvre; pl.132), strictly frontal in composition and consisting of two distinct halves: at the top, a

virtues and actions of the King, all set in a vast portrait of his realm. Had the scheme been carried out, it might not have been successful because it was over-sized and dull. It was interrupted at a very early stage, however, but Poussin's drawings and cartoons, and those of his collaborators who included Jean Lemaire and Rémy Vuibert, still convey the intentions of the chief designer, who brought to the scheme all his knowledge of Imperial Rome, plus his taste for archaeology and

136. Nicolas Poussin, *Hercules learning to play the Lyre.*
Pen and sepia ink, brown wash with white heightening,
18 × 42.3 cm.
Département des Arts Graphiques, Musée du Louvre, Paris.

sculpture and his ideas of how monumental decoration should be executed. Critics of the scheme were not slow in coming forward, led by Vouet. Poussin was therefore obliged to justify his scheme to Sublet and this must have contributed to his early return to Rome, and must also have confirmed his preference for easel painting. Although short, his stay in Paris allowed him time for other work such as the *Eucharist* in the chapel at Saint-Germain-en-Laye, the decoration of a bedroom in the Palais-Cardinal, and his austere title-pages for the first books published at the Imprimerie Royale; his presence certainly left its mark. Some of Poussin's best work was already in collections in Paris; the importance of his Roman patrons was diminishing; they were being

137. Nicolas Poussin, *Hercules and the Amazon Women.*
Pen and sepia ink, brown wash,
13.2 × 13.6 cm.
Collection of Her Majesty Queen Elizabeth II, Royal Library, Windsor.

138. Nicolas Poussin,
Eliezer and Rebecca.
Oil on canvas,
118 × 199 cm.
Musée du Louvre, Paris.

replaced by French art-lovers.[6] During the 1640s and 50s, the arrival of his *Sacraments* for Chantelou, or his *Eliezer and Rebecca* for Pointel (pl.138), caused a buzz of admiration. This input of energy was reinforced in 1648 by the founding of the Académie Royale de Peinture et de Sculpture.

MODELS AND THEORIES

At the outset, the Academy was nothing more than a syndicate of disgruntled artists who wanted to break the stranglehold of the system of master painters and apprentices, and to protect their own privileges and freedom.[7] They were anxious, however, for recognition, both artistic and social; their formation was accompanied by a reaction to Vouet's style, now considered sloppy and out of date. At first, it is true, the teaching method they were trying to promote consisted mainly of life drawing sessions with a model. But the meetings and debates that took place at the time encouraged some of their number to begin thinking about a painting style that was more controlled, and redefined on firmer foundations. Vouet had in fact made studies from nude and draped figures, but his teaching did not go beyond practical lessons in technique; neither composition nor expression was touched upon. It is easy to see why the alternative offered by Poussin, which made no concessions, was so seductive.

There were new models to be followed, whose diffusion, in Paris and throughout France, gradually rendered the traditional trip to Italy and sojourn in Rome less obligatory than they had been; outlets were beginning to increase. After Champaigne, important painters like La Hyre and Le Sueur never crossed the Alps. Did they really need to? Classical art had become much more accessible; there were originals and copies in the royal collections, and plaster casts like the ones Sublet de Noyers had commissioned the Fréarts to have made in Rome.[8] The repertoire of collections of engravings, first and foremost those of Perrier, broadened in scope. After Poussin, statues were measured and a set of norms defined. Drawing, more accurate than painting as a guide to such changes, now depicted firm, smooth

139. *Nicolas Chaperon seated at the foot of a
bust of Raphael.* Title page of a collection of
engravings taken from *Les Loges du Vatican
ou la Bible de Raphael,* 1649.
Département des Estampes, Bibliothèque
Nationale, Paris.

140. Anonymous (after François Perrier),
design for part of the ceiling of the gallery
in the Hôtel de La Vrillière.
Red pencil, 66 × 53 cm.
Musée des Arts Décoratifs, Paris.

models and employed a spare and economical
line, as can be seen in Stella's life-drawings or
Vuibert's engravings. Naturalism was sought,
tempered by the study of the Antique. At the
same time a return to Raphael was under way:[9] his
paintings were engraved and copied over and over
again by Vuibert, Perrier, Belly or Chaperon.
They were familiar in Paris thanks to a series of
originals as well as tapestry reproductions, and the
work of 'the most perfect of modern masters'[10]
was considered to be beyond compare. A typical
manifestation of this infatuation was the engraver
Pierre Daret's *Abrégé de la Vie de Raphaël Sansio,*
after Vasari (1651), which was responsible for a
good number of false attributions and fakes in the
art market. Paintings like Le Sueur's *St Paul at
Ephesus* (the *may* of 1649; pl.141) were directly
inspired by the tapestry of the *Acts of the Apostles.*
Michel Corneille the Elder, a co-student of Le
Sueur in Vouet's studio, painted the *Baptism of the
Centurion* (Toulouse, Saint-Pierre-des-Chartreux)
as the *may* of 1658, and it is typical of the neo-
Raphaelism of the time. Both La Hyre and
Bourdon used neo-Raphaelism in the develop-
ment of their mature style.

By the middle of the century quite a number of
contemporary Italian paintings could be seen in
the original in Paris. The schools of Bologna and
of Rome were represented in the gallery that the
wealthy La Vrillière was having decorated by
Perrier; here he had assembled large paintings by
Reni, Guercino, Pietro da Cortona, Turchi,
Maratta and Poussin, the only Frenchman
admitted to this exalted company, with his
Camillus and the Schoolmaster of the Falerii (1637,
Louvre; pl.144).[11] Perrier's painted ceiling was
based on Ovid's *Metamorphosis* and bore alternate
quadri riportati, trompe l'œil panels and illusionistic
sculptures; it was a synthesis of the Farnese Gallery
with novelties from the Roman Baroque. The
paintings on the walls, all adhering to the same
almost square format after the acquisition in 1631
of Guido's *Abduction of Helen* confirmed the
supremacy of the school of the Carracci. Scenes of
gallantry and heroism reflect the contemporary
taste for noble actions, thoughtfully staged. The
dramatic intensity of the three paintings by
Guercino (the dignified Guercino of the final

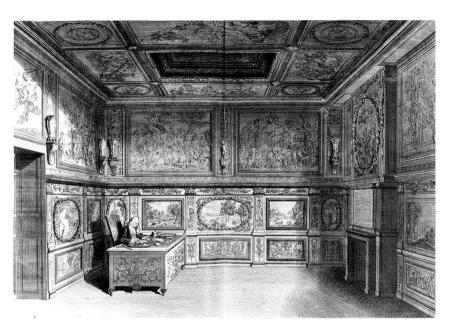

142. Bernard Picart,
*The Cabinet de l'Amour in
the Hôtel Lambert.*
Engraving.
Département des Estampes,
Bibliothèque Nationale,
Paris.

141. *previous page*:
Eustache Le Sueur,
St Paul at Ephesus, 1649.
Oil on canvas,
394 × 328 cm.
Musée du Louvre, Paris.

phase) and the severity of Poussin's painting contrast with the more playful tone and softer brushwork of Pietro da Cortona. La Vrillière aimed at a catholic display of the different styles then current in Rome.

Mazarin, when he required a decorator for his gallery in the residence in the Rue des Petits-Champs (now the Bibliothèque Nationale) hoped that Pietro da Cortona, celebrated for his decorations in the Palazzo Barberini and the Palazzo Pitti, would work for him.[12] In the end he had to make do with one of his pupils, Gianfrancesco Romanelli, who came to Paris in 1645 and stayed there for two years. Romanelli worked with Grimaldi, author of the landscapes in the panels and illusionistic niches opposite the windows; his contribution was the frescoes in the stucco-edged compartments of the ceiling. The cardinal-minister decided that mythological scenes would be more suited to French taste than the episodes from ancient history that had been planned originally. Mazarin's Roman origins are evoked, however, in the *Sack of Troy* and particularly in *Romulus and Remus* (pl.145). The central part was more straightforwardly political in theme, bearing a repetition of *The Fall of the Giants*, already used in the Petite Galerie du Louvre and the Hôtel Séguier. Romanelli's compositions are characterised by

simplicity and harmony, and are well-mannered compared with those of Pietro da Cortona. Their graceful, careful drawing and fresh colouring were much appreciated in Paris, where Romanelli painted other pictures for private clients, including the Cabinet de l'Amour in the Hôtel Lambert (pls 142 and 146). In a modest way, the collection of paintings in the Cabinet de l'Amour illustrated the growing renown of Paris and its increasing ability to attract foreign talent.[13] Le Sueur painted the ceiling and the decorative panels on the dado. The historical paintings illustrating the life of Aeneas were executed by the Italians Romanelli and Chiaro, with Berthollet Flémalle from Liège, Juste d'Egmont from Flanders and Perrier, who was French. Le Sueur was also assisted by landscape painters like Asselijn, Swanevelt, Mauperché and Pierre Patel. Painters from very different backgrounds worked together in compatible styles, generally in a reinterpretation of the Italian mode. The relationship between Perrier and Romanelli, Asselijn and Mauperché has already been mentioned. The taste of Nicolas Lambert, who had assembled some of the most impressive painters of the day in his small private museum, associating them with Le Sueur, now at last free of the influence of Vouet, makes it possible to define an early 'School of Paris'[14] in which elegance and rigour were combined.

A reasoned, thoughtful attitude to painting was beginning to be formulated, particularly in relation to perspective.[15] The compartmentalised ceiling in the Cabinet de l'Amour, decorated by Le Sueur, bore foreshortened figures, crisply drawn and seated on clouds, which reflected some of the theoretical debates of the 1640s. It was at this moment that the engraver Abraham Bosse enlarged and published the writings of the geometer Girard Desargues. In his *Sentiments sur la distinction des diverses manières de peinture, dessin et gravure* (*Thoughts on the distinction between different styles of painting, drawing and engraving*) (1649),[16] as in his later works, he upheld the supremacy of reason over art. He prescribed rigorous perspective, seen from a single standpoint, and truth to life. His intransigence conflicted with the laxer ideas of some of his colleagues, starting with Le Brun, who arranged to have him excluded from

the Academy, where he taught perspective, in 1661. His ideas had had time to make an impression on painters like La Hyre, Le Sueur, or Michel Corneille, who would make carefully graded preparatory drawings for their paintings, using architecture to frame their subjects with precision and to give shape to the ceilings that were becoming more and more important in decorative schemes. The *Abduction of Elias*, painted by Walthère Daméry from Liège in 1647 for the Eglise des Carmes is the only example (before Mignard in the Val de Grâce) of a *trompe l'oeil* cupola. The development was most evident in the decoration of private houses.[17] The traditional arrangement of caissons or small compartments between the ceiling beams and joists, which left little space for painting, was gradually replaced by plaster surfaces bordered with broad arches in the Italian manner. The centre would be reserved for ceiling designs, usually opening on to a painted sky. Around the edges the painter could choose from a great range of ornamentation: figures seated on the cornice, medallions of paintings in grisaille or in blue on a gilded background or 'au naturel', white or gold plaster frames, grotesque patterns . . . Le Sueur's ceilings (the Chambre des Muses and Cabinet des Bains in the Hôtel Lambert), those of Le Brun (the cabinet and the bedroom in the Hôtel La

Rivière, re-erected in the Musée Carnavalet) and also those of Corneille (Galerie de Psyché in the Hôtel Amelot de Bisseuil) are the most brilliant examples of work done in the 1650s, some of them more painstaking than others.

To the observation of geometrical shapes was added a strong interest in optical effects and aerial perspective.[18] Poussin adhered to the theories of Vitellion and Leonardo da Vinci, applying and developing their principles in his major works. These were written about in Academy circles right to the end of the century. Félibien wrote about *Eliezer and Rebecca* (pl.138) as follows:[19]

143. Pietro da Cortona, *Caesar returning Cleopatra to the Throne of Egypt.* Oil on canvas, 255 × 266 cm. Musée des Beaux-Arts, Lyon.

144. Nicolas Poussin, *Camillus and the Schoolmaster of the Falerii,* 1637. Oil on canvas, 252 × 265 cm. Musée du Louvre, Paris.

145. Gianfrancesco Romanelli, *Romulus and Remus.* Detail of the ceiling in the Galerie Mazarine. Bibliothèque Nationale, Paris.

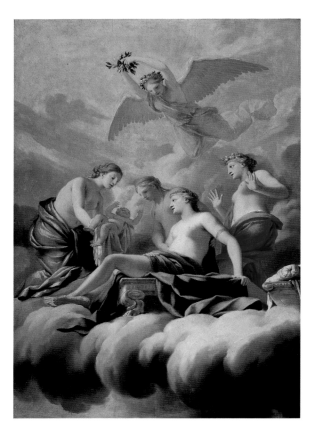

146. Eustache Le Sueur,
The Birth of Love.
Central compartment of
the ceiling in the Cabinet
de l'Amour in the Hôtel
Lambert.
Oil on wood,
182 × 125 cm.
Musée du Louvre, Paris.

147. Laurent de La Hyre,
Apollo and Phaeton.
Graphite and grey wash,
43.6 × 35.2 cm.
Staatliche Graphische
Sammlung, Munich.

Since he was aware that one of the most difficult secrets of painting, but one that renders it perfect, is to indicate clearly the quantity of air between the eye and the object, he had made a special study of this aspect of his art; and he put this into practice so well that it can truthfully be said that he excelled at it. It was by this means that he made his compositions so charming: the spectator has the feeling of walking through the countryside that he represents. His figures are so clearly distinguished one from the other that there is never any confusion or muddle. And even the brightest colours stay in the place allotted to them, without advancing or retreating too much and without doing harm to one another. The lighting effects, of whatever kind they might be, are never too strong or too weak. The reflections give the effect they are intended to give. And in whichever way he deals with a subject, however he lights it, the effect is always admirable because he knows exactly how to shade his colours and to juxtapose them according the relationship between them, and to apportion light and shade appropriately.

In the *Gathering of Manna* (pl.127) he distinguishes between 'three kinds of lighting effects worth noting: the first is the brightest, and the most powerful; the second the light that envelops objects and the third a light that is almost extinct and that gets lost in the opacity of the atmosphere.'[20] He emphasises the intensive use of blue and yellow, 'colours that play the most important part in light and air'. Both La Hyre and Le Sueur share the same feeling for clarity. They take care that distances disappear, and that the foreground is sharply defined and brightly coloured, the background lightly blurred with light diffused – as in Le Sueur's ceiling for the Chambre des Muses in the Hôtel Lambert, *Apollo and Phaeton*, now in the Louvre; or tinged with blue shadows, as in the landscapes of Patel or La Hyre.

THE NEW CLASSICISM: CHAMPAIGNE, LA HYRE, LE SUEUR AND OTHERS

After Vouet's death in 1649, a year after the founding of the Academy, the rejection of his style appeared to be total. In painting, there was an appreciable improvement in the organisation of composition, clearly-defined structure becoming the order of the day, within landscapes bedecked with architectural features. Bourdon, in his *Martyrdom of St Andrew* (about 1645, Toulouse), which comes close to the academic ideal, and especially in his *Finding of Moses* (about 1655, Washington; pl.148), makes a gesture in the

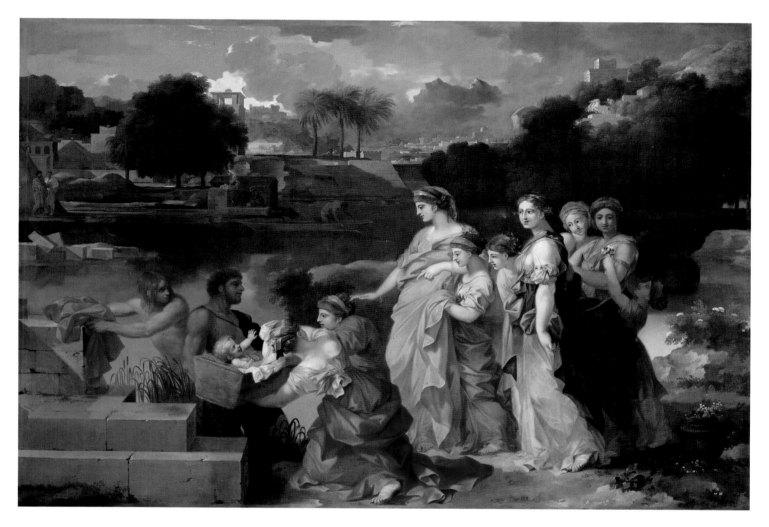

148. Sébastien Bourdon, *The Finding of Moses*. Oil on canvas, 119 × 173 cm.

National Gallery of Art, Washington. The Samuel H. Kress Collection.

direction of Poussin and even cultivates a measure of intellectual pretension, though rejecting the stoical severity of his mentor. In his *Eliezer and Rebecca* (Blois) the female figures are elegant, the modelling very gentle and there is an attractive *sfumato* over all. In the same way Perrier, although not abandoning his dramatic effects entirely, has his lyricism well under control in his last paintings: *Venus and Neptune* (Epinal), *Orpheus before Pluto and Persephone* (Louvre), *Acis and Galatea* (Louvre) and the affecting *Farewell of St Peter and St Paul* (Rennes; pl.149). Stella's figures are more delicate, almost sculptural with their genteel modelling and classical draperies – as in *Cloelia crossing the Tiber* (Louvre) or the *Judgement of Paris* (1650, Hartford; pl.150) with its strange, almost chilly,

charm. The same development can be seen in the work of Nicolas Loir, whose *may* of 1650, *St Paul blinding the false Prophet Bar-Jesus* (Notre-Dame, Paris, *modello* in the Musée Carnavalet), possesses a concentrated tension. A similar stiffening of forms can be found in the work of Rémy Vuibert who, in about 1650, decorated the ceiling of the nuns' choir in the Convent of the Visitation in Moulins with scenes from the *Life of the Virgin*.

In all these paintings there is a desire for structure and a search for attitudes capable of expressing the 'passions' of the soul, to encourage the spectator to 'read' the painting, as Poussin explained to Chantelou.[21] The canvases painted by Le Brun when he was in Rome (1642–5) or on

149. François Perrier,
*The Farewell of St Peter
and St Paul.*
Oil on canvas,
74 × 110 cm.
Musée des Beaux-Arts,
Rennes.

150. Jacques Stella,
The Judgement of Paris,
1650.
Oil on canvas,
75 × 99 cm.
The Wadsworth Atheneum,
Hartford.

his return to France, such as the violent *Massacre of the Innocents* (about 1647, Dulwich; pl.151) are extreme examples. Even in the most dramatic scenes illustrating the crucial moment of the action, the violent movements balance each other, giving a curious feeling of suspense. Poussin's impressive *Judgement of Solomon* (1649, Louvre), regarded by the painter as his most successful painting, is the finest example of this Classicism in which, paradoxically, the agitation of the individual figures contributes to the stability of the whole. This studied serenity is enhanced by a colour scheme of bright, clear colours, unafraid of the juxtaposition of primary colours, blue, yellow and red, and by the avoidance of any strong chiaroscuro effects, later regarded by Félibien as facile and artificial.[22] The painstaking, often very smooth execution gives the painting of this period a quality of perfection well expressed in the name Atticism.[23] The same search for correctness and refinement was manifest in the literary taste of the time as well. Linguistic and grammatical purity, the quest for proper and yet even unusual modes of expression, and the care taken to identify and explain psychological nuances are features of the preciosity (in its broadest sense) that preceded the Classicism of 1660. As we now know, this would prescribe a careful choice of models to imitate, truth to life and nature, and variety, all notions promoted in artistic circles centring on the Academy at the time.

Three painters, of different ages and backgrounds, none of whom had ever made the journey to Italy, perfectly illustrate the polished style that reached its peak at the middle of the century. First and foremost there is Philippe de Champaigne, whose official career slowed down after the death of the King and of Richelieu, his principal patrons, but who continued nevertheless to paint for the court. Anne of Austria commissioned work from him for the Palais-Royal and the Val-de-Grâce. Later he painted the *Duc d'Anjou received into the Order of the Holy Spirit* (1662, lost, a copy exists in Grenoble) at the request of Louis XIV. This period produced a large number of portraits which will be discussed later; among these were the famous *Ex-Voto* of 1662 (Louvre), and the works painted for Port-

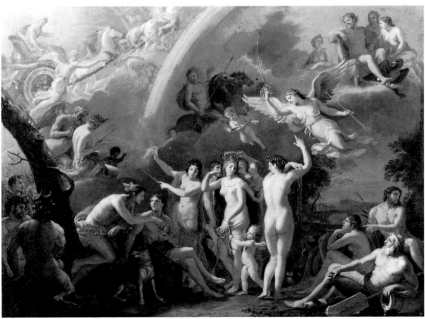

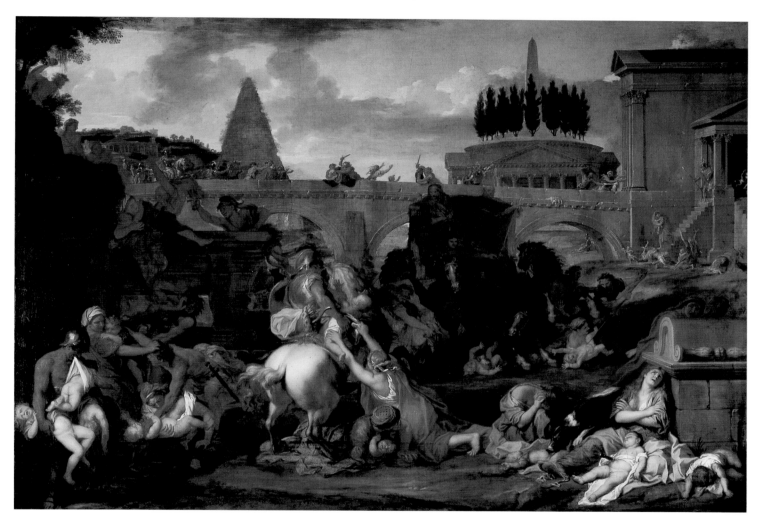

151. Charles Le Brun,
The Massacre of the Innocents.
Oil on canvas,
133 × 187 cm.
Dulwich Picture Gallery,
London.

152. Rémy Vuibert,
The Birth of the Virgin.
Detail of the ceiling of
the Choeur des
Religieuses in the
Couvent de la Visitation.
Lycée Banville, Moulins.

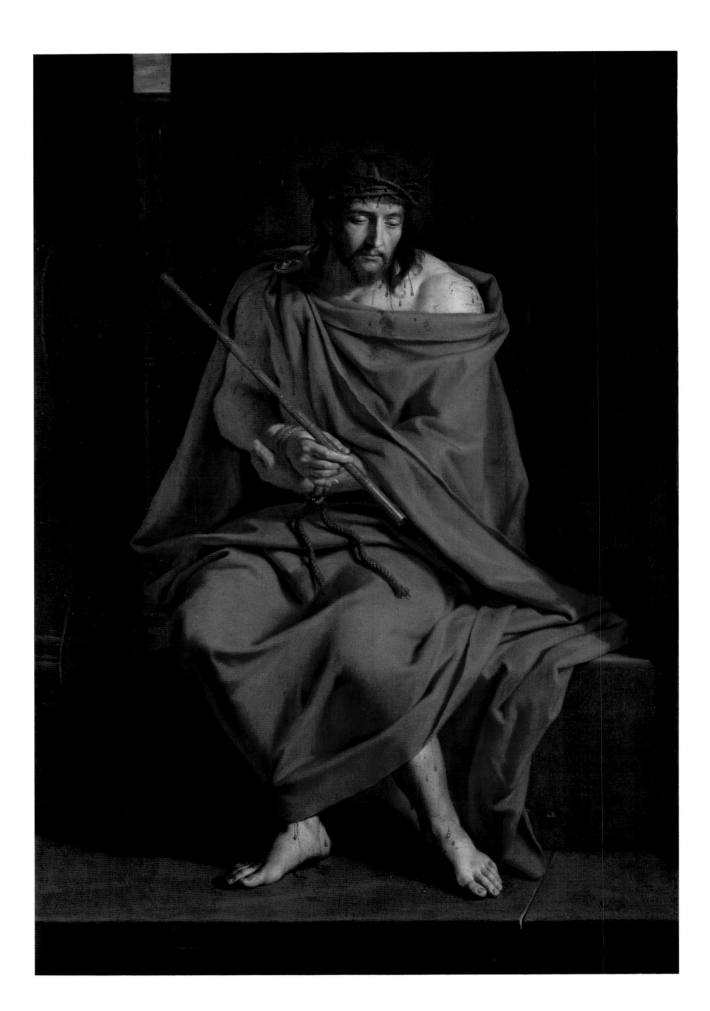

154. Philippe de
Champaigne,
*The Presentation of Jesus in
the Temple.*
Oil on canvas,
257 × 197 cm.
Musées Royaux des Beaux-
Arts, Brussels.

153. *opposite*:
Philippe de Champaigne,
Ecce Homo.
Oil on canvas,
186 × 126 cm.
Musée National des Granges,
Port Royal.

155. Philippe de
Champaigne,
*St Gervaise and St Protaise
appearing to St Ambrose.*
Oil on canvas,
360 × 681 cm.
Musée du Louvre, Paris.

Royal including the two *Last Suppers* (1648 and
1652, Louvre) in which the painter's earnest
integrity takes second place to the severe rhythms
imposed on it. Compared with the version
painted in 1629 for the Carmelites (Dijon), the
Presentation of Jesus in the Temple for the church of
the Oratory, rue Saint-Honoré (now in Brussels;
pl.154), dating from the years 1642–8, seems full
of diminuendo: less depth, less movement, fewer
people. The composition, with two groups on
either side of a central axis, is reminiscent of a
classical frieze.[24] From now on, the painter seems
to have become more sensitive to the interplay
of lines and the combination of colours. This
clarification of forms has been ascribed to
Champaigne's Jansenism, but it in fact followed
the general trend of the day.

It would be a mistake, nevertheless, to ignore
Champaigne's close relationship with Port-Royal.
There are few paintings of the seventeenth cen-
tury as impressive as his meditations on the
passion and death of Christ in the *Ecce Homo* he
painted for Port Royal (before 1654, Musée des
Granges; pl.153), the *Dead Christ* in the Louvre
(before 1654?) or the *Crucifix* for the Grande
Chartreuse (1655, Grenoble). Their chilly, leaden
colours show off the athletic forms, inviting the
spectator to recollection and meditation. But
Champaigne was obliged to adapt his style to the
commissions he received, not all of which (by a
long way) came from the Jansenists. In the car-
toons for the tapestries in St Gervais he became a
narrator; his staging, which is eloquent if a little
on the heavy side, is accompanied by scrupulous

attention to detail. His unswerving sobriety must
certainly have begun to seem out of date by 1660,
when he continued to promote the powerful style
of Pourbus. His main focus was on the figures in
his paintings, whom he liked to isolate instead of
making them participants in a complex chain of
actions, in the manner of Poussin or Le Brun.
Nevertheless he eschewed mystical effusion and
the supernatural. His *Annunciations* (Caen and the
Wallace Collection) are tranquil in character. His
St Gervaise and St Protaise appearing to St Ambrose
(Louvre; pl.155) has a magnificent setting, almost
obsessional in its precision and very far removed
from the vagueness and extreme austerity of the
Ex Voto. Champaigne was acutely aware of the
differing requirements of his clients and tried hard
to adapt his skills to historical, dramatic types of
religious painting as well as to the meditative and
the austere. His nephew Jean-Baptiste continued
successfully along the same path.

Laurent de La Hyre was probably the most
attractive of the heirs to the Mannerism of
Fontainebleau. Later, his painting became darker
in tone before developing along romantic lines,
brilliant and often very busy. In the 1640s he was
already showing consummate skill in his handling
of space: classical ruins give structure to his com-
positions and his colours, incomparably fresh,
lessen in depth as they move from the foreground
to the background. His figures are always elegant;
the idealised types in their finely pleated robes
show that he has classical models in mind. The
preparatory drawings for the tapestry of the *Life of*

156. Laurent de La Hyre,
Music.
Oil on canvas,
94 × 136 cm.

The Metropolitan Museum
of Art, New York. Charles
B. Curtis Fund.

St Stephen (Louvre), designed for the church of St
Etienne du Mont, are typical of his purism, yet his
skill as a story teller is expressed with variety as
well as precision. Subjects from ancient history,
combining archaeological details with a moral
fable (*Cornelia, Mother of the Gracchi*, 1646,
Budapest; pl.157), rub shoulders with biblical or
mythological episodes often set in painted land-
scapes. He was also employed on decorative
schemes like the refectory of the Minimes, where
he painted a row of *trompe l'œil* statues of the saints
in monochrome,[25] and altarpieces: *Christ's Entry
into Jerusalem* and *Christ appearing before the three
Maries*, painted in about 1648 for the Carmel de'
l'Incarnation (now in the church of Saint-
Germain-des-Prés and the Louvre), or the *Descent
from the Cross* for the Capuchins (1655, Rouen).
The field in which La Hyre really excelled, how-
ever, was cabinet painting (*Death of the Children of
Bethel*, in Arras, pl.131, or *Mercury and Herse* in

Epinal, both painted in 1649); these paintings
were sometimes located within a decorative
scheme, as for example the series of *Liberal Arts*
(about 1650) for the residence of Gédéon
Tallemant, now scattered. In this series he attained
an admirable equilibrium, but this was not in fact
to be the climax of his artistic career. Gradually
eliminating all the non-essential features of his
painting, he achieved new intensity in his last
work for the Grande Chartreuse (the *Supper at
Emmaus* and the *Noli me tangere*, about 1656, in
Grenoble).

The late work of La Hyre eschews movement
and agitation to a great extent. The stillness of
allegorical subjects suited his style perfectly, as is
evidenced in the *Regency of Anne of Austria* (1648,
Versailles; pl.2) where he handles the curvaceous,
pure volumes and the juxtaposition of primary
colours with admirable calm. He is skilled at
catching the moment when he can depict forms at

157. Laurent de La Hyre,
*Cornelia, Mother of the
Gracchi, rejecting Ptolemy's
Crown*, 1646.
Oil on canvas,
138 × 123 cm.
Museum of Art, Budapest.

their best, in repose, to the detriment perhaps of the narrative flow and of any vividness of expression. In the *Children of Bethel* (pl.131) the sense of horror is obliterated by the sorrow of the mothers weeping over the unmutilated corpses of their children, corpses with the grace of classical marble sculpture, yet he never lapses into frigidity. His art might be described as an elegant combination of Greco-Roman models (always in the back of his mind and often interpreted through the slightly distorting mirror of the School of Fontainebleau and of prints and engravings) with the vivacity and tactile richness of his details. The most beautiful of his figures from his series of *Liberal Arts*, including *Grammar* in London and *Music* in New York (pl.156), are watchful, radiant women, with glowing skin, shown to their best advantage against architectural backgrounds and a whole range of accessories — children, birds, vegetation, musical instruments. The artist's enjoy-

ment of his own art allows him to give his subjects their true weight, without abandoning the stylistic concerns evident in his youthful studies.

Younger than La Hyre, Eustache Le Sueur was trained by Vouet and imitated his style closely until the beginning of the 1640s. A complete change of style is perceptible, however, in his reception piece for the *maîtrise*, *St Paul exorcising the Man possessed* (about 1645–6, private collection), and even more so in the two decorative schemes that established his reputation: the series of twenty-two scenes from the *Life of St Bruno* for the small Carthusian cloister in Paris (1645–8, Louvre) and the ceilings and panelling in the Cabinet de l'Amour in the Hôtel Lambert (1646–7, Louvre and private collection). The uncluttered compositions with figures (themselves carefully studied) placed very unpretentiously, and the somewhat archaic feel, are new departures. Later, this reticence became increasingly self-confident. The *may* of 1648, *St Paul at Ephesus* (Louvre), something of a neo-Raphaelite manifesto and résumé of the intentions of the new Academy, bespeaks intense application. Le Sueur has abandoned easy decorative effects for a more logical layout. He tackles two problems here, although not without slight stiffness: the placing of the figures in a space that is both high and deep, in a well-ordered architectural setting, and the convincing expression of feeling. His success becomes even clearer when all the preparatory drawings are examined; these graduate, through constant re-working, to meticulous precision. The studies of draped figures have a simple grandeur that is reminiscent of another painting of the same period, *St Peter resuscitating the Widow Tabitha* (1647, Toronto; pl.159). Perhaps even more than La Hyre, Le Sueur had become painter to a clientèle able to interpret the moral message behind the artist's sometimes obscure subjects, often taken from the Bible or from ancient history. Episodes from the *Story of Tobias* for the Hôtel Fieubet (about 1647, Louvre, Grenoble and private collection), *Alexander and Philip, the Doctor* (1648, London, private collection) and *Darius ordering the Tomb of Nitocris to be opened* (1649, Hermitage), are *exempla*[26] of heroism comparable with those being painted at the same time

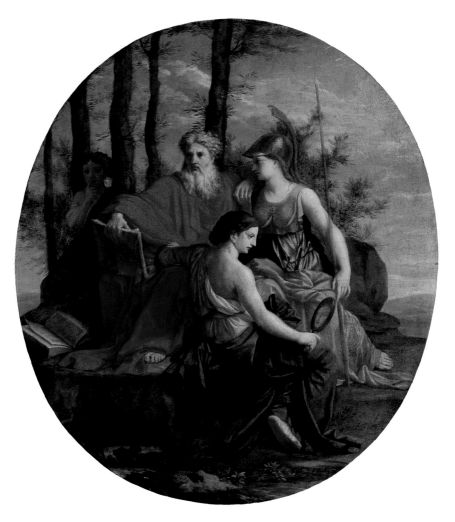

Of his successes in the 1650s, the first place must go to the decorations in the Chambre des Muses and the Cabinet des Bains in the Hôtel Lambert. In the bathroom the graceful, varied composition is enhanced by vivid colours which bring out the whites, greys and gold used in the ornamentation and illusionistic sculpture. The painter's sensuality is tempered throughout his career by an unworldly reticence. Le Sueur's careful organisation of line and surface is accompanied by immobility and silence. The *Annunciation* (1652, Louvre), the *Allegory of a perfect Minister* (1653, Dunkerque; pl.158), probably painted to flatter Mazarin, *St Sebastian tended by Irene* (1654, Tours) or the *Mass of St Martin*, with its primitive overtones (1654, Louvre), are paradoxes of their age, as far removed from the work of Poussin as they are from the work of Le Brun. For a long time, nevertheless, and particularly in the following century, the art of Le Sueur remained a point of reference, a symbol of correctness as well as of grace;[27] his paintings, particularly the small ones, project a musical resonance accompanied by emotion clothed in a sense of propriety. Examples like *Carrying the Cross* (1651, Louvre) also illustrate the unusual economy of his means. The material world, so powerfully present in the work of Champaigne, and still alive and kicking in the work of La Hyre, retreats here, behind an ideal harmony, the like of which later academicians sought in vain to recapture.

PARIS AND THE PROVINCES IN THE 1660S

The years preceding the reign of Louis XIV saw a modification of the relationship between Rome and Paris. The French feeling of inferiority began to diminish. A letter from Félibien to Louis du Guernier, dated 1647, bears witness to this new confidence. Pierre Mignard, speaking from the point of view of French artists in Rome, expresses amazement that Bourdon should be so revered there, and that he should have managed to have 'caught the good taste, unknown in France', Félibien adds:[28]

You must realise that folk here think that we are asses in France, and think that the French have no idea about what is beautiful;

158. Eustache Le Sueur, *The Allegory of a perfect Minister*, 1653. Oil on canvas, 84 × 71 cm. Musée des Beaux-Arts, Dunkerque.

by Le Brun in Rome (*Mucius Scaevola* in Mâcon, *Horatius Cocles* in Dulwich). Le Sueur respects historical verisimilitude and the poetic conventions adhered to by Poussin. This serious vein continues, in a more spacious register, in the cartoons for the tapestries for Saint-Gervais (1652–5, Louvre and Lyon) and the allegorical paintings, most now lost, for the winter apartment of Anne of Austria and the King's bedroom in the Louvre. These important commissions bear witness to the painter's success in Regency Paris, just before his premature death in 1655.

During his last years, Le Sueur returned to the ornaments of style used by Vouet, but used them in a measured manner. His skill and learning complement the innate elegance of his painting.

here, he tells me, we look at painting in quite a different way. I informed him that the French have just as refined judgement as the Italians; that I did not know how things stood when he left the country, but that at the moment Flemish painting was no longer in fashion. All the things studied there were also being studied here, and the beautiful methods of the Carracci and of M. Poussin were greatly admired, especially their way of painting landscape, these painters were instanced without his ever being named. And because M. Bourdon was the painter most demonstrating these beautiful methods, he had attracted the most attention.

After the Fronde, the reinforcement of royal power was accompanied by an increase in the number of large commissions. The new Academy, the presence of first-rate artists and the accumulation of models, originals or copies from Italy, now permitted Paris to compete with Rome on an equal footing. The flow of exchanges was reversed: not only did painters spend less and less time in Rome, but the most incorrigible 'Romans' came home, Dufresnoy in 1653, Pierre Mignard in 1657. Although they were opposed to the Academy, they reinforced the trend begun in the 1640s. The Latin poem, *De Arte Graphica*, worked on by Dufresnoy for many years,[29] was published in 1667 and, with the works of Bellori and Félibien, helped to endorse the triumph of classical idealism.

Under Mazarin, Paris began to exert its own power, particularly in the field of large-scale decoration. Mazarin summoned Romanelli to paint in the Italian style the summer apartment of Anne of Austria in the Louvre (1655–7). The work, even more brilliant than the painting in the Cardinal's gallery, is coupled with stucco decorations by Michel Anguier and the subject matter manages subtly to extol the virtues of the Regent and, at the same time, to laud the political success of her Minister (pl.160). In 1655, Le Sueur was commissioned to paint certain rooms in the winter apartments, the theme of Juno and Psyche providing material for a rich display, most notably in the Salon des Bains: the gold 'scattered with a kind of profusion', and the panels 'decorated with baskets of fruit in relief, enhanced with gold, enamel and paintwork'[30] conveyed an impression of opulence which was characteristic of the 'Mazarin style'. Le Sueur also at this time painted an *Allegory of Royal Magnificence* (about 1654,

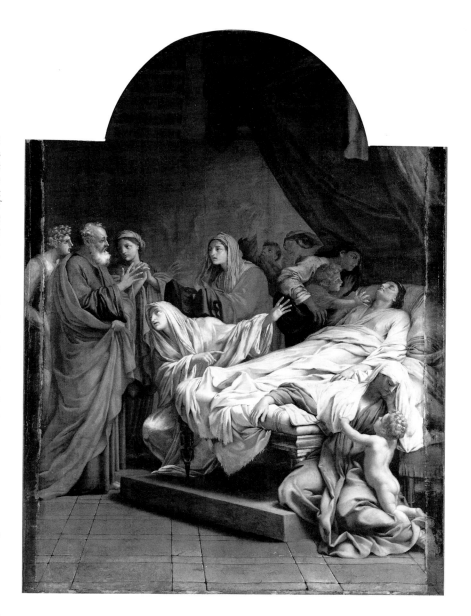

159. Eustache Le Sueur, *St Peter resuscitating the Widow Tabitha*, 1647. Oil on canvas, 185.4 × 137 cm.
Art Gallery of Ontario, Toronto. Gift from the Contributing Members' Fund.

160. Gianfranco Romanelli and Michel Anguier, ceiling of the Salle des Saisons, detail. Musée du Louvre, Paris.

161. Matthys Pool (after Charles Le Brun), ceiling of the gallery of the Hôtel Lambert. Engraving. Musée Carnavalet, Paris.

Dayton) in a cabinet in the apartments of the young Louis XIV, Le Brun and Errard sharing the work with him; Le Brun was on the threshold of an exceptional career and Errard was the omnipresent decorative painter. Other residences generated commissions, including Saint-Cloud, where Jean Nocret decorated the apartments of Henrietta of England, wife of the Duke of Orléans, in about 1660.

New private houses,[31] built by recently enriched ministers, financiers, and tradesmen, benefited from the assembly of talented artists in the capital. It was a prodigious decade, during which the artists' clients vied to outdo one another in magnificence; the monumental, over-elaborate style that now became the fashion was the direct precursor of Versailles. Panelled walls cried out for carved and gilded relief decorations, vaulted ceilings grew in width, domed rooms on two levels 'in the Italian style', galleries of various lengths, chambers with sumptuous parquet floors and sometimes hung with mirrors: these were the indispensable attributes of any private residence or hôtel worthy of the name. Michel Dorigny worked for Gruyn des Bordes (in the present Hôtel de Lauzun), Bourdon for Le Ragois de Bretonvilliers, Michel Corneille for Amelot de Bisseuil. Nicolas Loir could be found at the Hôtels d'Epernon and d'Hervart. The list of such schemes, many of which have since vanished, is a long one; the architect and interior designers would give a central role to the painters, particularly in painting ceilings. Le Brun, a terrific worker with a fertile imagination and excellent business sense, took over from Vouet. He decorated the Hôtels La Rivière, d'Aumont and La Bazinière, not forgetting the spectacular Galerie d'Hercule in the Hôtel Lambert (pl.161), where he painted alternate open and closed caissons on the ceiling, large illusionistic tapestries and flying figures, the latter giving the impression of being poised between the ceiling and the spectator.

In 1658 Le Brun entered the service of superintendent Fouquet and was given the job of managing the team of decorators in the Château de Vaux-le-Vicomte.[32] His brief here grew broader: he had to provide plans for tapestries, statues and

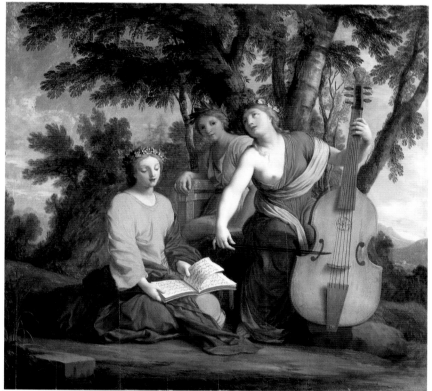

162. Eustache Le Sueur, *Melpomene, Erato and Polymnia*.
Oil on canvas,
130 × 138 cm.
Musée du Louvre, Paris.

furniture, and to be responsible for everything down to the smallest knick-knack, imposing an overall style that derived from previous examples but that also extended and amplified them. He took the matter in hand vigorously, uninhibited by rules or dogma. He skilfully mingled the fantastic with the realistic, playing with *trompe l'œil* effects (in the *Palace of the Sun* designed for the domed ceiling of the large oval drawing room; pl.163) as he played with surfaces. On the vaulted ceilings of the Salon des Muses and in the King's bedroom the powers of the three major Arts can be observed. Here, for the first time in France, is an interior scheme capable of withstanding comparison with schemes designed by someone of the stature of Pietro da Cortona in the palaces of Rome or Florence. Vaux was a huge success, and Le Brun was greeted as the leading painter of the day:[33]

Le Brun, whose intellect and skill we all admire,
Father of inventions pleasant to behold,
Rival of Raphael, successor to Apelles,
Thanks to you alone our debt to Rome is paid.

The celebration held on 17 August 1661 for Louis XIV and his court by the foolhardy Superintendent Fouquet helped to precipitate his downfall. The King, nonetheless, must have experienced a revelation that night when he saw the completed work of art, perfection in every detail and solely organised by Le Brun.

No greater contrast could be imagined than that between this overwhelming display of opulence and Poussin's late manner. His reputation was at its height. In Rome he had become a kind of patriarch in the art world, still sought out continually for advice. His paintings of the 1650s, such as the *Death of Saphira* or the *Woman taken in Adultery* in the Louvre, in which the rhetoric of gesture stands rooted in a landscape of implacable architectural ruins, still show the influence (though the tone is harsher) of Raphael. The *Annunciation* (1657, London; pl.167) and *Lamentation over the dead Christ* (about 1657–8, Dublin), stripped to the essentials, make no attempt to please; how incongruous they seem in the Rome of Bernini and, shortly, Carlo Maratta. The artist's thought processes grew more and more eccentric as the steadiness of his hand diminished. His unsure touch, the vibrations of the slightly grainy paint, a slight softening of contours and the attention paid to the surface at the expense of depth seem in a curious way to foreshadow certain aspects of nineteenth- and twentieth-century modernism. Poussin's intentions could be disconcerting as well, and the agenda of the *Birth of Bacchus* (1657, Cambridge, Mass.), *Blind Orion* (1658, New York) and, above all, *Apollo and Daphne* (Louvre; pl.166), the latter unfinished, has been the subject of scholarly debate. The growing importance of the landscape, the suggestion of mysterious presences at work in nature, could be explained by a pantheistic, or rather 'panpsychic'[34] emotion, recognising no distinction between sacred and profane subjects, mythology and Christianity. The *Four Seasons* in the Louvre (1660–4) bear witness to this. The dialogue between the opposing forces of the universe, the eternal cycle of birth, growth, decline and death are presented along with some daring cosmological systems such as the system promoted by Tommaso Campanella. The neo-stoicism of

163. Charles Le Brun, ceiling of the Salon des Muses in the Château de Vaux-le-Vicomte.

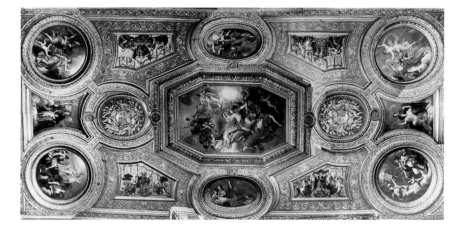

teaching in Paris. The French capital was becoming more and more self-sufficient, and the growing condescension of the French towards their neighbours, already clearly evident when Bernini visited Paris in 1665, when his design for the Louvre was rejected, became even more marked as the century wore on. Italian 'fire' was contrasted unfavourably with French 'correctness'. In 1692, La Teulière, then director of the Academy in Rome, was able to write to Superintendent Villacerf:[36]

Without seeing it with your own eyes, you would not believe how few good painters there are in Italy, particularly as far as accuracy in drawing goes. Pietro da Cortona and his school have disseminated such a libertine philosophy, under the pretext of prodigious brilliance, that most of their work looks like tawdry theatrical decoration: they allow full reign to their imagination, and spurn the wisdom and reliability of the Antique and of Raphael.

Paris was not the only centre to benefit from a relationship with Italy. In the provinces in 1660 there was great vitality, but also a certain uniformity. The models best adapted to current taste were now much better distributed and assimilated than they had been previously; regional idiosyncracies often retreated when faced with the onslaught of a common idiom dominated by academic correctness. Parisians would often be requested to take over the direction of building works because no local artist was sufficiently skilled: this is why Charles Errard and Noël Coypel painted the caissons in the ceiling of the great hall in the Breton parliament in Rennes (1656–62; pl.165). On the other hand provincial painters, often only modestly talented, would come to train in the renowned studios of Paris. Quite a number of places, however, boasted important painters whose fame spread well beyond their home town. This is how Nicolas Mignard and Jean Daret came to be invited to Paris in 1660, after the Court had been touring Provence. Having been admitted to the Academy, Mignard was given employment at the Tuileries; his portraits were in competition with those of his brother, with whom he fell out. He was a skilled decorator, influenced first by Vouet then by the school of Bologna, whose work he studied closely, as his *Pietà* of 1665 (Avignon) makes clear.

Poussin's maturity seems transcended. The painter was isolating himself more and more, and the meditations of his latter years were not easily accessible to the younger generation.

His prestige remained such that Colbert hoped that he would accept the directorship of the new French Academy in Rome,[35] a position that finally went to Charles Errard. The establishment of the Academy was part of the aggressive foreign policy of Louis XIV's minister, Colbert, who was a worthy heir to Richelieu and Mazarin. But while Mazarin had tried, sometimes successfully, to acclimatise Rome to Paris, Colbert imposed strict time limits on the study trips enjoyed by young French artists in Rome. His aim was twofold: the formation of a younger generation of artists to serve the King now that building work was starting again, and the copying of antique sculpture and of famous paintings to help art

166. Nicolas Poussin,
Apollo and Daphne.
Oil on canvas,
155 × 200 cm.
Musée du Louvre, Paris.

167. Nicolas Poussin,
The Annunciation, 1657.
Oil on canvas,
105 × 103 cm.
National Gallery, London.

He continued to send paintings to the south of France: the *Assumption* (1663, Chapelle des Pénitents-Noirs, Avignon) or the *Dream of St Joseph* (1664, Cathedral, Montpellier). As for Daret, although his *Diana and Callisto* of 1642 (Marseille) draws on the work of Vouet, his *St Matthew and the Angel* (Saint-Paul-de-Vence parish church) shows that he was familiar with painters such as Champaigne.

The fame of a number of provincial centres was boosted in this way. The traditional patrons (politicians, religious orders and lay brotherhoods) and a new class of enthusiasts were beginning to appreciate certain innovations. In Rouen,[37] so close to the capital city, the prim and upright Classicism of someone like Le Tellier or Sacquespée dominated the sixties and seventies. In the south, conversely, contact with contemporary Italian art, whether from Rome, Genoa or

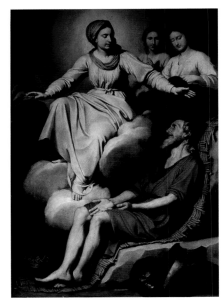

Venice, was of decisive importance. While Paris knew only a modified and diluted Italian 'fire', towns like Toulouse, Aix, Marseille and even Lyon produced first-rank painters whose culture came largely from south of the Alps. Thomas Blanchet, from Lyon, claimed to be as versatile as the traditional municipal painters who could turn their hand to anything. Elected painter-in-chief for the city of Lyon in 1655, he decorated the great hall of the Hôtel de Ville, taking his memories of Rome, in particular of the Palazzo Farnese, as his starting point (1655–8, no longer extant), as the drawings and *modelli* (pl.164) make clear. After this he started work on the grand staircase (1661–7) and other rooms. His visual frame of reference was still largely based on Bologna, influenced by Annibale and Lanfranco, as is evident in his *Pietà* in the Hôtel-Dieu in Lyon and his *may* painted for Notre-Dame in Paris in 1663, the *Ecstasy of St Philip* (Arras). In collaboration with the Jesuit Ménestrier, an inexhaustible creator of spectacles and devices, he provided designs for festivities, medals and monuments. The stucco decorations made for the refectory of the monastery of Saint-Pierre (now Musée des Beaux-Arts), executed in 1687 by the sculptor Simon Guillaume, rival the best Italian work of this type both in richness of imagery and skill of execution. Lyon provided a link between Rome and Paris.[38] The establishment of a local Academy in 1667 served as an example to other cities.

In Toulouse,[39] the painter and theorist Hilaire Pader was temperamentally divided between academic orthodoxy (he belonged to the Parisian mainstream and published treatises in prose and in verse) and southern Baroque; his double allegiance can be seen in the series of scenes from the Bible painted for the Pénitents-Noirs in 1656 and now in the Cathedral. He and Jean-Pierre Rivalz paved the way for the blossoming of the subsequent generation. Provence[40] was home to personalities as diametrically opposed as Reynaud Levieux, whose austerity largely derives from Poussin in his *Holy Family* (1651, Villeneuve-lès-Avignon) or *St William of Aquitaine* (pl.169), painted in about 1660 for the Pénitents-Noirs in Avignon, and Pierre Puget. Puget was mainly regarded as a sculptor and architect, and has only recently been recognised as a painter. His thick, sometimes aggressive paintwork draws attention to the fact that he was primarily a sculptor, and his very dark palette puts him in a category of his own. *Saint Cecilia* (1651, Marseille) and the *Saviour of the World* (1655, Marseille; pl.168) are reminiscent of both the early Guercino and Pietro da Cortona, with whom Puget worked in the Palazzo Barberini in 1638–1640. His long stay in Genoa, from 1661 to 1668, helped to refine his style, in the modelling as well as in the choice of colours. The *Holy Family with a Palm Tree* (1660, private collection) recalls Van Dyck in its strange melancholy. Lyricism, a dazzling sense of motion and the 'tachiste' nature of a sketch like the *Education of Achilles* (Marseille) place the artist somewhere between the painters of sixteenth-century Venice and a romantic like Delacroix. Puget's example, and he developed quite separately from the Parisian mainstream, heralded an expansion of Provençal painting at the end of the reign of Louis XIV.

Notes

1. Schleier, 1978; exh. cat. Paris, 1988 (1), no.42.

2. See J. Thuillier, 'De l'amateur à l'homme d'Etat', exh. cat. Paris, 1985 (2), pp.39–53.

3. On this church, see the note by C. Duvigneau, exh. cat., Paris, 1985 (2), pp.64–75.

4. On Stella's paintings for the chapel at Saint-Germain-en-Laye (for which Poussin painted the *Institution of the Eucharist*), see Davidson, 1984 (1990).

5. Aulanier, 1947; Henderson, 1977.

6. Noted in Mérot, 1990 (1), pp.129–33, and Schnapper, 1994. On the Pointel collection, see Thuillier and Mignot, 1978.

7. See above, chapter 2, p.29, note 13, and Schnapper, 1984 (1990).

8. Le Pas de Sécheval, 1991.

9. See exh. cat., Paris, 1983–4, *passim*.

10. Fréart de Chambray, 1662, p.65–70.

11. S. Cotté, 'La Vrillière, collectionneur et mécène', exh. cat., Paris, 1988–9, pp.29–46; Cotté, 1989.

12. Laurain-Portemer, 1973 and 1977.

13. Exh. cat., Paris, 1972 (3); Mérot, 1987, pp.262–70.

14. P. Rosenberg, exh. cat., Paris, New York and Chicago, 1982, p.145.

15. See especially Goldstein, 1965; Schnapper, 1966.

16. See the edition presented by Weigert, Paris, 1964.

17. Mérot, 1990 (2), pp.43–57.

18. Reinbold, 1982.

19. Félibien, 1666–88, part 4, *Entretien* 8, (1685), pp.357ff.

20. Ibid, pp.383–4.

21. On the subject of the *Gathering of the Manna*: 'Read the history of the painting in order to know if each object is appropriate to the subject.' (Letter of 18 April 1639; see Blunt and Thuillier, 1989, p.45)

22. Félibien, 1666–88, part 4, *Entretien* 8, (1685), p.358: 'And some people only use this (i.e. these 'strong patches of light and dark') as a prop to assist their weakness, and affect it often with so little thought and good judgement that in these contrasts of impulsive action and badly thought out movements faults in the drawing are hidden under great patches of shadow, and the ignorant are deceived by unnatural and ridiculous movements which they are presumed to regard as wonderful artistic effects.'

23. Thuillier, 1964 (1992), p.65.

24. Dorival, 1976, vol.I, p.158.

25. Pinault, 1982.

26. On the diffusion of the *exemplum virtutis*, see A. Mérot, 'Le héros dans la peinture française du XVIIe siècle', exh. cat., Cologne, Zurich and Lyon, 1987–8, pp.36–44. On the theme of Alexander, see Grell and Michel, 1988.

27. See also in 1851 the following remark by Delacroix (*Journal*, Paris, 1932, vol.I, p.437): 'Poussin loses out when compared with Lesueur. Grace is one of the Muses he never spotted. Harmony of line, of effect, of colour is also a quality, or a combination of qualities, of the most precious kind which has been completely denied to him.'

28. J. Thuillier, 'Lettres familières d'André Félibien', *XVIIe Siècle*, no.138, (1983), pp.141–57 (p.144).

29. The first edition (in Latin) appeared in 1667. A second edition, with a French translation and commentary by Roger de Piles, came out in 1673.

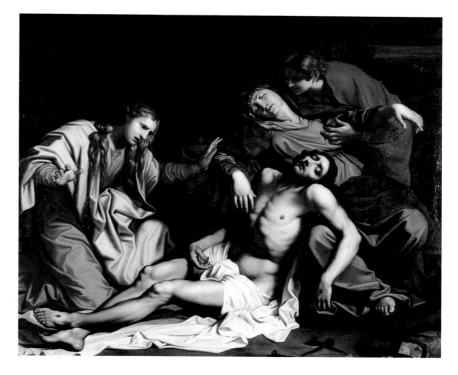

30. Sauval, 1724, vol.III, p.34.

31. Babelon, 1991; Lavalle, 1987; Mérot, 1990 (2). See also the special edition of *XVIIe Siècle* no.162 (1989) devoted to the hôtels of Paris in the seventeenth century.

32. On Vaux, in the absence of any recent study of the whole ensemble, see Cordey, 1924.

33. La Fontaine, *Le Songe de Vaux*, 1658–61 (published in fragments in 1671 and 1729).

34. See on this Blunt, 1967 (1). Chapter 11.

35. Lapauze, 1924 (vol.I: 1666–1801).

36. Letter of 6 December 1692, *Correspondance des directeurs de l'Académie de France à Rome*, Paris, 1887–1912, vol.I, p.341.

37. See exh. cat., Rouen, 1984.

38. On Lyons as an artistic centre see especially the documents of the Colloquium at Lyon, 1972 (1975), and papers nos 3 and 5 of the *Travaux de l'Institut d'histoire de l'art de Lyon* (1977 and 1979).

39. See exh. cat., Paris, 1947, and Mesplé, 1949.

40. See exh. cat., Marseille, 1978.

170. Nicolas Mignard, *Pietà*, 1655.
Oil on canvas,
115 × 150 cm.
Musée Calvet, Avignon.

APPROACHES TO REALITY

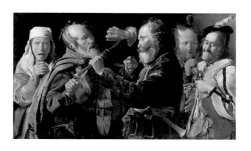

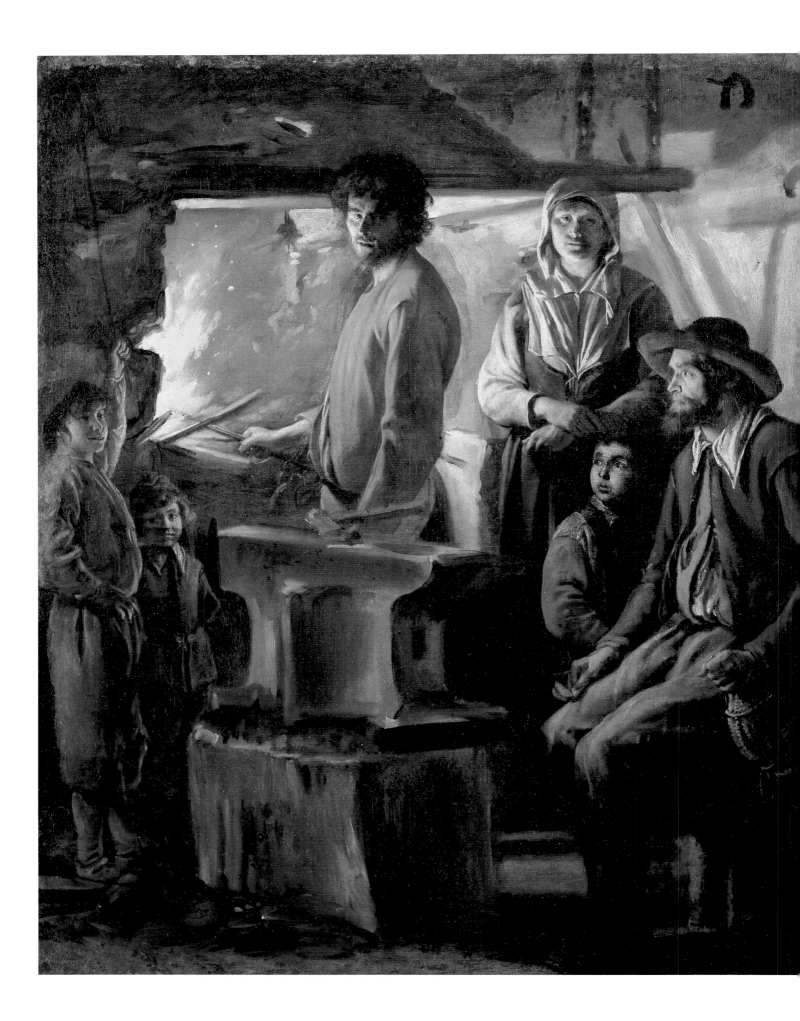

The popularity of certain seventeenth-century French paintings (La Tour's *Newborn Baby*, the *Forge*, pl.172, and the *Peasants' Repast* by the Le Nain brothers, Baugin's *Gaufrettes*) owes much to the exhibition organised by Paul Jamot and Charles Sterling in Paris in 1934. This was entitled *Les Peintres de la réalité* and most of the exhibition space was given to portraiture, landscape, genre paintings and still lifes; history painters, however, like Vouet, Champaigne or even Poussin were allowed in on the grounds that they too had occasionally represented 'reality'. The total rehabilitation of the Le Nain brothers, of La Tour and others, brewing since the last century in the writing of authors like Taine or Champfleury, was at last complete.[1] Thanks to Jamot and Sterling a continuous tradition running from Fouquet to Corot via Chardin, and characterised by integrity and measure, was identified and given promi- nence. At the same time, however, one seven- teenth-century faction was hounding the other. Distrust of the Academy and of classical idealism (artificially sustained by the monarchy, and exag- geratedly dependent on Italy) was on the increase. The notion began to take hold that French art contained two distinct strands, one official and based on artifice, the second deep-rooted and sincere; this notion has since been endorsed by the suspicious attitude of the vast majority of our contemporaries. Recent studies, however, rad- ically contradict this view; careful investigation of the trends and conventions loosely placed under the heading 'realist school' show that these devel- oped in the same way and shared the same goals as the art supposedly sponsored by the ruling élite: like religious or decorative art, genre painting, portraiture and landscape, assumed to have devel- oped in a vacuum and to have encouraged a craven servility towards real life, were in fact exposed to international movements, to the vagaries of other painters and to the changing expectations of the purchasing public to just the same extent. The search for a style was a constant factor at all levels, from the mere imitators to the great creative artists like La Tour and the Le Nain brothers. The last two have been regarded as *peintres témoins* (representative painters) of their time. In fact, every artist's approach to reality was

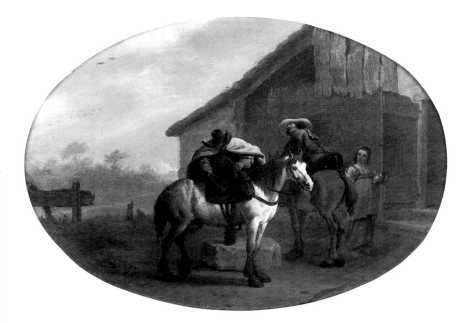

different, and though at the outset the evocation of reality was contained within quite a clearly- defined framework, the greater among the artists managed to bend this framework to suit their own requirements and, in the long term, to destroy it.

SOURCES AND MODELS: LOW LIFE

Analysis of posthumous inventories of members of the Paris bourgeoisie at the end of the sixteenth century and beginning of the seventeenth reveals a preponderance of paintings of scenes from daily life.[2] These were usually commercial paintings, of modest quality, produced in large quantity – as were portraits, landscapes and still lifes. Paintings like this were sold on market stalls, particularly at the Foire Saint-Germain, where humorous Flem- ish paintings after Brueghel, and later after Teniers, could be bought. The most prized specialities were scenes from the margins of social life: caricature, drinking and smoking dens, 'Egyptians' telling fortunes, beggars' brawls and other aspects of low life. The print sellers[3] also sold pictures on a great variety of subjects: fashion, trades, bawdy scenes, satire . . . Each page usually bore a legend explaining the moral or satirical significance of the image. Examples from abroad predominated. A large number of Flemish painters and printmakers had established them- selves alongside their French counterparts in Saint-Germain-des-Prés. The work of Brueghel and his disciples, of artists from Antwerp like Pieter Aertsen, then Brouwer and Teniers was freely available. Nor should the persistent pres- ence of the work of some of the Italian Manner- ists, which often gave new impetus to the northern tradition, be underestimated. Scenes from peasant life by the followers of Bassano, from

173. Pieter van Laer, *Leaving the Hostelry*. Oil on canvas, 32 × 43 cm. Musée du Louvre, Paris.

171. *previous pages*: Georges de La Tour, *The Beggars' Brawl*. Oil on canvas, 94.4 × 141.2 cm. The J. Paul Getty Museum, Malibu.

172. The Le Nain brothers, *The Forge*. Oil on canvas, 69 × 57 cm. Musée du Louvre, Paris.

159

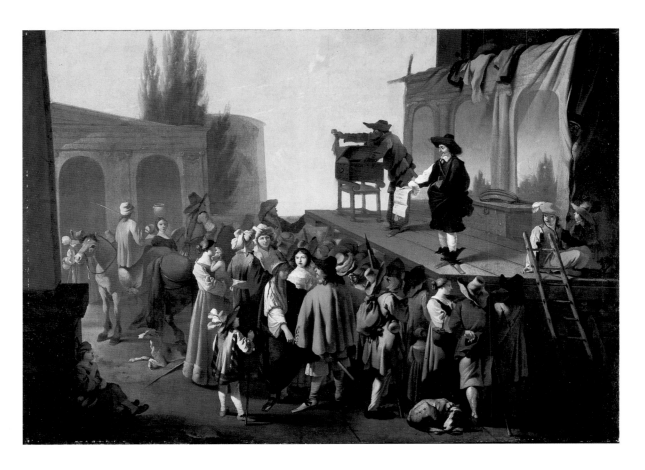

Bologna Passarotti's exaggerated tableaux and Annibale Carracci's caricatures and stereotypes of craftsmen, from Cremona Vincenzo Campi's markets and kitchens, all had their admirers. The success of the Caravaggesque painters, with their well-aimed frivolity and their boldly simplified forms should not be forgotten either.

At the crossroads of north and south was the *bambochade*, initiated in Rome in about 1630 by Pieter van Laer, nicknamed *Il Bamboccio* because of his small stature. While followers of Caravaggio were painting figures in close-up, dramatically clustered at the front of the composition and painted in half length on a large scale, van Laer made small compositions his speciality (everyday scenes of Roman life, pastoral scenes in landscapes, ruins; pl.173), filling them with dozens of little figures like puppets, generally painted in dull dark colours heightened by thicker patches of paint, with touches of bright colour here and there. He met with instant success, and a whole group of *Bamboccianti* began to paint in the same vein:[4] Dutch painters like Miel, Sweerts and Lingelbach; Italians like Cerquozzi and French painters like Bourdon and Jean Tassel.

Tassel's lumpen vitality is evident in his *Marauding Soldiers* (Langres), *The Charlatan* (private collection; pl.174) and *Sawing lengthways* (copy in Strasbourg), and in the religious paintings he produced after his return to France: *Tobias and the Angel* (Troyes) and the *Judgement of Solomon* (Sarasota). It is particularly his colours that connect him with van Laer: a few light, cool colours stand out against a brownish background, under unforgiving lighting that cuts shapes into prisms with exaggerated ridges. The *bambochades* painted by Bourdon in Rome between 1634 and 1637 illustrate his skill at imitation, as well as at transformation. To van Laer's formula he brings a strong feeling for structure, enlivening proceedings with oblique strokes and supple forms, his range of colours is much lighter, almost silvery, and he eschews vulgarity. Some of his large paintings, like the *Lime Kiln* (Munich; pl.175), through his use of architecture in which Rome ancient and modern rub shoulders, achieve a monumentality that is not far short of dramatic. He was capable of adapting biblical and historical subjects to the fashion of the day (the *Departure of Jacob*, Houston), relying as he was able to on commercial success. The paintings executed after his return to France are even more delicate, with their blue-grey and red harmonies; his subject matter meanwhile grew more serious, rivalling the compassionate humanity of the Le Nain brothers (*The Beggars*, Louvre). This was the period when Willem Kalf was resident in Paris,[5] and Bourdon exploited the northern fashion for interiors in a series of small canvases depicting gamblers, smokers and soldiers.

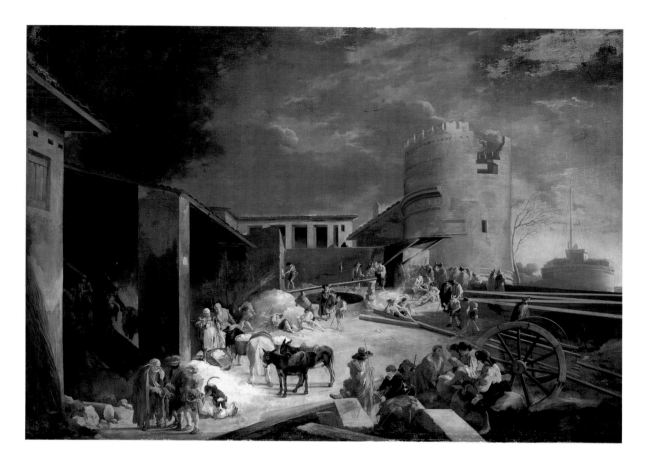

175. Sébastien Bourdon,
The Lime Kiln.
Oil on canvas,
172 × 246 cm.
Alte Pinakothek, Munich.

Conventional yet adaptable, sometimes gross, sometimes elegant, the *bambochade* developed in interesting directions: the study of manners combined readily with urban or landscape views; the genre lent itself as neatly to moralising, along the lines of the northern 'proverbs', as it did to burlesque. The latter trend also emerged in literature between about 1630 and 1645 with writers such as Saint-Amant and Scarron; like preciosity, of which it might be considered the reverse side of the coin, burlesque is based on a rhetoric of exaggeration. The lowly and the elevated styles were in fact both addressed to the same discerning public, who were hungry for contrasts and for original effects. In addition, burlesque in art was linked to Mannerism in decline, as certain aspects of the art of Lorraine demonstrate.[6] A theatrical repertory, close in feeling to the *commedia dell'arte* and fairground entertainment, is used with characteristic violence by Bellange – his *Beggars' Brawl* is one of his finest engravings – and Lallemant, in drawings like *The Procuress* (Musée Lorrain, Nancy) and a few paintings containing bawdy innuendo like *George too hasty to his Soup* (Warsaw; pl.179). There are echoes of this in the work of Callot and La Tour, but they gradually died away. Burlesque appeared more frequently in engravings, where the conventions were always of less concern than in painting.[7] Brébiette provided illustrations for the *Life of Geiton, the famous Drunkard*, which

foreshadow the comic strip; *Poor Badin* (pl.178) depicts the misfortunes of conjugal life, observing the strife between an old husband and his tyrannical young wife. This bawdy Gallic humour and mysogyny appears again in the series published by Jacques Lagniet. Satire, often suppressed by the censors, was not spurned by well-known artists nor by academics. An engraving by Samuel Bernard, *Spanish Arrogance overpowered by French Luxury* reproduces a somewhat laboured drawing by Louis Testelin (Dijon), who may also be the author of the *Captain of the Enfarinez* (Rouen), engraved by Lagniet in his *Proverbes* (1657).

The career of Jacques Callot exemplifies the diversity of the art of Lorraine in the early years of the century; it was a cosmopolitan art, capable of reacting to historical events as well as to styles imported from abroad. Callot executed his first great works in Florence, amid the excitement of the Medici court, and they already reveal the two major preoccupations of his art: fantasy in the first, the *Temptation of St Anthony*, and social commentary in the *Fair at Impruneta* (pl.176), a huge plate with more than 1,138 figures fitting comfortably into a panoramic landscape, minutely studied in a plethora of preparatory sketches. After his return to Nancy in 1621, his powers of observation and sense of order and accuracy found a number of outlets, from the recording of festivals and ceremonies, in which the artist's clarity and sense

161

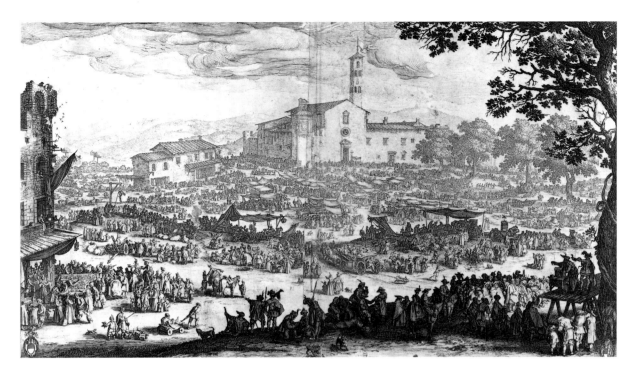

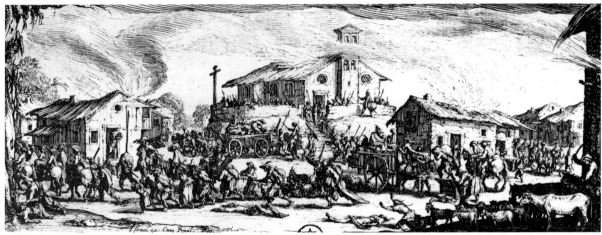

of rhythm testify to the importance of his Florentine training, to the *Misfortunes of War* (pl.177), a pitiless statement handled with a masterly sense of organisation, and via immense pictures of battlefields. Whether working in a large or small format, Callot can fit a whole world on to his plate; infinitesimal figures are depicted with the clarity of characters seen through a magnifying glass. His universality makes his style impossible to categorise. Perhaps the theatrical nature of his work attaches it to the last days of Mannerism; sacred and profane appear alternately in his theatre, courtly pastimes, contemporary poverty, the Passion, employing a cast of thousands (but mainly stereotypes). The artist keeps his distance, treating events with a grave, sometimes ironical, detachment; he achieves contrast by his addition of small scenes to the main characters. No other painter of the day has such a sharp, critical eye nor attains such realism; Callot's version of reality is

transcribed in a hand both sensitive and firm, whether in pen or in drypoint.

Callot's world deserves a place of its own: it should not tempt us to neglect the chronicles of urban or rural life left by other artists. In most cases description is subject to the conventions of fashion and includes entertaining details, amused familiarity or a certain idealisation as appropriate. The city is a colourful place in the poems of Scarron (*The Fair at Saint-Germain*, 1643) or Berthaut (*The City of Paris in burlesque verse*, 1652); first and foremost the city is the street and its trades, but also its dangers in Bosse's series of *Cries of Paris*, Chauveau's engraving of the *Herring Seller* (pl.182), or Michelin's street vendors; a stream of more or less threatening beggars should not be omitted, for example the *Thieves fighting* (in Moscow) painted by a follower of the Le Nain brothers, the Master of Processions.[8] The country is represented by Brébiette's scenes of the

sheepfold, the dignified, familiar peasants engraved by Jean Le Pautre the Elder or Stella, without forgetting Bourdon and Tassel's rural *bambochades*: stereotypes as old as time, soon to be brought to a conclusion by the great painting of the Le Nain brothers. Apart from compositions that are avowedly satirical in intention, the general aim was to turn observation to good account through balanced forms and the clarity of expression that characterised history painting in the 1630s and 1640s. Notable in this respect are the engravings of Bosse, professor of perspective at the Academy: in the *Ball in Evening Dress*, the *Palace Gallery* or the *Great Hall of the Hôpital de la Charité* (pl.181) the figures are distributed calmly in a geometrical and rational background in which every detail contributes to the whole. Bosse's social chronicle is handled firmly, almost disinterestedly, yet it contains moral guidance as well: Bosse, a convinced Huguenot, adapted biblical parables like the *Wise Virgins*, the *Foolish Virgins* (pl.180) and the *Prodigal Son* to contemporary taste.

THE COMPLEXITIES OF GEORGES DE LA TOUR

La Tour, son of a baker in Vic-sur-Seille, has tended to be regarded as an isolated provincial on the fringes of the artistic movements of his time. In fact, he underwent a most thorough training: he is presumed to have served his apprenticeship in Nancy, under Bellange. It is probable, though not proven, that he spent the years between 1610 and 1616 in Italy and from this sojourn he returned with a profound understanding of Caravaggism.[9] He established himself in Lunéville in 1620 but did not remain confined to the immediate area. The disasters that struck Lorraine between 1631 and 1642 forced him to move about, and it was during this difficult period that he may have made a visit to the Low Countries. We know now that he went to Paris in 1639, to the court of Louis XIII for whom he painted a night scene, almost certainly *St Sebastian and St Irene with a Lantern* (original lost, copies in Orleans, Rouen and Kansas City). This led to his being given the title of Painter in Ordinary to the King. His marriage in 1617 introduced him into the minor aristocracy of Lunéville, where he cut quite a figure. Documentary sources show us a kind of country squire, very full of himself, sometimes cruel, anxious to manage his assets to best advantage and to protect his possessions. The family's rapid ascent of the social ladder led in 1670 to the ennoblement of his son Etienne. His studio was one of the most active in Lunéville, and his clientèle extended well beyond the town. The Duke of Lorraine, Henri II, bought La Tour's paintings. When France took over the Duchy, La Tour was chosen on several occasions

178. Pierre Brébiette, *Poor Badin*. Engraving. Département des Estampes, Bibliothèque Nationale, Paris.

179. Georges Lallement, *George too hasty to his Soup*. Oil on canvas, 111 × 81 cm. National Museum, Warsaw.

180. Abraham Bosse, *The Foolish Virgins*. Engraving.

Département des Estampes, Bibliothèque Nationale, Paris.

to paint the pictures offered by the town of Lunéville to the Governor, Maréchal de La Ferté-Senneterre, who seems to have had a particular admiration for them.

La Tour has been portrayed as a profoundly original painter, who conjured his ageless, completely individual figures from the dark night. In fact, the real genius of this not particularly inventive painter was his ability to squeeze notes of exceptional intensity from hackneyed themes. François-Georges Pariset, Jacques Thuillier and others have demonstrated the extent to which he borrowed from others.[10] In Lorraine, genre paintings generally stuck to the usual subjects, as they did in the Caravaggesque tradition. As far as La Tour's 'nights' are concerned, neither the artificially lit scenes nor the religious paintings were especially innovative. What is more, although the formula went rapidly out of fashion, La Tour picked it up again during his latter years, as if he found it difficult to say goodbye to this circumscribed world in which he could die comfortably. He was obsessed by a universe even more restricted than the universe of Vermeer: no window to the outside world, no landscape or interior décor, only blank walls animated by the sporadic trick of light, a few human stereotypes and a couple of animals, and occasional but diminishing adjuncts. It is paradoxical therefore to group La

Tour with the genre painters; the only social information to be gleaned from his work relates to seventeenth-century Lorraine, its spiritual life and its poverty. Yet to look only for plastic values and undiluted painting, as modern art criticism might, would be to neglect the homogeneity of La Tour's *œuvre*, his spiritual development over the years and the links transcending differences of style that bind his first genre paintings to the religious scenes of his maturity.

The painter's development is difficult to trace with any accuracy. Firstly, because of the small number of original paintings in existence: out of a catalogue numbering about seventy-five works, more than half are known only through copies or engravings. Secondly, because of a lack of chronological landmarks: only two paintings are legibly dated, the *Penitent St Peter* (1645, Cleveland) and the *Denial of St Peter* (1650, Nantes), both painted at the end of his life. Also to be taken into account is the disappearance of a large proportion of La Tour's production in the fire and subsequent looting of Lunéville in 1638. Finally, the chronology is confused by the existence of different versions of the same composition, often painted several years apart. A hypothesis does however seem to have been built up, and especially since the exceptional exhibition devoted to La Tour in 1972, and neither documentary evidence nor close examination of the paintings appears to gainsay it. La Tour's output can, it seems, be divided into two main groups: the daytime scenes first of all, until the end of the 1630s, when the nocturnal scenes took over. This broad division should not, however, be regarded as categorical: the nocturnal scenes appear to have begun much earlier than was previously thought. The date of the *Settlement of Accounts* in Lvov (1634? 1631?; pl.183) has been variously deciphered, but the style of the painting is different from the style of the later 'nocturnes', recalling as it does the art of Jean Le Clerc, who returned to Lorraine in 1621 and was the great specialist in this kind of scene, as well (in certain respects) as the art of Bellange, assumed to have been La Tour's first teacher. It is conceivable that La Tour painted alternate day and night scenes at the beginning of his mature period, i.e. at the end

of the 1630s, and the day scenes would be the more accomplished of the two styles of painting at the time.

The earliest extant paintings echo the themes used by the genre painters of Lorraine: Lallemant, for example. In the *Pea eaters* (Berlin), the *Hurdy-Gurdy Player* (Bergues) or the *Apostles* (Albi) La Tour's realism is objective and still tranquil. The figures, half-length or full-length, are firmly placed and brightly lit, sometimes as if by theatrical footlights (as in the *Old Man* and its pendant *Old Woman* in San Francisco). The technique is meticulous, the searching brushstrokes appearing to paint and draw at the same time. In the manner of all Caravaggesque painters, La Tour attacks the canvas with no preliminary drawing, his virtuosity again harking back to Bellange. His colours are already refined, concentrating on tired, muted shades enlivened here and there by a more strident note. This technique became more exaggerated around 1630: the Nantes *Hurdy-Gurdy Player* (pl.184) and the Malibu *Brawl* (pl.171) bear some of the identifying features of the burlesque art of Lorraine, or even of Paris, but they are more intensely experienced; they are also enhanced by the painter's fresh approach to structure and presentation. In the *Brawl* the exchange of glances and gestures creates a frieze of half-length portraits, symmetrically framed on either side by the weeping woman and the violin player. Sometimes the colours are darker: the monumental *Hurdy-Gurdy Player* in Nantes painted in a range of browns, was formerly attributed to Ribera, Velázquez or Zurbarán; the figure is set in an unidentifiable background, animated only by the play of light. The same qualities are to be found in the two successive versions of *St Jerome Penitent* (Stockholm and Grenoble), technically virtuoso pieces, and the fearsome *St Thomas at Lance-point* in the Louvre.

A detachment denoting a degree of irony began to appear in the paintings at the end of the decade: the two *Card Sharps* (Fort Worth, pl.185; and the Louvre) and the *Fortune Teller* (New York) contain a large breath of the influence of Manfredi. The simplicity of the volumes is almost unsettling. The handwriting is still neat, but now seems less strained. There is a curious sophistication in the

181. Abraham Bosse, *The Great Hall of the Hôpital de la Charité*. Engraving.
Département des Estampes, Bibliothèque Nationale, Paris.

182. François Chauveau, *The Herring-Seller at les Halles*, plate for *La Ville de Paris en vers burlesques*, by Berthaut, 1652.
Département des Estampes, Bibliothèque Nationale, Paris.

pleading, oblique looks, in the deliberate contrast between the perfectly oval faces and the comical complexity of the hair styles, the vivid details of dress, with exotic embroidery in thickly encrusted paint and in the whole flavour of the subject. Anything conventional to be found in the *Brawl* is enriched by cynical and sharp-tongued criticism, which here transforms the traditional theme of the prodigal child fleeced by courtisans.

With his artificially lit night scenes La Tour was re-stating a successful formula first used by Dutch Caravaggesque painters like Honthorst. But he went beyond straightforward anecdote thanks to his profound mastery of Caravaggio's poetics.[11] He understood that a skilfully manipulated source of light can isolate figures from the outside world and outline them in random fashion, emphasising large masses and, when a single detail is highlighted, giving overwhelming intensity to that detail; also, that a light source can create a tonal equality in which colours dissolve into a brown harmony that ignites the few burning or chilling spots of red or blue. And so, although he was

trained in a milieu strongly influenced by Mannerism, La Tour raised the most radical objections to the style; the results included his most successful nocturnal scenes such as the two versions of *St Sebastian tended by Irene* (Berlin and Louvre; pl.186), and led him to an almost cubist simplification that enchanted the painters of the 'return to order' in the twentieth century.

Another of Caravaggio's contributions was his manner of treating religious subjects as if they were taking place in the present, rejecting conventional iconography in favour of humdrum, often poverty stricken, reality. It is sometimes difficult to tell the difference between genre scenes and religious meditation in La Tour's work. It is true that he sometimes chose minor but easily saleable subjects, as in the *Boy blowing on a Torch* (Dijon) or the *Young Singer* (Leicester). But a composition like the *Flea Catcher* (Musée Lorrain, Nancy) is at the same time resolutely trivial and impressively serious, bordering in places on abstraction. The *Newborn Baby* in Rennes is a Nativity treated with such economy

183. Georges de La Tour,
The Settlement of Accounts.
Oil on canvas,
99 × 152 cm.
National Gallery of the Ukraine, Lvov.

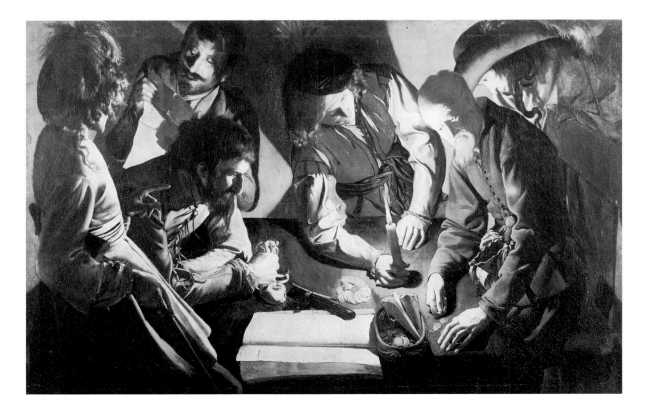

184. *opposite page*:
Georges de La Tour,
The Hurdy-Gurdy Player.
Oil on canvas,
162 × 105 cm.
Musée des Beaux-Arts, Nantes.

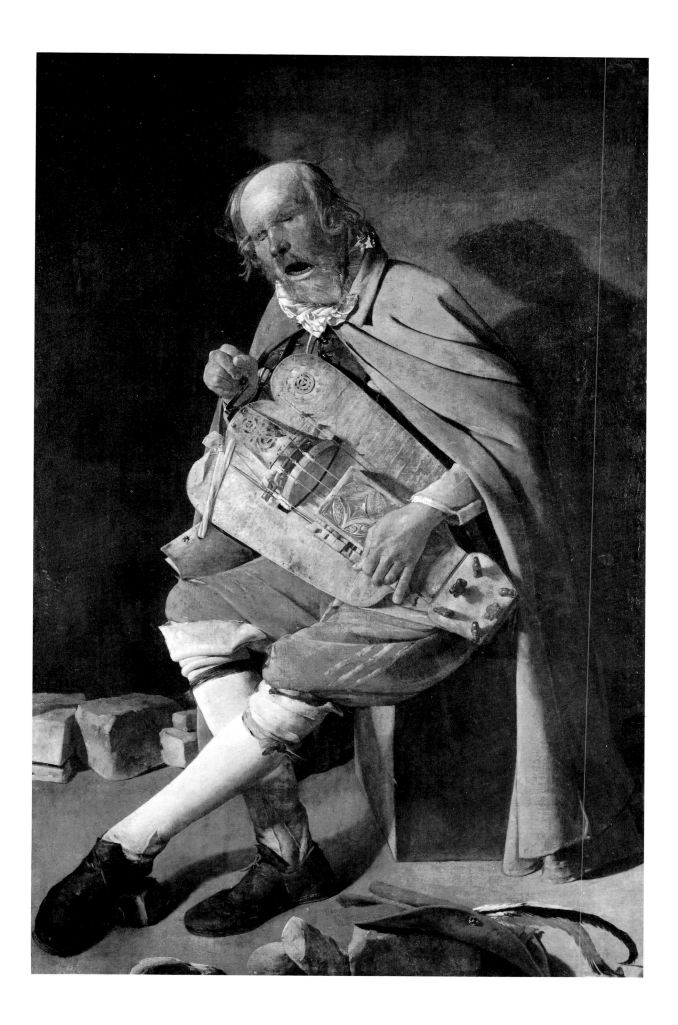

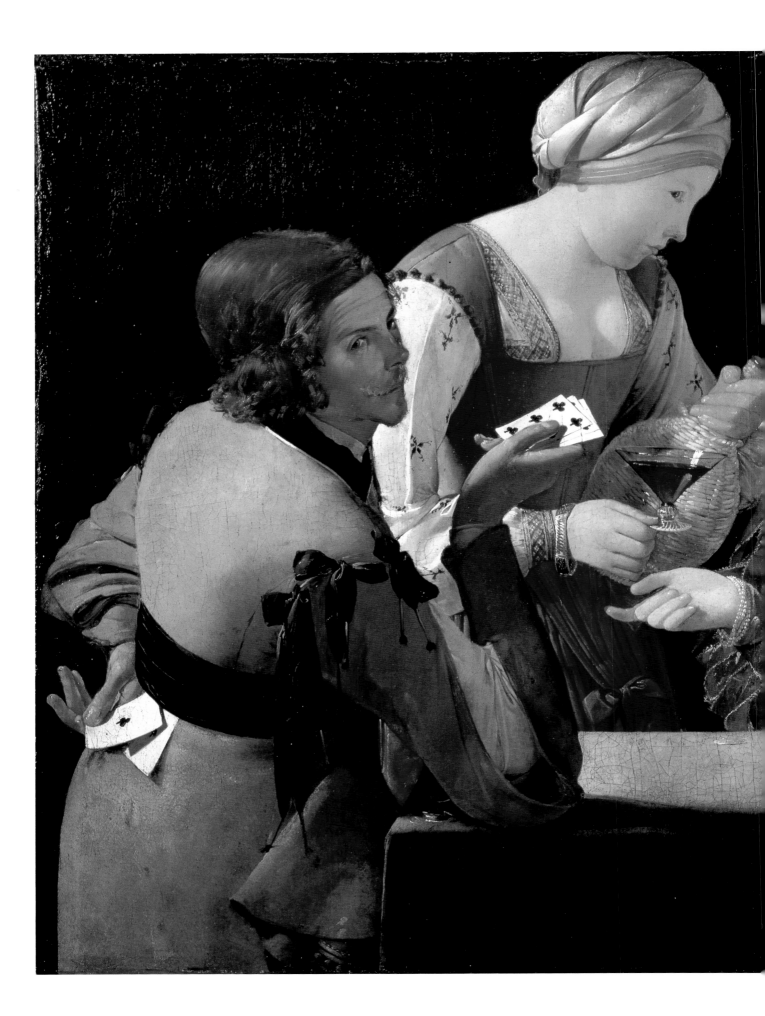

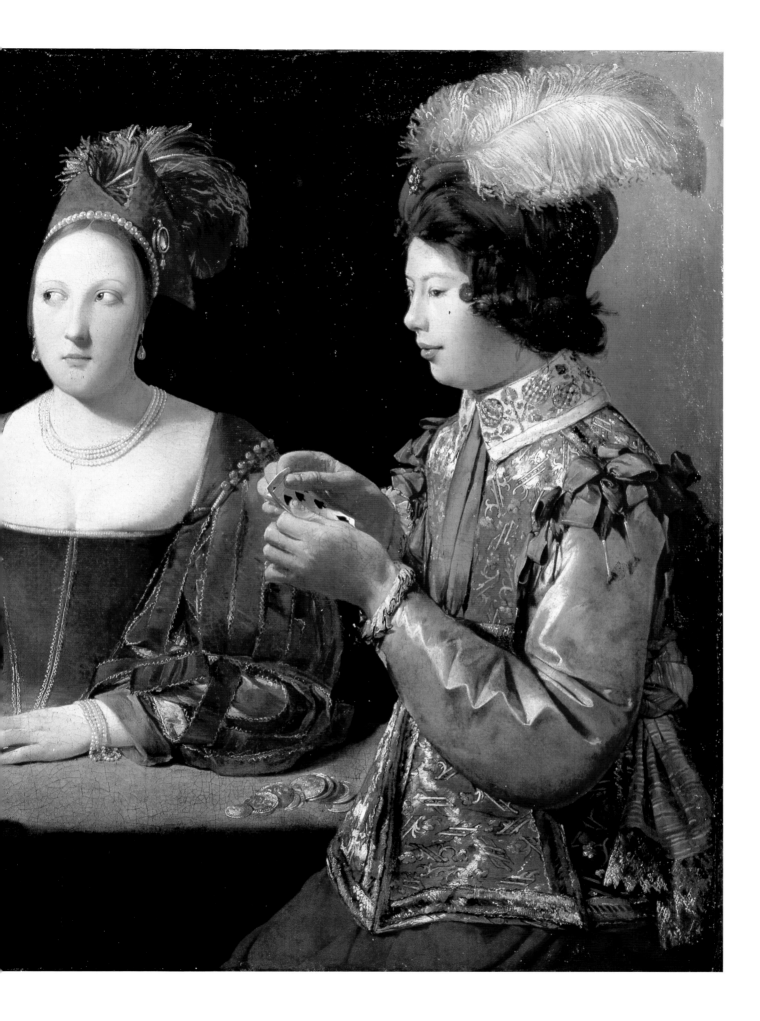

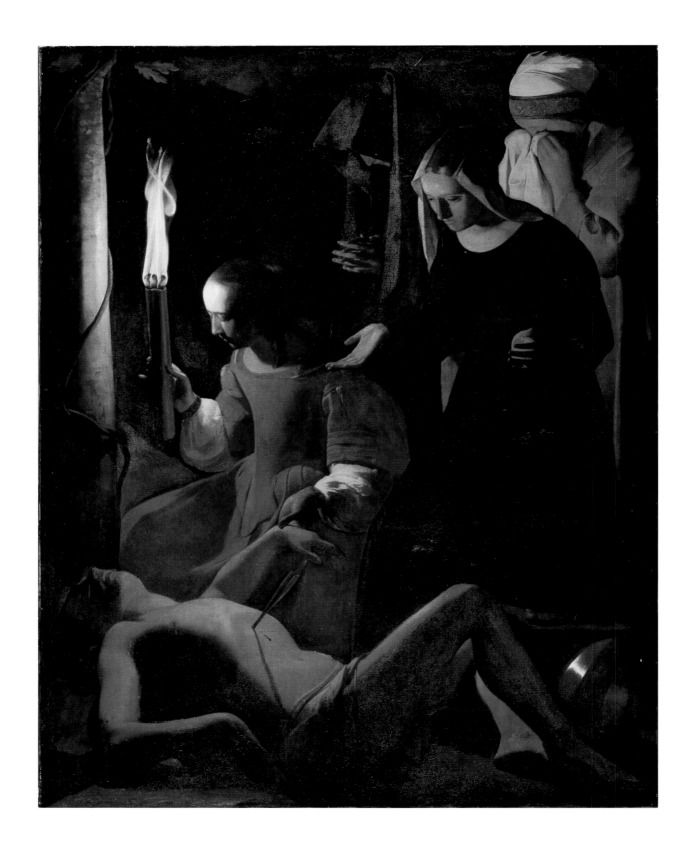

of means that traditional imagery is nowhere to be seen: the glowing kernel remains, the universal mystery of childbirth. The same intensity is to be found in the confrontation in *St Joseph the Carpenter with the Child* (Louvre) or *St Joseph asleep with the Angel* (Nantes), in both of which the shadows and candlelight destroy any distinction between sacred and profane. The *Job* in Epinal, still a subject of controversy, is handled with exteme daring; the biblical scene is reduced to the juxtaposition of two oppressive figures, the seated naked man, fragile but stoical, and the woman leaning towards him in vaguely threatening fashion, 'from atop the bulky tower of her skirts'.[12] All these characters have a presence well beyond that of their painted reality. They are like church statuary, carved from carefully polished hardwood in simple, authoritarian shapes, like the statues that inspired Jean Fouquet two centuries earlier in his *Pietà* in Nouans. The lighting effects lend additional grandeur.

The popularity of La Tour's nocturnal scenes, one of the pinnacles of seventeenth-century art, has led to some misunderstandings. Interpretation of their religious significance remains a problem. What exactly were La Tour's religious beliefs? A 'conversion' has been mentioned.[13] In fact, the popular, comic morality of his early paintings yields later to works that reflect certain devotions that were widespread in Lorraine, where the Counter Reformation had long since found one of its most fertile breeding grounds.[14] The twin themes of repentance and asceticism were compulsory, and the famous series of *Magdalenes* (Washington, New York, Louvre, Los Angeles and private collection) bears witness to this, as do paintings possessing exceptional emotional power like the *Penitent St Peter* (Cleveland) and *St Alexis* (lost, copies in Dublin and the Musée Lorrain, Nancy). Details of La Tour's personal beliefs are non-existant, in fact, and his presumed links with the Franciscan friars (see his *St Francis in Ecstasy*, known from a copy in the Musée du Mans) have never been proved. Should paintings like the *Flea Catcher* or *Job and his Wife* be interpreted as reflecting the artist's sympathy with humble folk, and his interest (sustained by his Caravaggesque vision) in the unique, irreplaceable personality of the indi-

vidual? This would ignore the 'detachment' and sometimes 'merciless'[15] tone of many of his youthful paintings, and also the 'emotional control'[16] manifested in his most admirable paintings like *St Sebastian tended by Irene*. At any rate, his very last works, the *Denial of St Peter* (Nantes) and the *Dice Players* in Middlesborough (Teesside), harsher in their execution, revive the irony of the daylight genre paintings. It has been assumed that La Tour was collaborating with his son Etienne. But the same confrontation between simple people is to be found here, toughened perhaps but still very powerful, and still motivated by basic emotions and the tensions that derive from them: the saint hastening to deny Jesus amid the soldiery, or the innocent duped by people more experienced at handling life's dangers than he. This is the art of experience and, though it undoubtedly reflects disillusion and is often cruel, it is also always ready to wonder at a childhood promise, at an elegant profile or at a single light in the darkness.

THE LE NAIN BROTHERS

On their arrival in Paris in 1629, Louis, Antoine and Mathieu Le Nain established themselves as history painters, particularly concentrating on religious subjects.[17] Towards the end of the 1630s, however, as Vouet's studio began to take the lead and the number of painters returning from Italy who were skilled at painting large decorative schemes increased, competition grew so great that the three brothers turned successfully towards portrait painting and genre scenes from peasant life. This did not prevent their being accepted into the Royal Academy from its inception in 1648. They established themselves in Saint-Germain-des-Prés where, surrounded as they were by Flemish painters, they were well placed to appreciate the different modulations of realist painting and the outlets it offered. Inevitably, they tried to disassociate themselves from current trends: their talent and their society connections, including connections at Court, stimulated them to try out ambitious and often novel techniques. Their careers and their paintings raise questions that have so far not been answered. What training

185. *previous pages:* Georges de La Tour, *The Card Sharp with the Ace of Spades.* Oil on canvas, 97.8 × 156.2 cm. Kimbell Art Museum, Fort Worth.

186. Georges de La Tour, *St Sebastian tended by Irene.* Oil on canvas, 167 × 131 cm. Musée du Louvre, Paris.

171

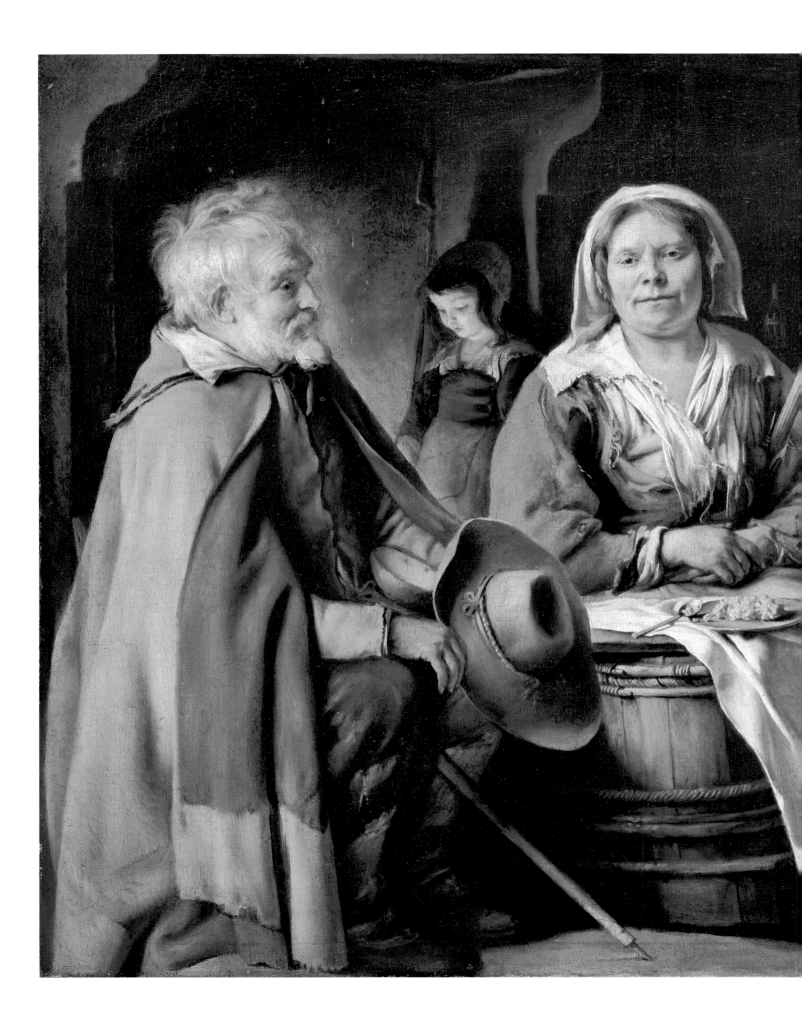

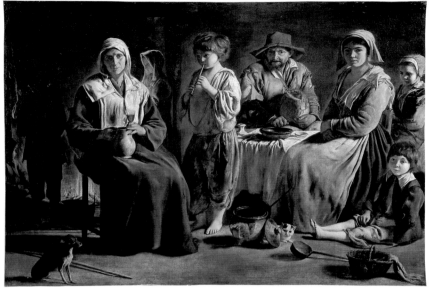

did they receive, and what were the sources of their inspiration? How did they come to shift from history to genre painting? How can the three hands involved in so diverse a repertoire be identified, when the *œuvre* contains such contrasts, and such striking breaches in workmanship and tone? Even if niggling questions of attribution and dates, closely connected, are glossed over, we still need to know what the ultimate aim of the brothers was: what do the famous scenes of peasant life really signify? At whom were they aimed and what were they trying to say?

At present it is not possible to establish a reliable chronology for the works of the Le Nain brothers. The three of them worked together, as the signature Le Nain without a forename proves, for about twenty years; their output, which must have been considerable, has not survived well: of an estimated two to three thousand paintings not even a hundred are known; the paintings that are dated cover only a short period, from 1641 to 1647. It is not therefore known what pictures were painted before 1640, and in which style. In addition, the works of Mathieu, after the sudden death of his brothers in 1648, are, in the absence of any secure references, lost to us: the *Painter's Studio* (Vassar College) shows, it is true, a post-1650 mode of dress, but its attribution is problematic.[18] Should the group known as the *Adoration* be placed alongside this picture? Its old-fashioned style seems closer to the youthful works.[19] In fact, if only the signed and dated works are considered, the conclusion must be drawn that various styles existed simultaneously. This variety may point to the existence of specialisation within the studio: in the same year, 1642, ambitious large paintings traditionally ascribed to Louis, like the *Peasants' Meal* and the *Family of Peasants* (Louvre; pl.188) appeared, and so did smaller, slightly stereotyped

188. The Le Nain brothers, *Family of Peasants*. Oil on canvas, 113 × 159 cm. Musée du Louvre, Paris.

187. The Le Nain brothers, *Peasant Interior*. Oil on canvas, 55.6 × 64.7 cm. National Gallery of Art, Washington. The Samuel H. Kress Collection.

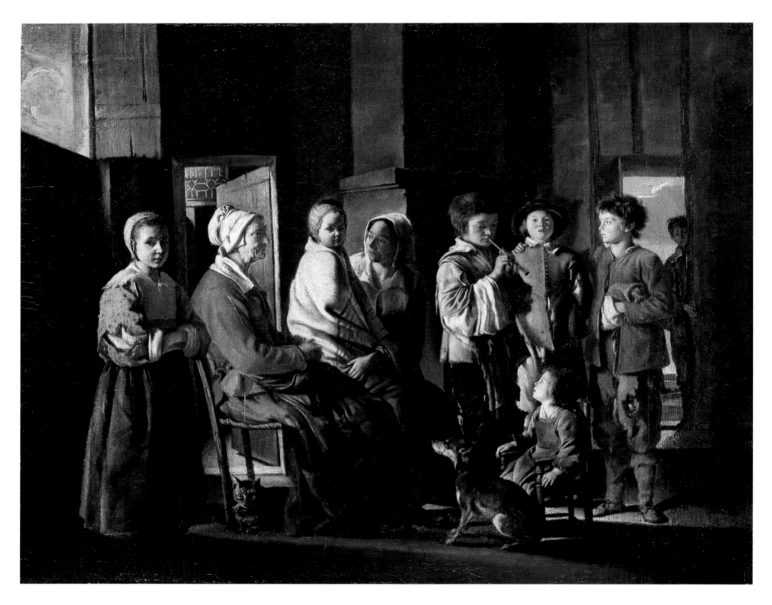

189. The Le Nain
brothers,
Grandmother's Visit.
Oil on canvas,
58 × 73 cm.
Hermitage Museum, St
Petersburg.

plates like the *Musical Gathering* in the Louvre and the *Mother with five Children* in London, both attributed to Antoine.[20] Behind this *Stilpluralismus* may have lurked a sound commercial strategy, since paintings bearing the trademark 'Le Nain' were sold at different prices to a very varied clientèle.

Trained in Laon by a 'foreign painter',[21] undoubtedly of Mannerist allegiance, the three brothers improved their skills in Paris and were in a position to familiarise themselves with the art of

Fontainebleau, as their history paintings reveal, as well as with Gentileschi and the young Champaigne. Their familiarity with Caravaggism, of which their *Cardplayers* (Aix-en-Provence) and *The Brawl* (Cardiff) are pastiches, does not necessarily pre-suppose a tour of Italy.[22] The structure of their work favours close-ups, the lighting is full of contrast, and the figures, turned to face the spectator, stand out against a plain background. The colour scheme is dominated by browns and pale greys, relieved by pale blues and a few touches of

red: the same tones can be seen in the *Peasant Interior* in Washington (pl.188), which bridges the transition from Caravaggism to rusticism.[23] The *Adoration of the Magi,* in Meaux, gives insight into the stages of the transition of their religious painting into genre painting, from a style still dogged by an uneasy Mannerism to a more robust, balanced manner,[24] the latter to characterise the production of the Le Nain brothers in religious and mythological subjects (*Venus in the Forge of Vulcan* in Reims) as well as allegory (*Victory* in the Louvre). Their world became more personal, and closely connected with a particular region: human types, houses and landscapes, proportions and colours draw attention to a vivid, refined art. The *Supper at Emmaus* (Louvre) and the *Birth of the Virgin* (Notre-Dame, Paris), contain elements borrowed from contemporary religious rhetoric, as well as elements from rural life, the slight disparities reminding us that this is collaborative work.[25] In other cases, like the *Peasant Family* in the Louvre, the match is seamless and the same insistent question recurs: which of the three brothers was able to plan such a masterpiece, so superior to Flemish and Italian genre paintings of the period, in particular the *bambochades*? The small scenes traditionally ascribed to Antoine are of gatherings, bourgeois or more elegant, or children playing games, dancing, making or listening to music. The liveliness of the colours disguised the narrowness of the format, the awkward way the figures are lined up, and the painstaking though lifelike modelling of the faces. The large version of the *Little Card Players* (Buckingham Palace) or *Grandmother's Visit* (Hermitage; pl.189), in connection with which the name of Louis has been mentioned,[26] are more ambitious and their originality is genuine: while the Flemish painters represented childhood by emphasising funny faces and funny walks, and the classic *putto* was still widely to be found in French painting, as Stella's *Games*, engraved by his niece, demonstrate, the Le Nains made the children into people in their own right, not seeking (and here they differed from their imitators) to make them act in moral or anecdotal playlets. They often immobilise their young subjects, placing them silently and sometimes solitarily in front of the spectator, listening

to music: the dialogue set up has an intensity that is still just as powerful today. In the scenes of peasant life, whether interior or exterior, all ages are grouped together evoking the passing of time, the meeting of experience and innocence. It is these juxtapositions that make paintings like the *Peasants' Meal* and *The Forge* in the Louvre, the *Peasants in front of their House* in San Francisco or the *Horseman's Repose* in the Victoria and Albert Museum[27] so exceptional. The Le Nains' ability to preserve the dignity and mystery of their models testifies to their skill as portrait painters, widely acclaimed at the time. Lovers of 'the glance',[28] the brothers display a psychological penetration enhanced, paradoxically, by their subjects' motionless poses, the sobriety or simplicity of their dress, the absence of superfluous accessories, indeed of all embellishment. The range of colours,

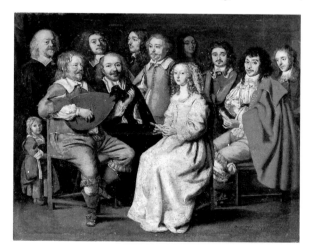

190. The Le Nain brothers, *Musical Gathering.* Oil on copper, 32 × 40 cm. Musée du Louvre, Paris.

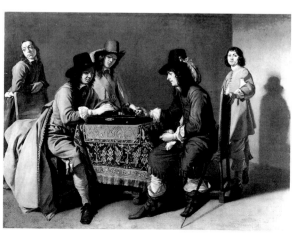

191. The Master of the Games, *The Backgammon Players.* Oil on canvas, 96 × 123 cm. Musée du Louvre, Paris.

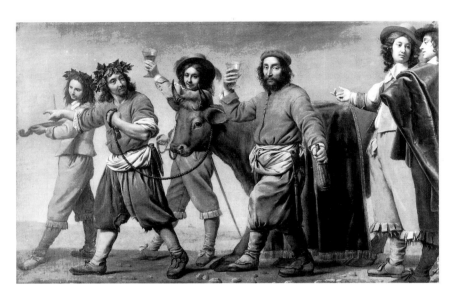

192. Le Maître des Cortèges, *The Cortège of the Ox*. Oil on canvas, 108 × 166 cm. Musée du Louvre, Paris.

narrowed to greys, browns and blues, is warmed by the glow of a hearth or a glass of wine. The painting is often very free, able to render a blade of corn in *The Cart* (Louvre) or sparks in *The Forge* (Louvre), excelling at capturing the thickness and wear of stout fabrics, the glaze on a pot, the gleam of copper or the glitter of a pair of eyes in the shadows, mixing dull shades with pinkish, bluish glints.

There are other artists, besides the Le Nain brothers, whose work was once confused with theirs (for commercial reasons) but who, since the 1978 exhibition, have been individually ident-ified. Paintings attributed previously to Mathieu, whose prototype is the *Backgammon Players* in the Louvre (pl.191), have now been ascribed to an anonymous 'Master of the Games'[29] who may have been someone who came to Paris from far-ther north. This plagiarist tirelessly repeats the same formula of figures seated round a table seen from a distance, their legs stiffly posed at an angle, in a neutral background, brightly lit from the side to accentuate the features of their not-very-expressive faces in sharply divided colours. Simi-larly chilly are the *Family Meal* (Toledo) and *Children's Dance* (private collection), which closely resemble Dutch paintings of the period. Another painter who, in about 1650–60, testifies to the success of the three brothers is the one named the 'Maître aux Béguins'.[30] His work can

be distinguished from the work of the three brothers by its compact, somewhat coarse and humdrum composition, the stereotyped faces of his models and an anecdotal streak verging on vulgarity. A conventional art has taken root, and this can be spotted in the roughly painted scenery, so much less bold and original than the exteriors in *The Cart*, *The Milkmaid* or the *Peasants in a Landscape* (Washington). The 'Maître des Cortèges'[31] gives signs of being better educated. His *Cortège of the Ox* in the Louvre (pl.192), his best known work, used to belong to Picasso, and this and his *Procession with a Ram* (Philadelphia) are identifiable by their frieze-like composition and their delicate colouring. The blind hurdy-gurdy player in the *Procession with a Ram*, compared with La Tour's, certainly lacks expressive power, but he is painted with a diffidence and empathy based on painstaking description.

Jean Michelin,[32] declared by Loménie de Brienne at the end of the seventeenth century[33] to have painted only fake Le Nains, also put his signature to a number of very fine paintings. The most remarkable are his *Soldiers in an Inn* (Louvre) and *The Baker's Cart* (New York; pl.193), dated 1656, in which the characters in the street are posed facing the spectator: the construction is rigorous, almost everything happening in the foreground. The painting is frank, the detail lively and the colours restrained. We leave the rural world of the Le Nain brothers for the world of the city and its trades, depicted earlier by Bosse and Brébiette. Something more idealistic, with some pseudo-classical features, appears in *Works of Char-ity* by Alexandre(?) Montallier[34] (Hermitage), skil-fully painted with a blond gleam reminiscent of Bourdon. Like the Le Nain brothers, this almost unknown painter distances himself from the *bambochade*, conferring on it a distinction which is typical of Parisian art in the 1650s.

The study of the painters who gravitated to the circle of the Le Nain brothers serves to highlight the originality and complexity of their own work: they rejected the conventions traditionally attached to genre subjects — burlesque and cari-cature, pastoral themes and stereotypical rep-resentations of rural life. The titles given to their paintings by eighteenth-century art dealers do

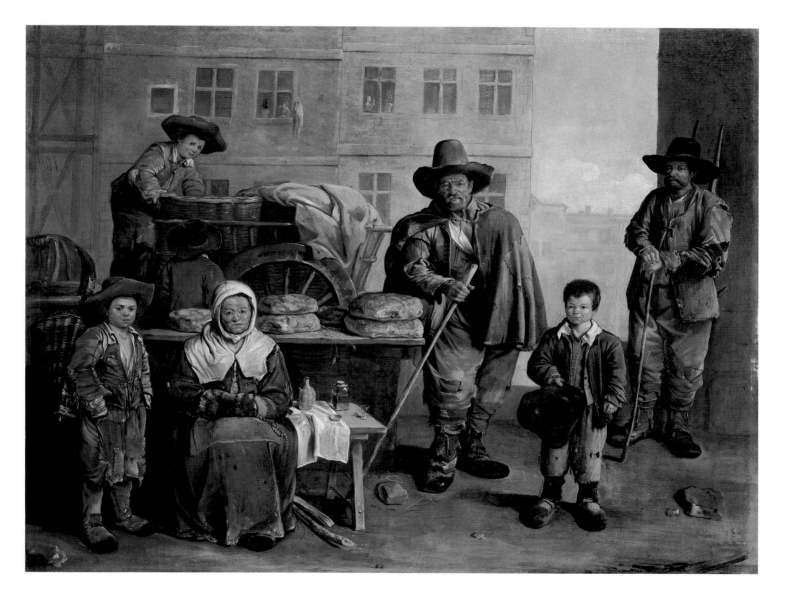

193. Jean Michelin,
The Baker's Cart, 1656.
Oil on canvas,
98.4 × 125.4 cm.

The Metropolitan Museum
of Art, New York. Fletcher
Fund.

them an immense disservice by suggesting stories, and connections between the characters that simply did not exist. It has been necessary to attach new, more general names to the paintings to refute such anecdotes. There is also a problem of interpretation. Champfleury[35] and the 'naturalist' critics of the nineteenth century regarded these brothers who had arrived in Paris from Laon as confirmedly socialist painters, bearing witness to the poverty of the local peasantry, enfeebled by war, looting and famine. The Le Nain brothers, however, although deeply attached to their birth-

place and its inhabitants, were not politically committed as artists and their realism, lacking any complacency or irony, is very different from the social satire of the north. Who do they represent? More often comfortably-off labourers than poverty-stricken peasants.[36] Frequently, however, people from different social classes rub shoulders in the same picture, and this makes explanation difficult.

The seriousness of tone may be explicable by the religious context. Sermons of the day emphasised the dignity of the poor and the presence

of Christ among the most dispossessed. The area around Saint-Germain-des-Prés, where the three brothers settled, was a hot-bed of Reformism and was home to several charitable foundations.[37] Is it permissible to go further, and to suggest that the children appearing so frequently in the paintings might be orphans given a home in peasant families? And what to construe from the recurrence of music, that lends a kind of reverence to many a rustic gathering in so many of the paintings? Another, equally hazardous, hypothesis has identified the Le Nain brothers as Protestants because of the repeated presence of bread and wine at their tables, which could symbolise the Eucharist.[38] Whatever the truth of the matter, their clients must have appreciated above all else the quality of the painting, the main factor differentiating their work from other genre paintings. Their admirers must have recognised, besides the refinement of the painting and the colours, the exceptional, respectful attention, without a hint of sentiment, paid by the artists to their models.

Was there any great realist art in France after the disappearance of Callot (1635), La Tour (1652) and Mathieu Le Nain (1677)? The reply is usually in the negative because the Manichean idea of a 'realist school' at loggerheads with (and eventually stifled by) official art has persisted for so long. As if the arrival of Louis XIV had succeeded in emasculating French art in favour of colourless academicism. The King's alleged ejaculation in front of the Teniers in his collection is well-known: 'Remove all those apes!' Félibien, probably irritated by the success of Flemish genre painting, criticised the Le Nain brothers for having portrayed 'lowly and frequently ridiculous activities'. He added: 'Works in which the intellect is little engaged soon grow wearisome.'[39] It is true that the success of the Le Nain brothers spawned a plethora of often quite mediocre imitations. Nevertheless at the end of the century artists in direct descent from Abraham Bosse, who died only in 1676, were continuing to produce fine, accurate portrayals of social reality. Thus Pierre Bergaigne, from Lille, in his *Card Players* (1699, Arras; pl.195), a delightful conversation piece, shows how provincial high society aped the manners of the court. Scenes engraved by Sébastien Le

Clerc, and the fashion plates of Jean de Saint-Jean and Bernard Picart, portrayed elegant ladies and gentlemen in their domestic surroundings. The attention given to dress and to contemporary customs had never been so strong, and was usually presented in engravings. At the same time, genre painting acquired a sort of theoretical dignity. Roger de Piles, disputing the 'simple truth' and the 'ideal truth' advocated by Bellori and the followers of Poussin,[40] tried to show that the one is not inferior to the other in difficulty. The search for individuality and variety went hand in hand with the development of the picturesque. The number of Dutch paintings in French collections increased towards the end of the century, providing accompaniment in a minor key to the triumph of the great colourists, Titian and Rubens. An important item in the collection of Roger de Piles (who was imprisoned in the Low Countries from 1693 to 1697, while on a diplomatic mission) was Rembrandt's begrimed *Woman*. The Salons of 1699, and particularly of 1704, endorsed the broadening of artistic taste and the triumph of genre painting[41] — genre painting that slipped easily into anecdote and fantasy and which, after the period of stability imposed by the Le Nain brothers, resumed its connection with 'reality' based entirely on convention.

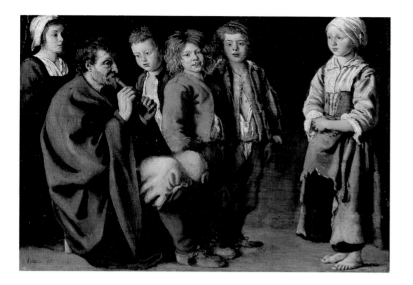

Notes

1. For a critical history of La Tour, see exh. cat., Paris, 1972 (2), pp.85–103; for a critical history of the Le Nain brothers, see exh. cat., Paris, 1978–9 (1), pp.61–71, and Rosenberg, 1993, pp.10–14.

2. Wildenstein, 1950–1.

3. Grivel, 1986 (see in particular pp.138–60).

4. The subject of the *Bamboccianti* is covered in two exh. cats: Rome, 1950, and Rome and Rotterdam, 1958.

5. Willem Kalf (1619–93) spent the years between 1642 and 1646 in France. The two paintings in the Museum in Strasbourg date from this period: *The old Well* and *Interior of a Barn*. The harmonious colour scheme and the free technique anticipate the work of Watteau and Chardin. See Brenninkmeyer-de Rooij, 1986.

6. Exh. cat. Nancy (1), 1992, pp.263–307.

7. Grivel, 1986, *passim*.

8. See below, note 31.

9. See J. Thuillier's recent (1992, pp.28–32) hypothesis proposing the attribution of *St Joseph's Workshop*, now in the church at Serrone, near Foligno, to the young La Tour.

10. Pariset, 1949; Thuillier, 1992. See also Thuillier, 1972 (1).

11. Caravaggio did not paint nocturnes as such. But a painting like the *Annunciation* in Nancy, which in La Tour's day adorned the high altar of the bishopric in Nancy, could, with its monochrome colours and deep shadows, have marked the young painter very deeply (see Pariset, 1972).

12. Thuillier, 1985 (1), p.8.

13. On the problem of La Tour's spirituality, possibly tinged with stoicism, see in particular Thuillier, 1985 (1), p.7, and 1992, pp.152ff. and 177.

14. R. Taveneaux, 'La Lorraine, terre de catholicité', exh. cat., Nancy, 1992 (1), pp.42–51.

15. Nicolson and Wright, 1974 (quoted by Thuillier, 1985 [1], p.14).

16. Ottani Cavina, 1966 (quoted in Thuiller, 1985 [1], p.13).

17. See above, chapter 5, p.113.

18. See on this Cuzin, 1979 (1); his hypotheses are reiterated by Rosenberg, 1993, no.76; Thuillier, 1979 (1).

19. On this group of paintings (ascribed by Cuzin and Rosenberg to Mathieu after 1648, whereas Thuillier and ourselves would identify them as early efforts by the three brothers) see above, chapter 3, p.69.

20. Rosenberg (1993, p.6) repeats the distinction traditionally made between Antoine and Louis while perfectly aware that it is an arbitrary distinction and still lacking any irrefutable evidence.

21. Claude Leleu, *Histoire de Laon*, manuscript in the municipal library in Laon, vol.II, p.592 (quoted by Thuillier, exh. cat. Paris, 1978–9 [1], p.42).

22. Paintings attributed to Mathieu by Rosenberg, 1993, nos 55 and 61.

23. Mathieu's masterpiece, according to Rosenberg, 1993, no.65.

24. Exh. cat. Meaux, 1988–9, no.43 (note by J. Thuillier).

25. Rosenberg, 1993, nos 52 and 28.

26. Attributed to Louis by Rosenberg, 1993, nos 22 and 47.

27. Attributed to Louis by Rosenberg, 1993, nos 40, 32, 36 and 41.

28. Jamot, 1929 (quoted by Rosenberg, 1993, p.12).

29. Cuzin, 1978.

30. Catalogue to the exhibition in Paris, 1978–9 (1), pp.318–29.

31. *Ibid*, pp.330–8.

32. *Ibid*, pp.339–47.

33. 'Bourdon and Michelin (the *bamboches*-maker; he would sell them at the fair as paintings by Le Nain) were two dangerous copyists, seasoned rogues as far as copying was concerned.' (Quoted by Thuillier, exh. cat., Paris, 1978–9 [1], p.339).

34. *Ibid*, pp.349–51.

35. His *Essai sur la vie et l'œuvre des Le Nain*, published in the *Bulletin de la Société historique et archéologique de Soissons* in 1849 is the first of many studies of the three brothers.

36. See MacGregor, 1979.

37. See Adhémar, 1979, and Cuzin, 'Le Nain' in Bluche, 1990.

38. Ménier, 1978.

39. Félibien, 1666–88, part 5, *Entretien* 9 (1688), pp.487–8.

40. De Piles, 1708 (1989), pp.21–2.

41. See below, chapter 12, p.295.

194. The Le Nain brothers,
The Children and the Old Whistle Player.
Oil on copper,
21 × 29 cm.
Art Institute, Detroit.

195. Pierre Bergaigne,
The Card Players, 1699.
Oil on canvas,
71.5 × 91 cm.
Musée des Beaux-Arts, Arras.

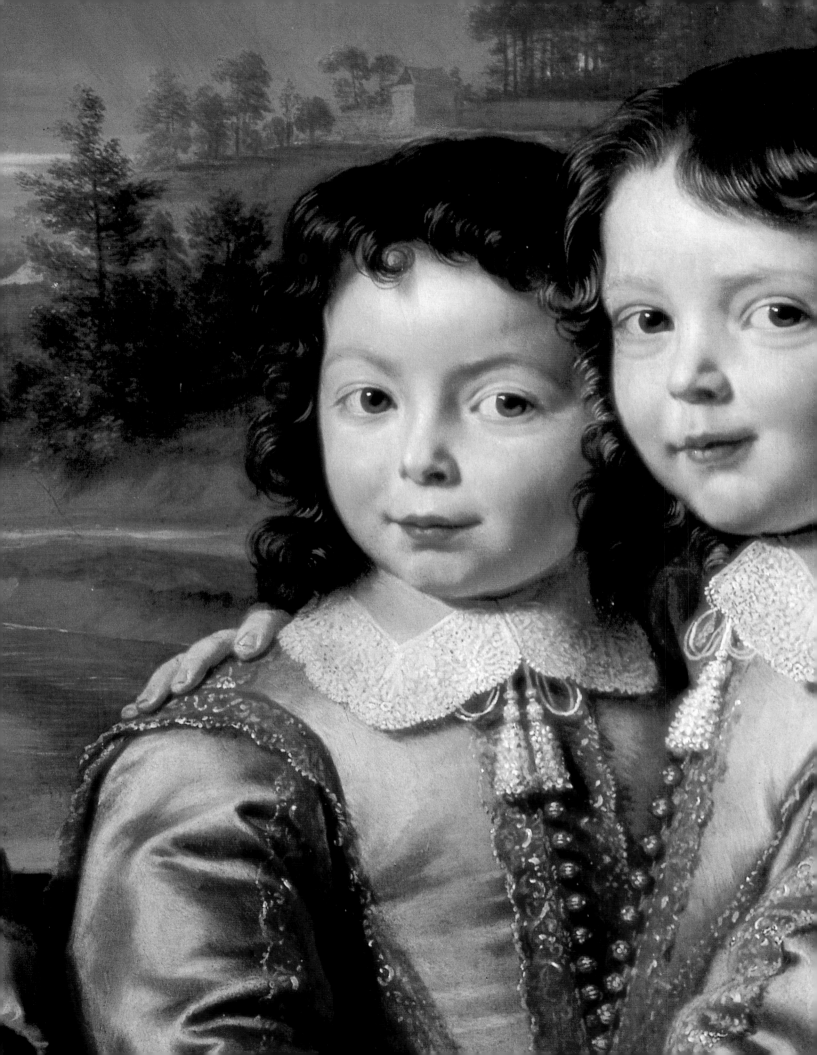

PORTRAITURE

In his *Historiettes*, an irreverent portrait of French high society at the time of Richelieu and Mazarin, Tallemant des Réaux mentions only one artist: Daniel Dumonstier, celebrated for his portraits in three coloured chalks, his collection of rare books and his outspokenness.[1] Portrait painters had frequent contact with members of the upper classes and therefore stood out from the normal run of painters. Without mentioning such celebrated names as Rubens and Van Dyck, befriended by princes, and worthy heirs to the mantle of Titian, the Le Nain brothers come to mind, launched in Parisian and court society by their talents as portrait painters, and portrayed as such in a *roman à clef* by Du Bail.[2] Later, Pierre Mignard, whose fame rested largely on his success as a portrait painter, was the protégé of an entire aristocratic and intellectual clique and the only painter permitted a mention in Saint-Simon's *Mémoires*.[3] An engraving by Bosse[4] and a painting attributed to Antoine Le Nain,[5] depict the portrait painter as an elegant figure, working among the aristocracy and gentry. The social usefulness of portraiture, an artistic style that was particularly valued and grew more and more lucrative as demand increased, contributed to the recognition and social advancement of painters in general.

Portraiture was considered to be inferior to history painting in both difficulty and dignity. 'The representation of a person in his or her natural state':[6] the subject was the individual, singly or in a group, but never engaged in activity. Lifelike by definition, the portrait was supposed to follow nature as closely as possible, thereby falling into the category of straightforward imitation. Reservations about the art of portraiture on the part of those close to Academy circles did not prevent the problems inherent in the genre from being acknowledged, nor did they stop portrait painters in droves being welcomed into the bosom of society at the end of the reign of Louis XIV. It is evident that, between the beginning and the end of the century, the portrait grew more ambitious; at the outset it was the domain of specialised painters and had to adapt to the demands of a diversified clientèle. Besides its official function (royal portraits and, more widespread, court portraits; group portraits painted for

municipalities or families; bourgeois portraits of greater or lesser sophistication) it had an equally important historical and documentary function. Curiosity about the facial features of 'great men' or forebears led to the formation of vast collections, often assembled in galleries but also sometimes consisting of collections of drawings or volumes of engravings, the latter being enjoyed by a large public. The portrait also had a part to play in fashionable life: it played a key rôle in the 'gallantry' of the day, as a representation of or substitute for the loved one, or as a eulogy in praise of the person represented, who would appear in historical or mythological disguise, or as an allegorical figure. The portrait is therefore omnipresent in seventeenth-century France, and could be the subject of a social history devoted entirely to it.

At the same time, however, the portrait was beginning to evade its real purpose. With increasing frequency, portrait painters were versatile artists who breathed new life and liberty into the portrait and did not wish to be confined to representing simply the rank and status of their model, or to giving an exact account of his or her facial features; they wanted to paint a real painting that would show off their culture and skill as well. The composition of the portrait, conventional and governed by strict rules at the beginning of the century, grew more flexible and more complicated by the end, by which stage it was able to accommodate landscape, still-life and genre scenes in a sometimes explicit spirit of rivalry with subjects held to be more noble. The rules governing this humdrum art were of necessity very closely

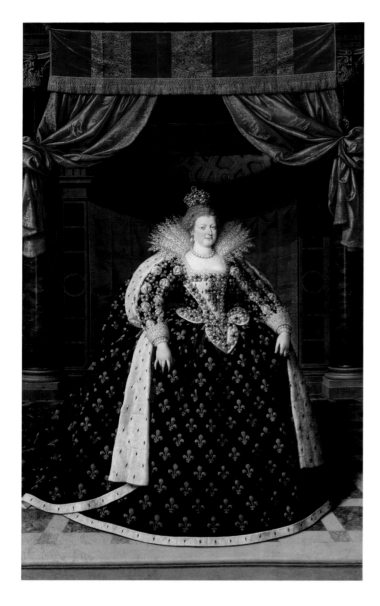

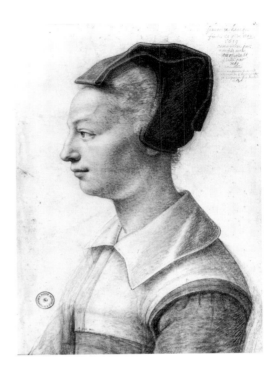

linked to its original purpose; above and beyond them, close attention needs to be paid to the great practitioners who broadened the register of portraiture, from the intimate to the ceremonial, using a diversity of styles, and, with ever increasing skill, were able to enrich the detail and increase the naturalness of the portraits they painted. In order to identify the main stages of this art, a selection must be made from a vast and often artistically quite uninteresting field; we need to concentrate on works in which the painter's creativity and imagination has succeeded in transforming tradition.

THE FRENCH TRADITION AND THE FLEMISH CONTRIBUTION

The principles of half-length or bust portraiture were already well established at the beginning of the century.[7] Under François I, Jean Clouet and Corneille, from Lyon, pieced together their style from Lombard and especially northern elements; later, François Clouet enriched the style with some Florentine Mannerism which strengthened

199. Frans Pourbus the Younger, *Marie de Médicis*, about 1609. Oil on canvas, 307 × 106 cm. Musée du Louvre, Paris.

200. Daniel Dumonstier, *Portrait of Françoise Hésèque*. Coloured pencils, 41.8 × 29 cm. Département des Estampes, Bibliothèque Nationale, Paris.

it without altering its quiet objectivity. The emphasis was on individual character, the face taking precedence over any incidental detail; the almost universal absence of hands further reduced the opportunity for animation. The success of this formula encouraged its rapid spread, from aristocratic circles down to the bourgeoisie, often to the detriment of quality. Nevertheless, the painted works, or, more often than not, the works in three coloured chalks by François Quesnel and Augustin Quesnel the Elder, Daniel Dumonstier and, sometimes in the caricature mode, Nicolas (?) Lagneau, are more than a match for the portraits of the previous century, with their delicate observation and unaffected composition and execution. Concern for objectivity verging on austerity was a notable feature of French portraiture during the first half of the seventeenth century and later, when it was taken up by a series of imitators and adaptors. A similarly dry and solemn style characterises Nicolas Moillon (*Eustache de La Salle*, 1613, Reims; pl.201), Jean Tassel (*Catherine de Montholon*, about 1648, Dijon) or the anonymous author (from Lorraine) of the double portrait of *Nicolas and Madeleine Fournier* (1625,

201. Nicolas Moillon,
Eustache de La Salle, 1613.
Oil on canvas,
58.5 × 49 cm.

Musée des Beaux-Arts,
Reims.

202. Jacob Bunel
(attributed to),
Portrait of King Henri IV.
Pencil, pen and white
wash and heightening on
buff paper.
40.4 × 29.5 cm.

Département des Arts
Graphiques, Musée du
Louvre, Paris.

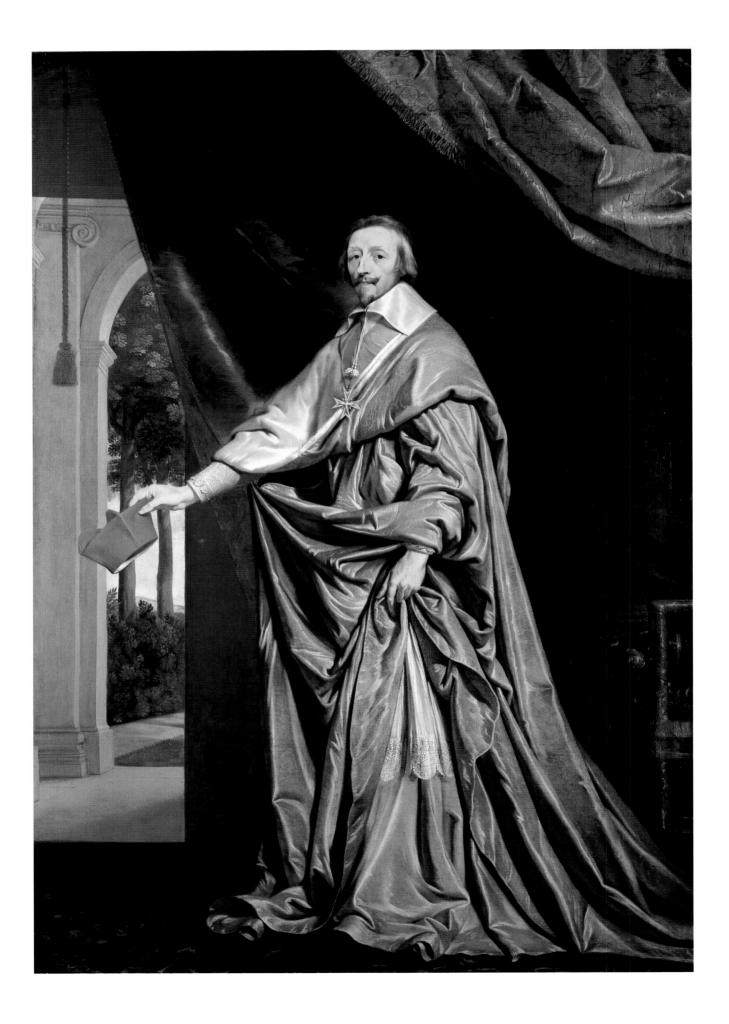

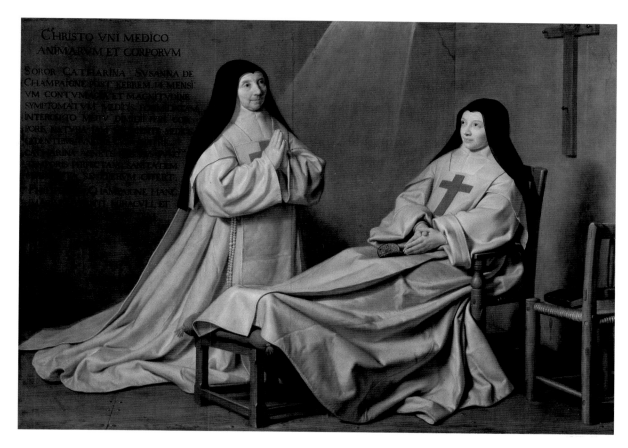

CHRISTO VNI MEDICO
ANIMARVM ET CORPORVM

SOROR CATHARINA SVSANNA DE
CHAMPAIGNE

204. Philippe de
Champaigne,
Ex-Voto, 1662.
Oil on canvas,
165 × 229 cm.
Musée du Louvre, Paris.

Nancy, Musée Lorrain). In Toulouse, Jean Chalette had just begun to soften his model's pose with a hint of background and slightly improved psychological insight, as can be seen in his *Canon* (1623, Toulouse) and *Jean de Caulet dressed as Apollo* (1635, also in Toulouse). This somewhat archaic mode persisted, even when the provinces had assimilated more modern models from abroad. The demand for a perfect likeness, and the solemnity that accompanied it, are still in evidence in the work of Laurent Fauchier in Aix, François Puget in Marseille or Jean-Pierre Rivalz in Toulouse.

The presentation of the human figure in an architectural setting, accompanied by various accessories, was appropriate to the ceremonial portrait that developed in sixteenth-century Europe, from Titian onwards, and was passed on by the Tuscan painter Bronzino and Antonio Moro, the Hispanicised painter from Flanders. With Pourbus, Rubens and Van Dyck international courtly portraiture, combining the traditions of the north and the south, experienced its golden age. Represented by artists more modest in scope, it featured at the court of Henri IV.[8] The imposing portrait of the King dressed as Mars, attributed to Ambroise Dubois (Pau; pl.197), has a certain stiffness but it also has authority, with the arrangement of the curtains and the *contrapposto* reminiscent of Michelangelo's sculpted dukes in the Medici Chapel. This is a good example of the

'historical' effigies erected for political purposes and often incorporated into a monumental decorative scheme. Jacob Bunel, his wife Marguerite Bahuche and Frans Pourbus the Younger contributed to such a scheme in the Petite Galerie in the Louvre. If the drawing in the Louvre attributed to Toussaint Dubreuil[9] is to be believed, each pier bore a full-length portrait surrounded by faces in medallions and monograms. The King's portrait only assumed its full significance in relation to the portraits surrounding it: it was a single link in a historical continuum, the outcome of a dynasty reconstructed from old documents with painstaking attention to detail. Pourbus painted a portrait of Marie de Médicis in full regalia for the same gallery (about 1609, Louvre; pl.199). His brilliant, rather cold skill, his feeling for clearly outlined mass, and his attention to detail can all be seen in a masterpiece like his *Duc de Chevreuse* (Spencer collection, Althorp); here the curtain, the table and the dog are all part of the structure, and the well-chosen contrast of red and black gives the figure a kind of heraldic impact. Flemish art, nurtured by Italian and Spanish examples, became firmly established in Paris: it was Ferdinand Elle who, having arrived in Paris in 1609, opened a successful studio and founded a dynasty of painters specialising first and foremost in portraiture; soon it would be Rubens. Having painted Marie de Médicis (Prado), Rubens with his usual energy painted the princesses' parents for

203. Philippe de
Champaigne,
Richelieu.
Oil on canvas,
260 × 179 cm.
National Gallery, London.

187

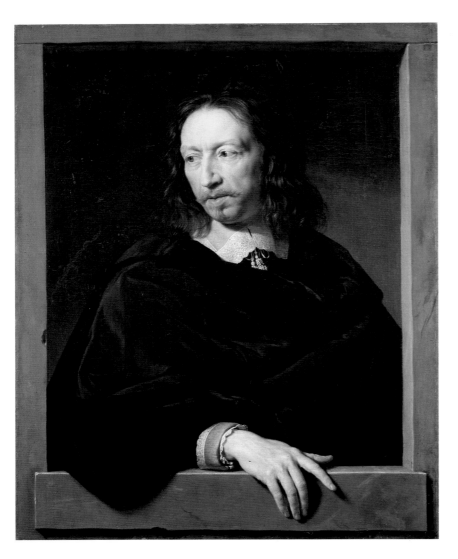

205. Philippe de
Champaigne,
Portrait of a Man, 1650.
Oil on canvas,
91 × 72 cm.
Musée du Louvre, Paris.

for ceremonial portraits, rejecting however
equestrian compositions and mythological per-
sonification. His *Louis XIII crowned by Victory*
(1635, Louvre), from the Palais Cardinal, consti-
tutes an exception in the *œuvre* of a painter who
scorned mixed genres, and who relied firmly on
the personality of his sitters and not on allegorical
artifice. His portrait of Richelieu, of which there
are versions in Paris (Sorbonne), London and else-
where, shows the statesman standing alone, seen
from a low view point which causes all the lines of
composition to converge on the face. The sculp-
tural drape of his *cappa magna* and the background
of columns and curtains contribute to the majesty
of the subject. The black and red *Omer II Talon*,
with his piercing gaze, in Washington, is only
slightly less intimidating. As in the work of
Pourbus, the figures gain dignity from the vast
surrounding space, which is almost devoid of
incident or clutter.

Once Richelieu and Louis XIII were gone,
Champaigne's clientèle broadened. The whole of
French society came to pose for him, mainly men,
very few women and children although he had
some notable successes in that field (*The Montmort
Children*, 1649, Reims; pl.196). He began to
practise more intimate portraiture, increasingly
painting half and three-quarter-length portraits,
softening the traditional head-and-shoulders; his
subjects would sometimes be painted in an archi-
tectural framework or framed in a window (as was
traditional in Holland), to emphasise the *trompe
l'œil* effect. This arrangement can be seen in the
Portrait of a Man (1650) and *Arnaud d'Andilly*
(1667) in the Louvre; in both the hands are
painted with unparalleled intensity and there is
the echo of the scholarly severity of some of
Poussin's self-portraits. The lucid, attentive ren-
dering of the figures captures their essence
without affectation. Neither the colours, deliber-
ately muted, nor the brushstrokes, painstaking but
without unnecessary panache, distract attention
away from the subject. The growing links
between Champaigne and Port-Royal reinforced
the painter's tendency towards objectivity and
impossibility. For the Jansenists, the self is detest-
able; the portraits of the priests and nuns and
Messieurs of Port Royal were sometimes drawn

the Galerie du Luxembourg (Louvre). But the
leading figure was Philippe de Champaigne.

Champaigne's Flemish training is noticeable in
very early paintings like the *Small Girl with the
Falcon* (Marie de Chevreuse) in the Louvre, dated
1628. The smoothly applied colour, the meticu-
lous painting of the carnation and the fabrics, and
the interest in detail mark him out as a warmer
version of Pourbus. His portraits, for years his
most admired work, were prepared in minutest
detail with studies of profiles and hands. As official
court painter he practised historical portraiture (as
seen in the Galerie des Hommes Illustres in
the Palais Cardinal[10]) and developed a formula

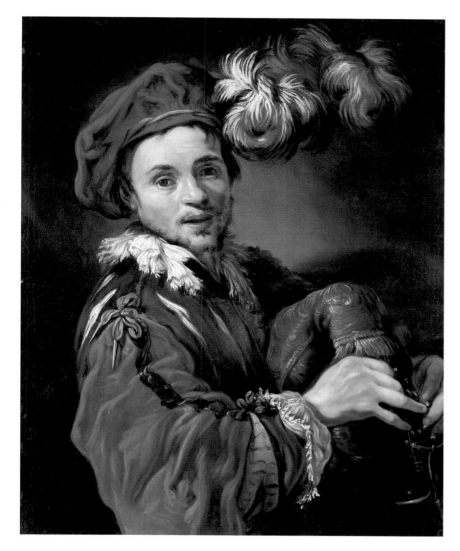

without their knowledge, but this does no harm to their exemplary quality: one only has to look at the posthumous portrait of *Saint-Cyran* (1643, Grenoble) painted from a death mask, or *Mère Angélique Arnauld* (1654, Louvre).

The *Ex-Voto* in the Louvre (1662; pl.204), a combination of religious painting and portrait, is certainly Champaigne's masterpiece. Within its very organised construction can be found the solemnity and sense of volume characteristic of medieval sculpture. Its timeless quality is emphasised by the ambiguity of the setting, in which the only points of reference are the angle of a wall and the oblique line made by the armchair

206. Claude Vignon,
*Langlois dressed as a
Bagpiper.*
Oil on canvas,
80 × 63 cm.
Davis Museum and Cultural
Center, Wellesley College,
Wellesley.

207. Simon Vouet,
Self Portrait(?), about
1618.
Oil on canvas,
64 × 48 cm.
Musée Réattu, Arles.

and the stool. In this rarefied atmosphere the divine light plays discreetly on the colours, restricted to a range of faded greys and browns against which the pale blue of the cushion and the brilliant red of the scapulars stand out. This painting, in which virtuosity is transcended, is often held up as the leading example of a particular kind of sober and measured French taste. The picture remains nevertheless on the margins of the general evolution of the portrait which, during the seventeenth century, moved more and more in the direction of animation, elegance and chiaroscuro effects. Van Dyck's seductive manner was quickly preferred to the severity of Pourbus.

SIMPLICITY AND FASHION: THE RELAXATION OF TRADITIONAL FORMS

With Simon Vouet and some of his companions in Italy a watershed was reached and a new set of references appeared: Venice and the great painters of the sixteenth century and their successors; Genoa and Bernardo Strozzi; Rome in particular

208. Jacques de Létin,
Self Portrait.
Oil on canvas,
65 × 52 cm.
Musée des Beaux-Arts,
Troyes.

209. Claude Mellan,
Profile of a Woman.
Pencil, 12.8 × 10.4 cm.
Statens Konstmuseen,
Stockholm.

210. *opposite*:
Sébastien Bourdon,
*The Man with black
Ribbons*, about 1657.
Oil on canvas,
105 × 85 cm.
Musée Fabre, Montpellier.

and shoulders, and by the naturalness of the pose. When he returned to France he worked chiefly in pastels (a medium also chosen by Vouet and his wife Virginia da Vezzo), which highlight speed of execution and the sensitivity of the artist. Vouet left a fine series of pastel portraits representing Louis XIII's intimate friends (private collection).[12] Their candour causes one to regret the almost complete disappearance of painted portraits dating from his Parisian period. Taking over from pencil portraits in the manner of Clouet, these portraits must surely have been influential: the different faces of Louis XIV by Le Brun come to mind and the meticulous, firm art of Robert Nanteuil, trained in Flanders and also an excellent engraver. Pastels offered increasing competition to paint, as Joseph Vivien's fine, very polished portraits demonstrate; later, pastel moved towards greater freedom.

Vouet's lively Roman portraits led to an art that was as aware of the individual as Clouet and his followers had been, but Vouet was without the stiffness of his predecessors, and he sought consciously to enlarge the range of expression. From the 1630s, the artists connected to the Premier

with Annibale Carracci and the draughtsman Ottavio Leoni. Nor should the northern colony be forgotten. Through contact with them, Vouet began to enliven his subjects with dissymmetries, and to try to catch fleeting, sometimes dreamy, expressions as his contemporary Bernini was trying to do in his sculpture and painting.[11] Vouet paints with a spacious, fierce touch seasoned with patches of thicker paint as can be seen in the supposed *Self Portrait* in Arles, probably painted in about 1618 (pl.207). Companions such as Le Valentin, Régnier or Vignon also produced some lively, candid portraits, brightly coloured and mildly bohemian, very different from the dignified objectivity of Champaigne: Vignon's *Langlois dressed as a Bagpiper* (1621[?]), Wellesley College; pl.206) is a superb example of the style. Nevertheless in official commissions like *Giancarlo Doria* in the Louvre (1621) Vouet selects a firmly frontal viewpoint that highlights the intensity of the sitter's gaze. Claude Mellan, in his drawings (there is an admirable series in the Hermitage) and engravings, achieves expressiveness by the direct way he approaches his sitter, seen only in head

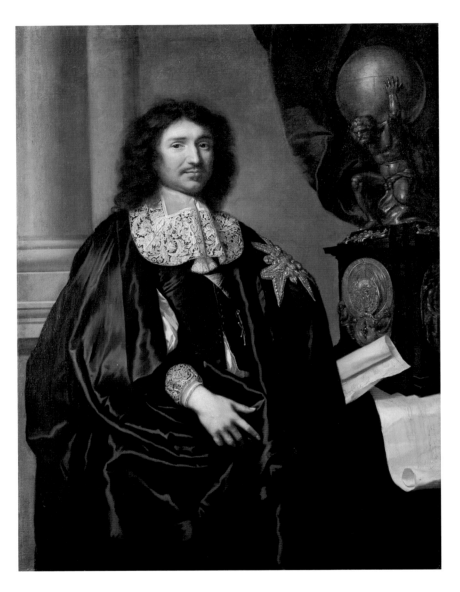

211. Claude Lefebvre,
*Portrait of Jean-Baptiste
Colbert*, 1663.
Oil on canvas,
138 × 113 cm.
Musée National du Château,
Versailles.

the model is preserved; the studied simplicity of pose and garb and the intensity of expression emphasise the sitter's elegance. To the example of Vouet and Mellan (pl.209) was added the influence of Van Dyck, who did not arrive in Paris until 1641 but whose work was already well known from engravings.[14] The presence of a number of portraits of artists, and of self-portraits, is significant. It indicates a network of acquaintanceship and a complicity and camaraderie, with some shared preoccupations as well; but it also indicates a heightened sense of dignity and of the special attributes of the artist, a newcomer to social and intellectual life and the possessor of a particular skill. Poussin's two unclassifiable *Self Portraits*, painted for his two main clients and friends in France, Pointel and Chantelou (1649, Berlin and 1650, Louvre) go even farther: indecision and charm seem deliberately excluded. Instead the portraits speak with the authoritarian voice of a manifesto.[15]

The founder members of the Academy, established in 1648, included a number of portrait painters: Juste d'Egmont, who was Flemish; the cousins Henri and Charles Beaubrun; Louis Elle, son of the afore-mentioned Ferdinand Elle; the brothers Henri and Louis Testelin; and, last but not least, Le Brun himself who, with his *Chancellor Séguier* (1661[?], Louvre), produced a fitting rejoinder to the equestrian portraits of Rubens and Van Dyck. A controlled rejoinder, nevertheless, in which the brilliance of the colours and costumes does not compromise the dignity accorded to such a solemn proposal. Sébastien Bourdon comes into a special category thanks to the distinction of his portraits in the 'Louis XIII romantic' style: *The Man with black Ribbons* (about 1657, Montpellier; pl.210) daydreams gracefully. At the same time, Bourdon's interest in structure led him to experiment with portraits in which blacks, greys and whites, measured out with care, set off the faces and hands to great effect, as in the *Portrait of a Man* (Chicago) evidently contemporary with the portrait in Montpellier. He was also able to deal with monumental size in his ceremonial portraits, the most celebrated being his *Christina of Sweden on Horseback* (Prado), painted during a spell at court in Stockholm in 1652–4, and fit to

Painter of Louis XIII, whether closely or more distantly, began to cultivate a confidential style, tinged with a kind of romanticism. A similar inflection could be found in Bologna in the portraits painted by Guercino between 1620 and 1640. Jacques Blanchard, Eustache Le Sueur, Jacques de Létin (pl.208), Jean Daret and the young Charles Le Brun (whose interest in physiognomy will be discussed later[13]) all at some time practised the portrait bust using a minimum of accessories, painted with almost casual rapidity in warm, dark colours. The private relationship with

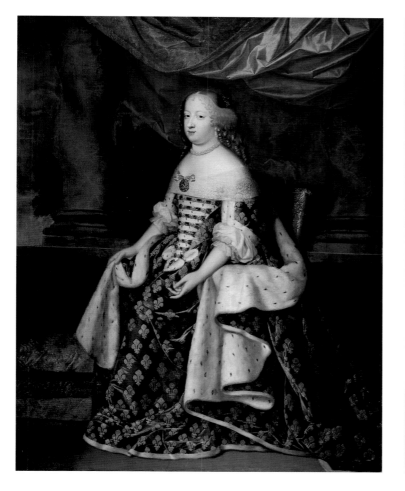

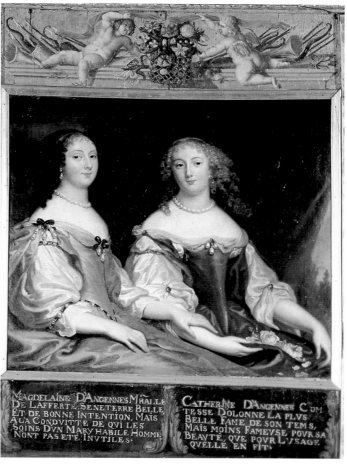

withstand comparison (a formidable challenge) with Velázquez.

The diversity of styles and large number of talented painters available by the middle of the century created an unprecedented passion for portraiture among the upper classes. One of the documents attesting to this is the inventory of the possessions of Claude Deruet, painter at the court of Lorraine, who died in 1660 and left a large number of portraits of all sizes and at all prices.[16] During the years 1640 to 1660 a type developed that might be classified as the society or *précieux* portrait,[17] which benefited from the psychological and intellectual sophistication of the literature then in fashion (novels, poetry, pastoral idylls). Far from rejecting conventions, this type of portraiture played with them tirelessly, responding indulgently to the whims of a largely female

212. Henri and Charles Beaubrun (attributed to), *Portrait of Maria-Theresa of Austria.* Oil on canvas, 180 × 140 cm. Musée National du Château, Versailles.

213. Anonymous, seventeenth century. *Catherine and Madeleine d'Angennes.* Oil on canvas. Château de Bussy Rabutin (Côte d'Or).

clientèle who preferred flattery to resemblance. One of Molière's heroines voices her thoughts on the matter:[18]

I am not like those women who, when they have their likeness painted, want portraits that are not of them, and are thoroughly dissatisfied with the painter if he does not make them lovelier than the day itself. To please them there should be only one portrait for all of them since they all require the same things: a complexion of lilies and roses, pretty nose, small mouth and large, sparkling eyes, well-spaced. Above all the face should be no larger than a fist (even if it is in reality a foot long). As far as I'm concerned, I require a portrait that is me, and which doesn't require people to ask who it is.

The art of the cousins Henri and Charles Beaubrun might seem highly conventional and contrived, because we judge it mainly from the numerous replicas and copies, of extremely uneven quality, that testify to its success. The

193

Beaubrun cousins painted flattering full or half-length portraits of aristocratic women, dressed in the attire of the period or disguised as mythological or pastoral characters, distantly reminscent of the court portraiture at Fontainebleau. The picture of *Claire-Clémence de Maillé, Princesse de Condé* is in bright enamel tones, the princess being dressed as a shepherdess crowned with a wreath of flowers (private collection); the official portraits of *Maria-Theresa of Austria* (Versailles; pl.212) and the *Grand Dauphin as a Child* (Prado) were painted during the 1660s. Juste d'Egmont, a disciple of Rubens, should be placed alongside the two cousins; he was responsible for a majestic series of royal portraits that were in the Luxembourg (about 1652?), and are now in the Château de Balleroy. There were certainly artists of lesser calibre as well, but the problem of attributions remains a very thorny one. Who painted the pictures (some of them of very modest quality) in the *Cabinet des Beautés* assembled by Roger de Bussy-Rabutin for his château in Burgundy? Is the fine double portrait of Catherine and Madeleine d'Angennes from the Beaubruns' studio or from the studio of Juste d'Egmont? Should the grisailles traditionally attributed to Jean de Saint-Igny, representing various princes and scenes from life at court (Versailles, Rouen, Vassar College and elsewhere), be attributed to Juste d'Egmont?[19] Not to be ignored also was the tremendous diffusion of the aristocratic portrait in all sorts of media: to the pastels, drawings and engravings discussed above should be added the miniature, the indispensible stimulus to 'gallantry' and enjoying a rapid boom.[20] The technique of painting in enamel on gold, widely practised in England, made it possible to create paintings in jewel-like colours that would withstand the passage of time. But the names of Petitot, Hanse (Louis van der Bruggen) and especially Louis du Guernier, one of the first members of the Academy, all celebrated in their day, are now no more than names. Very few secure attributions exist in this area, and it is hard to distinguish between the work of French artists and the contribution of their colleagues from abroad. The gouaches on parchment of Joseph Werner, summoned in 1642 to the court of Louis XIV, show

real ambition; these are reduced versions of large compositions in which the members of the royal family are portrayed in ceremonial dress or in mythological attire, painted with refinement in fairytale hues. The artist, a German trained in Italy, reveals an exquisite talent for detail. With him, the portrait enters the world of festivities and spectacle.

When Louis XIV, the Sun King, came to the throne a moment of stability was embodied in the person of Claude Lefebvre, who succeeded in combining dignified elegance with lively poses and psychological truth. His *Colbert* (1663, Versailles; pl.211) and *Madame de Sévigné* (about 1662–5, Musée Carnavalet) are masterly in this respect, but his development as an artist is little understood because most of his paintings have disappeared and are known only through prints. He seems to have started out observing his subjects in minutest detail, in the manner of Champaigne, but later, as soon as he started painting historical scenes, he sought more movement. *Charles Couperin and his Daughter* (Versailles), *Conrart* at his work table, pen in hand (engraving by Cossin), or *Le Camus playing the Theorbo* (quoted by Dézallier d'Argenville) are all examples of action portraits, typical of the period when the style was revived by the Italians. During his stay in Paris in 1665, Bernini carved a bust of Louis XIV that caused a sensation. Chantelou, who was present at the sittings, reports the sculptor's words as follows:[21]

The sculptor, continuing to work on the mouth [of the bust] said that, for a successful portrait, a single movement should be selected and the artist should attempt to reproduce this movement accurately; the best time to portray a mouth is when it has just finished speaking or is about to speak. The artist should try to capture that moment.

The portraits of Carlo Maratta, more theatrical than those of Claude Lefebvre, were as popular in France as in Italy; Lefebvre modified his theatricality, but it was taken up again and even exaggerated by Rigaud and others.

The style fashionable at mid-century under Louis XIV, with all its artificiality, was extended by Jean Nocret, Louis Elle the Younger and Pierre Mignard, but their work found little favour

214. Pierre Mignard, *Madame de Seignelay and her Son with the Attributes of Thetis and Achilles*, 1691.
Oil on canvas,
194 × 155 cm.
National Gallery, London.

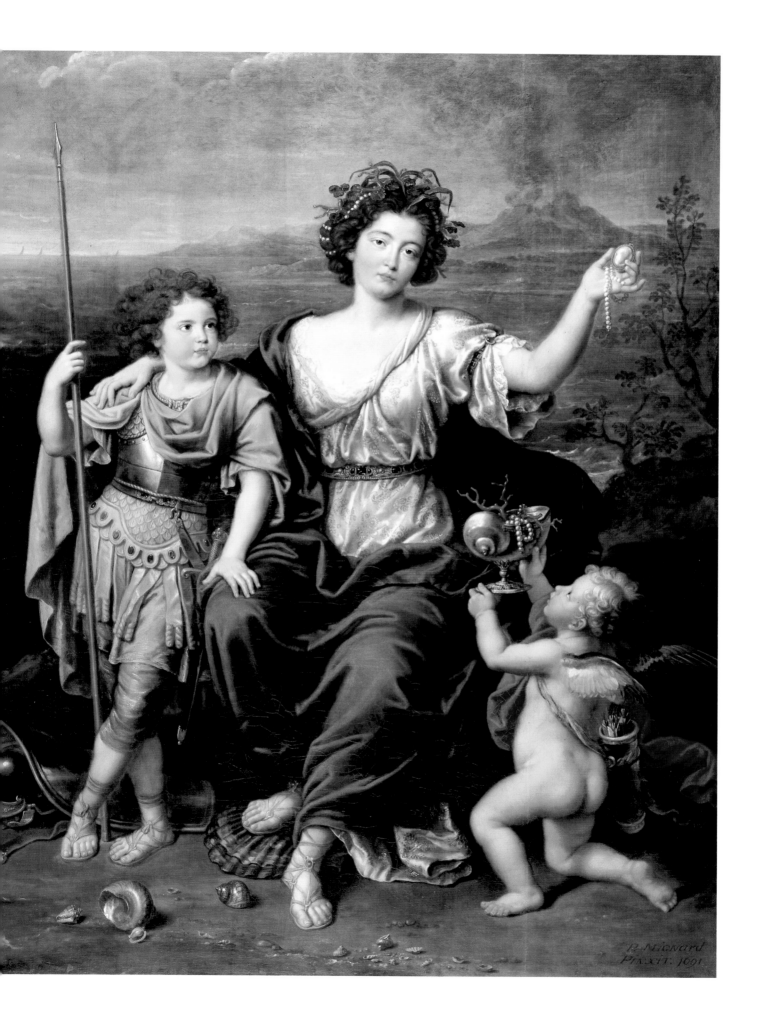

215. Pierre Mignard,
Portrait of a Man in a Fur Hat, 1654.
Oil on canvas,
119 × 98.5 cm.
National Gallery, Prague.

a masterpiece. His heads of *Molière* (Chantilly) or the police lieutenant, *La Reynie* (private collection), painted in the 1660s, use sobriety of pose and colour to set off the brightness of the model's eyes. Equally, in a slightly more self-conscious register, *Madame de Maintenon* (1691, Louvre) shows real powers of observation.

GROUP PORTRAITS

The group portrait in France, outshone by its rivals in Flanders and Holland, has had scant attention paid to it.[24] In its many guises, however (municipal, royal, society, family), it played an essential role in the portrayal of seventeenth-century society. At first the function of the group portrait was chiefly commemorative and official, and commissions emanated mainly from the administrations of large towns. Aldermen and provosts in Paris, consuls in Provence, magistrates or *capitouls* in Toulouse would have themselves painted periodically in full dress. Frequently these paintings have disappeared but the sketches, small scale versions and individual portraits in reduced size that accompanied them according to the terms of the contract, provide full and detailed documentation. In Toulouse the miniatures on vellum made to be included in the *Annales* of the city have kept alive the memory of some handsome (if somewhat stiff) paintings by Jean Chalette, André Lèbre or Jean de Troy.[25]

The development of a style that was stilted at first but grew more ambitious can be traced in Paris.[26] Lallemant in 1611 (Musée Carnavalet) or Guillaume Dumée (?) in 1614 (Versailles) present aldermen and provosts kneeling in a chapel, in strict order of rank. Philippe de Champaigne, in his painting in the Louvre (1648), does not upset the demure protocol, but gives his usual physical and spiritual intensity to the figures, as the Le Nain brothers had no doubt tried to do before him in their portrait of 1632, now lost. Under Louis XIV, municipal portraits vied with one another in flattering the monarchy, now returned to full strength after the Fronde: the portraits tended to become historical scenes with figures grouped around the King, who would be either present in the flesh or symbolically represented. In

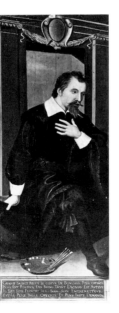

216. Jean Boucher,
Self Portrait with Palette,
1630. Left-hand panel of triptych of *St John the Baptist*.
Oil on canvas,
183 × 68.4 cm.
Musée du Berry, Bourges.

even when it was first painted. Poussin found Mignard's portraits 'cold, crushed, too done-up, and with neither fluency nor discipline'.[22] Naturalness is what is most lacking in portraits in which mythological disguises and all kinds of props and embellishments stand between the subject and the spectator. The movement is stiff and unnatural, even when Mignard is depicting *Louis XIV* on a rearing horse (1673, Turin; 1694, Versailles).[23] His most successful portraits, like *Madame de Seignelay and her Son with the Attributes of Thetis and Achilles* (1691, London; pl.214), or the *Girl with Soap Bubbles (Mademoiselle de Blois?)* (Versailles), still charm with the contrasts of (often chilly) colour, their careful execution and their chubby, softly contoured faces. Mignard's recourse to the propriety of Bolognese painters such as Domenichino and Albani, in particular, caused a revival of the tradition of court portraiture in France. But it also marked the end of an epoch; at his death in 1695 the style had already gone out of fashion. It would be a mistake, however, to look only at his official portraits. The success he enjoyed in Italy and after his return to Paris was based on a more sober, friendly style. The *Portrait of a Man in a Fur Hat* (Prague; pl.215), painted in Venice in 1654, is

1674, Noël Coypel started a new tradition in his painting showing the *Town Militia on its way to Notre-Dame after the Battle of Seneffe*; and, in 1682, François de Troy celebrated the *Birth of the Duke of Burgundy* (preparatory sketches in the Musée Carnavalet). In both cases, allegory lent animation to the group portrait. The sketches done by Largillierre and Rigaud for the commission of 1689 (Louvre; Amiens; private collection) use the device of a picture within a picture to celebrate the banquet offered to the King by a grateful city on 30 January 1687.[27] With Largillierre's big *Ex-Voto to St Geneviève*, painted in 1696 (Paris, Saint-Etienne-du-Mont), portrait and devotional painting merge in two registers, run through with light and shade. The diversity of poses and faces, emphasised by the ceremonial magnificence of the costumes, marks the climax of a genre that was dominated by the taste for grand production, yet was always dignified.

Family and society portraits were painted in different contexts. In the first third of the century donors would be included in religious works of art. In 1607, Nicolas Hoey painted Claude Bretagne, councillor in the parliament of Burgundy, and his family on either side of an *Adoration of the Shepherds* (Dijon); in 1630 Jean Boucher portrayed himself kneeling, his hand on his heart and his palette on the ground, before a monumental *St John the Baptist*, while his mother occupied the other wing of the triptych (Bourges, Cathedral and Musée du Berry; pl.216). In this type of painting the emphasis was on the faces, the rest of the picture being of the quietest nature to highlight the religious fervour of the sitters. These were survivals within a restrictive tradition.

At the same time, however, the group portrait was becoming contaminated by genre painting and this allowed the portrait to emerge from its formal straitjacket, from the figures in a row and from the frontal view. A crucial role in this transformation seems to have been played by the Le Nain brothers, who used different formulae for different clients, according to how demanding they were or how rich. The small group portraits on copper plates attributed to Antoine, like the *Pontifical Mass* or the *Musical Gathering* in the Louvre (pl.190), seem naive because of the care

217. Georges Lallemant, *Group Portrait of the Echevins of Paris, 1611.* Oil on canvas, 200 × 250 cm. Musée Carnavalet, Paris.

218. Nicolas de Largillierre, *The Provost of the Tradesmen and the Echevins of the City of Paris.* Sketch for the decoration of a chamber in the Hôtel de Ville, Paris. Oil on canvas, 31 × 43 cm.

with which they are painted and the slightly clumsy simplicity of their composition. They belong to a more popular stream than the paintings of the 1640s, which are larger and aimed at a different public: these include *The Academy* and the *Smoking Den*, dated 1643 (both in the Louvre and attributed to Louis). The second of these combines the fashionable taste for nocturnal scenes with an elegant melancholy tinged with psychological penetration. The same empathy with other people, be they ever so humble, colours his paintings of children, and their seriousness of tone repudiates anecdote. In the *Old Whistle Player* in Detroit (ascribed to Antoine; pl.194) as in *Grandmother's Visit* in the Hermitage (probably by Louis) the simple way the figures are

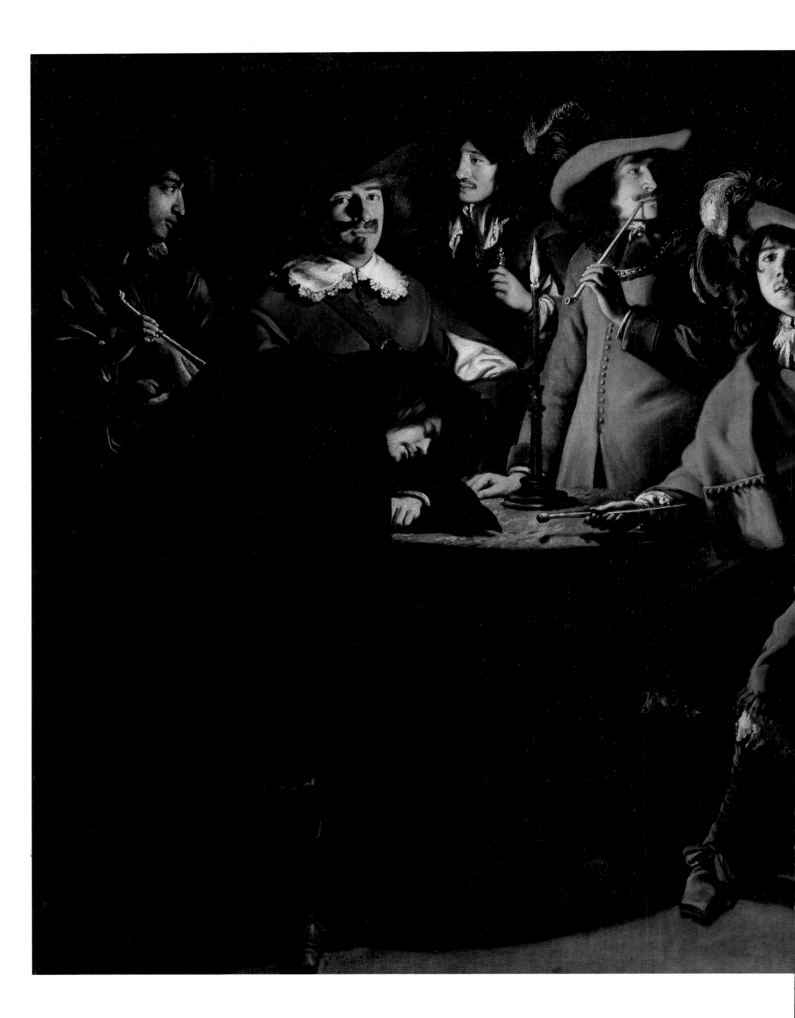

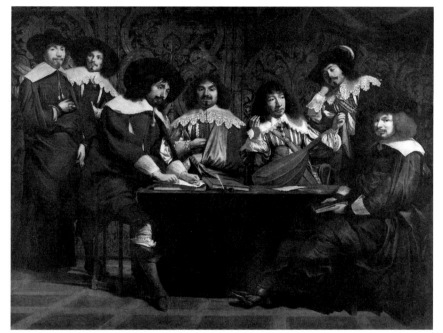

219. Louis (?) Le Nain,
The Academy.
Oil on canvas,
116 × 146 cm.
Musée du Louvre, Paris.

disposed does not inhibit the interplay of glances by which the motionless characters communicate. The revival of the group portrait in the 1640s was not only the result of the combination (sometimes skilful, sometimes less so) of several models in vogue in Paris at the time; it also resulted from a lively understanding of human nature.

Elaborate scenery began to make its appearance, along with complicated hidden meanings sometimes assisted by allegory. The *Academy* attributed to Louis Le Nain (Louvre) and the *Gathering of Friends* by Le Sueur (about 1640, Louvre; pl.23) may be compared. The first, whatever hidden meanings may be read in to it,[28] remains a photographic record and is concerned with accuracy and with social position rather like some of the Dutch 'company' portraits. In the second painting each individual is a portrait but is also the personification of an occupation or a hobby – from hunting to reading, via music and geometry, the last two seeming to take care of the harmonious blending of talents. The stylisation peculiar to Vouet and his pupils polished up the traditional formula for half-length portraits of groups of people as used by the Caravaggesques. Le Sueur included his own portrait in this painting, thereby

220. Louis Le Nain,
The Smoking Den, 1643.
Oil on canvas,
117 × 137 cm.
Musée du Louvre, Paris.

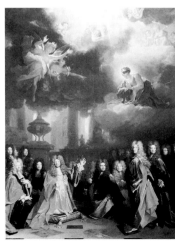

221. François de Troy,
*The Duchesse de Maine
being given a Lesson in
Astronomy.*
Oil on canvas,
96 × 188 cm.
Musée de l'Ile de France,
Sceaux.

222. Nicolas de
Largillierre,
Ex-Voto to St Genevieve,
1696.
Oil on canvas,
535 × 390 cm.
Eglise Saint-Etienne-du-
Mont, Paris.

equating painting with the liberal and noble professions.[29] The relaxed yet stylish nature of this still enigmatic work can be found in other *Concerts* of the century, as for instance the one by François Puget (1688, Louvre), which illustrates the persistence of the genre.

Family portraiture, beginning with royal family portraiture, gave rise to some elaborate composition.[30] Glamour and movement replaced simplicity and stiffness. In paintings like Nocret's *Olympus, or the Family of Louis XIV* (1670, Versailles; pl.224) the accumulation of mythological disguises is enough to raise a smile. In Mignard's *Family of the Grand Dauphin*, however (1687, Versailles; pl.223), the elegance of the

décor and the brilliance of the costumes are attractive; the painting has a more modern flavour, and is remarkable for the rhythm of the poses, used to define the relationship between the personages while maintaining regal decorum. The court set the tone, with bourgeois portraiture following at a respectful distance, in Paris as well as the provinces.[31] Le Brun's *The Jabach Family* (1658–9, previously in Berlin), with its patrician dignity, foreshadows the work of Rigaud (*The Leonard Family*, 1693, Louvre). The addition of delightful landscapes to frank and forthright portraits would wait for Largillierre. By the end of the century great (and lesser) masters were painting real conversation pieces. To mention but a few, there are Bergaigne's *Family Portrait* (Boston), *The Goldsmith Nicolas Launay and his Family* by Robert Tournières, which was exhibited at the Salon in 1704 (Caen), and above all the *Duchesse de Maine being given a Lesson in Astronomy*, by François de Troy (about 1702–4; Sceaux; pl.221) or, by the same artist, *The Painter's Family* (about 1708, private collection). These paintings may seem modest in comparison with many of the precursors, but they did supply what was most lacking in group portraits, namely intimacy and even imagination. The choice of details, the portrayal of domestic life, the search for diverting effects, and the exquisite execution characterise a 'minor taste', stemming from Dutch painting, which records certain of the changes that were happening to the society of the day.

THE END OF THE CENTURY: THE ACADEMY, THE COURT AND THE TOWN

From the 1680s onwards portrait painters were full members of the Academy.[32] Between 1680 and 1715 they made up a good quarter of the strength and included amongst their number painters of the first rank. François de Troy was admitted in 1674, Largillierre in 1686. Between 1700 and 1703 it was the turn of Rigaud, François Jouvenet, Vivien, Gobert, Tournières, Ranc, Belle . . . At the Salon of 1704 a little fewer than half the paintings on the walls were portraits. Academic portraits were first and foremost commemorative: in 1672, Jean II Garnier painted

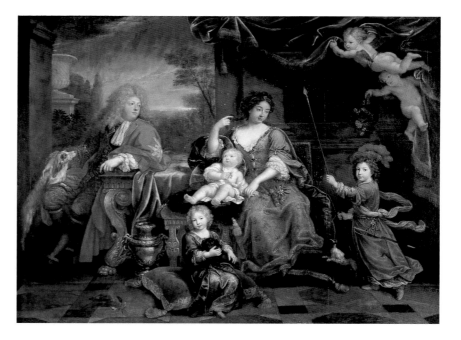

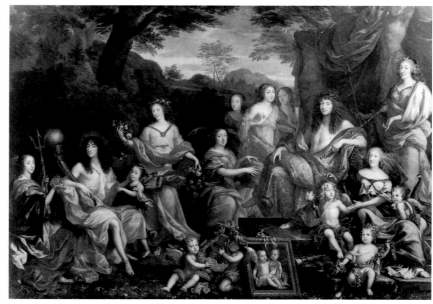

223. *above:*
Pierre Mignard,
The Family of the Grand Dauphin, 1687.
Oil on canvas,
232 × 304 cm.
Musée National du Château,
Versailles.

224. Jean Nocret,
Olympus, or The Family of Louis XIV, 1670.
Oil on canvas,
298 × 19 cm.
Musée National du Château,
Versailles.

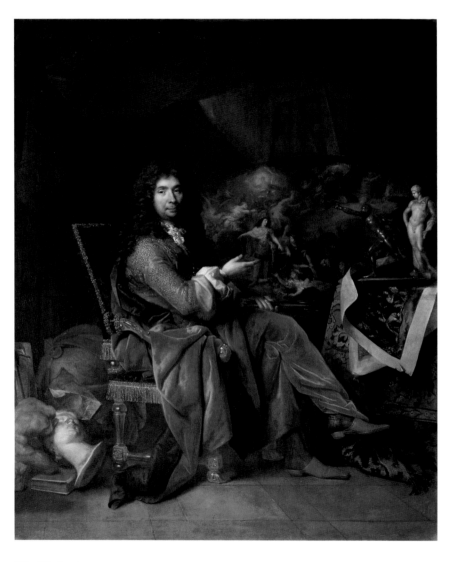

225. Nicolas de
Largillierre,
Charles Le Brun, 1686.
Oil on canvas,
232 × 187 cm.
Musée du Louvre, Paris.

226. Hyacinthe Rigaud,
Cardinal de Bouillon, 1708.
Oil on canvas,
247 × 217 cm.
Musée Hyacinthe Rigaud,
Perpignan.

Louis XIV surrounded by Attributes of the Arts (Versailles), and such homage to royal patronage became traditional. Besides the King, protectors of the institution and 'ancients' were extolled, as the series of reception pieces now mainly at Versailles makes clear. The subjects acquired a majesty that was emphasised by the symbolic accessories accompanying them. The best of these memorial portraits is the painting of Le Brun by Largillierre (1686, Louvre), a triple homage to the painter, teacher and courtier; the opulence of the setting does not stifle the warmth and sensitivity of the portrait. Pierre Mignard's *Self Portrait* (1690, Louvre) is a rejoinder and is just as splendid: the ambition and talent of Le Brun's great rival is given free rein. The social status and the great skill of the painter is proclaimed in a way that would have been inconceivable at the beginning or even the middle of the century.[33]

The two greatest portrait painters of the late seventeenth century, Largillierre and Rigaud, were accepted at the Academy as history painters as well. In fact, portrait painting became more and more difficult and comprehensive, requiring wide-ranging abilities and a keen sense of composition. Literature about art moved in the same direction. Félibien narrows the distance between portrait painters and history painters, emphasising 'the inclinations and affections of the soul' and stressing that 'extensive study is required and many observations are to be made' in this field if success is to be enjoyed and the perfection of a Van Dyck to be attained.[34] Later, Roger de Piles speaks highly of 'the agreement of the parts at the moment that marks the intellect and temperament of the person', drawing attention to the difficulty of representing 'the man in general' as well as 'a man in particular, different from all other men'.[35] This search for the indestructible, individual quality of a person put the portrait at the centre of the theoretical debates, and of efforts at renewal, at the end of the century; it also heralded the art of the Regency, with its rejection of formalism. The debates identified two different strands: the ceremonial portrait moved towards its apotheosis, the 'bourgeois' portrait towards increasing simplicity and austerity.

It was the Catalan Hyacinthe Rigaud who

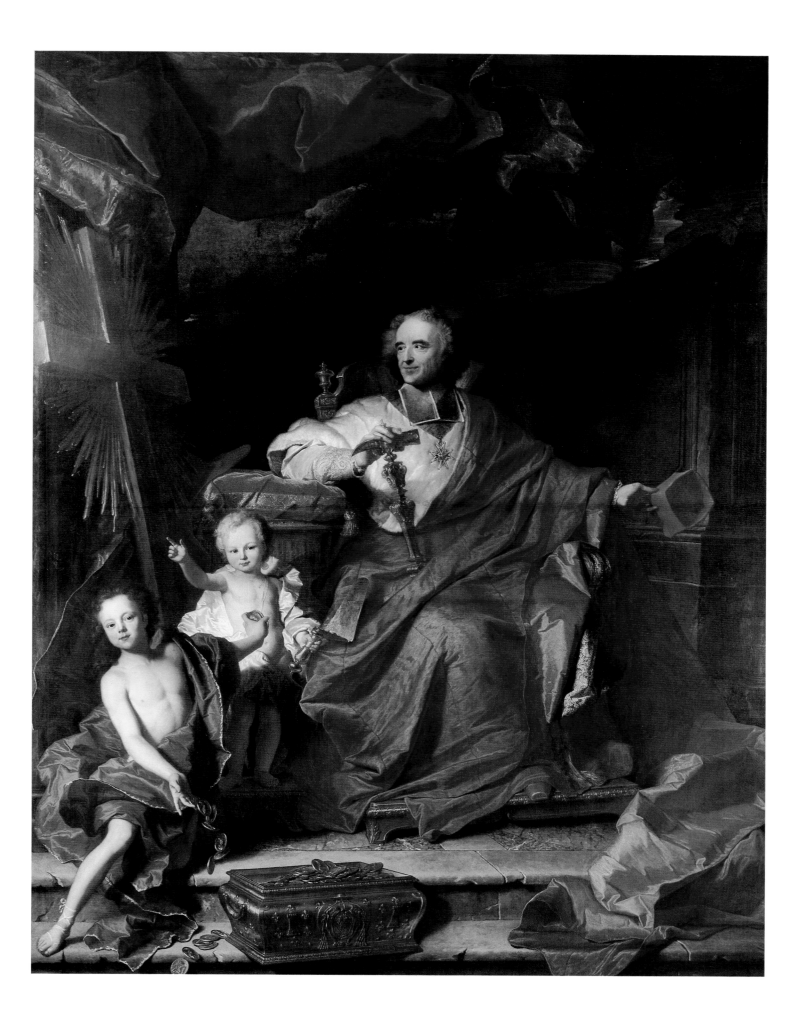

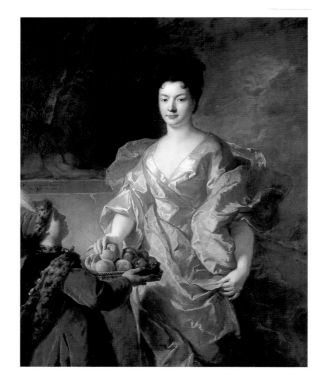

227. François de Troy,
The Duchesse de La Force,
1714.
Oil on canvas,
144 × 111 cm.
Musée des Beaux-Arts,
Rouen.

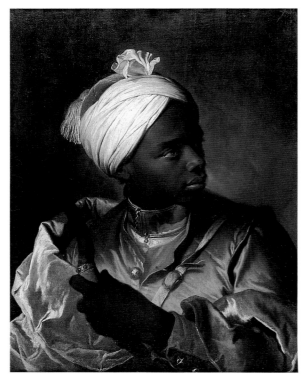

228. Hyacinthe Rigaud,
*Young black Man carrying a
Bow*.
Oil on canvas,
56 × 43 cm.
Musée des Beaux-Arts,
Dunkerque.

and bearing. Each stratum of society, each position had its own formula: there are portraits of prelates such as *Bossuet* (1702, Versailles) or *Cardinal de Bouillon* (1708, Perpignan); of dignitaries such as the *Marquis de Dangeau* (1702, Versailles); of generals painted against the background of a battlefield like *Maréchal de Matignon* (1708, Karlsruhe). Rigaud was the head of a well-run studio which allowed him to take on numerous commissions and to produce replicas, all recorded in his *Livre de raison*.[36] Although he confined his own contribution to the faces, he prepared the paintings with care, making sketches for the hands, draperies and all the details. Some of these studies are admirable portraits in themselves, like the *Young black Man* from the retinue of the Prince de Conti (1697, Dunkerque; pl.228). His world, largely male, is dominated by discreet quiet colours with a few splashes of brighter colour. François de Troy, generally more restrained, left some masterpieces, including the *Duchesse de La Force* (1714, Rouen; pl.227) in which he inaugurates the eighteenth century with his sensitive handling of the scenery and props, and the floating fabrics catching the light. The portraits of Jean-Baptiste Santerre (pl.230) have charm, whether he is painting ceremonial, sometimes allegorical pictures like the *Duchesse de Bourgogne* (1709, Versailles), or less formal portraits in which landscape plays a part (*Portrait of a Hunter*, Paris, Musée de la Chasse), or heads from his imagination like the two half-length *Curiosities* (Orléans), which may have been hung in the Salon of 1704.

There also existed a vein of intimate portraiture, destined for a less aristocratic clientèle: the world of the city, perhaps, rather than the court. Rigaud painted in this vein for churchmen, doctors, artists . . . His portrait of *Jean de Santeuil* (1704, Musée des Granges, Port-Royal; pl.229), head and shoulders on a neutral but vibrant background, expresses the model's intellectual distinction to perfection. The double portrait of the *Artist's Mother* (1695, Louvre), honest and touching, seems to be a product of Jansenism which made its appearance in more than one portrait of the period, for example in the paintings of Jean Jouvenet. The *Young Abbot* (about 1697),

achieved the greatest success in court portraiture. Having arrived in Paris in 1680, he was accepted by the Academy in 1684 and received in 1700 with his portrait of the sculptor *Martin Desjardins* (Louvre). With *Philip V of Spain* (1700, Louvre) and *Louis XIV* in coronation robes (1701, Louvre) he painted the archetypal royal portrait of the end of the century, with its source in Van Dyck rather than in Champaigne: the solemn architecture and great sweeps of drapery, plus his dazzling skill could transform the most unprepossessing faces

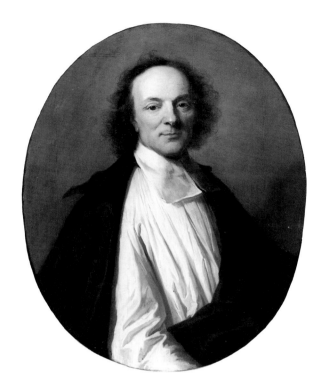

229. Hyacinthe Rigaud, *Jean de Santeuil*, 1704. Oil on canvas, oval. 81 × 65 cm. Musée National des Granges, Port-Royal.

230. Jean-Baptiste Santerre, *The Veiled Lady* or *The Cape*, 1699. Oil on canvas, 80 × 92 cm. Hermitage Museum, St Petersburg.

Raymond Finot (1704, Louvre) and *Bourdaloue* (1704, Rouen), the latter painted from a death mask, are strong images but do not challenge time-honoured formulae. On the other hand François de Troy's questioning *Self Portrait* (1704, Châlons-sur-Marne; pl.234) reflects the artist's interest, at the turning point of two centuries, in Dutch painting and figures seen through window frames in the manner of Gerrit Dou.[37] The art of Rigaud and Santerre reflects the influence of Rembrandt, perceptible in the attire, the colours and the artificial light effects.

Nicolas de Largillierrre is certainly the most complete and the most attractive of all these painters. His period and the extent of his learning and of his talent make him difficult to classify. He testifies, at any rate, to the great wealth of Paris as a centre in about 1700, more cosmopolitan and more welcoming to outside influences than ever before. His studies in Flanders and England place him in the tradition of Rubens and Van Dyck, Hals and Rembrandt but also, more immediately, of specialists like Peter Lely, Antonio Verrio, and Gaspar Netscher, the last of whom he imitated when he was starting out as a painter. An early encounter with the French tradition took place in about 1685 and is well exemplified in the *Tutor and his Pupil* in Washington (pl.233). The firmness and controlled liveliness of the composition are reminiscent of Claude Lefebvre; but they are enriched by a feeling for resonance and tone that are already at their peak by the end of the century: the *Portrait of a Man* in San Francisco, and the *Woman at her Toilet* in St Louis compete to be most sensual in the rendering of fabrics, sometimes matt and heavy, sometimes sparkling and crumpled. The distribution of tight and more relaxed areas, of patches of light and shade, of brighter and duller colours (the *repos*, or respite) is achieved with a particularly judicious eye, and demonstrates a knowledge (which may be intuitive) of the mechanics and science of vision.[38] During the 1700s, Largillierre deliberately concentrated on colour and tone, and the juxtaposition of model and background, the latter often a landscape, thereby developing a theory of colour that sought what Roger de Piles referred to as the '*tout ensemble*' (the 'whole') without sacrificing the

accuracy of the parts essential to the portrait as such, the face and hands which are skilfully highlighted. Two masterpieces illustrate this style: *La Belle Strasbourgeoise* (1703, Strasbourg; pl.232), pearly, black and fawn in a misty atmosphere, and the ruddy *Jean-Baptiste Forest*, the artist's father-in-law (1704, Lille; pl.231), complementing each other like fire and water. Largillierre's confident and distinguished eye and hand break the traditional mould, binding together the personality of the models to the forces governing the material

231. Nicolas de
Largillierre,
Jean-Baptiste Forest, 1704.
Oil on canvas,
129 × 96 cm.
Musée des Beaux-Arts, Lille.

232. Nicolas de
Largillierre,
La Belle Strasbourgeoise,
1703.
Oil on canvas,
138 × 206 cm.
Musée des Beaux-Arts,
Strasbourg.

233. Nicolas de
Largillierre,
A Tutor and his Pupil,
1685. Oil on canvas,
146 × 115 cm.
National Gallery of Art,
Washington. The Samuel H.
Kress Collection.

234. François de Troy,
Self Portrait, 1704.
Oil on canvas,
119 × 80 cm.
Musée Garinet, Châlons-sur-
Marne.

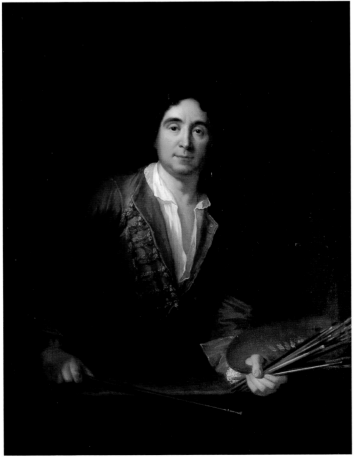

world. Here the physics and chemistry of painting are allowed a voice.

Notes

1. Tallemant des Réaux, about 1657 (1960–1), vol.I, pp.659–62.

2. *Les Galanteries de la Cour* (Paris, 1644). See Thuillier, exh. cat., Paris, 1978–9 (1), p.49. The three painters, Florange, Silidas and Polidon, are sought after by 'everybody at Court'.

3. Saint-Simon, *Mémoires*, year 1695, Paris 1983, 'Bibliothèque de la Pléiade', vol.I, pp.229 and 270. Mignard is described as being 'illustrious by his brush' and the 'premier painter of his day', while Le Brun does not even rate a mention.

4. Blum, 1924, cat. no.1076.

5. Private collection, Great Britain. (Thuillier, exh. cat., Paris, 1978–9 [1], no.42; Rosenberg, 1993, no.5).

6. Furetière, *Dictionnaire*, 1690, under 'Portrait'.

7. The fundamental text on the sixteenth-century French portrait remains L. Dimier's *Histoire de la peinture de portrait en France au XVIe siècle*, Paris and Brussels, 1924, 3 vols. and a supplement.

8. See Bardon, 1974, and exh. cat., Pau and in Paris, 1989–90 (in particular the study by S. Béguin entitled 'Tradition et modernité dans les arts plastiques', pp.327–46).

9. Cordelier, 1990.

10. On the subject of this lost decorative scheme, of which a few remnants remain, see Dorival, 1973; Rosenberg, 1974 (1876); MacGowan, 1983 (1985).

11. Sutherland-Harris, 1991 (1992).

12. B. Brejon de Lavergnée, 1982.

13. See below, chapter 11, p.268.

14. The *Iconography*, a collection of etchings made of his portraits by Van Dyck and his assistants, went through several editions between 1636 and 1759.

15. See the interpretations of these portraits (sometimes disputable) by Marin, 1983 and Winner, 1983 and 1987.

16. Published by Jacquot, 1894.

17. On the *précieux* portrait, see Blunt, 1957; Mérot, 1990 (2), pp.155–65.

18. Molière, *Le Sicilien ou l'Amour peintre* (1667), scene XII. See also the letter from P.C. Hooft reproduced in Samuel Van Hoogstraten, *Inleyding tot de hoog Schoole des Schilderkonst* (1678): 'You are painting me [. . .] as if the painting were to go to France, where it is wise always to be a bit wary of the beauty of a painted face because the flattery practised by artists usually embellishes an already handsome personage.' (Quoted by Brenninkmeyer-de Rooij, 1986, p.69).

19. On this, see Cuzin, 1989, p.587.

20. Long, 1933; Lightbown, 1969; Thuillier, exh. cat., Paris, 1978–9 (1), no.38 (the attribution of this miniature in the Victoria and Albert Museum to the Le Nain brothers is generally rejected).

21. Fréart de Chantelou, 1665 (1885), p.1339.

22. Poussin, letter to Chantelou, 2 August 1648 (Jouanny edition, no.163; Blunt and Thuillier, 1989, p.144).

23. Boyer, 1985: between the portrait in Turin and the portrait in Versailles there is a noticeable progression towards greater historical exactitude. The interest shifts from the celebration of a hero in classical dress towards the celebration of a political position.

24. No study comparable to A. Riegl's study of the Dutch group portrait (*Das höllandische Gruppenportrait*, Vienna, 1931) exists in France.

25. See most recently J. Penent *et al.*, exh. cat., Toulouse, 1987–8. On the miniaturists of the Capitole, see exh. cat., Toulouse, 1956.

26. Of the many publications, the most memorable are: Brière, Dumolin and Jarry, 1937; Montgolfier, 1977.

27. Georgel and Lecoq, 1987, pp.268–9.

28. Noted by Rosenberg, 1993, no.44, p.84.

29. Mérot, 1987, no.21, p.173.

30. Ariès, 1973, *passim* (and particularly chapter 3.1, 'Les images de la famille').

31. Ariès, *op. cit.*, suggests that the stiltedness still noticeable in family portraits dating from around 1700 was not connected with the 'academic' style but more with a moral ideal, the textbook for which was entitled *Règles de la bienséance et de la civilité chrétienne*, by Jean-Baptiste de La Salle, published in 1703 and read by a wide public.

32. Schnapper, 1981 (1) and 1983.

33. Georgel and Lecoq, 1987, pp.133–8.

34. Félibien, 1666–88, part 4, *Entretien* 7 (1685), pp.141–4.

35. De Piles, 1708 (1989), p.127.

36. Published by Roman, 1919.

37. On the influence of the Dutch portrait in France, see the catalogue to the exhibition in Lille, 1985, no.144 (by D. Brême).

38. W.B. MacGregor, 1993. On the *'tout-ensemble'* (whole) see below, chapter 12, p.296.

LANDSCAPE

The fashion for portraiture in seventeenth-century France was equalled only by the fashion for landscape, which constituted about a third of the total artistic production of the day. Posthumous inventories, in Paris and in the provinces, include a huge number of paintings, mainly quite small in size.[1] Paintings like this would arrive from Flanders by the hundred, or would be mass produced in local workshops before being sold in shops and at fairs. Paintings by recognised artists, however, and particularly the paintings sent up from Rome by Claude and Poussin, stood out from this huge mass of mediocre work and would be rapidly acquired for the large collections. From the 1640s on, interested bystanders would come to admire them and painters to immerse themselves in them. But apart from a few celebrated names, landscape painting would have remained a relatively unexplored area, if drawings, and especially prints, had not come to the rescue. The proportion of landscape paintings in the stock held by Parisian picture dealers, although never as large as the proportion of religious paintings or portraits, more than quadrupled over the century.[2] At first, engraved reproductions concentrated mainly on the Mannerism of Bril and Coninxloo; then Jean Morin promulgated Fouquières and Champaigne; later the Pérelle family, who ran a veritable landscape business, engraved their own compositions as well as those of other people. Original prints also flourished, quickly making the names of artists like the young La Hyre or Henri Mauperché; Claude Lorrain extended all his painterly skills into his very free etchings.

LANDSCAPE AND THE HIERARCHY OF GENRES

Landscape painting was first and foremost something to toy with, a diversion. The paintings of someone like Poussin, with their careful construction and complex iconography, were the exception, not the rule. Even Claude, whose work was often presented in contrasting pairs in which the subject was secondary to the effects of light and shade, was motivated primarily by a decorative ideal. These were easel paintings, able to be enjoyed for their own sake. In many instances, landscape would be inserted into larger paintings

237. Jacques Fouquières, *Woodland*. Gouache, 38.1 × 37.7 cm. Département des Arts Graphiques, Musée du Louvre, Paris.

238. Jacques Fouquières, *Large Landscape with Grooms*, 1620. Oil on canvas, 118 × 199 cm. Musée des Beaux-Arts, Nantes.

235. *previous pages*: Claude Lorrain, *Ulysses returning Chryseis to her Father*, 1644. Oil on canvas, 119 × 150 cm. Musée du Louvre, Paris.

and would only be a minor part of the whole. There were innumerable chambers designed so that landscape painting, framed in gilded moulding or grotesque designs, occupied the lower or middle portion of a panelled wall; the place of honour would be given to history painting.[3] In the galleries in the Palais Mazarin, for example, or the Hôtel Lambert, landscape panels simulated openings to the outside world. These illusionistic windows were designed to deceive the eye, as were the false perspectives drawn on the walls of courtyards and gardens. This was landscape playing its part in the 'enchantment' and illusion so dear to the mentality of the *Grand Siècle*.

Not surprisingly, the literature of art gives little space to landscape painting. This need not imply that no pleasure was taken in the contemplation of nature, nor that the spectacle offered by natural events failed to astonish. In some cases the skill of the painter was praised: in a famous passage in Félibien's fifth *Entretien*, the interlocutor describes in great detail a storm observed from the terrace at Saint-Cloud, adding:[4]

236. Henri Mauperché, *Landscape*. Oil on canvas, 115 × 89 cm. Musée du Petit Palais, Paris.

239. Philippe de
Champaigne,
*The Miracles of St Marie
Repentant*, 1656.
Oil on canvas,
219 × 336 cm.
Musée du Louvre, Paris.

It would be a wonderful opportunity for a Painter if he could see what we are seeing now. Do not you also think that it must have been on a similar occasion that M. Poussin made the drawing for the painting that you showed me a while ago, where he painted a storm similar to this one, and has given us cause for admiration as Appelles did in the old days: one and the other painted this kind of subject so well, perfectly imitating things that are really inimitable.

An artist might be applauded for the life-like quality of his foliage, or his analysis of light, but these would be regarded only as evidence of imitative skill or mastery of technique. In general, landscape was considered less difficult because it did not depict human activity nor the passions of the human heart. It demanded less effort on the part of the spectator, who could restrict his comments to praise of the accuracy of the representation. This prejudice goes back at least as far as Michelangelo's scornful comments on Flemish painting:[5] 'This painting they call landscape is all rags, tumbledown cottages, green fields, the shadows of trees, bridges, rivers, with here and there a figure [. . .] In truth, in Flanders they paint copies of the view from the window.'

It was not until Roger de Piles published his *Cours de peinture par principes* in 1708 that a positive appreciation of landscape for its own sake, freed from subject matter and from subordination to

history painting, was given. Obsessed with classification, de Piles divides landscape into two broad categories: the heroic and the rustic or *champêtre*. In the first, 'if Nature is not portrayed the way chance makes us see her every day, she is at least represented the way one feels she ought to be'; in the second, preferred by de Piles, can be found 'land that appears to have been abandoned to nature alone, rather than being cultivated'. Nature is to be seen here 'unadorned, but with all the embellishments she wears so much better when given her freedom than when violated by art.'[6] The historian is tempted to fit the output of the whole century, willy-nilly, into this convenient framework. This would produce a 'picturesque' stream, unaffected and stemming more from northern models, and a 'classical' stream, which would reduce everything to the human figure and the history of mankind and would focus mainly on Italy, on Claude as well as on Poussin and the Bolognese School.[7]

FONTAINEBLEAU AND THE FLEMISH PAINTERS:
DECORATIVE LANDSCAPE, TOPOGRAPHICAL
LANDSCAPE

From the mid-sixteenth century, engravers belonging to the School of Fontainebleau like

Antonio Fantuzzi and Maître I.O.V. had intro-
duced France to panoramic landscape in the
manner of northern painters like Joachim
Patenier.[8] By surrounding their pictures with
embellishments they gave landscape painting the
decorative, fanciful style it was to retain for years.
Mountain and marine views, broad expanses of
undulating countryside, twisted trees and tumble-
down houses were the material for the drawings
of Jean Cousin and his son, and of the paintings of
Nicolò dell'Abate. Having arrived in France in
1552, dell'Abate became a specialist in this style,
embellishing it with mythological figures and
fantastic architecture under a surreal light. The
gradation of shades of brown, green and blue was
used instead of aerial perspective to distinguish
distances in a conventional way. The pastoral
paintings of Ambroise Dubois, his series of draw-
ings for *Daphnis and Chloe*, for instance, was
inspired by dell'Abate's model; he de-centralised
his compositions, with vistas to left and right and
distant panoramas. These were definitely designed
as decoration, and were examples of the intern-
ational Mannerism to be found from Antwerp to
Venice. The homely landscapes attributed to the
followers (possibly the son) of Nicolò dell'Abate
were on a less excessive scale; these were scenes
from rural life, like *Winnowing Corn* (Louvre),
enlivened with tiny figures, which defined the
picturesque style that was to remain popular at
least until the time of Boucher.

The commonly held notion that France, from
the time of Henri IV to Marie de Médicis, had no
landscape tradition, and that a tradition was even-
tually built up based on the input of painters from
abroad, must be qualified. In fact, Fontainebleau
had already created a synthesis between the north
and Italy. But until 1636 the scales were tipped in
favour of the north. The art of engraving helped
to popularise the tormented, complex compo-
sitions of Gillis van Coninxloo and the School of
Frankenthal. The work of the Antwerp artist Paul
Bril, who died in Rome in 1626, set out less
tortured subjects in simpler settings, even if his
structures, based on interlocking triangles, and his
lighting schemes, remained conventional.

Commercial producers of landscapes, in par-
ticular the Flemish colony established in Saint-

240. Jean Morin (after
Fouquières),
Duck shooting.
Engraving.
Département des Estampes,
Bibliothèque Nationale,
Paris.

Germain-des-Prés in Paris, had to choose their
ingredients to suit public taste. In 1621, Jacques
Fouquières arrived from Brussels to begin a career
in Paris that brought him great success. He
became painter to Louis XIII and was ennobled
by the King. The unendurable 'Baron Fouquières'
had a head-on clash with Poussin when they were
working together on the site of the Grande
Galerie in the Louvre. Only a few of his paintings
survive (pl.238): mountain views, hunters in the
undergrowth. The gouache in the Louvre
(pl.237) depicting a stream running through a
forest is reminiscent of studies by Rubens. The
wild beauty of the site, and the apparent sponta-

241. Circle of Simon
Vouet, *Ceres*.
Oil on canvas,
147.6 × 189 cm.
National Gallery, London.

neity of the composition (which does, however, contain the oblique views that were *de rigueur* at the time), demonstrate a taste for untamed nature and for the 'solitude' dear to the poets of the day.[9]

In Brussels, one of Fouquière's students was Philippe de Champaigne, whose religious painting has obliterated the memory of the landscape painter he was in his earliest youth. It was a landscape that he apparently presented to Poussin before Poussin left for Rome. Throughout his life he continued to paint landscapes as a diversion,[10] bringing his concern for realism and all his skill and clarity to the job. His four large *Scenes from the Thebaïd* (1656), painted for the apartments of Anne of Austria in the Val de Grâce (Louvre, Tours and Mainz), are still stylistically close to Fouquières with their broad vistas, brownish hillsides, trees with heavy foliage and blue distances; but the painting of light has become more polished, as if the artist had been conducting some research of his own. The controlled layout of his work balances the subject matter and the use of colour. His subjects fit into the hermitic tradition developed jointly by Venice and the Low Countries, and just introduced by Philip IV of Spain to the Buen Retiro.[11] The solemnity of his later works is in keeping with their religious subjects: in *Christ curing the Deaf Mute* (Ann Arbor) the landscape dominates the figures; in *St John the Baptist* (Grenoble) the landscape is merely a back-

ground designed to show off the prophet to best advantage. Concern for truth to life is subservient to the religious message, and nature is here the tangible embodiment of the divine world. The realism to be found in Laurent de La Hyre's first paintings is less imposing, but it is nonetheless delicate and poetic: his *Dogs in a Landscape* (1632, Arras) and the series of six small etchings of 1640 are subtly and skilfully balanced with their soaring trees, exuberant vegetation, rocks and here and there a statue or a mausoleum beside a pool shimmering with reflected light. A mild melancholy pervades the scene. Reconstructed and enriched, the same elements reappeared at mid-century in the work of the Parisian landscape painters.

It may be appropriate here to mention the paintings, purely decorative in intention, produced by Simon Vouet and his workshop from 1627. Some of the collaborators of the Premier Painter were specialists, similar to those in Rubens's studio, employed according to Félibien to paint 'landscapes, animals and ornamentation'. These were 'Juste d'Egmont and Vandrisse, Flemings; Scalberge, Pastel (Patel, the father), Bel[l]in, Vanboucle, Bellange, Cotelle'.[12] Vouet would entrust the painting of the backgrounds of his painting to one of his assistants. Sometimes the decorative element would take on exceptional importance, as in the *Tapestry of the Old Testament*, woven for the Louvre in the weaving shops of Paris. *The Finding of Moses* and *The Sacrifice of Isaac* feature the powerful bent trees with mossy trunks and the rich vegetation found earlier in pastoral tapestry. Mythological and religious scenes often take place on the edge of dense woodland, beside a sunlit clearing. The one real landscape painting that can be attributed to Vouet today, or at least to one of his best assistants, is the *Ceres* in London, a composition like a stage-set with wings, reminiscent of the second School of Fontainebleau, a flavoursome combination of realism and delicacy of colour. This piece comes from a 'cabinet' in the Hôtel Bullion in Paris (about 1634), where it was partnered by a whole series of paintings depicting hunting and the wine harvest.

Beside this rapid style, with its supple, sometimes slightly blurred highlights, there existed a

242. Jacques Callot, *The Siege of the Ile de Ré*, 1631. Engraving. Département des Estampes, Bibliothèque Nationale, Paris.

meticulous, semi-scientific manner of painting that kept pace with progress in geodesy and optics. These topographical landscape paintings were also highly prized, albeit for different reasons. In this style were various *Views of Naples* by Didier Barra (Monsù Desiderio), from Lorraine, and some of Claude's early works such as the *Port at Genoa* (before 1634, Louvre). In the field of engraving, Jacques Callot has left some splendid examples: his *Fair at Impruneta* (pl.176), executed in Florence (1620), *The Siege of Breda* (1627), commissioned by the Infanta Isabella, and above all the *Siege of La Rochelle* and the *Siege of the Ile de Ré* (1631; pl.242), engraved by order of Louis XIII; these combine landscape painting with map making. Callot's panoramic vision, with its planes clearly differentiated by the play of light, and the innumerable tiny figures, make these pictures, meticulously prepared with dozens of sketches and drawings, most remarkable achievements. This topographical genre, requiring a methodical

understanding of space, had its links with war and politics, as Louis XIII and Richelieu realised; in 1626 they commissioned Fouquières to make ninety-six views of the principal towns of the kingdom to adorn the pillars in the Grande Galerie in the Louvre. The commission came to nothing and nothing remains of it, but it paved the way (a century in advance) for the *Sea Ports* commissioned from Joseph Vernet. More influential than actual painting in this genre were printmaking, cartography and illumination, which developed progressively; during the reign of Louis XIV masterpieces were produced in which accurate information was conveyed with an accompaniment of admirable ornamentation.[13]

If the faithful and, so to speak, objective description of a place is admitted to be the speciality of northern France — Holland gave evidence of it at the same period[14] — then the few landscapes painted by the Le Nain brothers around 1640 should be included in the inventory.

243. The Le Nain brothers,
Peasants in a Landscape.
Oil on canvas,
46.5 × 57 cm.

National Gallery of Art, Washington. The Samuel H. Kress Collection.

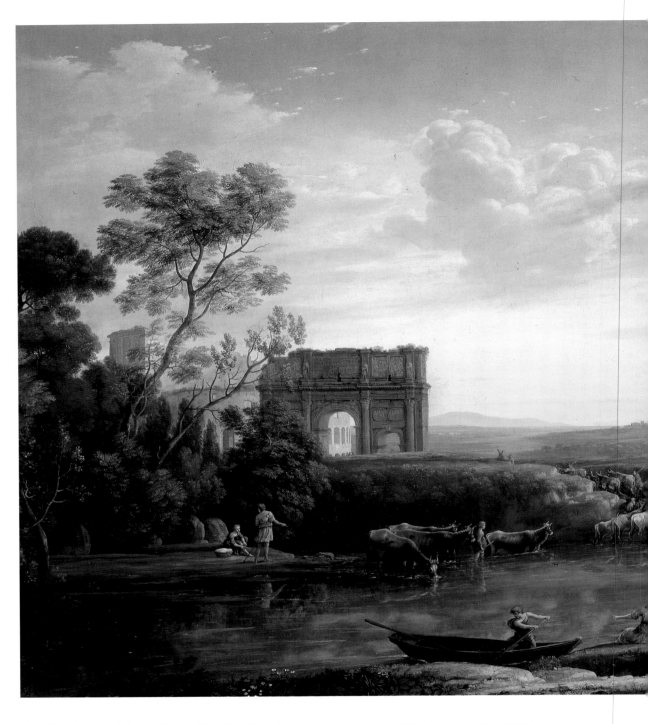

244. Claude Lorrain,
*Pastoral Capriccio with the
Arch of Constantine*, 1651.
Oil on canvas,
98 × 145 cm.
Collection of the Duke of
Westminster, London.

The *Landscape with a Chapel* (Hartford) and the
Peasants in a Landscape (Washington; pl.243) are
not painted to the conventional formulae: the
brothers preferred to give a truthful picture of the
countryside around Laon, inhospitable and devas-
tated by war as it was. Particularly the second
painting, with its plunging viewpoint, its gloomy
hills of a greyish green, its huge cloudy sky, pos-
sesses a kind of calm boldness — as do the back-
grounds of the *Allegory of Victory* (Louvre) or the
Horseman's Rest (Victoria and Albert Museum,
London). The Le Nain brothers occupy a unique
place in the art of their time, mainly thanks to the
sincerity of their intentions.

THE DEVELOPMENT OF CLASSICAL
LANDSCAPE IN ITALY: CLAUDE AND POUSSIN

From 1640 to 1650 new developments occurred.
The middle of the century saw a growing number
of paintings arriving in France from Italy,
especially from Rome which had been the ulti-
mate goal for travellers for many years. In 1586,
François Stella was in Rome: having received his
training in Antwerp, he was later to set up in Lyon
and found a dynasty of painters. Meanwhile,
accompanied by Etienne Martellange, the future
architect to the Society of Jesus, he was sketching
the Campagna and its monuments: the series of

Agostino Tassi in Rome, then possibly under Goffredo Wals in Naples, took place in a cosmopolitan milieu: he was part of a group of Italianate Dutch artists like Breenbergh, Poelenburgh or Swanevelt, all influenced by the Flemish painter Paul Bril and the German Adam Elsheimer. It is the international dimension that permits the inclusion of Claude in this book: many of the elements of his painting are features of the gradual development of a specifically French style of landscape painting, a cross between northern and Italianate models.

Claude's output was considerable in quantity as well as in quality: about three hundred paintings, twelve hundred drawings and fifty engravings are

pen and wash views of Tivoli (Louvre) is energetically presented, with strong contrasts of light and shade; this foreshadows studies by Swanevelt and Breenbergh on similar themes. In 1612, the young Claude Gellée set out from Lorraine, where he was born; after a spell in Naples and another in Nancy he established himself permanently in the Eternal City. Has he a place in the history of French painting? The question is certainly worth asking.[15] Although he has always been hailed as one of the greatest (if not the greatest) landscape painters of the 'French school', his long career was entirely spent in Rome and his principal patrons were Italian. His training, under

known today. They reveal sustained hard work, very precise and, at the outset, drawn from nature. Sandrart, who accompanied the artist on his excursions around Rome, emphasises his interest in 'distant views' and in variations of light,[16] at a time when most landscape artists were concentrating on the exact reproduction of the chosen subject. The study of light at different times of day, rapidly transferred to paper then made permanent with pen and wash resulted in very well orchestrated pictures, worked over slowly and with great care, often done in pairs with different lighting effects in each one. Claude, however, should not be thought of as a painter who worked

245. Claude Lorrain, *Fording the River*. Engraving.
Département des Estampes, Bibliothèque Nationale, Paris.

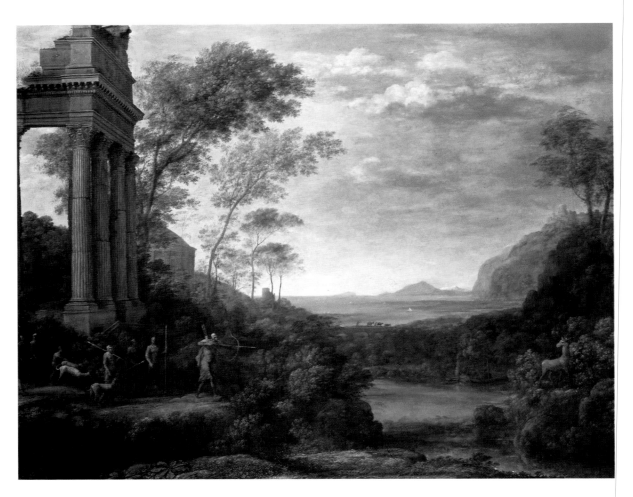

246. Claude Lorrain,
*Ascanius killing Sylvia's
Stag*, 1682.
Oil on canvas,
120 × 150 cm.
Ashmolean Museum,
Oxford.

mainly outside: his drawings show just how thorough was the elaboration of the work in the studio and this preparation grew more and more meticulous as the painter grew older. Claude attached great importance to construction, and used both the traditional bi-focal perspective, the most appropriate for wide landscape views, and Alberti's *costruzione legitima* with its single vanishing point:[17] the use of architecture helped him to create vividly theatrical scenes. Although Claude was no theorist, his compositions summarise and surpass previous examples and they were studied in French artistic circles with great attention: they kept pace with, or sometimes preceded, the musings of the academicians, particularly on the subject of aerial perspective and the observation and distribution of light. The presence of human figures, whose importance was underestimated for a long time, typifies his aesthetic, in which man is placed at the centre of nature.

Claude's career, an unusually long one (more than sixty years) went through gradual but perceptible transformations, growing progressively more profound. At the beginning he followed the dictates of fashion and demand: his pastoral landscapes and first seascapes were delicately painted in the manner of Elsheimer's small etchings, sometimes topographical and sometimes purely picturesque. They were executed with meticulous attention to detail. Their composition consisted of overlapping triangles of countryside, with trees and slopes to either side, in the tradition of Paul Bril. At the end of the 1630s, when Claude had received the commission from the King of Spain for the Buen Retiro, his compositions increased in scale. In the sea port views, where Classical and Renaissance architecture frames magnificent scenery,[18] the artist experiments with backlighting, with the sun rising or setting and light catching the crests of the waves, as in *Ulysses returning Chryseis to her Father* (1644, Louvre; pl.235) or the *Embarcation of the Queen of Sheba* (1648, London). Claude's keen sense of order is in evidence in the landscape as well. The influence of the Bolognese School, principally of Domenichino, is consolidated. The broadening of space, the interplay of horizontal lines and the development of biblical and historical subjects add up to a heroic, almost elegiac style in which something of the grandeur that was Rome lives on (as in the splendid pair of capriccios with ruins and shepherds, dated 1651, in the collection of the Duke of Westminster; pl.244).

Having achieved this stage of maturity, Claude continued to develop during the remaining twenty years of his life. His hand may have been

a little less firm, but slight distortions particularly of the figures, henceforward strangely elongated, more mystery in the lighting and a reserved, sustained touch create a totally personal world. Encouraged by patrons like Prince Colonna, Claude exploited all the poetic potential of the subjects he chose. In works like *The Enchanted Castle* (1664, London), *Erminia with the Shepherds* (1666, collection of Viscount Coke) or *Ascanius killing Sylvia's Stag* (1682, Oxford; pl.246) the elegiac element is more pronounced, with the characters flitting like ghosts in a silent landscape. The artist reasserts his independence. He rejects narrative in favour of the rendering of states of mind, evoked by the close and disquieting relationship between landscape and figures: the figures appear to stem from the bosom of nature and from the light that bathes the countryside. Although, like the late works of Poussin, the late works of Claude puzzled his contemporaries, they fascinated the pre-romantics and romantics alike, painters as well as poets, especially in England.

With a few exceptions, Poussin did not paint landscape as a separate genre. In fact the reverse is true, he made landscape subordinate to his analytical, disciplined notion of history painting. There is a striking contrast between the backgrounds of his paintings of the 1620s, Venetian in style and vigorously painted in warm tones, and the crisp rhythms of planes and motifs, inspired by the Bolognese School, to be found in his paintings from 1630 on, for example in the *Return from Egypt* (Cleveland) or *Juno and Argos* (Berlin). The sensual evocation of an atmosphere becomes something more precise, with structures that aim to be legible. This approach to nature should not obliterate Poussin's sensitivity to the natural world around him: the Roman Campagna with its frequent echoes of the Normandy where the painter spent his boyhood. His young brother-in-law, Gaspard Dughet, who worked with him from 1631 and started his own career as a landscape painter a few years later, may have encouraged him to take advantage of a genre to which he had hitherto paid scant attention. Many of his studies of nature date from this period. These wash drawings, more spontaneous than his paintings, suggest positive links with Claude, in whose company

Poussin made frequent excursions. But while Claude was interested in the play of light and the modification (and sometimes disappearance) of forms in different lights, Poussin used light to define the volume of his forms, whether these were trees in scrub woodland (drawings in the Louvre) or a hillside sculpted by sunshine (*View of the Aventino*, in the Uffizi; pl.247).

Poussin's lucidity, in sharp contrast with Dughet's aggressive realism (romantic before its time), is much in evidence in his work after the 1630s. In building up his variously-sized paintings, he made use of every landscape item in order to give the spectator an illusion of measurable, habitable space: trees, embankments, rocks, ruins or mills, the winding of a sunken lane, the straight or meandering progress of a river. Sometimes the rhythm of the landscape harmonises with the placing of the large figures in the foreground: it is thus in the *Baptism* in both series of *Sacraments*, or the *Finding of Moses* in the Louvre (1638); alternatively the landscape occupies the leading rôle and the characters are submerged in it, as in *St John on Patmos* in Chicago and *St Matthew and the Angel* in Berlin, painted as pendants in 1640. Poussin developed the second approach much farther during the following decade, as his stoicism intensified: human presences, human activities are negligible when viewed in the context of world order.[19] In and around 1650 this philosophy was illustrated in a series of masterpieces, from the *Man killed by a Snake* in London to *Pyramus and Thisbe* in Frankfurt (pl.248), via *Diogenes* in the Louvre, *Polyphemus* in the Hermitage and the pair of paintings depicting the *Funeral* and the *Ashes of*

247. Nicolas Poussin, *View of the Aventino*. Pencil with a brown wash, 134 × 31.2 cm. Uffizi, Florence. Gabinetto dei Disegni.

Phocion in Cardiff and Liverpool (pl.250) respectively. The multiplication of detail, meticulously painted and with a keen awareness of values, does no harm to the layout of the paintings; in fact, it tends to confer a sense of realism and simplicity.

One of the essential differences between Poussin and Claude is Poussin's distrust of process and his horror of repetition. In Claude's work, variety generally stems from differences of light and colour. In the work of Poussin, on the other hand, variety stems from the compositions themselves, each painting posing anew the whole question of landscape (structure and meaning being intimately connected). Compare the pendants designed in 1651 for Pointel, *Storm* (Rouen) and *Calm Weather* (Sudeley Castle), in which the painter plays games with contrasted outlines and rhythms, applying his research into the expression of human passion to the analysis of the natural world. The violence of the storm in *Pyramus and Thisbe* recalls Leonardo da Vinci's efforts at representing meteorological phenomena, and also foreshadows the eighteenth century and Joseph Vernet's 'Sublime'. Nothing could be stranger than the vast sheet of water that remains unruffled while lightning strikes, the wind is unleashed all around and beasts and men struggle to avoid death. Modern exegesis has seen this as a metaphor for the Stoical *logos*, the motionless motive power of the universe, or even the impassive gaze of the painter-demiurge.[20] Whether one subscribes to them or not, such interpretations emphasise the supremely controlled nature of this orchestration of disparate elements, and the dialectic of order and disorder through which Poussin expresses his feelings about the human condition.

After such cataclysmic reproductions of the natural world, Poussin settled for something different during his final years. His technique altered, thanks partly to the trembling of his hand, which made his touch less accurate. His brush was no longer used for drawing, but proceeded by dots and blotches, vastly increasing the intensity of paint effects and the resonance of light. At the same time, his spatial range grew less deep, tending to be organised on parallel planes rather than like a scene in a theatre. This gives the strange

248. Nicolas Poussin, *Pyramus and Thisbe.* Oil on canvas, 192.5 × 273.5 cm. Städelsches Kunstinstitut, Frankfurt.

flavour to late works like *Blind Orion* in New York, or *Hercules and Cacus* in Moscow (pl.249), with its whiff of pantheism.[21] Myths are used to evoke the forces at work in untamed natural surroundings. The painter's last will and testament has to be the *Four Seasons* in the Louvre (1664–5; pl.251).[22] These large landscapes differ in their lighting, but are underpinned by the same disciplined construction; they represent a cyclical summary of the story of mankind in which even death holds the promise of renewal. Discernible here once again is Poussin's dislike of formulae, in the sense that he did not paint these as models to be emulated. In Academic circles the *Seasons* came as a surprise; the painter's mature work was admired above all. Like Claude's mature work, possibly even more so, this played a crucial rôle between 1640 and 1660 in the consolidation of French classical landscape painting.

COMPOUND LANDSCAPE

By 1650, painters and art enthusiasts in Paris had a good selection of original paintings at their disposal: to the Renaissance masterpieces had been added, bit by bit, landscapes by Annibale Carracci, Albani and Domenichino, then important works by Claude and Poussin, sent to their admiring clientèle from Rome. The influence of the Bolognese School was certainly decisive. Until about 1635 they had represented an ideal, put into words by Giovanni Battista Agucchi in his *Treatise on Painting*, composed between 1607 and 1615.[23] A painter should beware of falling into Mannerist excess, or into the vulgarity of which Caravaggio and his followers are accused. A follower of the middle way, he should not stray too far from nature if he wants to remain in the real world and not fall into abstraction or fantasy; but, on the

249. Nicolas Poussin, *Landscape with Hercules and Cacus*. Oil on canvas, 156.5 × 202 cm. Pushkin Museum, Moscow.

other hand, he will not wish to copy nature slavishly, and he should select the elements that he needs with great care. Such an attitude towards landscape painting will signify clarity, structure and harmonious relations between mankind and the world. Agucchi's emphasis was on truth to life rather than on the very mundane or the very exceptional. This 'ideal' or 'classical' landscape (neither term is very explicit, nor is the adjective *'composé'* [compound], later adopted in the nineteenth century) was not impassive, nor was it colourless or drab. On the contrary, as Cesare Gnudi stressed, it required 'intense emotional participation' on the part of the painter, who was classed alongside the epic, pastoral or elegiac poet.[24] The choice of subject and characters in a particular situation (religious, historical, mythological) is essential and sets the tone, or what Poussin referred to as the 'mode',[25] of the painting. Landscape, from being a simple entertainment or decorative addition, became a poetic creation in its own right, and the pleasure to be gained from it, through the contemplation of nature carefully ordered by art, could lift the spirits.

Sébastien Bourdon, who returned from Italy to Paris in 1637, painted first in the flamboyant and brightly coloured style of the Genoese painter

250. Nicolas Poussin, *The Ashes of Phocion being gathered up by his Widow.* Oil on canvas, 116 × 176 cm. Walker Art Gallery, Liverpool.

251. Nicolas Poussin, *Summer. (Ruth and Boaz).* 118 × 160 cm. Musée du Louvre, Paris.

Castiglione, before being won over to Poussin's more disciplined manner. By the end of the 1640s his art had changed: using light colours, he began to experiment in arbitrary fashion with simple geometrical shapes. The *Finding of Moses* in Washington (about 1655) is joyful yet majestic; the *Landscape with a Mill* in Providence (about 1658) or the *Return of the Ark of the Covenant* in London (also about 1658; pl.252) both display a pleasant eye for detail, within their concise organisation. The backgrounds are broken into a thousand features off which the light glances. In a lecture given at the Academy in 1669, Bourdon advises fellow

painters to keep varying their effects and to use different moments of the day (he identifies six) to show subjects to best advantage.[26] Light, according to him, can fill the soul with 'different feelings and desires'. The rising sun, therefore, should be reserved 'for subjects liable to inspire the same joyful feelings that the sun inspires at dawn', or midday 'for restful activities'. Colour, shadows and reflected light must be modified as appropriate. Bourdon invites the painter to 'make notes' and to look at things closely. He observes that, after rain, objects are like mirrors 'in which the colours of surrounding objects are reflected and multiplied'.

Since the founding of the Academy, theoretical speculation had developed, and landscape as a genre could not escape being affected. The teaching of linear and aerial perspective, and the intro-

duction of the Academy lectures in 1667, helped to replace the empirical formulae with something more solid. As far as linear perspective was concerned, the theatrical model inherited from the *costruzione legitima* and Serlio's engravings of scenes by Vitruvius tended to take over, lending Claude's harbour scenes and Poussin's heroic landscapes an unforgettable authority. Pierre Patel, Laurent de La Hyre and Henri Mauperché also used architecture in this way, and in particular ruins whose every crack they detailed, using the tiniest lump or bump to break the monotony of straight lines and wreathing the ruins in vegetation painted delicately with the finest brush. Tricks of the light inspired them just as much: light glancing off still water, hazy distances and a misty or crystal-clear atmosphere according to the time of day. Mariette could term Patel 'the

252. Sébastien Bourdon, *The Return of the Ark of the Covenant.* Oil on canvas, 197 × 135 cm. National Gallery, London.

Claude Lorrain of France',[27] though he had neither the staying power nor the variety of Claude. His first influence was Fouquières, and then he became part of Vouet's team, but he later developed a refined style of his own. Whether painted to stand alone or as part of a decorative scheme (as in 1646 in the Cabinet de l'Amour in the Hôtel Lambert, pl.253, or in 1660 in the Cabinet of Anne of Austria in the Louvre), his paintings are among the purest expressions of Parisian atticism; they successfully marry elegant Classicism with extreme precision. His son Pierre-Antoine perpetuated the style until the beginning of the eighteenth century, with certain additions that paved the way to the Rococo; his delicate painting just stopped short of being fanciful, his colonnades and frail trees creating a network of lines sometimes inspired by Mauperché, another notable Parisian landscape painter.

La Hyre was incontestably the greatest landscape painter of the group. His starting point was the picturesque in the Flemish style; he chased all over the countryside of the Ile de France looking for lonely, often melancholy sites which he could then fill with ruins and figures as the spirit moved him. His most typical work is perhaps *Laban hunting for his Idols* (1647, Louvre) in which, behind the peaceful groups of figures that provide the pretext for the painting, a ruined temple and a winding valley on either side of a clump of trees constitute the central motif of the painting. In the *Landscape with a Shepherd* (Montpellier) painted in the same year, he reiterates the theme of the Italian pastoral idyll, repeating it more daringly in the *Landscape with a Swineherd* (Montreal): here the diagonal of the shadow separating the bright foreground from the broad panorama of a misty valley adds a surprising dynamic touch. In the *Landscape with a Man playing the Flute* (Lille; pl.254) the hillsides and thick clumps of trees are presented with Virgilian clarity. The sensitivity of the painting is astonishing, and the obsession with detail in no way harms the balance of the composition: the alternately thick and thin tree-trunks, the sequestered mirror of the pond, the hazy blue distances create the purest harmony, in response to the music of the shepherd's pipe. In later paintings, like the *Landscape with Women bathing* in the Lou-

vre (1653), classical and literary references seem to diminish in favour of something more direct and more rustic; the apportioning of warm and cold tones is unaffected, as is the skilful manipulation of light.

Such successes should not overshadow the existence of a large number of 'average' paintings, delightfully varied, from the caprices with classical architecture of Jean Lemaire to the rural landscapes of Thomas Pinagier. The large number of engravings published by Israël Silvestre and particularly by the Pérelles (pl.256), father and son, and enjoyed by an enormous public, bear witness to the popularity of the genre. Published to satisfy the whims of customers all over the country, from quite ordinary art lovers to the studios of artists or artisans, these eight hundred or so prints can be divided into a variety of categories: documentary views of places, towns or well known monuments; classical or picturesque ruins (dilapidated bridges, medieval towers, tumbledown cottages); 'solitudes' with trees and marshes; village scenes of daily life; the seasons or times of day, with their different lighting effects. Seascapes were popular too,[28] both harbour scenes and storms. Prints of the work of Matthieu de Plattemontagne, who came from Antwerp to Paris, where he died in 1660, show a talent able to excel at every level; none of his paintings has survived, but his *Seascape by Moonlight* (pl.257) seems worthy of Claude Lorrain. In Marseille, Jean-Baptiste de la Rose, who worked with Puget and was also a successful painter of views, was much in demand: in 1660 the King commissioned a *View of the Harbour at*

253. Pierre Patel, *Landscape with classical Ruins*. Painted for the Cabinet de l'Amour in the Hôtel Lambert. Oil on canvas, 73 × 150 cm. Musée du Louvre, Paris.

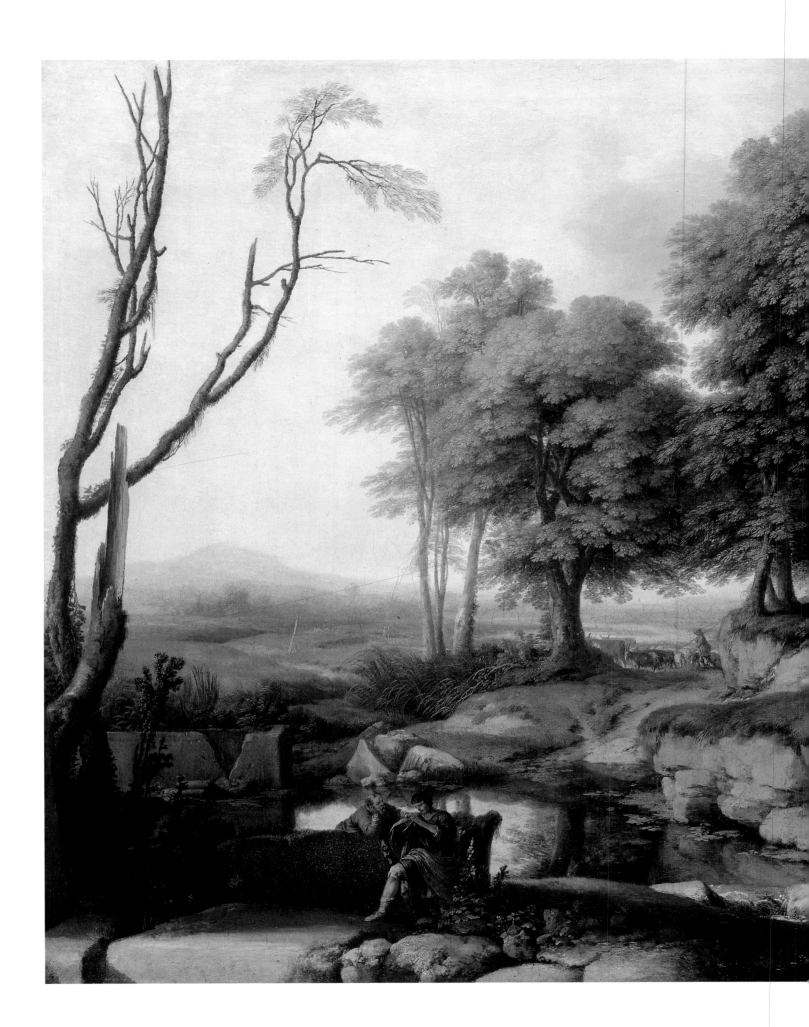

Marseille (lost) from him; in 1673, the Duc de Lesdiguières commissioned four large seascapes, each containing more than a hundred figures, for his Château de Vizille.

TRENDS AT THE END OF THE CENTURY

During the reign of Louis XIV, landscape painting, in the early stages of what was to be a long tradition, was notable for its diversity. At the Gobelins factory, where from 1664 van der Meulen and Flemish collaborators such as Bauduins and Genoels were employed, panoramic and topographical tapestries were being developed for an increasingly high-ranking clientèle. The glorification of the noble deeds and magnificence of the monarch required a description of his military campaigns and his possessions that was at once accurate and flattering. The tapestries depicting the *History of the King* and the *Royal Residences*, the seascapes of van der Beck or De La Rose include some of the most important landscape paintings of the period. The spontaneous nature of the final result should not obscure the elaborate preparatory work and detailed research that went into each one. Van der Meulen marched with armies, making drawings and painting watercolours (pl.258) in which he analysed battle sites and equipment with a keen eye. The *Capture of Maastricht* (Louvre, 1673; pl.259) reminds us of his close links with northern painting styles. The accuracy of his observations and the beauty of his great cloudy skies obliterate the horrors of war. In less eloquent mode, topographical painting had its place in the decoration of royal residences: views of the park at Versailles painted for the Trianon between 1680 and 1700 by Jean Cotelle the Younger (pl.260), Jean-Baptiste Martin (known particularly for his battle scenes) and Etienne Allegrain (pl.261) are good examples.[29] Their meticulous detail is contained within distorting perspective effects borrowed from the world of theatre. This was the period when the *trompe l'œil* paintings of Jacques Rousseau were popular in England as well as in France.[30]

As the century ended, the art of landscape painting was based less and less on the observation

254. *previous pages*:
Laurent de La Hyre,
*Landscape with a Man
playing the Flute.*
Oil on canvas,
106.5 × 131.5 cm.
Musée des Beaux-Arts, Lille.

255. Francisque Millet,
*Landscape with a Flash of
Lightning.*
Oil on canvas,
97 × 127 cm.
National Gallery, London.

256. Gabriel Pérelle,
Landscape in a Storm.
Engraving.
Département des Estampes,
Bibliothèque Nationale,
Paris.

of nature, more and more on the observation of recognised models, which were discussed at great length and their merits compared. When Poussin's *Seasons* arrived in 1664 for the Duc de Richelieu, experts and critics came running. Brienne made himself the mouthpiece of their reactions: work so unusual for the period left some of them quite disconcerted.[31] However, they provided material for discussion at academic gatherings, and the mysteries and rules of historical landscape painting being developed by Jean-François (called Francisque) Millet (pl.255) and Etienne Allegrain, continued to be sought within them. Millet, whose roots were Flemish, picked up the grand manner of Dughet and particularly Poussin; there is awareness in his work of the impressive construction of the paintings of Poussin's maturity as well as the more lyrical tone of the paintings of his old age: mountains, forests

and broad landscape views dotted with buildings provide a serene background to religious (*Christ and the Woman of Cana* in Toledo) and mythological scenes (*Mercury and Battus*, New York). The spectacular *Landscape with Lightning* in London (pl.255) is inspired by the storms and tempests of his Roman models. Millet's career was a short one, but his paintings were popularised by the engravings of Theodore, and his two sons perpetuated his style into the next century. Allegrain was a classic example of an academic landscape painter, equally at ease when decorating royal residences as when painting smaller cabinet paintings. His *Finding of Moses* (Hermitage) refers to the painting of the same subject by Poussin, as well as to the *Funeral of Phocion*. He also borrowed from the engravers, adapting their ruins and townscapes to suit his own style. Although he adhered strictly to the rules of classical landscape, psychologically he moved away from it and his style grew increasingly relaxed and decorative, closer at times to the rustic than to the heroic (as in his *Landscape with a Flock*, painted in 1700 for the Menagerie at Versailles and now in the Louvre).

Taste by now had developed and no longer felt comfortable with the rigid old formulae. Admiration for Rubens and the debate about colour had brought about a renewal of the Flemish style, but at an almost exaggerated pitch. Asymmetrical compositions now had to be full of movement; colour became less discreet, bold contrasts of warm and cool being employed. Everything aimed at delighting and surprising the eye. In fact, landscape painting from the end of the reign of Louis XIV is extremely scarce, apart from some studies in oils from motifs by François Desportes, now in the Sèvres porcelain factory (pl.263); these were used as backgrounds to hunting scenes and 'portraits' of the royal dogs. Views of the Ile-de-France, blue or cloudy skies, studies of trees, plants and flowers painted between 1690 and 1700, are unusually spontaneous for the period. The painter's method of working, as described by his son, was also unusual and presaged the Barbizon school,[32] via the quick colour sketches of Valenciennes:

[. . .] He would take his brushes and prepared palette to the fields in tin boxes; he had a stick with a long pointed steel tip to fix it into the ground. In the steel knob there was a little folding frame, also of steel, to which he would attach his portfolio and paper. He never went to his friends' houses in the country without this light piece of luggage; with it he was never bored or idle, and always made good use of it.

257. Matthieu de Plattemontagne, *Seascape by Moonlight*. Engraving. Private collection.

In spite of the fact that his contemporaries paid glowing tribute to his importance as a painter, Jean-Baptiste Forest is now little more than a name; his existing work amounts only to a few drawings and a single engraving. No single painting can be securely attributed to him, the one in the museum in Tours having rightly been dis-

258. *below*: Adam Frans van der Meulen, *View of a Northern City*. Watercolour, 28.5 × 40.8 cm. Département des Arts Graphiques, Musée du Louvre, Paris.

259. Adam Frans van der
Meulen,
The Capture of Maastricht,
1673.
Oil on canvas,
230 × 332 cm.
Musée du Louvre, Paris.

260. Jean Cotelle,
*The Woodland Entrance to
the Water Theatre.*
Gouache on paper,
45.5 × 36 cm.
Musée National du Château,
Versailles.

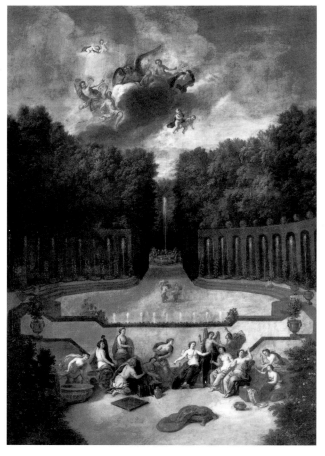

261. Etienne Allegrain,
Decorative Landscape.
Oil on canvas,
120 × 121 cm.
Musée National du Château,
Versailles.

puted.[33] We know that he was trained in Italy and was received into the Academy in 1674 in Paris, where he was also an art dealer. Everything suggests that he painted in the chiaroscuro style of the Venetians and of Pier Francesco Mola. We have to make do with appraisals by other people, such as Dézallier d'Argenville:[34] 'His colours are *terrific*, sometimes almost too exaggerated, and too black, but one is sure to find something arresting in his paintings, including those bold, masterly brushstrokes that other painters call *réveillons*.' Similar harmonies of rust red and blue, and similar shafts of light are to be found in the backgrounds of landscapes painted by his brother-in-law, Charles de La Fosse (as in the *Finding of Moses* in the Louvre) and his son-in-law, Nicolas de Largillierre. There is a handsome *Wooded Landscape with two People* by Largillierre in the Louvre (pl.262), warm in colour and lyrical in composition. The small figures appear lost in mystical communion with the landscape: Watteau does the same thing in his *fêtes galantes*, reviving the tradition of Giorgione and Van Dyck.[35] This painting resolutely turns its back on the cerebral harmonies of the Poussinists, replacing them with 'the first glance effect'[36] preferred by the colourists. The dialogue between these two strands continued during the eighteenth century, to the enrichment of French landscape painting, and a critique and redefinition of existing models developed.

Notes

1. G. Wildenstein, 1950–1 and 1956.

2. Grivel, 1986, pp.147–50.

3. Mérot, 1990 (2), pp.93–7.

4. Félibien, 1666–88, part 3, *Entretien* 5 (1679), pp.59–60. Poussin's painting, executed for Pointel, is now in the Musée de Rouen.

5. Comments ascribed to Michelangelo by Francisco de Holanda in his *Dialogues* (1548), quoted by Gombrich, 'Renaissance artistic theory and the birth of landscape', in Gombrich, 1983, p.27.

6. De Piles, 1708 (1989), pp.99–100. On the idea of 'heroic' landscape, see Thuillier, 1977.

7. See exh. cat., Bologna, 1962.

8. Zerner, 1969.

9. The *Ode à la Solitude*, by Saint-Amant, published with his collected works in 1629, had been composed about ten years earlier. *La Solitude*, by Théophile de Viau, is probably slightly earlier.

10. Félibien, 1666–88, part 5, *Entretien* 9 (1688), pp.165 and 175.

11. Brown and Elliott, 1980, pp.125–7. Champaigne took his subjects from the *Lives of the Desert Fathers*, translated by Robert Arnauld d'Andilly (1647).

12. Félibien, 1666–88, part 4, *Entretien* 7 (1685), p.88. See J. Thuillier exh. cat., Paris, 1990–1, pp.42–3.

13. See exh. cat., Paris, 1977, and Mérot, 1990 (3).

14. Alpers, 1990, chapter IV: 'L'appel de la cartographie dans l'art hollandais.'

15. J. Thuillier (although he included Claude in his panorama published in 1964, republished in 1992) states quite clearly that 'he does not belong to French painting' and that his influence in France is no greater than that of someone like Swanevelt (Thuillier, 1980 [1981], p.92).

16. Sandrart, 1675, *passim* and p.184.

17. Damisch, 1982 (1984).

18. Kennedy, 1972.

19. Verdi, 1982, sees the large landscape paintings of the late 1640s as a Stoic cycle, parallel to the *Sacraments*, illustrating the power of Fortune.

20. See especially Marin, 1981, and Bätschmann, 1987.

21. On these two landscapes, see Gombrich, 1983, p.9ff. ('The subject of Poussin's *Orion*') and Alpatov, 1965.

22. On the interpretation of the *Seasons*, see especially Friedländer, 1962, and Sauerländer, 1956.

23. Mahon, 1947, pp.111–54 ('Agucchi and the *Idea della Bellezza*'); Whitfield, 1973.

24. Gnudi, preface, exh. cat., Bologna, 1962.

25. Imitated from the modes of Greek music, Poussin's modes (see his letter to Chantelou of 24 November 1647) relate also to poetry (particularly to Virgil's poetry) and to the 'marvellous artifice' that consists in 'accommodation of the verses to the words, and the disposal of the metrical feet according to the rhythms of speech'. The notion of 'modes' contains the seeds of the idea of 'mediocrity' and 'moderation' — in short, of measure — which is central to Poussin's aesthetic.

26. Lecture published in Fontaine, 1903 (see especially p.124).

27. Mariette, about 1750 (1851–60), vol.IV, pp.88–9.

28. Thuillier, 1980 (1981).

29. Schnapper, 1967, *passim*.

30. On Rousseau in particular and *quadratura* in France in general, see Schnapper, 1966.

31. Loménie de Brienne: *Discours sur les ouvrages des plus excellents peintres anciens et nouveaux* (ms., 1693–5), quoted in Thuillier, 1960 (1), p.222.

32. Claude-François Desportes: 'La vie de M. Desportes . . .' (read in 1748 at the Académie Royale) in *Mémoires inédits*, 1854, vol.II, p.109.

33. Fohr, 1982, no.25, pp.37–9.

34. Dézallier d'Argenville (1745–52), 1762, vol.IV, p.186.

35. On Watteau's connection with the Venetians, via Flanders, see exh. cat., Washington, 1988.

36. The expression belongs to Roger de Piles. See below, chapter 12, p.296, and Puttfarken, 1985, pp.96–105.

262. Nicolas de Largillierre, *Wooded Landscape with two People*. Oil on canvas, 36 × 64 cm. Musée du Louvre, Paris.

263. *below*: François Desportes, *Forest Pool*. Oil on beige paper, 33 × 52 cm. Manufacture Nationale de la Céramique, Sèvres.

PAINTERS OF STILL LIFE AND ANIMALS

265. Louise Moillon,
*Basket of Fruit and
Asparagus*, 1630.
Oil on canvas,
53.5 × 71.3 cm.
Art Institute, Chicago.
Wirt D. Walker Fund.

264. *previous pages*:
Sébastien Stosskopf,
The Five Senses or
Summer.
Oil on canvas,
113 × 180.5 cm.
Musée des Beaux-Arts,
Strasbourg.

The twentieth century holds still life in very high esteem, regarding it as a pure kind of painting, freed from the restraints imposed by subject matter, one in which the artist can express himself, technically and emotionally, better than in any other genre. It should be remembered, however, that things were very different in the seventeenth century. A painting style that aimed no higher than the reproduction of nature in its humblest aspects, and which gave particular emphasis to inanimate objects, inevitably aroused suspicion, even scorn.[1] Pascal's opinion is well known: 'How vainglorious is painting: it attracts admiration by representing objects whose originals are by no means to be admired!'[2] — an unintended tribute to the painters' skill. More significant, perhaps, is Félibien's attitude to the genre. In his *Entretiens* he pays almost no attention to specialists in still life and animals; Karel van Mander, on the other hand, in his *Schilderboeck*, published in 1604, devotes a whole chapter to 'beasts, animals and birds'. There is an exception to the general neglect of the genre, however, in an anonymous manuscript dating from the first quarter of the century.[3] The currently most popular subjects of still-life painting are all named: 'painted fruits', 'roast game on a dish', 'cooked fish', or 'dishes of dessert'. The author gives practical advice to painters undertaking such subjects, to help them 'deceive the eye' more convincingly. The pleasure of the eye is more important than the pleasure of the intellect, and the almost complete silence of writers on this subject betrays their failure to comprehend an art which is frequently outstanding in terms of technique, but which is undeniably short on invention.

Although conspicuous by its virtual absence at the end of the sixteenth century (compared with genre painting) still life came, in time, to appeal to an enormous public.[4] It was practised first by artisan-craftsmen in a spirit of humility, and with close fidelity to their subjects; gradually, however, it grew more ambitious in both composition and choice of subject. Still life was an integral part of the large decorative schemes of the period, and in particular bouquets and garlands of flowers, and fruit; under Louis XIV it won its place in the Academy and in the Salons. The painter's skill at

imitating nature was by this time admired less than his skill at arranging his subject according to current taste, then heavily influenced by the Italian Baroque. Besides its purely visual aspect, still life could now, thanks to the language of allegory, claim to express ideas as well. Some of the most beautiful paintings of the first half of the century were *Vanitases*[5] which, with their rich symbolism and conceptual austerity, could be classed as aids to spiritual and religious meditation. The repeated presence of mirrors in evocations of the five senses, of engravings and paintings within paintings, and the growing success of *trompe l'œil*[6] helped to convey an ambiguous message: illusion was denounced, but the artist was elevated to the status of demiurge. The opulent products of the reign of Louis XIV were less serious in intent, aiming mainly to dazzle and to show off the amazing skill of their creators. In an attempt to

escape from any conventional straitjacket, the genres were sometimes mixed and compositions enlived by a variety of means. The accepted name '*nature morte*', which in fact did not appear until the mid eighteenth century,[7] could not be less appropriate for this style of painting, which aims to reproduce life itself.

THE SILENT LIFE OF OBJECTS

Like landscape, at the turn of the century the still life was a speciality of Flemish painting, particularly of the artists born and trained in the north and often belonging to veritable dynasties of painters; many of these had established their studios in Saint Germain des Prés and around the Pont Notre Dame. They worked side by side and shared the same repertory of subjects: examples are, between 1630 and 1640, Pieter van Boucle, Lubin Baugin, Jacques Linard and Sébastien Stosskopf, all of them, however, from different backgrounds. Such artists were often Protestants: François Garnier and his daughter-in-law Louise Moillon, René Nourrisson and later Jacques Samuel Bernard or Jean Baptiste Blin de Fontenay, both members of the Academy, who were obliged to abjure their faith. Attempts have been made to link the sobriety of an artistic style that made no use of the human body with reformed religion;[8] to make this link, however, it would be necessary to demonstrate that the paintings in question have a religious content. Symbolic or even eucharistic elements, such as bread, wine, bunches of grapes, fish, can be found in them, it is true. But the paintings of *vanitases* can just as easily be linked with the Catholic religion. Flower paintings could obviously be laden with Marian significance.[9] But in most cases, as the few contemporary references suggest, the artist's main aim was to depict the objects in front of him as faithfully as possible; a still life could not be classed as a devotional painting.

The painters of the 1620s and 30s were reliant on a tradition well established in northern Europe since the end of the sixteenth century and taken up in Italy and Spain as well.[10] Whether the subject was flowers, fruit or whole meals it would be viewed from above, with the table slightly tilted

towards the spectator in order to display the objects with maximum clarity; the individual items would be distinctly and precisely drawn, the colours contrasting sharply under a uniform light. The French, however, preferred something more direct and disciplined than the great kitchen or market scenes of painters like Pieter Aertsen or Joachim Beuckelaer; French still-life painters concentrated on a single motif (a vase, basket or dish filled with flowers and fruit), or, if there were a diversity of objects, they would organise them in a series of perpendicular lines (for example, Stosskopf's *Five Senses* or *Summer*, about 1630–5, Strasbourg; pl.264) or obliques (like Baugin's *Still Life with Chessboard*, about 1630–5, Louvre).

These careful arrangements sometimes contained figures as well, thus coming close to being genre paintings: Louise Moillon's most ambitious paintings, like the *Fruit and Vegetable Seller* (1630, Louvre; pl.267) or the *Lady with her Servant* (1630, Louvre) transpose Flemish models, embellishing and refining them.

Most French paintings of this period took as their subjects familiar, easily decipherable themes such as the *Five Senses* or *Vanitas*; the fateful skull standing surrounded by objects to remind the spectator of the fragility of human endeavour. Monotony was avoided when the artist was able to treat such hackneyed themes with technical skill and a sensitive reading of the objects chosen: examples of such handling are provided by Linard in his *Five Senses* (1638, Pasadena; pl.266), or Baugin in his *Dessert with Gaufrettes* (about 1630–5, Louvre; pl.269), with its muted colours and its moving restraint. One of the masterpieces of the genre is undoubtedly the anonymous *Vanitas* in the Louvre (pl.268), attributed to a painter in the circle of Georges de La Tour in Lorraine.[11] Still lifes could also record fashions of the day: the latest novel or devotional book; engravings after La Hyre, Callot or Vouet in some of the paintings of Stosskopf's Parisian period; items of gold jewellery introduced into his paintings by Stosskopf after his return to Strasbourg in 1640, when he married the daughter of a rich Strasbourg jeweller. Still lifes sometimes also conveyed information relating to 'curio chests' and the development of numismatics or the natural sciences, their painters taking pleasure in explaining in detail the different varieties of shells, insects or flowers, like the parrot tulips which were so sought after at the time. In this way painters of still life could participate in the great project being carried out at this period by scientists and their illustrators, the inventorying of the natural world. Examples are the 'vellums' of flowers by Jean Le Roy de la Boissière (1610), Daniel Rabel (1624) and, above all, Nicolas Robert and Jacques Bailly the Elder, both of whom worked for Gaston d'Orléans and then for Louis XIV.[12]

Flower painting was particularly popular at this time.[13] The diversity and beauty of the different species, their sparkling colours, the accuracy of

271. Nicolas Robert, *Tulipa Monstrosa.* Watercolour on vellum, 46 × 33 cm. Bibliothèque Centrale du Musée Nationale d'Histoire Naturelle, Paris.

the drawing, the simple or more elaborate arrangement of the blooms gave artists plenty of opportunity to excel. The pleasure of accurate description and the sophistication of a language of symbols characterise the *Garland of Julie*, that jewel of courtly culture offered to the daughter of Madame de Rambouillet by her suitor, the Duc de Montausier, in 1641. This exquisite manuscript (Paris, Bib. nat.) is a combination of 'portraits' of flowers illuminated by Nicolas Robert (pl.271), and poems that pretend to voice their thoughts, composed by the wits and littérateurs who frequented the Hôtel de Rambouillet. Specialised botanical illustrators were much in demand: there was no panelling, in residence or palace, without its garlands or bouquets of flowers, flowers in vases or stylised arrangements; these made a welcome counterpoint to historical subjects.[14] From the panelling in the Guard Room at Cheverny, painted by Jean Monnier (about 1634), to Vouet's 'grotesques', painted for Anne of Austria's bathroom in the Palais Royal[15] (about 1645, lost, engravings by Dorigny), or the over-door paintings executed by Blin de Fontenay in Versailles or Marly, not forgetting the reception rooms of Vaux le Vicomte and any number of Parisian *cabinets*. There is a whole series of dazzling examples, ranging from the demure arrangements of the 1630s to the imposing compositions of the end of the century. From Linard to Jean

270. Jean-Michel Picart, *Bouquet of Flowers.* Oil on canvas, 56 × 42.8 cm. Musée d'Art Moderne, Saint-Etienne.

Michel Picart (pl.270), and on to Baudesson and
Monnoyer, ornamentation grew bolder and less
rigidly symmetrical, lighting effects more sharply
contrasted, and the backgrounds filled up with
architecture and landscape. All was enchantment
and illusion, as Tristan L'Hermite, who gave an
important place to flowers in his picture collec-
tion,[16] was at pains to emphasise:

> Within these immortal pages
> Unfamiliar flowers bloom.
> Now we see just how Picart
> Has exploited all his art [. . .]
> Foliage appears in motion,
> Of scent and sound we gain the notion.
> With their exquisite appeal
> Our five senses they can steal.

ELABORATE STILL LIFE DURING THE REIGN OF LOUIS XIV

The study of paintings of flowers and fruit reveals
how, at the beginning of the reign of Louis XIV,
the transition from the intimacy of the earlier still
life to a much more decorative ideal came about.
New models appeared in Europe. Dutch still-life
painting became increasingly luxurious, begin-
ning to include valuable objects in the work of Jan
David de Heem or Willem Kalf (who was in Paris
during the 1640s). In Italy, especially in Naples

and Rome, with painters like Porpora, Recco or
Fieravino (the Maltese) compositions grew live-
lier, the objects engaging with each other in a
dramatic chiaroscuro, the colours powerful and
the painting technique more generous, with
brushstrokes that were sometimes thickly textured
and grainy.[17] French painters often had direct
experience of the Italian models: Nicolas
Baudesson spent a long time in Rome, working
with Pierre Mignard; Meiffren Conte, whose
career was spent in Aix and Marseille, where
he decorated ships, must have received his train-
ing in Italy. The growing opulence of the royal
residences and the establishment of the Gobelins
factory also explain the enrichment of the still life
as a genre: to its repertory were added trophies of
weaponry and musical instruments (Geneviève
and Madeleine Boullogne), oriental carpets
(Jacques Hupin) and increasingly heavy gold and
silverware (Meiffren Conte and Baudoin Yvart,
who worked with Le Brun at the Gobelins, give
us an idea of the famous collection of silverware at
Versailles; pl.273). Henceforward nature and art
came together in some ravishing combinations.

Two painters in particular illustrate this tran-
sition: Pierre Dupuis (pl.274) and Nicolas
Baudesson, who were admitted to the Academy
in 1663 and 1673 respectively. Although both
continued to be committed to the accurate rep-

273. Meiffren Conte,
Collection of Gold Plate.
Oil on canvas,
105.4 × 129.5 cm.
Staatliche Kunsthalle,
Karlsruhe.

resentation of their subjects, their paintings acquired a new kind of monumentality; they gave visible expression to their concern with compositional structure by including groups of classical sculpture, and painting their signatures in *trompe l'œil* engraving on stone in the Roman manner. Baudesson lights his abundant assemblages in an almost theatrical manner. To the trick of the 'tilted table', whereby the objects are placed just below eye level, was added another artifice invented by the Italian wall painters: subjects seen *da sotto in sù* (from below). Here the objects are viewed in perspective and are thus less clearly depicted; this suited the different physical locations in which paintings were now being placed — over doors, for example.

Although the art of *trompe l'œil*[18] was practised throughout the seventeenth century, the deception of the senses was no longer sufficient for the painters of the time of Louis XIV. Baudesson, Monnoyer and his pupil Blin de Fontenay rivalled the portrait painters and painters of history in their theatrical sense of presentation. Once the technical problems of life-like representation had been overcome, other ambitions raised their heads. Flowers and animals were juxtaposed to add animation and a certain elegant disorder. Bunches of flowers and fabrics were no longer confined to the interior but were displayed in a natural setting,

often in a park, where they tremble in the breeze. Intense concentration on detail was replaced by a dynamic that carried all before it. The sovereign and public alike appreciated the work of these flower painters, and they pursued highly successful careers, with their paintings being shown in the Salons. In the Salon of 1673 there were paintings by Baudesson, the Boullogne sisters, Pierre Dupuis, Jean Garnier the Younger, Claude Huilliot and Jean-Baptiste Monnoyer (pl.272). The reception pieces of newly elected members of the Academy bear witness to the same revival. Blin de Fontenay's piece, painted in 1687

274. Pierre Dupuis,
Basket of Grapes.
Oil on canvas,
50 × 60 cm.
Musée du Louvre, Paris.

(Louvre; pl.275), combines a bust of the King on a plinth, with a golden vase overflowing with flowers placed on a marble-topped table; the floor is littered with pieces of armour and fruit and the whole placed at an angle in front of a colonnade. As early as 1671 Jean Garnier had painted an oval portrait of Louis XIV surrounded by different attributes of the arts, music in particular; this was intended to symbolise 'the abundance of the kingdom and the perfect harmony to be found in the governance of the country'.[19]

With Largillierre, trained in Antwerp, and Desportes, a pupil of Nicasius Bernaerts, one of the animal designers at the Gobelins factory, the Flemish tradition, much enriched, enjoyed a spectacular new lease of life at the end of the reign of Louis XIV. Largillierre's portrait of Le Brun (1686, Louvre) stands out; the accessories (the

attributes of the arts that figured in so many paintings) play an essential rôle. The composition of the pendant paintings in the Musée de Dunkerque (pl.277) is reminiscent of Monnoyer and some of the Neapolitan painters like Porpora, but the range of warm colours, with explosions of red and orange, betray a most original streak. Desportes is best remembered for his arrangements of animals and objects, as in *Fruit, Flowers and Animals* (1717, Grenoble, pl.276), which is a masterly résumé of previous experience: the dish of peaches, the basket of plums and the bunch of roses represent 'still life', but they seem almost outshone by the tremendous display behind them: balustrades with stone urns, objects made of gold and silver, gold-fringed carpet, musical instruments and exotic animals all overlooking extensive grounds. The artist enjoys juxtaposing contrasting fabrics and

275. Jean-Baptiste Blin de Fontenay, *Gilded Vase, Flowers with a Bust of Louis XIV.* Oil on canvas, 190 × 162 cm. Musée du Louvre, Paris.

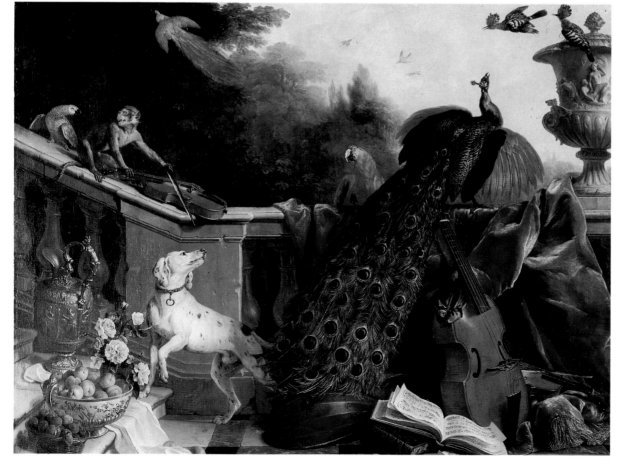

276. François Desportes, *Fruit, Flowers and Animals,* 1717. Oil on canvas, 124 × 231 cm. Musée de Peinture et de Sculpture, Grenoble.

using diagonal lines to animate his scene. In his Flemish-style arrangements of victuals, in which furred and feathered game (painted with sensitivity and care) is flanked by polished marble and gleaming metal, and with fruit reflected in silver dishes (Sèvres, Stockholm etc), Desportes carries forward the elaborate materialism of the previous century into the reign of Louis XV, handling the transition with the skill of someone like Chardin, who was accepted by the Academy in 1728 with two traditional paintings, *The Skate* and *The Sideboard*.

PAINTERS OF ANIMALS

Like the writers of the *Grand Siècle*, painters seldom represented animals except as adjuncts to human beings:[20] specialists in battle scenes were obliged to paint horses, as painters of hunting scenes had to paint dogs; a *Nativity* had, in theory,

279. Adam Frans Van
der Meulen,
Three Officers.
Département des Arts
Graphiques, Musée du
Louvre, Paris.

280. Pieter Boel,
Pack of Hounds.
Watercolour and oil on
paper, 22.8 × 34.2 cm.
Département des Arts
Graphiques, Musée du
Louvre, Paris.

281. François Desportes,
Self Portrait as a Hunter,
1699.
Oil on canvas,
197 × 163 cm.
Musée du Louvre, Paris.

to include an ox and an ass, not to mention the shepherds' sheep and the camels of the three Wise Men — Poussin nevertheless managed to exclude camels from his *Eliezer and Rebecca* in the Louvre.[21] The same anthropomorphism to be found in the *Fables* of La Fontaine can be found in Le Brun's studies of physiognomy; animals provided the stereotypes for the classification of human facial types from which dominant characteristics can be deduced:[22] animals are used as an aid to the comprehension of the mechanics of the physical expression of emotion. Emblems like Fouquet's squirrel were replaced at this period by real animals even in the stylised visual language of the decorators. They were still stereotypes, however, rather than individual portraits such as were being painted in the Low Countries: compare them with Potter's *Bull* (1654) for instance, or Fabritius's *Goldfinch* (1654). In daily life, nevertheless, relations between man and the natural world, including animals, were close: we only have to think of the hunt. It was a keen huntsman,

Georges de La Tour, who left some of the most touching animal portraits of the century: the dog in the *Hurdy Gurdy Player* (Bergues, pl.278), the cockerel in the *Tears of St Peter* (Cleveland). A concern for familiarity and domestic realism persuaded Le Brun to include a plump cat warming itself under a brazier in his *Holy Family* of 1655 (Louvre). In this he resembled the Le Nain brothers, who liked to include a few domestic animals in their scenes of peasant life, or Michel Corneille the Elder, already under the influence of the Flemish painters in his *Jacob and Esau* (1630, Orleans), in which the hunting dog and the cat meet face to face by the cottage fireplace. Dogs were often used in portraiture, sometimes to reflect the interest of the gentry in a particular breed: a few examples include Pierre Mignard (*The Family of the Grand Dauphin*, Versailles) and Largillierre (*La Belle Strasbourgeoise*, 1703, Strasbourg). Desportes's *Self Portrait as a Huntsman* (1699, Louvre), his reception piece at the Academy, is a highly successful painting, lively and colourful, that marked the beginning of a long career. The artist exhibited in the Salons from 1704 to 1742 and his work was sought after in France and abroad; he worked at the Gobelins factory throughout his career.

The decorative and expressive scope of animal painting burgeoned in the second half of the century. At the Gobelins, Flemish artists like Boel and Bernaerts adapted the art of Frans Snyders or Jan Fyt, following the northern tradition of representing animals in motion (hunting, fighting) in a landscape. At the same time the development of natural history and a renewed interest in the exotic enriched the artists' frame of reference, tempting them with unfamiliar forms and colours. Van der Meulen, Desportes and others produced dozens of very lively drawings (pl.279) and oil sketches from life. They improved their knowledge of anatomy in order to represent figures in motion more accurately. Le Brun set an example in the 1660s with his *Battles of Alexander*. First Bernaerts, then Desportes were made official painters to the royal hunt, and they were followed in the eighteenth century by Oudry, who painted portraits of Louis XV's favourite dogs. The production of a large number of tapestries in series

282. François Desportes (after), *Indian Fishermen*, part of the *Tapestry of Ancient India*. Tapestry, 385 × 377 cm. Collection du Mobilier National, Paris.

required the collaboration of specialised artists:[23] various still life and animal painters were employed on the *History of the King*, and more particularly on the *Months* (*The Royal Houses*), woven seven times between 1668 and 1694.

Interest in exotic species grew stronger and stronger. The royal family and various princes set up menageries where artists could come and study. The scientific aspects of this craze can be appreciated in Nicolas Robert's meticulous paintings of rare birds. But it was in fact the decorative and fanciful aspects that predominated. In 'Le Labyrinthe' in the park at Versailles, laid out between 1666 and 1667, there were thirty-nine fountains, each with an elegant group of mammals and birds, dozens of different species in all, in painted lead.[24] Bernaerts was employed to decorate the menagerie (also at Versailles).[25] Monkeys and parrots, the closest animals to mankind

because of their mimicry and their language, were the most commonly depicted; they were often used to lend vitality to portraits and still lifes, and they occupied a central position in the fancy decorative schemes painted by Jean Bérain the Elder and Claude Audran the Third; both Watteau and Desportes had a hand in these at the beginning of their careers. In the same exotic vein was the eight-piece tapestry of *Ancient India* (1689–90, pl.282) which was based on material brought back from an expedition to Brazil in 1637–44 by Prince Maurice of Nassau; the studies made for it by Albert Eeckhout and Frans Post are of particular interest. This tapestry was so successful that a second edition was woven at a later date (1735–41), to cartoons by Desportes.[26] The decorative arts in the reign of Louis XV thus extended the life of a style that had been formed some fifty years earlier, a style that favoured

colour and movement, putting at the disposal of highly skilled craftsmen elaborate compositions and a specialised knowledge of the natural history of the whole world.

Notes

1. 'The painter who is able to paint landscapes perfectly is above the painter who only paints fruit, flowers or shells. The painter who paints live animals is more to be admired than the ones who only represent dead and lifeless things.' (Félibien, 1668 [1725], vol.v. p.310.)

2. Pascal, *Pensées* (ed. Lafuma), Paris, 1963, 'L'Intégrale', fragment 40, p.504.

3. B.N., Mss. Suppl. fr. 3809 (published by Thuillier), 1968 (1), pp.129–30.

4. Still lifes are very rare in the late-sixteenth-century posthumous inventories published by G. Wildenstein (1950–1); they are, however, more numerous in those mentioned by Faré (1974). Five still lifes are to be found in the *Cabinet de M. de Scudéry* (see Scudéry, 1646 [1991], pp.119–20), and he emphasises the skill of their creators, virtuoso painters of illusionistic effects.

5. See exh. cat., Caen, 1990.

6. See Faré, 1974, pp.161–8; Georgel and Lecoq, 1987, pp.196–9.

7. In the seventeenth century the genre was, in France, known as '*vie coye*' (silent life), and in the Low Countries as *still leven* (translated by the English as 'still life'). It was not until the eighteenth century (the words were used by Diderot in 1756, writing about Chardin) that the term '*nature morte*' became current.

8. According to Faré (1974, p.384) the still life occupied, in Protestant circles, the same role as the devotional picture in Catholic circles. The still lifes introduced by the Le Nain brothers into their genre paintings have often been interpreted in this light (Menier, 1978).

9. See in particular O. Delenda, exh. cat., Caen, 1987.

10. For a European over-view, see Sterling, 1959, pp.43–79.

11. Exh. cat., Nancy, 1992 (1), no.102 (entry by J. Thuillier).

12. Schnapper, 1983 (1985), and 1988, pp.54–60.

13. Exh. cats Paris, 1979, and Caen, 1987.

14. Mérot, 1990 (2), pp.99–105.

15. Mérot, 1991 (1992).

16. Tristan L'Hermite, *Les Vers héroïques*, Paris, 1648.

17. The influence of Italy is evident in the handsome *Still Life with Bunches of Grapes, Figs and Pomegranates* by Pierre-Antoine Lemoine; it may have been his reception piece for the Academy in 1654 (private collection, Paris).

18. See the works of Jean-François de Le Motte, active around 1650 (Faré, 1974, p.162).

19. Guillet de Saint-Georges, 'Discours sur le portrait du roi [de Henri Testelin]', in *Mémoires inédits . . .* , 1854, vol.ı, p.235.

20. See the entry under 'Animals' (by S. Hoog) in Bluche, 1990.

21. The omission was criticised by Philippe de Champaigne in his lecture to the Academy on 7 January 1668, but Le Brun justified it in the name of decency.

22. See chapter 11, p.268.

23. Faré, 1974, p.356.

24. Hoog, 1988.

25. Mabille, 1974 (1976).

26. Exh. cat., Paris, 1982, pp.88–90.

THE TWO APELLES: LE BRUN AND MIGNARD

As Le Brun busied himself at Fontainebleau with the painting of his *Queens of Persia at the Feet of Alexander* (1660–1, Versailles, pl.286), under the watchful eyes of the reigning monarch, Louis XIV, how aware was he of having reached a turning point in his career? The downfall of Superintendent Fouquet, after the celebration at Vaux-le-Vicomte, had removed his most important patron, and had placed him under the direct authority of the King and his Prime Minister, Colbert. The paintings at Vaux had revealed Le Brun's genius as a decorator, now the *Queens of Persia* made him the rightful heir to Poussin. The latter painting was acclaimed at the time for its unity of action, for its analysis of the different 'passions' and for its exploration of 'costume', i.e. for historical accuracy and local colour: it was the material embodiment of Fréart de Chambray's treatise *Idée de la perfection de la peinture* (1662). Le Brun had assimilated Poussin's model of a history painting and amplified it, transferring its mode to an elaborate courtly ritual well-suited to the place where the painting was destined to be hung. The rich, dark colours, in contrast to the lighter tones of someone like Vouet, accentuated the serious impression it made.[1] But Le Brun was incapable of limiting himself to the safe mediocrity recommended by Poussin. His taste for grandeur, a streak of violence in his nature and a pronounced appetite for Herculean tasks led him to follow up with the *Battles of Alexander*,[2] immense canvases, perfectly in keeping with the unbridled ambition of the early years of Louis XIV.

If the *Queens of Persia* was the visual equivalent of tragedy, the *Battles* were the equivalent of epic poetry, still the leading literary genre in France in spite of there having been no very remarkable successes in it. Did Le Brun dream of decorating a large reception room or gallery with these paintings? Of exceptional size (more than twelve metres wide), they were eventually used as cartoons at the Gobelins tapestry workshop (1665–80) and were circulated as engravings by Sébastien Le Clerc (1696). Leaning heavily on Raphael and Giulio Romano as models, Le Brun piled up figures, animals and objects, allowing his sense of rhythm and balance to guide him. Pyramidal or triangular internal schemes and the distribution of

light highlight the exploits of the warrior king (*Crossing the Granicus*, *The Battle of Arbeles*, pls. 284, 285), magnanimous (*Alexander and Porus*) and triumphant (*Alexander's Entry into Babylon*). Each canvas has its own mood and its own lighting: from the well-orchestrated confusion of the battle scenes, the eye moves to the calm surrounding the act of clemency, to the majestic exhilaration of triumph. The three battle scenes take place in the light of morning, noon and evening, as recommended by Sébastien Bourdon in his lecture at the Academy in 1669, when he praised the painter for his ability to distribute light and dark areas in order to form groups and to distinguish one group from another.[3] The knots of cavalry and foot soldiers, the bold foreshortenings, physical assaults, massing of bodies and falling figures are all typical of Le Brun's world. One of the key figures in the *Battle of Arbeles*, the Persian soldier seen running and bellowing, the image of terror, illustrates Le Brun's fascination with frenzy. The violence is well orchestrated, however, and the qualities exhibited at Vaux-le-Vicomte are here enhanced by the heroic grandeur of the subject matter. There could have been no better choice of artist than Le Brun to interpret the ambitious plans of a monarchy just emerging, with increased powers, from the Fronde and in the process of imposing its rule over the whole of Europe. In Le Brun, Louis XIV, the latter-day Alexander, found his Apelles.

LE BRUN THE DECORATOR: FROM THE LOUVRE TO VERSAILLES

After the downfall of Fouquet, Le Brun was employed at the Louvre, where some years earlier he had worked on the decoration of the King's apartments with Le Sueur and Errard.[4] He was commissioned to continue with the work begun by Poussin in the Grande Galerie, still the main focus of the decorators' attentions, but was diverted from it by the need to redecorate the Petite Galerie after it had been ravaged by fire in 1661. Colbert chose subject matter that centred on Apollo. Three big paintings were planned for the ceiling, showing 'His Majesty, symbolised by

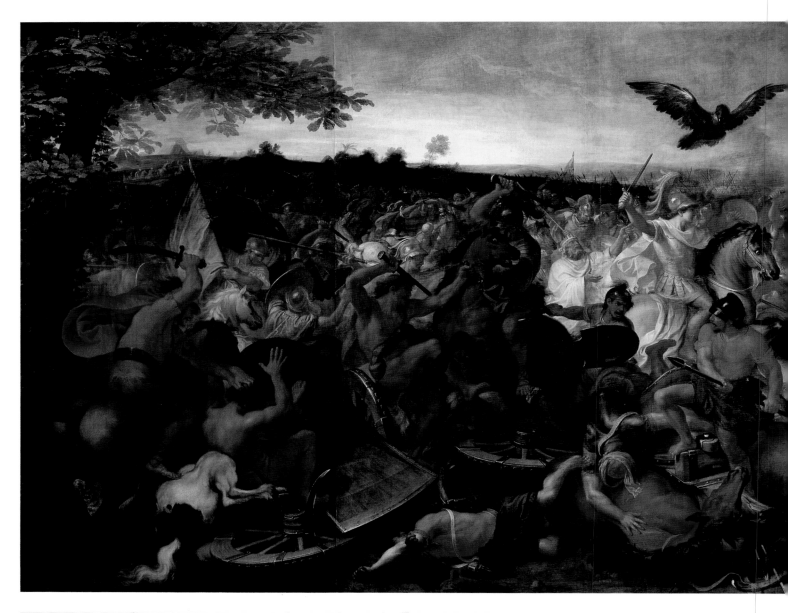

285. Charles Le Brun,
The Battle of Arbeles.
Oil on canvas,
470 × 1265 cm.
Musée du Louvre, Paris.

286. Charles Le Brun,
*The Queens of Persia at the
Feet of Alexander.*
Oil on canvas,
298 × 453 cm.
Musée National du Château,
Versailles.

the Sun, enjoying the reverence and admiration of the nation, on land and sea';[5] in the smaller compartments allegories of the seasons, the hours of the day, the months of the year and the signs of the zodiac accompanied the main subject. The myth of the Sun-King was already emerging, well before Versailles. The Louvre had to be the most beautiful palace in the world. Since the peace treaty of the Pyrenees, Colbert had ordered Le Vau to carry on with work in the Cour Carrée (1659). In 1664 he launched a competition for the eastern façade, built under the supervision of Claude Perrault after the dismissal of Bernini in 1667.

While this was going on, the King took up residence in the Tuileries, redecorated from 1664 by a team directed by Le Brun.[6] Once again the theme of Apollo was chosen by members of the Petite Académie, sent to assist Charles Perrault in the choice of subject matter for the royal residence. In the large apartment different episodes

from the legend of the sun-god embodied 'symbolic representations of the noble deeds of the monarch'.[7] This scheme, which was totally destroyed (with the palace) in 1871, marked the transition between two periods: the team of painters included 'ancients' of the Academy like Bourdon, Philippe de Champaigne, Nocret, Quillerier; established artists like Antoine Paillet, Nicolas Loir or Noël Coypel, but also some younger talents like Jean-Baptiste de Champaigne (pl.287), nephew of Philippe, Claude Audran the Younger, René-Antoine Houasse, Jean Jouvenet, Charles de La Fosse. There were painters from the provinces too, like Nicolas Mignard from Avignon and Berthollet Flémalle, from Liège. A transition was marked also in the style of decoration that was adopted: the French traditional ceiling, geometrically divided, was preferred to any new-fangled arrangement from across the Alps; little *trompe l'œil* was used, and few illusionistic openings, but compartmentalisation, with frames

287. Jean-Baptiste de Champaigne, *Aurora*, 1668. Oil on canvas, 144 × 189 cm. Musée du Louvre, Paris.

and vaulting in relief, played an important rôle. The only major concession to Italy was the Galerie des Ambassadeurs, begun in 1666, in which the ceiling was modelled on the Farnese gallery and was painted by young scholarship students from the recently-established French Academy in Rome. The best Italian paintings from the royal collections were hung on the walls.[8]

At about this time, the King's preference for Versailles began to assert itself; restoration work had begun in 1661 and bills were beginning to mount up (to the detriment of other royal residences), in spite of Colbert's protests; in Colbert's opinion, the Louvre was the only palace worthy of the King.[9] In 1678 Louis XIV left the Tuileries for Saint-Germain, where he waited until he was able to move into the palace that he had created. Colbert had failed to make the Louvre and the Tuileries the crowning achievement of his prestige politics. From now on, Versailles was the hub of the realm and Le Brun, of course, was the life and soul of the latest building works. He headed the team that had just distinguished itself at the Tuileries; by now he was confident of his position at the Academy and also at the Gobelins, and had at last found a task large enough even for him. He devoted himself to it entirely from 1672 on, while the architectural plan grew ever larger and more imposing. Leaving the decoration of the Salons

des Planètes in the King's main quarters to his pupils (1673–80), he appropriated to himself the Chapel, the Escalier des Ambassadeurs and the Galerie des Glaces.

Plans for the first chapel at Versailles were drawn up between 1672 and 1676, but the destruction of the chapel and the artist's disgrace after the death of Colbert, in 1683, prevented their execution.[10] We know the designs through drawings and various painted sketches (Le Mans, Dijon, Versailles and Langres, pl.289). The ceiling was to be a single space, with God the Father in majesty above the altar, the remainder of the space being occupied by a *Fall of the Rebel Angels* (pl.288). This was organised in large blocks and was reminiscent of Michelangelo's *Last Judgement* and contemporary Roman ceilings by painters from Pietro da Cortona to Gaulli. It owed much more, in fact, to Rubens, whose *Fall of the Rebel Angels* was the pride of the Duc de Richelieu's collection.[11] At Sceaux, in the chapel of Colbert's own château, Le Brun had already covered the ceiling with a *trompe l'œil* sky alive with flying figures. By breaking with the tradition of coffered ceilings, he caused a kind of revolution in French decorative painting. Thomas Blanchet drew his inspiration from Loir's engravings for his *Punishment of the Vices*, one of the compartments in the ceiling of the great audience chamber in the Palais

de Roanne in Lyon (about 1686).[12] At a later date, Antoine Coypel and François Lemoyne were to derive inspiration from the same source. The alarming nature of the subject and the dramatic interplay of light and shade would have perfectly suited the musical ceremonies that took place in the presence of the assembled courtiers. Such a piece, which celebrated 'God's omnipotence and majesty, his love and compassion with such majesty and grandeur' was ideally suited to 'the dwelling of a king who is his embodiment on earth and in the sight of man.'[13]

The still-birth of this great concept is regrettable, and even more regrettable is the destruction, under Louis XV, of another scheme, the Escalier des Ambassadeurs (pl.292), built between 1674 and 1678 and designed as a magnificent introduction to the public apartments on the first

288. François Verdier (attributed to) (after Charles Le Brun), *The Fall of the Rebel Angels*. Oil on canvas, 163.5 × 134.5 cm. Musée National du Château, Versailles.

289. Charles Le Brun, *God in His Glory*. Oil on canvas, 130 × 161 cm. Musée de Tessé, Le Mans.

floor.[14] For this ensemble, which brought together the noble professions of architecture, sculpture and painting, Le Brun pressed into service all the experience he had accumulated in Paris and at Vaux. The walls, divided horizontally into three layers with the divisions marked by a series of panels, pilasters and doors, bore coloured marble facings, illusionistic tapestries and *trompe l'œil* openings through which diplomatic envoys from all over the world could be seen gazing in admiration. The decorations were lit by a large glass roof, surrounded by a vaulted ceiling densely painted with figures (in colour), trophies, illusionistic openings and cameo bas-reliefs (also illusionistic) depicting the King's most recent exploits; a portrait bust of the King, with the arms of France and of Navarre, occupied the centre of this massive jewel-casket. The most important innovation here was Le Brun's use of colour,[15] in a position where bare stone and white walls, with the occasional piece of sculpture, might have been expected. However, the opulent paintwork did not conceal the architectural structure, massive below, lighter higher up thanks to the many openings, real or false. Where the walls met the

291. Charles Le Brun, *The King arming the Troops on Land and at Sea.* Sketch for the Galerie des Glaces. Oil on canvas, 72 × 98 cm. Musée d'Art et d'Histoire, Auxerre.

292. *right:* Model of the Escalier des Ambassadeurs, 1958. Musée National du Château, Versailles.

293. Charles Le Brun (after), *The Different Countries of Asia.* Oil on canvas, 58 × 71 cm. Musée National du Château, Versailles.

290. *opposite:* Charles Le Brun, *The King's own Governance* and *Splendour of Countries Bordering France.* Detail of the ceiling of the Galerie des Glaces, Château de Versailles.

294. View of the Galerie des Glaces, Château de Versailles.

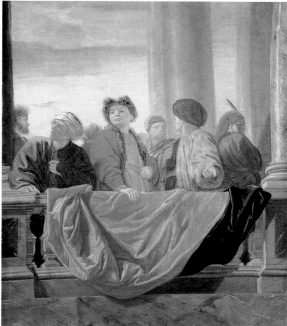

arch the architecture was particularly in evidence, with trophies in the form of the prows of ships, seated figures and gods on pedestals to prop up the composition and support a ceiling with a wide opening in the centre. The figures of ambassadors, some of them in oriental costume, are known through the cartoons and sketches in the Louvre and at Versailles (pl.293); they symbolise the nations of the world come to pay homage to the King of France.

When, in 1678, it was decided to replace the terrace on the west side of the chapel with a great gallery, the distribution of the apartments was altered. The Galerie des Glaces (pl.294), with the Salon de la Paix and the Salon de Guerre at either end, occupied the entire western façade (of the Le Vau building), a total length of seventy-three metres, and became the focal point of the building, a bravura piece whose decoration occupied Le Brun from 1679 to 1684.[16] Again the artist turned architect, designing the seventeen arcades whose walls (opposite the windows on to the

295. Charles Le Brun,
Study of a Fire-dog.
Sanguine,
31.7 × 23.5 cm.
Département des Arts
Graphiques, Musée du
Louvre, Paris.

296. Jean Le Pautre,
Alcove in the French Style,
1678.
Engraving.
Département des Estampes,
Bibliothèque Nationale,
Paris.

297. *opposite:*
View of the Salon de
Vénus in the Château de
Versailles.

298. Noël Coypel,
*Solon upholding the Justice
of his Laws against
Objections made by the
Athenians.*
Reduced version of a
ceiling painting in the
Salle des Gardes de la
Reine in the Château de
Versailles.
Oil on canvas,
50 × 87.5 cm.
Musée du Louvre, Paris.

directly on to the plaster. The techniques used by Pietro da Cortona in the Pitti Palace and by Romanelli in the Palais Mazarin in Paris are developed here by Le Brun. The elements are linked like the stanzas of an ode or the episodes of an epic poem. The enormous central composition sets the tone for the rest of the scheme (pl.290);[17] its significance depends on a dramatic antithesis that is communicated to all the other elements. On one side the King decides to take the government entirely on to his own shoulders, on the other 'the former pride of countries bordering France', Holland, Germany and Spain, is evoked. The start of the conflict, with the coalition of 1672, is depicted on the lunette over the door leading to the Salon de la Guerre; its dénouement with the treatise of Nijmegen is celebrated right at the other end. Between the beginning and the end, twenty-four scenes, of different sizes and layout, depict episodes from the war with Holland, or illustrate the monarch's interior and exterior policies.

At the beginning, Le Brun had planned two schemes around the traditional themes of Hercules and Apollo, used already in the two Galleries in the Louvre as well as in the Pitti Palace.[18] The King, however, insisted that Versailles should be decorated with representations of his recent military achievements. The painter therefore had rapidly to design a new and much more explicit scheme, which would demonstrate to the whole of Europe the newly-acquired supremacy of France.[19] Having previously concealed his identity behind the heroes of mythology, the King now appeared in person (although still in classical dress) in the most important episodes. From now on, the gods were at his service: in *The King arming the Troops on Land and Sea* (pl.291), Mars brings on the soldiers, Vulcan delivers weapons, Neptune comes to take orders, Apollo goes off to direct the construction of a citadel, Ceres sees to the provisioning of the troops, Minerva places a golden helmet on the prince's head and Mercury passes him a shield; seated on his right, Prudence holds an open book and a compass; above him sits Vigilance with his cockerel and his hourglass. Le Brun's layout is like perfect discourse, a period with hierarchical syntax. Is this art for propaganda

park) were faced with mirror to reflect the daylight or, during evening entertainments, the light of the torches. The coloured marbles, the capitals and trophies in gilt bronze, the antique statuary and silver furnishings, combined with the crowd of courtiers in richly coloured costumes, must have rivalled the paintings in brilliance, creating an overall effect of which we can only nowadays have the vaguest idea. Thanks to Le Brun, Versailles was probably the most extravagant ceremonial machine that ever existed. The ceiling is divided into nine large compartments painted on double canvas, with twelve medallions, six cameos and innumerable figures, all painted

purposes only? Not entirely: some of the battle scenes have an uninhibitedly emotional quality that foreshadows Delacroix. The King's chariot armed with the thunderbolts of Jupiter in *Crossing the Rhine*, or the black rearing horse in the *Capture of Maastricht* are vehement, unsettling pieces, which provide a foil for the scenes in which the Sun, the peace-giver, has created harmony and recreation.

THE INFLUENCE OF LE BRUN: THE CREATOR OF A STYLE AND THE THEORIST

Le Brun's work at Versailles was not limited to painting. Like Errard before him at the Louvre and at the Tuileries, he provided designs for every item of decoration in both the palace and the park: statues, fountains, panelling, ceremonial furniture, lighting arrangements, gold and silverware, sideboards and ephemeral architecture for festivities . . . All designed with generosity and fluency (pl. 295). To create a homogeneous style, Le Brun developed various motifs (such as grotesques) introduced by Vouet and his pupils, and incorporated elements of the exuberant Italian Baroque style (he was able to curb its exuberance). His authority, the authority of the person we should nowadays call the designer, did not exclude experiment or variety. Bernard Teyssèdre has demonstrated that the highly organised Versailles that we know today was not built in the proverbial day.[20] The laying out of the park and the shrubberies, in particular, was done in various stages, beginning with highly coloured, fanciful decorations and moving gradually towards a more restrained, unified aspect. The Premier Painter employed a variety of other artists, and did not attempt to force his own taste on them. In the Salons des Planètes (1673–80), in the King's spacious apartments, the opulence of the whole scheme, with its illusionistic architecture, gilded frames and *trompe l'œil* decoration gives a first impression of unity. But a closer look reveals areas that can be clearly distinguished as having been painted by different hands.[21]

Perhaps the best example of the 'Le Brun style' can be found in the Salon de Vénus, decorated by Houasse (pl.297). The walls are faced with marble

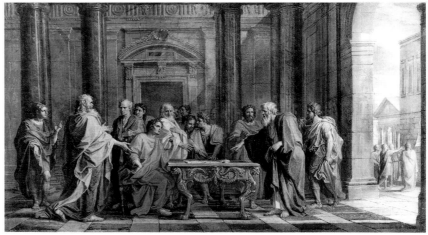

panels, pillars and fake perspectives in the manner of Peruzzi's Stanza delle Colonne in the Farnesina. The elaborate vaulted ceiling is reminiscent of Vaux-le-Vicomte, with the figures sitting two by two in the corners, the pictures crowded over the ceiling and the grisaille bas-reliefs (in *trompe l'œil*) along the edges. The design incorporates, in relatively relaxed manner, subjects from classical antiquity illustrating royal virtues. Jean-Baptiste de Champaigne worked marvels on the ceiling of the Salon de Mercure in this serious, neo-Poussinian style; his paintings in the vault are of Alexander, Ptolemy Philadelphus and Augustus. In the same vein, Michel Corneille the Younger painted the illustrious women of Antiquity in the Queen's Salon des Nobles. Noël Coypel decorated the Queen's Salle des Gardes (pl.298) with evocations of piety and justice embodied in portraits of Ptolemy Philadelphus, Severus Alexander, Solon and Trajan.[22] Sometimes a mismatch is perceptible. In the Salon de Diane, the luminous central panel of the ceiling, painted by Gabriel Blanchard, cuts into the scenes in the vault, painted in the style of Le Brun by Claude Audran the Younger and the young La Fosse.

La Fosse is seen at his best in the Salon d'Apollon: the deity is depicted in his chariot, painted in a range of shimmering colours well-suited to the vigour of the composition. The ceiling is designed in the conventional way, with classical figures in the vault and figures at the four corners, with an open central compartment. The structural framework is lighter than in the other rooms, and more lively thanks to the fretwork frames and the painted drapery, with space for the circulation of light and air and a consequent suppleness and harmony. In the Salon de l'Abondance, Houasse used Le Brun's plans for the chapel, transposing the subjects from sacred to profane: the ceiling, treated as a single space, consists of a *trompe l'œil* sky and flying figures above a balustrade decked with urns, carpets and figures painted around the lower edge of the vault. No longer is royal magnificence exemplified in a series of historical and mythological parallels, but in this charming, bright manner that foreshadows the illusionist schemes of the following century.

The same abundant variety is to be found in the tapestries made to cartoons by Le Brun and his collaborators at the Gobelins factory. The *History of the King* aims to chronicle the important events of the reign of Louis XIV between 1654 and 1668.[23] The most impressive and largest sections are given to battles and sieges, displaying the talent of van der Meulen. But sections like *The Audience with Chigi, the Papal Nuncio* and *The King's Visit to the Gobelins Factory*, in which Le Brun appears in person, are vital documents to the history of the decorative arts. In *The Months*, or the *Royal Residences* the cohesion and energy of the Gobelins team are shown at their best (pl.299). Each building is associated with a month of the year and a sign of the zodiac and is viewed like the back-drop of a stage set, through a framework of balustrades and columns adorned with flowers, fruit, animals and people, all admirably depicted by the different specialists: Yvart, Monnoyer, Boel, van der Meulen, Genoels, Bauduins, Francart and the elder Patel. The presentation combines topographical accuracy, opulent naturalism in the Flemish style, and an Italian sense of theatre, this last owing much to the engravings of Jean Le Pautre the Elder, who belonged to a dynasty of architects, decorators and sculptors;[24] his major collections appeared in about 1660. He went to Italy at the beginning of the 1640s and brought back a great number of models, proceeding to copy them and circulate them widely. Captivated by the vitality and assertiveness of contemporary Roman sculpture, he produced a more disciplined version of it in his engravings thanks to an almost obsessional feeling for geometrical organisation. It was the combination of these two tendencies that was to constitute the decorative style identified with the period of Louis XIV. The name of Le Pautre has been linked with a 'French Baroque' style (pl.296),[25] a style whose penchant for opulence and grandiose designs was based on the example of the opera as performed at the time of Mazarin, and mainly attributable to Torelli and Vigarani. Theatrical décor with a single vanishing point, impeccably centred and still richly ornamented became the prevailing fashion in the entertainments staged at Versailles. The whole palace, inside and out, is the

epitome of this hierarchical, theatrical vision which Le Brun, Le Vau and Le Nôtre were able to handle most skilfully.

Le Brun was also a theorist whose ideas and writing were influential in their day.[26] The reorganisation of the Royal Academy and the establishment of the Academy lectures[27] were just as important to his career as his paintings and his decorative schemes. At least until the death of Colbert, his powers were very extensive. His position as Premier Painter allowed him a guiding hand in the conservation and embellishment of the royal residences. He was also in charge of the royal collections, paintings and drawings, adding to them and beginning to make an inventory of the collection in 1683.[28] Throughout his long and quarrelsome career he knew how to rally support and handle publicity. Like Rubens or Vouet, he understood the need to make engraved reproductions: in 1656 he acquired a royal privilege prohibiting the copying or engraving of any of his works without his permission.[29] It was not only his paintings that were circulated in this manner, but to an even greater extent his large decorative schemes; Pierre Mignard countered by engraving his own. In the battle that developed between the two painters the printed work played a crucial role

for the first time. If Mignard could rely on some of the most brilliant writers of the day for support – Molière, Mme de Sévigné, Boileau – Le Brun leant on the *Mercure Galant*, which published detailed descriptions of his large schemes at Versailles. Other admirers were Félibien who, since the completion of Vaux-le-Vicomte, composed leaflets in praise of the works of Le Brun, from the *Queens of Persia* to the tapestries, via the *Portrait of the King*, and also Charles Perrault, who dedicated his poem *La Peinture* to Le Brun in 1668. In it he raised the trumpets of Fame to his lips:[30]

> Les Arts arriveront à leur degré suprême,
> Conduits par le Génie et la Prudence extrême
> De celui dont alors le plus puissant des Rois
> Pour les faire fleurir aura su faire choix.

(The Arts shall arrive at their highest point, led by Genius and the extreme Prudence of the man whom the most powerful of Kings has selected to bring them to fruition.)

Besides the Gobelins, where, in spite of the efforts of his enemies to get rid of him, he remained as director until his death, Le Brun's influence was based to a great extent on the pre-eminent position he occupied at the Acad-

299. Charles Le Brun (after),
October or *The Tuileries*.
Tapestry in the series called *The Months* or *The Royal Residences*,
400 × 650 cm.
Collection du Mobilier National, Paris.

emy, which he had founded and of which he became successively chancellor (1655), rector (1668) and then director (1683). As early as 1661 he was exerting his authority there by engineering the exclusion of Abraham Bosse, whose intransigence on matters of doctrine was becoming a nuisance. The reform of 1663 was his handiwork: the number of members was increased through the expedient of making all artists in possession of a royal warranty join the Academy. A wide variety of talents was thus admitted, but the hierarchical organisation operated as a means of controlling them: the officers, who were the only members with the rank of professor, were all history painters. Practitioners in other genres were considered inferior and were only councillors; six places were added for 'connoisseurs' or art enthusiasts, and these people often played an important role in the academic debates of the last quarter of the century. Academicians were granted a royal pension. Students were selected competitively, the successful ones being given scholarships to the French Academy in Rome. Exhibitions at which members of the Academy could show their work were, in theory, to be organised every two years, from 1667 onwards.[31] With one long interruption, between 1683 and 1699, when funds were short, there were ten Academy exhibitions during the reign of Louis XIV, some of them accompanied by a printed booklet. This was the start of the tradition of the Salons.

The establishment of the lectures in 1666 was by the far the most remarkable outcome of the reorganisation of the Academy. Although the institution appeared to be more rigidly controlled than at any time since its inception, it in fact played host to debates that were often quite virulent.[32] In the early days the professor simply gave a talk about 'the interpretation of one of the best paintings in the King's collection'. The teaching was based on concrete examples, and the lecture would be published afterwards. Le Brun inaugurated the series on 7 May 1667 with a commentary on Raphael's St Michael; in November of the same year he presented Poussin's Gathering of the Manna. Raphael and Poussin were thus presented as the reigning orthodoxy, but this state of affairs was not to continue unchallenged. During the

same year Philippe de Champaigne chose Titian's Entombment, and Jean Nocret Veronese's Supper at Emmaus. Appreciation of legible, logical composition, controlled by drawing began now to come into conflict with the rehabilitation of colour as a criterion.[33] Roger de Piles's Dialogue on colour caused a sensation. He set out to demonstrate that, far from being an embellishment or an accident as compared with form (represented by drawing), colour is just as essential as form and of equal importance because it encapsulates information about light and shade. In 1665, the Duc de Richelieu was obliged to sell his collection of paintings by Poussin, replacing them with works by Rubens. The publication of the Cabinet de Monseigneur le duc de Richelieu by de Piles in 1676 was instrumental in the return of the taste for art, and also for artistic debate. From now on, the two cliques were at loggerheads: the 'Poussinists' led by Le Brun and some loyal supporters, like Henri Testelin and Noël Coypel, and the 'Rubenists', the partisans of colour. Pamphlets began to fly, often quite vicious in tone. The crisis moved into the heart of the Academy, venom being added by the rivalry between Le Brun and Mignard and by the death of Colbert. Despite receiving assistance from Félibien and Perrault, Le Brun, trying in vain to play his part as disinterested arbitrator, realised that he was outnumbered. It became fashionable to name colour as the defining factor in the superiority of the 'moderns' over the 'ancients'. The academic debates having by now dried up completely, a kind of reign of taste came into force, promoted by enlightened amateurs of whom Roger de Piles was a typical example. Henceforward painting was viewed and judged according to the general effect it made, and by the pleasure given to the eye rather than by the intellectual enjoyment provided by skilful drawing. A large group of the younger generation of painters, often trained under Le Brun, now came into direct contact with the Venetian painters and Rubens.

The most important and original of all Le Brun's contributions to the Academy were his lectures on the expression of passions given in April 1668, and on 'the physiognomy of man in his relations with animals', delivered in the

autumn of 1668.[34] The many surviving drawings suggest that he had planned an illustrated booklet to go with these (pls 300 and 301). Basing himself on the theories of Cureau de La Chambre (*Les Caractères des passions*, 1640 and 1662), and more particularly on Descartes (*Les Passions de l'âme*, 1649) in which the pineal gland in the centre of the brain was identified as the seat of the human soul, Le Brun attempted a typology of facial structure and of the different movements or 'passions' affecting the face and to be read in it. Comparing frontal and profile views, he emphasised the lines made by the nose, the forehead and especially the eyes and eyebrows: according to whether the latter rose towards the seat of the soul, or descended towards the nose and the 'animal' parts of the face, the person's character would be noble or base. In this way Le Brun built up masks showing simple passions, and their more complex derivatives. His use of facial studies for the *Queens of Persia*, or the *Battle of Arbela*, shows that he had been interested in these ideas for a long time, and that for him, even more than for Poussin, expression was at the heart of painting. His lecture on physiognomy was accompanied by about 250 drawings (Louvre), animal heads being contrasted very strikingly with human heads. Le Brun was trying to use the latest scientific discoveries to revive some very ancient theories, set forth in *De humana physiognomia* by G.B. Della Porta (1586, French translation 1656). The procession of men-monkeys, men-wild boar, men-goats, or men-screech owls leads eventually to a classification that contrasts generous people with atrociously bestial people, according to the general layout of their facial features and the alteration of their features when provoked by passion. This has nothing to do with caricature, everything to do with science. It appears that, in the end, Le Brun was reticent about publishing his lecture; perhaps he was afraid that influential patrons would find themselves categorised as crows or camels.

LE BRUN'S FINAL WORKS

After the death of Colbert in 1683 and his replacement by Louvois, the cabal orchestrated by Pierre Mignard increased its effort to discredit Le

300. Charles Le Brun, *Studies in Physiognomy*. Pencil, 38.6 × 28.1 cm.

301. Charles Le Brun, *Studies in Expression* (*Fright*). Pen and black ink on a pencil sketch, 19.5 × 25.5 cm.

Département des Arts Graphiques, Musée du Louvre, Paris.

302. Pierre Mignard,
Christ Carrying the Cross,
1684.
Oil on canvas,
150 × 198 cm.
Musée du Louvre, Paris.

Brun and to prevent his winning important commissions. Although the King sustained his support of Le Brun until the end, the attacks on him had a profound effect on the old artist. He returned to easel painting, a field in which Mignard believed himself to be without rival, trying to prove himself the rightful heir to Poussin, several of whose large paintings, like *Eliezer and Rebecca* and the *Death of Saphira*, had just entered the royal collection. The two canvases now in Modena, *Moses Defending the Daughters of Jethro* and *Moses Wedding Saphora* (1686–7), make much of the study of expression, local colour and archaeological detail; 'modes' adapted to each subject area are contrasted, serious in one place, violent in another. As homage to the painter of the *Sacraments*, Le Brun planned a cycle of scenes from the life and Passion of Christ, encouraged by the enormous success of Mignard's *Christ Carrying the Cross* (pl.302), presented by Seignelay to Louis XIV in 1684. These were *Christ on the Cross* (1685, Troyes), painted at the express request of the King, *Christ Carrying the Cross* (1688, Louvre, pl.303), the *Entry into Jerusalem* (1689, St Etienne) and an *Adoration of the Shepherds* (1689, Louvre), of which Le Brun painted a smaller replica (Louvre) for his wife. He

appears to have left sketches for a *Last Supper* and an *Adoration of the Magi*: there are drawings for these as well as for a *Christ Reviled*. On grounds of subject matter, these works belong with seventeenth-century devotional painting, and their sentiment and tenderness are still moving; they sustain the mood of some of Le Brun's successes of the 1650s, like the *Holy Family*, known as *Silence*, in the Louvre. Their execution is particularly meticulous, as if the head of public works at Versailles was taking special delight in picking up his brush and 'stroking' the canvas again. The pale, delicate colours and the multiple sources of light in the night scene of the *Adoration* reflect the subject matter of the latest academic debates, without jeopardising the perfect legibility, or the energetic modelling that invariably makes Le Brun's forms stand out so distinctly.

A dazzling career thus petered out quietly. Old age and difficult circumstances led the artist from the triumphs of Alexander and Louis, the Sun King, to this silent, almost painful meditation, without, however, affecting the quality of his painting, which had never been broader nor more supple, its synchronised rhythms making Poussin seem dry and Mignard affected. It was his facility

that characterised Le Brun to the end of his life; he had the opportunity to pit his talents against a vast variety of enterprises, from the title page of a thesis to the ceiling of the most magnificent gallery in Europe. His almost invariable success has harmed the appreciation of his work, which is always displayed at its most official and most stilted, the quality of the artist generally lying undetected behind the screen of his public office and his official titles. The screens need to be drawn back and the artist's impatience, restlessness, even cruelty, revealed,[35] as well as his habit of minor but perceptible exaggeration, in composition as well as in expression, the mark of a generous, demonstrative personality who was apparently stimulated only by the largest of commissions. When Louvois threatened him with disgrace in 1686, he wrote to Maréchal de Créqui:[36] 'This misfortune would discourage me completely and would make me incapable of doing anything worthwhile in the future. I have been accustomed to favourable treatment for years. This is what sustains and supports men of genius.'

THE SECOND APELLES: PIERRE MIGNARD

Although prevented from undertaking royal commissions until about 1680, and rejecting membership of the Academy, Mignard occupied a marginal but brilliant position in Paris after his return from Rome in 1657. He enjoyed the support of men of high rank, like the Grand Condé,[37] and of some of the great intellectuals of the day: Molière (whom he met in Avignon), Racine, Boileau, La Rochefoucauld, Mme de Sévigné and Mme de Lafayette all praised his talent to the skies. As a portrait painter, he enjoyed considerable social success. The ceilings he painted in a number of Parisian private houses bore witness to the skill of an artist whose twenty-year sojourn in Rome had earned him the nickname 'Mignard the Roman', to distinguish him from his brother Nicolas.

The dome of the Val-de-Grâce (pl.304), commissioned by Anne of Austria in 1663 and completed in eight months, aroused admiration as well as a series of pamphlets, among them Molière's poem *The Glory of the Val-de-Grâce* (1669), which reiterated some of the themes contained in Dufresnoy's *De arte graphica*, translated from Latin in 1667 by Roger de Piles. Supporters of Le Brun

303. Charles Le Brun,
Christ Carrying the Cross,
1688.
Oil on canvas,
153 × 214 cm.
Musée du Louvre, Paris.

did not enjoy being outshone, and the dome became the subject of an impassioned exchange of views.[38] For many years it was difficult to assess the quality of the painting because the ceiling was in such poor condition. Recent restoration has revived the colours and given precision to the outlines, making appreciation of the painting possible. Molière emphasised Mignard's outstanding achievement. When it was painted there were no other painted cupolas in Paris, except for the much smaller ones in the Eglise des Carmes (by Walthère Damery) and in the chapel of the Sorbonne (by Philippe de Champaigne).[39] The fresco technique employed brought to Paris echoes of some of Italy's most successful paintings. Fresco painting requires 'a hand ready to follow swiftly where a guiding light beckons';[40] it is much more difficult and hazardous than the oils that were generally used for ceilings in France. Fresco allows no second thoughts, binding at once with the plaster and promising 'everlasting brightness'. Mignard was behaving as a 'true Roman' here, taking his inspiration from illustrious models like Lanfranco's cupola in Sant'Andrea della Valle (itself inspired by Correggio's dome in Parma). The spiral composition, with more than two hundred figures disposed in concentric circles, shows Anne of Austria presented by St Anne and St Louis, on her knees, presenting to the Holy Trinity (visible at the apex in a cloud of glory) a model of the abbey built at her request. The spectacular foreshortenings, the variety of colours and the lighting effects marked an important stage in the history of religious decoration in France, although Mignard seems pedestrian compared with his models. Highbrow yet playful, the painting was, according to Molière, as attractive to 'skilled amateurs' and 'learned society' as it was to 'our courtiers with the scantiest education'. The King came to see the fresco and was fulsome in his praise; Colbert followed the King, and in 1669 commissioned Mignard to decorate his funerary chapel in St Eustache.

By singling out for special praise Mignard's 'Passions, grace and range of colour, which gives such exceptional richness to his paintings', Molière was attempting to classify the unique attributes of his favourite painter. Although the 'passions' were a speciality of Le Brun as well, 'grace' belonged only to Mignard and his colours were responsible for the 'exceptional richness' of his paintings and gave them their sophistication. The painter was thus admitted into the colourists' camp, in opposition to the partisans of drawing and their sponsor Le Brun. His activity as a theorist, however, and his authority in this field were negligible: he was only admitted to the Academy in 1690, too late to have any influence, and departed five years later. Some of his paintings nevertheless, were real manifestos. It is their mannered, often affected style that differentiates them from the paintings of Le Brun. Mignard's desire to attract attention by treating similar, or identical, subjects in different ways is all too obvious: *Darius's Tent*, in the Hermitage (1689), is clearly a rejoinder to the *Queens of Persia*, and his religious paintings of the 1680s and 90s share the same ulterior motive.

Most of Mignard's decorative paintings have disappeared. His two major works can now be appreciated only through drawings, engravings and tapestries. These were the Galerie d'Apollon at St Cloud and the two *Salons*, dedicated to Mars and Diana, flanking it (1677–1680),[41] the whole ensemble just pre-dating the Galerie des Glaces; and the Petite Galerie (pl.306), in the King's smaller apartments at Versailles, begun in 1685 and demolished under Louis XV. Mignard regarded these as his masterpieces. Compared with Le Brun's heroics, Mignard's work is elegant and intimate. At Versailles royal patronage was represented by Apollo rewarding the Sciences and the Arts, and Minerva placing a crown on the head of French genius. At St Cloud his handling of mythological subjects foreshadowed the eighteenth century. In the central vault of the gallery, around the main subject, *Daybreak*, there were four separate compartments depicting the Seasons, with carefully contrasted rhythms. There are echoes here of the Carracci, Domenichino and Albani, the latter one of Mignard's favourite painters. The different parts of the décor, inspired by the La Vrillière gallery and the Galerie d'Apollon in the Louvre, were linked by frames and ornamentation that was pleasantly light compared with the opulence of Le Brun; Mignard

304. Pierre Mignard, The cupola of the Val de Grâce.

favoured young women, *putti*, domestic details and scraps of landscape. In the Salon de Mars, Mignard's attempt at creating a dramatic narrative between the ceiling paintings and the lunettes comes closer to the baroque style of decoration; it may have influenced Le Brun when, shortly afterwards, he was painting the lunettes in the Galerie des Glaces. The importance of St Cloud in the history of design was great. Well-publicised by pamphlets and prints, it enjoyed considerable success.[42]

The easel paintings, much better preserved, give a more accurate picture of Mignard's talent as well as his limitations. His reputation was to a great extent based on devotional paintings like the *Mystic Marriage of St Catherine* (1669, Hermitage), a pleasing piece of plagiarism from Albani, or the *Virgin and Child*; these are the famous 'Mignardes' in which the effete delicacy of the drawing is softened by a well-judged *sfumato*, as in the example in Angers, probably painted while he was still in Rome. *Perseus and Andromeda* (1679, Louvre, pl.307), painted for the Grand Condé, is heroic, to be sure, but departs from Le Brun's style of heroism: Mignard's movement is ponderous, his composition frieze-like and his colours brilliant, almost acid, recalling the colours used by

the Bolognese painters. His treatment of the subject differs from his predecessors': by concentrating on the gratitude expressed to Perseus by the parents of Andromeda, rather than on the deliverance of the young lady, he rejects animation in favour of the proprieties, thereby humanising the hero.[43] Even more significant is *Christ carrying the Cross* (1684, Louvre) to which Le Brun responded four years later. Here again Mignard's deference to Italian models in this meticulously organised painting makes it seem rather dry and scholarly. It must have surprised critical attention at a time when interest in Rubens and Titian was reviving; the French now regarded contemporary Italian painting with a certain condescension. Mignard's art was anachronistic, even nostalgic. Exemplifying this most clearly are the paintings painted right at the end of his career: *Christ and the Reed* (1690, Toulouse), painted for Versailles; the *Ecce Homo* (1690, Rouen, pl.308), painted for St Cyr; *St Cecilia* (1691, Louvre). The meek expressions, after the manner of Guido Reni, verge on vapidity. The touch is melting, the colour scheme unusual, with faded shades of deep red, purple and green. These paintings are in tune with the piety of the end of the Grand Siècle, and share the listless perfection to be found in Racine's *Esther* and in

307. Pierre Mignard,
*The Deliverance of
Andromeda*, 1679.
Oil on canvas,
150 × 198 cm.
Musée du Louvre, Paris.

some of Fénelon's writing; this is the autumn of
Classicism. The figure of the old painter, in the
disguised self-portrait in *St Luke painting the Virgin*
(1695, Troyes), has symbolic value:[44] while Le
Brun remained a history painter until his death,
Mignard, in his last paintings, put storytelling
aside in favour of the skilful, fervent glorification
of the *imago pietatis*; the 'Mignardes' of his youth,
although more worldly in tone, foreshadowed this
final development.

Notes

1. In his pamphlet on the *Queens of Persia* (Paris, 1663), Félibien draws attention to the way Le Brun has 'extinguished' his colours 'removing their brilliance and their natural vivacity, with the intention of softening them and preventing their offending the eye with too much light.'

2. On the *Battles*, see especially Posner, 1959; Grell and Michel, 1988, Beauvais, 1990.

3. Fontaine, 1903, p.127.

4. Mérot, 1986.

5. Nivelon, 1699–1704, fols 154 and 163. See also, on this scheme, Aulanier, 1955.

6. On the decoration of the Tuileries, see Sainte-Fare-Garnot, 1988.

7. Félibien, 1666–88, part 5, *Entretien* 9 (1688), p.74.

8. O. Michel, 1986 (1988); Schnapper, 1994.

9. This is in Colbert's famous letter to the King (28 September 1665): 'This house [Versailles] has more to do with Your Majesty's pleasure and amusement than with glory.' (Quoted by Sainte-Fare-Garnot, 1988, p.91.)

10. See Thuillier, exh. cat., Versailles, 1963, nos 34–5, pp.101–7.

11. Teyssèdre, 1963.

12. Galactéros, 1991, pp.196–201.

13. Nivelon, 1699–1704, fol.297.

14. See most recently exh. cat., Versailles, 1990–1.

15. Thuillier, exh. cat., Versailles, 1990–1, p.24.

16. Kimball, 1940; Hoog and Vitzthum, 1969.

17. Sabatier, 1988, pp.416ff.

18. See the two sketches in the Louvre (Département des Arts graphiques, inv. 27 642 and 27 067) studied by Montagu, exh. cat., Versailles, 1963, nos 157–8, and Beauvais, exh. cat., Paris, 1985–6, nos 36–9.

19. Nivelon, 1699–1704, fol.309.

20. Teyssèdre, 1967 (see in particular the chapter: 'Versailles, a living folly, 1666–78', pp.128–202).

21. On the succession of building works in the large apartment see Schnapper, 1974 (1), pp.55–6.

22. On the passage from warrior hero to virtuous sovereign, see Mérot, exh. cat., Cologne, Zurich and Lyon, 1987–8, pp.36–44.

23. D. Meyer, 1980.

24. On the Le Pautre dynasty, see: Lieure, n.d.; Isarlo, 1960, pp.63–7; the entries under 'Le Pautre' (by diverse hands) in Bluche, 1990.

25. On the definition of a 'French baroque style' or a 'classical baroque style', see: Tapié, 1957 (1972); Bottineau, 1986, pp.211ff.; Minguet, 1988.

26. On Le Brun the theorist, see most recently (but debatable in more than one instance) Bryson, 1981, pp.29–57.

27. Vitet, 1861; Fontaine, 1914; Teyssèdre, 1957 (1965), pp.35–8.

28. A. Brejon, 1987.

29. Reproduced by Thuillier, exh. cat., Versailles, 1963, p.LII.

30. Perrault, 1668 (1992), p.101 (a stanza has been added after line 224).

31. The absence of any study of the earliest Salons is to be deplored: nevertheless, see: Isarlo, 1960, pp.75–9 and 93–100; Lesné, 1979; Crow, 1985, chapter 1; Loire, 1992 (1994).

32. Fontaine, 1914; Teyssèdre, 1957 (1965).

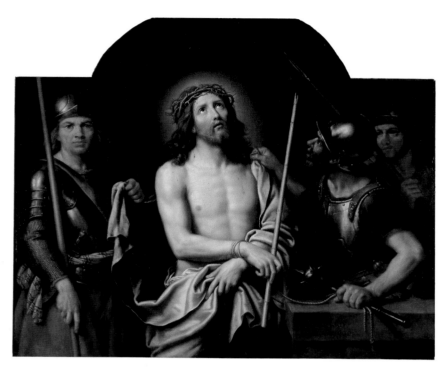

308. Pierre Mignard, *Ecce Homo*, 1690. Oil on canvas, 138 × 163 cm. Musée des Beaux-Arts, Rouen.

33. On the beginnings of the debate on Colour, see: Teyssèdre, 1957 (1965); Puttfarken, 1985; Thuillier's preface to de Piles, 1708 (1989).

34. Montagu, 1994; Wrigley, 'The afterlife of an Academician', exh. cat., Dulwich; 1990–1, pp.29–43; Dandrey, 1986. On animal physiognomy, see Baltrusaitis, 1957 (1983), pp.9–53.

35. On cruelty in Le Brun's painting, see exh. cat., Dulwich, 1990–1, pp.29–43 (in particular, the essay on the *Massacre of the Innocents*). His violence may have been inspired by Rubens (see Thuillier, 1967).

36. Letter of 24–5 June 1686, quoted in exh. cat., Versailles, 1963, p.LXXI.

37. Boyer, in exh. cat., Paris, 1989 (1), *passim*.

38. Teyssèdre, 1957 (1965), pp.92–100.

39. See above, chapter 5, pp.115–16.

40. Quoted from Molière's poem (as are the subsequent quotations).

41. Berger, 1993.

42. An allegorical interpretation of the gallery at St Cloud was provided in 1682 by Laurent Morellet: *La Gallerie de S. Clou et ses peintures expliquées sur le sujet de l'éducation des princes* (see Berger, 1993).

43. Boyer, exh. cat., Paris, 1989.

44. Georgel and Lecoq, 1987, p.79.

FROM LOUIS XIV TO THE REGENCY

Between the deaths of Le Brun in 1690 and, five years later, Mignard, and the death of Louis XIV in 1715, there ensued a period when talent abounded; it was a period more difficult than most to define, however, because of the absence of any obvious leader. It is significant that the position of Premier Painter remained vacant for twenty years. For France as a country this was a difficult time, interrupted as it was by wars, rebellions and famine. Protestants were the victims of violent repression, with disastrous consequences that are well-known, as were the Jansenists. The continuation of the ruling dynasty seemed gravely threatened as, one by one, in 1711 and 1712, the son, then the grandson, then the oldest great-grandson of the old King died. This crisis in the monarchy was accompanied by a decline in royal patronage, until only a few building projects remained. Fortunately, continuity was assured by princes like the Duc d'Orléans, the King's nephew and future regent, by aristocratic amateurs like the Comtesse de Verrüe and by newly-affluent patrons from the world of finance like Pierre Crozat.[1] Versailles, the focal point and 'artistic laboratory',[2] was succeeded by decentralisation and the fragmentation of styles, particularly in the decoration of private residences. The grand manner survived in genres that developed more slowly, such as large-scale religious paintings and monumental decorative schemes. Easel painting, on the other hand, was carried forward by the buying public's enthusiasm for novelty: it responded rapidly to the changes of style that accompanied debates on art taking place in academic and social circles.[3] The mythology of courtly love saw a remarkable revival, while portraiture, landscape and still-life painting reflected, as has already been shown, a more observant, more liberated attitude towards the natural world. Genre painting moved easily between the real world and a theatrical, fantastical representation of life, and new themes emerged, like the *fête galante* in which familiar subjects were given a poetic turn.

As the importance of private clients grew, and it became socially advantageous to know something about the history of painting, to the extent of being able to distinguish between different schools and to appreciate different styles, artists were faced with a huge diversity of models but no prevailing orthodoxy. French painting around 1700 tended to be painting for painters: the sources of inspiration were a jumble, and artists were experimenting with elaborate techniques garnered from previously unexplored territory. Now that the colourists reigned supreme, Titian, Rubens and Van Dyck were the summit of good taste, equalling or even outdoing Raphael and Annibale Carracci;[4] the Bolognese and Roman painters were lower in the hierarchy and contemporary Italian painters were regarded with some disdain.[5] Poussin remained a painter of reference, but was admired from a respectful distance. Ease of travel, the circulation of paintings made possible by the growing art trade and by printing, and the existence of well-stocked collections like that in the Palais-Royal brought to the attention of the public artists like Correggio, with his 'grace', not previously widely known. The painting of the Netherlands brought mundane subjects to the fore, as well as techniques ranging from the freedom of Rembrandt and his striking chiaroscuro effects to the fine, supple skill of Gerrit Dou and Frans van Miéris.[6] This enrichment of the visual experience of artists, and the growing expectations of their public, led to a confused situation in which each category of painting evolved at its own pace; it also led to some unexpected cross-breeding. Although his senior by forty years, Jouvenet was still active when Watteau was just starting out. Between their two worlds, which have very little in common, there are innumerable halfway stages and commingling currents! The period of La Fosse, the Boullogne family and Coypel, but also of Largillierre, Rigaud and Desportes requires us to make some appraisal of the seventeenth century, taking into account premonitory glimpses of the century to follow.

TRADITION AND INNOVATION IN RELIGIOUS PAINTING

At the end of the reign of Louis XIV, religious painting was dominated by the figure of Jean Jouvenet,[7] who perpetuated the art of Le Brun by continuing to tackle big, serious subjects, with

309. *previous pages:*
Charles de La Fosse,
The Presentation of the Virgin in the Temple,
1682.
Oil on canvas,
302 × 393 cm.
Musée des Augustins,
Toulouse.

310. Jean Jouvenet,
The Descent from the Cross,
1697.
Oil on canvas,
424 × 312 cm.
Musée du Louvre, Paris.

grandiose settings and powerfully modelled figures. These attributes are well displayed in the theatrical *Martyrdom of St Ovide* (Grenoble), painted in 1690 for the Capuchins in the Place Louis-le-Grand; their culmination came in his most admired painting, also painted for the Capuchins, the *Descent from the Cross* of 1697 (Louvre, pl.310). The influence of Rubens on his work has already been noted. Jouvenet's composition, however, is powerfully constructed and centred, and although his subjects are presented diagonally, contains no redundant movement; the pale patches of colour representing Christ's body and his shroud stand out against a generally dark background. His debt to Le Brun, and to La Hyre who painted the same subject for the Capuchins in Rouen, is plain to see: a more trivial Le Brun, forthright in his drawing, balancing the overall effect with individual characterisation. A great religious painter, nonetheless, whose paintings are able to catch the spectator's attention from a distance, in the half-light of the churches where his figures are seen to best advantage. He builds up tension, resolving it with declamatory gestures; to add novelty to his chosen subjects he painted rough, rugged characters and gave close attention to everyday details. The attraction of late works like the *Death of St Francis* (1714, Rouen), with its austere symphony of browns, is this mixture of the natural and the supernatural; Jouvenet's Jansenism reveals itself here.

Like Le Brun, Jouvenet enjoyed large scale commissions, and perhaps his most important contribution to French religious painting is the intentionally gigantic proportions of his canvases,

sometimes repeated in tapestries; he depicts large crowds with a strong diagonal bias, an effective if slightly monotonous technique. In 1689 he painted a big *Christ healing the Sick* (Louvre) for the Carthusian monks in Paris. Between 1697 and 1706 he provided the priory of Saint-Martin-des-Champs with four compositions, each about seven metres wide: the *Meal at the House of Simon* (Lyon), *Christ expelling the Merchants from the Temple* (Lyon), *The Raising of Lazarus* (Louvre) and the *Miraculous Draught of Fishes* (Louvre, pl.311); for the latter he would have had no hesitation in going to the seaside if it helped him to get the detail right. In spite of their adherence to convention, the lack of variety in the colouring and the yellowish light that bathes them, these vast canvases win our admiration by the authority of the interplay of gesture, and by the weight and energy of the figures. Jouvenet has extracted vivid, even epic narrative from the Gospels, and draws the spectator in to it by placing the figures, with their exaggerated, tactile anatomy, in the foreground. Jouvenet maintains the same strength of conviction in the *Magnificat*, painted in the choir of Notre-Dame-de-Paris between 1715 and 1717, when he was an old man with a paralysed right hand. This painting is simpler than the four earlier ones, and the lighting effects are stronger; it was painted as part of a decorative ensemble in which a number of painters well-known at the time had a hand.[8] In the company of La Fosse, Louis de Boullogne, Claude-Guy Hallé and Antoine Coypel, who contributed a disappointing *Jesus among the Doctors* (1717, Chapelle des Pénitents-Blancs, Villeneuve-sur-Lot), Jouvenet

was the only artist capable of perpetuating effortlessly the energy and grandeur that had characterised painting during the reign of Louis XIV.

Religious painting, and altarpieces in particular, was the most restrictive of the genres. Innovative painters felt inhibited by the constraints put upon them. This conservatism is evident in the series of *mays* painted for Notre-Dame.[9] Pupils of Le Brun like François Verdier, Claude Audran the Younger or René-Antoine Houasse acquitted themselves respectably, if unexcitingly, within the tradition. Jouvenet's influence is noticeable in some of the paintings, like *Christ and the Centurion* by Louis de Boullogne (1686, Arras). Twenty years later, Claude Simpol's *Christ in the House of Martha and Mary* (1704, Arras) is a tribute to Le Sueur and Le Brun. A painting like *The Preaching of St John the Baptist* (1694, Arras, pl.312), by the southern painter Joseph Parrocel, is unusual, with its dramatic effects, the high-toned figures in the foreground, the colours that gleam and go dull in places, the patches of thickly-applied paint and above all the atmosphere of fantasy that seems to hark back to Tintoretto or Salvator Rosa, neither of them on the Academy's list. Innovations were produced outside the regular routine of the *mays*. In the painting he produced for the altar of the soldiers' church in the Invalides, *St Louis ministering to the Soldiers stricken by Plague* (about 1680, *modello* in Rouen), Louis de Licherie proved himself a worthy follower of Le Brun; his carefully worked out theological system reveals that he was also capable of original light effects (*The nine Choirs of Angels*, 1679, church of Saint-Etienne-du-Mont). It is the lighting, too, that gives power and originality to *The Raising of Lazarus*, painted in about 1695 by Jean-Baptiste Corneille for the Carthusians in Paris (Rouen). The powerful, tortured temperament of this member of the Corneille family, who was close to Le Brun and Jouvenet, distinguished him from his brother Michel, who drew his inspiration more from Mignard.

The *Presentation of the Virgin in the Temple* by Charles de La Fosse, painted in 1682 for the Carmelites in Toulouse and now in the museum there (pl.309), is a pioneering work. Although the

vigorous outlines and clearly defined shadows still suggest Le Brun, the general organisation of the painting and the sensuality of the subject matter recall some of Titian's larger paintings, possibly seen by La Fosse in Venice in the 1660s: the *Presentation of the Virgin* from the Scuola della Carità (Accademia) and the *Ex-Voto of the Vendramin Family* (National Gallery, London), two models, one narrative and one votive, which had escaped from the tradition of the perpendicular altarpiece, with all its limitations. Some contemporary easel paintings illustrate this attempted revival even more graphically. Admittedly, Nicolas Colombel was content to reproduce Poussin with chilling accuracy (*The Woman taken*

312. Joseph Parrocel, *The Preaching of St John the Baptist*, 1694. Oil on canvas, 440 × 345 cm. Musée des Beaux-Arts, Arras.

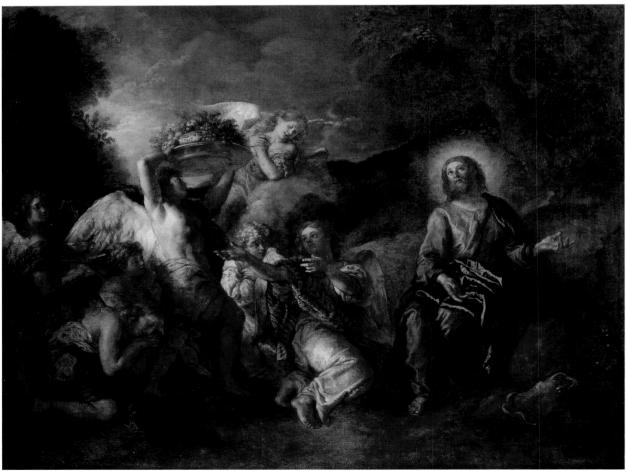

in *Adultery*, 1682, Rouen), and Jean-Baptiste Santerre remained loyal to the Bolognese school and to an archaic type of perfectionism, perpetuating the style of Mignard or even of Champaigne (*Virgin and Child*, private collection, USA; *St Theresa*, rather more stormy, in the chapel at Versailles). Nevertheless, a considerable number of cabinet paintings demonstrated their support for colourism. The small paintings by the Boullogne brothers were not subject to the same etiquette as their altarpieces or their decorative schemes. Antoine Coypel's *Crucifixion* (1692, Toronto, private collection, pl.313), which belonged to the Duc de Richelieu and appeared in the Salons of 1699 and 1704, makes conspicuous reference to Rubens, with its agitated composition, broken and circular rhythms, emotive use of light and shade and reddish colour scheme. It was in paintings like these, painted for connoisseurs, that an artist could show his skill and brushwork to best effect and try out new versions of biblical stories in the manner of Rubens and the Venetians.

Coypel was never so daring again. In response to his detractors he attempted to reconcile 'the drawing of Raphael with the colours of Titian'[10] in *Suzanna and the Elders* (1695, Prado), much calmer in construction, and to achieve a synthesis between Le Brun and Rubens in *Esther overcome by a Faint* (1697, Louvre) and *Athaliah expelled from the Temple* (1696, Louvre). These are appealing works at first glance, weakened, however, by their desire to please at any cost: 'All manner of talents can be spotted therein. It caresses you but is not itself loveable', wrote Louis Dimier severely.[11] In his *Christ dying on the Cross* (1696, Perpignan, pl.315), Rigaud repeated the subject of his reception piece for the Academy, painted in 1689, deliberately allying himself with the Flemish painters, in particular Van Dyck whose characteristic orange and blue colour scheme he borrowed. Later, he turned more towards Rembrandt and Gerrit Dou, as can be seen in his jewel-like *Presentation in the Temple* (1743, Louvre). The example of the Venetians survived in La Fosse, especially in his late paintings: his *Finding of Moses* (about 1700, Louvre) has all the charm of a Veronese; on a more meditative note, *Christ in the*

315. Hyacinthe Rigaud, *Christ dying on the Cross*, 1696. Oil on canvas, 95 × 61 cm. Musée Hyacinthe-Rigaud, Perpignan.

Desert Waited on by Angels (about 1710, private collection, New York, pl.314), the final version of a subject he had returned to a number of times, is supple if a bit limp, the technique providing a foil for shades of gold and delicate colouring. A work like this marks the close of one era and the opening of the next; the example of La Fosse was not lost on Watteau, who worked and lived with him in the Crozat household.

MONUMENTAL DECORATION

After the death of Le Brun, the decoration of large buildings, churches as well as palaces, continued to rely on the scale and movement that were characteristic of Versailles and Rome during the Baroque period. With unfailing virtuosity, the painters covered the spaces allotted them by the architects: ceilings, domes and galleries. Their compositions are rich, theatrical, often lyrical; great attention is paid in them to detail even if architectural *trompe l'œil* is dealt with more carefully than is the foreshortening of figures.[12] Nevertheless, the perfect harmonies of the 1660s and 1680s seem a long way off. Rivalry between artists in the hunt for commissions, the vacillation of the Surintendance and lack of funds because of war combined to create an unstable period. In spite of everything, two large enterprises were brought to a successful conclusion: the dome of

313. *opposite*:
Antoine Coypel,
Crucifixion, 1692.
Oil on canvas,
111 × 168 cm.
Private collection, Toronto.

314. Charles de La Fosse,
Christ in the Desert being waited on by Angels, about 1710.
Oil on canvas,
86 × 114 cm.
Private collection, New York.

316. Charles de La Fosse,
Sketch for the cupola in
Les Invalides, 1702.
Oil on canvas, diameter:
102 cm.
Musée des Arts Décoratifs,
Paris.

the Invalides (1691–1706) and the ceiling of the chapel at Versailles (1709–1710).

After months of procrastination, La Fosse was chosen in 1702 to carry out the major part of the job at the Invalides (pl.316):[13] the high dome of Mansart's cupola and its pendentives. The lower part of the dome, divided into twelve, was allotted to Jouvenet (pl.317); the fresco over the altar to the aging Noël Coypel; finally, the decoration of the four chapels flanking the central area to the Boullogne brothers and Michel Corneille the Younger. La Fosse, who was Hardouin-Mansart's favourite painter, was certainly the best equipped to paint his allotted area. In 1676 he had painted a *Gloria* in the dome of the Eglise de l'Assomption. Using a more relaxed version of the circular composition employed by Mignard at the Val-de-Grâce, he lightened and brightened the whole with an irridescent colour scheme: the *bozzetto* in the Musée Magnin in Dijon gives an idea of how it must have been. He gave further

proof of his skill as a decorator in the Salon d'Apollon at Versailles. In 1677, with the support of Le Brun, he presented a plan for the decoration of the dome even before building work had started. The final result is in perfect harmony with the architect's soaring dome. The pendentives, treated as *quadri riportati*, bear portraits of the Evangelists whose gaze is fixed on the first layer of the dome and Jouvenet's twelve Apostles (sketches in Rouen); they in their turn appear to be holding up the dome where the main story unfolds. St Louis presents Christ with the sword used to vanquish the enemies of the Church. Likened by contemporaries to the temple of Solomon, the Eglise du Dôme in the Invalides was, according to Jean-François Félibien, designed to 'serve to perpetuate the homage and thanksgiving rendered by this invincible Monarch to the Divine Saviour, the God of armies [. . .] whose all-powerful protection he seeks to retain on behalf of himself and his people through the

intercession of St Louis and St Charlemagne'.[14] Here the figures are grouped around a vast sky open at the top. The energy of the Evangelists and the Apostles, whose movements follow the upward sweep of the cupola, links the different areas right up to the light source at the summit, its light emphasising the lightness of the whole. Each small, compartmentalised cupola over the chapels bears scenes from *The Life of the four Doctors of the Church*. These mainly consist of *quadri riportati*, largely history paintings in a building in which painting is dwarfed by architecture: the choice of a fresco instead of an altarpiece is significant.

The impression created in the chapel at Versailles is quite different:[15] here oil paint was employed and the role of the decorators was much less circumscribed. Mansart finished the building work in 1707. He died the following year and La Fosse, whom he favoured, had to hand over the vault to Antoine Coypel, now back in favour: La Fosse made do with the apse, Jouvenet decorated the tribune and the Boullogne brothers, Santerre and Louis de Silvestre shared the rest, in particular the ceilings of the lateral bays and the chapel dedicated to the Virgin. Sculpture, grisaille paintings and illusionistic architecture completed the décor, the most elaborate of the period. The artists were prevented from painting the whole chapel in *trompe l'œil* (as Le Brun had planned in his design for the first chapel in 1675) by a number of constraints. Coypel especially had to take the narrowness of the barrel vault into account, and to skirt around the bays of the tall windows; he also had to observe two different points of view, from the nave on the ground floor and from the royal gallery. He skilfully divided his ceiling into three false openings: the largest, in the centre, depicts Christ in majesty with angels (pl.318); in the two others the angels present the instruments of the passion. As in the Gesù in Rome, decorated by Gaulli thirty years earlier, aerial figures and clouds fly in front of the *trompe l'œil* architecture, making the chapel seem suffused with light. The exhilaration of the movement compensates for some mawkishness in the detail; the bright, varied colours and the use of gold make this one of the most brilliant pieces of its period. In it the features of eighteenth-century

decoration can already be glimpsed: 'Ragged outlines, a predominance of empty space with figures bunched together in groups, clear, glancing colours, dislocated lines and a certain increase in lightness and flow, an added abandon – this is the Rococo without its grace, wit and fun.' Louis Gillet's comments,[16] although not doing justice to the undoubted masterpiece that (in spite of everything) remains, do nevertheless identify therein the seeds of what was to come. La Fosse, for his part, succeeded in his *Ascension* in the upper part of the apse in equalling his own best paintings: the asymmetrical, layered construction, all a-quiver, and the warm colour scheme are yet another example of the monumental and decorative qualities of the style of the Rubenists. Jouvenet's decoration of the gallery is typically calm and reliable.

317. Jean Jouvenet, *St Matthew*. Sketch for Les Invalides. Oil on canvas, 84 × 50 cm. Musée des Beaux-Arts, Rouen.

He tackled an awkward space by painting a *Pentecost* on the wall and its surmounting arch (pl.319). He succeeded in uniting two very different surfaces by a subtle use of foreshortening and tricks with light, the latter lending the scene a lyricism in harmony with the general sense of exultation of the whole.

As decorator, Jouvenet always showed restraint; this is demonstrated in his ceilings in the parliaments in Rennes (1694–1695) and Rouen (1715, pl.321). At Rennes he was dependent on the fragmented plan used by Charles Errard and Noël Coypel in the large audience chamber (1656–62), and his *trompe l'œil* effects were as demure as the foreshortening of his allegorical figures. At Rouen, as the sketches in Grenoble and Rennes reveal, he covered the whole surface in one, placing figures against a fictional sky in a fake architectural framework. At the foot of the composition the Vices, struck down, afford some striking views *da sotto in sù* and an academic soundness in the disposition and handling of the nude: the confusion below is offset by the serenity of the upper part, depicting the triumph of Justice. All in all, the scheme is timid in comparison with Le Brun's *Fall of the Rebel Angels* or Thomas Blanchet's *Punishment of the Vices*.[17]

The unified ceiling, open at the top, began to predominate everywhere. Experiments carried out by Le Brun and some of his pupils, like Houasse in the Salon de l'Abondance at Versailles, were developed during the last decade of the century. The fame of La Fosse had reached England and he was summoned to London to decorate the London residence of the Duke of Montagu.[18] The plan of the grand staircase, known through a watercolour by Georg Scharf (pl.320), is symptomatic of the changes taking place. With the assistance of Monnoyer and Rousseau, he covered the walls with grisaille lower down and, in the upper part, landscapes seen through architectural frames which were opposite the real windows. Above a cornice, seated figures provided the connection with the ceiling. The ceiling was a vast sky containing the story of Phaeton. This part, reminiscent of a lighter version of the Escalier des Ambassadeurs, foreshadowed the taste for a more relaxed style by

318. Antoine Coypel,
The Glory of the Eternal Father.
Vault of the Chapelle Royale, Château de Versailles.

320. *opposite*:
Georg Scharf (after Charles de La Fosse),
View of the Staircase at Montagu House.
Watercolour.
British Museum, London.

321. Jean Jouvenet,
The Triumph of Religion.
Sketch for the ceiling of the Parlement de Rouen.
Oil on canvas,
170 × 134 cm.
Musée de Peinture et de Sculpture, Grenoble.

allowing the natural world into the building. Should this also be connected with the Villa Barbaro at Maser, where Palladio and Veronese had together created a décor that was at once noble and playful? Here the gaps were as important as the filled areas and the delights of everyday life jockeyed for position with the mythological programme. This would be yet another reference to Venice and the Veneto in La Fosse's work.

The same concern for sources of ventilation characterised the vault of the Galerie d'Enée at the Palais Royal, decorated by Antoine Coypel for his principal patron, the Duc d'Orléans, between 1703 and 1705.[19] The scheme itself having been destroyed, we have to rely on the evidence of a preparatory sketch (Anger, pl.322). The flowery style of Pietro da Cortona and the Romans is here respectfully interpreted.[20] False architecture, opening wide in the centre on an *Assembly of the Gods* full of graceful creatures, is adorned around its circumference with caryatids and slaves in a well-orchestrated variety of poses recalling the *ignudi* in the Galleria Farnese, and flanked with a patchwork of paintings illustrating episodes from the *Aeneid*. Coypel here appears to cling to the balance, so dear to Le Brun, between open and closed, between illusion and respect for the surface as it stands. He went even further on a less demanding commission, a ceiling in the residence of the Comtesse d'Argenton, the mistress of the future Regent, near the Palais-Royal. Painted in 1708, this ceiling, which has now been transferred to Asnières by the Banque de France, was painted as a single unit. It represented the *Triumph of the Cupids over the Gods* (the subject itself indicative of a new sensibility) and was designed as a bright sky filled with 'that pleasant, elegant playfulness that so delights the spirit, and of which the spirit alone can be the inventor', to quote the artist's own son.[21] With its theme of gallantry and its supple, light construction, it heralded the Regency. Coypel, however, who was the painter of the transition period par excellence, revealed himself even in his changes of mind; he returned to more serious matters at the end of his work in the Galerie d'Enée, decorating the walls opposite the windows with a series of seven dramatic episodes (1715–17). The division of Virgil's poem and the

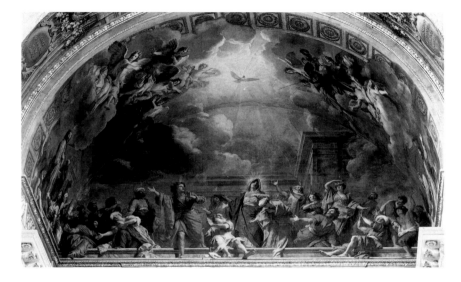

choice of subjects seems to hinge more on decorative expediency than on narrative continuity; the political message, always in the background when a royal gallery was being decorated, is far from clear. In these paintings (pl.323), several of which are in very poor repair (Louvre, Montpellier and Arras), Coypel takes up again with the spacious draughtsmanship and the taste of someone like Le Brun. The organisation is disciplined (*The Descent to the Underworld*), the presentation generally theatrical (*Aeneas and Achates appearing before Dido*), sometimes with a touch of Rubenesque sensuality (*The Death of Dido*). In

319. Jean Jouvenet, *Pentecost*.
Tribune of the Chapelle Royale, Château de Versailles.

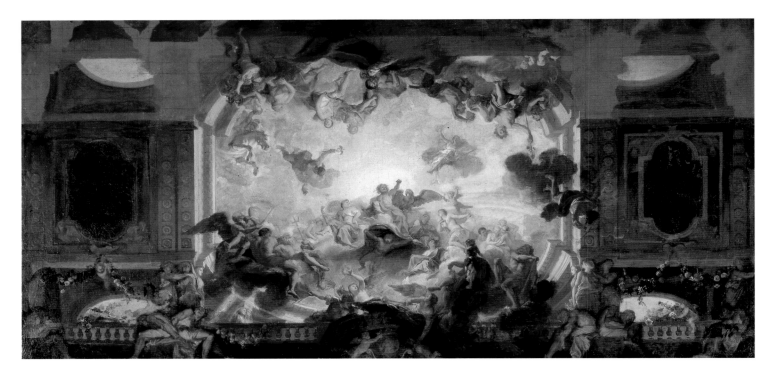

322. Antoine Coypel,
The Assembly of the Gods.
Sketch for the ceiling of
the Galerie d'Enée at the
Palais-Royal.
Oil on canvas,
95 × 195 cm.
Musée des Beaux-Arts,
Anger.

323. Antoine Coypel,
Aenaeas carrying Anchises.
Oil on canvas,
387 × 190 cm.
Musée Fabre, Montpellier.

similar fashion, Coypel, Philippe d'Orléans'
painter, appointed Premier Painter in 1715,
became the guardian of a tradition into which the
liberties that had attracted him slightly earlier
were fully integrated and disciplined.

TOWARDS THE 'PETIT GOÛT'

A short distance from Versailles, smaller châteaux
and country houses, designed for relaxation, re-
flected the changes in taste that had come about
during the final years of the seventeenth century.
In 1683, the pavilion in the middle of the garden
at Marly[22] was decorated with military scenes by
van der Meulen and his collaborators, and with
bouquets of flowers from the brushes of
Monnoyer and Blin de Fontenay; in the living
quarters, Flemish and Dutch paintings were being
hung. In 1688 Louis XIV ordered twenty-seven
mythological paintings based on Ovid's
Metamorphoses for the marble Trianon, the 'Pavil-
ion of Flora' in which landscape and still life were
to occupy most of the space.[23] Le Brun's pupils
gave free rein to their various talents. The stilted
Classicism of Noël Coypel, François Verdier and

Jouvenet rubbed shoulders with the 'neo-classi-
cism', colder and less substantial, with delicate
colouring, of someone like Houasse, the neo-
Bolognese style of the Boullogne brothers with
the colourism of Antoine Coypel. Among the
many successful results of this scheme two very
different ones stand out in particular: *Iris and
Morpheus*, by Houasse, commends itself on
grounds of its crisp drawing, its unusual combina-
tion of greys and blues and a pervasive melan-
choly. The subject is a distant harbinger of Guérin
and Girodet. La Fosse's *Clytie transformed into a
Sunflower* (pl.325) is an intensely nostalgic and
poetic exercise in light, in which the monarchical
theme of Apollo is interpreted with intimacy and
tenderness but without sentimentality. His nudes
possess a fullness that has seldom been equalled.

The Trianon marked the beginning of an artis-
tic period that was gathering speed in about 1700.
The traditional plan persisted, in the sense that
history and other noble subjects continued to be
pre-eminent. However, changes that were more
radical followed soon at Marly and at Meudon, as
well as in the Ménagerie at Versailles. In 1699 the
great reception room in the Pavillon du Roi at

Marly was restored by Mansart. Between the high windows in the dome four allegorical pictures of the *Seasons*, painted by the most prominent painters of the day, were placed: *Zephyr and Flora*, or *Spring* (in ruined condition, Louvre), by Antoine Coypel; *Ceres*, or *Summer* (Nantes), by Louis de Boullogne; *Bacchus and Ariadne* (Dijon, pl.324), representing autumn, by La Fosse; and *Winter* (in ruined condition, Louvre, drawing in the Bibliothèque Nationale), an old man warming himself in front of a fire, by Jouvenet. Each of these large canvases, designed to be seen from very low down, summarises both its painter and the current situation of official art — from Jouvenet's powerful draughtsmanship to the sweetness of La Fosse's colours, via the reserve of Coypel and Boullogne, the latter two perpetuating the graceful style of the Trianon. At Meudon,[24] bought by the Grand Dauphin from Louvois's widow in 1694, the vaulted ceiling decorated by La Fosse at the beginning of the 1680s in the style of Le Brun was demolished, and grotesque designs were painted in its stead. The portion allotted to painting grew less; now the painters contributed fancy ornamentation all over the ceilings and on the woodwork, the latter being painted in gold on a white background, or in colour on a gold background. Nevertheless the team of painters at Marly started a series of paintings in the antechamber, used as a dining room; these were bacchic scenes, the best of them being Coypel's *Silenus smeared with Blackberries by Eglé* (Reims) and La Fosse's *Triumph of Bacchus* (Louvre).

At this time, Louis XIV was having the Ménagerie at Versailles[25] decorated for the infant Duchesse de Bourgogne. The original design by Mansart had a tribute to a different goddess in every room, but it was rejected by the King, who wrote in the margin: 'I think something here needs changing. I think the subjects are too solemn and that there should be some youth included in the plan [. . .] There should be children and childhood throughout.'[26] A dozen painters, most of whom had already been employed at the Trianon, painted small, mythological paintings, amorous and cheerful in tone, and these were framed above the doors and fire-

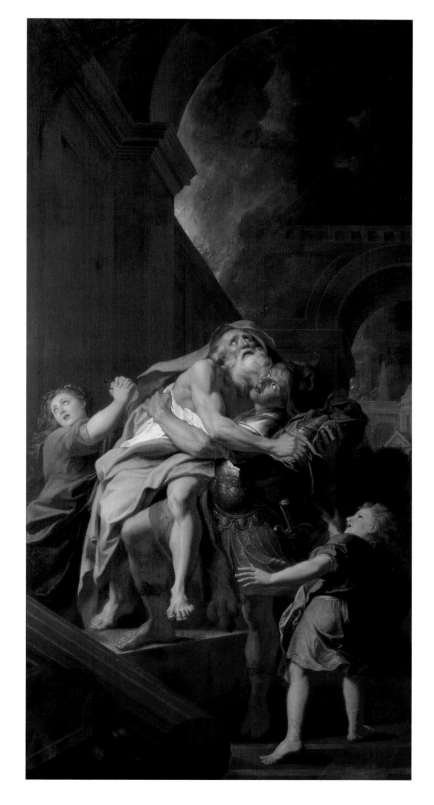

324. Charles de La Fosse,
Bacchus and Ariadne.
Oil on canvas,
242 × 185 cm.
Musée des Beaux-Arts,
Dijon.

326. René-Antoine
Houasse,
Iris and Morpheus.
Oil on canvas,
203 × 143 cm.
Musée National du Château,
Versailles. Grand Trianon.

325. Charles de La Fosse,
*Clytie transformed into a
Sunflower*.
Oil on canvas,
131 × 159 cm.
Musée National du Château,
Versailles. Grand Trianon.

places: memorable are Louis de Boullogne's *Venus requesting Weapons from Vulcan*, of which a replica dated 1703 has recently appeared (private collection, New York, pl.327), and *Venus in a Conch transported by the Tritons* (Louvre) by Antoine Coypel. There were indeed children and childhood throughout. Thus the Fable lost some of its solemnity. The freshest pages of Vouet and Le Sueur were being revisited.

In the Ménagerie, as at Meudon, grotesque designs[27] were integral to the scheme. Claude Audran the Third, with whom Jean Bérain the Elder, Desportes and the young Watteau (pl.329) were working, covered the walls and sometimes the ceilings with aerial figures, extraordinary hybrids of man and beast (pl.328), bringing a lighter touch to the motifs previously employed by Vouet and his pupils and subsequently stiffened into angular candelabra by Errard and Le Brun. The straight line, still favoured by Bérain, was retreating in favour of curves and flourishes. A humoristic style, disjointed and resolutely superficial was beginning to develop, later to be one of the sources of the Rococo. The classical and Renaissance ornamentation that had supplied the seventeenth century was succeeded by a craze for

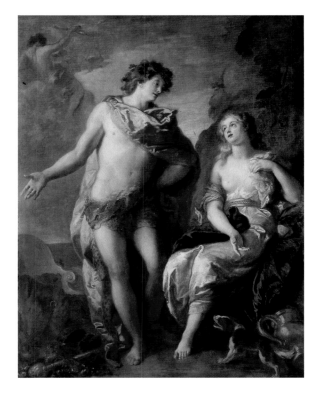

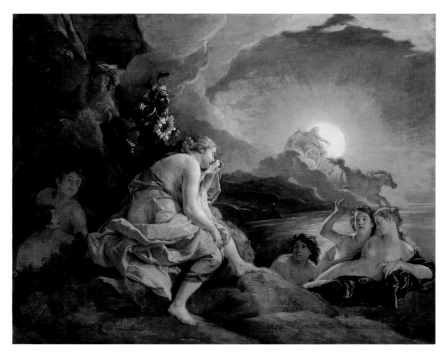

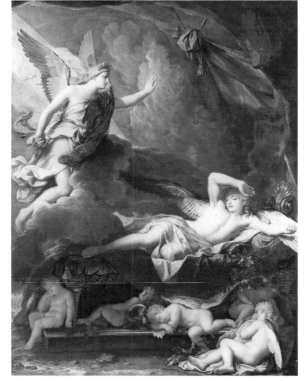

the exotic and oriental. In fashion now were the 'singeries' and 'chinoiserie' particularly favoured by Claude Gillot, and by Vigoureux-Duplessis (pl.330) who worked for the Opéra and for the Manufacture de Beauvais: it is interesting to contrast the fireguard that he painted in 1700 with the more stilted offerings of the Louis XIV style in decline. The serious, literary idea of history painting was now challenged by a proliferation of ornamentation, which had until now been the province of the architect. However innovatory they may have seemed, Coypel's and La Fosse's paintings for Meudon were nevertheless still painted with an eye on the great painters of the past, from the Correggio of the *Virtues* and *Vices* to the Titian of the *Bacchanals*. Would they not soon be totally outmoded and incongruous in comparison with the grotesques that surrounded them and monopolised attention?

History painting was, however, able to adapt itself to the taste of the day. It became mythological and pastoral, romantic, even erotic, full of grace and charm. The painters' broad visual field of reference, their eclecticism combined with their delightful use of colour were all put at the disposal of the Fable and those 'loves of the gods' that were to enjoy such success during the reign of Louis XV.[28] Even more than in the work of La Fosse, who retained an old fashioned dignity in his composition as well as in his monumental figures, the new spirit can be sensed in someone like Louis de Boullogne, always ready to catch the prevailing wind. In *Diana's Repose*, painted in 1707 for the Château de Rambouillet (Tours, pl.332), the sensuality of the half-naked, dozing figures in the foreground and their presentation in a rustic setting demonstrates a desire to interpret and modernise the celebrated painting by Domenichino in the Galleria Borghese. The close-up view allows the spectator to participate in the intimacy of the scene like a kind of voyeur, as later in Lemoyne or Boucher. A more ambitious painting, Coypel's *Bacchus and Ariadne* (Philadelphia, pl.331), painted in 1693 for the Cabinet de Monsieur at Saint-Cloud,[29] is a skilful synthesis of hitherto orthodox examples from Poussin to Rubens and Titian, expressed with completely original felicity of style. This is an absolutely typical cabi-

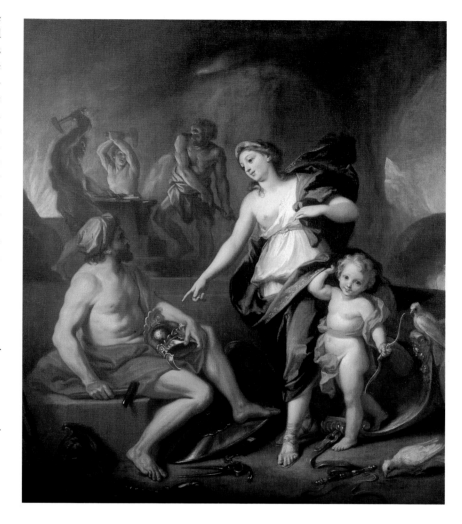

net painting, cut off from the world of official commissions and brilliantly executed; the erudition of the history painter is modified by 'grace' in the name of 'amiable truth'. Coypel stressed, in his advice to his son: 'If profound erudition is not seasoned with a certain ability to please then it becomes dreary and dull.'[30] This lesson was of course passed on to the younger generation by the painters of the Ménagerie. No attention was paid until very recently to the artists who fell between the two periods, like Alexandre Ubeleski, still under the influence of Le Brun, or Nicolas Bertin, dainty to the point of affectation: his *Anacreon and Cupid* (about 1700–10, Autun and Baltimore, pl.333), his *Bacchus and Ariadne* (about 1710–20, Saint-Etienne) are uncompromisingly frivolous

327. Louis de Boullogne, *Venus requesting Weapons from Vulcan*, 1703. Oil on canvas, 68 × 56 cm. Private collection, New York.

328. Claude Audran the
Third,
Singerie.
Pencil and sanguine,
69.7 × 49.5 cm.
Statens Konstmuseen,
Stockholm.

329. Antoine Watteau,
The Wheedler, 1707–8.
Oil on wood,
79.5 × 39 cm.
Private collection, Paris.

with the mannered elongation of their figures, exquisite colours and supple rhythms echoing those of the grotesque designs. The decorative language in use around Versailles accompanied the development of history painting towards a 'minor taste' and a frivolity that were later to be sharply criticised.

ECLECTICISM AND MODERNITY

The year 1699 marked a decisive stage in this transition.[31] Jules Hardouin-Mansart took up his post as Directeur des Bâtiments and La Fosse was elected head of the Academy. Roger de Piles joined this company with the rank of councillor

just as his *Abrégé de la vie des peintres* was published, followed shortly by *L'Idée du peintre parfait*. In July he gave a lecture in which he outlined to the students a whole course of study. The Academy thus regained its prestige and its pedagogical responsibilities, after several years of grave problems: the institution was henceforward under the control of the colourists. Nevertheless the public exhibition held in August in the Grande Galerie du Louvre[32] reflected a degree of indecision. The Poussinists and the direct heirs of Le Brun were well represented by Colombel, Plattemontagne, Jouvenet, Poërson (the son), Claude-Guy Hallé, Paillet and above all Noël Coypel – La Fosse's predecessor as head of the Academy – who

showed nineteen paintings. The new trends were timidly represented by the Boullogne brothers, Gabriel Blanchard and Michel Corneille the Younger, or more radically by Antoine Coypel (pls 334, 335), Joseph Parrocel (pl.336) and in particular Largillierre, who had thirteen paintings in the exhibition, mainly portraits. Along with biblical, historical and mythological scenes (pl.332) the lesser genres achieved remarkable exposure. Some artists moved easily from one category to another: beside a *St Cecilia*, a *Jephthah's Daughter* and a *Sacrifice of Iphegenia*, Bon Boullogne showed a *Guardroom with Soldiers playing Cards*, a *Fortune Teller* and even a *Girl searching for Fleas*. Five years later, at the Salon of 1704,[33]

this tendency was even more pronounced. Mythological paintings were more numerous, and still lifes, landscape, domestic scenes and especially portraits occupied a considerable part of the Salon. Painters were increasingly attracted towards the art of the Netherlands and were experimenting with new forms. The colours used by northern painters became synonymous with enhanced naturalness: nature now was agreeable and picturesque, could be arranged in diverting ways, with magnificent colour schemes and a level of wit and imagination that was at odds with the conscientious sobriety of the painters of the first half of the century.

The debate about colour came to a head in two

330. Jacques Vigoureux-Duplessis, Firescreen with chinoiserie, about 1700. Oil on canvas, 87 × 117 cm. Walters Art Gallery, Baltimore.

331. Antoine Coypel,
Bacchus and Ariadne, 1693.
Oil on canvas,
73 × 85.5 cm.

Museum of Art, Philadelphia.
Bequest of Edna M. Welsh
and gift of Mrs. P. Barclay
Scull.

major publications by Roger de Piles: the *Abrégé*
of 1699 and the *Cours de peinture par principes*,
published in 1708, handbooks for a new gener-
ation of scholars.[34] Drawing was returned to its
rightful position as a generic notion governing all
the visual arts, painting, sculpture and engraving.
Colour was promoted to being the 'specific
difference' in painting, and an arcane science since
it comprehended henceforth chiaroscuro, the play
of light and shade – in short, the feature that
brings a painting to life. At the same time the way
of looking at painting altered. The analytical read-
ing of a picture and the relegation of its parts to a
hierarchical progression, sometimes a narrative,
was replaced by a global perception in which the
pleasure of the senses played a leading role. By
assembling different objects into groups and the
groups into a harmonious ensemble, the painter
had to elicit a 'first glance' response: the combin-

ation of colours, light transparent tones (dullness
was to be avoided), and the transition from light
to dark would catch the eye. Following in the
footsteps of Dufresnoy, who himself referred to
Titian, de Piles compared a finished painting to a
bunch of grapes, an organic combination of con-
vex and luminous elements. Using the example of
Rubens, he recommended circular compositions
in which the lightest part would be in the centre
and the parts round the edge would be of lesser
intensity.[35] This led to the idea of a visual music,
whose harmonies would enrapture the eye before
transmitting their message to the mind. Seen from
this angle, expression, on which Le Brun (follow-
ing Poussin) had placed the most stress, was rel-
egated to a subordinate position because it
assumed the decoding of a painting figure by
figure before it could be understood. In addition
Roger de Piles rejected classical idealism in favour

of naturalness and simplicity, thus opening the door to a type of painting that would glorify the particular at the expense of the general: his distinction between heroic and pastoral landscape operates to that effect.[36] Painting was therefore to experience a lowering of tension. At the same time, however, the emphasis was transferred to the pictorial content of the painting and the hand of the artist. The connoisseur was supposed to enjoy studying the painting techniques of different painters for clues to individual styles of brushwork, the effects of different paints and glazes and the flavour of the artist's flights of fancy, rather than seeking any education or enlightenment.

The writings of Antoine Coypel, composed between 1700 and 1710 but not published until 1721,[37] are revealing on the subject of these changes, at a time when the colourists' case was virtually won but when certain assumptions from the earlier period continued to prevail. Coypel, trained by his father, perpetuated the memory of Poussin when he extolled the unities of time, place and action, the rejection of unnecessary ornament and respect for the proprieties and 'costume'; when he refused to tackle history subjects in a 'lowly' manner; when he recommended (after Le Brun) the detailed study of physiognomy and gesture for the depiction of passions without affectation: he passed on his interest in theatre to his son Charles. Though he shows unfailing admiration for the skill of drawing, he also praises the variety of colours and the essential role of chiaroscuro in the overall effect. The painters he commends as models are, besides the Venetians (Giorgione and Titian in particular), Rubens, Van Dyck and Rembrandt, familiar to him through study of the collections of the Duc d'Orléans and in the Palais du Luxembourg, then in the possession of the Duc d'Orléans; he also possessed originals and copies of works by these artists. The painter whose skill he admired most was Correggio. During his youth he had made a copy of the dome of the Cathedral in Parma, and he knew the twelve paintings by Correggio that hung in the Palais Royal very well. In them he thought he had found the right course to follow: 'Everything in them is mellow and well-blended, even in the largest canvases, without doing any

damage to the character of the drawing.'[38] Fragile equilibrium: 'To give [the pictures] the finishing touch you must so to speak spoil them; that is to say that with light and lively brushstrokes you must remove their faded gentility and their cold uniformity.'[39] Still hesitating between studied carelessness and a perfect finish, Coypel submitted the profession of artist to close scrutiny, without however causing many repercussions: La Fosse[40] and above all Largillierre went much further along this road than he did.

As colourism took hold in Paris, a number of painters in the provinces, mainly in the south,

332. Louis de Boullogne, *Diana's Repose*, 1707. Oil on canvas, 105.5 × 163 cm. Musée des Beaux-Arts, Tours.

333. Nicolas Bertin, *Anacreon and Cupid*. Oil on canvas, 46 × 37.5 cm. Musée Rolin, Autun.

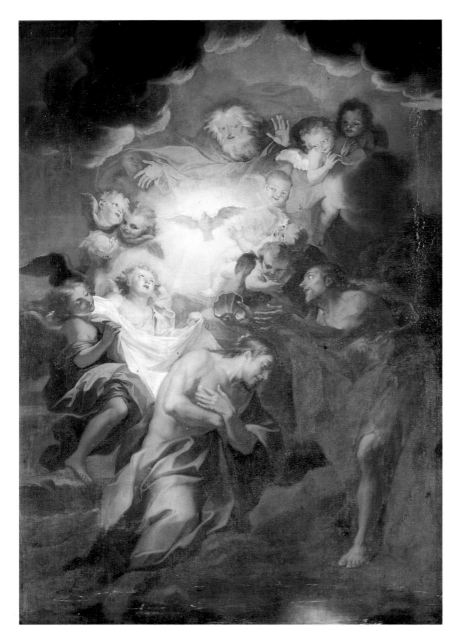

334. Antoine Coypel,
The Baptism of Christ.
Oil on canvas,
152 × 102 cm.
Abbaye de Saint-Riquier
(Somme).

335. Antoine Coypel,
Democritus, 1692.
Oil on canvas,
69 × 57 cm.
Musée du Louvre, Paris.

were influenced by *pittura di macchia*[41] and the troubled vision of eccentric Italians such as Pierfrancesco Mola, Salvator Rosa or Valerio Castello. A recognisable idiom links the great Italian centres (Rome and Florence, Parma and Venice, but also particularly the ports of Genoa and Naples) with busy cities like Marseille, Toulouse and Lyon. This idiom is characterised by freedom of inspiration and an inclination towards the bizarre, aggressive, rather negligent style, and brushwork that is sometimes flowing, producing spectacular light effects. The paintings are drenched in often unusual and glittering colour, with strong contrasts of light and shade. Of the individual and still little-known artists working at the turn of the century the greatest was perhaps Joseph Parrocel, who specialised in battles and hunting scenes; in 1685 he was commissioned to paint eleven military paintings for the King's dining room at Versailles (*in situ*), and in 1699 a *Crossing the Rhine* for Marly (Louvre). These subjects encouraged his lyrical, vivid temperament to manifest itself in a way that pleased Louis XIV and influenced a whole dynasty of

painters. In Toulouse, Antoine Rivalz continued until his death in 1735 to paint in a darker, more tragic vein, underpinned by powerful drawing reminiscent of the art of Pietro Testa: examples of this are his *Allegory in honour of Poussin*, engraved in 1700, his paintings for the Capitole (*History of the Tectosages*, pl.338), begun in 1703, and easel paintings like *The Rape of the Sabine Women* and the *Death of Cleopatra* (Toulouse). Marseille, then enjoying a period of tremendous economic expansion, provided broad and varied scope to the successors of Puget: in addition to the Neapolitan painter Barthélemy Chasse and painters like Gilles Garcin and André Boisson there was the Catalan Michel Serre, a virtuoso of very uneven quality. His fame won him a seat in the Academy in 1704, but he retained his individuality, persisting in a style that was less concerned with correctness than with sometimes quite violent expressiveness. In Pierre-Louis Cretey, from Lyon, this individuality bordered on strangeness; he decorated the refectory of the Couvent de Saint-Pierre (now the Musée des Beaux-Arts) with two enormous compositions, the *Multiplying of the Loaves* and the *Last Supper* (1684–86, *in situ*, pl.337), but also painted small religious and mythological paintings, ghostly in appearence, for private clients. In works like these the importance of drawing is overshadowed by the need to make a personal statement, however disorderly; brutality and refinement combine in the search for unusual effects.

The painters of this generation, still scarcely understood, have been criticised for an eclecticism bordering in some cases (like Bon Boullogne) on a complete absence of style. Perhaps allowances should be made for their sense of confusion[42] in the wake of newly acquired freedom, the weakening of tried and trusted references and the huge diversity of models to be studied. These artists were often victims of their own education, which covered two centuries of painting and countries as different as Holland and Italy – or the Italies, as perhaps one should term them. The corpus was ever increasing. Also crucial was the break-up of a tradition whose main accomplishment had been the Versailles of Le Brun and, to a lesser extent of Mignard. The building of country houses involved an exploration of the charm of the inci-

dental, the intimate, the imaginative rather than an exercise in coherence and opulent monumentality. At Meudon, Sceaux and the Palais Royal small courts took over from the old court of Louis XIV and Mme de Maintenon, shaking off the rigid constraints of etiquette and routine. The city,[43] dormant for years, recovered its artistic preeminence. Private residences were built or restored to house the affluent financiers and aristocrats of the day. Paris, now filled with visitors from abroad, set the tone in every field. Architecture began to be concerned with convenience and comfort. The rooms, often smaller than they had been, received light and lively decoration instead of the great chunks of painting on ceilings and panelled walls. Demand for easel painting increased, encouraging painters to try out new skills

336. Joseph Parrocel, *Crossing the Rhine*, 1699. Oil on canvas, 234 × 164 cm. Musée du Louvre, Paris.

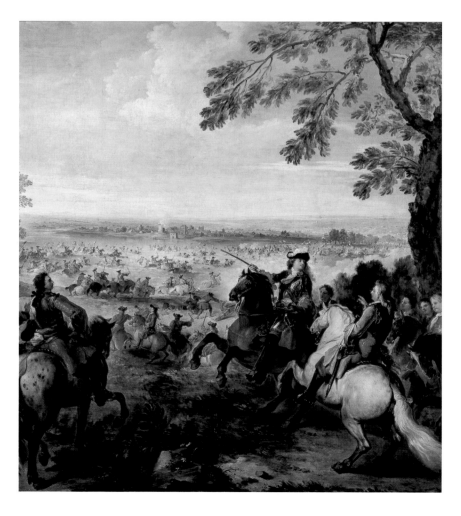

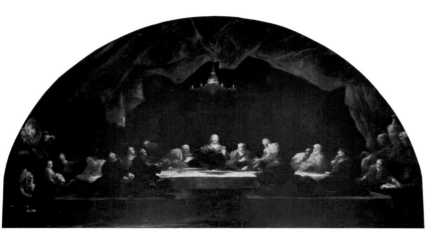

337. Pierre-Louis Cretey,
The Last Supper, 1684–
1686.
Oil on canvas,
1000 × 525 cm.
Réfectoire du Palais Saint-
Pierre, Lyon. Musée des
Beaux-Arts.

338. Antoine Rivalz,
*The Founding of the Town
of Ancyra by the Tectosages*
Oil on canvas,
466 × 823 cm.
Musée des Augustins,
Toulouse.

and to mix the genres. The most important studio of the period belonged to Bon Boullogne.[44] He trained artists like Santerre (pl.341), Raoux (pl.339), Tournières or Grimou who imitated Dutch genre painting: the fashion was for 'fantasy heads' and 'history painting or caprices in the manner of Schalcken or Gerardau (*sic*)'.[45] The young Watteau, who had sailed down from Valenciennes to be exploited by a dealer on the Pont Notre-Dame, who had him copying Dutch[46] paintings 'by the dozen', imitated Willem Kalf in compositions like *The Copper Burnisher* (1709–10, Strasbourg, pl.340).[47]

A modern taste was beginning to be formed, as a reaction against whatever might seem inhibiting in the legacy of former generations. Grotesque painting represented freedom and the subversion

of order, stability and solemnity; the grotesque introduced a climate of gaiety and artifice that developed alongside the theatre of the Comédie-Italienne and the Fairs.[48] Joseph Parrocel's *Fair at Bezons* (about 1700, Tours), and especially the works of Claude Gillot (who was nevertheless accepted by the Academy in 1715 with a *Christ about to be Nailed to the Cross* (church of Noailles, Corrèze), are the truest expression of the modern taste. Paintings like *The two Carriages* (pl.343) or *The Tomb of Maître André* (Louvre) seem dull compared with the witty, sometimes quite bizarre drawings that have the energy of a Brébiette or even a Callot. Watteau, the pupil of Gillot from 1704 to 1708, developed the genre initiated by his teacher, the *fête galante*, a nostalgic revival of the pastoral (pl.342). Originally trained in the north of France with Flemish models, he studied the paintings by Rubens in the Luxembourg in Paris when Claude Audran the Third was the 'concierge'; he was in contact with an enlightened patron, Pierre Crozat, the protector of La Fosse. His paintings, like those of Gillot, are intensely personal and poetic, though his *fêtes galantes* may seem enigmatic this is because they fall outside any known academic category; later they were to become a recognised genre of their own.[49] Watteau enjoyed scrambling messages and disguising the usual reference points.[50] The analysis of passions made way for uncertainty and allusion. These paintings were often without organisation, leaving the spectator to make his own interpretation. A set of conventions was followed – décor, rôles, costumes – but they were beneficent conventions. By rejecting description, narrative and the world order, by retreating to a discrete, minimal, apparently anodyne position Watteau could turn his attention to other matters – in the nature of the *je ne sais quoi*.[51] By developing the connection between, for example, a colour, a fabric, a fleeting emotion and a few notes of music, Watteau, who was obviously fully aware of the new opportunities afforded to painting by Roger de Piles and the colourists, was able to develop to the full all his powers of suggestion.

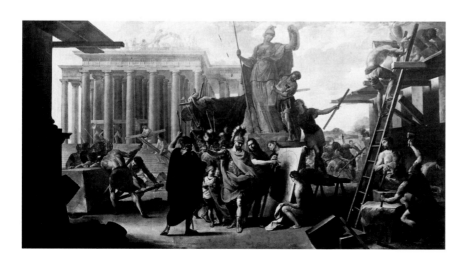

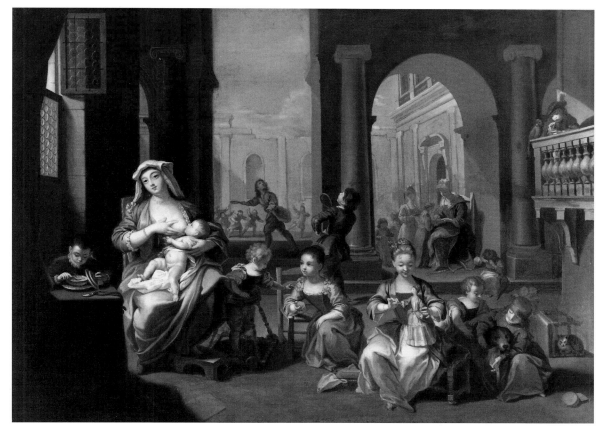

339. Jean Raoux,
Childhood.
Oil on canvas,
152 × 94 cm.
Musée Fabre, Montpellier.

341. Jean–Baptiste
Santerre (after
Rembrandt),
*The Young Girl at the
Window.*
Oil on canvas,
81 × 65 cm.
Musée des Beaux-Arts,
Orléans.

340. *left*:
Antoine Watteau,
The Copper Burnisher,
1709–1710.
Oil on canvas,
53 × 44 cm.
Musée des Beaux-Arts,
Strasbourg.

342. Antoine Watteau,
The Island of Cythera,
1706.
Oil on canvas,
43.1 × 53.3 cm.
Städelsches Kunstinstitut,
Frankfurt.

343. Claude Gillot,
The two Carriages.
Oil on canvas,
127 × 160 cm.
Musée du Louvre, Paris.

Notes

1. On these new patrons see Crow, 1985, chap. I. On Pierre Crozat: Stuffmann, 1968; B. Scott, 1973.

2. Moureau, 1984–5, p.474.

3. On the evolution of taste and collecting, see most recently K. Scott, 1991–2, and Schnapper, 1994.

4. Roger de Piles, 'La balance des peintres', in de Piles, 1708 (1989), pp.236–41.

5. See the letter to Colbert de Villacerf from La Teulière quoted above, chapter 6, p.154.

6. On the taste for Correggio, see Schnapper, 1968 (1969); on the attraction towards the art of the Low Countries, see exh. cat., Lille, 1985.

7. The monograph by Schnapper, 1974 (1), contains a section on the position of religious painting at the time of Jouvenet.

8. On this ensemble, see Auzas, 1969.

9. Auzas, 1949 and 1953.

10. The Abbé Ménard de Tiffauges, *Description du tableau de Suzanne*, 1695, B.N. Est., coll. Deloynes no. 1925, p.255 (quoted by Garnier, 1989, p.121).

11. Dimier, 1928–30, vol.I. chap.II, p.106.

12. See for example the ceiling painted by Bon Boullogne for Investigation Room no. 11 in the Parlement de Paris (1685–90); there is a *modello* in the Musée Carnavalet.

13. On the chronology of the building works, see Schnapper, 1974 (1), pp.109–19.

14. J-F. Félibien, 1702, pp.7–8.

15. On the building works, see Schnapper, 1974 (1), pp.119–25, and Garnier, 1989, p.28.

16. Gillet, 1913, p.216.

17. See above, chapter 11, p.260.

18. Stuffmann, 1964, pp.76–80.

19. On the programme and the chronology of the building works, see Schnapper, 1969.

20. The part taken on by Coypel was the same as that taken on by La Fosse for the gallery in the Hôtel Crozat (1702–4, destroyed), with the *Assembly of the Gods* and the *Birth of Minerva* in the vault.

21. Charles Coypel, 'Vie d'Antoine Coypel', in Lépicié, 1752, vol. II, pp.1–41 (pp.24–5).

22. See Magne, 1934; Marie, 1947; Schnapper, 1974 (1), pp.137–9.

23. Schnapper, 1967.

24. See Schnapper, 1968 (1), and 1974 (1), p.140.

25. See Mabille, 1974 and 1974 (1976).

26. Quoted by Kimball, 1943, p.107.

27. See Kimball, 1943, *passim*; Chastel, 1988.

28. Exh. cat., Paris, Philadelphia, Fort Worth, 1991–2.

29. On the collections of Monsieur (the Regent's father), see the summary by C. Bailey, exh. cat. quoted in the preceding note, no.8, p.51.

30. A. Coypel, 'Discours prononcé dans les conférences de l'Académie Royale de peinture et de Sculpture', Paris, 1721, in Jouin, 1883, p.261.

31. See Teyssèdre, 1957 (1965), pp.449–500.

32. *Liste des tableaux et des ouvrages de sculpture exposés dans la Grande Galerie du Louvre [. . .] en la présente année 1704*, Paris 1704 (B.N. Est., coll. Deloynes no.2).

33. *Liste des tableaux et des ouvrages de sculpture exposés dans la Grande Galerie du Louvre [. . .] en la présente année 1704*, Paris, 1704 (B.N. Est., coll. Deloynes no.4).

34. On the new ideas introduced by de Piles, see in particular Puttfarken, 1985, *passim*, and the preface by J. Thuillier to the new edition (1989) of the *Cours de peinture par principes* (1708).

35. Antoine Coypel had already tried this in a work like *The Baptism of Christ* (1688–90, Abbaye de Saint-Riquier).

36. See above, chapter 9, p.214.

37. On the artistic theories of A. Coypel, see Garnier, 1989, pp.65–77.

38. Quoted by Garnier, 1989, p.73.

39. *Ibid*.

40. '[La Fosse] used sometimes to say that it was too dangerous to make ones art too deep and to spend too much time on theory; he would add that the painter needs to practise assiduously, and that the workings of the head must be supported by suppleness of hand to follow "enthusiasms whose faults are often . . . to connection, (which is) languishing and committed with difficulty" [c'est la comchin qui est languidante, pas les famtes]' (Dézallier d'Argenville, 1762, vol.IV, p.192).

41. It would be risky to translate this as 'tachisme': what is praised here is rather a freedom of touch. On this trend, also sometimes called 'luminism', see Chomer, Galactéros and Rosenberg, 1988, p.34.

42. Schnapper, 1978 (1), p.123 ('But this liberty can sometimes approach a state of disarray; is this not how we should interpret the pastiches of Bon Boullogne, exemplary in demonstrating an extreme of indecision in someone of a generation still searching for a style?').

43. Moureau, 1984–5, pp.474ff. (on Paris, 'intellectual capital of Europe', and on the warring tastes of court and city and the role of 'parallel' courts).

44. See Schnapper, in the preface, exh. cat. Lille, 1985.

45. (*sic*) Dézallier d'Argenville, 1762, vol.IV, p.363 (on the subject of Tournières).

46. Exh. cat. Washington, Paris and Berlin, 1984–5, p.404.

47. *Ibid*, p.256, no.7.

48. Moureau, 1984–5.

49. Crow, 1985, chap.II; exh. cat. Washington, Paris and Berlin, 1984–5, *passim*.

50. Bryson, 1981, chap.III.

51. On the notion of 'je ne sais quoi', to which P. Bouhours devoted one of his *Entretiens d'Ariste et d'Eugène* (Paris, 1671), see Puttfarken, 1985, pp.106–15.

Bibliography

ABBREVIATIONS

A.A.F.: *Archives de l'Art français*.
A.B.: *The Art Bulletin*.
A.E.A.: *Archivio Español de Arte*.
B.M.: *The Burlington Magazine*.
B.M.M.L.: *Bulletin des Musées et Monuments lyonnais*.
B.S.H.A.F.: *Bulletin de la Société de l'Histoire de l'Art français*.
G.B.A.: *Gazette des Beaux-Arts*.
J.W.C.I.: *Journal of the Warburg and Courtauld Institute*.
M.D.: *Master Drawings*.
R.A.: *Revue de l'Art*.
R.A.A.M.: *Revue de l'Art ancien et moderne*.
R.L.M.F.: *Revue du Louvre et des Musées de France*.
R.S.B.A.D.: *Réunion des Sociétés des Beaux-Arts des Départements*.

ADHÉMAR H., 1979 H. Adhémar, 'Les frères Le Nain et les personnes charitables à Paris sous Louis XIII', *G.B.A.*, February 1979, pp.69–74.

ADHÉMAR J., 1970 J. Adhémar, 'Les dessins de Daniel Dumonstier au cabinet des Estampes', *G.B.A.*, March 1970, pp.129–50.

ALCOUFFE, 1979 D. Alcouffe, 'Nouvelles acquisitions des musées de province. Caen, musée des Beaux-Arts. Notes sur un portrait de Tournières: *Nicolas de Launay et sa famille*', *R.L.M.F.*, 1979, pp.444–8.

ALPATOV, 1965 M. Alpatov, 'Poussins Landschaft mit Herkules und Cacus in Moskau', in *Walter Friedländer zum 90. Geburtstag*, Berlin, 1965, pp.9–20.

ALPERS, 1983 S. Alpers, *The Art of Describing*.

ARIÈS, 1973 Ph. Ariès, *L'Enfant et la Vie familiale sous l'Ancien Régime*, Paris, 1973.

ARIKHA, 1989 A. Arikha, 'Réflexion sur Poussin', in Blunt and Thuillier, 1989, pp.203–41.

ASTRO and THÉVENON, 1985 C. Astro and L.F. Thévenon, *La Peinture au XVIIᵉ siècle dans les Alpes-Maritimes*, Nice, 1985.

AULANIER, 1947 Ch. Aulanier, *Histoire du palais et du musée du Louvre, I-La Grande Galerie*, Paris, 1947.

AULANIER, 1955 Ch. Aulanier, *Histoire du palais et du musée du Louvre, V-La Petite Galerie*, Paris, 1955.

AULANIER, 1958 Ch. Aulanier, *Histoire du palais et du musée du Louvre, VII-Le Pavillon du Roi et les appartements de la Reine*, Paris, 1958.

AUZAS, 1949 P.M. Auzas, 'Les grands mays de Notre-Dame de Paris', *G.B.A.*, July–September 1949, II, pp.177–200.

AUZAS, 1953 P.M. Auzas, 'Précisions nouvelles sur les mays de Notre-Dame de Paris', *B.S.H.A.F.*, 1953, pp.40–4.

AUZAS, 1958 P.M. Auzas, 'Lubin Baugin à Notre-Dame de Paris', *G.B.A.*, March 1958, I, pp.129–40.

AUZAS, 1958 (1959) P.M. Auzas, 'L'influence du Guide sur la peinture française du XVIIᵉ siècle', in *Actes du XIXᵉ Congrès d'histoire de l'art* (Paris, 1958), Paris, 1959, pp.357–67.

AUZAS, 1961 (1) P.M. Auzas, 'Les quatre mays des trois Corneille', *R.L.M.F.*, 1961, 4–5, pp.87–196.

AUZAS, 1961 (2) P.M. Auzas, 'Précisions sur Michel Corneille et ses fils', *B.S.H.A.F.*, 1961, pp.47–8.

AUZAS, 1969 P.M. Auzas, 'La *Visitation* de Jouvenet et les sept autres tableaux du chœur de Notre-Dame de Paris', *B.S.H.A.F.*, 1969, pp.21–38.

AVEL, 1972 (1973) N. Avel, 'Les Pérelle, graveurs de paysages du XVIIᵉ siècle', *B.S.H.A.F.*, 1972 (1973), pp.145–53.

BABELON, 1991 J.-P. Babelon, *Demeures parisiennes sous Henri IV et Louis XIII*, Paris, 1991 (new, revised edition 1965, second edition 1977).

BADT, 1969 K. Badt, *Die Kunst des Nicolas Poussin*, Cologne, 1969, 2 vol.

BAGLIONE, 1642 G. Baglione, *Le Vite de' Pittori, Scultori ed Architetti*, Rome, 1642.

BALTRUSAITIS, 1957 (1983) J. Baltrusaitis, 'Physiognomonie animale', in *Aberrations. Essai sur la légende des formes*, Paris, 1957 (new ed. 1983), pp.9–53.

BARDON, 1974 F. Bardon, *Le Portrait mythologique à la cour de France sous Henri IV et Louis XIII*, Paris, 1974.

BÄTSCHMANN, 1982 O. Bätschmann, *Nicolas Poussin, Dialectics of Painting*, English ed. London, 1990.

BÄTSCHMANN, 1987 O. Bätschmann, *Nicolas Poussin. Landschaft mit Pyramus und Thisbe. Das Liebesunglück und die Grenzen der Malerei*, Frankfurt, 1987.

BEAUVAIS, 1990 L. Beauvais, 'Les dessins de Le Brun pour l'histoire d'Alexandre', *R.L.M.F.*, 1990, pp.285–95.

BÉGUIN, 1967 S. Béguin, 'Guillaume Dumée, disciple de Dubreuil', in *Studies in Renaissance and Baroque Art presented to Anthony Blunt*, London and New York, 1967, pp.91–7.

BELLIER DE LA CHAVIGNERIE, 1864 E. Bellier de La Chavignerie, 'Les mays de Notre-Dame', *G.B.A.*, May 1864, pp.457–69.

BELLORI, 1672 G.P. Bellori, *Le Vite de' Pittori, Scultori ed Architetti moderni*, Rome, 1672.

BERESFORD, 1985 R. Beresford, 'Deux inventaires de Jacques Blanchard', *A.A.F.*, 1985, XXVII, pp.107–34.

BERGER, 1993 R.W. Berger, 'Pierre Mignard at Saint-Cloud', *G.B.A.*, January 1993, I, pp.1–58.

BERTOLOTTI, 1886 A. Bertolotti, *Artisti francesi in Roma nei secoli XV, XVI e XVII*, Mantua, 1886.

BLUCHE, 1986 F. Bluche, *Louis XIV*, Paris, 1986.

BLUCHE, 1990 F. Bluche (edited by) *Dictionnaire du Grand Siècle*, Paris, 1990.

BLUM, 1924 A. Blum, *L'œuvre gravé d'Abraham Bosse, and Abraham Bosse et la société française du XVIIᵉ siècle*, Paris, 1924, 2 vol.

BLUNT, 1943 A. Blunt, 'Jean Lemaire, painter of architectural fantasies', *B.M.*, 1943, pp.241–6.

BLUNT, 1953 A. Blunt, *Art and Architecture in France (1500 to 1700)*, Harmondsworth, (1953 revised edition 1973).

BLUNT, 1957 A. Blunt, 'The Précieux and French Art', in *Fritz Saxl: A Volume of Memorial Essays from his Friends in England*, London, 1957, p.326–38.

BLUNT, 1959 A. Blunt, 'Poussin Studies IX: additions to the work of Jean Le Maire', *B.M.*, 1959, pp.440–3.

BLUNT, 1966 A. Blunt, *The Paintings of Nicolas Poussin. A Critical catalogue*, London, 1966.

BLUNT, 1967 (1) A. Blunt, *Nicolas Poussin*, The A.W. Mellon Lectures in the Fine Arts, Washington and London, 1967, 2 vol.

BLUNT, 1967 (2) A. Blunt, 'A series of Paintings illustrating the History of the Medici Family executed for Marie de Médicis', *B.M.*, 1967, pp.492–8 and 562–6.

BLUNT, 1970 A. Blunt, 'Nicolas Colombel', *R.A.*, no 9, 1970, pp.27–36.

BLUNT, 1979 A. Blunt, *The Drawings of Poussin*, New Haven and London, 1979).

BLUNT and THUILLIER, 1989 A. Blunt and J. Thuillier, *Nicolas Poussin. Lettres et propos sur l'art*. Collected and edited by A. Blunt. Foreword by J. Thuillier, Paris, 1989.

BODART, 1970 D. Bodart, *Louis Finson* (Académie royale de Belgique, classe des beaux-arts, Mémoires, deuxième série, t. XII, fasc. 4), Brussels, 1970.

BOISCLAIR, 1986 M.-N. Boisclair, *Gaspard Dughet: sa vie et son œuvre*, Paris, 1986.

BONNAFFÉ, 1884 E. Bonnaffé, *Dictionnaire des Amateurs français au XVIIᵉ siècle*, Paris, 1884.

BONNEFOY, 1970 Y. Bonnefoy, *Rome 1630. L'horizon du premier baroque*, Paris, 1970.

BOSSE, 1649 (1964) A. Bosse, *Sentiments sur la distinction des diverses manières de peinture, dessin, gravure* Edited by R.A. Weigert, Paris, 1964.

BOSSE, 1667 (1964) A. Bosse, *Le Peintre converti aux précises et universelles règles de son art*. Edited by R.-A. Weigert, Paris, 1964 (see Bosse, 1649 [1964]).

BOTTINEAU, 1986 Y. Bottineau, *L'Art baroque*, Paris, 1986.

BOUSQUET, 1955 J. Bousquet, 'Un rival inconnu de Poussin: Charles Mellin dit "le Lorrain" ', *Annales de l'Est*, 1955, no 1.

BOUSQUET, 1959 J. Bousquet, 'Un compagnon des caravagesques français à Rome: Jean L'homme', *G.B.A.*, February 1959, I, pp.79–96.

BOUSQUET, 1980 J. Bousquet, *Recherches sur le séjour des peintres français à Rome au XVIIᵉ siècle*. Preface by J. Thuillier, Montpellier, 1980.

BOUVY, 1924 E. Bouvy, *Nanteuil*, Paris, 1924.

BOYER, 1980 (1982) J.-C. Boyer, 'L'inventaire après décès de l'atelier de Pierre Mignard', *B.S.H.A.F.*, 1980 (1982), pp.137–65.

BOYER, 1984 J.-C. Boyer, 'Un cas singulier: le *saint Charles Borromée* de Pierre Mignard pour le concours de San Carlo ai Catinari', *R.A.*, no 64, 1984, pp.23–34.

BOYER, 1985 J.-C. Boyer, 'Les représentations guerrières et l'évolution des arts plastiques en France au XVIIᵉ siècle', *XVIIᵉ Siècle*, 1985, no 148, pp.291–305.

BOYER, 1988 (1990) J.-C. Boyer, 'Peintures italiennes et négoce parisien au XVIIᵉ siècle: figures du marchand de tableaux', *in* Colloque, Paris, 1988 (1990), pp.157–68.

BOYER, 1991 J.-C. Boyer, 'Boulbène, Ripa, Richeome', *R.A.*, no 92, 1991, pp.42–50.

BOYER and BREJON, 1980 J.-C. Boyer and A. Brejon de Lavergnée, 'Une commande de tableaux à des artistes français et italiens à Rome en 1639', *R.L.M.F.*, 1980, pp.231–9.

BOYER and VOLF, 1988 J.-C. Boyer and I. Volf, 'Rome à Paris: les tableaux du maréchal de Créquy (1638)', *R.A.*, no 79 (1988), pp.22–41.

BREJON A., 1974 A. Brejon de Lavergnée, 'Pour Nicolas Tournier sur son séjour romain', *Paragone*, no 287, 1974, pp.44–55.

BREJON A., 1979 A. Brejon de Lavergnée, 'À propos de Jean Jouvenet', *Bulletin des Amis du Musée de Rennes*, 1979, no 3, pp.79–95.

BREJON A., 1987 A. Brejon de Lavergnée, *L'Inventaire Le Brun de 1683. La collection de Louis XIV*, Paris, 1987.

BREJON A., 1991 (1992) A. Brejon de Lavergnée, 'Nouveaux tableaux de chevalet de Michel Dorigny', *in* Colloque, Paris, 1991 (1992), pp.417–33.

BREJON A. and CUZIN, 1976 A. Brejon de Lavergnée and J.-P. Cuzin, 'Une œuvre de Nicolas Régnier au musée de Lyon', *B.M.M.L.*, 1976, no 4, pp.455–66.

BREJON B., 1982 B. Brejon de Lavergnée, 'some new pastels by Simon Vouet: portraits of the court of Louis XIII', *B.M.*, 1982, pp.689–93.

BREJON B., 1982 (1984) B. Brejon de Lavergnée, 'Contribution à la connaissance des décors peints à Paris et en Ile-de-France au XVIIᵉ siècle: le cas de Michel Dorigny', *B.S.H.A.F.*, 1982 (1984), pp.69–84.

BREJON B., 1987 B. Brejon de Lavergnée, *Musée du Louvre. Cabinet des Dessins. Inventaire général des dessins. École française. Dessins de Simon Vouet*, Paris, 1987.

BRENNINKMEYER-DE ROOIJ, 1986 B. Brenninkmeyer-De Rooij, 'Correspondances et interactions entre peintres français et hollandais', *in* catalogue to the exhibition *De Rembrandt à Vermeer. Les peintres hollandais au Mauritshuis de La Haye*, Paris, Grand Palais, 1986, pp.47–76.

BRIÈRE, DUMOLIN and JARRY, 1937 G. Brière, M. Dumolin and P. Jarry, *Les Tableaux de l'Hôtel de Ville de Paris*, Paris, 1937.

BROWN and ELLIOTT, 1980 J. Brown and J.H. Elliott, *A Palace for a King. The Buen Retiro and the Court of Philip IV*, New Haven and London, 1980.

BRYSON, 1981 N. Bryson, *Word and Image. French Painting of the Ancien Régime*, Cambridge, 1981.

BUSIRI-VICI, 1965 A. Busiri-Vici, 'Opere romane inedite di Jean Lemaire', *Palatino*, 1965, nos 8–12, pp.161–8.

BUSIRI-VICI, 1977 A. Busiri-Vici, 'Ulteriori acquisizioni di Jean Lemaire', *Antichità Viva*, 1977, no 6, pp.23–31.

CAIX de SAINT-AMOUR, 1919 Comte Caix de Saint-Amour, *Une famille d'artistes*

et de financiers aux XVIIe et XVIIIe siècles: les Boullongne, Paris, 1919.

CAMUS, 1990 (1992) F. Camus, 'Alexis-Simon Belle, portraitiste de cour (1674–1734)', *B.S.H.A.F.*, 1990 (1992), pp.27–70.

CHARVET, 1876 L. Charvet, 'Les Audran', *Revue du Lyonnais*, 1876, 1, p.448ff.

CHASTEL, 1966 (1978) A. Chastel, 'Michel-Ange en France', in *Atti del convegno di studi Michelangioleschi*, 1966, pp.261–78 (re-edited in A. Chastel: *Fables, Formes, Figures*, Paris, 1978, vol. II, pp.189–266).

CHASTEL, 1988 A. Chastel, *La grottesque*, Paris, 1988.

CHENNEVIÈRES, 1847–1862 Ph. de Chennevières-Pointel, *Recherches sur la vie et les ouvrages de quelques peintres provinciaux de l'ancienne France*, Paris, 1847–1862, 4 vol.

CHOMER, 1977 (1979) G. Chomer, 'Charles Le Brun avant 1646: contribution aux problèmes de sa formation et de ses œuvres de jeunesse', *B.S.H.A.F.*, 1977 (1979), pp.93–107.

CHOMER, 1980 G. Chomer, 'Jacques Stella, "pictor lugdunensis" ', *R.A.*, no 47, 1980, pp.85–9.

CHOMER, 1987 G. Chomer, 'Horace Le Blanc: essai de catalogue raisonné', *B.M.M.L.*, 1987, no 3, pp.20–52.

CHOMER, GALACTÉROS and ROSENBERG, 1988 G. Chomer, L. Galactéros de Boissier and P. Rosenberg, 'Pierre-Louis Cretey: le plus grand peintre lyonnais de son siècle?', *R.A.*, no 82, 1988, pp.19–38.

COLLARD and CIPRUT, 1963 L.M. Collard and E.J. Ciprut, *Nouveaux documents sur le Louvre*, Paris, 1963.

COLLOQUE PARIS, 1958 (1960) *Nicolas Poussin. Actes du colloque international Nicolas Poussin* (1958), Paris, 1960, 2 vol. edited by d'A. Chastel.

COLLOQUE FONTAINEBLEAU and PARIS, 1972 (1975) *Actes du colloque international sur l'art de Fontainebleau* (Fontainebleau and Paris, 1972), Paris, 1975 (edited by d'A. Chastel).

COLLOQUE LYON, 1972 (1975) *L'Art baroque à Lyon. Actes du colloque* (Lyon, 1972), Lyon, 1975 (edited by D. Ternois).

COLLOQUE WASHINGTON, 1982 (1984) *Claude Lorrain (1600–1682): A Symposium.* Proceedings of the Symposium (National Gallery of Washington, 1982), Washington, 1984 (edited by P. Askew and H.A. Millon).

COLLOQUE PARIS, 1983 (1985) *L'Âge d'or du mécénat (1598–1661).* Proceedings of the international symposium (Paris, 1983), Paris, 1985 (edited by R. Mousnier and J. Mesnard).

COLLOQUE MARYLAND, 1984 (1990) *The French Academy Classicism and its Antagonists.* Proceedings of the symposium held at the University of Maryland and at the Walters Art Gallery of Baltimore (1984), edited by J. Hargrove, Newark, London and Toronto, 1990.

COLLOQUE GRENOBLE, 1985 *La France et l'Italie au temps de Mazarin. Actes du XVe colloque du C.M.R. 17* (Grenoble, 1985) edited by J. Serroy, Grenoble, 1985.

COLLOQUE ROME, 1986 (1988) *Les Carrache et les décors profanes. Actes du colloque organisé par l'École française de Rome* (Rome, 1986), Paris and Rome, 1988.

COLLOQUE PARIS, 1988 (1990) *Seicento. Actes du colloque* (Paris, 1988), Paris, 1990 (published under the editorship of J.-Cl. Boyer).

COLLOQUE PARIS, 1991 (1992) *Simon Vouet. Actes du colloque* (Paris, 1991), Paris, 1992 (published under the editorship of S. Loire).

COLLOQUE FONTAINEBLEAU, 1992 *Les Arts au temps d'Henri IV. Actes du colloque* (Fontainebleau, 1992), Pau and Fontainebleau, 1992.

CONSTANS, 1976 C. Constans, 'Les tableaux du Grand Appartement du roi', *R.L.M.F.*, 1976, no 3, pp.157–73.

CORDELLIER, 1985 D. Cordellier, 'Dubreuil, peintre de la Franciade de Ronsard au Château-Neuf de Saint-Germain-en-Laye', *R.L.M.F.*, 1985, nos 5–6, pp.357–78.

CORDELLIER, 1990 D. Cordellier, 'Un modèle de Dubreuil pour les portraits de la Petite Galerie du Louvre', *R.L.M.F.*, 1990, no 6, pp.484–8.

CORDEY, 1924 J. Cordey, *Vaux-le-Vicomte*, Paris, 1924.

CORRESPONDANCE DES DIRECTEURS: *Correspondance des Directeurs de l'Académie de France à Rome.* Edited by J.-J. Guiffrey and A. de Montaiglon, Paris, 1887–1912, 18 vol. (Vol. I, 1887).

COTTÉ, 1989 S. Cotté, '250 × 265', *F.M.R.*, no 19, 1989, pp.25–64.

COURAL-STARCKY, 1988 L. Coural-Starcky, *Paris, Mobilier national. Dessins de Van der Meulen et de son atelier*, Paris, 1988.

COYPEL, 1721 A. Coypel, *Discours prononcés dans les Conférences de l'Académie royale*, Paris, 1721.

CRELLY, 1962 W.R. Crelly, *The painting of Simon Vouet*, New Haven and London, 1962.

CROW, 1985 T.E. Crow, *Painters and Public Life in Eighteenth-Century Paris*, New Haven and London, 1985.

CROZET, 1954 R. Crozet, *La Vie artistique en France au XVIIe siècle (1598–1661)*, Paris, 1954.

CUZIN, 1975 J.-P. Cuzin, 'Pour Valentin', *R.A.*, no 28, 1975, pp.53–61.

CUZIN, 1978 J.-P. Cuzin, 'A hypothesis concerning the Le Nain Brothers', *B.M.*, 1978, pp.875–6.

CUZIN, 1979 (1) J.-P. Cuzin, 'Les frères Le Nain: la part de Mathieu', *Paragone*, 1979, nos 349–51, pp.58–70.

CUZIN, 1979 (2) J.-P. Cuzin, 'Jeunes gens par Simon Vouet et quelques autres. Notes sur Simon Vouet portraitiste en Italie', *R.L.M.F.*, 1979, no 1, pp.15–29.

CUZIN, 1989 J.-P. Cuzin, 'Meaux, French Painting', *B.M.*, 1989, p.587.

CUZIN and ROSENBERG, 1978 J.-P. Cuzin and P. Rosenberg, 'Saraceni et la France', *R.L.M.F.*, 1978, no 3, pp.186–96.

DA COSTA-KAUFMANN, 1985 T. Da Costa-Kaufmann, *L'École de Prague The School of Prague: Painting at the Court?*

of Rudolph II, Chicago and London, 1988, Paris, 1985.

DAMISCH, 1982 (1984) H. Damisch, 'Claude: A Problem in Perspective', in Colloque, Washington, 1982 (1984), p.29–44.

DANDREY, 1986 P. Dandrey, 'Un tardif blason du corps animal: résurgences de la physiognomonie comparée au XVIIe siècle'', *XVIIe Siècle*, 1986, no 153, pp.351–70.

DARGENT and THUILLIER, 1965 G. Dargent and J. Thuillier, 'Simon Vouet en Italie. Essai de catalogue critique', *Saggi e Memorie di Storia dell'Arte* (4), Venia 1965, pp.25–63 and 143–66.

DAVIDSON, 1984 (1990) G.S. Davidson, 'Nicolas Poussin, Jacques Stella and the Classical Style in 1640: the Altar Paintings for the Chapel of Saint-Louis at Saint-Germain-en-Laye', in Colloque, Maryland, 1984 (1990), pp.37–67.

DAVIES, 1948 M. Davies, 'A note on Francisque Millet', *Bulletin de la Société Poussin*, 2, 1948, p.24.

DAVIES and BLUNT, 1962 M. Davies and A. Blunt, 'Some corrections to M. Wildenstein's "Graveurs de Poussin au XVIIe siècle" ', *G.B.A.*, 1962, II, pp.205–22; 'Catalogue des graveurs de Poussin par A. Andresen, traduction française abrégée avec reproductions', *ibid.*, pp.139–202.

DEMORIS, 1978 R. Demoris, 'Le corps royal et l'imaginaire au XVIIe siècle: "Le Portrait du roy" par Félibien', *Revue des Sciences humaines*, Lille, 1978, no 172, pp.9–30.

DEMPSEY, 1988 Ch. Dempsey, 'The Greek Style and the Prehistory of Neo-Classicism', in the catalogue to the exhibition *Pietro Testa, 1612–1650. Prints and Drawings*, Philadelphia, 1988, pp.XXXVII to LXV.

DÉZALLIER D'ARGENVILLE, 1749 A.J. Dézallier d'Argenville, *Voyage pittoresque de Paris*, Paris, 1749.

DÉZALLIER D'ARGENVILLE, 1745–1752 (1762) A.J. Dézallier d'Argenville, *Abrégé de la vie des plus fameux peintres*, Paris, 1745–1752, 3 vol.; new, enlarged edition, Paris, 1762, 4 vol.

DIMIER, 1924–1925 L. Dimier, *Histoire de la peinture de portraits en France au XVIe siècle*, Paris and Bruxelles, 1924–1925.

DIMIER, 1926–1927 L. Dimier, *Histoire de la peinture française, du retour de Vouet à la mort de Le Brun (1627 à 1690)*, Paris and Brussels, 1926–1927, 2 vol.

DIMIER, 1928–1930 L. Dimier (edited by) *Les Peintres français du XVIIIe siècle*, Paris and Brussels, 1928–1930, 2 vol.

DORIVAL, 1942 B. Dorival, *La Peinture française*, Paris, 1942.

DORIVAL, 1973 B. Dorival, 'Art et politique en France au XVIIe siècle. La galerie des Hommes illustres du Palais-Cardinal', *B.S.H.A.F.*, 1973 (1974), p.43–60.

DORIVAL, 1976 B. Dorival, *Philippe de Champaigne, 1602–1674: la vie, l'œuvre et le catalogue raisonné de l'œuvre*, Paris, 1976, 2 vol.

DORIVAL, 1979 B. Dorival, 'La peinture française au XVIIe siècle', in A. Brejon de

Lavergnée and B. Dorival, *Baroque et classicisme au XVIIe siècle en Italie et en France*, Geneva, 1979.

DORIVAL, 1985 (1987) B. Dorival, 'Richelieu inspirateur de Philippe de Champaigne', in Actes du colloque, *Richelieu et la culture*, Paris, 1985 (1987), pp.153–61.

DORIVAL, 1992 (1) B. Dorival, *Supplément au catalogue raisonné de l'œuvre de Philippe de Champaigne*, Paris, 1992.

DORIVAL, 1992 (2) B. Dorival, *Jean-Baptiste de Champaigne*, Paris, 1992.

DU FRESNOY, 1667 Charles-Alphonse Du Fresnoy, *De arte graphica*, Paris, 1667; French translation by R. de Piles: *L'Art de peinture*, Paris, 1673.

DUPRÉ, 1868 A. Dupré, 'Notice sur quelques peintres blésois', *G.B.A.*, September 1868, pp.265–74.

DUPUY DU GREZ, 1699 B. Dupuy du Grez, *Traité sur la peinture pour en apprendre la théorie et se perfectionner dans la pratique*, Toulouse, 1699.

EIDELBERG, 1977 M. Eidelberg, 'A chinoiserie by Jacques Vigouroux Duplessis', *Journal of the Walters Art Gallery*, 1977, pp.62–76.

ERLANDE-BRANDENBURG, 1965 A. Erlande-Brandenburg, 'Les appartements de la reine mère Marie de Médicis au Louvre', *B.S.H.A.F.*, 1965, pp.105–13.

ESTOURNET, 1905 O. Estournet, *La Famille des Hallé*, Paris, 1905.

FANTELLI, 1974 P.L. Fantelli, 'Nicolo Renieri "Pittor Fiamengo" ', in *Saggi e Memorie di Storia dell'Arte* (9), Venice, 1974, pp.77–115.

FARÉ, 1955 M. Faré, 'Baugin peintre de natures mortes', *B.S.H.A.F.*, 1955, pp.15–26.

FARÉ, 1957 (1958) M. Faré, 'Jean-Michel Picart (1600–1682), peintre de fleurs et marchand de tableaux', *B.S.H.A.F.*, 1957 (1958), pp.91–102.

FARÉ, 1974 M. Faré, *Le Grand Siècle de la nature morte en France: le XVIIe siècle*, Fribourg, 1974.

FARÉ M. and F., 1986 M. and F. Faré, 'Louise Moillon. Les Girardot, marchands de bois parisiens et une œuvre inédite de Louise Moillon', *G.B.A.*, July–August 1986, pp.49–65.

FÉLIBIEN A., 1663 A. Félibien, *Les Reines de Perse aux pieds d'Alexandre. Peinture du Cabinet du Roy*, Paris, 1663.

FÉLIBIEN A., 1666–1688 A. Félibien, *Entretiens sur la vie et les ouvrages des plus excellents peintres anciens et modernes*, Paris, 1666–1688, 5 vol.

FÉLIBIEN A., 1668 (1725) A. Félibien, *Conférences de l'Académie royale de Peinture et de Sculpture pendant l'année 1667*, Paris, 1668 (ed. cit.: Trévoux, 1725, à la suite de la réédition des *Entretiens*).

FÉLIBIEN J.-F., 1702 J.-F. Félibien, *Description de la nouvelle église de l'Hôtel royal des Invalides*, Paris, 1702.

FLEURY, 1969 M.-A. Fleury, *Documents du Minutier central concernant les peintres, les sculpteurs et les graveurs au XVIIe siècle (1600–1650)*, vol.I, Paris, 1969.

FOHR, 1982 (1) R. Fohr, *Tours, musée des Beaux-Arts; Richelieu, Musée municipal;*

Azay-le-Ferron, château. Tableaux français et italiens du XVIIe siècle, Paris, 1982.

FOHR, 1982 (2) R. Fohr, 'Pour Charles Dauphin', *Mélanges de l'École française de Rome*, 1982, vol.XCIV, no 2, pp.979–94.

FONTAINE, 1903 A. Fontaine, *Conférences inédites de l'Académie royale de peinture et de sculpture*, Paris, 1903.

FONTAINE, 1914 A. Fontaine, *Académiciens d'autrefois*, Paris, 1914.

FOUCART, 1975 J. Foucart, 'Pieter Van Boucle, un peintre flamand à Paris', in *Études d'art français offertes à Charles Sterling*, Paris, 1975.

FOUCART 1987 J. Foucart, 'La Transverbération de sainte Thérèse, un nouvel Horace Le Blanc (1621) pour le musée de Lyon', *B.M.M.L.*, 1987, no 3, pp.4–19.

FOUCART and THUILLIER, 1969 J. Foucart and J. Thuillier, *La Galerie Médicis au palais du Luxembourg*, Milan and Paris, 1969 (French edition).

FRÉART DE CHAMBRAY, 1662 R. Fréart de Chambray, *L'Idée de la perfection de la peinture*, Paris, 1662.

FRÉART DE CHANTELOU, 1665 (1885) P. Fréart de Chantelou, *Journal du voyage du Cavalier Bernin en France*, edited by L. Lalanne, Paris, 1885.

FRIEDLÄNDER, 1957 W. Friedländer, Mannerism and Anti-Mannerism in Italian Painting, New York, 1957.

FRIEDLÄNDER, 1962 W. Friedländer, 'Poussin's Old Age', *G.B.A.*, September 1962, II, pp.249–64.

FRIEDLÄNDER and BLUNT, 1939–1974 W. Friedländer and A. Blunt, *The Drawings of Nicolas Poussin*, London, 1939–74, 5 vol.

FUMAROLI 1982 (1984) M. Fumaroli, 'Muta Eloquentia: la représentation de l'éloquence dans l'œuvre de Nicolas Poussin', *B.S.H.A.F.*, 1982 (1984), pp.29–48.

GALACTÉROS, 1991 L. Galactéros-de Boissier, *Thomas Blanchet (1614–1689)*, Paris, 1991.

GARNIER, 1989 N. Garnier, *Antoine Coypel (1661–1722)*, Paris, 1989.

GAUCHERY-GRODECKI, 1963 C. Gauchery-Grodecki, 'Les fresques d'Antoine Paillet à l'hôtel Sully à France, III (1963), pp.90–102.

GEORGEL and LECOQ, 1987 P. Georgel and A.-M. Lecoq, *La Peinture dans la peinture*, Paris, 1987.

GILLET, 1913 L. Gillet, *La Peinture des XVIIe et XVIIIe siècles*, Paris, 1913.

GLOTON, 1985 M.-C. Gloton, *Pierre et François Puget, peintres baroques*, Aix-en-Provence, 1985.

GOLDSTEIN, 1965 C. Goldstein, 'Studies in Seventeenth Century French Art Theory and Ceiling Painting', *A.B.*, 1965, pp.231–56.

GOLDSTEIN, 1969 C. Goldstein, 'Theory and Practice in the French Academy: Louis Licherie's *Abigail and David*', *B.M.*, 1969, pp.346–51.

GOMBRICH, 1983 E.H. Gombrich, *L'Écologie des images*, traduction française, Paris, 1983.

GRAUTOFF, 1914 O. Grautoff, *Nicolas Poussin*, Munich, 1914, 2 vol.

GRELL and MICHEL, 1988 C. Grell and C.

Michel, *L'École des Princes ou Alexandre disgrâcié*, Paris, 1988.

GRIVEL, 1986 M. Grivel, *Le Commerce de l'estampe à Paris au XVIIe siècle*, Geneva, 1986.

GRIVEL and FUMAROLI, 1989 M. Grivel and M. Fumaroli, *Bibliothèque nationale. Devises pour les Tapisseries du Roi*, Paris, 1989.

GRIVEL, 1991 (1992) M. Grivel, '*Excudit* et privilèges: les éditeurs de Simon Vouet', in Colloque, Paris, 1991 (1992), pp.307–30.

GUIFFREY J., 1905–1906 J. Guiffrey, 'Les Dumoustier', *R.A.A.M.*, 1905–6, pp.5–16, 325–42.

GUIFFREY J.-J., 1915 J.-J. Guiffrey, 'Histoire de l'Académie de Saint-Luc', *A.A.F.*, 1915.

GUILLAUME, 1980 (1983) M. Guillaume, 'À propos de Philippe Quantin: essai de catalogue raisonné', *B.S.H.A.F.*, 1980 (1983), pp.101–25.

HAUG, 1949 H. Haug, 'Sébastien Stosskopf, peintre de natures mortes', in *Trois Siècles d'art alsacien*, Strasbourg, 1949.

HÉDOU, 1887 J. Hédou, *Jean de Saint-Igny, peintre, sculpteur et graveur rouennais*, Rouen, 1887.

HENDERSON, 1977 N. and A. Henderson, 'Nouvelles recherches sur la décoration de Poussin pour la Grande Galerie', *R.L.M.F.*, 1977, no 4, pp.225–34.

HENDRICK, 1973 J. Hendrick, *La Peinture liégeoise au XVIIe siècle*, Gembloux, 1973.

HIMMELFARB, 1983 (1985) H. Himmelfarb, 'L'apprentissage du mécénat royal: le futur Louis XIII face aux arts dans le journal d'Heroard pour l'an 1608', in Colloque, Paris, 1983 (1985), pp.25–36.

HOMET, 1987 M.-Cl. Homet, *Michel Serre et la peinture baroque en Provence*, Aix-en-Provence, 1987.

HOOG, 1988 S. Hoog, 'Royal dédale', *Connaissance des Arts*, September 1988, pp.129–39.

HOOG and VITZTHUM, 1969 S. Hoog and W. Vitzthum, *Charles Le Brun à Versailles. La galerie des Glaces*, Milan and Paris, 1969.

HORNIBROOK and PETITJEAN, 1985 M. Hornibrook and C. Petitjean, *Catalogue of the engraved portraits by Jean Morin*, Cambridge, 1985.

ISARLO,' 1960 G. Isarlo, *La Peinture en France au XVIIe siècle*, Paris, 1960.

JACQUOT, 1894 A. Jacquot, 'Note sur Claude Deruet peintre et graveur lorrain (1588–1660)', *R.S.B.A.D.*, 1894, pp.763–945.

JAL, 1867 (1872) A. Jal, *Dictionnaire critique de biographie et d'histoire*, Paris, 1867; 2nd revised edition, Paris, 1872.

JAMOT, 1929 P. Jamot, *Les Le Nain*, Paris, 1929.

JANNEAU, 1965 G. Janneau, *La Peinture française au XVIIe siècle*, Geneva, 1965.

JOST, 1964 I. Jost, 'Bemerkungen zur Heinrichsgalerie des P. P. Rubens', *Nederlands Kunsthistorisch Jaarboek*, 1964, pp.219–37.

JOUANNY, 1911 Ch. Jouanny, *Correspondance de Nicolas Poussin publiée d'après les originaux*, Paris, 1911.

JOUIN, 1883 H. Jouin, *Conférences de l'Académie royale de peinture et de sculpture*, Paris, 1883.

JOUIN, 1889 H. Jouin, *Charles Le Brun et les arts sous Louis XIV. Le premier peintre, sa vie, son œuvre, ses écrits, ses contemporains, son influence, d'après le manuscrit de Nivelon et de nombreuses pièces inédites*, Paris, 1889.

KAGAN, 1993 J. Kagan, 'La "galerie des antiques" du château de Tanlay' *Monumental*, 2, 1993, pp.24–39.

KAPOSY, 1980 V. Kaposy, 'Remarques sur quelques œuvres de François Verdier', in *Acta Historiae Artium*, XXVI, nos 1–2, Budapest, 1980, pp.75–91.

KENNEDY, 1972 I.G. Kennedy, 'Claude and Architecture', *J.W.C.I.*, 1972, p.260–283.

KIMBALL, 1940 F. Kimball, 'Mansart and Le Brun in the Genesis of the Grande Galerie de Versailles', *A.B.*, 1940, pp.1–6.

KIMBALL, 1941 F. Kimball, 'Sources and Evolution of the Arabesque of Berain', *A.B.*, 1941, pp.307–16.

KIMBALL, 1943 F. Kimball, *The Creation of the Rococo Style*, Philadelphia, 1943.

KITSON, 1978 M. Kitson, *Claude Lorrain: Liber Veritatis*, London, 1978.

KUNZE, 1942 I. Kunze, 'Joseph Werner (1637–1710)', *Pantheon*, XXX, 1942, pp.163–7.

LACLOTTE and CUZIN, 1979 M. Laclotte and J.-P. Cuzin (edited by), *Petit Larousse de la peinture*, Paris, 1979, 2 vol.

LA GORCE, 1981 (1983) J. de La Gorce, 'Un peintre du XVIIIe siècle au service de l'Opéra de Paris: Jacques Vigoureux Duplessis', *B.S.H.A.F.*, 1981 (1983), pp.71–80.

LA GORCE, 1986 J. de La Gorce, *Bérain, dessinateur du Roi-Soleil*, Paris, 1986.

LAPAUZE, 1924 H. Lapauze, *Histoire de l'Académie de France à Rome, I (1666–1801)*, Paris, 1924.

LASTIC, 1981 G. de Lastic, 'Nicolas de Largillière. Documents notariés inédits', *G.B.A.*, July 1981, II, pp.1–27.

LASTIC, 1982 G. de Lastic, 'Largillière et ses modèles. Problèmes d'iconographie', *L'Œil*, 1982, no 323, pp.24–31 and 78–9.

LASTIC, 1983 G. de Lastic, 'Propos sur Nicolas de Largilière. En marge d'une exposition', *R.A.*, no 61, 1983, pp.73–82.

LASTIC, 1989 G. de Lastic, 'Une nature morte de Desportes venant du Muséum central des arts', *R.L.M.F.*, 1989, no 4, pp.233–5.

LAURAIN-PORTEMER, 1973 M. Laurain-Portemer, 'Le palais Mazarin et l'offensive baroque de 1645–1650', *G.B.A.*, March 1973, I, pp.151–68.

LAURAIN-PORTEMER, 1977 M. Laurain-Portemer, 'La politique artistique de Mazarin', in *Atti dei Convegni Lincei, 35: Il Cardinale Mazzarino in Francia*, Rome, 1977, pp.41–76.

LAVALLE, 1987 D. Lavalle, 'Plafonds et grands décors peints dans les hôtels du Marais au XVIIe siècle', in the catalogue to the exhibition *Le Marais, mythe et réalité*, Paris, hôtel de Sully, 1987, pp.179–96.

LE BLANT, 1978 (1980) R. Le Blant, 'La Lorraine. Études archéologiques. Les Scalberge, peintres et graveurs du XVIIe siècle', in *Actes du 103e congrès national des*

sociétés savantes (Nancy and Metz, 1978), Paris, 1980, pp.297–311.

LE BLANT, 1984 (1985) R. Le Blant, 'Documents inédits sur Claude Lefébure, alias Lefebvre', in *Actes du 109e congrès national des sociétés savantes*, Archéologie et Histoire de l'Art (Dijon, 1984), Paris, 1985, I, pp.343–60.

LE BLANT and PARISET, 1960 (1961) R. Le Blant and F.G. Pariset, 'Documents sur Georges Lallemant', *B.S.H.A.F.*, 1960 (1961), pp.183–92.

LE COMTE, 1699–1700 Fl. Le Comte, *Cabinet des Singularitez . . .* , Paris, 1699–1700, 3 vol.

LEFRANÇOIS, 1981 Th. Lefrançois, *Nicolas Bertin (1668–1736), peintre d'histoire*, Neuilly-sur-Seine, 1981.

LEJEAUX, 1946 J. Lejeaux, 'Charles Poërson (1609–1667) and the tapestries of the Life of the Virgin in the Strasbourg cathedral', *G.B.A.*, July 1946, pp.17–29.

LE LEYZOUR, 1990 Ph. Le Leyzour, 'Le portrait de Jean de Santeuil de Hyacinthe Rigaud (1659–1743)', *R.L.M.F.*, 1990, no 6, pp.489–90.

LE PAS DE SÉCHEVAL, 1991 A. Le Pas de Sécheval, 'Les missions romaines de Paul Fréart de Chantelou en 1640 et 1642: à propos des moulages d'antiques commandés par Louis XIII', *XVIIe Siècle*, 1991, no 172, pp.259–74.

LÉPICIÉ, 1752 B. Lépicié, *Vies des Premiers peintres du Roi depuis M. Le Brun jusqu'à présent*, Paris, 1752, 2 vol.

LEROY-BEAULIEU, 1985 S. Leroy-Beaulieu, 'Les plafonds peints dans l'hôtel de Vigny', *Cahiers de l'Inventaire*, 5, 1985, pp.36–8 and 43–7.

LESNÉ, 1979 Cl. Lesné *Les Salons de 1699 et de 1704*. Master's dissertation (unpublished), Université de Paris IV-Sor-bonne, 1979.

LESNÉ, 1988 (1989) Cl. Lesné, 'Jean-Baptiste Santerre (1651–1717)', *B.S.H.A.F.*, 1988 (1989), pp.75–118.

LESPINASSE, 1892 R. de Lespinasse, *Histoire générale de Paris. II: Orfèvrerie, sculpture, mercerie, ouvriers en métaux, bâtiment et ameublement*, Paris, 1892.

LESTRADE, 1901 J. Lestrade, 'Hilaire Pader, peintre toulousain du XVIIe siècle', *Revue des Pyrénées*, 1901, pp.253–69.

LHUILLIER, 1892 Th. Lhuillier, 'Le peintre Claude Lefebvre de Fontainebleau', *R.S.B.A.D.*, 1892, pp.487–511.

LHUILLIER, 1893 Th. Lhuillier, 'Les deux Cotelle, peintres du Roi', *R.S.B.A.D.*, 1893, pp.625–37.

LICHTENSTEIN, 1989 J. Lichtenstein: *La Couleur éloquente. Rhétorique et peinture à l'âge classique*, Paris, 1989.

LIEURE, s.d. J. Lieure, *L'École française de gravure. XVIIe siècle*, Paris, s.d.

LIGHTBOWN, 1969 R. Lightbown, 'Les origines de la peinture en émail sur or: un traité inconnu et des faits nouveaux', *R.A.*, no 5, 1969, pp.46–53.

LINNIK, 1973 I.V. Linnik, 'Un tableau de Jacques de Bellange nouvellement découvert', *R.A.*, no 20, 1973, pp.65–70.

LOIRE, 1991 (1992) S. Loire, 'François Tortebat', in Colloque, Paris, 1991 (1992), pp.435–54.

LOIRE, 1992 (1994) S. Loire, 'Le Salon de 1673', *B.S.H.A.F.*, 1992 (1994), pp.31–68.

LONG, 1933 B.S. Long, 'Quelques miniatures françaises à South Kensington', *G.B.A.*, January 1933, pp.14–16.

LONGHI, 1935 R. Longhi, 'I pittori della realtà in Francia, ovvero i Caravaggeschi Francesi del Seicento', *Italia letteraria*, 19 January 1935.

LONGHI, 1943 R. Longhi, 'Ultimi Studi sul Caravaggio e la sua cerchia', *Proporzioni*, I, 1943, pp.5–63.

LOSSEL-GUILLIEN, 1988 A. Lossel-Guillien, 'À la recherche de l'œuvre d'Étienne Allegrain, paysagiste de la fin du règne de Louis XIV', *Histoire de l'Art*, no 4, 1988, pp.69–78.

LUNA, 1973 (1978) J.J. Luna, 'Jean Ranc, pintor de camàra de Felipe V. Aspectos ineditos', in *Actas del XXII Congreso Internacional de Historia del Arte. España entre el Mediterraneo y el Atlantico* (Granada, 1973), III, Granada, 1978, pp.129–39.

LUNA, 1976 J.J. Luna, 'Pinturas de Pierre Gobert en España', *A.E.A.*, 1976, pp.363–85.

LUNA, 1978 J.J. Luna, 'Hyacinthe Rigaud et l'Espagne', *G.B.A.*, May-June 1978, I, pp.185–93.

LUNA, 1980 J.J. Luna, 'Jean Ranc: Ideas artisticas y métodos de trabajo, a través de pinturas y documentos', *A.E.A.*, 1980, pp.449–65.

MABILLE, 1974 G. Mabille, 'La Ménagerie de Versailles', *G.B.A.*, January 1974, I, pp.5–36.

MABILLE, 1974 (1976) G. Mabille, 'Les tableaux de la Ménagerie de Versailles', *B.S.H.A.F.*, 1974 (1976), pp.89–101.

MACGOWAN, 1983 (1985) M. MacGowan, 'Le phénomène de la galerie des portraits des Illustres', in Colloque, Paris, 1983 (1985), pp.411–22.

MACGREGOR N., 1979 N. MacGregor, 'The Le Nain brothers and changes in French rural life'. *Art History*, 1979, no 4, pp.401–12.

MACGREGOR W.B., 1993 W.B. MacGregor, 'Le *Portrait de gentilhomme* de Largillierre: un exercice d'attention', *R.A.*, no 100, 1993, pp.29–43.

MACLEAN, 1977 I. MacLean, *Woman Triumphant. Feminism in French Literature, 1610–1652*, Oxford, 1977.

MAGNE, 1934 E. Magne, *Le Château de Marly d'après des documents inédits*, Paris, 1934.

MAHON, 1947 D. Mahon, *Studies in Seicento Art Theory*, London, 1947.

MAHON, 1958 (1960) D. Mahon, 'Poussin au carrefour des années trente', in Colloque, Paris, 1958 (1960), pp.237–64.

MAISON and ROSENBERG, 1973 F. Maison and P. Rosenberg, 'Largillierre, peintre d'histoire et paysagiste', *R.L.M.F.*, 1973, no 2, pp.89–94.

MÂLE, 1951 (1972) E. Mâle, *L'Art religieux de la fin du XVIᵉ siècle, du XVIIᵉ siècle et du XVIIIᵉ siècle. Étude sur l'iconographie après le Concile de Trente. Italie, France, Espagne, Flandres*, Paris, 1951; Second ed., Paris, 1972.

MANCINI, c.1617–1621 (1957) G. Mancini, *Considerazioni sulla pittura*, edited by A. Marucchi and L. Salerno, Rome, 1957.

MARIE, 1947 J. and A. Marie, *Marly*, Paris, 1947.

MARIETTE, c.1750 (1851–1860) P.J. Mariette, *Abecedario de P.J. Mariette et autres notes inédites de cet amateur sur les arts et les artistes*, edited by Ph. de Chennevières and A. de Montaiglon, Paris, 1851–60, 8 vol.

MARIN, 1981 L. Marin, 'La description du tableau et le sublime en peinture. À propos d'un paysage de Poussin et de son sujet', *Communications*, no 34 1981, pp.61–84.

MARIN, 1983 L. Marin, 'Variations sur un portrait absent: les autoportraits de Poussin, 1649–1650', *Corps Écrit*, 1983, no 5, pp.87–107.

MAROLLES, c.1677 (1855) M. de Marolles, *Le Livre des peintres et graveurs*, Paris, c.1677; new edition, Paris, 1855.

MARROW, 1979 D. Marrow, 'Maria de' Medicis and the Decoration of the Luxembourg Palace', *B.M.*, 1979, pp.783–91.

MARROW, 1982 D. Marrow, 'The Art Patronage of Maria de' Medici', *Studies in Baroque Art History*, no 4, Ann Arbor, 1982.

MEAUME, 1877 E. Meaume, *Sébastien Le Clerc et son œuvre*, Paris, 1877.

MEAUME, 1885 E. Meaume, 'Jean Nocret, peintre lorrain', *Mémoires de l'Académie Stanislas*, III, Nancy, 1885.

MÉMOIRES INÉDITS, 1854 *Mémoires inédits sur la vie et les ouvrages des membres de l'Académie royale de peinture et de sculpture, publiés d'après les manuscrits conservés à l'École impériale des beaux-arts* by MM. L. Dussieux, E. Soulié, Ph. de Chennevières, P. Mantz, A. de Montaiglon, Paris, 1854, 2 vol.

MÉNARD, 1980 M. Ménard, *Mille retables du diocèse du Mans*, Paris, 1980.

MÉNIER, 1978 M. Ménier, 'Une hypothèse sur deux tableaux de Le Nain', in *Du Moyen Âge au XXᵉ siècle. Hommage à René Jullian, A.A.F.*, 25, 1978, pp.157–62.

MÉROT, 1981 A. Mérot, 'La place des sujets mythologiques et leur signification dans le décor peint à Paris, dans la première moitié du XVIIᵉ siècle', in Actes du colloque *La Mythologie au XVIIᵉ siècle*, Nice, 1981, pp.219–24.

MÉROT, 1983 (1985) A. Mérot, 'Les paroisses parisiennes et les peintres dans la première moitié du XVIIᵉ siècle: le rôle des fabriques', in Colloque, Paris, 1983 (1985), pp.183–90.

MÉROT, 1986 A. Mérot, 'Décors pour le Louvre de Louis XIV (1653–1660): la mythologie politique à la fin de la Fronde', in Actes du colloque *La monarchie absolutiste et l'histoire en France*, Paris (Sorbonne), 1986, pp.113–37.

MÉROT, 1987 A. Mérot, *Eustache Le Sueur (1616–1655)*, Paris, 1987.

MÉROT, 1990 (1) A. Mérot, *Poussin*, London, 1990.

MÉROT, 1990 (2) A. Mérot, *Retraites mondaines. Aspects de la décoration intérieure à Paris au XVIIᵉ siècle*, Paris, 1990.

MÉROT, 1990 (3) A. Mérot, 'Les Baléares enluminées. Cartes et légendes du Grand Siècle', *F.M.R.*, no 24, 1990, p.97–112.

MÉROT, 1991 (1992) A. Mérot, 'Simon Vouet et la grotesque: un langage ornemental', *in* Colloque, Paris, 1991 (1992), p.563–572.

MESPLÉ, 1949 P. Mesplé, 'Une école de peinture provinciale française au XVIIᵉ siècle: l'École de Toulouse', *G.B.A.*, March 1949, I, pp.187–212.

MESURET, 1955 R. Mesuret, 'Jean de Troy', *G.B.A.*, January 1955, I, p.35–44.

MESURET, 1957 R. Mesuret, 'L'œuvre peint de Nicolas Tournier. Essai de catalogue', *G.B.A.*, December 1957, II, pp.327–50.

MEYER D., 1980 D. Meyer, *L'Histoire du Roy*, Paris, 1980.

MEYER V., 1983 V. Meyer, 'L'œuvre gravé de Daniel Rabel', *Nouvelles de l'Estampe*, 1983, no 67, pp.6–15.

MEYER V., 1992 (1991) V. Meyer, 'Gravures allégoriques exécutées dans l'entourage de Simon Vouet', *in* Colloque, Paris, 1991 (1992), pp.331–48.

MICHEL E., 1884 E. Michel, *Les Audran, peintres et graveurs*, Fontainebleau 1884.

MICHEL O., 1986 (1988) O. Michel, 'Avoir tout ce qu'il y a de beau en Italie' ou quelques avatars de la galerie des Carrache', *in* Colloque, Rome, 1986 (1988), pp.477–90.

MICHEL O., 1991 (1992) O. Michel, 'Virginia Vezzi et l'entourage de Simon Vouet à Rome', *in* Colloque, Paris, 1991 (1992), pp.123–33.

MIGNOT, 1984 C. Mignot, 'Le cabinet de Jean-Baptiste de Bretagne, un curieux parisien oublié (1680)', *A.A.F.*, 26, 1984, pp.71–87.

MILLEN and WOLF, 1989 R.F. Millen and R.E. Wolf, *Heroic Deeds and Mystic Figures. A new reading of Rubens' Life of Maria de' Medici*, Princeton, 1989.

MINGUET, 1988 Ph. Minguet, *France baroque*, Paris, 1988.

MIRIMONDE, 1964 A.P. de Mirimonde 'Les Natures mortes à instruments de musique de Pieter Boel', *Annuaire du Musée royal d'Anvers*, 1964.

MOJANA, 1989 M. Mojana, *Valentin de Boulogne*, Milan, 1989.

MONTAGU, 1963 (1) J. Montagu, 'The Unknown Charles Le Brun: Some Newly Attributed Drawings', *M.D.*, 1963, no 2, pp.40–6.

MONTAGU, 1963 (2) J. Montagu, 'The Early Ceiling Decorations of Charles Le Brun', *B.M.*, 1963, pp.395–408.

MONTAGU, 1991 (1992) J. Montagu, 'Les œuvres de jeunesse de Charles Le Brun: l'influence de Simon Vouet et d'autres', *in* Colloque, Paris, 1991 (1992), pp.531–43.

MONTAGU, 1994 J. Montagu, *The Expression of the Passions: the Origin and Influence of Charles Le Brun's 'Conference Sur L'expression générale et particulière'*, New Haven and London, 1994.

MONTAIGLON, 1853 A. de Montaiglon, *Mémoires pour servir à l'histoire de l'Académie royale*, Paris, 1853.

MONTGOLFIER, 1960 B. de Montgolfier, 'Charles Le Brun et les confréries parisiennes', *G.B.A.*, May-June and October 1960, I, pp.323–42, et II, pp.195–206.

MONTGOLFIER, 1967 (1968) B. de Montgolfier, 'Georges Lallemant', *B.S.H.A.F.*, 1967 (1968), pp.49–54.

MONTGOLFIER, 1977 B. de Montgolfier, 'Les fastes de la ville de Paris aux XVIIᵉ et XVIIIᵉ siècles', *Bulletin du musée Carnavalet*, 1977, no 1, pp.6–34.

MONTGOLFIER and WILHELM, 1958 B. de Montgolfier and J. Wilhelm, 'La Vierge de la famille de Vic et les peintures de François II Pourbus dans les églises de Paris', *La Revue des Arts, Musées de France*, 1958, no 5, pp.221–8.

MOUREAU, 1984–1985 F. Moureau, 'Watteau dans son temps', *in* catalogue to the exhibition in Washington, Paris and Berlin, 1984–5, pp.471–508.

MOUSNIER, 1976 R. Mousnier, *Recherches sur la stratification sociale à Paris aux XVIIᵉ et XVIIIᵉ siècles. I- La stratification sociale dans la première moitié du XVIIᵉ siècle*, Paris, 1976.

MOUSNIER, 1978 R. Mousnier, *Paris capitale au temps de Richelieu et de Mazarin*, Paris, 1978.

MOUSSEIGNE, 1974 A. Mousseigne, 'À propos du portrait d'un chanoine par Jean Chalette (1581–1644)', *G.B.A.*, January 1974, I, pp.53–61.

NEXON, 1980 (1983) Y. Nexon, 'L'hôtel Séguier: contribution à l'étude d'un hôtel parisien au XVIIᵉ siècle', *Bulletin archéologique du Comité des Travaux historiques et scientifiques*, 16, 1980 (1983), pp.143–77.

NEXON, 1982 Y. Nexon, 'La collection de tableaux du chancelier Séguier', *Bibliothèque de l'École des chartes*, 140, 1982, pp.189–214.

NICOLSON, 1960 B. Nicolson, 'The Candlelight Master: a follower of Honthorst in Rome', *Nederlands Kunsthistorisch Jaarboek*, 1960, pp.121–64.

NICOLSON, 1964 B. Nicolson, 'Un caravagiste aixois, le Maître à la Chandelle', *Art de France*, IV, 1964, pp.116–39.

NICOLSON, 1979 B. Nicolson, *The International Caravaggesque Movement*, Oxford and New York, 1979 (revised edition: *Caravaggism in Europe*, Turin, 1990, 3 vol.).

NICOLSON and WRIGHT, 1974 B. Nicolson and C. Wright, *Georges de La Tour*, London, 1974.

NIKOLENKO, 1983 L. Nikolenko, *Pierre Mignard, the portrait painter of the Grand Siècle*, Munich, 1983.

NIVELON, 1699–1704 C. Nivelon, *Vie de Charles Le Brun et description détaillée de ses ouvrages*. Unpublished Manuscript, Paris, B.N., Mss. fr. 12 987.

OTTANI CAVINA, 1966 A. Ottani Cavina, *Georges de La Tour*, Milan, 1966.

PACHT-BASSANI, 1993 P. Pacht-Bassani, *Claude Vignon (1593–1670)*, Paris, 1993.

PARISET, 1936 F.-G. Pariset, 'Peintures de Jacques de Bellange', *G.B.A.*, April 1936, I, pp.235–40.

PARISET, 1949 F.G. Pariset, *Georges de La Tour*, Paris, 1949.

PARISET, 1952 F.G. Pariset, 'Documents sur Georges Lallemant', *B.S.H.A.F.*, 1952, pp.169–76.

PARISET, 1954 F.G. Pariset, 'Georges Lallemant émule de Jacques de Bellange', *G.B.A.*, May-June 1954, pp.299–308.

PARISET, 1972 F.G. Pariset, 'L'exposition

Georges de La Tour à l'Orangerie' *G.B.A.*, October 1972, II, pp.207–11.

PARROCEL, 1861 E. Parrocel, *Monographie des Parrocel*, Marseille, 1861.

PAVIERE, 1966 S.H. Paviere, *Jean-Baptiste Monnoyer (1634–1699)*, Leigh-on-Sea, 1966.

PÉREZ, 1975 M.-F. Pérez, 'Le décor de l'église du Puy', *Congrès archéologique de France*, 133, 1975, pp.386–98.

PÉREZ et al., 1979 M.-F. Pérez, S. Piloix and H. Pommier, 'État des recherches sur les décors peints dans la région lyonnaise du XVIᵉ au XVIIIᵉ siècles', *Travaux de l'Institut d'histoire de l'art de Lyon*, 1979, no 5, pp.3–40.

PERRAULT, 1668 (1992) Ch. Perrault, *La Peinture*, Paris, 1668. critical edition by J.-L. Gautier-Gentès, Geneva, 1992.

PETITJEAN and WICKERT, 1925 Ch. Petitjean and Ch. Wickert, *Catalogue de l'œuvre gravé de Robert Nanteuil*, Paris, 1925, 2 vol.

PEVSNER, 1940 (1973) N. Pevsner, *Academies of Art. Past and Present*, New York and Cambridge, 1940; new edition, 1973.

PICART, 1982 Y. Picart, *La Vie et l'Œuvre d'Aubin Vouet (1595–1641): un cadet bien oublié*, Paris, 1982.

PICART, 1987 Y. Picart, *La Vie et l'Œuvre de J.B. Corneille (1649–1695): une âme violente et tourmentée*, Paris, 1987.

PICART, 1991 (1992) Y. Picart, 'Michel Corneille, un des premiers collaborateurs de Simon Vouet. Aperçus sur sa vie et sa carrière', *in* Colloque, Paris, 1991 (1992), pp.455–71.

PIGANIOL DE LA FORCE, 1742 J. A. Piganiol de La Force, *Description de Paris, de Versailles . . . et de toutes les autres belles maisons et châteaux des environs de Paris*, Paris, 1742, 3 vol. (2nd ed., 1765).

PILES (DE), 1673 R. de Piles, *Dialogue sur le coloris*, Paris, 1673.

PILES (DE), 1677 R. de Piles, *Conversations sur la connaissance de la peinture*, Paris, 1677.

PILES (DE), 1681 R. de Piles, *Dissertation sur les ouvrages des plus fameux peintres*, Paris, 1681.

PILES (DE), 1699 R. de Piles, *Abrégé de la vie des peintres*, Paris, 1699 (new edition 1715).

PILES (DE), 1708 (1989) R. de Piles, *Cours de peinture par principes*, Paris, 1708. Edited by J. Thuillier, Paris, 1989.

PINAULT, 1982 M. Pinault, 'Laurent de La Hyre et le couvent des Minimes de la place Royale à Paris', *R.L.M.F.*, 1982, no 2, pp.89–98.

POISSON, 1989 G. Poisson, '*La leçon d'astronomie* de la duchesse du Maine par François de Troy', *R.L.M.F.*, 1989, no 4, pp.239–44.

PONSONAILHE, 1883 Ch. Ponsonailhe, *Sébastien Bourdon, sa vie et son œuvre*, Paris, 1883.

POPULUS, 1930 B. Populus, *Claude Gillot*, Paris, 1930.

POSNER, 1959 D. Posner, 'Charles Le Brun's Triumphs of Alexander', *A.B.*, 1959, pp.237–48.

PRÉAUD, 1980 M. Préaud, *Bibliothèque nationale. Département des Estampes. Inventaire du fonds français. Graveurs du XVIIᵉ*

siècle. VIII et IX: Sébastien Le Clerc, Paris, 1980, 2 vol.

PRÉAUD, 1984 M. Préaud, 'L'inventaire après décès de François Chauveau, 20–28 février 1676', *A.A.F.*, 26, 1984, pp.91–105.

PUTTFARKEN, 1985 T. Puttfarken, *Roger de Piles' Theory of Art*, New Haven and London, 1985.

REINBOLD, 1982 A. Reinbold, 'Les peintres du XVIIᵉ siècle et les diverses perceptions de la lumière', *XVIIᵉ Siècle*, 1982, no 136, pp.331–9.

REINBOLD, 1991 A. Reinbold, *Georges de La Tour*, Paris, 1991.

RESTOUT, 1681 J. Restout, *La Réforme de la Peinture*, Caen, 1681.

RICHEFORT, 1986 (1988) I. Richefort, 'Nouvelles précisions sur la vie d'Adam François Van der Meulen, peintre historiographe de Louis XIV', *B.S.H.A.F.*, 1986 (1988), p.57–80.

RICHEFORT, 1989 I. Richefort, *Le Métier et la Condition sociale du peintre dans le Paris de la première moitié du XVIIᵉ siècle*. Unpublished doctoral thesis, Université de Paris IV-Sorbonne, 1989.

RICHEOME, 1601 le P.L. Richeome, *Tableaux sacrés des figures mystiques du très auguste sacrifice et sacrement de l'Eucharistie*, Paris, 1601.

ROETHLISBERGER, 1961 M. Roethlisberger, *Claude Lorrain. The Paintings*, New Haven and London, 1961, 2 vol.

ROETHLISBERGER, 1968 M. Roethlisberger, *Claude Lorrain. The Drawings*, Los Angeles, 1968, 2 vol.

ROETHLISBERGER, 1970 M. Roethlisberger, 'Quelques nouveaux indices sur Francisque' November *G.B.A.*, 1970, II, pp.319–24.

ROETHLISBERGER, 1971 M. Roethlisberger, *The Claude Lorrain Album in the Norton Simon, Inc. Museum of Art*, Los Angeles, 1971.

ROETHLISBERGER and CECCHI, 1986 M. Roethlisberger and D. Cecchi, *Tout l'œuvre peint de Claude Lorrain*, Paris, 1986 (1st Italian edition, Milan, 1975).

ROMAN, 1919 J. Roman, *Le Livre de raison de Rigaud*, Paris, 1919.

RONOT, 1990 H. Ronot, *Richard et Jean Tassel, peintres à Langres au XVIIᵉ siècle*, Paris, 1990.

ROSENBERG, 1974 (1976) P. Rosenberg, 'La participation de Vouet à la galerie des Hommes illustres au Palais-Cardinal', *B.S.H.A.F.*, 1974 (1976), pp.21–3.

ROSENBERG, 1975 P. Rosenberg, 'Quelques nouveaux Blanchard', in *Études d'art français offertes à Charles Sterling*, Paris, 1975, p.217–225.

ROSENBERG, 1979 P. Rosenberg, 'L'exposition Le Nain: une proposition', *R.A.*, no 43, 1979, pp.91–100.

ROSENBERG, 1989 P. Rosenberg, 'Un nouveau tableau à sujet religieux de N. de Largillierre', *R.L.M.F.*, 1989, no 4, pp.245–8.

ROSENBERG, 1990 P. Rosenberg, 'Un émule polonais de Le Brun: Alexandre Ubelesqui', *Artibus et Historiae*, no 22, 1990, pp.163–88.

ROSENBERG, 1993 P. Rosenberg, *Tout*

l'œuvre peint des Le Nain, Paris, 1993.

ROSENBERG and LAVEISSIERE, 1978 P. Rosenberg and S. Laveissière, 'Jean Tassel dans les musées français', *R.L.M.F.*, 1978, no 2, pp.122–33.

ROSENBERG and MACÉ DE LÉPINAY, 1973 P. Rosenberg and F. Macé de Lépinay, *Georges de La Tour. Vie et œuvre*, Freiburg, 1973.

ROSENBERG and VOLLE, 1980 P. Rosenberg and N. Volle, 'Nicolas de Plattemontagne dessinateur', in *Études de la Revue du Louvre*, 1, 1980, pp.46–53.

ROSENFELD, 1984 N. M. Rosenfeld, 'Largillierre: problèmes de méthodologie', *R.A.*, no 66, 1984, pp.61–74.

ROSENTHAL, 1911 L. Rosenthal, 'Pierre Brébiette, graveur français', *G.B.A.*, January 1911, pp.37–52.

RUSSELL, 1985 H. D. Russell, *Robert Nanteuil: Portrait Engraver of the Sun King*, Washington, 1985.

SABATIER, 1985 (1986) G. Sabatier, 'Politique, histoire et mythologie: la galerie en France et en Italie pendant la première moitié du XVIIᵉ siècle', *in* Colloque, Grenoble, 1985 (1986), pp.283–301.

SABATIER, 1988 G. Sabatier, 'Le parti figuratif dans les appartements, l'escalier et la galerie de Versailles', *XVIIᵉ Siècle*, no 161, 1988, pp.401–26.

SAINTE FARE-GARNOT, 1988 N. Sainte Fare-Garnot, *Le Décor des Tuileries sous le règne de Louis XIV*, Paris, 1988.

SAINTE FARE-GARNOT, 1991 (1992) N. Sainte Fare-Garnot, 'Noël Quillerier peintre', *in* Colloque, Paris, 1991 (1992), pp.473–98.

SALIES, 1961 P. Salies, 'Ambroise Frédeau', in *Mémoires de l'Académie des sciences de Toulouse*, 1961, pp.123–45.

SALIES, 1973–1974 P. Salies, 'Nicolas Tournier, peintre en Languedoc', *Archistra*, nos 11–12, 1973–4, pp.99–105, et nos 14–15, 1974, pp.29–34.

SAMOYAULT-VERLET, 1972 (1975) C. Samoyault-Verlet, 'Précisions iconographiques sur trois décors de la seconde école de Fontainebleau', *in* Colloque, Fontainebleau and Paris, 1972 (1975), pp.241–8.

SANDRART, 1675 (1925) J. von Sandrart, *Academie der Bau-, Bild und Mahlerey - Künste*, Nüremberg, 1675. Edited by R.A. Peltzer, Munich, 1925.

SAUERLÄNDER, 1956 W. Sauerländer, 'Die Jahreszeiten: Ein Betrag zur allegorischen Landschaft beim Später Poussin', *Münchner Jahrbuch der bildenden Kunst*, 1956, pp.169–84.

SAUVAL, 1724 H. Sauval, *Histoire et recherches des antiquités de la ville de Paris*, Paris, 1724, 3 vol. (Written between 1640 and 1660, sole rights 1654.)

SCAILLIÉREZ, 1992 C. Scailliérez, 'Deux peintures de l'invention de Toussaint Dubreuil', *in* Colloque, Fontainebleau, 1992, pp.299–312.

SCHLEIER, 1968 E. Schleier, 'Affreschi di François Perrier a Roma', *Paragone*, 1968, no 217, pp.42–54.

SCHLEIER, 1972 E. Schleier, 'Quelques tableaux inconnus de François Perrier à Rome', *R.A.*, no 18, 1972, pp.38–46.

SCHLEIER, 1978 E. Schleier, 'A proposal for Mellan as a painter: the 'St Bruno' for Cardinal de Richelieu', *B.M.*, 1978, pp.511–18.

SCHLODER, 1980 (1982) J. Schloder, 'Un peintre oublié: Nicolas Prévost, peintre de Richelieu', *B.S.H.A.F.*, 1980 (1982), pp.59–69.

SCHLOSSER, 1924 (1984) J. von Schlosser, *La Littérature artistique*, French translation, Paris, 1984 (1st German edition Vienna, 1924).

SCHNAPPER, 1959 A. Schnapper, 'Quelques œuvres de Joseph Parrocel', *Revue des Arts. Musées de France*, 1959, nos 4–5, pp.163–76.

SCHNAPPER, 1962 A. Schnapper, 'De Nicolas Loir à Jean Jouvenet: quelques traces de Poussin dans le dernier tiers du XVIIᵉ siècle', *R.L.M.F.*, 1962, no 3, pp.115–22.

SCHNAPPER, 1966 A. Schnapper, 'Colonna et la *quadratura* en France à l'époque de Louis XIV', *B.S.H.A.F.*, 1966, pp.65–97.

SCHNAPPER, 1967 A. Schnapper, *Tableaux pour le Trianon de marbre, 1688–1714*, Paris and The Hague, 1967.

SCHNAPPER, 1968 (1) A. Schnapper, 'Le Grand Dauphin et les tableaux de Meudon', *R.A.*, nos 1–2, 1968, pp.57–64.

SCHNAPPER, 1968 (2) A. Schnapper, 'Houasse et le cabinet des Beaux-Arts de Perrault', *R.L.M.F.*, 1968, nos 4–5, p.241–244.

SCHNAPPER, 1968 (1969) A. Schnapper, 'Le Corrège et la peinture française vers 1700', in *Atti del Convegno sul Settecento Parmense nel 2º Centenario della morte di C.I. Fragoni* (Parma, 1968), Parma, 1969, pp.341–50.

SCHNAPPER, 1969 A. Schnapper, 'Antoine Coypel: la galerie d'Énée au Palais-Royal', *R.A.*, no 5, 1969, pp.33–42.

SCHNAPPER, 1970 (1) A. Schnapper, 'Esquisses de Louis de Boullogne sur la vie de saint Augustin', *R.A.*, no 9, 1970, pp.58–64.

SCHNAPPER, 1970 (2) A. Schnapper, 'Deux tableaux de Joseph Parrocel au Musée de Rouen', *R.L.M.F.*, 1970, no 2, pp.78–82.

SCHNAPPER, 1974 (1) A. Schnapper, *Jean Jouvenet et la peinture d'histoire à Paris (1644–1717)*, Paris, 1974.

SCHNAPPER, 1974 (2) A. Schnapper, 'Two unknown Ceiling Paintings by Mignard for Louis XIV', *A.B.*, 1974, pp.82–100.

SCHNAPPER, 1976 A. Schnapper, 'Louis de Boullogne à l'église de Chantilly', *R.A.*, no 34, 1976, pp.56–60.

SCHNAPPER, 1977 A. Schnapper, 'Noël Coypel et le grand décor peint des années 1660', *Antologia di Belle arti*, 1977, no 1, pp.7–17.

SCHNAPPER, 1978 (1) A. Schnapper, 'Plaidoyer pour un absent: Bon Boullogne (1649–1717)', *R.A.*, no 40–41, 1978, pp.121–40.

SCHNAPPER, 1978 (2) A. Schnapper, 'Louis XIV collectionneur', *Clefs*, no 1, 1978, pp.68–77.

SCHNAPPER, 1981 (1) A. Schnapper, 'La

place du portrait en France à la fin du règne de Louis XIV (1680–1715)', *in catalogue to the exhibition in Montreal*, 1981, pp.60–7.

SCHNAPPER, 1981 (2) A. Schnapper, 'Après l'exposition Nicolas Mignard', *R.A.*, no 52, 1981, pp.29–36.

SCHNAPPER, 1983 A. Schnapper, 'Le portrait à l'Académie au temps de Louis XIV', *XVIIᵉ Siècle*, no 138, 1983, pp.97–123.

SCHNAPPER, 1983 (1985) A. Schnapper, 'Fleurs, fruits, vélins', *in* Colloque, Paris, 1983 (1985), pp.353–62.

SCHNAPPER, 1984 (1990) A. Schnapper, 'The Debut of the Royal Academy of Painting and Sculpture', *in* Colloque, Maryland, 1984 (1990), pp.27–36.

SCHNAPPER, 1988 A. Schnapper, *Le Géant, la Licorne et la Tulipe. Collections et collectionneurs dans la France du XVIIᵉ siècle. I– Histoire et histoire naturelle*, Paris, 1988.

SCHNAPPER, 1988 (1990) A. Schnapper, 'La cour de France au XVIIᵉ siècle et la peinture italienne contemporaine', *in* Colloque, Paris, 1988 (1990), pp.422–37.

SCHNAPPER, 1994 A. Schnapper, *Curieux du Grand Siècle. Collections et collectionneurs dans la France du XVIIᵉ siècle. II – Œuvres d'art*, Paris, 1994.

SCOTT B., 1973 B. Scott 'Pierre Crozat: a Maecenas of the Régence', *Apollo*, January 1973, pp.11–19.

SCOTT K., 1991–2 K. Scott, 'D'un siècle à l'autre. Histoire, mythologie et décoration à Paris au début du XVIIIᵉ siècle', *in* catalogue to the exhibition in Paris, Philadelphia and Fort Worth, 1991–92, p.XXXII–LIX.

SCUDÉRY, 1646 (1991) G. de Scudéry, *Le Cabinet de M. de Scudéry*, Paris, 1646. Edited by Ch. Biet and D. Moncond'hu, Paris, 1991.

STECHOW, 1948 W. Stechow, 'Drawings and Etchings by Jacques Foucquier', *G.B.A.*, December 1948, pp.419–34.

STERLING, 1934 C. Sterling, 'Un précurseur français de Rembrandt: Claude Vignon', *G.B.A.*, October 1934, pp.130–6.

STERLING, 1958 C. Sterling, 'Gentileschi in France', *B.M.*, 1958, pp.112–20.

STERLING, 1959 C. Sterling, *La Nature morte de l'Antiquité à nos jours*, Paris, 1959 (new edition.).

STERLING, 1961 C. Sterling, 'Les peintres Jean et Jacques Blanchard', *Art de France*, I, 1961, pp.76–118.

STERLING, 1964 C. Sterling, 'Musée des Beaux-Arts de Nantes. Une nouvelle œuvre de Gentileschi peintre en France', *R.L.M.F.*, 1964, nos 4–5, pp.217–20.

STROEHLIN, 1905 E. Stroehlin, *Jean Petitot et Jacques Bordier*, Geneva, 1905.

STUFFMANN, 1964 M. Stuffmann, 'Charles de La Fosse et sa position dans la peinture française à la fin du XVIIᵉ siècle', *G.B.A.*, July-August 1964, II, pp.1–121.

STUFFMANN, 1968 M. Stuffmann, 'Les tableaux de la collection de Pierre Crozat', *G.B.A.*, July-September 1968, pp.1–144.

SUTHERLAND-HARRIS, 1991 (1992) A. Sutherland-Harris, 'Vouet, le Bernin et la "ressemblance parlante"', *in* Colloque

Paris, 1991 (1992), pp.193–208.

TALLEMANT DES RÉAUX, *c.*1657 (1960–1961) G. Tallemant des Réaux, *Historiettes*. Edited by A. Adam, Paris, 1960–1, 2 vol.

TAPIÉ, 1957 (1972) V.-L. Tapié, *Baroque et classicisme*, Paris, 1957; new ed., Paris, 1972.

TAPIÉ, LE FLEM AND PARDAILHÉ-GALABRUN, 1972 V.-L. Tapié, J.-P. Le Flem and A. Pardailhé-Galabrun, *Retables baroques de Bretagne*, Paris, 1972.

TERNOIS, 1962 (1) D. Ternois, *L'Art de Jacques Callot*, Paris, 1962.

TERNOIS, 1962 (2) D. Ternois, *Jacques Callot. Catalogue complet de son œuvre dessiné*, Paris, 1962.

TERNOIS, 1981 D. Ternois, 'François Perrier et Lyon', in *Mélanges offerts à Georges Couton*, Lyon, 1981, pp.222–35.

TEYSSÈDRE, 1957 (1965) B. Teyssèdre, *Roger de Piles et les débats sur le coloris au siècle de Louis XIV*, Paris, 1957 (1965).

TEYSSÈDRE, 1963 B. Teyssèdre, 'Une collection française de Rubens au XVIIᵉ siècle: le cabinet du duc de Richelieu décrit par Roger de Piles, 1676–1683', *G.B.A.*, November 1963, II, pp.241–300.

TEYSSÈDRE, 1967 B. Teyssèdre, *L'Art français au siècle de Louis XIV*, Paris, 1967.

THIEME AND BECKER, 1908–1950 U. Thieme and F. Becker (edited by): *Allgemeines Lexicon der Bildenden Künstler von der Antike bis zur Gegenwart*, Leipzig, 1908–50 (new ed. 1947–55), 37 vol.

THOISON, 1903 E. Thoison, 'Pierre Gobert', *R.S.B.A.D.*, 1903, pp. 98–137.

THOISON, 1905 E. Thoison, 'Claude Lefebvre', *R.S.B.A.D.*, 1905, pp. 358–83.

THORNTON, 1978 P. Thornton, *Seventeenth-Century Interior Decoration in England, France and Holland*, New Haven and London, 1978.

THUILLIER, 1957 J. Thuillier, 'Polémiques autour de Michel-Ange au XVIIᵉ siècle', *Revue du XVIIᵉ siècle*, 1957, nos 36–7, pp. 353–91.

THUILLIER, 1958 J. Thuillier, 'Pour un peintre oublié: Rémy Vuibert', *Paragone*, 1958, no 97, pp.22–41.

THUILLIER, 1960 (1) J. Thuillier, 'Pour un *Corpus Pussinianum*', in Colloque, Paris, 1958 (1960), II, pp.49–238.

THUILLIER, 1960 (2) J. Thuillier, 'Poussin et ses premiers compagnons français à Rome', *in* Colloque, Paris, 1958 (1960), I, pp.71–116.

THUILLIER, 1961 J. Thuillier, 'Brébiette', *L'Œil*, 1961, no 77, pp.48–56.

THUILLIER, 1963 J. Thuillier, 'Lubin Baugin', *L'Œil*, 1963, no 102, pp.16–23 and 69.

THUILLIER, 1963 (1964) J. Thuillier, 'Documents pour servir à l'étude des frères Le Nain', *B.S.H.A.F.*, 1963 (1964), pp.155–284.

THUILLIER, 1963 (1992) J. Thuillier (et A. Châtelet), *La Peinture française. I- De Fouquet à Poussin*, Geneva, 1963. New ed., Geneva, 1992. (We refer to the first edition.)

THUILLIER, 1964 (1992) J. Thuillier (et A. Châtelet), *La Peinture française. II- De Le Nain à Fragonard*, Geneva, 1964. New ed.,

Geneva, 1992. (We refer to the first edition.)

THUILLIER, 1965 J. Thuillier, 'Les Observations sur la peinture' de Charles-Alphonse Dufresnoy', in *Walter Friedländer zum 90. Geburtstag*, Berlin, 1965, pp.193–210.

THUILLIER, 1967 J. Thuillier, 'Le Brun et Rubens', *Bulletin des musées royaux des Beaux-Arts de Belgique*, 1967, pp.247–68.

THUILLIER, 1968 (1) J. Thuillier, 'Doctrines et querelles artistiques en France au XVIIᵉ siècle: quelques textes oubliés ou inédits', *A.A.F.*, 23, 1968, pp.125–217.

THUILLIER, 1968 (2) J. Thuillier, 'Claude Mellan peintre', *Bulletin de la Société d'émulation historique et littéraire d'Abbeville*, 1968, pp.285–96.

THUILLIER, 1969 (1) J. Thuillier, 'La galerie de Médicis de Rubens et sa genèse: un document inédit', *R.A.*, no 4, 1969, pp.52–62.

THUILLIER, 1969 (2) J. Thuillier, 'Un tableau de Louis Licherie: *Saint Louis soignant ses soldats atteints de la peste*', *R.L.M.F.*, 1969, no 6, pp.347–54.

THUILLIER, 1969 (3) J. Thuillier, *Nicolas Poussin*, Novara, 1969.

THUILLIER, 1972 (1) J. Thuillier, 'Georges de La Tour: trois paradoxes', *L'Œil*, 1972, no 208, pp.2–11.

THUILLIER, 1972 (2) J. Thuillier, 'Musée des Beaux-Arts de Dijon: deux tableaux de François Perrier', *R.L.M.F.*, 1972, nos 4–5, pp.307–14.

THUILLIER, 1972 (1975) J. Thuillier, 'Fontainebleau et la peinture française du XVIIᵉ siècle', *in* Colloque, Fontainebleau and Paris, 1972 (1975), pp.249–66.

THUILLIER, 1974 J. Thuillier, *Tout l'œuvre peint de Poussin*, Paris, 1974.

THUILLIER, 1975 J. Thuillier, 'Peinture et politique: une théorie de la galerie royale sous Henri IV', *Études d'art français offertes à Charles Sterling*, Paris, 1975, pp.175–205.

THUILLIER, 1976 (1978) J. Thuillier, 'Documents sur Jacques Blanchard', *B.S.H.A.F.*, 1976 (1978), pp.81–93.

THUILLIER, 1977 J. Thuillier, 'Le paysage dans la peinture française du XVIIᵉ siècle: de l'imitation de la nature à la rhétorique des "belles idées"', *Cahiers de l'Association internationale des Études françaises*, 1977, no 29, pp.45–64.

THUILLIER, 1978 J. Thuillier, 'Propositions pour I. Charles Errard peintre', *R.A.*, nos 40–1, 1978, pp.151–72.

THUILLIER, 1978 (1981) J. Thuillier, 'Charles Mellin, "très excellent peintre"', *in* Actes du colloque *Les Fondations nationales dans la Rome pontificale* (Rome, 1978), Rome, 1981, pp.583–684.

THUILLIER, 1979 (1) J. Thuillier, 'Exposition Le Nain: leçon d'une exposition', *R.L.M.F.*, 1979, no 2, pp.158–66.

THUILLIER, 1979 (2) J. Thuillier, 'Un chef-d'œuvre de François Perrier au musée des Beaux-Arts de Rennes: *Les Adieux de saint Pierre et de saint Paul*', *Bulletin des Amis du Musée de Rennes*, 1979, no 3, pp.52–65.

THUILLIER, 1980 (1981) J. Thuillier, 'La mer et les peintres français au XVIIᵉ siècle', *in* Actes du colloque de l'Association des historiens modernistes des Universités

(1980), *Bulletin de l'Association des historiens modernistes des Universités*, 1981, no 5, pp.91–120.

THUILLIER, 1983 (1) J. Thuillier, 'La Galerie de Marie de Médicis: peinture, poétique et politique', in *Rubens e Firenze*, Florence, 1983, pp.249–66.

THUILLIER, 1983 (2) J. Thuillier, 'Pour André Félibien' and 'Lettres familières d'André Félibien', *XVIIᵉ Siècle*, 1983, no 138, pp.67–96 and 141–58.

THUILLIER, 1983 (3) J. Thuillier, 'Textes du XVIIᵉ siècle oubliés ou peu connus concernant les arts', *XVIIᵉ Siècle*, 1983, no 138, pp.125–40.

THUILLIER, 1983 (4) J. Thuillier, 'Propositions pour 2. Charles-Alphonse Du Fresnoy peintre', *R.A.*, no 61, 1983, pp.29–52.

THUILLIER, 1983 (1985) J. Thuillier, 'Réflexions sur la politique artistique de Colbert', in Actes du colloque *Un nouveau Colbert* (Paris, 1983), Paris, 1985, pp.275–86.

THUILLIER, 1984 J. Thuillier, 'Les voyages des artistes français au XVIIᵉ siècle', in Actes du colloque *Voyages, récits et imaginaire* (Montreal, 1984), Paris, Seattle and Tübingen, 1984.

THUILLIER, 1985 (1) J. Thuillier, *Tout l'œuvre peint de Georges de La Tour*, Paris, 1985 (2nd revised edition).

THUILLIER, 1985 (2) J. Thuillier, 'Mathieu Montaigne, natif d'Anvers', in *Rubens and his World* (Miscellany in honour of R.A. d'Hulst), Antwerp, 1985, pp.279–88.

THUILLIER, 1986 (1988) J. Thuillier, 'L'influence des Carrache en France: pour un premier bilan', *in* Colloque, Rome, 1986 (1988), pp.421–55.

THUILLIER, 1987 (1) J. Thuillier, 'La peinture à Liège au XVIIᵉ siècle: foyer provincial ou foyer international?', *in* catalogue to the exhibition in Alden Biesen, 1987, pp.1–21.

THUILLIER, 1987 (2) J. Thuillier, 'Il se rendit en Italie . . . Notes sur le voyage à Rome des artistes français au XVIIᵉ siècle', in *Études d'histoire de l'art offertes à André Chastel*, Paris and Rome, 1987, pp.321–36.

THUILLIER, 1988 J. Thuillier, *Nicolas Poussin*, Paris, 1988.

THUILLIER, 1992 J. Thuillier, *Georges de La Tour*, Paris, 1992.

THUILLIER, 1993 J. Thuillier, 'Les dernières années de François Perrier (1646–1649)', *R.A.*, no 99, 1993, pp.9–28.

THUILLIER AND MIGNOT, 1978 J. Thuillier and C. Mignot, 'Collectionneur et peintre au XVIIᵉ siècle: Pointel et Poussin', *R.A.*, no 39, 1978, pp.39–58.

TOLIOPOULOU, 1991 E. Toliopoulou, *L'Art et les Artistes des Pays-Bas à Paris au XVIIᵉ siècle*. Unpublished doctoral thesis, Université de Paris IV-Sorbonne, 1991.

TROY (DE), 1955–6 P. de Troy, 'François de Troy', *Études d'art publiées par le musée national des Beaux-Arts d'Alger*, 1955–6, nos 11–12.

VERDI, 1982 R. Verdi, 'Poussin and the "Tricks of Fortune"', *B.M.*, 1982,

pp.681–5.

VILLA, 1967 N. Villa, *Le XVIIᵉ Siècle vu par Abraham Bosse, graveur du Roy*, Paris, 1967.

VITET, 1861 L. Vitet, *L'Académie royale de peinture et de sculpture*, Paris, 1861 (repub 1880).

VOSS, 1961 H. Voss, 'Neues zum Werk von Rémy Vuibert', *Zeitschrift für Kunstgeschichte*, 1961, pp.177–83.

WARNKE, 1993 M. Warnke, *The Court Artist: On the Ancestry of the Modern Artist*, English translation, Cambridge, 1993 (1ʳᵉ éd., Cologne, 1985).

WEIGERT, 1936 R.A. Weigert, *Jean I Bérain*, Paris, 1936.

WEIGERT, 1937 R.A. Weigert, *Jean I Bérain, dessinateur de la Chambre et du Cabinet du Roi (1640–1711)*, Paris, 1937.

WEIGERT, 1950 R.A. Weigert, 'Quelques travaux décoratifs de Claude III Audran', *B.S.H.A.F.*, 1950, pp.85–93.

WEISBACH, 1932 W. Weisbach, *Französische Malerei des 17. Jahrhunderts*, Berlin, 1932.

WHITFIELD, 1973 C. Whitfield, 'A Programme for "Erminia and the Shepherds" by G. B. Agucchi', *Storia dell'Arte*, 1973, no 19, pp.217–29.

WHITFIELD, 1979 C. Whitfield, 'Poussin's Early Landscapes', *B.M.*, 1979, pp.10–19.

WILD, 1980 D. Wild, *Nicolas Poussin*, Zürich, 1980, 2 vol.

WILDENSTEIN D., 1963 D. Wildenstein, 'Claude Lefebvre restitué par l'estampe', *G.B.A.*, December 1963, II, pp.305–13.

WILDENSTEIN D., 1964 D. Wildenstein (edited by), 'L'œuvre gravé des Coypel: I: Noël Coypel', *G.B.A.*, May-June 1964, I, pp.261–4.

WILDENSTEIN G., 1950–1 G. Wildenstein, 'Le goût pour la peinture dans la bourgeoisie parisienne entre 1550 et 1610', *G.B.A.*, October-December 1950, pp.153–273, et July–December 1951, pp.11–343.

WILDENSTEIN G., 1956 G. Wildenstein, 'Le goût pour la peinture dans le cercle de la bourgeoisie parisienne autour de 1700', *G.B.A.*, September 1956, pp.1–86.

WILDENSTEIN G., 1957 (1) G. Wildenstein, 'Les Ferdinand Elle: à propos de deux inventaires inédits', *G.B.A.*, October 1957, II, pp.225–36.

WILDENSTEIN G., 1957 (2) G. Wildenstein, *Poussin et ses graveurs au XVIIᵉ siècle*, Paris, 1957.

WILDENSTEIN G., 1958 G. Wildenstein, 'Le peintre Jean-Baptiste Forest révélé par son inventaire après décès', *G.B.A.*, April 1958, pp.242–54.

WILDENSTEIN G., 1959 G. Wildenstein, 'Les Vierges de Nicolas Loir. Contribution à l'histoire de l'académisme', *G.B.A.*, March 1959, pp.145–52.

WILDENSTEIN G., 1960 G. Wildenstein, 'Les Beaubrun', *G.B.A.*, November 1960, pp.261–74.

WILHELM, 1956 (1957) J. Wilhelm, 'La galerie de l'hôtel Bretonvilliers', *B.S.H.A.F.*, 1956 (1957), pp.137–50.

WILHELM, 1964 J. Wilhelm, 'Quelques œuvres inédites ou oubliées des peintres de la famille Beaubrun', *R.A.*, no 5, 1969, pp.19–32.

WILHELM, 1987 (1989) J. Wilhelm, 'Portraits peints à Paris par Juste d'Egmont', *B.S.H.A.F.*, 1987 (1989), pp.25–44.

WILHELM, 1994 J. Wilhelm, 'Quelques portraits peints par Claude Lefebvre (1632–1674)', *R.L.M.F.*, 1994, pp.18–35.

WINNER, 1983 M. Winner, 'Poussins Selbstbildnis im Louvre als kunstheoretische Allegorie', *Römisches Jahrbuch für Kunstgeschichte*, 1983, pp.417–49.

WINNER, 1987 M. Winner, 'Poussins Selbstbildnis von 1649', in *Études d'histoire de l'art offertes à André Chastel*, Paris and Rome, 1987, pp.371–401.

WITTKOWER, 1958 (1973) R. Wittkower, *Art and Architecture in Italy, 1600–1750*, Harmondsworth, 1958; 3rd ed., revised, 1973.

WRIGHT, 1985 C. Wright, *The French Painters of the Seventeenth Century*, Boston, 1985.

WYTENHOVE, 1990 H. Wytenhove, *Reynaud Levieux et la peinture classique en Provence*, 1990.

ZERI, 1957 F. Zeri, *Pittura e Controriforma. L' 'arte senza tempo' di Scipione da Gaeta*, Turin, 1957.

ZERNER, 1969 H. Zerner, *École de Fontainebleau. Gravures*, Paris, 1969.

EXHIBITIONS CITED IN ABBREVIATED FORM

PARIS, 1934 *Les Peintres de la réalité en France au XVIIᵉ siècle*, Paris, musée de l'Orangerie, 1934 (catalogue by C. Sterling).

PARIS, 1947 *L'Âge d'or de la peinture toulousaine*, Paris, musée de l'Orangerie, 1947 (catalogue by R. Mesuret).

ROME, 1950 *I Bamboccianti*, Rome, Palazzo Massimo alle Colonne, 1950 (catalogue by G. Briganti).

DIJON, 1955 *Les Tassel*, Dijon, musée des Beaux-Arts, 1955 (catalogue by M. Geiger, H. Ronot and Ch. Sterling).

TOULOUSE, 1956 *Les Miniaturistes du Capitole de 1610 à 1790*, Toulouse, musée Paul Dupuy, 1956 (catalogue by R. Mesuret).

ORLÉANS, 1958 *Lubin Baugin, artiste orléanais du XVIIᵉ siècle*, Orléans, musée des Beaux-Arts (catalogue by J. Pruvost-Auzas).

PARIS, 1958 *Le XVIIᵉ Siècle français. Chefs-d'œuvre des musées de province*, Paris, Petit Palais, 1958, Exhibition (catalogue by M. Laclotte) presented at the Royal Academy, London, 1958: *The Age of Louis XIV*, and at Washington, Toledo and New York, 1960: *The Splendid Century, French Art, 1600–1715*.

ROME and ROTTERDAM, 1958 *Michael Sweerts e i Bamboccianti*, Rome and Rotterdam, 1958 (catalogue by R. Kultzen).

ROME, 1960 *Nicolas Poussin*, Paris, musée du Louvre, 1960 (catalogue by A. Blunt and Ch. Sterling).

PARIS, 1961 *Mazarin, homme d'État et collectionneur, 1602–1661*, Paris, Bibliothèque nationale, 1961 (catalogue by M. Laurain-Portemer, J. Vallery-Radot, R.A. Weigert).

BOLOGNA, 1962 *L'Ideale classico del Seicento in Italia e la pittura di paesaggio*, Bologne, Palazzo dell'Archiginnasio, 1962 (catalogue by C. Gnudi *et al.*).

VERSAILLES, 1963 *Charles Le Brun (1619–1690) peintre and dessinateur*, château de Versailles, 1963 (catalogue by J. Montagu and J. Thuillier).

LILLE, 1968 *Au temps du Roi-Soleil. Les peintres de Louis XIV (1660–1715)*, Lille, musée des Beaux-Arts, 1968 (catalogue by A. Schnapper *et al.*).

PARIS, 1972 (1) *L'École de Fontainebleau*, Paris, Grand Palais, 1972 (catalogue by S. Béguin *et al*).

PARIS, 1972 (2) *Georges de La Tour*, Paris, Orangerie des Tuileries, 1972 (catalogue by P. Rosenberg and J. Thuillier).

PARIS, 1972 (3) *Le Cabinet de l'Amour de l'hôtel Lambert*, Paris, musée du Louvre (3ᵉ Dossier du département des peintures), 1972 (catalogue by J.-P. Babelon, G. de Lastic, P. Rosenberg and A. Schnapper).

PARIS, 1973 '*La Mort de Germanicus*' de Poussin du musée de Minneapolis, Paris, musée du Louvre (7ᵉ dossier du département des peintures), 1973 (catalogue by N. Butor and P. Rosenberg).

ROME and PARIS, 1973–4 *Valentin et les caravagesques français*, Rome, Villa Médicis, and Paris, Grand Palais, 1973–4 (catalogue by A. Brejon de Lavergnée and J.-P. Cuzin, preface by J. Thuillier).

LE PUY and SAINT-ÉTIENNE, 1974 *Guy François*, Le Puy, musée Crozatier, and Saint-Étienne, musée d'Art and d'Industrie, 1974 (catalogue by M.-F. Pérez).

TOULOUSE, 1974 *Jean Chalette et Ambroise Frédeau*, Toulouse, musée des Augustins, 1974 (catalogue by A. Mousseigne *et al.*).

TROYES, 1976 *Jacques de Létin, Troyes 1597–1661*, Troyes, musée des Beaux-Arts, 1976 (catalogue by J. Thuillier and J.-P. Sainte-Marie).

NICE and RENNES, 1976–7 *Trente Peintres du XVIIᵉ siècle français. Tableaux d'inspiration religieuse des musées de province*, Nice, musée national Message biblique Marc Chagall, and Rennes, musée des Beaux-Arts, 1976–7 (catalogue by Fr. Bergot, P. Provoyeur and J. Vilain, preface by J. Thuillier).

FLORENCE, 1977 (1) *Rubens e la pittura fiamminga del Seicento nelle collezioni pubbliche fiorentine*, Florence, palazzo Pitti, 1977 (catalogue by D. Bodart *et al.*).

FLORENCE, 1977 (2) *Pitture francese nelle collezioni pubbliche fiorentine*, Florence, palazzo Pitti, 1977 (catalogue by P. Rosenberg *et al.*).

PARIS, 1977 (3) '*La Diseuse de bonne aventure*' du Caravage, Paris, musée du Louvre (13ᵉ dossier du département des peintures), 1977 (catalogue by J.-P. Cuzin).

PARIS, 1977–8 (1) *Le Siècle de Rubens dans les collections publiques françaises*, Paris, Grand Palais, 1977–8 (catalogue by J. Foucart and J. Lacambre).

PARIS, 1977–8 (2) *Collections de Louis XIV. Dessins, albums, manuscrits*, Paris, Orangerie des Tuileries, 1977–8 (catalogue by R. Bacou, M.-R. Séguy *et al.*).

ROME and DÜSSELDORF, 1977–8 *Nicolas Poussin*, Rome, Villa Médicis, and Düsseldorf, Kunstmuseum, 1977–1978 (catalogue by P. Rosenberg, prefaces by A. Blunt and J. Thuillier).

FONTAINEBLEAU, 1978 *Le Château de Fontainebleau sous Henri IV*, château de Fontainebleau, 1978 (*Petit Journal* by J.-P. Samoyault and C. Samoyault-Verlet).

MARSEILLE, 1978 *La Peinture en Provence au XVIIᵉ siècle*, Marseille, musée des Beaux-Arts, 1978 (catalogue by H. Wytenhove *et al.*).

REIMS, 1978 *Robert Nanteuil*, Reims, Bibliothèque municipale, 1978 (catalogue by R. Laslier).

PARIS, 1978–9 (1) *Les Frères Le Nain*, Paris, Grand Palais, 1978–9 (catalogue by J. Thuillier).

PARIS, 1978–9 (2) *Claude Lorrain. Dessins du British Museum*, Paris, musée du Louvre, cabinet des Dessins, 1978–9 (catalogue by J. Gere *et al.*).

AVIGNON, 1979 *Mignard d'Avignon (1606–1668)*, Avignon, palais des Papes, 1979 (catalogue by A. Schnapper).

PARIS, 1979 *Peintres de fleurs en France du XVIIᵉ au XIXᵉ siècle*, Paris, Petit Palais, 1979 (catalogue by M. and F. Faré).

ROUEN, 1980–1 *La Renaissance à Rouen*, Rouen, musée des Beaux-Arts, 1980–1 (catalogue by Fr. Bergot *et al.*).

EDINBURGH, 1981 *Poussin: Sacraments and Bacchanals*, Edinburgh, National Gallery of Scotland (catalogue by H. Brigstocke and H. MacAndrew).

MONTREAL, 1981 *Largillière and the Eighteenth Century Portrait*, Montreal, musée des Beaux-Arts, 1981 (catalogue by M.N. Rosenfeld *et al.*).

PARIS, 1981 *Paris et Rome vus par Israël Silvestre*, Paris, mairies annexes des Xᵉ and Iᵉʳ arrondissements, 1981 (catalogue by J.-P. Babelon *et al.*).

PARIS, 1982 *L'Art du XVIIᵉ siècle dans les carmels de France*, Paris, Petit Palais, 1982 (catalogue by G. Chazal *et al.*).

PARIS, NEW YORK and CHICAGO, 1982 *La Peinture française du XVIIᵉ siècle dans les collections américaines*, Paris, Grand Palais, New York, The Metropolitan Museum of Art, and Chicago, The Art Institute, 1982 (catalogue by P. Rosenberg, preface by M. Fumaroli).

ROME and NANCY, 1982 *Claude Lorrain e i pittori lorenesi in Italia nel XVIIᵉ secolo*, Rome, Villa Médicis, and Nancy, musée des Beaux-Arts, 1982 (catalogue by J. Thuillier *et al.*).

PARIS, 1982–3 *L'Atelier de Desportes. Dessins et esquisses conservés par la Manufacture de Sèvres*, Paris, musée du Louvre, cabinet des Dessins, 1982–3 (catalogue by L. Duclaux and T. Préaud).

WASHINGTON and PARIS, 1982–3 *Claude Gellée dit le Lorrain*, Washington, National Gallery, and Paris, Grand Palais, 1982–3 (catalogue by H.D. Russell).

HOUSTON and PRINCETON, 1983 *Nicolas Poussin. The Rape of the Sabines*, Houston, Museum of Fine Arts, and Princeton University, Art Museum, 1983 (catalogue by A. Arikha).

PARIS, 1983 *Colbert, 1619–1683*, Paris, hôtel de la Monnaie, 1983 (catalogue by N. Felkay and J.-C. Boyer *et al.*).

PARIS, 1983–4 *Raphaël et l'art français*, Paris, Grand Palais, 1983–4 (catalogue by J.-P. Cuzin, M. Vasselin *et al.*, preface by J. Thuillier).

BOURG-EN-BRESSE, 1984 *Peinture religieuse en Bresse au XVII*ᵉ *siècle*, Bourg-en-Bresse, musée de Brou, 1984 (catalogue by M. Duflot).

MADRID, 1984 *Claudio di Lorena y el ideal clàsico de paisaje en el siglo XVII*, Madrid, museo del Prado, 1984 (catalogue by J.J. Luna).

ROUEN, 1984 *La Peinture d'inspiration religieuse à Rouen au temps de Pierre Corneille, 1606–84*, Rouen, église Saint-Ouen, 1984 (catalogue by F. Bergot, D. Lavalle *et al.*).

WASHINGTON, PARIS and BERLIN, 1984–5 *Watteau, 1684–1721*, Washington, National Gallery, Paris, Grand Palais, and Berlin, Schloss Charlottenbourg, 1984–5 (catalogue by M. Morgan-Grasselli, F. Moureau, N. Parmantier and P. Rosenberg).

DUBLIN and BUDAPEST, 1985 *Le Classicisme français. Masterpieces of French XVII th. Century*, Dublin, National Gallery of Ireland, and Budapest, musée des Beaux-Arts, 1985 (catalogue by S. Laveissière, preface by J. Thuillier).

LILLE, 1985 *Au temps de Watteau, Fragonard et Chardin. Les Pays-Bas et les peintres français du XVIII*ᵉ *siècle*, Lille, musée des Beaux-Arts, 1985 (catalogue by J. Foucart, H. Oursel, A. Schnapper *et al.*).

NEW YORK, 1985 *The First Painters of the King. French Royal Taste from Louis XIV to the Revolution*, New York, Stair Sainty-Matthiesen, 1985 (catalogue by C. B. Bailey, prefaces by J.-L. Bordeaux, P. Conisbee, T. Gaethgens and G. Stair-Sainty).

PARIS, 1985 (1) *Richelieu et le monde de l'esprit*, Paris, Sorbonne, 1985 (catalogue by J. Thuillier *et al.*).

PARIS, 1985 (2) *Saint-Paul-Saint-Louis. Les Jésuites à Paris*, Paris, musée Carnavalet, 1985 (catalogue by J.-P. Willesme *et al.*).

PARIS, 1985–6 *Le Brun à Versailles*, Paris, musée du Louvre, cabinet des Dessins, 1985–6 (catalogue by L. Beauvais and J.-F. Méjanès).

CAEN, 1986 *L'Allégorie dans la peinture. La représentation de la Charité au XVII*ᵉ *siècle*, Caen, musée des Beaux-Arts, 1986 (catalogue by A. Tapié *et al.*).

MARSEILLE, 1986–7 *La Peinture en Provence au XVII*ᵉ *siècle*, Marseille, musée des Beaux-Arts, 1986–7 (catalogue by M.-C. Leonelli *et al.*, preface by M. Laclotte).

ALDEN BIESEN, 1987 *Walthère Damery (1614–1678)*, Alden Biesen, Flemish Community Cultural Centre 1987 (catalogue by P. Farcy, R. Jans, P.-Y. Kairis, preface by J. Thuillier).

CAEN, 1987 *Symbolique et botanique. Le sens caché des fleurs dans la peinture au XVII*ᵉ *siècle*, Caen, musée des Beaux-Arts, 1987 (catalogue by A. Tapié *et al.*).

CREMONA, 1987 *Dopo Caravaggio: Bartolomeo Manfredi e la Manfrediana Methodus*, Cremona, Museo Civico, 1987 (catalogue by J.-P. Cuzin, M. Gregori *et al.*).

NANCY, 1987 *Georges Lallemant, peintre d'origine lorraine (c. 1575–1636). Deux chefs-d'œuvre des Musées de la Ville de Paris*, Nancy, musée des Beaux-Arts, 1987 (catalogue by Cl. Petry and M. Sylvestre).

PARIS, 1987 *La Chartreuse de Paris*, Paris, musée Carnavalet, 1987 (catalogue by J.-P. Willesme *et al.*).

COLOGNE, ZURICH and LYON, 1987–8 *Triumph und Tod des Helden / Triomphe et mort du héros*, Cologne, Wallraf-Richartz Museum, Zurich, Kunsthalle, and Lyon, musée des Beaux-Arts, 1987–8 (catalogue by E. Mai *et al.*).

TOULOUSE, 1987–8 *Le Portrait toulousain de 1550 à 1800*, Toulouse, musée des Augustins, 1987–8 (catalogue by J. Penent *et al.*).

BOURGES and ANGERS, 1988 *Jean Boucher de Bourges (c. 1575–c. 1633)*, Bourges, musées du Berry, and Angers, musée des Beaux-Arts, 1988 (catalogue by J. Thuillier).

FORT WORTH, 1988 *Poussin: the Early Years in Rome*, Fort Worth, Kimbell Art Museum, 1988 (catalogue by K. Oberhuber).

PARIS, 1988 (1) *L'Œil d'or de Claude Mellan*, Paris, Bibliothèque nationale, 1988 (catalogue by B. Brejon de Lavergnée and M. Préaud).

PARIS, 1988 (2) *Le Palais-Royal*, Paris, musée Carnavalet, 1988 (catalogue by F. Bercé, L. Boubli, F. Mardrus *et al.*).

WASHINGTON, 1988 *Places of Delight. The Pastoral Landscape*, Washington, The Phillips Collection, 1988 (catalogue by R. Cafritz, L. Gowing and D. Rosand).

FRANKFURT, 1988–9 *Guido Reni e l'Europa. Fama e fortuna*, Frankfurt, Schirn Kunsthalle, 1988–9 (catalogue by S. Ebert-Schifferer, A. Emiliani, E. Schleier, J.-P. Cuzin).

GRENOBLE, RENNES and BORDEAUX, 1988–9 *Laurent de La Hyre*, Grenoble, musée de Peinture et de Sculpture, Rennes, musée des Beaux-Arts, and Bordeaux, musée des Beaux-Arts, 1988–9 (catalogue by P. Rosenberg and J. Thuillier).

MEAUX, 1988–9 *De Nicolò dell'Abate à Nicolas Poussin: aux sources du classicisme (1550–1660)*, Meaux, musée Bossuet (catalogue edited by J.-P. Changeux, prefaces by J.-P. Changeux and D. Cordellier).

PARIS, 1988–9 *Seicento. Le Siècle de Caravage dans les collections françaises*, Paris, Grand Palais, 1988–9 (catalogue edited by A. Brejon de Lavergnée and N. Volle, prefaces by Y. Bonnefoy, S. Cotté *et al.*).

CLEVELAND, 1989 *From Fontainebleau to the Louvre. French Drawings from the Seventeenth Century*, Cleveland, Museum of Art, 1989 (catalogue by H. Goldfarb).

PARIS, 1989 (1) *Le Peintre, le roi, le héros. L'Andromède de Pierre Mignard*, Paris, musée du Louvre (37ᵉ dossier du département des peintures), 1989 (catalogue by J.-Cl. Boyer).

PARIS, 1989 (2) *L'Inspiration du poète de Poussin. Essai sur l'allégorie du Parnasse*, Paris, musée du Louvre (36ᵉ dossier du département des peintures), 1989 (catalogue by M. Fumaroli).

ROME, 1989 *Claude Mellan, gli anni romani: un incisore tra Vouet e Bernini*, Rome, Palazzo Barberini, 1989 (catalogue by L. Ficacci).

SPOLETO, 1989 *Pittura del Seicento. Ricerche in Umbria*, Spoleto, Rocca Albornoziana, 1989 (catalogue by B. Toscano *et al.*).

PAU and PARIS, 1989–90 *Henri IV et la reconstruction du royaume*, château de Pau and Paris, Archives nationales (hôtel de Rohan), 1989–90 (catalogue by J.-P. Babelon, S. Béguin *et al.*).

CAEN, 1990 *Les Vanités dans la peinture au XVII*ᵉ *siècle*, Caen, musée des Beaux-Arts, 1990 (catalogue by A. Tapié *et al.*).

NEW YORK, 1990 *Claude to Corot. The development of landscape painting in France*, New York, Colnaghi, 1990 (catalogue by M. Kitson *et al.*).

DULWICH, 1990–1 *Courage and Cruelty. Le Brun's Horatius Cocles and The Massacre of the Innocents*, London, Dulwich Picture Gallery, 1990–1 (catalogue by N. Kalinsky, J. Montagu *et al.*).

PARIS, 1990–1 *Vouet*, Paris, Grand Palais, 1990–1 (catalogue by J. Thuillier, B. Brejon de Lavergnée and D. Lavalle).

VERSAILLES, 1990–1 *Charles Le Brun. Le décor de l'escalier des Ambassadeurs*, Château de Versailles, 1990–1 (catalogue by J.-P. Babelon, C. Constans *et al.*, preface by J. Thuillier).

MUNICH, 1991 *Simon Vouet. 100 neuendeckte Zeichnungen aus den Beständen der Bayerischen Staatsbibliothek*, Munich, Neue Pinakothek, 1991 (catalogue by R. Harprath *et al.*).

BOIS-LE-DUC and STRASBOURG, 1991–2 *Theodor Van Thulden. Un peintre baroque du cercle de Rubens*, Bois-le-Duc (Hertogenbosch), Noordbrabants Museum, Strasbourg, musée des Beaux-Arts, 1991–2 (catalogue by A. Roy).

PARIS, PHILADELPHIA and FORT WORTH, 1991–2 *Les Amours des dieux. La peinture mythologique de Watteau à David*, Paris, Grand Palais, Museum of Art and Fort Worth, Kimbell Art Museum, 1991–2 (catalogue by C. B. Bailey, K. Scott *et al.*).

NANCY, 1992 (1) *L'Art en Lorraine au temps de Jacques Callot*, Nancy, musée des Beaux-Arts, 1992 (catalogue by C. Petry, J. Thuillier *et al.*).

NANCY, 1992 (2) *Jacques Callot*, Nancy, Musée Lorrain, 1992 (catalogue by P. Choné, D Ternois *et al.*).

TOULOUSE, 1992 *Le Dessin baroque en Languedoc et en Provence*, Toulouse, musée Paul Dupuy, 1992 (catalogue by J. Penent *et al.*).

MONTREAL, RENNES and MONTPELLIER, 1993 *Grand Siècle. Peintures françaises du XVII*ᵉ *siècle dans les collections publiques françaises*, Montreal, musée des Beaux-Arts, Rennes, musée des Beaux-Arts, Montpellier, musée Fabre, 1993 (catalogue by M. Hilaire and P. Ramade, preface by J. Thuillier).

PARIS, 1993 *Dessins français du XVII*ᵉ *siècle dans les collections publiques françaises*, Paris, musée du Louvre, département des Arts graphiques, 1993 (catalogue by J.-C. Boyer, B. Brejon de Lavergnée, M. Hilaire and J.-F. Méjanès).

PARIS and LONDON, 1994–5 *Poussin*, Paris, Grand Palais, 1994–5 (catalogue by P. Rosenberg, L.-A. Prat *et al.*) London, Royal Academy, 1995 (catalogue by R. Verdi).

I-SOURCES

Mancini, c. 1617–21 (1957); Baglione, 1642; Tallemant des Réaux, c. 1657 (1960-1); Félibien, 1666–88; Bellori, 1672; Sandrart, 1675 (1925); Marolles, c. 1677 (1855); de Piles, 1699; Le Comte, 1699–1700; Dupuy du Grez, 1699; Sauval, 1724; Piganiol de La Force, 1742; Dézallier d'Argenville A.J., 1745–52 (1762); Dézallier d'Argenville A.J., 1749; Mariette, c. 1750 (1851–60); Lépicié, 1752; Montaiglon, 1853; *Mémoires inédits . . .*, 1854; Jal, 1867 (1872); Fleury, 1969. Numerous documents and texts published in: *Archives de l'Art français, Bulletin de la Société de l'Histoire de l'Art français, Réunion des Sociétés des Beaux-Arts des Départements, XVII^e Siècle,* etc.

II-GENERAL WORKS

Dictionaries
Thieme and Becker, 1908–50; Laclotte and Cuzin, 1979; Bluche, 1990.
Comprehensive works
Gillet, 1913; Dimier, 1926–7 and 1928–30; Weisbach, 1932; Dorival, 1942; Blunt, 1953 (1983); Tapié, 1957 (1972); Isarlo, 1960; Thuillier, 1963 (1992) and 1964 (1992); Janneau, 1965; Teyssèdre, 1967; Dorival, 1979; Wright, 1985; Bottineau, 1986; Minguet, 1988.
Exhibition catalogues
Paris, 1934; Paris (and London) 1958; Nice and Rennes, 1976–7; Florence, 1977 (2); Paris, New York, Chicago, 1982; Dublin and Budapest, 1985; Meaux, 1988–9; Montreal, Rennes and Montpellier, 1993.

III-CENTRES AND COMMUNICATION

Provincial centres
– Bresse: Exhibition, Bourg-en-Bresse, 1984.
– Brittany: Tapié, Le Flem and Pardailhé-Galabrun, 1972.
– Lorraine: Exhibition, Nancy, 1992 (1).
– Lyon: Colloque, Lyon, 1972 (1975); Pérez et al., 1979; Galactéros, 1991.
– Maine: Ménard, 1980.
– Provence: Exhibition, Marseille, 1978; Astro and Thévenon, 1985.
– Rouen: Exhibition, Rouen, 1984.
– Toulouse: Exhibition, Paris, 1947; Mesplé, 1949; Exhibition, Toulouse, 1987–8.
Journeys
Thuillier, 1984 and 1987 (2).
Relations with other countries
– School of Fontainebleau: Zerner, 1969; Exhibition, Paris, 1972 (1); Thuillier, 1972 (1975); Exhibition, Meaux, 1988–9.
– French painters in Italy: Bertolotti, 1886; Longhi, 1935 and 1943; Thuillier, 1960 (2); Exhibition, Rome and Paris, 1973–4; Nicolson, 1979; Bousquet, 1980; Exhibition, Rome and Nancy, 1982.
– French painting and Italian models:

• General: Bonnefoy, 1970; Exhibition, Paris, 1988–9; Boyer, 1988 (1990); Schnapper, 1988 (1990); colloque Paris, 1988 (1990). See also under IV (Collections).
• Raphael: Exhibition, Paris, 1983–4.
• Michelangelo: Thuillier, 1957; Chastel, 1966 (1978).
• Correggio: Schnapper, 1968 (1969).
• Carracci: O. Michel, 1986 (1988); Thuillier, 1986 (1988).
• Guido Reni: Auzas, 1958 (1959); Exhibition, Frankfurt, 1988–9.
– France and the Low Countries: Exhibition, Lille, 1985; Brenninkmeyer-De Rooij, 1986; Toliopoulou, 1991; Exhibition, Bois-le-Duc and Strasbourg, 1991–2.
– Liège: Hendrick, 1973; Thuillier, 1987 (1).

IV-PAINTERS AND THEIR PUBLIC

General: Social Status of Painters
Crozet, 1954; Mousnier, 1976; Richefort, 1989; Warnke, 1989.
Commissions
Many sales published in: *Archives de l'Art français* et le *Bulletin de la Société de l'Histoire de l'Art français,* in monographs, etc. See also: Fleury, 1969.
– Brotherhoods: Montgolfier, 1960.
– The 'mays' of Notre Dame de Paris: Bellier de La Chavignerie, 1864; Auzas, 1949 and 1953.
– Church commissions: Mérot, 1983 (1985).
– Municipal commissions: Montgolfier, 1977.
– Corporate commissions: Roman, 1919.
Artistic institutions
– Académie royale de peinture et de sculpture: Montaiglon, 1853; *Mémoires inédits,* 1854; Vitet, 1861; Jouin, 1883; Fontaine, 1903 and 1914; Pevsner, 1940 (1973); Schnapper, 1984 (1990).
– Académie de Saint-Luc: J.-J. Guiffrey, 1915.
– French academy in Rome: Directors' correspondance, vol. I (Paris, 1887); Lapauze, 1924.
– Premiers peintres du roi: Lépicié, 1752; Exhibition, New York, 1985.
– Salons: Lesné, 1979; Crow, 1985; Loire, 1992 (1994).
Patrons and collectors
– Kings and Queens:
• Henri IV: Exhibition, Pau and Paris, 1989–1990; Colloque, Fontainebleau, 1992.
• Marie de Médicis: Marrow, 1979 and 1982; Thuillier, 1983 (1); Millen and Wolf, 1989.
• Louis XIII: Himmelfarb, 1983 (1985); Le Pas de Sécheval, 1991.
• Louis XIV: Teyssèdre, 1967; Exhibition, Lille, 1968; Konstans, 1976; Exhibition, Paris, 1977–8 (2); Schnapper, 1978 (2) and 1994; Bluche, 1986; A. Brejon, 1987.
– Royal princes:
• Grand Dauphin: Schnapper, 1968 (1).

• Duc d'Orléans: Schnapper, 1969; Mardrus, *in* exh. Cat. in Paris, 1988 (2), p.79–115.
– Ministers:
• Richelieu: Exhibition, Paris, 1985 (1).
• Séguier: Nexon, 1980 (1983) and 1982.
• Mazarin: Exhibition, Paris, 1961; Laurain-Portemer, 1973 and 1977; Colloque, Grenoble, 1985.
• Colbert: Exhibition, Paris, 1983; Thuillier, 1983 (1985).
– Various collectors:
• J.-B. de Bretagne: Mignot, 1984.
• Maréchal de Créquy: Boyer and Volf, 1988.
• Crozat: Stuffmann, 1968; Scott, 1973.
• La Vrillière: Cotté, *in* exh. cat. in Paris, 1988–9, pp.29–46; Cotté, 1989.
• Pointel: Thuillier and Mignot, 1978.
• Duc de Richelieu: Teyssèdre, 1963.
Collections, the art mancet
Bonnaffé, 1884; G. Wildenstein, 1950–1 and 1956; Grivel, 1986; Schnapper, 1988; Boyer, 1988 (1990); Schnapper, 1994.

V-THEMES AND STYLES

Religious painting
Mâle, 1951 (1972); Exhibition, Nice and Rennes, 1976–7.
– Altarpieces: Tapié, Le Flem and Pardailhé-Galabrun, 1972; Ménard, 1980; Minguet, 1988.
– Carmélites: Exhibition, Paris, 1982.
– Chartreux: Exhibition, Paris, 1987.
– Jésuites: Exhibition, Paris, 1985 (2).
Allegory
Exhibition, Caen, 1986 and 1987; Exhibition, Paris, 1989 (2); Exhibition, Caen, 1990.
Mythology
Mérot, 1981; Exhibition, Paris, Philadelphia, Fort Worth, 1991–2.
Heroes of history or Fable
Exhibition, Paris, 1973; Exhibition, Cologne, Zurich and Lyon, 1987–8; Grell and Michel, 1988; Exhibition, Paris, 1989 (1).
Politics
Thuillier, 1975 and 1983 (1); MacGowan, 1983 (1985); Sabatier, 1985 (1986); Mérot, 1986; Grell and Michel, 1988.
– War, battles: Boyer, 1985.
Women and feminism
Blunt, 1957; MacLean, 1977; Mérot, 1990 (2).
Decorative schemes
Schnapper, 1966; Exhibition, Paris, 1972 (3); Thornton, 1978; Pérez et al., 1979; Lavalle, 1987; Minguet, 1988; Sainte Fare-Garnot, 1988; Mérot, 1990 (2); Exhibition, Versailles, 1990–1; Babelon, 1991.
– The grotesque, arabesque: Kimball, 1941 and 1943; Chastel, 1988; Mérot, 1991 (1992). See also AUDRAN (Claude III), BÉRAIN (Jean I).
Portraits
Exhibition, Toulouse, 1956; Bardon, 1974; Montgolfier, 1977; Schnapper, 1981 (1) & 1983; Exhibition, Toulouse, 1987–8.
Genre
Exhibition, Paris, 1978–9 (1), pp.318–51.

– Bambochades: Exhibitions, Rome, 1950; Rome and Rotterdam, 1958.
Landscape
Exhibition, Bologna, 1962; Thuillier, 1977 and 1980 (1981); Exhibition, Madrid, 1984; Exhibition, Washington, 1988; Exhibition, New York, 1990.
Still life
Sterling, 1959; Faré, 1974.
– (Flowers and fruit): Exhibition, Paris, 1979; Schnapper, 1983 (1985).

VI-LITERATURE AND ARTISTIC THEORY

17th century documents
Scudéry, 1646 (1991); Bosse, 1649 (1964); Fréart de Chambray, 1662; Fréart de Chantelou, 1665 (1885); Félibien, 1666–88; Bosse, 1667 (1964); Du Fresnoy, 1667; Félibien, 1668 (1725); Perrault, 1668 (1992); de Piles, 1673; de Piles, 1677, de Piles, 1681; de Piles, 1708 (1989); Restout, 1681; Dupuy du Grez, 1699; Coypel A., 1721; Jouin, 1883; Fontaine, 1903; Poussin, see Jouanny, 1911; Thuillier, 1960 (1) et 1983 (3).
Recent contributions
Schlosser, 1924 (1984); Mahon, 1947; Teyssèdre, 1957 (1965); Thuillier, 1968 (1); Goldstein, 1969; Demoris, 1978; Reinbold, 1982; Thuillier, 1983 (2); Puttfarken, 1985; Lichtenstein, 1989.

VII-PAINTERS

ALLEGRAIN (Étienne) [Paris, 1644-Paris, 1736].
Bibliogr.: Lossel-Guillien, 1988.
ALLEGRAIN (Gabriel) [Paris, 1679-Paris, 1748].
ASSELIJN (Jan) [Diemen, 1615-Amsterdam, 1652].
Bibliogr.: Exhibition, Paris, 1972 (3).
AUDRAN (Claude II) [Lyon, 1639-Paris, 1684].
Bibliogr.: Charvet, 1876; Michel E., 1884.
AUDRAN (Claude III) [Lyon, 1658-Paris, 1734].
Bibliogr.: Charvet, 1876; Michel E., 1884; Kimball, 1943, *passim*; Weigert, 1950.
BAHUCHE (Marguerite)
Bibliogr.: See BUNEL (Jacob).
BAILLY (Jacques I) [Graçay, c. 1634-Paris, 1679].
Bibliogr.: Faré, 1974, pp.196-8; Grivel and Fumaroli, 1989.
BARRA (Didier, known as Monsù Desiderio) [Metz, c. 1590-5-documented in Napks until 1647].
Bibliogr.: Exhibition, Rome and Nancy, 1982, p.179–186 (Thuillier). See also NOMÉ (François de).
BARRIÈRE (Dominique) [Marseille, c. 1618-Rome, 1678].
BAUDESSON (Nicolas) [Troyes, 1611-Paris, 1680].
Bibliogr.: Faré, 1974, pp.277–90; Exhibition, Paris, 1979 (Faré M. and F.).

BAUDUINS (Adriaen Frans I Baudewyns or) [Brussels, 1644-Brussels, 1711].

BAUGIN (Lubin) [Pithiviers (?) c. 1612-Paris, 1663].
Bibliogr.: Faré, 1955; Auzas, 1958; Exhibition, Orléans, 1958 (Pruvot-Auzas J.); Thuillier, 1963; Faré, 1974, pp.106–15; Exhibition, Meaux, 1988–9 (Thuillier).

BEAUBRUN (Charles) [Amboise, 1604-Paris, 1692].

BEAUBRUN (Henri) [Amboise, 1603-Paris, 1677].
Bibliogr.: Wildenstein G., 1960; Wilhelm, 1969.

BELLANGE (Jacques de) [active at the court of Lorraine, in Nancy, between 1595 and 1616].
Bibliogr.: Pariset, 1936; Linnik, 1973; Exhibition, Meaux, 1988–9 (Rosenberg); Exhibition, Nancy, 1992 (Thuillier).

BELLE (Alexis-Simon) [Paris, 1674-Paris, 1734].
Bibliogr.: Camus, 1990 (1992).

BELLIN (François) (documented in Paris in 1637).
Bibliogr.: Exposition, Paris, 1990–1, pp.42–3 (Thuillier).

BELLY (Jacques) [Chartres, 1609-Chartres, 1674].
Bibliogr.: Exhibition, Paris, 1990–1, p.46 (Thuillier).

BÉRAIN (Jean I) [Saint-Mihiel, 1640-Paris, 1711].
Bibliogr.: Weigert, 1936 and 1937; Kimball, 1941, and 1943, *passim*; La Gorce, 1986.

BERGAIGNE (Pierre) [Marœuil, 1652 (?)-Lille, 1708].

BERNAERTS (Nicasius) [Antwerp, 1620-Paris, 1678].
Bibliogr.: Faré, 1974, *passim*.

BERNARD (Jacques-Samuel) [Paris, 1615 (?)-Paris, 1687].
Bibliogr.: Faré, 1974, pp.256–60.

BERTIN (Nicolas) [Paris, 1667-Paris, 1736].
Bibliogr.: Lefrançois, 1981.

BIGOT (Trophime, known as Le Vieux) (Arles, 1579-after 1649).
Bibliogr.: Exhibition, Marseille, 1978 (Thuillier).

BIGOT (Trophime, known as Le Jeune, also known as The Candlelight Master) [known to have been in Rome from 1620 to 1634].
Bibliogr.: Nicolson, 1960 and 1964; Exhibition, Marseille, 1978 (Thuillier).

BLANCHARD (Gabriel) [Paris, 1630-Paris, 1704].

BLANCHARD (Jacques) [Paris, 1600-Paris, 1638].
Bibliogr.: Sterling, 1961; Rosenberg, 1975; Thuillier, 1976 (1978); Beresford, 1985.

BLANCHET (Thomas) [Paris, 1614-Lyon, 1689].
Bibliogr.: Galactéros, 1991.

BLIN DE FONTENAY (Jean-Baptiste) [Caen, 1653-Paris, 1715].
Bibliogr.: Faré, 1974, pp.326–50; Exhibition, Paris, 1979 (Faré M. et F.).

BOEL (Pieter) [Antwerp, 1622-Paris, 1674].
Bibliogr.: Mirimonde, 1964; Exhibition, Paris, 1977–8 (2) (Caracciolo-Arizoli).

BOISSON (André) [Aix-en-Provence, 1643-Aix-en-Provence, 1733].

Bibliogr.: Exhibition, Marseille, 1978 (Wytenhove and Gentet).

BOLLERY (Nicolas) [Paris, c. 1560 (?)-Paris, 1630].
Bibliogr.: Exhibition, Meaux, 1988–9 (Kerspern).

BOSSE (Abraham) [Tours, 1602-Paris, 1676].
Bibliogr.: Bosse, 1649 (1964); Blum, 1924; Villa, 1967.

BOUCHER (Jean) [Bourges, c. 1575-Bourges, 1633].
Bibliogr.: Exhibition, Bourges et Angers, 1988 (Thuillier).

BOULBÈNE or BOULVÈNE (Jacques) [documented in Toulousere from 1575-Toulouse, 1605].
Bibliogr.: Boyer, 1991.

BOULLOGNE (Bon) [Paris, 1649-Paris, 1719].
Bibliogr.: Caix de Saint-Amour, 1919; Schnapper, 1978.

BOULLOGNE (Louis I) [Paris, 1609-Paris, 1674].
Bibliogr.: Caix de Saint-Amour, 1919.

BOULLOGNE (Louis II de) [Paris, 1654-Paris, 1733].
Bibliogr.: Caix de Saint-Amour, 1919; Schnapper, 1970 (1); Schnapper, 1976.

BOULLOGNE (Geneviève) [Paris, 1645-Aix-en-Provence, 1709].

BOULLOGNE (Madeleine) [Paris, 1646-Paris, 1710].
Bibliogr.: Faré, 1974, pp.245–9.

BOURDON (Sébastien) [Montpellier, 1616-Paris, 1671].
Bibliogr.: Ponsonailhe, 1883; Wilhelm, 1956 (1957).

BRÉBIETTE (Pierre) [Mantes, 1598-(?), 1650 (?)].
Bibliogr.: Rosenthal, 1911; Thuillier, 1961; Pacht-Bassani 1993, p.517.

BREENBERGH (Bartholomeus) [Deventer, 1598/1600-Amsterdam, 1657].

BUNEL (Jacob) [Blois, 1558-Paris, 1614].
Bibliogr.: Exhibition, Paris, 1972 (1).

CALLOT (Jacques) [Nancy, 1592-Nancy, 1635].
Bibliogr.: Ternois, 1962 (1) et (2); Exhibition, Nancy, 1992 (2).

CHALETTE (Jean) [Troyes, 1581-Toulouse, 1644].
Bibliogr.: Mousseigne, 1974; Exhibition, Toulouse, 1974 (Mousseigne); Exhibition, Toulouse, 1987–8 (Penent).

CHAMPAIGNE (Jean-Baptiste) [Brussels, 1631-Paris, 1681].
Bibliogr.: Dorival, 1992 (2).

CHAMPAIGNE (Philippe de) [Brussels, 1602-Paris, 1674].
Bibliogr.: Dorival, 1976 and 1992 (1).

CHAPERON (Nicolas) [Châteaudun (?), 1612-Rome, 1656].
Bibliogr.: Exhibition, Paris, 1990–1, p.51 (Thuillier).

CHASSE (Barthélemy) [Naples, 1659-Marseille, 1720].
Bibliogr.: Exhibition, Marseille, 1978 (Homet M.-C.).

CHAUVEAU (François) [Paris, 1613-Paris, 1676].
Bibliogr.: Préaud, 1984.

CHIARO (Fabrizio) [documented in Paris c. 1646–7].

Bibliogr.: Exposition, Paris, 1972 (3).

COLOMBEL (Nicolas) [Sotteville-lès-Rouen, 1644-Paris, 1717].
Bibliogr.: Blunt, 1970; Exhibition, Rouen, 1984 (Bergot).

CONSTANT (Rémond) [Nancy, c. 1575-Nancy, 1637].
Bibliogr.: Exhibition, Nancy, 1992 (1) (Sylvestre).

CONTE (Meiffren) [Marseille, c. 1630-Marseille, 1705].
Bibliogr.: Faré, 1974, pp.205–32; Exhibition, Marseille, 1978 (Volle).

CORNEILLE (Jean-Baptiste) [Paris, 1659-Paris, 1695].
Bibliogr.: Auzas, 1961 (1) et (2); Picart, 1987.

CORNEILLE (Michel I) (Orléans, 1603 (?)-Paris, 1664).
Bibliogr.: Auzas, 1961 (1) et (2); Exhibition, Meaux, 1988–9 (Boyer); Exhibition, Paris, 1990–1, pp.48–49 and 121–3 (Thuillier); Picart, 1991 (1992).

CORNEILLE (Michel II) [Paris, 1642-Paris, 1708].
Bibliogr.: Auzas. 1961 (1) et (2).

COTELLE (Jean I) [Meaux, 1607-Paris, 1676].
Bibliogr.: Lhuillier, 1893.

COTELLE (Jean II) [Paris, 1642-Villiers-sur-Marne, 1708].
Bibliogr.: Lhuillier, 1893; Schnapper, 1967.

COYPEL (Antoine) [Paris, 1611-Paris, 1722].
Bibliogr.: Schnapper, 1969; Garnier, 1989.

COYPEL (Noël) [Paris, 1628-Paris, 1707].
Bibliogr.: Wildenstein D., 1964; Schnapper, 1977.

CRETEY (Pierre-Louis) [active in Lyon between 1681 and 1688].
Bibliogr.: Chomer, Galactéros and Rosenberg, 1988.

DAMERY (Walthère) [Liège, 1614-Liège, 1678].
Bibliogr.: Exhibition, Alden Biesen, 1987.

DARET (Jean) [Brussels, 1613 or 1615-Aix-en-Provence, 1668].
Bibliogr.: Exhibition, Marseille, 1978 (Heilbrun and Rosenberg); Exhibition, Montreal, Rennes and Montpellier, 1993 (Hilaire).

DAUPHIN (Charles) [Lorraine, c. 1620-Turin, 1677].
Bibliogr.: Exhibition, Rome and Nancy, 1982 (Di Macco and Thuillier); Fohr, 1982 (2).

DERUET (Claude) [Nancy, c. 1588-Nancy, 1660].
Bibliogr.: Exhibition, Rome and Nancy, 1982 (Thuillier); Exhibition, Nancy, 1992 (1) (Boyer).

DESPORTES (Alexandre-François) [Champigneulles, 1661-Paris, 1743].
Bibliogr.: Exhibition, Paris, 1982–3 (Duclaux and Préaud); Lastic, 1989.

DORIGNY (Michel) [Saint-Quentin, 1617-Paris, 1665].
Bibliogr.: Brejon de Lavergnée B., 1982 (1984); Exhibition, Paris, 1990–1, pp.53–4 (Thuillier); Brejon de Lavergnée A., 1991 (1992).

DUBOIS (Ambrosius Bosschaert, known as Ambroise) [Antwerp, c. 1543-Fontainebleau, 1614].

Bibliogr.: Exhibition, Paris, 1972 (1) (Béguin); Exhibition, Meaux, 1988–9 (Samoyault-Verlet).

DUBREUIL (Toussaint) [Paris (?), c. 1561-Paris, 1602].
Bibliogr.: Exhibition, Paris, 1972 (1) (Béguin); Cordellier, 1985; Exhibition, Meaux, 1988–9 (Cordellier); Cordellier, 1990; Scailliérez, 1992.

DUCHESNE (Nicolas) [Documented in Paris between 1599 and 1630].

DUFRESNOY (Charles-Alphonse) [Paris, 1611-Villiers-le-Bel, 1668].
Bibliogr.: Thuillier, 1965; Thuillier, 1983 (4).

DUGHET (Gaspard, known as le Guaspre or le Guaspre-Poussin) [Rome, 1615-Rome, 1675].
Bibliogr.: Boisclair, 1986.

DU GUERNIER (Louis I) [Paris, 1614 (?)-Paris, 1659].
Bibliogr.: Exhibition, Paris, 1990–1, p.40 (Thuillier).

DU JONCQUOY (Michel) [Tournai, c. 1525 (?)-Tournai, 1606].
Bibliogr.: Exhibition, Rouen, 1980–1 (Bergot).

DUMÉE (Guillaume) [Fontainebleau (?), 1571-Paris, 1646].
Bibliogr.: Béguin, 1967; Exhibition, Paris, 1972 (1) (Béguin).

DUMONSTIER (or DUMOUSTIER, Daniel) [Paris, 1576-Paris, 1646].
Bibliogr.: Guiffrey J., 1905–6; Dimier, 1924–5; Adhémar J., 1970.

DUPUIS (Pierre) [Montfort-l'Amaury, 1610-Paris, 1682].
Bibliogr.: Faré, 1974, pp.198–204.

EGMONT (Justus Van Egmont, known as Juste d') [Leyden, 1601-Antwerp, 1674].
Bibliogr.: Wilhelm, 1987 (1989).

ELLE (Ferdinand, known as le Vieux) [Malines, c. 1580-Paris, 1649].
Bibliogr.: Exhibition, Meaux, 1988–9 (nos 32–35, in 'Cercle de Lallemant') (Ramade).

ELLE (Louis-Ferdinand, known as Ferdinand le Père) [Paris, 1612-Paris, 1689].
Bibliogr.: Wildenstein G., 1957.

ELLE (Louis, known as Ferdinand le Jeune) [Paris, 1648-Rennes, 1717].
Bibliogr.: Wildenstein G., 1957.

ERRARD (Charles, known as le Fils) [Nantes, c. 1606-Rome, 1689].
Bibliogr.: Thuillier, 1978; Boyer and Brejon A., 1980.

FAUCHIER (Laurent) [Aix-en-Provence, 1643-Aix-en-Provence, 1672].
Bibliogr.: Exhibition, Marseille, 1978 (Latour).

FINSON (Louis) [Bruges, before 1578-Amsterdam, 1617].
Bibliogr.: Bodart, 1970; Exhibition, Marseille, 1978 (Thuillier).

FLÉMALLE (Berthollet) [Liège, 1614-Liège, 1675].
Bibliogr.: Hendrick, 1973.

FOREST (Jean-Baptiste) [Paris, c. 1636-Paris, 1712].
Bibliogr.: Wildenstein G., 1958.

FOUQUIÈRES (Jacques) [Antwerp, c. 1580–1590-Paris, 1659].
Bibliogr.: Stechow, 1948.

FRANCART [?, c. 1622–8–Paris, 1672].
FRANÇOIS (Guy) [Le Puy, 1578 (?)–Le Puy, 1650].
Bibliogr.: Exhibition, Le Puy and Saint-Étienne, 1974 (Pérez); Pérez, 1975; Exhibition, Paris, New York and Chicago, 1982 (Rosenberg).
FRÉDEAU (Ambroise) [Paris, c. 1589-Toulouse, 1673].
Bibliogr.: Salies, 1961; Exhibition, Toulouse, 1974 (Mousseigne).
FRÉMINET (Martin) [Paris, 1567-Paris, 1619].
Bibliogr.: Exhibition, Paris, 1972 (1) (Thuillier); Samoyault-Verlet, 1972 (1975); Exhibition, Meaux, 1988–9 (Cordellier).
GARCIN (Gilles) [Aix-en-Provence, 1647-Aix-en-Provence, 1702].
Bibliogr.: Exhibition, Marseille, 1978 (Seyve).
GARNIER (François) [Paris, c. 1600-Paris, before 1658].
Bibliogr.: Faré, 1974, pp.44–8.
GARNIER (Jean II) [Meaux, 1633-Paris, 1705].
Bibliogr.: Faré, 1974, pp.249–53.
GENOELS (Abraham) [Antwerp, 1640-Antwerp, 1723].
GENTILESCHI (Orazio) [Pisa, 1563-London, 1639].
Bibliogr.: Sterling, 1958.
GILLOT (Claude) [Langres, 1673-Paris, 1722].
Bibliogr.: Populus, 1930; Exhibition, Washington, Paris and Berlin, 1984–5, *passim*.
GOBERT (Pierre) [Paris or Fontainebleau, 1662-Paris, 1744].
Bibliogr.: Thoison, 1903; Luna, 1976.
GRIMALDI (Giovanni Francesco) [Bowgna, 1606-Rome, 1680].
Bibliogr.: Exhibition, Bowgna, 1962.
GRIMOU (Alexis) [Argenteuil, 1678-Paris, 1733].
Bibliogr.: Réau, *in* Dimier, 1928–30, vol. II, pp.195–216.
HALLÉ (Daniel) [Rouen, 1614-Paris, 1675].
Bibliogr.: Estournet, 1905; Exhibition, Rouen, 1984 (Willk-Brocard).
HALLÉ (Claude-Guy) [Paris, 1652-Paris, 1736].
Bibliogr.: Estournet, 1905.
HANSE (Louis Van der Bruggen, known as Louis) [Paris, c. 1615-Paris, 1658].
Bibliogr.: Exhibition, Paris, 1990–1, p.40.
HOEY (Nicolas d') [mentioned in accounts of the royal nonsehow between 1590 and 1609].
HOEY (Jean d') [mentioned at Fontainebleau at the same period may have been father of the aforementioned].
Bibliogr.: Exhibition, Paris, 1972 (1).
HONNET (Gabriel) [active in Paris and Fontainebleau at the beginning of the century].
Bibliogr.: Erlande-Brandenburg, 1965; Béguin, 1967; Exhibition, Paris, 1972 (1).
HOUASSE (René-Antoine) [Paris, 1645-Paris, 1710].
Bibliogr.: Schnapper, 1967; Schnapper, 1968 (2).
HUILLIOT (Claude) [Reims, 1632-Paris,

1702].
Bibliogr.: Faré, 1974, pp.350–6.
HUPIN (Jacques) [active at mid-century].
Bibliogr.: Faré, 1974, pp.238–42.
JOUVENET (François) [Rouen, 1664-Paris, 1749].
JOUVENET (Jean) [Rouen, 1644-Paris, 1717].
Bibliogr.: Schnapper, 1974 (1); Brejon A., 1979.
KALF (Willem) [Rotterdam, 1619-Amsterdam, 1693].
Bibliogr.: Brenninkmeyer-De Rooij, 1986.
LA FOSSE (Charles de) [Paris, 1636-Paris, 1716].
Bibliogr.: Stuffmann, 1964.
LAGNEAU (Nicolas [?]) [Active during the first half of the century.
Bibliogr.: Exhibition, Cleveland, 1989 (Goldfarb).
LA HYRE (Laurent de) [Paris, 1606-Paris, 1656].
Bibliogr.: Exhibition, Grenoble, Rennes and Bordeaux, 1988–1989 (Rosenberg and Thuillier).
LALLEMANT (Georges) [Nancy, c. 1575-Paris, 1630].
Bibliogr.: Pariset, 1952; Pariset, 1954; Le Blant and Pariset, 1960 (1961); Montgolfier, 1967 (1968); Exhibition, Nancy, 1987; Exhibition, Meaux, 1988–1989 (Ramade); Exhibition, Nancy, 1992 (1) (Lavalle).
LARGILLIERRE, or LARGILLIÈRE (Nicolas de) [Paris, 1656-Paris, 1746].
Bibliogr.: Maison and Rosenberg, 1973; Exhibition, Montreal, 1981 (Rosenfeld *et al.*); Lastic, 1981, 1982 and 1983; Rosenfeld, 1984; Rosenberg, 1989; W. B. MacGregor, 1993.
LA ROSE (Jean-Baptiste de) [Marseille, 1612–Toulon, 1687].
Bibliogr.: Exhibition, Marseille, 1978 (Latour).
LA TOUR (Georges de) [Vic-sur-Seille, 1593-Lunéville, 1652].
Bibliogr.: Pariset, 1949; Exhibition, Paris, 1972 (2) (Rosenberg and Thuillier); Rosenberg and Macé de Lépinay, 1973; Nicolson and Wright, 1974; Reinbold, 1991; Thuillier, 1992.
LE BLANC (Horace) [Lyon, c. 1580-Lyon, 1637].
Bibliogr.: Chomer, 1987; Foucart, 1987.
LÈBRE (André) [Toulouse (?), c. 1629-Toulouse, 1700].
Bibliogr.: Mesuret, 1955.
LE BRUN (Charles) [Paris, 1619-Paris, 1690].
Bibliogr.: Nivelon, 1699–1704; Jouin, 1889; Fontaine, 1914; Montagu, 1959 (1994); Posner, 1959; Montgolfier, 1960; Exhibition, Versailles, 1963 (Thuillier and Montagu); Montagu, 1963 (1) and (2); Thuillier, 1967; Chomer, 1977 (1979); Exhibition, Paris, 1985–6 (Méjanès and Beauvais); Exhibition, Dulwich, 1990–1 (Montagu, Kalinsky *et al.*); Exhibition, Versailles, 1990–1 (Thuillier and Constans); Montagu, 1991 (1992).
LE CLERC (Jean) [Nancy, c. 1587-Nancy, 1633].
Bibliogr.: Exhibition, Rome and Nancy, 1982 (Thuillier); Exhibition, Nancy 1992

(1) (Petry and Silvestre).
LE CLERC (Sébastien) [Metz, 1637-Paris, 1714].
Bibliogr.: Meaume, 1877; Préaud, 1980.
LEFEBVRE (Claude) [Fontainebleau, 1632-Paris, 1675].
Bibliogr.: Lhuillier, 1892; Thoison, 1905; Wildenstein D., 1963; Le Blant, 1984 (1985); Wilhelm, 1994.
LEMAIRE (Jean, known as le Gros Lemaire) [Dammartin, 1598-Gaillon, 1659].
Bibliogr.: Blunt, 1943 and 1959; Busiri Vici, 1965 and 1977.
LEMAIRE (Pierre, known as Lemaire-Poussin) (?) c. 1612-Rome (?), 1688].
Bibliogr.: Exhibition, Paris, 1993, no 54 (Boyer).
LEMOINE (Pierre-Antoine) documented in Paris at mid-century].
Bibliogr.: Faré, 1974, p.184–6.
LE MOYNE (François) [Paris, 1688-Paris, 1737].
LE NAIN (Antoine) [Laon, between 1602 and 1610-Paris, 1648].
LE NAIN (Louis) [Laon, betwee 1602 and 1610-Paris, 1648].
LE NAIN (Mathieu) [Laon, between 1602 and 1610-Paris, 1677].
Bibliogr.: Thuillier, 1963 (1964); Exhibition, Paris, 1978–9 (Thuillier); Cuzin, 1978; Cuzin, 1979 (1); Rosenberg, 1979; Thuillier, 1979 (1); Exhibition, Meaux, 1988–9 (Thuillier); Rosenberg, 1993.
LE PAUTRE (Jean I) [Paris, 1618-Paris, 1682].
LE PAUTRE (Pierre I) [Paris, 1652-Paris, 1716].
Bibliogr.: Lieure, s.d.; Caye and La Moureyre, in Bluche, 1990.
LE PILEUR (Jérémie) [active from 1619 to 1638 in Anjou, Poitou and Touraine].
LE ROY DE LA BOISSIÈRE (Jean) [documented in 1610].
Bibliogr.: Faré, 1974, p.365.
LE SUEUR (Eustache) [Paris, 1616-Paris, 1655].
Bibliogr.: Mérot, 1987.
LE TELLIER (Pierre) [Vernon, 1614-Rouen (?) after 1680].
Bibliogr.: Exhibition, Rouen, 1984 (Dupuis).
LÉTIN, or LESTIN (Jacques de) [Troyes, 1597-Troyes, 1661].
Bibliogr.: Exhibition, Troyes, 1976 (Sainte-Marie).
LEVIEUX (Reynaud) [Nîmes, 1613-Rome, 1699].
Bibliogr.: Exhibition, Marseille, 1978 (Wytenhove); Wytenhove, 1990.
LHOMME (Jacques) [Troyes (?), 1600-documented in Paris until 1650].
LHOMME (Jean) [Troyes (?), c. 1593-Rome (?), 1633].
Bibliogr.: Bousquet, 1959; Exhibition, Spoleto, 1989 (Falcidia).
LICHERIE (Louis de) [Houdan, 1629-Paris, 1687].
Bibliogr.: Goldstein, 1969; Thuillier, 1969 (2).
LINARD (Jacques) [Paris, 1600-Paris, 1645].
Bibliogr.: Faré, 1974, p.17–40; Exhibition, Paris, 1979 (Faré M. and F.).
LOIR (Nicolas) [Paris, 1624 (?)-Paris, 1679].

Bibliogr.: Wildenstein G., 1959; Schnapper, 1962; Leroy-Beaulieu, 1985.
LORRAIN (Claude Gellée, known as le) [Chamagne, 1600-Rome, 1682].
Bibliogr.: Roethlisberger, 1961, 1968 and 1971; Kitson, 1978; Exhibition, Paris, 1978–9 (2) (Gere *et al.*); Exhibition Washington and Paris, 1982–3 (Russell); Colloque, Washington, 1982 (1984); Exhibition Rome and Nancy, 1982 (Thuillier); Exhibition, Madrid, 1984 (Kitson); Roethlisberger and Cecchi, 1986; Exhibition, New York, 1990 (Kitson).
MASTER, CANDLELIGHT. See BIGOT (Trophime, known as le Jeune).
MASTER OF THE JUDGEMENT OF SOLOMON French or Northern painter, active in Rome between 1615 and 1625.
Bibliogr.: Exhibition, Rome and Paris, 1973–4 (Brejon A. and Cuzin); Nicolson, 1979.
LE MAITRE AUX BÉGUINS
LE MAITRE DES CORTÈGES
LE MAITRE DES JEUX
Followers of the brothers Le Nain.
Bibliogr.: Exhibition, Paris, 1978–9 (Thuillier); Cuzin, 1978; Rosenberg, 1993.
MARTELLANGE (Étienne) [documented in Ly on after 1565].
MARTIN (Jean-Baptiste, known as Martin des Batailles) [Paris, 1659-Paris, 1735].
Bibliogr.: Schnapper, 1967.
MAUPERCHÉ (Henri) [Paris, between 1602 and 1610-Paris, 1686].
Bibliogr.: Exhibition, Paris, 1972 (3); Exhibition, Paris, 1993 (Méjanès).
MELLAN (Claude) [Abbeville, 1598-Paris, 1688].
Bibliogr.: Thuillier, 1960 (2), p.86–96; Thuillier, 1968 (2); Exhibition, Paris, 1988 (1) (Brejon B. and Préaud M.); Exhibition, Rome, 1989 (Ficacci).
MELLIN (Charles) [Nancy, 1597 (?)-Rome, 1649].
Bibliogr.: Bousquet, 1955; Thuillier, 1978 (1981); Exhibition, Rome and Nancy, 1982 (Thuillier).
MEULEN (Adam Frans Van der) [Brussels, 1632-Paris, 1690].
Bibliogr.: Richefort, 1986 (1988); Coural-Starcky, 1988.
MICHELIN (Jean) [Paris, c. 1616 (?)-Paris, 1670].
Bibliogr.: Exhibition, Paris, 1978–9 (1) (Thuillier); Rosenberg, 1993.
MIGNARD (Nicolas, known as Mignard d'Avignon) [Troyes, 1606-Paris, 1668].
Bibliogr.: Exhibition, Avignon, 1979 (Schnapper); Schnapper, 1981 (2).
MIGNARD (Pierre, known as le Romain) [Troyes, 1612-Paris, 1695].
Bibliogr.: Boyer, 1980 (1982); Nikolenko, 1983; Boyer, 1984; Exhibition, Paris, 1989 (1) (Boyer); Berger, 1993.
MILLET (Jean-François, known as Francisque) [Antwerp, 1642-Paris, 1679].
Bibliogr.: Davies, 1948; Roethlisberger, 1970; Exhibition, New York, 1990 (Sutherland-Harris).
MIMAULT (François) [Parthenay, 1580-Aix-en-Provence, 1652].
Bibliogr.: Exhibition, Marseille, 1978

(Alfonsi and Pettier).

MOILLON (Louise) [Paris, 1610-Paris, 1696].
Bibliogr.: Faré, 1974, pp.48–69; Faré M. and F., 1986.

MOILLON (Nicolas) [Paris, 1555-Paris, 1619].

MOL (Pieter Van) [Antwerp, 1599-Paris, 1650].
Bibliogr.: Exhibition, Paris, 1977–78 (1) (Foucart).

MONIER, or **MOSNIER** (Jean) [Blois, 1600-Blois, 1656].
Bibliogr.: Dupré, 1868; Faré, 1974, pp.361–2.

MONNOYER (Jean-Baptiste) [Lille, 1636-London, 1699].
Bibliogr.: Paviere, 1966; Faré, 1974, p.290–316; Exhibition, Paris, 1979 (Faré M. and F.).

MONSÙ DESIDERIO. See **BARRA** (Didier) and **NOMÉ** (François de).

MONTALLIER (Alexandre [?]) [documented in Paris in 1642].
Bibliogr.: Exhibition, Paris, 1978–9 (1) (Thuillier); Rosenberg, 1993.

MORIN (Jean) [Paris, before 1600-Paris, 1650].
Bibliogr.: Hornibrook and Petitjean, 1985.

MUTI (the brothers, vonet's collaborators in Rome in the 1620s).
Bibliogr.: Exhibition, Paris, 1990–1, pp.30–2 (Thuillier).

NANTEUIL (Robert) [Reims, 1623-Paris, 1678].
Bibliogr.: Bouvy, 1924; Petitjean and Wickert, 1925; Exhibition, Reims, 1978; Russell, 1985.

NOCRET (Jean) [Nancy, c. 1617-Paris, 1672].
Bibliogr.: Meaume, 1885.

NOCRET (Jean-Charles) [Paris, 1648-Paris, 1719].

NOMÉ (François de) [Metz, c. 1593-Naples, before 1650 (?)].
Bibliogr.: Exhibition, Rome and Nancy, 1982 (Thuillier).

NOURRISSON (René) [documented in Paris from 1640 to 1652].
Bibliogr.: Faré, 1974, pp.40–2.

PADER (Hilaire) [Toulouse, 1617-Toulouse, 1677].
Bibliogr.: Lestrade, 1901; Exhibition, Toulouse, 1992 (Penent).

PAILLET (Antoine) [Paris, 1626-Paris, 1701].
Bibliogr.: Gauchery-Grodecki, 1963.

PARROCEL (Joseph) [Brignoles, 1646-Paris, 1704].
Bibliogr.: Parrocel, 1861; Schnapper, 1959; Schnapper, 1970 (2).

PATEL, or **PASTEL** (Pierre) [Picardie (?), c. 1605-Paris, 1676].
Bibliogr.: Exhibition, Paris, 1972 (3); Exhibition, New York, 1990 (Maloney).

PATEL (Pierre-Antoine) [Paris, 1646-Paris, 1707].

LE 'PENSIONANTE DEL SARACENI' [French (?) painter, active in Rome between 1610 and 1620].
Bibliogr.: Nicolson, 1979; Exhibition, Paris, New York and Chicago, 1982 (Rosenberg).

PÉRELLE (Adam) [Paris, 1640-Paris, 1695].

Bibliogr.: Avel, 1972 (1973).

PÉRELLE (Gabriel) [Vernon, c. 1602-Paris, 1677].
Bibliogr.: Avel, 1972 (1973).

PÉRELLE (Nicolas) [Paris, 1631-Paris, after 1678].
Bibliogr.: Avel, 1972 (1973).

PERRIER (François) [Pontarlier, 1594-Paris, 1649].
Bibliogr.: Schleier, 1968 and 1972; Thuillier, 1972 (2) and 1979 (2); Ternois, 1981; Exhibition, Paris, 1988–9, p.44ff. (Cotté); Thuillier, 1993.

PETITOT (Jean, known as l'Ancien) [Genève, 1607-Vevey, 1691].
Bibliogr.: Stroehlin, 1905; Lightbown, 1969.

PICART (Bernard) [Paris, 1673-Amsterdam, 1733].

PICART (Jean-Michel) [Antwerp, 1600-Paris, 1682].
Bibliogr.: Faré, 1957 (1958), and 1974, p.84–98; Exhibition, Paris, 1979 (M. and F. Faré).

PINAGIER (Thomas) [Paris (?) c. 1616-Paris, 1653].

PLATTEMONTAGNE (Mathieu Van Plattenberg, known as de) [Antweps, 1606-Paris, 1660].
Bibliogr.: Thuillier, 1980 (1981); Thuillier, 1985 (2).

PLATTEMONTAGNE (Nicolas de) [Paris, 1631-Paris, 1706].
Bibliogr.: Rosenberg and Volle, 1980.

POËRSON (Charles, known as le Père) [Vic-sur-Seille, c. 1609-Paris, 1667].
Bibliogr.: Lejeaux, 1946; Exhibition, Paris, 1990–1, pp.49–50 (Thuillier).

POËRSON (Charles-François, known as le Fils) [Paris, 1653-Rome, 1725].

POURBUS (Frans II, known as François II) (Antwerp, 1569-Paris, 1622].
Bibliogr.: Montgolfier and Wilhelm, 1958; Exhibition, Paris 1977–8 (1) (J. Foucart).

POUSSIN (Nicolas) [Villers, near Les Andelys, 1594-Rome, 1665].
Bibliogr.: (Sources): Félibien, 1666–88, vol. IV (1686); Jouanny, 1911; Thuillier, 1960 (1).
(Biography): Thuillier, 1988.
(Catalogue of paintings): Blunt, 1966; Thuillier, 1974.
(Catalogue of drawings): Friedländer and Blunt, 1939–74.
(Catalogue of engravings): Wildenstein G., 1957 (2); Davies and Blunt, 1962.
(Exhibitions): Paris, 1960 (Blunt and Sterling; Rome and Düsseldorf, 1977–8 (Rosenberg); Edinburgh, 1981 (MacAndrew and Brigstocke); Fort Worth, 1988 (Oberhuber); Paris, 1989 (2) (Fumaroli); Paris, 1994–5 (Rosenberg *et al.*).
(Studies): Grautoff, 1914; Blunt, 1967 (1); Badt, 1969; Wild, 1980; Bätschmann, 1982; Mérot, 1990 (1).

PRÉVOST (Nicolas) [Paris, 1604-Richelieu, 1670].
Bibliogr.: Schloder, 1980 (1982).

PUGET (François) [Toulon, 1651-Marseille, 1707].
Bibliogr.: Exhibition, Marseille, 1978 (Gloton); Gloton, 1985.

PUGET (Pierre) [Marseille, 1620-Marseille,

1694].
Bibliogr.: Exhibition, Marseille, 1978 (Gloton); Gloton, 1985.

QUANTIN (Philippe) [Dijon, c. 1600 (?)-Dijon, 1636].
Bibliogr.: Guillaume, 1980 (1983).

QUESNEL (Augustin I) [Paris, 1595–(?), 1661].
Bibliogr.: Dimier, 1924–5.

QUESNEL (Augustin II) [Paris, 1630-Paris, 1697].

QUESNEL (François) (Edinburgh, c. 1545-Paris, 1616).
Bibliogr.: Dimier, 1924–5.

QUILLERIER (Noël) [Orléans, 1594-Paris, 1669].
Bibliogr.: Exhibition, Spoleto, 1989, pp.212–21 (Barroero and Casale); Sainte Fare-Garnot, 1991 (1992).

RABEL (Daniel) [Paris, c. 1578-Paris, 1637].
Bibliogr.: Faré, 1974, p.365; Meyer V., 1983.

RANC (Jean) [Montpellier, 1674-Madrid, 1735].
Bibliogr.: Luna, 1973 (1978) and 1980; Exhibition, Paris, Philadelphia and Fort Worth, 1991–2, pp.99–105 (Bailey).

RAOUX (Jean) [Montpellier, 1677-Paris, 1734].
Bibliogr.: Bataille, *in* Dimier, 1928–30, II, pp.267–82.

RÉGNIER (Nicolas) [Maubeuge, 1591-Venice, 1667].
Bibliogr.: Exhibition, Rome and Paris, 1973–4 (Brejon de Lavergnée A. and Cuzin); Fantelli, 1974; Brejon de Lavergnée A. and Cuzin, 1976.

RIGAUD (Hyacinthe Rigo y Ros, known as) [Perpignan, 1659-Paris, 1743].
Bibliogr.: Roman, 1919; Luna, 1978; Le Leyzour, 1990.

RIVALZ (Antoine) [Toulouse, 1667-Toulouse, 1735].
Bibliogr.: Exhibition, Paris, 1947 (Mesuret); Exhibition, Toulouse, 1992 (Penent).

RIVALZ (Jean-Pierre) [Labastide d'Anjou (Languedoc), 1625-Toulouse, 1706].
Bibliogr.: Exhibition, Toulouse, 1987–8 (Milhau), and 1992 (Penent).

ROBERT (Nicolas) [Langres, 1614-Paris, 1685].
Bibliogr.: Faré, 1974, pp.365–6; Schnapper, 1988, pp.57–9.

ROMANELLI (Giovanni Francesco) [Viterbo, 1610-Viterbo, 1662].
Bibliogr.: Laurain-Portemer, 1973 and 1977.

ROUSSEAU (Jacques) [Paris, 1631-London, 1693].

RUBENS (Petrus-Paulus) [Siegen, 1577-Antwerp, 1640].
Bibliogr.: (on Rubens in France and the Galeries du Luxembourg): Jost, 1964; Foucart and Thuillier, 1969; Thuillier, 1969 (1); Thuillier, 1983 (1); Millen and Wolf, 1989.

RUGGIERI (Ruggero de') [documented in 1540 in Bologna, and from 1557 to 1596 in Fontainebleau].

SACQUESPÉE (Adrien) [Caudebec-en-Caux, 1629-Caudebec-en-Caux (?), 1692].

Bibliogr.: Exhibition, Rouen, 1984 (Georges-Picot).

SAINT-IGNY (Jean de) [Rouen, c. 1600-Paris, after 1649].
Bibliogr.: Chennevières, 1847–62, I, pp.161–2; Hédou, 1887; Exhibition, Rouen, 1984 (Rosenberg); Exhibition, Meaux, 1988–9 (Bergot).

SAINT-JEAN (Jean de) [active in Paris throughout the 1680s].

SANTERRE (Jean-Baptiste) [Magny-en-Vexin, 1658-Paris, 1717].
Bibliogr.: Lesné, 1988 (1989).

SCALBERGE (Frédéric) [in Rome c. 1623-7, documented in Paris in 1636].

SCALBERGE (Pierre) [(?), c. 1592-Paris, 1640].
Bibliogr.: Le Blant, 1978 (1980); Exhibition, Paris, 1990–1, p.42 (Thuillier).

SENELLE (Jean) [Meaux, 1605 (?)-Paris, between 1654 and 1671].
Bibliogr.: Exhibition, Meaux, 1988–9 (Kerspern).

SERRE (Michel) [Tarragona, 1658-Marseille, 1733].
Bibliogr.: Exhibition, Marseille, 1978 (Homet); Homet, 1987.

SILVESTRE (Israël) [Nancy, 1621-Paris, 1691].
Bibliogr.: Exhibition, Paris, 1981; Exhibition, Rome and Nancy, 1982 (Thuillier).

SILVESTRE (Louis de, known as le Jeune) [Sceaux, 1675-Paris, 1760].

SIMPOL, or Saint-Paul (Claude) [Clamecy, c. 1666-Paris, 1716].

STELLA (François Stellaert, known as) [Antwerp (?), 1563-Lyon, 1605].
Bibliogr.: Exhibition Marseille, 1986–7 (Chomer).

STELLA (Jacques) [Lyon, 1596-Paris, 1657].
Bibliogr.: Thuillier, 1960 (2), p.96–112; Chomer, 1980.

STOSSKOPF (Sébastien) [Strasbourg, 1597-Idstein, 1657].
Bibliogr.: Haug, 1949; Faré, 1974, pp.115–34.

SWANEVELT (Herman Van) [Woerden, c. 1600-Paris (?), 1655].
Bibliogr.: Exhibition, Paris, 1972 (3).

TASSEL (Jean) [Langres, c. 1608-Langres, 1667].
Bibliogr.: Exhibition, Dijon, 1955; Rosenberg and Laveissière, 1978; Ronot, 1990.

TASSEL (Richard, known as le Père) [Langres, c. 1582-Langres, 1660].
Bibliogr.: Exhibition, Dijon, 1955; Ronot, 1990.

TESTELIN (Henri) [Paris, 1616-The Hague, 1695].

TESTELIN (Louis) [Paris, 1615-Paris, 1655].
Bibliogr.: Exhibition, Paris, 1993 (Boyer and Hilaire).

THULDEN (Theodor Van) [Bois-le-Duc, 1606-Bois-le-Duc, 1669].
Bibliogr.: Exhibition, Bois-le-Duc and Strasbourg, 1991–2 (Roy *et al.*).

TORTEBAT (François) [Paris, c. 1615-Paris, 1690].
Bibliogr.: Exhibition, Paris, 1990–1, p.52–3 (Thuillier); Loire, 1991 (1992).

TOURNIER (Nicolas) [Montbéliard, 1590-Toulouse, 1639 (?)].

Bibliogr.: Mesuret, 1957; Salies, 1973–4; Exhibition, Rome and Paris, 1973–4 (Brejon de Lavergnée A. and Cuzin); Brejon de Lavergnée A., 1974.

TOURNIÈRES (Robert Le Vrac, known as) [Caen, 1668–Caen, 1752].
Bibliogr.: Bataille, *in* Dimier, 1928–30, I, pp.227–44; Alcouffe, 1979.

TROY (François de) [Toulouse, 1645-Paris, 1730].
Bibliogr.: de Troy, 1955–6; Poisson, 1989; Exhibition, Toulouse, 1992 (Brême).

TROY (Jean III Troy, known as Jean III de) [Toulouse, 1638–Montpellier, 1691].
Bibliogr.: Mesuret, 1955; Exhibition, Toulouse, 1992 (Penent).

UBELESKI or **UBELESQUI** (Alexandre) [Paris, c. 1649-Paris, 1718].
Bibliogr.: Rosenberg, 1990.

VALENTIN DE BOULOGNE (Coulommiers, 1591-Rome, 1632].
Bibliogr.: Exhibition, Rome and Paris, 1973–4 (Brejon de Lavergnée A. and Cuzin); Cuzin, 1975; Mojana, 1989.

VANBOUCLE (Pieter Van Boeckel, known as) [Antwerp (?), c. 1610-Paris, 1673].
Bibliogr.: Faré, 1974, pp.98–106; Foucart, 1975.

VANDRISSE (Frans Van Dries, known as) documented in Paris 1625].
Bibliogr.: Exhibition, Paris, 1990–1, p.42.

VARIN (Quentin) [Beauvais, c. 1570-Paris, 1634].
Bibliogr.: Exhibition, Marseille, 1986–7; Exhibition, Meaux, 1988–9 (Thuillier).

VERDIER (François) [Paris, c. 1651-Paris, 1730].
Bibliogr.: Schnapper, 1967; Kaposy, 1980.

VEZZO, or **VEZZI** (Virginia Da) [Rome, 1596-Paris, 1638].
Bibliogr.: Exhibition, Paris, 1990–1, pp.34–6; Michel O., 1991 (1992).

VIGNON (Claude) [Tours, 1593-Paris, 1670].
Bibliogr.: Pacht-Bassani, 1993.

VIGOUREUX-DUPLESSIS (Jacques) [documented in Paris from 1699 Paris, 1732].
Bibliogr.: Eidelberg, 1977; La Gorce, 1981 (1983).

VIVIEN (Joseph) [Lyon, 1657-Bonn, 1734].

VOUET (Aubin) [Paris, 1599-Paris, 1641].
Bibliogr.: Picart, 1982.

VOUET (Simon) [Paris, 1590-Paris, 1649].
Bibliogr.: Crelly, 1962; Dargent and Thuillier, 1965; Exhibition, Rome and Paris, 1973–4 (Brejon de Lavergnée A. and Cuzin); Cuzin, 1979 (2); Brejon de Lavergnée B., 1987; Exhibition, Paris, 1990–1 (Thuillier, Brejon de Lavergnée B. and Lavalle); Exhibition, Munich, 1991 (Harprath); Actes du colloque, Paris, 1991 (1992).

VUIBERT (Rémy) [Troyes, c. 1600-Moulins, 1652].
Bibliogr.: Thuillier, 1958; Voss, 1961; Kagan, 1993.

WATTEAU (Jean-Antoine) [Valenciennes, 1684-Nogent-sur-Marne, 1721].
Bibliogr.: Exhibition, Paris, Washington and Berlin, 1984–5 (Morgan-Grasselli, Rosenberg, Parmentier *et al.*).

WAYEMBOURG (Jean de) [active at the court of Lorraine from 1592 to 1603].
Bibliogr.: Exhibition, Nancy, 1992 (1)
(Sylvestre).

WERNER (Joseph) [Berne, 1637-Berne (?), 1710].
Bibliogr.: Kunze, 1942.

YVART (Baudoin) [Boulogne-sur-mer, 1611-Paris, 1690].
Bibliogr.: Faré, 1974, pp.242–5.

★ In the absence of an individual bibliographical note, see the general bibliography.

Index of Names and Works

Photographic Acknowledgements

Numbers refer to pages on which illustritions appear. Unless listed below, photographs have been provided by the owners of the works concerned.

Artephot, Paris/A. Held: 166; /Terebenine: 205b. Artothek, Peissenberg-Joachim Blauel: 52–3, 77, 161; Ursula Edelmann: 222–3. Jean Bernard, Aix-en-Provence: 62b, 154l. Gérard Boullay, Paris: 112, 113. Bridgeman Art Library, London: 119. Bulloz, Paris: 197m, 249, 301br. Christophe Camus, Clermont-Ferrand: 141b. Arnaud Carpentier, Paris: 150–1. CNMHS, Paris © Spadem 1994/ Patrick Cadet: 8–9; Caroline Rose: 40; Pierre Laure: 74; Marc Jeanneteau: 105t. D R: 81, 231t. Foto Alessandro Vasari, Rome: 85. Giraudon, Vanves: 39, 86, 115b, 213b. Inventaire général, Dijon © Spadem 1994/ Michel Thierry: 41, 193r. Inventaire général, Nantes © Spadem 1994/F. Lasa: 34. Inventaire général, Rennes © Spadem 1994/Artur-Lambart: 152b. Inventaire général, Rouen © Spadem 1994: 63t; /Jean Le Chartier: 28r, 129b. Laboratoire de recherche des musées de France/J. Marsac:

62t. Lauros-Giraudon, Vanves: 56b, 294r. Lichtbildwerkstätte 'Alpenland', Vienna: 104t. Mobilier national, Paris/Vaysse: 252; Sebert: 267. Musée d'Art moderne, Saint-Étienne/Yves Bresson: 242. Musée des Arts décoratifs, Paris/L. Sully-Jaulmes: 134b, 286. Bernard Delorme: 36. Musée des Beaux-Arts, Arras/Claude Theriez: 126–127, 179r, 283. Musée des Beaux-Arts du château, Blois/P. Boyer, Montlouis-sur-Loire: 65. J. Quecq d'Henripret: 228–9. Musée des Beaux-Arts, Lyon/Studio Basset: 64, 137tl, 152t, 300t. Musée des Beaux-Arts, Nantes/ Alain Guillard: 167. Musée des Beaux-Arts, Reims/C. Devleeschauwer: 124t, 180–1, 185l. Musée des Beaux-Arts, Rennes/Louis Deschamps: 68t, 125, 140t. Musée des Beaux-Arts, Rouen/D. Tragin and C. Lancien: 121, 204t, 277, 287, 237, 301bl. Musée des Beaux-Arts, Troyes/Jean-Marie Protte: 71l, 190t. G. Puech: 59b. Musée Fabre, Montpellier/Frédéric Jaulmes: 191, 291, 301t. Musée historique lorrain, Nancy/ Mangin: 54. Musée de l'Ile-de-France, Sceaux-Pascal Lemaître: 200t. Musée de

peinture et de sculpture, Grenoble-André Morin: 247, 289br. Musée Réattu, Arles/ Bernard Delgado: 189r. Musée Hyacinthe-Rigaud, Perpignan/Michel Jauze: 203, 285. Musées de Châlons-sur-Marne/Hervé Maillot: 208b. André Pelle: 298l. Photo Daspet, Villeneuve-lès-Avignon: 154r, 155. Photoexpress, Dijon: 75t. Photothèque des Musées de la Ville de Paris © Spadem 1994: 22t, 22m, 55, 148b, 197t, 212. Enrico Polidori, Genoa 80b. Réunion des musées nationaux, Paris: 10, 23, 24l, 25t, 26, 27, 32–3, 46, 48, 49, 71r, 72–3, 87, 88t, 90, 94–5, 98b, 99b, 101tl, 105b, 106, 107, 117b, 122–123, 128, 131t, 132–3, 135, 137tr, 138t, 142, 143b, 148t, 149, 153t, 158, 159, 170, 173, 175, 176, 182, 184l, 185r, 187, 188, 192, 193l, 197b, 198, 199, 201, 202, 205t, 210–11, 213t, 214, 225b, 227, 231b, 232–3, 234, 235, 240b, 241, 244, 245b, 246, 250, 251, 254–5, 256, 258, 259, 260, 261l, 262, 263r, 263b, 264t, 265, 269, 270, 271, 274, 276, 280, 282, 288, 289t, 292b, 297t, 298r, 299, 302b. Caroline Rose, Paris: 272. Royal Collection Enterprises, Windsor: 29b, 131b.

Scala, Antella (Florence): 83, 91, 98t, 174, 221, 224. Scott Bowron Photography, New York: 284b. Service départemental du Patrimoine de Seine-et-Marne, Dammarie-les-Lys-Yves Courtaux: 56t. Service des objects d'art religieux des églises de la Ville de Paris-J.-M. Moser and J.-C. Loty: 57; E. Michot and J.-C. Loty: 58t, 66–7, 88b, 89, 93, 108, 109b, 110br, 114, 200b. Société Labatut, Paris: 160. Sotheby's, Paris: 284t. Städelsches Kunstinstitut, Frankfurt/Ursula Edelmann: 302t. Stair Sainty, New York: 293. Studio Regard, Marseille: 75b. Trustees of the National Museums & Galleries on Merseyside, Liverpool: 225t.